3D Recording, Documentation and Management of Cultural Heritage

3D Recording, Documentation and Management of Cultural Heritage

Edited by

Efstratios Stylianidis
Fabio Remondino

WHITTLES PUBLISHING

Published by
Whittles Publishing,
Dunbeath,
Caithness KW6 6EG,
Scotland, UK

www.whittlespublishing.com

© 2016 Efstratios Stylianidis and Fabio Remondino

ISBN 978-184995-168-5

Thanks are due to the following for cover images:

András Patay-Horváth and Gábor Gedei; Guidi, G., Remondino, F., Russo, M.,
Menna, F., Rizzi, A. and Ercoli, S.; Michael Doneus; and the Zamani project.

Printed by

Contents

Preface

Cultural heritage is the lasting remains of our cultural tradition. It is the harmonious blend of art, philosophy and technology worldwide, and the outcome of various factors working together, influencing humanity for generations. Cultural heritage is a representation of our history and our identity; our affiliation to the past, to our present, and the future for the next generations.

When we refer to cultural heritage we often bring to mind artefacts such as paintings, prints, drawings, mosaics and sculptures, historical monuments and buildings, as well as archaeological sites. Nevertheless, the notion of cultural heritage is even broader and it has gradually developed to include all the expressions of human ingenuity represented by images, documents, instruments, etc. Nowadays, the natural environment, towns and underwater heritage are also considered as an integral part of cultural heritage.

Moreover, cultural heritage represents not only physical objects that we can see and touch. It also consists of intangible heritage such as music, dance, traditions, oral history, performing arts, and even knowledge and skills transmitted from generation to generation within a community.

The protection of all kinds of cultural heritage has been a common concern of mankind for many years. Civil wars, terrorism, the difficult relationship between the interests of the individual and the community, are the most challenging obstacles in this process. But protection is a necessity. Cultural heritage is passed down by our ancestors to the current generations and must be preserved for the benefit of all.

Recording and documenting cultural heritage is a fundamental part of the process in its protection and sustainable management. The aim of *3D Recording, Documentation and Management of Cultural Heritage* is to contribute to this endeavour by reporting the latest developments in conservation and 3D modelling. The book is divided into the following chapters:

Chapter 1 discusses the current trends in cultural heritage documentation and explains the challenges and recommendations regarding the selection of the appropriate technique.

Chapter 2 focuses on conservation techniques used in the cultural heritage field.

Chapter 3 reviews the role of GIS and BIM as management tools in cultural heritage.

Chapter 4 presents an extensive treatment of the basics of photography for cultural heritage imaging.

Chapter 5 considers image-based 3D recording and modelling of cultural heritage, with particular attention to the photogrammetric technique.

Chapter 6 delivers basics in range-based recording and modelling techniques in cultural heritage.

Chapter 7 introduces the use of RPAS/UAV for cultural heritage documentation.

We hope that you enjoy reading the book but also that you find it informative, stimulating and of practical use.

Efstratios Stylianidis and *Fabio Remondino*

The Authors

Michael Doneus is Professor of landscape archaeology at the Department for Prehistoric and Medieval Archaeology at the University of Vienna. He specializes in archaeological prospection and remote sensing. Since 2010, he has been deputy director of the Ludwig Boltzmann Institute for Archaeological Prospection and Virtual Archaeology (LBI ArchPro). Since 1996 he has been actively engaged with CIPA where he held the positions of secretary general and vice-president.

Rand Eppich is a practising architect and researcher whose focus is economic and community development through cultural heritage. He has led development and conservation projects in Cyprus, the Balkans, Latin America and the Middle East for UNDP, IDB and EuropeAid and has collaborated with UNESCO, Cultural Heritage without Borders, ICCROM and ATHAR - Architectural-Archaeological Tangible Heritage in the Arab Region. He was senior project manager at the Getty Conservation Institute where he founded the Documentation Lab to record cultural heritage sites and edited the two-volumes *Recording, Documentation and Information Management for the Conservation of Heritage Places*. He received a masters in architecture and an MBA from the University of California, Los Angeles, an undergraduate (BArch) with a focus on preservation from LSU and is writing his PhD at the Universidad Politécnica de Madrid. His teaching includes coordinating courses at UCLA, ICCROM and conducts lectures at the Built Heritage & Stone Conservation courses at ICCROM, at ATHAR, The Raymond Lemaire International Centre for Conservation, KU Leuven and University of Pennsylvania. He is a member of ICOMOS CIPA.

Andreas Georgopoulos is professor of photogrammetry in the School of Rural & Surveying Engineering of NTUA (National Technical University of Athens). He graduated from the School of R&S Eng (1976), obtained a Diploma (1977) and an MSc and later (1981) a PhD in photogrammetry from University College London, where he first taught photogrammetry. Since 1985 he has been a faculty member of NTUA teaching photogrammetry, metrology, photographic data acquisition, monument surveys, etc.

He has been director of the Laboratory of Photogrammetry since 1996 and has served as Vice Head (1998–2002) and Head (2002–2006) of the School and Vice-President of the NTUA Research Committee (2006–2010). Since 2005 he has been an executive board member of CIPA-Heritage Documentation, serving as Secretary General (2011–2014) and as President since 2015. He has published more than 200 scientific articles in conference proceedings and peer reviewed journals. His research interests focus mainly on geometric recording of monuments using contemporary techniques.

Pierre Grussenmeyer is professor at the department of civil engineering and surveying at INSA (Graduate School of Science and Technology) Strasbourg, France. Since 1996, he has been chairing the Photogrammetry and Geomatics Group at INSA, currently affiliated to the ICube UMR 7357 Laboratory of the University of Strasbourg. His current research interests include close-range architectural photogrammetry and laser scanning for cultural heritage documentation, mobile mapping technology, integration and accuracy of data in 3D building models. He has been a CIPA executive board member since 1999, and organized the 24th CIPA Symposium in Strasbourg in 2013.

Tania Landes is associate professor at the department of civil engineering and surveying at INSA (Graduate School of Science and Technology) in Strasbourg, France. She is currently director of the department of surveying and the Photogrammetry and Geomatics Group (PAGE) of ICube UMR 7357 Laboratory at INSA Strasbourg. Her research interests include the processing and assessment of laser scanning for 3D building modelling, for cultural heritage documentation and for urban microclimate studies. She is director of publications and a member of the editorial board of the XYZ Journal of the French Surveyor's Association. She also recently joined the executive board of CIPA as an associate member.

José Luis Lerma is Dr. Eng. in geodesy and cartography from the Universitat Politècnica de València (UPV), Spain. He was appointed associate professor of photogrammetry at the UPV in 2003. He is a specialist in the documentation of cultural heritage. He is author of seven books on photogrammetry and laser scanning, and has extensively published scientific papers in subjects related to imaging, range and multispectral sensors in the field of engineering and architectural-archaeological heritage. Nowadays, he is the Coordinator of the PhD programme in Geomatics Engineering, the Editor-in-Chief of the *Virtual Archaeology Review* and the treasurer of the Internatiuonal Scientific Committee of CIPA Heritage Documentation.

Anna Osello obtained her degree in building engineering from Politecnico di Torino, Italy in 1992 and her doctorate in drawing and survey of buildings in 1996 from l'Università degli Studi la Sapienza in Rome, Italy. Since 1999 she has been associate professor of drawing at Politecnico di Torino where she coordinates the laboratory 'drawingTOthefuture' (http://www.drawingtothefuture.polito.it/) with the goal

of carrying out theoretical and applied research on the issues of BIM and software interoperability. She is presently engaged in several research projects, including Smart Energy Efficient Middleware for Public Spaces – SEEMPubS and DIMMER (District Information Modelling and Management for Energy Reduction).

Mario Santana-Quintero has degrees in architecture and conservation of historic buildings and is an assistant professor at the department of Civil and Environmental Engineering, Carleton University teaching architectural conservation and sustainability. He is also an associate at the Carleton Immersive Media Studio Lab (CIMS) and director of the NSERC Create program on Heritage Engineering. He is a guest professor at the Raymond Lemaire International Centre for Conservation (University of Leuven) and in recent years has taught at the Universidad Central de Venezuela, Universidad de Guadalajara (Mexico) and Universidad de Cuenca (Ecuador). He was a professor at the University College St Lieven and lecturer at the University of Aachen RWTH and the Historic Preservation Programme at the University of Pennsylvania between 2006 and 2011. Along with his academic activities, he serves as an ICOMOS board member and is past president of the ICOMOS Scientific Committee on Heritage Documentation (CIPA). Furthermore, he has collaborated in several international projects in the field of heritage documentation for UNESCO, The Getty Conservation Institute, ICCROM, World Monuments Fund, UNDP, Welfare Association, and the Abu Dhabi Authority for Culture and Heritage.

Fabio Remondino received his Laurea degree in environmental engineering (1998) from Politecnico of Milano, Italy. In 2006 he received his PhD in photogrammetry from ETH Zurich, Switzerland. Since 2010 he has led the 3D Optical Metrology research unit in the Bruno Kessler Foundation (FBK), a public research centre in Italy. He has authored five books and more than 150 articles in scientific journals and international conferences, and has given more than 20 keynote lectures and organized around 30 scientific events. He is acting as CIPA Vice-President (2015–2017), EuroSDR Technical Commission I President (2013–2017) and ISPRS Technical Commission V President (2012–2016). He won 10 awards for best papers at conferences and he is Associate Editor for the *Journal of Cultural Heritage* and the ACM *Journal on Computing and Cultural Heritage* (JOCCH).

Fulvio Rinaudo graduated in civil engineering from the Politecnico di Torino, Italy and obtained his PhD on geodesy and cartography from the Italian Ministry of Research. He was appointed associate professor of geomatics at Politecnico di Torino in 1998. Since 2013 he has been full professor and since 2010 vice-coordinator of the Ph.D. School on Cultural Heritage. He has been a member of the CIPA-HD Executive Bureau since 2008 and co-chair and chair of ISPRS WG V/2. Until 2014 he was president of the Scientific Committee of the Italian Society of Photogrammetry and Surveying. He is a member of editorial committees of *Applied Geomatics* and *Virtual Archaeology Review*.

Minna Silver (formerly Lönnqvist) earned her PhD in archaeology at Helsinki University, Finland, in 2000 after pursuing an expert programme in GIS. Since 2004 she has been adjunct professor in Near Eastern Archaeology in Finland, and has served as assistant professor in archaeology in Mesopotamia, Turkey. In 2007 she became associate member of the CIPA executive board under ICOMOS (UNESCO) and ISPRS and in 2010 a full board member. Silver is author of over 100 articles, papers and several authored, co-authored and edited monographs and is the lead author of the archaeological chapter in *Manual of Geographic Information Systems* (ed. Madden) published by ASPRS. She has peer-reviewed numerous papers and has been an invited speaker at a number of scientific institutions. She has organised an extensive GIS course for the Antiquities Department of Syria (DGAM) and with Prof. Michael Doneus organized the CIPA workshop on Saving the Heritage of Syria in Vienna in 2016.

Efstratios Stylianidis received his diploma in surveying engineering (1996) and his PhD in photogrammetry (2001) from the Aristotle University of Thessaloniki, Greece. He is a member of various International organisations, such as ISPRS, CIPA-Heritage Documentation and ICOMOS. He served as Secretary General of ICOMOS Cyprus (2003–2009) and nowadays, he is acting as CIPA-Heritage Documentation Secretary General (2015–2018). During the last 20 years he has prepared one book, two theses and more than 60 scientific publications for peer reviewed journals, conference proceedings and contributions to books (invited book chapters). His research interests include photogrammetry and geo-informatics and he has participated in more 40 research projects, in eight as project manager and coordinator.

Geert Verhoeven graduated in archaeology in 2002 and received his PhD degree in 2009 from Ghent University (UGent, Belgium). Afterwards, he worked three years as a part-time professor at UGent teaching archaeological prospection and archaeological IT. In June 2010, he moved to Vienna to become senior researcher in the LBI ArchPro where he has been conducting research in airborne photography and imaging spectroscopy, archaeological image fusion and image-based modelling. Much of his work can be found in various international peer-reviewed papers and book chapters. He is also a CIPA expert member and member of AARG, ISAP and SPIE.

Abbreviations and acronyms

ABM	area-based matching
ADC	analogue-to-digital converter
AECO	architecture, engineering, construction and operation
ALS	airborne laser scanning
AR	augmented reality
BRDF	bidirectional reflectance distribution function
CA	chromatic aberration
CCD	charge-coupled device
CCM	colour correction matrix
CFA	colour filter array
CH	cultural heritage
CIE	Commission Internationale de l'Éclairage
CIPA	International Committee for Heritage Documentation
CMF	colour-matching function
CMOS	complementary Metal oxide semiconductor
CMOS APS	complementary metal oxide semiconductor active pixel sensor
CoC	circle of confusion
CRM	conceptual reference model
CS	coordinate system
CSC	compact system camera
CT	computer tomography
CP	control point
D-SLR	digital single-lens reflex
DC	dark current
DEM	digital elevation model
DGPS	differential global positioning system
DLT	direct linear transformation
DN	digital number

DNG	digital negative
DoF	depth of field/degrees of freedom
DR	dynamic range
DSC	digital still camera
DSM	digital surface model
DT	digital technology
DTM	digital terrain model
EDM	electronic distance measurement
EM	electromagnetic
EV	exposure value
Exif	exchangeable image file format
FBM	feature based matching
FoV	field of view
FPA	focal plane array
FWF	full waveform
GCP	ground control point
GIS	geographic information system
GNSS	global navigation satellite system
GPR	ground penetrating radar
GPS	global positioning system
GPU	graphic processing unit
GSD	ground sample/sampling distance
HBIM	historic building information modelling
HVS	human visual system
ICCROM	International Centre for the Study of the Preservation and Restoration of Cultural Property
ICOM	International Council of Museums
ICOMOS	International Council for Monuments and Sites
ICP	iterative closest point
ICT	information and communication technology
IFC	industry foundation class
IMU	inertial measurement unit
INS	inertial navigation system
IPTC	International Press Telecommunications Council
IR	infrared
ISPRS	International Society for Photogrammetry and Remote Sensing
IT	information technology
JPEG	Joint Photographic Experts Group
LCA	longitudinal chromatic aberration
LiDAR	light detection and ranging
LoD	level of development/detail
LRM	local relief model

MdGIS	multidimensional GIS
MIS	monument information system/management information system
MVS	multiview stereo
NCC	normalized cross correlation
ND	neutral density
NIR	near-infrared
NUV	near-ultraviolet
PCA	principal component analysis
PSF	point-spread function
RANSAC	random sample consensus
RPAS	remotely piloted aircraft system
RTI	reflectance transformation imaging
SfM	structure from motion
SI	Système International d'unités or International System of Units
SPD	spectral power distribution
SVF	sky-view factor
TCA	transverse chromatic aberration
TIFF	tagged image file format
TIN	triangular irregular network
TLS	terrestrial laser scanning
ToF	time of flight
UAV	unmanned aerial vehicle
UNESCO	United Nations Educational, Scientific and Cultural Organization
UV	ultraviolet
UVS	unmanned vehicle system
VR	virtual reality
VRML	virtual reality modelling language
WMF	World Monuments Fund
XMP	extensible metadata platform

Introduction – Current Trends in Cultural Heritage and Documentation | 1

Mario Santana Quintero and Rand Eppich

1.1 Innovation is human nature

Innovation is human nature. We are always searching for new tools – to move, entertain, automate and help us in all forms of work. Never before in our history have we been able to capture our memories, record our surroundings and communicate so rapidly, to so many people in such a wide variety of forms. We have a natural tendency to create, improve, and invent and are compelled to do so. Yesterday´s technology is old with funding and grants awarded to those who innovate with the next big idea.

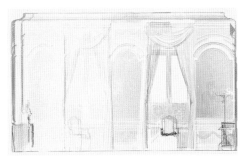

Figure 1.1 Recording a historic building using photogrammetry and laser scanning to record character-defining elements [Afrodoti Nerologou *et al*., 2014].

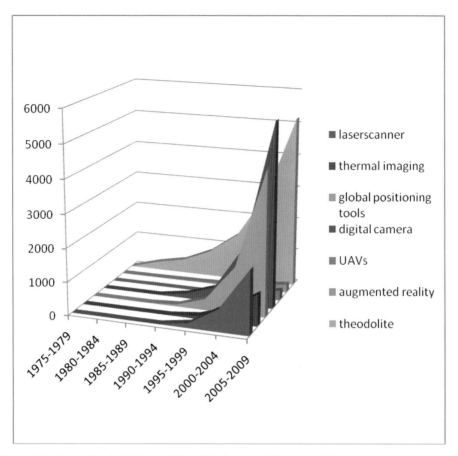

Figure 1.2 Analysis of articles published in the past 40 years with correlation between conservation and documentation technologies [Eppich and Hadzic, 2013].

Documentation of our cultural heritage is experiencing an explosion of innovation. New tools have appeared in the last decades including the laser scanner, rapid prototyping, high dynamic range spherical and infra-red imagery, drone photography, augmented and virtual reality and computer rendering in multiple dimensions. They give us visions and data that are at once seductive, intriguing and even sometimes deceptive. Their applications are used in conservation education, research, risk assessment, planning and design. The past generation had only the film camera, paper and pencil, tape measures and slide rules – now we carry computers with cameras in our pockets.

1.2 Innovation in contrast to conservation

To preserve is also human nature – we give values to places and things and wish to save, retain and pass on these ideals. Such places are our homes and communities and remind us of important events, people and families and bind us to our past and future generations. They are physical manifestations of our education, culture and history.

Figure 1.3 Conservation of cultural heritage sites is still firmly rooted in physical interventions and materials.

Conservation of cultural heritage is to save objects, architecture or historic places as they exist; to preserve authenticity, materials and values. By their very nature conservators work thoughtfully, with study and testing. They understand the significance of these places and objects and that their interventions in heritage must be careful and deliberate with every possible avenue discussed, debated and researched.

Herein lies the challenge. Conservation seeks to retain and protect the past while technology to document it rapidly advances. Innovations feed upon one another creating a widening gap – a gap between those who work in conservation and those who generate information [Letellier, 2001]. Communication through documentation, while seemingly becoming easier, simultaneously becomes more complex. Documentation of cultural heritage is at its core a means of communication but while new innovations make this documentation richer and multidimensional it has also made communication more difficult.

What can be done to ensure innovation in documentation is applicable and relevant to the conservation of our cultural heritage?

1.3 Current trends, challenges and recommendations

The first step is to identify the current trends and challenges related to conservation and the use of innovative technology for documentation technology. By understanding these trends and challenges, recommendations can be made to help close the gap

between documentation technology and conservation. Several overarching trends are identified below, and these are followed by recommendations directly related to each trend.

1.3.1 Trend 1 – Widening definition of the conservation profession

The conservation profession is undergoing a renaissance, becoming wider and more inclusive of different views and ideas besides purely physical interventions. These include the broader concepts of education, communication and interpretation [Smith, 1978]. The profession is truly multidisciplinary and includes not only architects and engineers but also historians, archaeologists, surveyors, curators and conservators specialising in a wide variety of fields as diverse as wall painting and mosaic conservation to site interpretation.

1.3.2 Trend 2 – Enlarging scale of cultural heritage

Preventive maintenance, monitoring, conservation, rehabilitation, and sustainability of cultural resources are crucial issues worldwide. The magnitude of the problem, the need for action and its urgency are motivated by a number of factors.

At the international level, according to the UNESCO World Heritage Convention, there are 1007 listed properties from 161 countries that have ratified this important international treaty and 46 of these sites are on the endangered list. Furthermore, there are an additional 1601 properties from 171 countries on the tentative list. Tentative lists of all member states must comply with the operational guidelines [UNESCO, 2013] and this list is growing every year as states seek to have their important sites added.

Focusing only on countries, regions and continents it is impossible to estimate the number of properties designated as 'heritage' by federal, provincial and local authorities in each country. Furthermore, looking at these places, a large number of them require some degree of documentation to identify risks, monitor their physical condition, assess their value and also understand their contribution to history and culture. These require management and conservation programmes for their protection in the short, medium and long term.

1.3.3 Trend 3 – Developing new themes in cultural heritage

In addition to the expanding scope of what is considered cultural heritage there are new themes and trends. One current important theme is energy efficiency. A newly constructed energy-efficient building cannot offset its embodied energy for many decades. Rehabilitating existing structures contribute to the reduction of the overall carbon footprint and may help mitigate the acceleration of climate change. Knowing how to document their performance and being capable of conducting these assessments is needed. Gelfand and Duncan state that: 'the vast majority of the buildings to be occupied during the next thirty years are already constructed, existing buildings are the most important places to realise big changes now and in the near future' [Gelfand and

Duncan, 2011]. M. Demas [2014] says that 'for those concerned with climate change and other environmental impacts, reusing an existing building and upgrading it to maximum efficiency is almost always the best option regardless of building type and climate, reusing existing buildings can offer an important means of avoiding unnecessary carbon outlays and help communities achieve their carbon reduction goals in the near term'.

1.3.4 Trend 4 – Increasing threats

However, built heritage is not the only issue. Movable objects and intangible heritage also suffer from abandonment, negligence and mismanagement, as well as looting and illegal trafficking. Although the problem is starting to be addressed, in order to develop and deploy advanced digital technologies, there is a pressing and critical need for interdisciplinary training among heritage specialists, authorities and stakeholders.

Peter Stone, chairman of the UK National Committee of the Blue Shield, explains that 'Accurate, complete, accessible, and secure inventories of all types of cultural property are an obvious requirement for the good management of such resources – which include archaeological sites, historic buildings, museums, archives and libraries. These inventories form the bedrock of most national legislation concerning heritage protection and are a

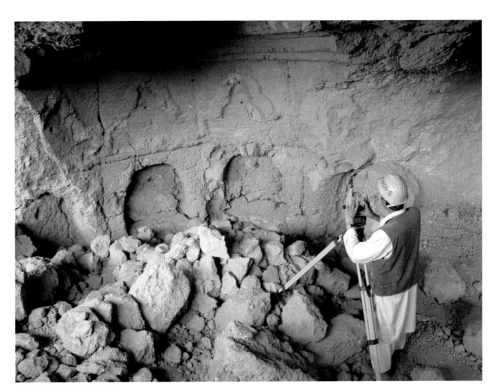

Figure 1.4 Recording the Bamyan Buddhas after their destruction from conflict.

fundamental element of many international conventions'. He argues that 'unfortunately, such inventories frequently exist only as aspiration' [P. Stone, 2014, 13–15].

1.3.5 Trend 5 – Increasing pace of innovation

As mentioned in the introduction, the pace of technological change is continuing to increase. This is the trend most responsible for the widening gap between documentation technology and its use in conservation. It is in the interest of the developers of technology to ensure the widest possible use by making easy-to-use tools. However, this is not always possible or may be delayed. There seems to be a significant lag between the increasing pace of innovation and training.

1.3.6 Trend 6 – Fragmentation of data

Ensuring that information is available for posterity to researcher and the public is a growing concern. From the Venice Charter (1964) to the latest CIPA Symposium, the issues of the need for adequate provenance information (e.g. metadata, ontologies, accuracy reports) and longevity (and integrity) of digital data are regularly discussed.

The explosion of data gathering has produced a highly fragmented and overwhelming amount of heritage information (e.g. 3D Point clouds, databases) available on the internet and elsewhere. The quality of this data is also frequently questionable.

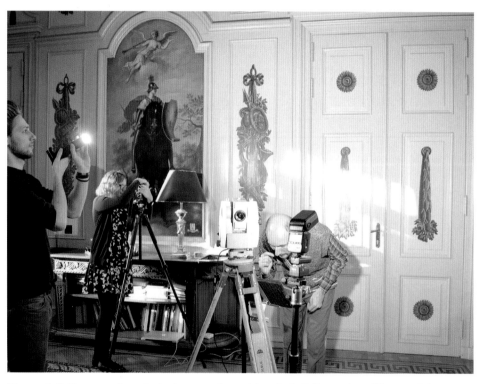

Figure 1.5 Conservation students recording a historic building using different digital tools and sensors.

The development or evolution of libraries to offer storage in digital repositories based on cloud technology seems a reasonable way to ensure that the heritage information generated by the private sector, educational institutions, government and non-governmental organisations can be hosted for posterity, as well as offering standards and guidelines on how that data should be characterised. But this remains uncertain.

These new innovations in storage and characterisation of data can potentially offer adequate answers to the following issues:

- Dissemination methods and sharing of locally produced data by different groups and organisations
- Lack of dissemination, transparency and interoperability between systems
- Information systems largely not based on recognised data structure standards
- Disconnection between information users and providers
- Lack of standardised methodologies and terminology
- Issues of digital information longevity
- Inadequacy of shared methodological approaches
- Lack of recognition and protection

It is important to ensure perpetual access to data and the ability to update the information if modifications or interventions occur to a site. It is also necessary to anticipate information that may be used in future conservation efforts at heritage sites, as well as to overcome data obsolescence (sustainability, functionality and adaptability) and the technical challenges associated (durability, knowledge and experience of material conservation, repair versus replacement).

To meet the pressing issue of heritage inventories, risk, and the need for sustainability, this publication seeks to provide knowledge and contribute to building capacity that can mitigate the inherent threats and external causes to cultural heritage by appropriate and accurate documentation. It is the authors´ belief that informed decisions are based on reliable information about heritage places, aimed at safeguarding the values of these places for future generations and preparing for the eventual need for conservation and regular maintenance.

1.4 Recommendations

In order to adapt to these trends, meet the upcoming challenges and address the widening gap, the authors suggest the following recommendations. These challenges are to apply new developing technologies for appropriate documentation to meet the needs of cultural heritage conservation.

1.4.1 Ensure that multidisciplinary teams are formed

As the profession, scope and concept of conservation becomes broader and more inclusive, it is a requirement that multidisciplinary teams be formed. This seems obvious. However, given various practical constraints, it is not always possible. Therefore, it is important that communication between multidisciplinary team members is clear to create strong networks of conservation professionals.

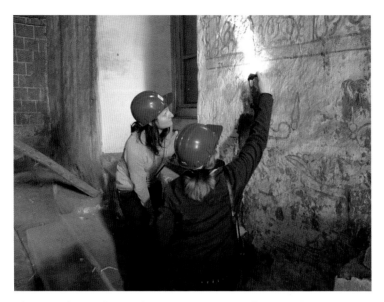

Figure 1.6 A team of recording and conservation specialists working together to create a glossary of weathering forms affecting the integrity of wall painting for its documentation using photogrammetry.

1.4.2 Establish principles, guidelines and specifications

Principles, guidelines and specifications for recording heritage information are extremely important. While there are currently such standards they are not widely acknowledged, adopted or used. Education of these standards is a key recommendation. These guidelines and principles must also be reviewed and re-established on a regular basis to maintain relevancy and reduce the gap previously discussed.

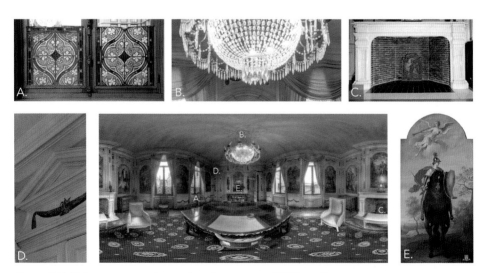

Figure 1.7 Referencing photographs of character-defining elements.

1.3.3 Engage communities

Sustainability is a key concept in conservation. While experts are absolutely necessary for most conservation and documentation projects, engagement of local community organisations can ensure that projects are sustainable. It is especially important for those with limited financial resources to keep up with the requirements of technology. There should be a plan to engage local professionals and build expertise in projects that utilise documentation technology. Collaboration between international and local institutions should ensure that the import of technology heavy recording instrumentation from developed countries must not be not allowed to dominate projects that could be conducted by local organisations.

1.4.4 Train and educate

Education seems an easy way to bridge the gap between conservation and technology. However, courses must have key elements including the necessity of including multi-disciplinary participants because conservation is so diverse. As technology is rapidly advancing, tools quickly become obsolete so training may quickly become ineffective. Therefore, there must also be an emphasis on principles in addition to specific use of any technology or technique. In addition, while theory is essential it must be supported by practical work on actual sites in order to understand the challenges in the field. Providing training to local educational institutions is very useful, but many organisations working internationally to preserve cultural heritage are completely independent from these organisations and often cooperation is secondary.

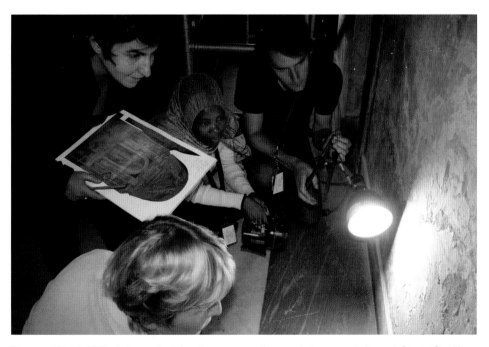

Figure 1.8 Multidisciplinary training in conservation and documentation at Santa Cecilia, Rome, Italy (courtesy Eppich & IRCROM).

1.4.5 Identify good practice

Many examples of good practice can assist in connecting technology with conservation. Often conservation professionals find it difficult to see how technology can be applied to their projects unless they are shown successful examples. Good examples must be identified, vetted then clearly described. Failures as well as successes must be included and it is also helpful to include budget considerations.

1.4.6 Focus on risk assessment and sustainability

Documentation of cultural heritage resources should also serve to demonstrate inherent features that make existing or historic sites more sustainable than new construction. This approach should extend beyond the acquisition of basic data and include information that covers its thermal performance and comfort, as well as the utilisation of indigenous materials and reparability of features.

Furthermore, preparing records of cultural heritage resources can contribute to the safeguarding of their values, especially in the case of potential conflict, decay or negligence in their conservation. However, documentation can also contribute to risk preparedness policymaking and evaluation of risk to the integrity of these resources.

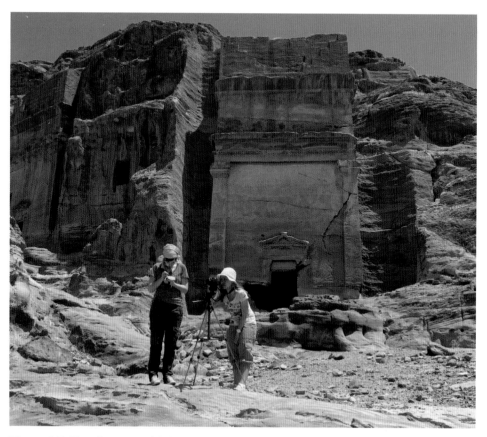

Figure 1.9 Mapping potential threats to the integrity of heritage places, Petra, Jordan.

For instance, integrated information systems that identify potential disturbances and therefore future threats can be very useful in decision-making processes in prioritising of actions that should be implemented to prevent cumulative or sudden damage, such as vandalism, looting, earthquakes or war.

1.4.7 Focus on value-centred assessment

When dealing with the conservation of cultural heritage resources, the relation between understanding significance and integrity plays an essential role. Figure 1.10 illustrates how values can be evaluated using a layered assessment approach. This uses physical and intangible aspects that define significance, which is evidenced by the degree to which those aspects (significance) are present in the fabric (integrity). This is a paramount shift in the way documentation should be conducted. It includes not only the preparation of measured drawings, 3D representations, photographs and any other graphic material, but is an approach that allows other experts identified to communicate what character-defining elements are currently present, and to what extent, in the geometric configuration. A good example of this type of assessment is the Nara Grid approach developed by Van Balen [2008] and based on the Nara Authenticity Document, where the attributes are confronted with dimensions generating a multilayered approach to define the statement of significance of any particular heritage place.

This approach is very effective, but requires careful study, sufficient historic information and a consistent approach. A combination of this study and measured records are used in the preparation of an evaluation plan.

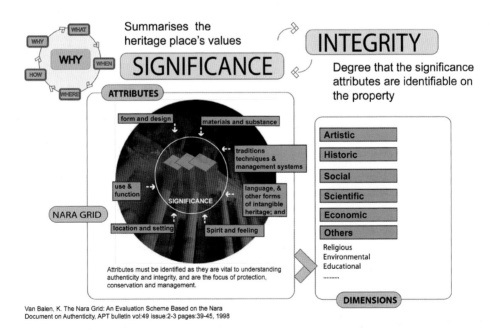

Van Balen. K. The Nara Grid: An Evaluation Scheme Based on the Nara Document on Authenticity, APT bulletin vol:49 issue:2-3 pages:39-45, 1998

Figure 1.10 Significance and integrity: assessing the values of heritage places [Van Balen, 2008, 39–45].

1.5 Conclusions

The application of new technologies for the recording, visualisation and documentation of cultural heritage resources is a powerful tool. However, the appropriate application must be used and the conservation team should access the conflicts and compromises of these techniques to deliver adequate and reliable information not only for the dissemination of information, but actually conserving them. A good selection and application of recording and documentation tools is assured when preparing a comprehensive approach derived from the conservation needs.

Furthermore, all records resulting from this activity should be integrated in a central repository and managed as part of an integrated project dossier, enabling longevity. It is also important to distribute and contribute the records to existing digital library initiatives to ensure transfer (and eventual update) of this information. In addition, the inclusion of appropriate provenance information must be considered. This will insure

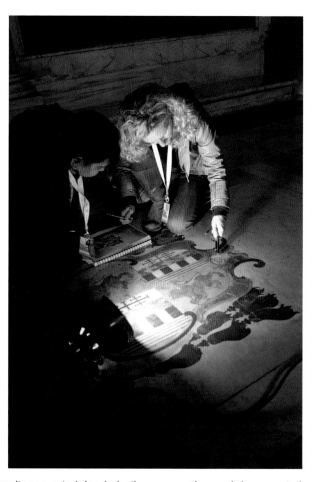

Figure 1.11 Simultaneous training in both conservation and documentation technologies is essential (courtesy Eppich & IRCROM).

that in the future there will be integrity and quality of those records (e.g. date of compilation, author, accuracy) to be judged.

Finally, a holistic approach, centred in the relevance of information to understanding the significance, integrity and threats to our heritage is of paramount importance. Values are a crucial concept in defining the extent and effective capturing and dissemination of knowledge of heritage places.

References

Afrodoti Nerologou, T.R., Rochez, M. and Seker F., 2014. Architectural heritage documentation for conservation workshop report on Recording the Mayor's Office at Leuven's City Hall, Raymond Lemaire International Center for Conservation, University of Leuven, Leuven, Belgium.

Demas, M., 2004. 'Site unseen': the case for reburial of archaeological sites. In: *Conservation and Management of Archaeological Sites*, vol. 6, Los Angeles, CA: The Getty Conservation Institute, 137–154.

Eppich, R. and Hadzic L., 2013. Heritage conservation – aligning technologies. In: *5th International Conference on Hazards and Modern Heritage*.

Gelfand, L. and Duncan, C., 2011. *Sustainable Renovation: Strategies for Commercial Building Systems and Envelope*.

Letellier, R., 2001. 'Bridging the gap' between the information user and the information provider. In: *18th International Symposium of CIPA*, Potsdam, Germany, 1–5.

Smith, J., 1978. The scope of heritage conservation, Conservation Technology Manuals, *Bulletin of the Association for Preservation Technology*, 10, 33–38.

Stone, P., 2014, War and heritage. *Conservation Perspectives: The GCI Newsletter*, 28, 13–15.

UNESCO, 2013. 01/26. *The Operational Guidelines for the Implementation of the World Heritage Convention*. Available: http://whc.unesco.org/en/guidelines/

Van Balen, K., 2008. An evaluation scheme based on the Nara Document on Authenticity, *Bulletin of the Association for Preservation Technology*, 39, 39.

Conservation Techniques in Cultural Heritage | 2

Minna Silver

2.1 From a moment to preserving the past in 3D

2.1.1 Encapsulating a moment in the past

In archaeology there is an approach called the 'Pompeii premise' [Schiffer, 1985] – the premise referring to the perception how completely the past recovered at archaeological sites may be understood. The idea is derived from the extraordinary preservation of the remains of the Roman city of Pompeii in Southern Italy covered under lava and pumice in the eruption of the Mount Vesuvius in AD 79 [Harris, 2007].

Pompeii and its sister city Herculaneum, both now World Heritage Sites, captured and encapsulated a moment in the past. Market places, theatres, baths, streets, houses with their interiors including libraries, and bakeries with fresh bread were covered and extraordinarily preserved [Harris, 2007]. A moment, even the pain of the escapers, was mummified in petrified postures, preserved in cavities that were cast into plaster in the 19th century. Now, X-ray techniques adapted from medical technology to archaeology, such as computer tomography (CT) scanning including 3D digitalization has been carried out for anthropological and palaeopathological studies of the petrified bodies from Pompeii that are cultural patrimony themselves [Lazer, 2009; Varea and Lemerle, 2013] (Figure 2.1).

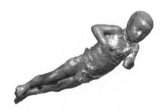

Figure 2.1 A digitised petrified body of a child in 3D from Pompeii. [Courtesy: S. Varea and J.-B. Lemerle 2013.]

However, neither archaeologists nor the public at large should be trapped in the 'Pompeii premise', the assumption that the information of the ancient sites and remains has been preserved in its relative fullness. The assumption is misleading, even though Pompeii and Herculaneum are exceptional sites for their excellent preservation. 'The time's arrow', cultural and natural agents have aged sites and remains differentially. The degree of preservation depends on a number of factors including environment, the reasons why and how the sites/monuments were abandoned and/or buried and what materials were involved. Pompeii is the world's longest ongoing archaeological dig, and the discipline of archaeology (definition *archaios logos*, discipline of antiquity) has evolved alongside it. Despite the detailed preservation discovered when remains were first exposed at Pompeii in 1748 followed by the excavations by J.J. Winckelmann [Harris, 2007], since then the deterioration of the site has speeded up because its buildings with frescoes and mosaics have been exposed to various threats. Current archaeological work in Pompeii focuses on the protection, preservation and conservation of the site [Lönnqvist, 2013].

UNESCO defines cultural heritage as 'the entire corpus of material signs – either artistic or symbolic – handed on by the past to each culture and, therefore, to the whole of humankind' [Jokilehto, 2005]. The concept of cultural patrimony also refers to valued things passed down from previous generations [www.oxforddictonaries.com]. The human legacy of ways of life can be expressed in tangible and intangible heritage. The tangible cultural heritage comprises natural environment, cultural landscapes, archaeological sites, historical places, buildings, monuments and artefacts including works of art worthy of protecting and preserving [UNESCO, Cairo]. The application of the most appropriate techniques, practices and methods in recording as well as documenting cultural heritage, are needed to ensure its protection and preservation.

Microscopic transillumination of a movable artefact has been a traditional way to reveal materials ranging from identification of stone, mineral content of ceramics and pigments to wood species and textile fibres. Now, there are various kinds of powerful microscopes available to carry out analyses in multiple ways. Since its invention by Röntgen in the late 19th century, transillumination with X-rays and later with gamma rays has been augmented with the modern techniques to be used in conservation, revealing structural features of remains in 3D. This has helped us understand the production process and deterioration of metal objects such as statues and weapons, and skeletons such as those in mummies [Riederer, 1987]. However, material science in itself is too large a subject to cover in this chapter.

The aim here is to offer an overview to the information about modern techniques that provide means to visualise tangible cultural heritage especially in 3D for recording and documentation purposes in conservation. Although the techniques that will be discussed in this chapter are chosen according to the target and the possibilities for digital and computer-based applications, the purpose here is not to provide comprehensive guidance in conservation methods using mechanical, physical, chemical or biological approaches to directly prevent decay, physically restore or repair a target.

When dealing with the recording and documentation of archaeological sites and monuments the use of International Core Data Standard by ICOM (International Council of Museums) is recommended [http://archives.icom.museum/objectid/heritage/int.html]. The CIDOC conceptual reference model (CRM) provides the standard definitions and structure to describe the implicit and explicit concepts and relationships used in cultural heritage documentation. CIDOC offers a semantic avenue for information sharing in the field of cultural heritage [http://www.cidoc-cm.org/].

2.1.2 Protection, preservation and conservation

The concepts such as *protection*, *preservation*, *conservation*, *restoration* and *renovation* are associated with actions taken to save cultural heritage. There are certain nuances in the words. *Protection* refers to safety and preservation from injury or harm. In the field of cultural heritage it often refers to preservation, and it may involve legally weighted protection and action. Legislation can protect artefacts and inhibit their removal. Landscapes, sites and monuments can all be under various degrees of protection expressed by buffer zones around them. In some computerised systems the zones or degrees of protection can be visualised, for example, in those based on Geographic Information Systems (GIS). Protection is also a term that is implicit in preservation and conservation in the broad sense of these terms.

Preservation and *conservation* are terms that are often used as alternatives to each other. However, there is some distinction between them. Preservation implies an action to save or protect something from damage, loss, destruction or decay. Conservation has a similar but sometimes more extensive meaning, comprising both protection and preservation. There are three types of conservation: preventive conservation, remedial conservation and restoration (Lat. *restaurare* > to restore). All the measures and actions of conservation and restoration should be reversible. Preventive action means slowing down the aging or deterioration process. Remedial action means helping the target recover and represent its original meaning. In restoration, all the actions that are applied to a stable target aim to achieve the state that facilitates its appreciation and use.

In the definitions of ICOM (International Council of Museums), conservation applies to all means and actions that aim to safeguard the tangible cultural heritage and ensure access to the target to present it and save it for future generations. The Getty Conservation Institute has provided various publications that concentrate on heritage conservation. François Le Blanc has collected a useful terminology of conservation online: www.icomos.org. The term renovation (Lat. *renovare* > to renew) is often incorrectly used interchangeably with restoration. Rather, it is a way to renew something old, and it does not necessarily have to bear ethical aspects of the preservation or conservation of old parts.

Apart from the mentioned recording and documentation, conservation can include mechanical, physical and chemical ways to treat various types of material. Recording and documentation of a conservation process is a modern approach to keep up scientific standards. A conservation notebook / lab notebook or database can be kept like a log

book to record and describe every step of the conservation procedure. This will help in future treatments of the target and also in the understanding of possible failures in conservation. The approaches and techniques to be used depend on the materials and their state of preservation.

The conservation of historic environment refers to the heritage conservation in town and country. The planning of heritage protection is at its core. The ethical approach to cultural heritage comprises all the ways to protect and preserve the material remains of humans. Antiquarianism is only part of the heritage conservation and its history, even with the cabinets of curiosities. However, its eventual conceptual connection to antiquities trade cannot be included into the ethical and scientific sphere of the protection and preservation of culture. The new approaches to heritage preservation and its required scientific standards emphasise that all the remains need to be studied in their context, if possible. The original context also provides the information, cycle and history of the remains that are needed for understanding the ways and purpose of conservation.

2.1.3 Three-dimensional view to the past

Clay and lime-plaster were basic media of the ancients in modelling objects in 3D, even starting a mass production by casting various materials, including metals, with moulds. The association with sculptors, coroplasts and clay-moulding was described in antiquity by Pliny the Elder in his *Natural History* (*HN* 35).

In Pompeii, the conservation of cultural heritage by documentation and recording in 3D has been used increasingly in the digital era. The focus on the 3D modelling of heritage data may have various purposes. It can reveal data that is hidden from the naked eye [Reilly, 1992]. The roots of visual 3D representations, however, are in the manual and analogue 3D applications in photography. F. Willème developed a way to produce the so-called photo sculpture in 1859–1868. He used two dozen cameras to reproduce object profiles that were reproduced on photographic plates. After the process they were projected onto a screen with *laterna magica*, the magic lantern. Then the images were moved to clay with a pantograph [Sobieszek, 1980; Moulden, 2009].

Stereo pairs of photographs have been used to create images in 3D for almost as long as photography has existed. Antiquities of Egypt and other heritage sites were documented by stereo photos in the 1850s and 1860s. The Sphinx and the Great pyramids in Giza were photographed by F.M. Good ca. 1860, the Temple of Philae, the sculptures of the Abu Simbel Temples were photographed by Francis Firth ca. 1856–1860 (Figure 2.2) and mummies brought from Egypt were documented ca. 1876 [www.photoarchive3D.org].

The largest stereo view collection of heritage sites is the Keystone–Mast Collection, archived and managed by the California Museum of Photography. The collection comprises over 250,000 stereoscopic glass-plates and film negatives from the period of 1870–1963. It is a valuable source for remodelling and for studying the changes in the sites and landscapes of cultural value [Schur and Kanngieser, 2006]. Stereoscopy is

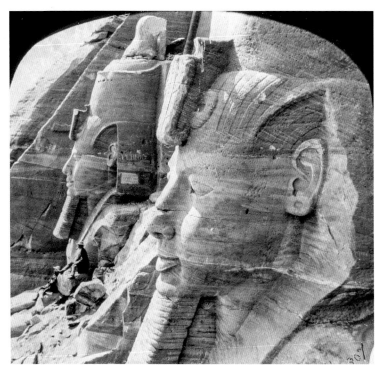

Figure 2.2 A stereophotograph of the Abu Simbel temple colossi of Pharaoh Ramesses II from Egypt. Photo: Francis Firth ca. 1856–1860. [Courtesy: Photoarchive3D.org.]

still used in documentation for displaying and analysing cultural heritage in 3D [e.g., Livatino *et al.*, 2006].

Modern technologies have changed the possibilities for recording and documentation of cultural heritage. Development of cameras (even the availability of 3D cameras), lenses and scanners, as well as computers and computer systems, programmes and software have provided the means for digital data capture, storage, mining and dissemination for decades. GPS (Global Positioning Systems), EDM/total stations and laser scanners have become increasingly used in data capture to build up models in ever-increasing detail, also providing possibilities for georeferencing. GIS (Geographic Information Systems) are computer-based systems for spatial data storage, mining, visualisation, dissemination and analysis. GIS is especially used in archaeological mapping and cultural heritage management [Lönnqvist and Stefanakis, 2009]. CAD/CAM, i.e., computer-aided design and manufacturing, such as used by AutoCAD software, has been applied for a long time in 3D modelling.

Laser scanners of various types, used on either static or moving platforms, on the ground or from the air, belong to the latest technologies providing powerful tools that have also enabled the use of new methods in documentation of landscapes, sites and artefacts also revealing features hidden from the naked eye and providing data for modelling in 3D. Used from any kind of platform laser scanners create a point

cloud consisting of the *x*, *y* and *z* coordinates in a coordinate system and present to the viewer a spatial distribution of the target. Laser scanners can be used in any type and stage of heritage documentation. There is a useful guide to the subject provided by English Heritage [https://www.english-heritage.org.uk/publications/3d-laser-scanning-heritage2/3D_Laser_Scanning_final_low-res.pdf]. Optical 3D scanners that are used for accurate object recording and documentation in 3D can be based either on laser beam or on structured light technology, so not all 3D scanners are laser scanners.

Computer-based visualisation has become the focus on the field in recent decades. Photographic and non-photographic (graphic) documentation are merging [Haddad, 2011]. Data visualisation aims for visual interpretation, and its boundaries are constantly expanding. It offers techniques that provide visualisation of solids, surfaces, properties and animations with graphics, image processing, visions and various user interfaces. It can involve numerically intensive computing, simulation and representation of multidimensional data [Reilly, 1992]. *The London Charter* [Beacham *et al.*, 2006; http://www.londoncharter.org] provides guidelines for intellectually and technically rigorous computer visualisation for cultural heritage, especially in 3D.

Nowadays, both image-based and range-based modelling can be applied to the digital documentation and preservation of cultural heritage. Four basic approaches can be distinguished in 3D modelling: image-based rendering, image-based modelling, range-based modelling and a combination of both image- and range-based approaches [Remondino and El-Hakim, 2006; Rizzi *et al.*, 2007]. The concept of a 'solid image' refers to the combination of traditional RGB radiometric data of an image with laser scanned data [Bornaz and Dequal, 2003]. The storage of digital data for cultural heritage is still a challenge. Contextual information needs to be attached to the objects that are stored [Moulden, 2009], for example, in a database created on GIS. The question of sustainability of digital data is a continuing issue to be solved. Encoding is needed to protect the data, enable its dissemination and make it usable in the future.

Virtual reality (VR) and augmented reality (AR) are concepts that are extensively used in the field of cultural heritage documentation and visualisation in 3D today. VR is a computer-based artificial reality which uses 3D models. One can immerse oneself into virtual spaces or worlds, and computer games are a large sector that applies VR. VR can be either strictly based on scientific data replicating the actual target or if more loosely created, it can only provide hypothetical reconstructions. VR can also be used to offer physical reconstructions of a virtual space or objects in 3D for presenting cultural heritage by using, for example, 3D printing technique. Archaeology uses scientifically reconstructed landscapes and sites as well as hypothetical reconstructions. It may apply various scientifically simulated situations, even simulating or replicating an excavation process. AR adds computer visions or interaction by artificial means to model data into natural environments or into photorealistic spaces or worlds. Virtual site visits, recreations in films, exhibitions and museums with interactive possibilities using 3D reconstructions and AR are part of today's ways to present and preserve cultural heritage. We can even talk about cyber-exhibitions and cyber-museums [Lönnqvist and

Stefanakis, 2009; Petridis *et al.*, 2005; Reilly 1992]. The principles of *The Seville Charter* aim to build a clear and rigorous basis for presenting cultural heritage virtually, especially archaeology [see Lopez-Menchero and Grande, 2011].

2.2 The duty to protect and preserve

2.2.1 Developments in protection

The duty of states and the public to protect and preserve their cultural heritage was perceived by a number of nations during the course of the 19th and 20th centuries. Several governments have included protection and preservation into their programmes and legislation. Because of the growing interest by foreigners in the Near East and the looting of archaeological sites, the Ottoman Empire passed an antiquities law in 1874 to govern the movement of antiquities out of its areas. The division of excavated finds between landowners, the empire and a foreign excavation team was regulated at that time. This practice continued in the laws of the mandate areas after the World War I. Before this, finds from Iraq, for example, were interpreted as international and were transported to foreign countries. Gertrude Bell drafted an antiquities law for Iraq to ensure a share for foreign expeditions [Kersel, 2010].

Since the first recoveries of archaeological finds along with the birth of archaeology as a discipline, the world has changed from European centrism to internationalism and globalisation, enabling the enlargement of our appreciation of diverse cultures and their heritage. Colonialism affected actions in a number of ways: it encouraged exploration and the accumulation of knowledge, but at the same time it changed and destroyed many cultures. Even the interpretation of the Great Zimbabwe and its ruins [see Ndoro, 2005] under colonial tones stripped African culture of its originality and innovative nature. D. Randall-MacIver's studies at the site changed the course of the tide. He concluded that the ruins of the Great Zimbabwe were not built by the Israelites or Arabs but by native Africans [Brisch, 2010]. Nations and ethnic groups, including tribal and aboriginal heritage, in Africa, Asia, America, Australia and Greenland have started to protect their sites. Now the ruins of the Great Zimbabwe, a World Heritage Site, with its large enclosure can also be visited virtually through a 3D model produced by the Zamani project [see http://www.zamaniproject.org/index.php/animations.html] (Figure 2.3).

Cultural heritage managers or antiquities authorities have been involved in developing legislation with governments aiming to safeguard heritage, ranging from landscapes, sites, monuments to portable antiquities in a number of countries. Surveys and excavations need official permission from the authorities. In the new amendments to the antiquities law of Egypt from 2010 the law abolished the share of finds for foreign missions and required all who have antiquities in their possession to come forward. Also, copying of artefacts 1:1 without permission was made criminal [Law No. 117 of 1983 as amended by Law No. 3 of 2010]. In the USA there is the Archaeological Resources Protection Act (ARPA) of 1979 which controls archaeological remains on public, federal or Indian tribal land [Shelbourn, 2008]. The Treasure Act 1996 of

Figure 2.3 The large enclosure of the Great Zimbabwe in Zimbabwe, laser scanned and modelled in 3D by the Zamani project. [Courtesy: Zamani project.]

Britain requires those who have a treasure in their possession to report it to officials. In British legislation the finders or/and landowners can be rewarded for a find. The Portable Antiquities Scheme in Britain offers a database [www.finds.org.uk] where researchers can access numerous finds [Bland, 2010].

2.2.2 Safeguarding bodies

Since the United Nations Educational, Scientific and Cultural Organisation (UNESCO) was established in 1945 it has worked as the central body in the worldwide venture to preserve cultural heritage. UNESCO provides statements, protocols and charters to guide the protection and preservation of landscapes, sites, architectural remains and portable antiquities. Intergovernmental organisations, especially those working under or with UNESCO in the field, include ICOMOS (International Council for Monuments and Sites), ICCROM (International Centre for the Study of the Preservation and Restoration of Cultural Property) and ICOM (International Council of Museums).

The World Monuments Fund (WMF) has goals partly comparable with those of ICOMOS to preserve the world's architectural heritage of significant monuments, buildings and sites. CIPA Heritage Documentation, originally the International Committee for Architectural Photogrammetry, is the joint organisation of ICOMOS and ISPRS (International Society of Photogrammetry and Remote Sensing) that develops the best technical means to preserve tangible cultural heritage. UNESCO, with its mentioned organisations or co-operating bodies, provides guidance as to the best approaches, studies and practices in protection and preservation. It compiles the lists of the World Heritage Sites of particular importance and nature for preserving the memory of humankind.

2.2.3 Challenges for protection and preservation

The 1960s was a period of great challenges in conservation and developing new methods in various frontiers. The International Charter for the Conservation and Restoration of Monuments and Sites, known as the Venice Charter, was laid out in 1964 and adopted by ICOMOS in 1965. The charter emphasises the setting of cultural patrimony as part of the site or monument that is inseparable from its history (Articles 1, 7), and that in the conservation and restoration of monuments best scientific and technical approaches should be applied (Article 2). Sculptural remains, paintings and decoration should be preserved *in situ* as an integral part of a monument only to be removed if preserving them on site becomes hazardous. The Charter guides how restoration work is carried out, with care based on archaeological and historical studies with respect to the original part of the monument and using the original materials, and if some parts are added they should be recognisable in the structural composition (Article 9). In the case that traditional techniques turn out to be inadequate, the consolidation can use scientifically proven modern techniques (Article 10).

The ICOMOS Sofia Principles [1996] provide guidelines for the recording of monuments, groups of buildings and sites. This refines the initiatives taken by the Venice Charter calling for consistency, integration and transparency in documentation in the conservation planning and heritage asset management in response to the cultural environment [www.icomos.org]. RecorDIM (Recording, Documentation and Information Management, An International Initiative for Historic Monuments and Sites) under CIPA was a five year (2002–2007) programme supported by the Getty Conservation Institute to improve recording standards and practice in heritage documentation. One can download online its publication by R. Letellier [2007] which provides basic guidelines and includes frameworks for the use of various tools and technologies with the target.

As the world is undergoing several transformations and threats to cultural heritage, ranging from natural catastrophes to wars and conflicts, from construction and urban growth to the gradual or accelerating speed of the climatic change (whether caused by natural effects or human agency), there is a need for constant vigilance and action. There are international organisations which act in the case of emergency. A couple of major actors are ICOMOS–ICORP (the International Scientific Committee on Risk Preparedness) and the Blue Shield. CyArk is an organisation that aims to digitally preserve 500 important cultural heritage sites that are at risk around the world [www.cyark.org]. As already indicated, *in situ* preservation of archaeological sites and structures is preferred, also stated in the European Convention for the Protection of Archaeological Heritage from 1969 and by the Valletta Convention from 1992. However, if there are natural or human threats to sites, they need to be assessed, and the remains may need to be removed to a safe place [Gregory and Matthiesen, 2012].

Unfortunately the recent wars in the Near East have caused damage to a number of sites and museums. The substantial looting of the Iraq Museum in Baghdad in 2003 is still vivid in the public mind. There can be no full return to the richness of the museum before the pillaging, because a number of artefacts representing the earliest

civilisation of humankind have now been lost. Illicit diggings and antiquities trafficking, today particularly noticeable in or from Iraq and Syria, are worldwide phenomena and there is extensive organised crime in the antiquities market [Dietzler, 2012]. The Islamic State of Iraq and the Levant (ISIS or ISIL) has fuelled its war through looting ancient sites and organising the trade of antiquities recovered from them. A number of organisations are now trying to protect the sites. Since 2006, eBay, the internet-based commercial site, has had an agreement with the British Museum, to notify the museum about the treasures traded on the site [Bland, 2010].

Some challenges in the history of conservation in the 1960s

Removing the temples of Abu Simbel

The removal of the Abu Simbel Temples (built by Pharaoh Ramesses II in the 13th century BC) from their original site in Egypt was a major endeavour of the recently founded UNESCO under the United Nations. The image of four colossal statues carved in sandstone in the façade of the Abu Simbel Temples in Assuan in Egypt is famous, as is the salvage operation for the monuments [Berg, 1978]. As mentioned above, in the 1850–1860s stereo photographs were taken of the temples in their original site, producing views in 3D (Figure 2.2).

A hundred years later, the temples were moved to protect them from the rising water of Lake Nasser due to the building of the Assuan dam. The project started in 1959, and the re-erection began in 1964. A commission set up to carry out the preservation worked actively for ten years. Vattenbyggnadsbyrå (VBB) in Stockholm, Sweden, with its engineers and architects, was set up to take care of the consultation. Over 50 nations contributed to the project that initially was to cost US$ 36 million [Berg, 1978]. Since then, archaeological salvage projects of other dams have taken place, for example, on the Euphrates in Syria and Turkey and on the Nile in Sudan, but none on the scale of the Abu Simbel temples.

The Venice and Florence floods of 1966

In 1966, flooding due to high tides and the flooding of the river Po destroyed art and damaged buildings in Venice. As a result, UNESCO started the Campaign for the Safeguarding of Venice. Several projects have followed, such as the MOSES Project of the Government of Italy [Moore, 2005]. Since 1984 the barrier system has been developed by engineers to protect against further flooding. Whilst Venice is unique, solving its problems has led to techniques and technology which can benefit a number of other sites also facing the possibility of flooding. Climate change is causing comparable new challenges to cultural heritage around the world [Fletcher and Spencer, 2005].

The flooding of the river Arno also created problems in the Florence region in Italy in the same year of 1966. The natural catastrophe led to a landmark in the development of art restoration. Flood threats raised public awareness of the need to save common

cultural heritage. The so-called mud angels, international teams of volunteers, helped to save cultural artefacts from the flood. The list of damaged works of art included hundreds of valuable paintings and sculptures. Libraries, archives and other institutions were stricken and 18 churches faced destruction [Maheu, 1967; Plenderpleith, 1967]. There were over a million waterlogged books and manuscripts [*The UNESCO Courier*, 1967]. After the flooding of Venice and Florence, conservation and restoration work moved to the public eye, and it was no longer a guild-like undertaking guarded by a few.

The Acropolis monuments

In the 1960s international scientists became alarmed that the standing Acropolis structures in Athens in Greece might collapse and become damaged due to pollution. In 1975 UNESCO and the Greek Ministry of Culture established a team called the Committee for the Conservation of the Acropolis Monuments (CCAM = ESMA) to lead the conservation and restoration of the Acropolis. This work followed the principles of the Venice Charter, with the possibility for the future removal of added materials and reversion to the original situation. These conservation and restoration programmess face both theoretical and practical problems. Most of the damage to the structures has been caused by human activity. Past fires, repairs, changes, explosions and even past restoration projects have harmed these unique architectural remains [Lönnqvist, 1998; Mallouchou-Tufano and Alexopoulos, 2007] (Figure 2.4).

Figure 2.4 The anastylosis work of the Parthenon in process on the Acropolis of Athens in Greece, one of the major projects supported by UNESCO. [Photo: Kenneth Lönnqvist 1991.]

Lifting the Vasa

One reason for the rescue of underwater archaeological sites and remains is the eventual looting that they face if they are left as unguarded and open sites. The 1960s was also the decade of important undertakings in the history of maritime archaeology. The lifting of the Vasa in Sweden in 1961 was a unique endeavour that began in the 1950s. This ship originally sank during its maiden voyage in 1628, and was recovered in the waters near Stockholm. Partly because of the salinity and temperature of the Baltic Sea, the ship was well preserved. The worms typical of warm waters were not a threat. However, it was decided that this ship was worth lifting [Cederlund *et al.*, 2006].

The excavation, documentation, conservation and display of the ship have been exceptional. The work has resulted in new understanding and the development of methods in the conservation of items to be rescued from the seabed. PEG, polyethylene glycol, had to be sprayed over the wooden parts of the ship for nearly twenty years as part of the conservation process. In several respects, the conservation of the ship and its contents needed experimental work as there was no previous knowledge. The contents of the ship, including food and rum in the sailors' mugs, have been of great interest to science and the public [Cederlund *et al.*, 2006]. A museum covers this famous ship in Stockholm, but the vessel is gradually deteriorating despite all effort.

2.3 Landscapes, sites and structures in 3D

2.3.1 Landscapes and contexts

A bird's eye view of a Swiss landscape in relief was first modelled in the 18th century by F.L. von Wyher (1716–1802). This miniature model, based on cartography, is one of the oldest and largest known landscape models and is a valuable piece of cultural heritage in itself. This unique model has been remodelled in 3D by photogrammetric documentation and study [Niederoest, 2003]. In archaeology General Pitt Rivers (1827–1900) also constructed wooden 3D models of archaeological structures and landscapes in Britain in the 19th century, including a barrow surrounded by a cremation cemetery [Bowden, 1991]. Before this, the Langweil model containing over 2000 buildings from Prague was created to reveal the detailed urban landscape of the city from 1826–1834. Furthermore, the model has been documented by a robot in great detail applying photogrammetric methods to produce a digital textured 3D model with fly-over animation [Buriánek, 2011].

There are various landscape values ranging from natural aspects and aesthetics to cultural impact. The study of landscape has its basis in geography, but its interests range from biosociology to the psychology of aesthetics. Fractal geometry has been used to analyse and study landscapes, because it upholds the patterns of nature [Perry *et al.*, 2008]. Humans can have both a visible and an invisible impact on cultural landscapes. They may have modified the natural landscape through various periods and time. Understanding landscapes and their changes is important for cultural heritage management, for landscape and site conservation as well as for academic research.

Environmental reconstruction[1] provides a means for understanding landscape evolution and changes from a long-term perspective. Landscape archaeology emerged as a sub-field of archaeology in the 1970s. C. Vita-Finzi [1978] emphasised that archaeological sites needed to be studied in their setting, which largely means their environmental and landscape setting. Nowadays the concept of 'context' is often preferred to that of 'setting'.

Urban areas consist of special types of landscapes that require particular methods of documentation and preservation. There are recommendations how to conserve/restore old architectural remains and preserve their cultural values in the urban context. For the preservation of the historical cities the previously indicated *Valetta Principles* by ICOMOS provide guidelines on how to integrate cultural heritage into an urban milieu. Measures have been taken for protecting and preserving several historical town centres around the world. The Old City of Beijing in the midst of masses is an example. Beijing was founded ca. 3000 years ago. The walls of the Forbidden City are still standing, and the modelling of the old parts of the city is under way with digital recording in 3D. Old photographs, maps and a wooden miniature from the 1950s are used as informative sources in the digital reconstruction. A spatial information management system is built on GIS to provide various layers in time to monitor the development of the Old City [Shi *et al.*, 2011].

Industrial heritage can be detected in many urban landscapes but also as separate industrial compounds materials. The main impact of the industrialisation is visible from the time of the Industrial Revolution in the 18th century as part of the human past. Industrial archaeology studies and works to protecting industrial landscapes and remains [Lewis, 1980]. The Volponi kiln, dating from ca. 1800 and situated in Urbino in Italy, has, for example, been studied archaeologically and documented in 3D in its landscape [see Agostinelli *et al.*, 2007]. The Tang-Rong brick factory in Taiwan was opened in 1913 and is one of the few remaining Hoffman kilns in the world. It has been under heritage investigation. Its chimney and brick structures have been meticulously recorded and documented architecturally, and simulation has been used to model structures in 3D. The bricks are documented in colour, and controlled damages are presented to carry out analyses [Lin *et al.*, 2011].

2.3.2 Applying remote sensing from air and space

The use of remote sensing equipment and methods to see landscapes, sites and structures from the data captured from space, air and under the ground is applied in surveying and prospecting [Scollar, 1990]. Remote sensing by aerial photography in various

[1] Environmental and landscape reconstructions have provided new approaches to understanding sites and other remains. Remote sensing methods are used as valuable techniques to study changes in topography, even recognising paleolakes and ancient rivers. Geomorphology, palynology or phytoarchaeology, zooarchaeology and palaeopathology of human remains are fields which are used in environmental studies aiming to find conditions of past populations. Proxy data is collected from soil and vegetation samples, and statistical methods are applied to analyse the data in order to trace climatic or environmental changes.

seasons and daylight conditions has revealed sites and structures since the earliest photographs from hot air balloons in 1858 [Brooks and Johannes, 1990]. Various possibilities for low-cost aerial photography are still utilised to record and document cultural heritage [Eppich *et al.*, 2011].

Crop-marks are traced in seasonal studies over agricultural fields. They serve as indicators which can reveal hidden remains not visible at ground level. They can provide impressions in 3D through favourable light conditions. Infrared (IR) black-and-white film has been used to distinguish various kinds of vegetation since before the World War II, and later using colour film [Brooks and Johannes, 1990]. Traditional photogrammetric methods applied to aerial photography, such as stereoscopy, can also reveal topography, sites and structures in 3D. Apart from aerial photography, remote sensing today uses instruments on other platforms, such as space satellites or shuttles that can also provide imagery and radar data as DEM (digital elevation model) tiles. Radar data has been provided, for example, by the X-SAR SRTM shuttle mission 2000 and by ASTER imagery. The data enables reconstruction of landscapes and views in 3D and view-shed analyses. The spatial resolution of the DEM tiles and imagery dictates whether the outcome of landscape models is accurate and photo-realistic [Lönnqvist and Törmä, 2003; Lönnqvist *et al.*, 2012].

Remote sensing based on DEM tiles from SRTM mission has been used to identify tell sites, ruined heaps of ancient towns or villages, and visible topographic mound

Figure 2.5 A photo-realistic 3D landscape model displaying the steppic area of Jebel Bishri in Central Syria constructed by fusing QuickBird and ASTER DEM image. [Courtesy: Jebel Bishri project, Markus Törmä 2013.]

forms in the flat Mesopotamian plain: 184 possible tell sites have been identified [Menze *et al.*, 2005]. A large archaeological area called Chan-Chan, an Inca site founded in the 9th century AD in Northwest Peru and now near the city of Trujillo, is at risk and has been surveyed and modelled using remote sensing methods. A survey has been carried out applying low-altitude photogrammetry and satellite image interpretation. The use of high-resolution QuickBird imagery was combined with a tacheometry and differential Global Positioning System (DGPS) [Fangi *et al.*, 2005]. Ancient roads, cart ruts and bridges have also become the target of several investigations and modelling in recent years. Roads have been traced by remote sensing including aerial reconnaissance, satellite image analyses and ground penetrating radar combined with field surveys. There has been documentations of roads within landscapes in 3D [Haggrén *et al.*, 2001; Lönnqvist *et al.*, 2005; Varea *et al.*, 2013].

Light detection and ranging technology known as LiDAR is the latest advance in the remote sensing of landscapes, sites and structures. It consists of airborne laser scanning (ALS) and terrestrial laser scanning (TLS), TLS being a ground-based device. In ALS a 3D laser scanner is attached to an aircraft. It captures elevation and intensity data on time reception and alternating reflections from various material properties. It is used for territorial mapping by applying efficient ways to produce high radiometric and spatial resolution. The system detects topographical features in 3D [Doneus and Briese, 2006; Moulden, 2009]. LiDAR enables creation of DEMs and digital terrestrial models (DTM) in high spatial resolution in 3D, and it provides new ways to study landscape topography [Sasaki *et al.*, 2008]. English Heritage (EH) has provided a useful guide for archaeological surveys using airborne LiDAR [http://www.english-heritage.org.uk/publications/light-fantastic.pdf].

By determining a point cloud of high density produced by full-length echo system one can trace sites and structures that preserve remains in relief even in forested areas [Doneus and Briese, 2006]. A project in Gloucestershire in Britain used LiDAR to trace Romano-British and Medieval signs of human activity in an area of which 118 km^2 was wooded land. An algorithm to remove vegetation was used revealing the micro-topography of the ground surface that is normally covered by woods. Features such as earthworks (enclosures, mounds, hill-forts etc.) of various kinds can be recognised and their borders defined in 3D [Hoyle, 2009]. In Britain the documentation of Stonehenge and its surroundings with LiDAR has opened up new ways to approach this World Heritage Site from the air and to understand the monuments in space. New structures and features have been exposed in 3D with this LiDAR survey [see http://www.wessexarch.co.uk/stonehenge?ex].

The application of LiDAR technology offers a way to protect and preserve ancient remains that otherwise would not be recognised and be put under protection, monitoring and conservation initiatives. However, as with the application of other remote sensing methods, one needs to carry out field work either by surveying or excavating in order to evaluate the attained data by identifying sites and structures and define their real nature and dating.

2.3.3 Penetrating the ground: searching for sites and structures

Geophysical methods are remote sensing applications increasingly used in field work, especially in prospecting and surveying. As with using remote sensing methods from space and the air, the detection of new and unknown sites or structures by geophysical means reveals sub-surface features in 3D, providing valuable information for landscape and site planning, especially for builders and construction plans. GPR (Ground Penetrating Radar) and magnetometers are perhaps the best known geophysical devices used to trace and study buried cultural heritage [see Scollar, 1990; Alcock and Watters-Wilkes, 2009]. Amazing results with geophysical methods have been achieved: for example, the identification of Pre-Columbian settlements under the pavements of Mexico City in Central America [Barba, 2003].

The effectiveness of GPR depends on the type of soil and the frequency (in MHz) the equipment antenna provides. GPR and the magnetometer can reveal walls and hollow spaces like tombs or tunnels under the ground and track their dimensions in 3D [see Scollar, 1990; Baturayoglu *et al.*, 2001; Eppelbaum and Itkis, 2003] (Figure 2.6). Earth-resistant area surveys may use a twin probe or twin electrode probe [English Heritage, 2008]. Electrical resistivity survey can pinpoint the true size and shape of subsurface features more clearly than a magnetometer [Baturayoglu *et al.*, 2001]. Seismic reflection methods are used in marine environments, but they have also been applied to the studies of some structures.

Floodplains and lands where isostatic changes are taking place at the coasts are areas where sites and landscapes may have been buried or submerged over a period of time. Bogs may now be covering areas of human activities in the past. V.Gaffney and his co-operators have developed methods to recognise and study submerged landscapes. GPR was used to find the pre-peat topography, and LiDAR and boreholes were utilised to estimate the depth of peat and take samples for radiocarbon datings. GIS software was applied in data modelling and manipulation. Neolithic timber trackways were modelled in Hatfield Moors in Britain in this way to the time when there was a dramatic environmental change and the woodland was disappearing, opening up wetland landscapes. The pre-peat landscape was modelled and radiocarbon chronologies for growth of peat were traced, showing that the site had once been situated at the edge of dry land [Chapman and Gearey, 2009].

A metal detector, another geophysical remote sensing device [Scollar, 1990], can be a useful technical aid for cultural heritage professionals in their field studies. This device is also used extensively by laymen, and it has unfortunately become a popular tool among looters. It needs to be emphasised that the application of a metal detector in field work has special implications as far as the find context is concerned, as the detectors only search for metal. Therefore, there should be special legislation restricting the use of such devices by laymen [English Heritage, 2008]. Metal detectors are especially popular in battlefield studies. Battlefields are landscapes which encompass information of human conflict in time [see for example Sutherland, 2005]. Normandy, the site of the World War II landings of the Allied forces, is a popular field for layman

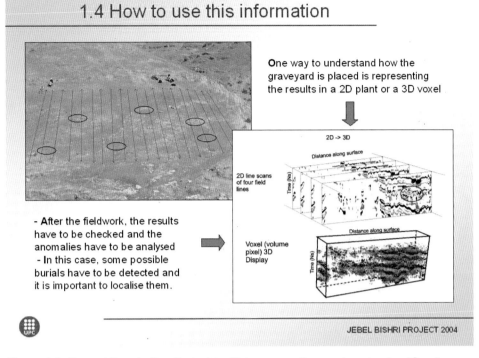

1.4 How to use this information

One way to understand how the graveyard is placed is representing the results in a 2D plant or a 3D voxel

2D → 3D

2D line scans of four field lines

Voxel (volume pixel) 3D Display

- After the fieldwork, the results have to be checked and the anomalies have to be analysed
- In this case, some possible burials have to be detected and it is important to localise them.

JEBEL BISHRI PROJECT 2004

Figure 2.6 Ground Penetrating Radar identifying anomalies, such as tombs. [Courtesy: Jebel Bishri project, Joseph Pedres-Rodez 2004.]

studies in which metal detectors are often used. All the battlefield finds need to be recorded and documented in their context, even if they are not from the period of the studied battle or are not under the antiquities law schemes. For example, a battlefield site such as Pointe du Hoc in Normandy has been professionally recorded, documented and studied using laser scanning and geotechnology [Warden *et al.*, 2007]. In all cases, researchers need to be aware of local legislation.

2.3.4 Digging deep at sites

As indicated earlier, the value of applying the tools and methods, such as GPS, DGPS and GIS, in the documentation and studies of cultural heritage has been recognised for decades. Archaeological recording is based on three dimensions, so the latest technical applications, such as TLS, can be applied to record and document stratigraphical excavations studying cultural layers. All the data can be imported to ArcView and ArcGIS [Doneus *et al.*, 2003].

The so-called 3D digging is under way in the Neolithic site of Çatal Höyük, a proto-city, in southern Anatolia, Turkey. The site provides evidence of some of the first agricultural and settled societies in the Near East. The first stages of the settlement date to ca. 7400 BC, to the Pre-Pottery Neolithic period. The site has been given the World

Heritage status. The settlement has a distinctive layout with back-to-back houses without streets as people moved over the roofs and had access from the roofs to their houses. Excavations have revealed a large number of wall paintings, reliefs and sculptures that provide information of the religious and symbolic world of the Neolithic people of the region. Laser scanners have been used in the recording and documentation of the site [Forte *et al.*, 2012].

Because archaeological digging destroys upper layers while the excavation is getting to lower levels, the 3D documentation of a dig preserves the layers that vanish. The Çatal Höyük project has integrated various 3D data recording and visualisation technologies. These techniques have been further integrated into virtual reality systems. All data is available at hand and approached from a remote position through the teleimmersive system. The data are set in internet and intranet using Vrui 3D web players [Forte *et al.*, 2012]. Dense stereo reconstruction tools can also nowadays produce precise models in 3D of a target starting from uncalibrated images. With the tools one can also document the evolution of an archaeological excavation using a digital camera and freeware software for data processing. This approach also provides a means to integrate 3D data to traditional documentation and offers tools for analysing the process of an archaeological excavation [Dellepiane *et al.*, 2012].

Multidimensional GIS (MdGIS) has also provided archaeologists with a new scientific way to use 3D in field work in both surveys and excavations (Figure 2.7). MdGIS

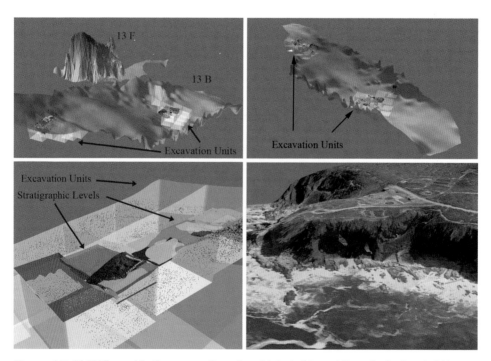

Figure 2.7 MdGIS used in the excavation of prehistoric Mossel Bay site in South Africa. [Courtesy: C. Marean and E. Fisher]

provides dynamic possibilities for visualisation, for example, the distribution of archaeological finds in space in 3D and therefore it helps to understand better their position [Fisher, 2005]. The Mossel Bay Archaeological Project (MAP) has been excavating a number of prehistoric cave sites on the southern coast of South Africa. The project has applied MdGIS to model archaeological deposits. The focus has been to understand the environmental changes in the life of *homo sapiens*. The huge amount of finds and their relationships were able to be quickly visualised, studied and spatially better understood through MdGIS [Fisher, 2005].

2.3.5 On-site conservation and site conservation

Heritage sites, whether excavated or not, require conservation management [see Demas, 2003; Sullivan and Mackay, 2013].The conservation of a site needs to be kept in mind when planning an excavation, and the effects of various interventions should be considered during excavations. DTM (digital terrain model) and accurate site plans help both during an excavation and also site conservation afterwards. On-site (*in situ*) conservation is an important approach, especially when structures and artefacts are exposed, for example, by an archaeological excavation. The treatment of finds and the consolidation of structures may need instant action. There is always a need for a first-aid kit. Atmospheric changes take place when closed deposits and structures with objects are revealed or opened, so deterioration starts. R. Payton's *Retrieval of Objects from Archaeological Sites* [1992] provides traditional methods for the first-hand conservation techniques of structures and lifting of vulnerable artefacts. More recent guidebooks for *in situ* conservation include Pedeli and S. Pulga's *Conservation Practices on Archaeological Excavations: Principles and Methods* [2014].

Knossos, in Crete, the Bronze Age Minoan palace from the 2nd millennium BC commonly called the Palace of Minos, is an early example of site conservation endeavours *in situ*. The palace was excavated by A. Evans from 1900. The aim was also to reconstruct the palace at the site. The use and interpretation of the materials in conservation and restoration, such as concrete, as well as the interpretation in reconstructing frescoes have been criticised over the years [Hitchcock and Koudounaris, 2002]. The approach is not consistent with present-day conservation philosophy but, despite heavy conservation interventions for the reconstruction of the site, it has endured tourist masses quite well and provided a visual interpretation of the past for generations.

The ancient city of Urkesh identified as Tell Mozan in Syro-Mesopotamia has provided a large royal Bronze Age palace of Tupkish built of mudbricks dated to the 3rd millennium BC and conserved *in situ*. Mudbricks are especially vulnerable to atmospheric changes and erosion. The snow and wind in the winter time and heat of ca. 50°C in the summer made the conservation plans very challenging. The construction of a roof or a canopy over the palace to protect it would have also caused the collapse of the palace elements. A system based on metal structures and latticework covered by waterproofed tarp was developed. The system provided a cover for the walls immediately they were revealed. After ten years it was seen that the system worked well, preserving the mudbrick walls. Objects were documented in their contexts [Buccellati *et al.*, 2005].

Göbekli Tepe, situated in southeastern Turkey close to the city of Urfa, is the site of the 'World's oldest temple' discovered through excavations in 1995 based on earlier surveys. The main structure dates back to the Early Neolithic period (the 10th and 9th millennia BC) [Schmidt, 2012] and has proved a particular challenge for site restoration and conservation work. A laser scanner has been used for documentation in 3D by Christofori & Partner with the German Archaeological Institute during the excavations [www.christofori.eu]. The whole temple area has been covered by a temporary wooden and roofed structure or canopy that is a major work taken up in 2012–2015 to preserve the site [Schmidt's lecture, 2 June 2014, in Gaziantep]. Wooden bridge-type ways have been constructed for visitors to see the temple. The various periodic layers of the temple are presented using wooden shelves.

The consolidation of T-shaped steles or pillars incorporating early images of animals cut in relief inside the temple is ongoing (Figure 2.8). The steles have also been documented by 3D laser scanning technology. Pillar 35 has been reconstructed virtually from broken pieces and appears to have been 5 m in height. The conservation of the pillars is not a problem but the walls which include mud that can be washed away by rains have been a challenge. Harran University has tested various mortars for wall preservation. Small plastic particles have been inserted into the mortar used in conservation to differentiate the new material from the old mud cover [Schmidt's lecture, 2 June 2014, in Gaziantep].

Figure 2.8 *In situ* consolidation of a T-shaped stele in the Neolithic temple of Göbekli Tepe in Turkey. [Photo: K. Silver.]

2.4 Prehistory in Mind

2.4.1 From the first foot prints to rock art

New ways to record art

Reflectance transformation imaging (RTI) is based on polynomial texture mapping (PTM), developed by Hewlett Packard. The technique has been used in 3D modelling of the oldest human footprint (780,000 to 1 million years old) in Europe found on the coast of England [Wong, 2014]. RTI can nowadays be divided into various approaches: microscopic RTI, multispectral RTI, infrared RTI, transmitted RTI, transillumination RTI and transirradiation RTI. Highlight-RTI is also sometimes called the 'Egyptian method'. This is actually a 2D or 2½D recording method that reveals information about 3D objects and surfaces [Dellepiane *et al.*, 2006; Mudge *et al.*, 2006].

RTI is especially well suited for documenting rock art, such as geoglyphs, petroglyphs and graffiti that have been executed in hard surfaces by carving, incising or scratching. English Heritage has produced the booklet *Multi-light Imaging for Heritage Applications* [2013] which provides information and practical guidance in recording and documentation of graffiti, rock carvings and worked bone. The booklet can be downloaded from the English Heritage website [www.english-heritage.uk.org]. It deals with previously mentioned RTI techniques, especially PTM. Information on the user-friendly method to capture with Highlight-RTI is provided. PTM uses multiple photographs from one stationary position, and a special software re-lits the object so that the surface texture becomes prominent. This enhances the visibility of even faint marks.

Geoglyphs, petroglyphs and pictographs

The Nasca lines are some of the most famous geoglyphs, large drawings over landscapes, in the world and are on the World Heritage List. They are enormous zoomorphic figurations in the Nasca plains in Peru that can be best approached and visualised from the air. The figures can be up to 200 m in size, and trapezoids and straight lines in the plain may be several kilometres long. The lines belong to the so-called Nasca culture dating between ca. 400 BC and AD 500 [Bahn, 1997; Cumo *et al.*, 2005]. The Nasca–Palpa project has collected data of the lines producing a data model for GIS-based analyses. The data model was not restricted to a particular GIS package, but the project has found ArcGIS software especially useful in their work. 3D models have been produced of the lines based on aerial photographs and their digitalisation. The models have been produced by computing symmetrical elevation silhouette skeletons of the drawings following an implicit function interpolation of the data that was produced by the silhouette and the skeleton. The interpolation created soft contours for organic shapes. 3D modelling of the various fantastic animals has made their shapes more visible [Bahn, 1997; Cumo *et al.*, 2005; Lambers and Sauerbier, 2003].

Spanish teams have been recording and documenting rock art in Galicia, in the northwestern part of the Iberian Peninsula. The art dates from the Bronze Age and

consists of petroglyphs representing animals, humans, weapons and geometric pat-terns The research team has been experimenting with photogrammetric approaches. It has acquired data with a low-cost digital camera and applied the use of worksta-tion Photomodeler Pro that includes DSM (dense surface modelling) module. A more costly device was used by acquiring point cloud data with a laser scanner mounted with a digital camera. With topographic equipment, point clouds were connected to the global coordinate system and orthoimages were produced. When a polygonal 3D model was achieved the texture was projected over the model [Riveiro *et al.*, 2011].

A polishing technique was originally used in executing one type of Pre-Columbian rock art on the beach of Santinho in the city of Florianópolis in Brazil. Photogram-metric data acquisition was carried out at the site, after which images were processed using SSK of Z/1 Imaging Image Station Photogrammetric Management to document the rock surfaces. Next, the Image Station Digital Photogrammetric Mensuration was carried out, and MicroStation software was used to edit the images. 3D models of the rock art were displayed using Image Station Stereo Display [Miranda Duarte and Von Altrock, 2005].

Aboriginal petroglyphs and pictographs have been surveyed extensively in Aus-tralia. One project used a cheap digital camera producing accuracy of ± 3 mm resolu-tion, high-resolution DEMs and orthophotos [Chandler and Fryer, 2005]. Stereopairs of digital photographs have also been used to record, document and visualise rock art. A scale bar or 3D coordinated targets applying theodolite or reflectorless EDM (Elec-tronic Distance Measurement) were used with photogrammetric software to produce DEMs, orthophotos and fly-over models. It was the first time that such approach was used for the documentation of the kind of petroglyphs and pictographs produced by Aboriginals [Chandler and Bryan, 2007].

Specific approaches to cave sites

As indicated, the application of TLS has proved benefical in the documentation of cave sites, also known as grotto sites, for the purpose of the information preservation, conser-vation and even virtual reconstruction. Cave sites vary in their nature and size and may have been in use during prehistoric or/and historic times. The kind of site may be difficult to enter and work on, and therefore portable equipment is often the best solution. The surfaces of caves may be irregular and can comprise speleothems, which in return requires special care in recording and documentation. In the areas vulnerable to earthquakes, caves can become damaged or even destroyed. Fissures can also be caused by other geolo-gical processes. So, there is always need for information preservation. Also, after opening caves for visitors and researchers the changes in atmospheric conditions, calcification and growth of micro-organisms, the surfaces, eventual paintings, petroglyphs, pictographs and sculptures can deteriorate and the threat to their state and existence can be acceler-ated [Beraldin *et al.*, 2006, 45–52; Brunet and Vidal, 1981; Pattyn, 1981].

It may sometimes be necessary to close a cave to the public for one reason or another. New technologies can produce full views and models of caves and their interiors in 3D

(Figures 2.9 and 2.10), including the detailed data of the surface textures and colours. These sites can be brought back as a 'virtual restoration' to the public to visit. The high-tech reconstruction of the Altamira caves in Spain is one of the most famous endeavours to record and document a cave site for its virtual presentation. The caves are famous for their beautiful Palaeolithic paintings and were open to the public until 1970, but the hoards of visitors changed the temperature and humidity in the caves, endangering the famous rock art [Beraldin *et al.*, 2006, 45–52]. Therefore, the initiative was taken to build a replica as a 3D reconstruction so that visitors could experience the size of the cave and admire its paintings. 3D Systems software was used to bring the image data to the shared coordinate system and build a 3D model through the process of registration and data merging. The produced model and CNC (computer numerical control) milling machine were used for making foam blocks on walls. Wax and silicon moulding

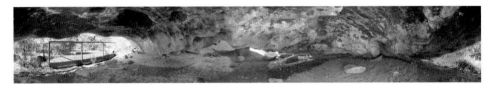

Figure 2.9 A stitched panorama image of a cave comprising Aboriginal art in Australia. [Courtesy: C. Ogleby.]

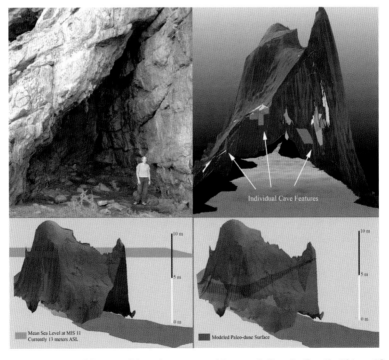

Figure 2.10 The Mossel Bay prehistoric cave and its modelling in South Africa. [Courtesy: C. Marean and E. Fisher]

were used to reconstruct the cave surface. Artists completed the replica with paintings using original types of pigments [www.rapidform.com/altamira-cave].

The 3D scanning of the caves and parietal Palaeolithic art at the cave of Parpalló in Spain has also produced laser scanned data that preserves the site and its cultural value for posterity [Lerma *et al.*, 2010]. The Grotta dei Cervi in Italy is a cave decorated with rock art and used in the Neolithic period, and Canadians and Italians have recorded and documented the site capturing 100 GB of 2D and 3D data for modelling. A 3D model was produced from a mosaic consisting of 3D image sections. 2D photographs were produced from difficult areas in high-resolution (4500 × 3000 pixels). High-resolution photographs were manually mapped on a 3D object using software package such as TextCapture [Beraldin *et al.*, 2006, 45–52].

2.5 Sacred spaces of Ancient Greece and stumbling blocks

2.5.1 The Acropolis – the crumbling sacred rock of the Athenians

The rock under the Acropolis of Athens, a World Heritage Site, is crumbling. The rock platform is the base upon which the famous Propylaia and the temples such as those of the Parthenon (Figure 2.4), Erechtheion and Athena Nike, were erected in the 5th century BC, during the golden era of Greece. A large boulder fell out of the rock in 2014. Crumbling and erosion have constantly affected the surface and stability of the area. The slopes were strengthened commencing in 1979, but the 1981 earthquake prompted the need for more comprehensive consolidation work that continued until 1991. Various projects have inserted anchors and wires made of chrome, molybdenum, nickel and titanium into the rock. Masses of tourists have resulted in a cumulative effect that has needed special arrangements: for example, to plan the pathways. More recently teams from the Central Archaeological Council have been investigating the area, and since 2014 they have found more instability in wide areas of the Acropolis rock. The southern areas need to be further consolidated as they have suffered due to the water pipes of the museum on top [Korres, 1994b; Lönnqvist, 1998; http://phys. org/news/2014_10-acropolis-crumbling.html].

The *anastylosis*, the raising of the fallen marbles from the Acropolis structures to their original place, has been ongoing for decades. A number of architectural members appear built in the walls as reused material. During the consolidation works and archaeological excavations a lot of remains belonging to the sacred structures have also been discovered. But some parts, like friezes of the Parthenon, were acquired by Lord Elgin in the 19th century and transported to England, where they are still on display at the British Museum [St. Clair, 1972]. These so-called Elgin marbles are at the centre of repatriation debates in the field of cultural property. Greece has repeatedly requested their repatriation.

The first photogrammetric studies on the Acropolis were carried out in the 1970s. Since that time orthomosaics based on elevation information and 3D phototextured models have been used in the archaeological and architectural conservation as well as restoration work. More recently 3D surface models have been produced with laser scanners [Moullou and Mavromati, 2007]. The database for the restoration of the Acropolis

was established during the conservation and restoration work of Erechtheion in 1987 using Sigmini software. However, after the restoration the software was changed. The new database called EsmaTool was developed in 1996/1997. It includes four archives: architectural members, photographs, drawings and texts [Mallouchou-Tufano and Alexopoulos, 2007].

A special project was set up to take care of the surface conservation of the monuments. The monuments have been constructed of Pentelic marble, and their deterioration was due to mechanical, physical and chemical agents in addition to pollution and the impact of microclimatic conditions and microstructure of the stone material. Gypsum has covered some areas of the marble. The colours of polluted areas have become modified. A special method to clean the surfaces of stone structures has been developed along with their conservation using laser beams, which have made combination of several methodologies possible. Infrared radiation technique used in cleaning has ensured selective and self-limiting removal of the encrustation without damage [Papakonstantinou *et al.*, 2007].

A 3D reconstruction of the Acropolis hill has been produced with 3ds Max, [Kruklidis, 2011b, 133], and a virtual reconstruction of the buildings that once stood in the area during the Mycenaean era has also been created [Kruklidis, 2011a].

2.5.2 Augmented reality and sculptural modelling in 3D in Olympia

Olympia is another famous site in Greece known for its sacred arbories, temples and above all for the Olympic Games that originated there in 776 bc. ARCHEOGUIDE (Augmented Reality-based Cultural Heritage On-site Guide) was an international project that focused on building a virtual guide to cultural heritage sites for visitors, providing tailor-made tour-guiding with virtually reconstructed monuments. The touring of a site like ancient Olympia takes place by wearing a high-tech wearable computer with a head-mounted display (glasses, earphone, speaker, camera etc). The visitor chooses the personal preferences in the system and walks with it through a tour that provides visions of reconstructed ancient monuments in the sites of the ancient ruins as augmented reality. The visitor can communicate with the system making various queries about the site [Lönnqvist and Stefanakis, 2009].

Also in Olympia, the sculptures in the east pediment of the temple of Zeus, built in the 5th century bc, have been scanned and modelled in 3D in order to try to answer the questions of their original position and arrangement. Despite the difficulties in scanning large sculptures and reconstructing them, the virtual 3D model of the pediment was produced in 2011. It enables the visualisation of the partly preserved sculptures as virtual reconstructions (Figure 2.11). A CD-ROM was produced for a larger audience for the interactive study of the structures and sculptures by navigation [Patay-Horváth, 2011]. Over a century ago the reconstructions were able to be made by using miniature or life-size plaster-cast statues. Furthermore, the comparison of old drawings and the plaster casts of the sculptures with the results of the scanning and virtual reconstructions have been carried out [Patay-Horváth, 2012].

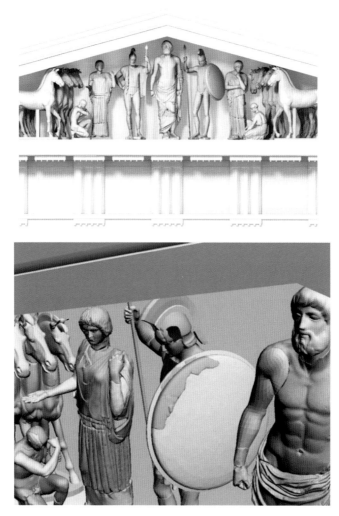

Figure 2.11 3D reconstruction of the sculptures in the east pediment of the Temple of Zeus in Olympia, Greece. [Courtesy: A. Patay-Horváth.]

2.6 Reconstructing Ancient Roman public and domestic spaces

2.6.1 Virtual villas and palaces in 'eternal' Rome

Several projects have digitally documented the ruins of the 'eternal' city of Rome on the ground, but only a few examples are presented here, to elucidate the systems of the documentation from the conservation point of view.

In the neighbourhood of Via Flaminia there is a compound of ruined buildings dating from the 1st century BC of the Roman Imperial era and surrounded by gardens. The remains belong to the Villa of Livia with its beautiful frescoes of nature scenes. The Villa belonged to Livia, the Emperor Augustus' wife. The emperor's own domus

of a similar type is to be found on the hill of the Palatine above the Forum Romanum. The virtual reconstruction of the Villa of Livia has required the collecting of both architectural and topographic data. The instruments which were used in the Via Flaminia project consisted of a laser scanner, total station and GPS [Vico *et al.*, 2006; Moro *et al.*, 2007; Iakopi, 2007].

Photogrammetric methods were used in assembling photographs for the reconstruction of the Villa. The acquisition of data in 3D was needed for scientific results. A DEM was constructed through interpolation of GPS data. The laser scanner provided the data for georeferencing so that the structures could be located in the terrain. 7000 m² were recorded, and the resolution reached 30,000 points per square metre for the laser scanned point cloud (Cyclon by Cyrax Technology). The real-time data required optimisation of the bulky material by reducing polygons and making texture more representative. Rapidform and 3ds Max software were tested for this purpose. Photoshop was used for adjusting the colours of the images. Rooms were modelled with Rapidform, and the texture was produced by 3ds Max. The virtual model of the spaces was reconstructed using complex algorithms. Research was carried out using typological and chronological parallels in creating the 3D reconstruction, and it needed to be transparent. The scientific model produced presents possible truths. The model provides the means to acquire information of the building in various periods of time and to follow the interventions that have taken place. It therefore offers possibilities for analyses, studies as well as the preservation of the building [Vico *et al.*, 2006; Moro *et al.*, 2007].

Near the Forum Romanum in the Palatine hill area stand the brick ruins belonging to the largr complex of the Domus Severiana dating from the 3ʳᵈ century AD of the Roman Imperial era. The structures rise to ca. 48 m in height and form an impressive architectural compound with Circus Maximus. The project to study the architectural remains of this Roman imperial palace complex took place in 1998–2003. The aim of the project was to understand the arrangement and connection of various spaces in the construction [Riedel and Weferling, 2001]. The plans that provide information about the construction, joints, decorations and various phases were produced. Altogether five floor plans and six sections provide an understanding of the constructional phases in the horizontal and vertical planes. The complex has been surveyed and documented in high accuracy from pencil drawings and photogrammetric image acquisition, recording with a tacheometer and producing computer-based models. The building was modelled using CAD. However, it was realised that there was a limitation of the section drawings to produce models in 3D. Therefore, there was a need to scan the architectural plans for geometric position and to combine the data with information from 'Raumbuch', the so-called room book with plans and sketches [*ibid.*].

Later, a www-based building information system (BIS) was created for the Domus Severiana based on Open Source software. The system was developed to enable 3D data to be integrated. The database system was set up modularly to consist of several databases. Three specific modules were constructed: the database for room inventory, the database of architectural fragments and the database of 3D objects.

The digital database not only stores information about rooms and their special structural attributes, but also provides the topology of geometrical constructive objects. The previously mentioned 3D model is composed of individual room elements. It is based on the 'Raumbuch'. There was a need to retrieve information from the database of various building elements like walls, while navigating through the 3D model. This was carried out with SQL-queries (SQL=Structured Query Language, a programming language for a special purpose) to the data of the walls that had been stored in VRML format. A benefit of the system is that one can search all the elements of the building from the Flavian period, such as walls with brick-stamps. 2D plans were added to the database to retrieve a better overall view of the structures [Heine *et al.*, 2006].

2.6.2 The forum, insulae and villas in Pompeii and Herculaneum

The Forum, the public square and market place of Pompeii, have been documented taking into account both the landscape and architecture, integrating the architecture into its context. Archaeological sites require surveys of various resolution, so multi-resolution data was acquired using a top-bottom approach. The documentation of the Forum included data from traditional aerial photographs to terrestrial data of higher resolution. Photogrammetric methods and a laser scanner were used to produce 3D models (Figure 2.11). Using internet and multimedia technologies, the data can be used by scholars and scientists alike [Balzani *et al.*, 2004; Guidi *et al.*, 2008, 2009].

The Swedish Pompeii project has aimed to record and document a Pompeian city block, known as Insula V 1. In the complex, special 3D documentation with laser scanning using Faro Focus 3D and Pharo PHOTON 120 has been carried out in the house of Caecilius Iucundus integrating information from old reports. A workflow which worked in a virtual environment was tested using a scanned model as a geometrical reference; this workflow integrating old data provided possibilities for analysis and interpretations of the house. Furthermore, a cave automatic virtual environment (CAVE) was used as a platform for various hypotheses to be discussed and analysed in spatial context with an immersive experience [Dell'Unto *et al.*, 2013].

Villa dei Misteri in Pompeii with its famous frescoes has been surveyed combining traditional and computer-based methods. Apart from the old drawings from the time of the excavations of the compound that took place in the 1920s and 1930s, up until the 21st century, the house lacked complete graphic documentation. The old drawings were integrated into the new recording. The textures of frescoes and mosaics as well as *opus reticulatum* and *opus incertum* were documented [Canciani *et al.*, 2007].

In several houses of Pompeii there are also *nymphea*, decorated niches including fountains for nymphs. One of them in the Grand Duke's house has been recorded and documented by photogrammetric methods acquiring stereoscopic photographs (Scale 1:40–1:250), scanned and elaborated with a digital photogrammetric workstation (DPW) and orientation procedure on a StereoView 300 system in 3D. In addition,

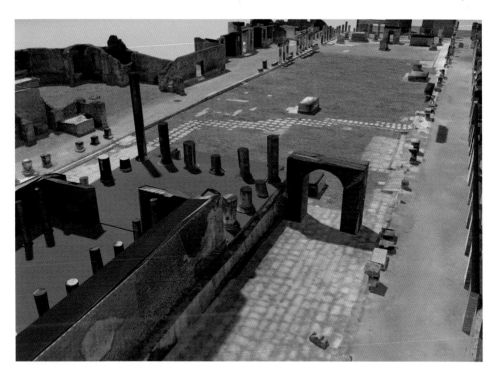

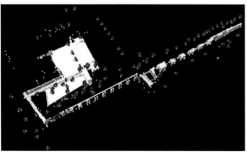

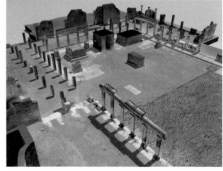

Figure 2.12 3D model of the Forum of Pompeii and architectural features based on remote sensing and laser scanning. [Courtesy: G. Guidi *et al.*]

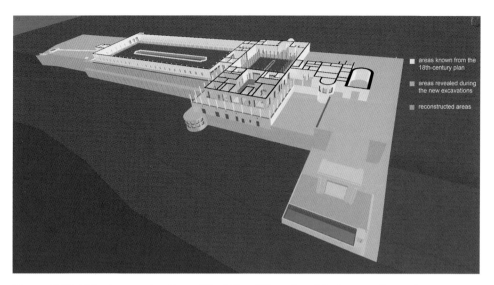

areas known from the
18th-century plan

areas revealed during
the new excavations

reconstructed areas

Figure 2.13 Virtual reconstruction of the Villa of Papyri and its famous library in Herculaneum. [Courtesy: M. Zarmakoupi.]

the small fountain and big fountain *nymphea* were recorded and documented with the Cyclop photogrammetric system using Menci software and a TLS producing a 3D model [Bitelli *et al.*, 2001].

Like in Rome and Pompeii, at Herculaneum there have also been conservation projects based on information systems. For example, standing structures have been systematically recorded in the *Insula Orientalis I*. The archive studies of the site have been integrated into the project. The 3D laser scanning technologies have also been successfully applied in conservation purposes, including the suburban baths [Brizzi *et al.*, 2005, 2006].

The Villa of Papyri in Herculaneum has provided the only intact library from antiquity, and the villa has been virtually reconstructed (Figure 2.13). Its famous library has revealed papyrus texts with CT technology as will be discussed in due course. The building itself is an example of a Roman luxury villa that was imitated by Paul J. Getty to house his art collection in Malibu, California [Zarmakoupi, 2011].

2.7 Documenting caravan cities in the Ancient East

2.7.1 Hatra, Palmyra and Petra revisited

The Silk Road was the major caravan road in Greco-Roman antiquity leading from China to Rome. O. Vileikis *et al.* [2011] have been conducting a project to build up the information management system of this road's significant cultural value.

In the Near East the ancient cities of Hatra and Palmyra on the Silk Road as well as Petra on the Incense Route and the Spice Road were caravan cities that mediated Parthian impact on the Greco-Roman styles of architecture and sculpture [Rostovtzeff, 1932; Stoneman, 1992]. The imposing ancient architecture with walls, colonnaded streets, temples and tombs of various kinds were preserved in these ancient cities that are

all World Heritage Sites. Each of them is peculiar in its own right and constitutes part of the invaluable heritage of humankind. ISIS/ISIL has caused large-scale destruction to ancient structures in two of these sites, namely in Hatra in Iraq and Palmyra in Syria.

The city floruit of Hatra, a site situated in Northern Mesopotamia, dates from the 1st century BC to the 4th century AD. Before the capture of the city by ISIS a database based on GIS had been planned for the conservation of the city integrating all the data needed for the work [Cordera and Ricciardi Venco, 2005]. Furthermore, E. Foietta has applied new technologies to the studies on the defences of Hatra. The defences, constructed of stone, include a ditch, tower tombs in the curtain wall (ca. 6 km in circumference), massive walls and towers. Data was collected for a database using Microsoft Word in hypertext model for a catalogue. In addition, a geographic database including a topographic relief has been constructed on GIS using ArcView. A 3D modelling of the defences was carried out using AutoCAD and Sketch-up 8. The database using GIS provides a basis for the conservation and restoration of the defensive structures [Foietta, 2011].

The ancient city of Palmyra is situated in an oasis in the Syrian Desert. Its heyday dates from the 1st century BC to the 3rd century AD. Now valuable remains from antiquity have been destroyed, and looting has taken place according to the reports of the UNITAR. Some of the famous tower tombs that belong to the funerary landscape of Palmyra were fortunately partly recorded and documented using photogrammetric methods before the civil war. It was conceived that archaeological study of such structures needs exact documentation. The main target was the Tomb of Elahbel with the aim to produce plans of the façades. Analogue cameras were used but all the images were digitised with a desktop scanner. Two ways to create a DSM (digital surface model) for the tomb façades were studied. The use of TopoSurf software did not bring satisfactory results. The second approach with Pictran to calculate the DM from convergent images was useful after some problems with the software were avoided. The work based on stereopairs was visualised using VRML (virtual reality modelling language) [Brall *et al.*, 2001]. Before the civil war G. Fangi and his students also had an opportunity to photogrammetrically document and model Elahbel's tomb (Figure 2.14) and take a spherical image of the ancient theatre in Palmyra [see Fangi, 2015].

The ancient site of Petra in southern Jordan has been documented by various groups during recent decades. The site is a famous city representing Nabatean architecture with its carved façades in sandstone mostly dating from the 1st century BC to the 2nd century AD. Weathering in the area is a serious problem that causes damage to the structures. The porous surfaces and structures deteriorate due to the crystallisation of salts [Bala'awi *et al.*, s.a.]. Special assessments have been carried out in the 3D documentation of the damage to the structures affected by erosion and changes in temperature. Some façades have even collapsed in recent years, and therefore conservation has needed studies with thermal imaging to detect the possibly vulnerable areas in stone [see, e.g., Alshawakbeh *et al.*, 2010; Lerma *et al.*, 2011].

Laser scanner and photogrammetric methods have been used to document the entrance way to the town called the Siq and the façades of tombs, such as the Treasury (Figure 2.16), and temples [Haala and Alshawabkeh, 2006, the Zamani project]. N. Haddad and F.

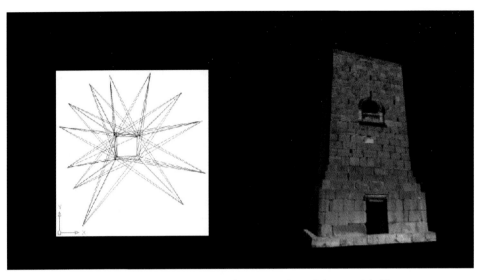

Figure 2.14 Palmyra Tomb Tower - orientation network and the model. [Courtesy M. Franca and G. Fangi.]

Figure 2.15 The top view of the Siq, the rocky tunnel-like passage to Petra. [Courtesy: the Zamani project.]

Ishakat [2007] compared the use of a 3D laser scanner and a reflectorless total station in recording and documenting of the Treasury, known as the Khazneh. Furthermore, E. D'Annibale [2011a, 2011b] has applied spherical photogrammetry and stereoscopic methods to record and document the buildings in Petra, including the Treasury. In addition, the Finnish Jabal Harun project has documented the monastic remains on the Mount of Aron and its landscapes in 3D above Petra [Haggrén *et al.*, 2001, 2005].

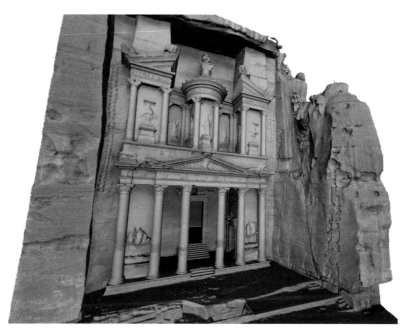

Figure 2.16 The 3D model of the façade of the tomb known as the Treasury in Petra. [Courtesy: the Zamani project.]

2.8 Capturing and saving architecture from the Common Era

We have already dealt with some sacred spaces, such as the temple of Göbekli Tepe in Turkey and those in Athens and Olympia in Greece that have been documented and conserved using the latest technology. Tombs in places such as Hatra, Palmyra and Petra can also be considered sacred spaces. There are various other types of sacred buildings that often also appear in an urban context, such as churches, mosques and synagogues. The Pre-Columbian temples of Meso- and South America, as well as the great Hindu and Buddhist shrines in Asia, are large complexes that are found in the midst of jungles instead. There are many examples of work carried out among these types of buildings that often are very elaborate constructions with decorated and complicated surfaces to be recorded and documented.

2.8.1 Saving sacred spaces: churches, mosques and synagogues

The Holy Sepulchre in Jerusalem

The church of the Holy Sepulchre in Jerusalem in Israel is the central church of Christianity based on the basilica originally built by Emperor Constantine in the 4th century AD on the traditional place of the crucifixion and the tomb. The basilica and the so-called Anastasis rotunda have faced fire, war and destruction through the centuries. The site is currently shared by various churches and creeds of Christianity. It has been documented by laser scanners and photogrammetric methods in recent years. A team led by Biddle *et al.* [1992] produced the first report of their photogrammetric work.

A Greek interdisciplinary team further documented the monument. The team generated the cross section of the monument with AutoCAD. For the projection of points a 3D rotation was applied. All the stereo pairs were oriented and plotted on a Leica DVP digital stereo plotter or Adam MPS-2 analytical stereo plotter. 3D photogrammetric outputs were produced by architects [Balodimos *et al.*, 2003]. The seismic vulnerability of the basilica prompted another 3D documentation carried out by an Italian team using GPS, total stations, photogrammetry and 3D laser scanning. The main aim was to carry out a survey to establish the state of conservation of the basilica, and special attention was paid to the area of the rock on which the basilica was built [Tucci and Bonora, 2011].

The wooden domes on the Basilica of St. Mark

The Basilica of St. Mark in Venice (built in AD 827–829) in Italy is another outstanding architectural monument of Christianity. The entire St. Mark's square has been surveyed and documented photogrammetrically, also from the air [Lingua and Rinaudo, 2003; Monti *et al.*, 2001].

The wooden domes of the basilica that apparently date to AD 1210–1270 have been modelled in 3D in order to enable one to understand the form, composition, wood species and conservation state of the beams and to build a database for the purpose of analysis and monitoring. The documentation aimed at understanding the static function of the beams in the architectural study. First, traditional survey methods were used with total station (TCRM1101), after which CAD and laser scanning were applied to build a 3D model. Visualisation and rendering of the dome structures were carried out using 3ds Max 2009 (Figure 2.17) [Fregonese and Taffurelli, 2009].

Figure 2.17 3D visualisation of a wooden dome from St. Mark's Basilica in Venice, using 3ds Max. [Courtesy: L. Fregonese and L. Taffurelli.]

The façade of Milan Cathedral

For the stone façade of Milan Cathedral in Italy, laser scanning was first applied to support the planned restoration. A digital surface map served as a cartographic base to generate an orthophotomap. The photogrammetric survey was complicated because of the dimensions of the target and its numerous details. Stereoplotting of the façade was carried out using SVPlotterAC: a StereoView software that produces stereoplotting from the vectorial model of AutoCAD. In addition, a thermographic survey with a thermo camera and X-ray fluorescence (XRF) survey were carried out to study the state of the marble, the presence of eventual pigments, the effects of the previous conservation and the effects of pollution. In the end, a 3D database for the conservation purposes was built for the gathered data and also for integrating the textual documents to be used [Giunta *et al.*, 2005].

Wooden churches in Russia

The Kizhi site on an island of Onega in northern Carelia in Russia contains elaborate post-medieval churches with onion-like domes constructed of wood in the 18th and 19th century. The site is on the World Heritage List. The architecture of the churches has been recorded and documented using Electro, an application for the tied-display high-resolution graphics visualisation system. 3D images have been produced using AutoDesk Maya software. The texture is attained by photographic data captured *in situ* [Tsoupikova, 2007].

Fatih Mosque in its landscape in Istanbul

In the 3D documentation of the Ottoman era Fatih Mosque in Istanbul in Turkey the surrounding landscape was included using DTM. The documentation of the façades was carried out by taking stereophotos. CAD was used in modelling. After the generation of stereomodels MicroStation software was used to 3D vector plot the façades. After the modelling the added texturing was based on photographic information [Yastıklı, *et al.*, 2003].

Mosques in Yemen

Five mosques were completely surveyed by a French team in Yemen in 2004–2005. The survey team documented the mosque of Asnaf, the great mosque of Sana'a and the mosques of Shibam–Kawkaban, following those of Al Ashrafieh and Al Muzzafar in Taez. The datings of the mosques range from the 7th to the 13th century AD. The team combined and applied topometry, photogrammetry and 3D scanning in its work. Images and laser scenes were adjusted to a common coordinate system. 3D laser scanning (Trimble GS100) was carried out for general architectural documentation, such as interior and exterior walls, terraces, arches and columns. Orthoimages were produced for the mosques of Sana'a and Shibam, for the façades in resolution of 5 mm and ceilings in the resolution of 3 mm. The documentation

of the façades was printed in the scale of 1:50 and ceilings in 1:10. The aerotriangulation of the façades and wooden ceilings was carried out successfully with IGN software Topaero. Cumulus, a new software, was also developed for the scanned 3D data. This software was able to visualise all the colours faithfully [Héno and Egels, 2011].

A ruined mosque in Spain

In the historical Seville in Spain there is an area called Alcazar dating from the 10th century AD. The area includes a cathedral, remains of a mosque, a palace and archives called Archivo de Indias. The area is now a World Heritage Site. Today, the cathedral is situated in the site of the old Almohade mosque of which there are still some remains like a minaret and a part of a courtyard. Archaeological excavations have revealed some other structures of the mosque providing information of its plan. The mosque was one of the largest in the western world covering an area of 135 m × 113 m. After the Christian conquest in 1248 a Gothic cathedral was built in the district. A virtual reconstruction of the Almohade mosque with panoramas and animations has been produced to represent its appearance in the past [Almagro, 2005].

Minarets in Algeria, Iraq and Syria

A World Heritage Site in Algeria in North Africa dating from the 11th century AD comprises an interesting minaret with a square plan at the Qala of Beni Hammad. The survey of the minaret was carried out providing a 3D model with four stereoscopic pairs and four oblique photographs linking a façade and its distance of height. Vector drawings and photo-rectification were applied to the data. Another square minaret dating from the 14th century was similarly documented and reconstructed at the ruins of Mansura near Tlemecen in Algeria [Almagro, 2013].

The 14th century Choli minaret situated in Erbil in Iraq has also been recorded and documented for producing a 3D reconstruction. The upper part of the round minaret is diverting from its vertical axis as much as 65 cm, putting it in danger of collapse. Digital cameras and a total station were used in data capture, and one camera was calibrated for the use of Photomodeler software. Innner parts of the minaret were only documented with a tape measurer for the use of AutoCAD. A real 3D model and true-photo rendered 3D model with animation were produced [Pavelka *et al.*, 2007].

The Great Mosque of Aleppo in Syria has faced destruction since 2011 during the civil war. Fangi [2015] (Figure 2.18) and P. Grüssenmeyer were able to document the building photogrammetrically before its minaret was destroyed. Fangi has also photogrammetrically documented the Great Mosque of Damascus that offers unique mosaics and architectural members from the Roman times.

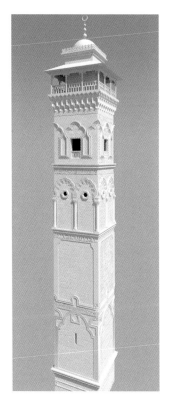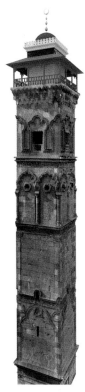

Figure 2.18 3D modelling and spherical mapping of panoramic photos of the now-destroyed minaret of the Great Mosque of Aleppo in Syria. [Courtesy: G. Fangi, W. Wasbeh and A. Aboufares.]

Synagogues in Prague

Synagogues, such as the Maisel Synagogue, the Spanish Synagogue, the Klausen Synagogue and the Ceremonial Hall, have been documented in 2D in Prague in the Czech Republic. These synagogues date from the 16th century onwards. The documentation was carried out with a reflectorless total station with the view that the data can be modelled in 3D in the future. Some of the naves and galleries were documented with a laser scanner [Dolanský *et al.*, 2011].

2.8.2 Buddhist and Hindu temples

Angkor Wat is a large temple complex that is situated in the midst of jungles in Cambodia and is now a World Heritage Site. The temple was built by the Khmer civilisation that flourished from the 9th to the 14th century AD. The architecture of the temples was influenced by both Buddhism and Hinduism.

The temples are mainly built of sandstone and laterite that have contributed to the deterioration of the structures. Remote sensing using satellite imagery has revealed

elaborate canal systems of the area and also a number of other ruins [Watanabe *et al.*, CIPA WG5]. Reality-based 3D modelling of the temples has been carried out using aerial images. An orthomosaic of the aerial photographs was combined for modelling. The architectural reconstruction of the ruins was carried out by stereo-measurements [Sonnemann *et al.*, www.cutorweb.com/Angkor].

The Bayon temple project has especially studied the bio-deterioration of a sand-stone temple in the Angkor complex. Micro-organisms have affected inner areas of the buidling, and it was necessary to analyse the biological colonisation and its distri-bution in order to find out what kind of means were needed for its removal. A new multi-spectral imaging system was developed to collect spectral information of the micro-organisms on surfaces such as walls and a bas relief. A panoramic multispectral camera was applied. Classification was carried out in studying the various changes of the growth in respect to seasons [Morimoto *et al.*, 2011].

Gedongsongo area on the island of Jawa in Indonesia comprises nine Hindu temples in five complexes divided by a river in a beautiful landscape. The temples have been mapped and laser-scanned in their surroundings with the Leica HDS-3000 TL system taking into account the topography of the area. The results consist of high-resolution 3D models that preserve the documentation of the tempes [Mustafa and Amhar, 2011].

2.8.3 Modelling historical castles, palazzos, houses and gardens

Crusader castles

Crusader castles are Medieval structures that appear in the areas that were under the impact of the Christian crusades, which started in the 12th century AD and continued until the end of the Middle Ages. One of them, namely Crac des Chevaliers in Syria, has been at risk since 2011. In 2003 J. Yasmine started surveying and documenting the Beaufort castle built in 1139 in southern Lebanon using images taken from the air and at ground level following the CIPA 3 × 3 rules. The restitution of some structures was made to imagery adding data from old photographs, such as aerial photographs from the 1930s. After calibration, the images were computerised using a PhotoModeller package. The restoration programme could use the hidden information revealed, for example, from the banks of the castle [Grussenmeyer and Yasmin, 2003].

Castle of Shawbak (Crac de Montréal) near Petra in Jordan, built in the 12th century, is one of the largely ruined Crusader castles in the Near East. The University of Florence has had a regional campaign in the area including excavation. The site has been recorded and documented using photogrammetric methods. Accurate orthorectified images were produced from the outset for archaeologists to analyse the structures. A system was built that enabled survey by 3D images. Binary CAD files were produced to be used on MicroStation or textual files in XML and X3D format. After objects such as blocks were measured, ARPENTEUR software provided the means to have the data available in XML, SVG and X3D format to carry out various queries. Immersive studies can be carried out among these models [Drap *et al.*, 2005, 2006].

Palaces from the West and East

At Xkipiché in Mexico a Mayan palace representing the Pre-Columbian Puuc style and dating from the 10th century AD has been studied and reconstructed in 3D applying procedural modelling. The Puuc style buildings were built on a platform with rubble-filled concrete walls, and the surface was modelled by *stucco* ornamentation. The *CGA Shape* grammar framework was used to ensure that all the important information for the work was available and used in the documentation of the palace. It was noted that the the approach was especially well suited for the reconstruction of archaeological remains. A CityEngine was applied in the reconstruction, and mesh modeling software was used in surface details [Müller *et al.*, 2006].

The Royal Palace of Stockholm in Sweden is one of the largest palaces in Europe. A pilot project was set up to record and document the façades of this Baroque building from the 17th century. An event that showed a need for documentation and conservation was the fall of large pieces of the sandstone façades in 2005. A laser scanner was used to assemble a point cloud which was partly processed with AutoCAD to produce a 3D model. The data offered possibilities for quick line drawings, such as 1:50, that were needed. Images were acquired by a full frame Canon camera and orthophotos were produced of some of the areas [Heymowski *et al.*, 2011].

Villa Reale in Monza in Italy is a large 18th century palace complex with gardens that have been topographically and photogrammetrically surveyed to produce information for the conservation of the area. 3D models were created from orthophotos from outside and inside the buildings [Achille *et al.*, 2005b]. In Venice, some of the Grand Canal's panoramic Gothic and Renaissance palaces have been mapped using mobile photographing and laser scanning from a moving boat. The registered photos and point clouds were evaluated. 2D scans of façades were produced, and an orthophoto and a 3D CAD model were created using Phidias software [Studnicka *et al.*, 2011].

The 200-year-old Khaplu Palace in the mountainous region of Baltistan in Pakistan is a unique example of vernacular architecture with wooden structures. An architectural survey has been carried out at the palace, and its structures were recorded and documented for conservation purposes using EDM (total station) and applying rectified photographs to take into account the historic agricultural walls. Drawings and a 3D wireframe model were produced. The wooden loggia at the entrance of the palace was lifted and pulled back to its position to enable conservation measures: documentation was a pre-requisite for this work [Muhammad, 2011].

Vernacular houses

The Ottoman era in the Near East covered nearly 500 years. Vernacular architecture known in Turkey as 'Turkish houses' appears in the region under various names: in Macedonia they are called 'Macedonian houses', in Greece they are called 'Greek houses' and in Bulgaria they are known as 'Bulgarian houses'. The earliest dating of such houses goes back to the 18th century. The definitions vary and the most characteristic Turkish houses are actually found in Istanbul and in the Marmara district. The chief materials used for construction of various types of Turkish houses are usually

Figure 2.19 Two different house layouts of the traditional Mardin houses and house models in 3D [Source: H. Özbek, 2004.]

stone and wood. The type includes both timber-framed houses and masonry-houses [Torus, 2011; see also Akbaylar and Hamamcoğlu-Turan, 2007].

In Mardin in eastern Turkey the masonry type rules with *eyvans* (open spaces). The houses have central courtyards with surrounding rooms. The enclosing walls are facing and forming the narrow streets. The terraced appearance of the location of the houses overlooks the Mesopotamian plain. H. Özbek has studied the type of houses constructing modular 3D plans for them (Figure 2.19). A PLG (plan layout generator) programme and 3ds Max were used to generate the layout grammar for these traditional houses [Torus, 2011].

Wooden bay windows in Arab houses

Wooden bay windows called *rowshan* are typical features projecting from the façades of town houses in the Arabic world. These balcony-like windows are usually 3.0–3.5 m in height, 2.5 m in width and 0.5–0.7 m in depth. A conservation project in Saudi Arabia has digitally documented such windows in the historical parts of old Jeddah and produced some decorations in 3D. Many buildings in the area including the wooden windows are decaying and collapsing, and a conservation programme has started to restore these old buildings [Adas, 2013].

Environmental fluctuations in humidity, light, temperature, as well as pollution, damage caused by insects like termites, borers and spiders, microbiological growth such as fungus as well as rot and unsuitable reparations are seen as major factors influencing the deterioration of the wooden structures in these buildings. Dense stereo matching was applied as a digital modelling technique in reproducing some parts such as a decorative panel for windows [Adas, 2013].

The Model Houses of Bauhau

Walter Gropius' unique estate of the modern Master Houses originally built in Dessau in Germany in the mid-1920s has received World Heritage status. The houses

represent functional architecture known as the Bauhaus style and some of the foremost architects and artists of the 20th century lived in them [Thöner, 2002–2003]. The Nazis closed the Bauhaus Architectural School in 1932 and took over the houses. After the war in 1945 the houses became part of East Germany, and some of them were demolished and others changed [Fleischer *et al.*, 2001].

The restoration work only started in the 1990s after the reunification of Germany. The results of extensive restoration work of the Master House that originally belonged to Wasily Kandinsky and Paul Klee was opened to the public in 2000. The house was surveyed and modelled in 3D using AutoCAD and 3ds Max software. The colour scheme of the house was coded using the natural colour system for the animation of rooms in the house; the user of the animation can toggle between two colour traditions [Fleischer *et al.*, 2001].

Modelling Lloyd Wright's wooden maquettes

The wooden architectural models in miniature of the Masieri Memoria designed by architect Frank Lloyd Wright in the 1950s for Venice are unique and controversial pieces of architectural history. The building project never materialised but the delicate models remain, and they have been digitally surveyed, recorded and documented using 3D scanner with the triangulator sensor Minolta Range 7 for photographing in order to build 3D models. Accuracy with the scanner reached 0.1 mm, higher than with the camera but more difficult to handle. Photogrammetric methods were used beside the scanner data, and results were compared between two acquired models. Furthermore, a virtual model of the planned location of the house in Venice was produced to study the possible impression the building would have created if it had been built. Visibilities and views of the location were able to be studied with the model [Baletti *et al.*, 2011].

Gardens

The documentation of historical gardens and parks in 3D for their preservation as cultural heritage is a field that is just beginning to develop. *The Florence Charter* of ICOMOS especially provides guidance in preserving historical gardens.

The Mantua Palace is a World Heritage Site in Italy. It is a Renaissance building surrounded by large gardens. It has been multi-range surveyed and documented with its surrounding gardens [Chiarini *et al.*, 2014]. The great gardens of the palace complex of Mofakham built in Iran in the late 19th century have also been documented and recreated by a 3D model. Old maps and photographs were used as the basis to study and build the model (Figure 2.20) [Mehralizadeh, 2013]. In the deep South of the USA the great Atlantic homes and plantations with gardens such as the Wormsloe heritage site in Georgia have been the target of documentation with a laser scanner and producing 3D models of buildings and gardens [Madden, 2012].

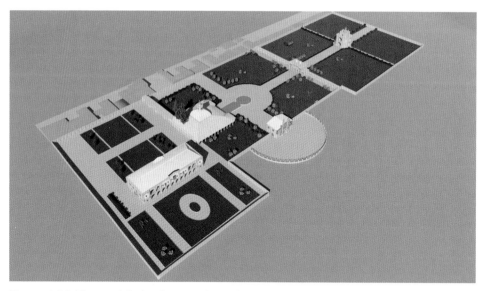

Figure 2.20 The modelled palace gardens of Mofakham in Iran [Courtesy: S. Mehralizadeh]

2.9 Viewing walls, ceilings and floors

2.9.1 Wall paintings

Murals, painted using the *tempera*, *secco* or *fresco* techniques, as well as paintings with oil on canvas, belong to cultural materials and artefacts that need special attention in conservation. Light, humidity and temperature have to be set to an appropriate level and monitoring needs to be carried out.

Ariadne's house in Pompeii offers Roman frescoes that are exposed to heat and light, and they are vulnerable to atmospheric changes. The microclimate of the house was studied for the preservation of those wall paintings that are exposed to excessive heat in the summertime. Dozens of data-loggers were located in the house for over a year. The collected data was analysed by graphical methods and by ANOVA (analysis of variance). The rooms with transparent roofs were most vulnerable. The work provided guidelines for applying thermohydrometric sensors in the atmospheric monitoring of the spaces with frescoes [Merello *et al.*, 2012].

Infrared and Ultraviolet light have been utilized in studying paintings and writing since the 1930s [Riederer, 1987]. IR is not too strong for the materials and can reveal various layers. UV also has the ability to expose features in organic and inorganic artefacts, such as objects of art and archaeological finds. Electro-optic holography and IR thermography are used in diagnostics and to assess defects in frescoes. UV images of paintings are used to identify varnishes and over-paintings, particularly with fluorescence imaging systems [Rizzi *et al.*, 2007; Spagnolo *et al.*, 2000].

As already indicated in the case of the Acropolis restoration work, in recent decades laser-based techniques have been increasingly found to be powerful tools

in studying wall paintings because of their minimum invasiveness. The combination of laser induced fluorescence technique, Raman spectroscopy and laser induced breakdown spectroscopy provides means for carrying out diagnostics and cleaning. Laser induced breakdown spectroscopy offers the possibility to approach the composition of the studied artefacts in a special way for documentation purposes. It has been useful in studying pigments, copper-based alloys, ceramics and marble [Caneve *et al.*, 2010].

Optical devices and studies have traditionally been applied to the conservation of murals, such as frescoes. Image-based data provides an important source for 3D modelling, even if IR and UV solutions are applied. Range-based techniques, however, are often combined [Rizzi *et al.*, 2007]. The Vasari project and the study of Pre-Hispanic murals in Mexico have applied photogrammetry, building a 3D model (Figure 2.21) for the conservation and restoration of paintings that face danger in their preservation. Such parameters as spectrum, colour, levels of detail and geometric accuracy were taken into account in documenting the murals. Digital photogrammery enables enhancement of the geometric accuracy. It was found that sub-millimetre resolution was needed, and 3–4 pixel accuracy was found satisfactory [Lucet, 2013].

The so-called hidden paintings of the ancient Hindu temple Angkor Wat have been revealed with new technological developments in digital image enhancement. A technique called decorrelation stretch analysis exaggerates subtle colour differences of images. Among the revealed paintings traditional Khmer musicians and animals are illustrated [Gannon, 2014].

Optical 3D scanning has been used on Leonardo da Vinci's painting *Adoration of the Magi* situated in the Uffici Gallery in Florence. The accuracy of the lateral scanning was 0.3 mm. This was done to plan the future conservation of the work including the wooden parts which are warping [Guidi *et al.*, 2004].

Figure 2.21 3D reconstruction of a Pre-Columbian mural from Mexico. [Courtesy: G. Lucet.]

2.9.2 Mosaics

Mosaics are surfaces often displaying inlaid figures or patterns by arranging pebbles, tiles, or *tesserae* (small cubes). The small items of hard material, such as stone, glass or terracotta, are executed in soft surfaces like clay, plaster or cement. *Opus sectile* is a method that resembles mosaics but uses large stone slabs (for example, marble) placed in geometric shapes, sometimes using different colours to form patterns. Floor mosaics often suffer deterioration and cracking by swelling, and depressions caused by environment, structures and people. Encrustation and wax can affect the *tesserae*.

Mosaics appear on large floor surfaces which may be all that remains of various ancient buildings. They are vulnerable to deterioration for various reasons. Often canopies or roofs are needed for the on-site conservation of such floors, and walking on the floor should be avoided. However, if the mosaics are threatened, they can be moved to safe places. A good example is the Roman city of Zeugma in Turkey with its fabulous mosaics which were saved from the Euphrates dam construction. A museum was purpose-built for them and for the beautiful frescoes in Gaziantep.

Photographic surveys are traditional ways to document mosaic floors. A good vantage point for photographing needs to be found; a tripod and a short extension bar are used. Digital rectification software can be used for photos. But rectified photographs are only best for flat surfaces, and therefore orthophotography is needed for undulating floors. Stereoviews are acquired, and DEM can be applied to follow the uneven surface when produced [Andrews *et al.*, 2003].

Photogrammetric methods have also been applied in the documentation of mosaics in Butrint in Albania. Developments in 3D graphics, virtual reality, GIS and semantic web were used in the documentation. Once the photographs were taken they went through chromatic graduation, rectification and assembling according to a network prepared in advance for juxtaposing and reunifying the chromatic graduation to assemble the photographs to a single image. A panoramic photography was also applied using Quick Time Virtual Reality (QTVR) programme for zooming in and out while scouting the target in 360° [Omari, 2011].

The floor mosaics of St. Mark's Basilica in Venice in Italy have been surveyed and are being monitored. The building of the domes on the church in the 13th century caused extra weight for the walls of the original basilica, and the mosaics have also been affected by the undulation of the floors caused by this weight as well as natural disturbances. Orthophotography in the scale of 1:1 was produced for the 3D reproduction of the mosaic floors of the basilica (Figure 2.22) [Fregonese, 2003]. High resolution models of the floors have been further produced using both digital photographs and laser scanning. High resolution orthophotographs were used [Achille *et al.*, 2005a; Brumana *et al.*, 2005].

The 3D modelling of mosaics as graphic interfaces and information repositories has been applied to offer access to the data. Digital survey in 3D enables the creation of 3D reality-based models of mosaics such as plaster casts which can be used for exhibitions as well as for reconstruction purposes and can be viewed in 3D information systems

Figure 2.22 A digital orthophoto of the mosaic floor in St. Mark's basilica in Venice, Italy. [Courtesy: C. Achille *et al*. 2005a.]

[Manferdini and Cipriani, 2011]. As far as the minute scale 3D models are concerned, Guidi *et al.* [2002] have generated such of Roman mosaic fragments using pattern projection range camera. The fragments were oriented with photogrammetry and further added to the data from a laser scanner.

2.10 Documenting detailed features and artefacts

2.10.1 Relevant methods for 3D

Accurate 3D visualisation is a valuable way also to study small artefacts without touching them. It is also the way to present objects to a larger audience in museums and at original sites without exposition or transportation of the actual objects. As indicated, the methods are chosen with respect to accuracy, occlusion, space and time used in data capture [Rizzi *et al.*, 2007]. ALS used for remote sensing, surveying, landscape studies and architectural documentation is not applicable to the documentation of sculpture, ornamentation and smaller artefacts. TLS and close-range scanners have, however, been used for documenting large artefacts, such as sculptures. On the other hand, TLS does not produce fine documentation in detail, and only close-range 3D scanners can achieve adequate accuracy for architectural details, statues, ornamentation and small

artefacts. Image-based modelling can be a way to present small objects in 3D, but the accuracy may suffer [see, e.g., Yılmaz *et al.*, 2003]. RTI and CT are also used to document details as mentioned above. E. Payne [2013] has listed some pros and cons of various techniques used in the documentation of artefacts in 3D. In addition, nowadays there are stereomicroscopes for art conservation and high-powered and high-resolution microscopes using digital imaging in 3D that can be used for studying glass, ceramic and stone objects.

In 2006 NextEngine Inc. launched its first 3D scanner to the consumer market. The NextEngine scanner is a table scanner which uses Multistripe Laser Triangulation and ScanStudio software producing images in JPG format and *range maps* RAW. The models can be elaborated with Geomagic Studio and processed with 3ds Max and Adobe Photoshop CS5. The scanner can produce reliable models. It is a low-cost method of producing models that can be used to analyse artefacts, for archiving and dissemination of data [Moulden, 2009; Tucci *et al.*, 2011]. Z-Scan of Menci Software can be applied to generate 3D models RGB that can be used to study objects. The technology is based on digital photography and stereophotogrammetry, and it can be integrated to laser scanning [Menci *et al.*, 2011].

H. Mara and J. Portl [2013] have used 3D scanners for the documentation of small artefacts applying optical methods such as stereo and/or structured light. Optical 3D scanning can be carried out by mounting a scanner on a tripod or setting the device on a turntable to rotate it. Some feel that low-cost 3D laser scanners are not always well suited to the documenting of large quantities of objects that need to be handled in strict time-scales, for example, at museums. In Mara and Portl's studies the size of the objects documented by optical 3D scanners varies from 1 cm in height or diameter up to 60 cm. For line drawings to be extracted from the archaeological documentation precision to less than 0.1 mm is needed and can be reached. Architectural structures with features in detail need a combination of various 3D techniques. To acquire a texture-map for a 3D model, the 3D scanners usually can capture data in colour or in greyscale from the surface of an object. Comparing smartSCAN to the Vi-9i and its successor the Range5, the smartSCAN seems to have advantages as far as colour and accuracy are concerned.

The 3D replicas and virtual moulds of sculpture and smaller artefacts can be made with high resolution scanning [Tucci and Bonora, 2007]. Iuliano and Minetola [2005] compared the use of various 3D optical laser scanners to make replicas of sculptures. The replication of marble sculptures with marble powder was developed with photogrammetry and both the laser scanner and the optical laser scanner; the laser scanning was found to be more accurate. High marble percentage mixtures were used for manufacturing [Skarlatos *et al.*, 2003]. In cases where replicas for artefacts are needed the development of the 3D printing technology provides a solution [Moulden, 2009]. But there have also been critical tones in producing replicas as they lack the genuine life and material of an artefact [Payne, 2013]. However, delicate artefacts may need to be stored out of light and safe from atmospheric changes, and to do this it may be necessary to represent them using replicas.

2.10.2 Sculptured monuments, statues and ornamentation

The Great Sphinx and simulating wind erosion

3D laser scanning has been applied in the conservation of the Great Pyramids built in the mid-3rd millennium BC and the Great Sphinx on the Giza plateau in Cairo in Egypt (Figure 2.23) [see Neubauer *et al.*, 2005]. The pyramids belonged to the Seven Wonders of the Ancient World, and now also to the World Heritage Sites. They have so amazingly endured the threat of time that an Arabic saying refers to the human fear of time, but that time fears pyramids instead. The Great Sphinx, however, has faced a different fate.

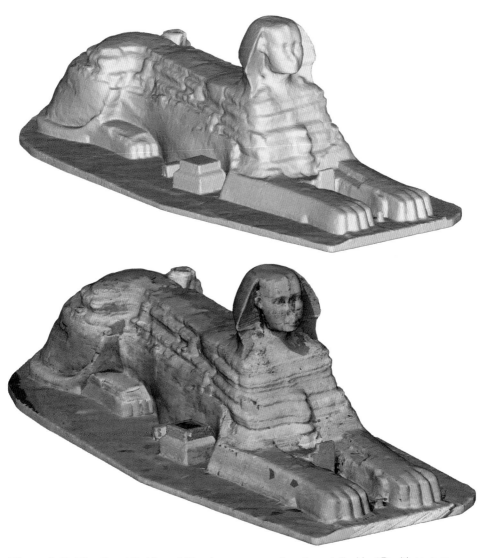

Figure 2.23 The Great Sphinx of Giza laser-scanned and modelled in 3D with texture. [Courtesy: W. Neubaver, Doneus, N. Studnicka and J. Riege]

The unique colossal statue of the Sphinx has been originally carved out of bedrock and was already restored in the Pharaonic era. It was later buried in sand. The 18th and 19th century travellers saw only the head and shoulders but later the statue had been exposed by excavations and restored in several stages. The various agents which have been affecting the degradation process of the statue include the impact of time, nature and humans. The statue is a ruin that needs to be kept as such from a conservation point of view [Helal, 2006].

There has been a need for a comprehensive conservation and restoration plan for the Sphinx. A major problem that has been recently assessed is the stability of the rock materials and the analysis of the context of the sculpture and its effects. Stress in the rock was analysed, especially in the Sphinx's neck. The left shoulder and back haunches of the Sphinx have been most exposed to the wind. CFD (computational fluid dynamics), a state-of-the-art-technique, has been used to study the wind and erosion impact on the monuments in the Giza plateau. Wind erosion is one of the major factors denuding the sculpture. Simulation of the wind in 3D has now been carried out to study its effects, like stress [Hussein and El-Shishiny, 2009]. The LIC (line integral convolution) algorithm provides the means to see the shape of the flowing air and pressure values. The ISL (illustrated stream lines) algorithm has been used in visualising in 3D the whole flow of air. The Flex system allows one to get into the ISL field. The frictions can be measured and visualised [Bibliotheca Alexandrina, International School of Information Science/IBM Center for Advanced Studies, Cairo).

Capturing the beauty of Nefertiti

The famous bust of Queen Nefertiti, King Akhenathen's wife, dating from ca. 1340 BC, found in Amarna in Egypt in 1912 and now at the Egyptian Museum in Berlin in Germany, has also been documented and reconstructed virtually. The limestone statue added with gypseous stucco was carved by sculptor Thutmose and has been the source of admiration or its excellent workmanship and beauty. The painting on the bust is remarkably preserved, as is one inlaid eye of crystal with a pupil of black wax [http://www.egyptian-museum-berlin.com/c53.php]. A voxel-based object reconstruction technique has been applied to compute a realistic volume model of Nefertiti's bust. CCD (charge-coupled device) cameras were used to acquire images from various points. An algorithm was applied to produce a reconstruction in 3D [Kuzu and Sinram, 2003].

The revealing ears of China's terracotta army

Studying the great terracotta army found in the tomb of China's Emperor Qin Shi Huan has been a major endeavour. The army belongs to the World Heritage List. The life-size statues were buried with the emperor in his mausoleum in 210–209 BC. In a recent study the intention of the 3D modelling was to study whether the statues have individual features and are perhaps representing soldiers that once served in the army

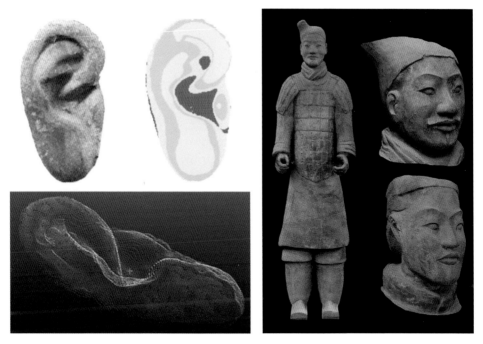

Figure 2.24 The 3D modelling of an ear from an ancient statue in the terracotta army of China's emperor. [Courtesy: A. Bevan *et al*.]

[Callaway, 2014]. Digital photographing of the statues is cheap and non-destructive. Several photographs from various angles can be used by computer algorithms to produce a 3D map of the images. Then the images can be plotted with other models for the purpose of comparison. The structure-from-motion and multi-view-stereo (SfM-MVS) provide together a computer vision using 3D colour-realistic models from a series of photographs overlapping each other [Bevan *et al.*, 2014]. Faces and ears of a number of warriors were modelled in 3D to assess the individual features, and it was realised that none of the two ears were the same (Figure 2.24).

The Bamiyan Buddhas – filling the gaps and landscape

In 2001 the Talebans destroyed colossal Buddha statues in the Bamiyan Valley, a World Heritage Site on the Silk Road, in Afghanistan. Televised news of these explosions caught the world's attention. Three colossal statues were carved in sedimentary rocks ca. 2000 years ago. Of the destroyed statues, a larger statue was 53 m tall, while a smaller one was 35–38 m in height. After the destruction a consortium took an initiative to rebuild the Great Buddha statue based on photogrammetric modelling using VirtuoZo, also capturing the folds of the garments. Fortunately there had been a survey in the 1970s that had documented the area with photogrammetry producing stereoscopic images. A milling machine was used for the physical

reconstruction of the Great Buddha in 1:200 in scale for museum purposes [Gruen *et al.*, 2003].

The landscape of the Bamiyan valley was also modelled and visualised using satellite imagery (SPOT-5 and IKONOS pansharpened mosaic). The cliff in which the Buddha statues were carved is ca. 1 km long and 100 m in height. It was photographed with an analogue camera Rollei 6006 with 39 camera positions and a total station gathered 30 control points for the images [Gruen *et al.*, 2005]. Also, UNESCO has taken further action to consolidate the site and produce virtual reconstructions. A detailed laser scanning of the hollow niches has been carried out. The image of a statue reaching 38 m was reconstructed from old photographs. A complicated stereo view was computed to a high-end computer cluster adapting the projected image to the spectator [Tsoubekis *et al.*, 2011].

The stepped well of Rani ki Vav

The Stepped Well of Rani ki Vav (Queen's well) in Patan, Gujarat, is one of the World Heritage Sites in India dating from the 11th century AD. It is a large well complex with numerous ornate carvings and sculpture that were scanned in 3D by a Scottish team working with CyArk and the Archaeological Survey of India (ASI) in 2011. The result is an amazing vision of sculptures that are very difficult to access *in situ* [see www. CyArk.org].

Lions of San Marco in Venice

Manual laser scanners provide simple and transportable technology. Ultra-high resolution (0.2 mm) scans were carried out with HandyScan 3D portable system produced by Creaform while documenting the bronze lion sculptures of St. Mark in Venice in Italy. The system was easy to transport and connect to a laptop with a fire-wire cable. The results of the scans were realised using partly VxScan software and partly RapidformXo-Scan for the purpose of 3D modelling. Finally, the 3D models received texture from digital images that had been produced from images of the sculptures captured with Panasonic LUmix DMC of 10.2 MPixel. The model was also exported to VRLM in order to experience 3D navigation environments [Achille *et al.*, 2007].

Michelangelo's David

Michelangelo's statue of David, now situated in the Uffici Gallery in Florence in Italy, is a Renaissance masterpiece that has appealed to people for centuries. A study of several old photographs of the statue was carried out for the purpose of conservation for the 500th anniversary of the completion of the sculpture. The images taken in 1858–1862, including stereopairs, were calibrated to estimate the interior orientation parameters, and consequently a photogrammetric model was constructed to estimate the three-dimensional coordinates of any common point in the images. It was realised

that the statue had inclined 11 cm from its vertical position before it was moved from the Galleria dell' Accademia [Fastellini *et al.*, 2005].

Stucco ornamentation

Ornamentation or decoration in *stucco* is produced by lime-plaster, gypsum plaster and/ or sand and cement plaster. It appears as light sculptured coating in relief on various walls and ceilings. The decoration could have been modelled *in situ* or brought as moulded pieces from elsewhere. Lime-plaster coating was used on floors, walls and ceilings already in the Pre-Pottery Neolithic period, like at Çatal Höyük in Turkey. Especially elaborate *stucco* decorations were executed in Greco-Roman antiquity. In palazzos and churches they became popular during the Baroque, Rococo and Empire eras that imitated motifs from antiquity. Nowadays, these patterns are still favoured in interior designs even in synthetic forms.

In Pompeii, detailed ornamentation in relief has been modelled in high resolution applying advanced multi-photo matching [Guidi *et al.*, 2009]. A survey in the Royal Palace of Turin in Italy, dating from the 16th and 17th centuries, concentrated on the documentation of the *stucco* ornamentation in the Sala degli Stucchi. Laser scanning was carried out with LiDAR, and photographing took place with a camera installed on the laser instrument. Photogrammetric models and orthophotos were produced. A dense digital surface model was produced with LiDAR [Agosto *et al.*, 2005].

The Orario del SS. Rosario in Santa Cita, situated in Palermo in Sicily, dates from the 17th and 18th centuries and has elaborate *stucco* decorations on its walls and ceilings. They are the work of Giacomo Serpotta, a famous sculptor and *stucco*-worker. Laser scanning was applied in surveying these sculptural faces. Surface models were produced using photogrammetric correlation and polygonising process. The surface models were refined applying breaklines and CAD surfaces. They were further used for making and comparing various orthophotos [*ibid.*].

2.10.3 Some types of artefacts and materials

Stone axes and obsidian tools

Robust stone artefacts from the Stone Age need very little conservation, apart from cleaning, because of their durability. However, thin stone blades can be damaged or broken easily. An ATOS II sensor mounted on a tripod has been successfully used in documentation of Stone Age lithic artefacts, such as hand axes, in 3D. An artefact was positioned in plasticine on a block of wood, where ATOS reference points were attached. During the measuring process fringe patterns were projected on the artefact for a few seconds captured by two integrated cameras on both sides of the sensor. In a few seconds the ATOS software calculated precise 3D coordinates for ca. 1.3 million object points. The software checks the illumination and the movement of the scanner and the artefact [Boehler *et al.*, 2003]. Furthermore, 3D scanning has been been found

to be useful in analysing post-depositional damage in stone tools, such as in Acheulian bifaces from the Palaeolithic era [Grosman *et al.*, 2008, 2011].

Obsidian is volcanic glass that appears in various colours and can be translucent. It was largely used during the Stone Age, especially in the Neolithic period, chiefly to produce tools and weapons. Topometrical high definition 3D surface scanners have been applied for the documentation of archaeological finds that need the highest possible resolution and accuracy such as obsidian. The state-of-the-art systems can achieve 10 μm spatial resolution and a depth resolution of a few μm, which is important for shiny objects. Scanning and digitalisation of obsidian with a modified high dynamic range technique has produced amazing results. Images are first recorded in 2D, after which they are recorded and visualised in 3D [Bathow and Breuckmann, 2011].

Ceramics and glass

The typological study of pottery has long been used for the relative dating of archaeological contexts. The profiles of vessels are studied for typological classification and analysis, and reconstructions of vessels are produced. SemanticArchaeo as a symbolic approach for pottery classification applies 3D models of ceramic vessels [Maiza and Gaildrat, 2006].

H. Mara and M. Kampel [2003] have developed a method to extract pottery profiles from sherds through 3D pottery reconstructions using a laser scanner. 3D scanning and profile reconstruction are now a standard procedure in studying pottery in various projects [Karasik and Smilansky, 2008]. The documentation of ancient Greek pottery has been successfully carried out using smartScan-3D-HE (High-End) [Mara and Portl, 2013] (Figure 2.25). In addition, CT is a useful method in documenting ceramic vessels and their fragments in 3D [Dimitrov *et al.*, 2006; Mara and Portl,

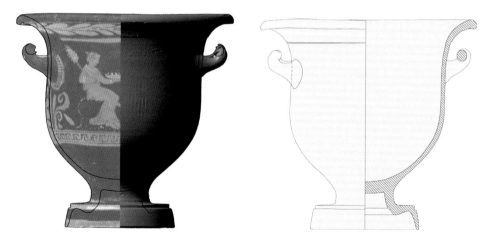

Figure 2.25 The documentation of an ancient Greek red-figured krater with a 3D scanner and generating a line drawing. [Courtesy: H. Mara.]

2013]. Voxel-based object reconstruction has also been applied for modelling pottery by using a CCD camera for image acquisation [Kuzu and Sinram, 2003].

Japanese pottery has been modelled using the low-cost scanner, such as NextEngine Desktop 3D Scanner Model 2020 i. The colour and surface texture of the pottery was faithfully produced [Kaneda, 2011]. Close-range laser scanning has also been applied to fragments of a 16th century pot of non-vitrified fine reddish ceramic that was discovered in the archaeological excavations of a convent in Portugal. Because of the incised vegetation patterns and the relief decoration of medallions representing knights with long hair and moustaches, a hypothetical reconstruction of the pot in 3D was presented after mathematical computations and geometric analysis of the decoration [Pires *et al.*, 2006].

RTI technology has also been successfully applied into the documentation of painted pottery such as Classical Greek figured vases. The so-called microscopic RTI uses either Highlight RTI method or a small dome [Kotoula, 2012, 2013]. RTI and laser confocal microscopy have been used in studying a red-figured Greek *stamnos* from the Worcester Art Museum in Britain. With the technique the incised contour lines of figures and points in relief were revealed in detail. The artistic hand and the used technique were able to be studied [Artal-Isbrand *et al.*, 2011].

Characterisation of glass morphology has been carried out using optical coherence tomography [Kunicki-Goldfinger *et al.*, 2009]. Corrosion in historical glass objects can be assessed by 3D micro X-ray fluorescence analysis [Kaungriesser *et al.*, 2008].

Metal objects

There are various methods that have been developed in documenting the surface fields of delicate objects that cannot be touched [Larue and Dischler, 2006]. Patina and/or corrosion appear in metal objects over time except for valuable inert metals such as platinum and gold. Metals can be especially vulnerable to atmospheric changes [Tidblad, 2013] and exposure to water.

Moisture causes corrosion, and corrosion can destroy a metal artefact completely. Archaeological objects may also have been contaminated by ions (salts), and they speed up the corrosion process if exposed to air when, for example, found in the ground. Metals should be stored in dry places, but the change in atmospheric conditions should not be rapid. The diagnostics of the state of the artefact is needed for stabilisation, conservation or replacement. The scales of corrosion should be analysed [Tidblad, 2013]. As previously mentioned, X-ray techniques, including CT, are used to analyse the structures and production processes of metal objects. Microscopes of various types and Raman spectroscopy can also be applied to diagnose metal artefacts [Neff *et al.*, 2013].

The famous Antikythera mechanism made of bronze and apparently dating from the 2nd century BC was found in a shipwreck site near the island of Antikythera off the Greek coast in 1900–1901 by sponge divers. The mechanism has been called 'the earliest computer'. The inner structure of the mechamism was analysed by using X-rays with analogue computer to see inside the mechanism. It has also been documented

with digital radiographs and CT, and the surface has been studied with PTM (cf. RTI) to extract inscribed texts [www.antikythera-mechanism.gr].

One can examine corrosion, dirt deposits, treatment and production processes of metal objects or analyse the structure of the metal and their alloy components with special Leica Microsystems. The combination of featured stereo and research micro-scopes with digital cameras and 3D software supports material analysis, cleaning and documentation [http://www.leica-microsystems.com]. Studies on strikes using metal objects such as Bronze Age axes have been carried out producing effects in 3D [Kovács and Hanke, 2013].

Metal requires special circumstances for visual documentation, as light conditions have to be taken into account. The Golden Madonna of the Essen Cathedral in Ger-many dates from the 10th century and has been modelled using a laser scanner with close-ranged photogrammetry applying a fringe-projection system [Peipe and Przy-billa 2005]. The treasures from the cathedral contain other metal objects that have been scanned, and details have been recorded and documented of crowns, crosses and swords in 3D, with precision ranging from 0.1 mm to 1 mm. Reverse engineering software is well applicable to data processing and modelling of complex cultural objects after laser scanning. The applications can be seen in decorated details in relief [Przybilla and Peipe, 2011]. RTI has also been used in the documentation of gilded silver objects from Derveni, Macedonia [Kotoula, 2013].

Wooden and bone objects

Electron microscopy reveals the production process of artifacts made of organic mater-ials and enables the characterisation of small particles. Raster electronic microscope is also used for organic and unorganic material studies, their origins and form. Xerora-diography can be used to study objects made of wood, bone, waxes and clay [Riederer, 1987].

Wooden objects, like many other organic substances, are sensitive to atmospheric changes. Old furniture is one of the specific studies in which wood appears as a com-mon material to be conserved. Wood can preserve relatively well in very dry/hot or cold atmospheres. As already indicated, wooden artefacts should be protected from micro-organisms and insects. As will be discussed below, in warm underwater condi-tions, worms eat wooden boat structures. Recently wooden and bone items of eskimos have been found in numbers, over 20,000 artefacts have been recovered at Nunalleq, a site in the west of Alaska, because climate change has caused the ancient settlement to melt in the areas that were previously under permafrost. The artefacts date from the 14th to 17th century [Globus, 2014].

As far as new techniques in 3D modelling of wood are concerned, modelling of tra-ditional Japanese kitchen ware called 'shikki' has taken place. The spoons were manu-ally produced from thin pieces of wood that had been painted with various colours and covered with natural lacquer. After the modelling 3D printers were used to reproduce the spoons [Vilbrant *et al.*, 2006].

An ivory *pyxis*, a small box, from the 5th/6th century AD, was documented by laser scanning, and the data was processed with Geomagic Studio to receive detailed elements of the sculptural decoration in relief. The software used also provided a means for texture mapping of the 3D model [Przybilla and Peipe, 2011].

Textile and holoprinting

Textiles, like organic materials in general, are vulnerable to changes in atmospheric conditions. They are especially sensitive to light that can shade the dyes and can damage the structure of fibres. X-ray studies can be carried out to assess the original techniques used in producing the textile artefacts. The combination of X-radiography with digital imaging has been applied to textile investigation and conservation. Radiographic film images are analogue images that can also be digitised to digital radiographs [O'Connor and Brooks, 2007]. The analysis of dyes in textiles is important for their conservation. The analyses can reveal information about the place of origin and dating. Techniques and methods from test-tubes to 3D fluorescence spectroscopy have been used to characterise dyes [Soltzberg *et al.*, 2012; Timar-Balázsy, 2002]. There are not many studies of recording and documenting leather objects in 3D, but we shall discuss leather in the case of writing materials below.

The Holy Shroud or Shroud of Turin is one of the most interesting relics of Christianity. Its history is, however, obscure and controversial. Debates are ongoing about the origins and dating of this linen cloth. Several new analyses and studies have been carried out in recent decades. C-14 datings were gained by using AMS (accelerating mass spectrometry) in the 1980s [Damon *et al.*, 1989]. However, the questions of size of the dated samples, contamination and later additions of textile patches have raised questions about the authenticity of the samples used for the dating. In 1997 there was a fire in Guarini Chapel in Turin, where the shroud is housed. The Duomo was largely damaged but the shroud was rescued from the flames in time [Vidal and Marangoni, 2000].

Photogrammetric studies have been carried out of black-and-white negatives revealing a frontal and dorsal image of a man in full scale on the shroud. The first photographs were taken in 1898. In the 1950s L. Vala produced a 3D model of the face on the shroud using two cameras and clay. Later on J. P. Jackson and E.J. Jumper extracted another 3D image. The shroud image has also been digitalized for computer enhancement, and it has been possible to produce a 3D image by mathematical procedures. Details invisible to the naked eye have also been revealed in this way. For example, N. Balossino has produced fine 3D images by image enhancing (Figure 2.26). Furthermore, holographic studies have been carried out on the shroud revealing inscriptions [Manon, 1998; Moretto, 1998]. The negatives that were taken by G. Enrie in 1931 of the shroud have also been digitalized and enhanced by P. Soons. He produced stereopairs and multiplied the images. A holoprinter was applied to create a hologram or 3D image of the face and the body of the figure previously recognised on the shroud [shroud3d.com].

Figure 2.26 3D image of the Shroud of Turin. [Courtesy: N. Balossino]

2.11 Inscriptions, tablets, scrolls and codices

Inscriptions are writings that are incised or cut into some hard material such as stone, plaster, glass, metal and pottery. They can appear in natural rock faces, monumental remains or on small artefacts. Coins that are minted have texts and can be seen as inscriptions, but in numismatics these texts are called 'legends'. On coins the legends and the images such as portraits have usually been produced in relief.

2.11.1 Monumental inscriptions

Apart from RTI technology, there are other efficient photogrammetric methods to capture details of sculpture in relief and inscriptions for their recording, documentation and conservation. Orthomosaics of images have been used for studying monumental inscriptions. One example of a low-cost approach has been applied to the Temple of Ramesses II from the 13th century BC in Thebes in Egypt. Surface reflectance varies with the angle of a camera. 3D documentation of the inscribed walls was carried out using terrestrial scan data for input feature points providing accuracy to the rectified images. [Cain and Martinez, 2006]. In addition, photometric stereo was applied for Maya inscriptions for the educational planetarium film *Maya Skies* [Paterson and Cain, 2006].

Some of the most difficult endeavours in documenting monumental cuneiform inscriptions and sculptural art in relief have been taking place in Behistun in Iran. After pictograms and pictographs, the wedge-shaped cuneiform writing was introduced and used in Mesopotamia from ca. 3000 BC. The famous monumental inscriptions of Dareios I from the 6th century BC rise on the face of a cliff. They had originally provided the keys for deciphering the ancient Mesopotamian writing system. In Behistun the nearly vertical location of the inscriptions has made the taking of hand copies or moulding difficult ever since they were first studied. Photogrammetric methods have successfully been applied in the modern documentation. The Iranians have documented the inscriptions in very difficult circumstances working on a semi-hanging scaffolding in the air. They have mapped the inscriptions in the scale of 1:5 with 5 mm contour intervals. P31 Wild Photogrammetric camera was used and photographs were taken in the scale of 1:30 using a control network and a Sokkia PowerSet 1000 total station [Zolfaghari and Malian, 2004] (Figure 2.27).

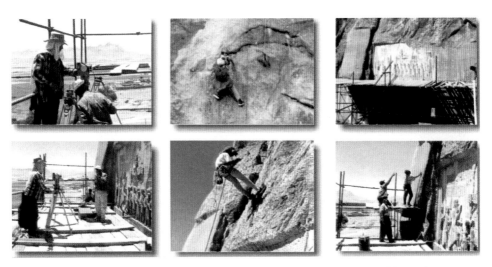

Figure 2.27 Documenting the monumental inscription of Dareios I in Behistun, Iran. [Courtesy: M. Zolfaghari.]

The documentation of the *Res Gestae Divi Augusti* bilingual inscription in Latin and Greek on the walls of the Temple of Augustus in Ankara in Turkey was also based on photogrammetric methods. In documenting these inscriptions a high resolution LiDAR instrument and 3D Handyscan were used for the first time in epigraphic recording and documentation. The instrument was used in an elevated and scaffolded area, where it was stable and reliable, and the work could be continued for a long time without interruption. A realistic 3D model was produced of the inscription by mapping the oriented images onto a 3D model after a surface generation (TIN) [Bornaz *et al.*, 2007].

An early Christian upright stone called 'the lost stone of Kirkmadrine' that comes from Scotland has been documented and studied by photogrammetric methods producing 3D models for its conservation. The performance of the image-based and the range-based documentation were compared with each other. In the image-based documentation an off-the-shelf zoom semi-professional Canon Powershot G12 digital camera was used with RAW and JPEG images taken from the mean distance of 200 mm. A dense multi-image matching was carried out to create 3D point clouds. For the range-based acquisition a Konica Minolta Vivid 91 laser scanner was used. It appeared that the image-based documentation could deliver feasible 3D recording and documentation. The flexibility and simplicity of 3D modelling, the efficiency of the image-based approach and its low cost make this a valuable tool when one compares the tools and approaches available to yield information for conservation purposes [Lerma and Muir, 2014].

2.11.2 Small inscriptions and coins

Nowadays there are 3D microscopes available to study surface profiles of small items, like incised decorations, texts and minted legends.

Large numbers of cuneiform texts written on clay tablets have been digitised. The West Semitic Research Project of the University of Southern California in the USA has carried out some digitalisation using RTI technologies [http://www.usc.edu/dept/LAS/wsrp/information]. Furthermore, H. Mara [2012] also describes the application of 3D scanning for documenting cuneiform documents (Figure 2.28).

Multispectral imaging has been used for documentation of *ostraca*, namely pot sherds that have been written by incising or with ink or another material. Sober *et al.* [2014] have used a low-cost system to achieve good results, and they provide instructions on how to do this on *ostraca*. In these kinds of document, writing is sometimes hard to recognise. The ink also starts to fade away more quickly after the documents have been unearthed and taken into standard room conditions. For this reason, it is recommended to document them with multispectral imaging before their storage. The system can be used effectively for enhancing other kinds of inscriptions for the purpose of deciphering as well.

As mentioned, coins usually bear human portraits, figures or inscriptions the latter called as legends. Coins and medals are small items that are minted from various metals and alloys. Gems can be worked in *intaglio* as incised technique on precious or

Figure 2.28 3D model of a cuneiform document. [Courtesy: Universal museum Joanneum (UMJ), Graz, Austria, Inv. Nr. 4611, H. Mara and S. Karl]

semi-precious stone, or *cameo* on relief on other materials like shell. Three-dimensional plaster casts of coins and gems have been traditionally used for their study. Earlier the problem in photographing such small items was to achieve adequate accuracy, and there were often difficulties in lighting conditions. But digital methods have offered new approaches and coins have been successfully documented and modelled using RTI. The method reveals surface reliefs and legends [Mudge *et al.*, 2005]. Medals have also been scanned with multisensory laser scanner systems making 3D models and experimenting with the accuracy of results, including a device with a micro touch probe [Salemi *et al.*, 2011].

2.11.3 Papyrus and parchment rolls, wax and wood tablets, palm leaves, bark and paper

As indicated also all organic writing materials are vulnerable to atmospheric changes. They need to be protected from light, insects and the growth of micro-organisms. Papyrus and parchment preserve well in dry conditions, and therefore Egypt and the Judean Desert have been major areas to reveal ancient libraries and archives. Laser technology has been used to clean paper and parchment. However, there may be risks for the material when exposed to laser beams. As previously mentioned, UV light has

been used for decades in extracting texts from old materials, and the light does not harm the materials as much as various bleaching agents. The development of documentation by digital images and use of light have been applied in reading the texts in these materials as well [Kite, 2006].

However, papyri went through pyroplastic conditions in Herculaneum when it was buried under volcanic lava and pumice. Carbonised papyri can nowadays be read in various ways, but the latest 3D technology has revolutionised the study, allowing virtual opening and reading scrolls without physically touching or unrolling them. The interior of papyri from Herculaneum have been imaged and studied applying X-ray CT, a non-destructive method to visualise the interior of the scrolls. It has enabled a 3D reconstruction of some scrolls. The microcomputer tomography has allowed to see the layers of scrolls, fractures, fissures and air gaps, which provides valuable information for an eventual conservation plan. The reading of text has become possible because of the carbon-based ink (not metal-based ink) used in writing [Gregory, 2004; Seales *et al.*, 2011]. The latest advances have shown how X-ray phase-contrast tomography can reveal hidden letters inside carbonised scrolls without opening them (Figure 2.27) [Mocella *et al.*, 2015].

Since their discovery in the caves of Qumran in Jordan (now in Israel) for the first time in 1947, the Dead Sea Scrolls have continuously required conservation and restoration work. Many scrolls were made of parchment (Lat. *pergamentum*) and were originally found in bits and pieces, requiring patch-work to assemble the original sen-

Figure 2.29 *Left*: The virtual opening of a Herculaneum papyrus: The close-up photography of a Herculaneum Papyrus scroll PHerc.Paris.4. (Courtesy: E. Brun and V. Mocella).
Right: Photograph of Herculaneum Papyrus scroll PHerc.Paris.4 (length : 16cm)
[Photo D. Delattre © Bibliothèque de l'Institut de France]

tences and whole texts [Tov, 2011]. Parchment, the worked leather that was used as a writing material in antiquity and Medieval times, alters its consistency in too hot, fluctuating or wet conditions. Hot and wet conditions cause the material to blacken and fuse together, while too dry conditions make it brittle and cause it to crack [Kite, 2006].

DNA and C-14 studies have been applied to find matching pieces of goat skin in the Dead Sea Scrolls. Also, a special digital imaging technique has been developed to match the fragments with each other [see Tov, 2011]. The Israel Museum includes the Shrine of the Book which stores a number of the famous scrolls. The scrolls have been restricted from exposure to extensive light during display and preservation. The temperature is kept constant at 19 °C, light 25 Lux and 47% relative humidity. The scrolls are only on display for 90 days a year. Combined methods using RTI and IR imaging have been applied to the fragments during their conservation process. RTI also provides possibilities to penetrate the surface and IR imaging contributes towards the analysis of the surface texture, so the fusion of these two methods provides good results [Caine and Magen, 2011]. Spectral imaging has also been used for monitoring the scrolls [Bearman *et al.*, 2011].

Wax tablets, for which a stylus was used as a writing implement, were popular in the Greco-Roman and Medieval world, but they have rarely been preserved intact as the wax that had covered wooden tablets has often vanished. Some examples, however, have been found in Roman contexts: for example, in Egypt [Robinet, 2002] and in Britain. RTI has been used in documenting such tablets [Manfredi *et al.*, 2013]. There are also Roman wooden tablets consisting of documents written directly with ink. Such documents were found in Vindolanda in Northern England in 1973. They had been preserved because of waterlogged conditions. The tablets are made of wafer-thin slices of wood. They were first photographed in normal light, UV and IR, of which IR became the standard method [Birley, 1977].

Texts and pictures have been written and drawn on palm leaves as well: for example, those on Indian palm leaves from the 8th century AD that are kept at the Museum Rieberg in Zurich. The collection consists of 66 palm leaves. On leaves there are poems in ancient Sanskrit. Digital images were acquired of them and an inner boundary-tracing algorithm was executed in the bundle of leaves to segment them. The boundary coordinates of the leaves were fundamental in the work. The neighbouring leaves were traced, and a texture map model of the manuscript of leaves was constructed [Akca and Gruen, 2003].

Medieval illuminated manuscripts were usually written on parchment or vellum, bound in codex form. But paper that was invented in China before the Common Era, arrived in Europe as late as the 12th century. Techniques to separate the foreground from the background have applied hybrid methods with algorithms, k-means clustering and ML (maximum likelihood) estimation in enhancing texts in historical Arabic paper manuscripts that face the danger of fading away [Boussellaa *et al.*, 2006]. Several early manuscripts are documented by digitising them and are thus made available to the public [see, e.g., Jobst, 2003]. In Novgorod in Russia, some ancient texts dating

from the 13th century were written on pieces of birch bark. Sweden has provided similar examples, and a letter of the same type has been found in excavations in Finland. The find from Finland dates back to the 15th century [Harjula, 2012], to the time when the printing technique was invented by Gutenberg in Germany. Spectral imaging techniques can be applied to these kinds of wooden documents.

There are visual ways via VR and AR techniques to provide virtual visits to libraries and archives. For example, MUBIL is an international project that uses novel technology providing access to manuscripts and old books from historical archives [see, e.g., Angeletaki *et al.*, 2013].

2.12 Graves, tombs and human remains

2.12.1 Funerary monuments

Remote sensing methods, such as GPR, have been especially useful in locating and recording burial sites. Burial mounds can also be detected with aerial reconnaissance, satellite image interpretation and LiDAR. The mounds can form various sizes and shapes. Keyhole-shaped ancient burial mounds have been documented in Japan. These large funerary formations date from the 4th to 6th century AD and appear around the country. Computer-based graphic restorations in 3D were carried out using digitised contour maps as a base. The three ratios used were compared between various tombs to analyse similarities [Ozawa, 2006].

The previously mentioned pyramids of Giza in Egypt are probably the most famous funerary monuments in the world. Unlike the pyramids, the Mausoleum of Halikarnassos from the 4th century BC, also one of the Seven Wonders of the Ancient World, has only a podium and scattered architectural fragments left, at its original site in Bodrum in Turkey. This monument originally gave the name to the funeral structure known as *mausoleum*. We have already discussed funerary monuments in the case of Hatra, Palmyra and Petra, where *mausolea* have faced intentional destruction or deterioration by whethering. Tombs like *mausolea* located in structures can now be detected, for example, with micro-resistivity methods by modelling and through inversion of field data in 3D. Surveys using dipole–dipole, gradient and pole–pole arrays can be used in walls and hidden cavities like those in *mausolea* [Matias *et al.*, 2006].

2.12.2 Underground Etruscan and Greco-Roman tombs and catacombs

In the Etruscan *necropoleis*, the cities of the dead, of Tarquinia and Cerveteri in Italy, there are *hypogea*, underground tombs dating from the 7th to 4th century BC. They have been surveyed and documented constructing 3D models that offer virtual access to some tombs. The tombs contain valuable frescoes that are vulnerable to atmospheric changes. Visible, IR and UV digital images were acquired for photogrammetric 3D reconstructions. Spherical and panoramic photography were applied. The used IR reflectography and UV-induced fluorescence were used to record and document the frescoes. The work provides valuable information on materials used in fresco paintings. The acquired 3D models that use high-resolution panoramic data were rendered

in predefined flying paths in monoscopic and stereoscopic (anaglyph) videos. 3D geobrowsers and web-tools can provide 3D data visualisation in a way needed to present the data in its context, but the complexity of the data still prevents its use on the web [Remondino *et al.*, 2011].

A 'distance museum' was also created for a virtual visit to Hellenistic *hypogeum* tombs situated in the necropolis of Taranto in Magna Graecia in Sicily. The work was based on digital photomodelling and photogrammetry. All the data in 3D was brought to a multimedia system by integrating it to a single viewing environment. RealTime 3D platform was used as a user interface providing the viewing environment [Gabellone, Giannotta, 2005].

The subterranean Rome in Italy is a city in itself. An archaeological information system has been planned to manage this world with multiple remains [Crespi *et al.*, 2005]. Some catacombs, underground *necropoleis,* have been documented for virtual visits. The Early Christian catacomb of Domitilla has been documented, modelled and texture mapped as well [Mayer *et al.*, 2011].

2.12.3 3D printing of Tutankhamen's tomb

The discovery of the tomb of Tutankhamen in the Valley of the Kings in Western Thebes, Egypt, in 1922 was a major break-through in archaeology [see, e.g., Fox 1951] and in conservation techniques. The access to the tomb developed the understandingof the deterioration process and advancing decay that various materials face due to atmospheric changes. Alfred Lucas' notes on the conservation procedures of artefacts including furniture are kept in the Griffith Institute at Oxford University in Britain and are available on its website.

Decisions have been made to protect the tomb of Tutankhamen from the exposure that could lead to the loss of its beautiful murals. The latest developments in 3D technology have been applied to the famous tomb. 3D printing is one of the solutions. Factum Arte has carried out the documentation of the tomb by digital photographing, laser scanning and 3D printing to recreate its murals in great accuracy. In this high resolution recording 100 million points of data were collected per square metre capturing the texture of the paintings in detail [The Griffith Institute, Factum Arte, 2014] (Figure 2.30). Tutankhamen's mummy has also been printed in 3D [http://www.materialise.com/cases/king-tut-revealed-through-an-accurate-3d-replica].

2.12.4 Sarcophagi

Sarcophagi and cenotaphs are coffins produced from hard materials like stone, metal or terracotta. They often include decorated features in relief on their surface, either sculptured, moulded or executed as graphical ornamentation.

A test to use a total station to document sarcophagi in 3D showed that the accuracy of 2 cm minimum is not readily applicable to recording and documenting such objects in detail [Yildiz *et al.*, 2007]. The German Emperor Maximilian's cenotaph has been

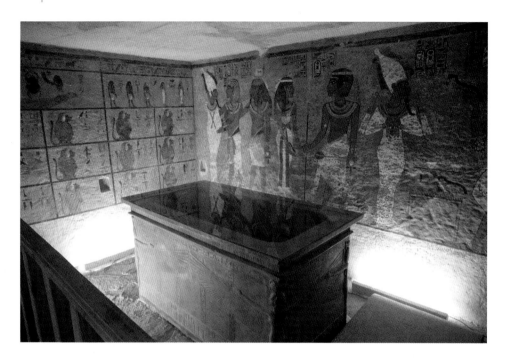

Figure 2.30 3D printed tomb of Tutankhamen by Factum Arte. [Courtesy: Factum Arte.]

more successfully documented with a laser scanner in 3D. The cenotaph belonged to the Habsburg dynasty in Innsbruck in Austria (1420–1665), and it is decorated in relief with the statue of the emperor on the top [see, e.g. Boehler *et al.*, 2003]. PTM or RTI has also been applied in documenting sculptured details producing fine results of the faces of sarcophagi in relief [Dellepiane *et al.*, 2006].

The computed colour has been the subject of a research in 3D digitalisation of the recumbent statue of Philippe Dagobert of France (ca. 1222–1232 AD) on its cenotaph situated in St. Denis' Basilica in Paris in France [Genty *et al.*, 2006].

2.12.5 Scientific approaches to studying human remains

In archaeological excavations an archaeologist needs to find out whether the material recovered in a burial is associated with it or not. Building projects, ditch cutting, land filling and drainage work reveal and can disturb human graves [Hunter *et al.*, 1997]. However, human burials often create a sensitive issue that comprises questions of ethics and rights. Such sites as concentration camps have been sanctified in respect to the dead. In recent decades, archaeological studies of mass burials have been applied in studies of war crimes. The graves from the wars in Bosnia and Iraq have been under special investigation recently. [Steele, 2008].

Palaeopathologists emphasise the value of excavating, analysing and curating human remains. From the archaeological point of view, disregarding human remains at

archaeological sites leads to a large gap in our ability to reconstruct the past. As already indicated, palaeopathology, forensic archaeology, bioarchaeology and osteology can all nowadays employ 3D techniques in documentation and preservation of such remains. There are special environments which preserve organic materials. Acidity and alkality of soil, humidity, temperature (also body temperature has an effect), micro-organisms, mesofauna and macrofauna may all affect preservation. In acid soils, bone disappears much more rapidly than in neutral or slightly alkaline soils. The process is also affected by the physical condition of the deceased, like the bone density at the time of death and whether burial occurred after some decomposition had started. For the preservation of human soft tissues, some extreme conditions, such as bog environment, permafrost or drought, are needed [Janaway, 1997].

Modelling prehistoric people in graves

3D modelling of human remains at the Neolithic site of Çatal Höyük in Turkey has produced images of skeletons *in situ* in tombs and burial pits. A special challenge is an intramural multilayered context, which can be documented well using 3D modelling. The modelling from the data captured from burials was carried out without using expensive laser scanners. The work was based on digital photographs that were taken from multiple directions. 15–50 photographs were needed to produce high quality models. Beside a digital camera, two softwares were used to produce the models: PhotoScan and MeshLab. The models can be then georeferenced into a GIS. ArcGIS was used in the case of the burials. The scales of the skeletons and the burials can be studied later from the models, even if the burials have been removed [Knüsel *et al.*, 2013]. The models can especially be used to study positions of tombs inside buildings, assessing burial types, whether articulated or disarticulated, and human postures.

Palaeopathology and mummies

The CT imaging system slices anatomical parts, and these cross-sectional images can be used for various medical purposes. The mummification process of the ancient Egyptians is described by the historians Herodotos and Diodoros Siculus. Their accounts have been compared with the CT imaging of an ancient mummy from the Greco-Roman era using Vitrea 2 workstation. The analyses have confirmed the accurate description of the mummification process. Radiological studies have also revealed the sexes and injuries of mummies. CT has been found not only useful in studying the mummification process, but also in observing anatomical detail and post-mortem changes [Davey *et al.*, 2013]. Computer-assisted technologies can also be useful for physical anthropology. The studies of damaged mummies, features in bones and the intentional deformation of skulls *in vivo* have been carried out among Inca mummies from Peru [Fantini *et al.*, 2006]. A Pre-Pottery Neolithic plastered human skull originating from Jericho, now in the Palestinian territories of Israel, has also been studied with CT technology, that has revealed new evidence for understanding skull deformation and the so-called skull cult [Fletcher, 2015].

Furthermore, radiological studies have revealed valuable information about the Tyrolean mummified Iceman known as Ötzi dating to ca. 3300 BC. The mummy was first studied by X-ray methods in 2001 and 2002, and the CT was carried out with Somatom 4 (Siemens Erlangen) and later on in 2005 with a Sensation 16 multislice CT and Leonardo Leo Symgo 2004A VD108 work station (Siemens Erlangen). For example, a 3D image was produced of the shoulder region from various angles. In this way palaeopathological studies of the corpse revealing various inner organs could be carried out without damage [Gostner *et al.*, 2011]. Also, Raman spectroscopy applications have been used in studying the remains of the Iceman [The 11th Confocal Raman Imaging Symposium, 2014]. His nutrition, as well as the environment prevailing at the death of the man, were traced from 30 different types of pollen preserved in his stomach. Researchers have even been able to trace his movements through different landscapes in mountainous areas [Owen, 2013].

Forensic archaeology as an aid in 3D reconstruction

Forensic archaeology based partly on forensic sciences has also developed techniques and methods to study human remains. Facial reconstruction is nowadays used in forensic studies. Earlier these reconstructions were manually executed in clay or plasticine, but computerised digital reconstructions in 3D are currently used in adding the flesh parts on a skull. A face for a skull from Tomb II in Vergina in Greek Macedonia was already reconstructed in the 1980s by a team from the Manchester Museum in Britain. The skull was thought to have belonged to King Philip II, Alexander the Great's father, who lived late in the 4th century BC and was injured in a battle [Prag, 1990]. There have been ophthalmological studies in tracing the evidence of the wounded right eye of the king through ancient literature as well as human bone remains found in the tomb. However, the studies with macrophotography did not find any evidence of the reported wounds in the skull. There has been a continuing controversy regarding whether during some decades the signs of healed wounds in bones have disappeared [Lascaratos, 2004].

In 2012 King Richard III's remains were found underneath a car park in Leicester in Britain. The king had been buried in a pit in haste and his skull showed a trauma, probably due to being slashed with a sword or halberd on the back of his head. The king is known to have been killed in battle. DNA analysis was used in the identification of the remains. Moreover, the remains were replicated in plastic with a 3D printer after which the reproduced skeleton was laid on display in a museum in Leicester. A detailed facial reconstruction was also produced (Figure 2.31), and a 3D model of his grave was made with a laser scanner. [King Richard III Visitor Centre, Leicester: http:/krii.com].

2.13 Underwater / maritime / nautical archaeology

The UNESCO Convention on Underwater Cultural Heritage of 2001 includes definitions of underwater remains in its Article 1:

> This heritage consists of sites, structures, buildings, artefacts and human remains together with their archaeological and natural contexts as well as vessels, aircrafts or any parts from

Figure 2.31 3D reconstruction of King Richard III of England. [Facial depiction by Prof. Caroline Wilkinson, Liverpool John Moores University and Janice Aitken, University of Dundee].

them, their cargo or other contents, together with their archaeological and natural context, and objects of prehistoric character.

Furthermore, in Article 2 the preservation of the underwater remains *in situ* was given priority and responsible access without non-intrusive methods to the heritage sites which do not have incompatible protection and management in place should be allowed to build awareness.

The Nautical Archaeology Society of Britain has produced *Underwater Archaeology: The NAS Guide to Principles and Practice* [Bowden, 2009]. It provides, for example, practical guidance in underwater photographing. UNESCO [www.unesco.org] has also published guide books available on the web, such as *Training Manual for the UNESCO Foundation Course on the Protection and Management of Underwater Cultural Heritage in Asia and the Pacific* and *Manual for Activities Directed at Underwater Cultural Heritage*.

Harbours and piers can be the focus of underwater documentation. One famous site is the location of ancient Pharos in Alexandria in Egypt - the lighthouse that also belonged to the Seven Wonders of the Ancient World. Now architectural remains are scattered and sunken into the sea with various artefacts of cultural heritage [Empereur, 2000]. Underwater sites, such as shipwrecks, often preserve evidence of maritime

heritage well because of low light and oxygen-free conditions. But wooden structures such as shipwrecks and piers can also face environmental hazards in currents and tides. If exposed to aerobic conditions organisms, such as bacteria, fungi, molluscs and crustaceans, may affect them. As briefly mentioned, woodborers are likely to attack wrecks in warmer waters, especially if the vessel is less than 0.5 m under the sediments. Global warming may increase the colonisation of various new species that destroy wood [Palma, 2009]. The Mediterranean and the Caribbean are famous for their wreck sites, and over 1000 wrecks are known to exist in the shallow areas of the Mediterranean. Deep-sea submersibles have also more recently been discovered in deep waters [Renfrew and Bahn, 2003].

But as briefly indicated, wreck sites are best preserved in cool and salty waters, where worms do not affect the disintegration of wooden remains. On the other hand, the famous shipwreck of the Titanic that sank in icy waters during its maiden voyage in 1912 is made of iron and is speedily deteriorating, because of rust and iron-eating bacteria called *Halomonas titanicae* [Sanchez-Porro *et al.*, 2010]. As the site is in international waters and up till 2012 the wreck was under 100 years old, it was difficult to protect and preserve the site. In memory of the centenary of its maiden voyage and its fate, the site was given the World Heritage status to highlight its protection. The documentation of the site was previously largely neglected by several groups lifting the finds. The public interest in underwater remains and maritime history has been extensive, and the enthusiasm can be empowered through public archaeology to save the common heritage through information sharing and prevent looting of sites [Scott-Ireton, 2014].

Diving is costly, as is the use of submarines such as "cupmarines" and carrying out hundreds of dives for covering an area of a square kilometre for prospection and surveying underwater sites. In the seabed there may be a problem detecting archaeolgical relics by the naked eye because of vegetation, including plankton, mud, sand or encrustation. Geophysical instruments can be used in prospecting and survyeing the seabed, as on the ground surface. Electronic instruments, such as an echo-sounder, are also used in prospecting and surveying. Sonar is a common technical device in ships echoing the bottom of seas, and it is often used in prospecting underwater archaeolo- gical remains. The combination of magnetometer and side-scan sonar has revealed 19th century war ships on the coast of Canada [Linder and Raban, 1975; Renfrew and Bahn, 2003].

Photogrammetry has successfully been applied to underwater surveys, document- ation and mapping. Especially the documentation of an underwater excavation is a complicated and expensive process. Coordinates need to be recorded, finds labelled and conserved in challenging conditions. Measurements in 3D can be carried out from the data captured under water using stereophotography. One can make reconstructions in 3D (Figure 2.26), orthophotographs and vector restitution. A Japanese team has already used computer-generated mosaics of photographs from underwater excavations of a Byzantine wreck site off the Syrian coastline in the 1980s. The photographs were

Figure 2.32 The wreck of a clipper known as the *City of Adelaide* from the 19th century has been laser scanned and documented in 3D by Headland Archaeology in Scotland. The boat is the oldest clipper in the world. [Courtesy: Headland Archaeology.]

taken with Hasselblad MK-7 with the focal length of 60 mm. The detailed study of discovered piles of amphoras and their position on the seabed was possible using photogrammetric methods [Murai *et al.*, s.a]. New underwater cameras have been developed in the digital era, and the prices of cameras have gone down.

Furthermore, the combination of optic and acoustic data has produced promising results in the field of underwater mapping in recent years. Photomosaics on bathymetric digital terrain maps have been produced from sonar maps in 3D. *In situ* artefact recording methods have been applied for the studies of the *Grand Rebaud F*, an Etruscan ship, found in Hyères in France. The recorded artefacts were modelled in 3D and all the photogrammetric georeferenced data and survey data were stored in a database for queries [Drap, 2012]. A detailed 3D model of a Roman wooden boat has also been scanned in a museum using MENSI SOISIC LD laser scanner with 3Dipsos software [Boehler *et al.*, 2001].

The VENUS project develops scientific use of technological tools and methods for underwater virtual studies of archaeological sites. VR and AR are applied in the studies of the sites and digital 3D modelling is taken to immersive interaction. *VENUS Preservation Handbook* can be downloaded from the project's website and *Marine Remote Sensing and Photogrammetry: A Guide to Good Practice* can be found on the website as well [http://archaeologydataservice.ac.uk/research/venus].

References

Achille, C., Brumana, R., Fassi, F., Fregonese, L., Monti, C. Taffurelli, L. and Vio, E., 2007. Transportable 3D acquisition systems for cultural heritage reverse engineering and rapid prototyping of the bronze lions of the Saint Isidoro Chapel in the Basilica of San Marco in Venice. In: *Anticipating the Future of the Cultural Past*, Georgopoulos, A. (Ed.), 21st CIPA Symposium, 01–06 October, Athens, Greece, ISPRS International Archives of the Photogrammetry, Remote Sensing and Spatial Information Sciences, XXXVI-5/C53, 1–6.

Achille, C., Fregonese, L., Monti, C. and Savi, C., 2005a. Advanced methodologies for surface analysis: methods, comparison and monitoring of the mosaic surface floor of the St. Mark's Basilica in Venice. In: *Proceedings of the XXth International Symposium CIPA*, Dequal, G. (Ed.), Torino, Vol. 1, The International Archives of Photogrammetry, Remote Sensing and Spatial Information Sciences, XXXVI-5/C34/1, 37–42.

Achille, C., Monti, C., Monti, C.C. and Savi C., 2005b. Survey and representation of the Villa Reale di Monza to support the International Design Competition. In: *Proceedings of the XXth International Symposium CIPA*, Dequal, G. (Ed.), Torino, Vol.1, The International Archives of Photogrammetry, Remote Sensing and Spatial Information Sciences, XXXVI-5/C34/1, 43–58.

Adas, A.A., 2013. Wooden Bay Window (Rowshan) Conservation in Saudi–Hejazi heritage buildings. In: *Proceedings of the XXIV International CIPA Symposium*, Grussenmeyer, P. (Ed.), 2–6 September 2013, Strasbourg, France, International Archives of the Photogrammetry, Remote Sensing and Spatial Information Sciences, XL-5/W2, 7–9.

Adcock, J. and Watters-Wilkes, M., 2009. Ground penetrating radar: recent improvements. *The Archaeologist*, 71, 16–17.

Agnello, F., Lo Brutto, M. and Lo Meo, G., 2005. DSM and digital orthophotos in cultural heritage documentation. In: *International Cooperation to Save the World's Cultural Heritage*, Dequal, S. (Ed.), Proceedings of the XX International Symposium CIPA, Turin, 26 September – 1 October, Vol. 1, The International Archives of Photogrammetry, Remote Sensing and Spatial Information Sciences, XXXVI-5/C34/1, 49–54.

Agostinelli, M., Clini, P., L'Ancioni, N., Qauttrini, R. and Sabattini, G., 2007. The Volponi's Kiln in Urbino, Industrial Archaeology and Historic Landscape in the Cradle of the Renaissance, Documentation, Survey and Drawing. In: *Anticipating the Future of the Cultural Past*, Georgopoulos, A. (Ed.), 21st CIPA symposium, 01–06 October, Athens, Greece, The ISPRS International Archives of the Photogrammetry, Remote Sensing and Spatial Information Sciences, XXXVI-5/C53, 17–22.

Agosto, E., Ardissone, P., Maschino, P., Porporato, C. and Ranieri, P., 2005. A survey of 'the Sala degli Stucchi' in ornate baroque hall. In: *International Cooperation to Save the World's Cultural Heritage*, Dequal, S. (Ed.), Proceedings of the XX International Symposium CIPA 2005, Turin, 26 September–1 October, Vol. 1, The ISPRS International Archives of Photogrammetry, Remote Sensing and Spatial Information Sciences, XXXVI-5/C34/1, 59–62.

Akbaylar, I. and Hamamacoğlu-Turan, M., 2007. Documentation of a vernacular house with close-range digital photogrammetry. In: *Anticipating the Future of the Cultural Past*, Georgopoulos, A. (Ed.), 21st CIPA Symposium, 01–06 October, Athens, Greece, The ISPRS International Archives of the Photogrammetry, Remote Sensing and Spatial Information Sciences, XXXVI-5/C53, 46–51.

Akea, D. and Gruen, A., 2003. Re-sequencing a historical palm leaf manuscript with boundary-based shape descriptors. In: *New Perspectives to Save the Cultural Heritage*, Altan, O. (Ed.), XIX CIPA 2003 International Symposium, 30 September–4 October, Antalya, Turkey, The ISPRS International Archives of the Photogrammetry, Remote Sensing and Spatial Information Sciences, XXXIV-5/C15, 55–60.

Almagro, A., 2005. Survey, research and virtual reality in the monuments of Seville included in the World Heritage List. In: *International Cooperation to Save the World's Cultural Heritage,* Dequal, S. (Ed.), Proceedings of the XX International Symposium CIPA 2005, Turin, 26 September–1 October, Vol. 2, The International Archives of Photogrammetry, Remote Sensing and Spatial Information Sciences, XXXVI-5/C34/1, 637–642.

Almagro, A., 2013. Surveying World Heritage Islamic monuments in North Africa: experiences with simple photogrammetric tools and no previous planning. In: *Proceedings,* Grussenmeyer, P. (Ed.), XXIV International CIPA Symposium, 2–6 September, Strasbourg, *France,* The ISPRS Annals of the Photogrammetry, Remote Sensing and Spatial Information Sciences, II-5/W1, 13–18.

Alshawabkeh, Y., Ba'lawi, F. and Haala, N., 2010. 3D digital documentation, assessment, and damage quantification of the Al-Deir monument in the Ancient City of Petra, Jordan, *Conservation and Management of Archaeological Sites,* 12, 124–145.

Andrews, D.P., Beckett, N.J., Clowes, M. and Tovey, S.M., 2003. Photographic survey of mosaic and tiled floors – methodology. In: *New Perspectives to Save the Cultural Heritage,* Altan, O. (Ed.), XIX CIPA 2003 International Symposium, 30 September–4 October, Antalya, Turkey, The ISPRS International Archives of the Photogrammetry, Remote Sensing and Spatial Information Sciences, XXXIV–5/C15, 241–246.

Angeletaki, A., Carrozzino, M. and Johansen, S., 2013. Implementation of 3D tools and immersiive experience interaction for supporting learning in a library–archive environment, visions and challenges. In: *Proceedings of the XXIV International CIPA Symposium,* Grussenmeyer, P. (Ed.), 2–6 September, Strasbourg, France, ISPRS Annals of the Photogrammetry, Remote Sensing and Spatial Information Sciences, XL-5/W2, 37–41.

Artal-Isbrand, P., Klausmeyer, P. and Murray, W., 2011. An evaluation of decorative techniques on a red-figure attic vase from the Worcester Art Museum using reflectance transformation imaging (RTI) and confocal microscopy with a special focus on the 'relief line', *MRS Proceedings,* 1319, mrsf10-1319-ww01-06. DOI: http://dx.doi.org/10.1557/opl.2011.793.

Bahn, P., 1997. *Geoglyphs. Mysteries of the Ancient World.* London: Weidenfeld & Nicholson.

Bala'awi, F., Alshawabkeh, Y., Alawneh, F. and Al-Masri, E. (s.a.) *Damage Assessment and Digital 2D–3D Documentation of Petra Treasury.* Queen Rania's Institute of Tourism and Heritage.

Baletti, C., Guerra, F. and Adami, A., 2011. From wooden maquettes to digital model: virtual reconstruction of a design path. In: *Proceedings,* Pavelka, K. (Ed.), XXIIIrd CIPA Symposium, Prague, Czech Republic, 12–16 September, http://cipa.icomos.org/fileadmin/template/doc/PRAGUE/015.pdf.

Balodimos, D., Lavvas, G. and Georgopoulos, A., 2003. Wholly documenting the holy monuments. In: *New Perspectives to Save the Cultural Heritage,* Altan, O. (Ed.), CIPA 2003 XIX International Symposium, 30 September–4 October, Antalya, Turkey, The ISPRS International Archives of the Photogrammetry, Remote Sensing and Spatial Information Sciences, XXXIV-5/C15, 502–505.

Balzani, M., Santopuoli, N., Grieco, A. and Zaltron, N., 2004. Laser scanner 3D survey in archaeological field: the Forum of Pompeii. In: *International Conference on Remote Sensing Archaeology,* Beijing, 18–21 October, 169–175.

Barba, L., 2003. The geophysical study of Burid archaeological remains and the preservation of the architectural patrimony of Mexico City. In: *New Perspectives to Save the Cultural Heritage,* Altan, O. (Ed.), CIPA 2003 XIX International Symposium, 30 September–4 October, Atalya, Turkey, The ISPRS International Archives of the Photogrammetry, Remote Sensing and Spatial Information Sciences, XXXIV-5/C15, 401–405.

Bathow, C. and Breuckmann, B., 2011. High-definition 3D acquisition of archaeological objects: an overview of various challenging projects all over the World. In: *Proceedings,*

Pavelka, K. (Ed.), XXIIIrd CIPA Symposium, Prague, Czech Republic, 12–16 September, http://cipa.icomos.org/fileadmin/template/doc/PRAGUE/026.pdf

Baturayoglu, N., Summers, G.D., Summers, F. and Aydin, N., 2001. The survey and documentation of an Iron Age City in Central Anatolia: Kerkenes Dag. In: *Surveying and Documentation of Historic Buildings – Monuments –Sites: Traditional and Mothern Methods*, XVIIIth International Symposium of CIPA, Potsdam (Germany), 18–21 September, The ISPRS International Archives of Photogrammetry, Remote Sensing and Spatial Information Science, XXXIV-5/C7, 407–414.

Beachman, R., Denard, H. and Niccolucci, F., 2006. An introduction to the London Charter. In: *The e-volution of Information Communication Technology in Cultural Heritage: Where Hi-Tech Touches the Past: Risks and Challenges for the 21ˢᵗ Century*, Ioannides, M., Arnold, D., Niccolucci, F. and Mania, K. (Eds.), Project papers from the joint event CIPA/VAST/EG/EuroMed 2006, 30 October–4 November 2006, Nicosia, Cyprus, Budapest: EPOCH Publication, 263–269.

Bearman, G., Christens-Barry, W. and Boydston, K., 2011. How much data is enough: quantitative spectral imaging of texts and cultural objects. In: *EIKONOPOIIA: Digital Imaging of Ancient Textual Heritage*, Proceedings of the International Conference Helsinki, 28–29 November, 2010, Helsinki: Societas Scientorum Fennicae, 1–8.

Beraldin, J.-A., Blais, F., Cournoyer, L., Picard, M., Gamache, D., Valzano, V., Bandiera, A. and Gorgoglione, M., 2006. Multi-resolution digital 3D imaging system applied to the recording of grotto sites: the case of Grotta dei Cervi. In: *CIPA/VAST/EG/EuroMed 2006*, Ioannides, M., Arnold, D., Niccolucci, F. and Mania, K. (Eds.), The 37ᵗʰ CIPA International Workshop Dedicated on e-Documentation and Standardisation in Cultural Heritage Incorporating: The 7ᵗʰ Symposium on Virtual Reality, Archaeology and Intelligent Cultural Heritage and the 4ᵗʰ Eurographics Workshop on Graphics and Cultural Heritage, 1ˢᵗ Euro-Med Conference on IT in Cultural Heritage, Nicosia, Cyprus, 30 October –4 November, 2006, Aire-la-Ville: Eurographics Association, 45–52.

Berg, L., 1978. The salvage of the Abu Simbel temples, *Monumentum*, 17(2), 25–56.

Bevan, A., Li, X., Martinón-Torres, M., Green, S., Xia, Y., Zhao, K., Zhao, Z., Ma, S., Cao, W. and Rehren, T., 2014. Computer vision, archaeological classification and China's terracotta warriors. *Journal of Archaeological Science*, 49, 249–254.

Biddle, M., Cooper, M.A.R. and Robson, S., 1992. The Tomb of Christ, Jerusalem: a photogrammetric survey, *Photogrammetric Record*, 14(79), 25–43.

Birley, R., 1977. *Vindolanda: A Roman Frontier Post on Hadrian's Wall*. London: Thames & Hudson.

Bitelli, G., Capra, A. and Zanutta, A., 2001. Photogrammetric surveying of Nymphea in Pompeii. In: *Surveying and Documentation of Historic Buildings – Monuments –Sites: Traditional and Mothern Methods*, VIIIth International Symposium of CIPA, Potsdam (Germany), 18–21 September, The ISPRS International Archives of Photogrammetry, Remote Sensing and Spatial Information Science, XXXIV-5/C7, 236–242.

Bland, R., 2010. The Portable Antiquities Scheme and Treasure Act. *The Archaeologist*, 76, 22–23.

Boehler, W., Boehm, K., Heinz, G., Justus, A. Schwartz, Ch. and Siebold, M., 2003. Documentation of Stone Age Artifacts. In: *New Perspectives to Save the Cultural Heritage*, Altan, O. (Ed.), CIPA 2003, XIX International Symposium, 30 September–4 October, Antalya, Turkey, The ISPRS International Archives of the Photogrammetry, Remote Sensing and Spatial Information Sciences, XXXIV-5/C15, 506–510.

Boehler, W., Heinz, G. and Marbs, A., 2001. The potential of non-close range laser scanners for cultural heritage recording. In: *Surveying and Documentation of Historic Buildings – Monuments – Sites: Traditional and Mothern Methods*, XVIIIth International Symposium of

CIPA, Potsdam (Germany), 18–21 September, The ISPRS International Archives of Photogrammetry, Remote Sensing and Spatial Information Science, XXXIV-5/C7, 430–436.

Bornaz, L. and Dequal, S., 2003. A new concept: the solid image. In: *New Perspectives to Save the Cultural Heritage*, Altan, O. (Ed.), CIPA 2003 XIX International Symposium, 30 September–4 October, Antalya, Turkey, The ISPRS International Archives of the Photogrammetry, Remote Sensing and Spatial Information Sciences, XXXIV-5/C15, 169–174.

Bornaz, L., Botteri, P., Porporato, C. and Rinaudo, F., 2007. New application field for the handyscan 3D: the Res Gestae Divi Augusti of the Augustus Temple (Ankara), a restoration survey. In: *Anticipating the Future of the Cultural Past*, Georgopoulos, A. (Ed.), 21st CIPA symposium, 01–06 October, 2007, Athens, Greece, The ISPRS International Archives of the Photogrammetry, Remote Sensing and Spatial Information Sciences, XXXVI–5/C53, 182–187.

Boussellaa, W., El Abed, H. and Zahour, A., 2006. A Concept for the Separation of Foreground/Background in Arabic Historical Manuscripts using Hybrid Methods. In: *VAST 2006, CIPA/VAST/EG/EuroMed 2006*, Ioannides, M., Arnold, D., Niccolucci, F. and Mania, K. (Eds.), The 37th CIPA International Workshop Dedicated on e-Documentation and Standardisation in Cultural Heritage Incorporating: The 7th Symposium on Virtual Reality, Archaeology and Intelligent Cultural Heritage and the 4th Eurographics Workshop on Graphics and Cultural Heritage, 1st Euro-Med Conference on IT in Cultural Heritage, Nicosia, Cyprus, 30 October–4 November, Aire-la-Ville: Eurographics Association, 131–137.

Bowden, M., 1991. *Pitt Rivers: the life and archaeological work of Lieutenant-General Augustus Henry Lane Fox Pitt Rivers, DCL, FRS, FSA*. Cambridge: Cambridge University Press.

Bowens, A. (Ed.), 2009. *Underwater Archaeology: The NAS Guide to Principles and Practice*. Nautical Archaeology Society (NAS). Oxford: Blackwell.

Brall, A., Breuer, M., Henning, A., Hohmuth, F., Prümm, O. and Stamm, T., 2001. Documetation of the Palmyrene tower-tombs in Syria using terrestrial photogrammetry – archaeological and photogrammetric results. In: *Surveying and Documentation of Historic Buildings – Monuments – Sites: Traditional and Mothern Methods*, XVIIIth International Symposium of CIPA, Potsdam (Germany), 18–21 September, The ISPRS International Archives of Photogrammetry, Remote Sensing and Spatial Information Science, XXXIV-5/C7, 212–217.

Brisch, G. (Ed.), 2010. *The Travel Chronicles of Mrs. J. Theodore Bent*. Vol. III: Southern Arabia and Persia. Oxford: Archaeopress.

Brizzi, M., D'Andrea, A., Sepio, D., De Silva, M. and Court, S., 2005. Planning a conservation project: the information system of the Insula Orientalis I at Herculaneum. In: *International Cooperation to Save the World's Cultural Heritage*, Dequal, S. (Ed.), Vol. 2, Proceedings of the XX International Symposium CIPA, Turin, 26 September–1 October, The ISPRS International Archives of the Photogrammetry, Remote-Sensing and Spatial Information Sciences, XXXVI-5/C34, 691–696.

Brizzi, M., Court, S., D'Andrea, A. Lastra, A. and Sepio, D., 2006. 3D Laser scanning as a tool for conservation: the experiences of the Herculaneum Conservation Project. In: *The e-volution of Information Communication Technology in Cultural Heritage: Where Hi-Tech Touches the Past: Risks and Challenges for the 21st Century*, Ioannides, M., Arnold, D., Niccolucci, F. and Mania, K. (Eds.), Project papers from the joint event CIPA/VAST/EG/EuroMed 2006, 30 October–4 November, Nicosia, Cyprus, Budapest: EPOCH Publication, 72–78.

Brooks, R.R. and Johannes, D., 1990. Phytoarchaeology. In: *Historical, Ethno & Economic Botany Series*, Dudley, T.R. (Ed.), Vol. 3. Portland, Oregon: Discorides Press.

Brumana, R., Monti, C., Monti, G. and Vio, E., 2005. Laser scanner integrated by photogrammetry for reverse engineering to support architectural site and restoration of the mosaic floor inside St. Mark's Basilica, in Venice. In: *International Cooperation to Save the World's Cultural Heritage*, Dequal, S. (Ed.), Proceedings of the XX International Symposium CIPA 2005, Turin, 26 September–1 October, Vol. 1, The ISPRS International Archives of the

Photogrammetry, Remote-Sensing and Spatial Information Sciences, XXXVI-5/C34, 159–164.

Brunet, J. and Vidal, P., 1981. Conditions biologique. In: *Monuments historiques, Les grottes ornées,* 118, 54–62.

Buccellati, F., Dell'Unto, N. and Forte, M., 2005. The Mozan/Urkesh archaeological project: an integrated approach of spatial technologies. In: *The Reconstruction of Archaeological Landscapes through Digital Technologies,* Proceedings of the 2nd Italy – United States Workshop, Rome, Italy, 3–5 November, 2003, Berkeley, USA May 2005, BAR International Series 1379, Oxford: Hadrian Books, 171–183.

Buriánek, J., 2011. Digital Langweil model of Prague. In: *Proceedings of the XXIIIrd CIPA Symposium, Prague, Czech Republic,* Pavelka, K. (Ed.), 12–16 September, http://cipa.icomos.org/fileadmin/template/doc/PRAGUE/030.pdf

Cain, K. and Martinez, P., 2006. Large ortorectified photo mosaics for archaeology. In: *The e-volution of Information Communication Technology in Cultural Heritage: Where Hi-Tech Touches the Past: Risks and Challenges for the 21st Century,* M. Ioannides, D. Arnold, F. Niccolucci and K. Mania (Ed.), Short papers from the joint event CIPA/VAST/EG/EuroMed 2006, 30 October–4 November, Nicosia, Cyprus, Budapest: EPOCH Publication, 22–23.

Caine, M. and Magen, M., 2011. Pixels and parchment: the application of RTI and infrared imaging to the Dead Sea Scrolls. In: *Electronic Visualisation and the Arts,* London, 140–146.

Callaway, E., 2014. 3D images remodel history: digital-photo software promises to offer unprecedented access to artefacts and sites. In: *Nature,* 510, 319–320.

Canciani, M., Maestri, D. and Spadafora, G., 2007. The integrated survey for the knowledge and the documentation of the archaeological heritage: the 'Villa dei Misteri' in Pompei. In: *Anticipating the future of the cultural past,* Georgopoulos, A. (Ed.), 21st CIPA symposium, Athens, 1–6 October, The ISPRS International Archives of the Photogrammetry, Remote Sensing and Spatial Information Sciences, XXXVI-5/C53, 193–198.

Caneve, L., Diamanti, A., Grimaldi, F., Palleschi, G., Spizzichino, V. and Valentini, F., 2010. Analysis of fresco by laser induced breakdown spectroscopy. In: *Spectrochimica Acta, Part B,* 702–706.

Cederlund, C.O. with contributions Hafström, G. and Wender, P., 2006. *VASA 1: The Archaeology of the Swedish Warship 1628.* Stockholm, Sweden: National Maritime Museum of Sweden.

Chandler, J.H. and Bryan, P., 2007. Cost-effective rock-art recording in a production environment: is there a wider message? In: *Anticipating the Future of the Cultural Past,* Georgopoulos, A. (Ed.), 21st CIPA symposium, October 01–06, Athens, Greece, The ISPRS International Archives of the Photogrammetry, Remote Sensing and Spatial Information Sciences, XXXVI-5/C53, 210–215.

Chandler, J. and Fryer, J.G., 2005. Recording aboriginal rock art using cheap digital cameras and digital photogrammetry. In: *International Cooperation to Save the World's Cultural Heritage,* Dequal, S. (Ed.), Proceedings of the XX International Symposium CIPA 2005, Turin, 26 September–1 October, Vol. 1, The ISPRS International Archives of the Photogrammetry, Remote-Sensing and Spatial Information Sciences, XXXVI-5/C34, 193–198.

Chapman, H. and Gearney, B., 2009. Understanding hidden landscapes. *The Archaeologist,* 71, 20–21.

Chiarini, S., Cremonesi, S., Fregonese, L., Fassi, F. and Taffurelli, L., 2014. A multi-range approach for cultural heritage survey: a case study in Mantua Unesco site. In: *The Proceedings of the ISPRS Technical Comission V Symposium 23–25 June, Riva del Garda, Italy,* International Archives of Photogrammetry, Remote Sensing and Spatial Information Sciences, XL-5.

Cordera, L. and Ricciardi Venco, R., 2005. The Hatra project, a proposal for the creation of database comprising the whole of the city's archaeological records, In: *International Cooper-*

ation to Save the World's Cultural Heritage, Dequal, S. (Ed.), Proceedings of the XX International Symposium CIPA 2005, Turin, 26 September–1 October, Vol. 1, The ISPRS International Archives of the Photogrammetry, Remote-Sensing and Spatial Information Sciences, XXXVI-5/C34199–202.

Crespi, M., De Vendictis, Fabiani, U., Luzietti, L. and Mazzoni, A., 2005. The archaeological information system of the underground of Rome: a challenging proposal for the next future. In: *International Cooperation to Save the World's Cultural Heritage*, Dequal, S. (Ed.), Proceedings of the XX International Symposium CIPA 2005, Turin, 26 September –01 October, Vol. 1, The ISPRS International Archives of the Photogrammetry, Remote-Sensing and Spatial Information Sciences, XXXVI-5/C34, 209–214.

Cumo, A., Esperança, C. and Roma Cavalcanti, P., 2005. 3D Nasca's zoomorphic geoglyphs reconstruction. In: *International Cooperation to Save the World's Cultural Heritage*, Dequal, S. (Ed.), Proceedings of the XX International Symposium CIPA, Turin, 26 September–1 October, Vol. 2, The ISPRS International Archives of the Photogrammetry, Remote-Sensing and Spatial Information Sciences, XXXVI-5/C34, 736–745.

Damon, P.E., Donahue, D.J., Gore, B.H. *et al.*, 1989. Radiocarbon dating of the Shroud of Turin, *Nature*, 337(6208), 611–615.

D'Annibale, E., 2011a. Image based modeling from spherical photogrammetry and structure in motion, the case of the Treasury, Nabatean Architecture in Petra. In: *Proceedings* of the *XXIIIrd CIPA Symposium*, Pavelka, K. (Ed.), Prague, Czech Republic, 12–16 September 2011, http://cipa.icomos.org/fileadmin/template/doc/PRAGUE/038.pdf

D'Annibale, E., 2011b. 3D stereoscopic navigation of metric and highly textured archaeological models. In: *Proceedings* of the *XXIIIrd CIPA Symposium*, Pavelka, K. (Ed.), Prague, Czech Republic, 12–16 September, http://cipa.icomos.org/fileadmin/template/doc/PRAGUE/039.pdf

Davey, J., Stewart, MEB, and Drummer, O.H., 2013. The value of CT imaging of Horus in determining the method of mummification and the sex of the mummy. *Journal of Medical Imaging and Radiation Oncology*, 57, 657–662.

Dellepiane, M., Corsini, M., Calliere, I. M. and Scopigno, R., 2006. High quality PTM acquisition: reflection transform imaging for large objects. In: *VAST 2006, CIPA/VAST/ EG/EuroMed 2006*, Ioannides, M., Arnold, D., Niccolucci, F. and Mania, K. (Eds.), The 37th CIPA International Workshop Dedicated on e-Documentation and Standardisation in Cultural Heritage Incorporating: The 7th Symposium on Virtual Reality, Archaeology and Intelligent Cultural Heritage and the 4th Eurographics Workshop on Graphics and Cultural Heritage, 1st Euro-Med Conference on IT in Cultural Heritage, Nicosia, Cyprus, 30 October –4 November, Aire-la-Ville: Eurographics Association, 179–193.

Dellepiane, M., Dell'Unto, N., Callieri, M., Lindgren, S. and Scopigno, R., 2012. Archaeological excavation monitoring using dense stereo matching techniques, *Journal of Cultural Heritage*, DOI: http://dx.doi.org/10.1016/j.culher.2012.01.011.

Dell'Unto, N., Leander, A.M., Dellepiane, M., Callieri, M., Ferdani, D. and Lindgren, S., 2013. Digital reconstruction and visualization in Archaeology. In: *Digital Heritage International Congress (Digital Heritage) 2013*, 621–628.

Dietzler, J., 2012. On 'organized crime' in the illicit antiquities trade: moving beyond the definitional debate, *Trends in Organized Crime*, 15(4), DOI: http://dx.doi.org/10.1007/sl2117–012-9182-0.

Dimitrov, L.I., Wenger, E., Šrámek, M., Trinkl, E. and Lang-Auinger, C., 2006. VISAGE: An integrated environment for visualization and study of archaeological data generated by industrial computer tomography. In: *The e-volution of Information Communication Technology in Cultural Heritage: Where Hi-Tech Touches the Past: Risks and Challenges for the 21st Century*, Ioannides, M., Arnold, D., Niccolucci F. and Mania, K. (Eds.), Short papers from the joint

event CIPA/VAST/EG/EuroMed 2006, 30 October–4 November, Nicosia, Cyprus, Budapest: EPOCH Publication, 49–55.

Dolanský, T., Štrodenovà, J. and Dolanska, M., 2011. Detailed documentation of synagogues in Prague using combination of tachymetry, laser scanning and close-range photogrammetry, In: *Proceedings of the XXIIIrd CIPA Symposium*, Pavelka, K. (Ed.), Prague, Czech Republic, 12–16 September, http://cipa.icomos.org/fileadmin/template/doc/PRAGUE/162.pdf

Doneus, M. and Briese, C., 2006. Digital terrain modelling for archaeological interpretation within forested areas using full-waveform laser scanning. In: *VAST 2006, CIPA/VAST/EG/EuroMed 2006*, Ioannides, M., Arnold, D., Niccolucci, F., Mania, K. (Eds.), The 37th CIPA International Workshop Dedicated on e-Documentation and Standardisation in Cultural Heritage Incorporating: The 7th Symposium on Virtual Reality, Archaeology and Intelligent Cultural Heritage and the 4th Eurographics Workshop on Graphics and Cultural Heritage, 1st Euro-Med Conference on IT in Cultural Heritage, Nicosia, Cyprus, 30 October – 4 November, Aire-la-Ville: Eurographics Association, 155–162.

Doneus, M., Neubauer, W. and Studnicka, N., 2003. Digital recording of stratigraphic excavations. In: *New Perspectives to Save the Cultural Heritage*, Altan, O. (Ed.), CIPA 2003 XIX International Symposium, 30 September–4 October, Antalya, Turkey, The ISPRS International Archives of the Photogrammetry, Remote Sensing and Spatial Information Sciences, XXXIV-5/C15, 451–456.

Drap, P., 2012. Underwater photogrammetry for archaeology. In Techopen.com.

Drap, P., Durand, A., Nedir, M., Seinturier, J., Papini, O., Boucault, F., Chapman, P., Viant, W., Vannini, G. and Nuccioti, M., 2006. Towards a photogrammetry and virtual reality based heritage information system: a case study of Shawbak Castle in Jordan. In: *VAST 2006, CIPA/VAST/EG/EuroMed 2006*, Ioannides, M., Arnold, D., Niccolucci, F. and Mania, K. (Eds.), The 37th CIPA International Workshop Dedicated on e-Documentation and Standardisation in Cultural Heritage Incorporating: The 7th Symposium on Virtual Reality, Archaeology and Intelligent Cultural Heritage and the 4th Eurographics Workshop on Graphics and Cultural Heritage, 1st Euro-Med Conference on IT in Cultural Heritage, Nicosia, Cyprus, 30 October –4 November, Aire-la-Ville: Eurographics Association, 67–74.

Drap, P., Durand, A., Seinturier, J., Vannini, G. and Nucciotti, M., 2005. Full XML documentation from photogrammetric survey to 3D visualization, the case study of Shawbak Castle in Jordan. In: *International Cooperation to Save the World's Cultural Heritage*, Dequal, S. (Ed.), Proceedings of the XX International Symposium CIPA 2005, Turin, 26 September –01 October, Vol. 2., The ISPRS International Archives of the Photogrammetry, Remote-Sensing and Spatial Information Sciences, XXXVI-5/C34, 771–776.

Empereur, J.-Y., 2000. *Underwater Archaeological Investigations of the Ancient Pharos*. Coastal management sourcebooks 2. Paris: UNESCO.

English Heritage, 2008. *Geophysical Survey in Archaeological Field Evaluation*. http://www.english-heritage.org.uk/publications/geophysics.

Eppelbaum, L.V. and Itkis, S.E., 2003. Geophysical examination of the Christian archaeological site Emmaus-Nicopolis (Central Israel). In: *New Perspectives to Save the Cultural Heritage*, Altan, O. (Ed.), CIPA 2003, XIX International Symposium, 30 September –04 October, Antalya, Turkey, The ISPRS International Archives of the Photogrammetry, Remote Sensing and Spatial Information Sciences, XXXIV-5/C15, 395–400.

Eppich, R., Almagro, A., Santana, M. and Almagro, A., 2011. The view from above: overview and comparison of low cost aerial photographic techniques, In: *Proceedings* of the *XXIIIrd CIPA Symposium*, Pavelka, K. (Ed.), Prague, Czech Republic, 12–16 September, http://cipa.icomos.org/fileadmin/template/doc/PRAGUE/133.pdf.

Fangi, G., 2015. Documentation of Some Cultural Heritage Emergencies in Syria in August 2019 in Syria by Spherical Photogrammetry, In: *Proceedings, 25th International CIPA Sym-*

posium, Yen, Y.–N., Weng, K.–H., and Cheng, H.–M. (Eds.), 31 August–4 September 2015, Taipei, Taiwan, The ISPRS International Annals of the Photogrammetry, Remote-Sensing and Spatial Information Sciences, II-5/W3, 401–408.

Fangi, G., Malinverni, E.S. and Schiavoni, A., 2005. Integrated surveying techniques for the archaeological park of Chan-Chan in Peru. In: *International Cooperation to Save the World's Cultural Heritage,* Dequal, S. (Ed.), Proceedings of the XX International Symposium CIPA 2005, Turin, 26 September –01 October, Vol. 1, The ISPRS International Archives of the Photogrammetry, Remote-Sensing and Spatial Information Sciences, XXXVI-5/C34, 259–264.

Fantini, M., De Cresenzio, F., Perisani, F., Benazzi, S. and Gruppioni, G., 2006. Computer assisted archaeo-anthropology on damaged mummified remains. In: *The e-volution of Information Communication Technology in Cultural Heritage, Where Hi-Tech Touches the Past: Risks and Challenges for the 21st Century,* Ioannides, M., Arnold, D., Nicolucci, F., and Mania, K. (Ed.), Short papers from CIPA/VAST/EG/EuroMed 2006, 30 October – 4 November, Nicosia, Cyprus, Budapest: Epoch Publications, 112–118.

Fastellini, G., Grassi, S., Marucci, M. and Radicioni, F., 2005. Michelangelo's David: historicali for the preservation of a masterpiece. In: *International Cooperation to Save the World's Cultural Heritage,* Dequal, S. (Ed.), Proceedings of the XX International Symposium CIPA 2005, Turin, 26 September–1 October, Vol. 1., The International Archives of Photogrammetry, Remote Sensing and Spatial Information Sciences, XXXVI-5/C34/, 265–270.

Fisher, E., 2005. Multi-dimensional GIS beneath the surface, *GEOconnexion,* July/August, 48–50.

Fleicher, H., Simon, K.-J. and Ziemann, H., 2001. Colour-correct 3D computer presentation of the Masters' House Kandisnky-Klee. In: *XVIIth International Symposium of CIPA,* Potsdam (Germany), September 18–21, The ISRPS International Archives of Photogrammetry, Remote Sensing and Spatial Information Sciences, XXXIV-5/C7, 310–314.

Fletcher, A., 2015. Finding the Perosn within: A Neolithic Plastered Skull from Jericho. In: *Digging up Jericho: Past Present and Future,* conference held at the Univeristy College of London, 29–30 June, 2015, Programme, abstracts.

Fletcher, C.A. and Spencer, T. (Ed.), 2005. *Flooding and Environmental Challenges for Venice and Its Lagoon: State of Knowledge.* Cambridge: Cambridge University Press.

Foietta, E., 2011. The defences of Hatra: new technologies applied to the fortifications (Database, GIS, 3D Modelling), poster and paper 'The defences of Hatra: a revaluation through the archive of the Italian expedition'. In: *BH4-Broadening Horizon, 4th Conference of Young Researchers Working in the Ancient Near East* (in print).

Forte, M., Dell'Unto, N., Issavia, J., Onsureza, L. and Lercaria, N., 2012. 3D archaeology of Çatalhöyük. *Heritage in the Digital Era,* 1(3), 352–378.

Fox, P., 1951. *Tutankhamun's Treasure.* London: Oxford University Press.

Fregonese, L., 2003. Usability and potential use of the high resolution digital camera in the determination of 3D digital model. In *New Perspectives to Save the Cultural Heritage,* Altan, O. (Ed.), CIPA 2003, XIX International Symposium, 30 September–04 October, Antalya, Turkey, The ISPRS International Archives of the Photogrammetry, Remote Sensing and Spatial Information Sciences, XXXIV-5/C15, 275–279.

Fregonese, L. and Taffurelli, L., 2009. 3D model for the documentation of cultural heritage: the wooden domes of St. Mark's Basilica in Venice. In: *3D-ARCH-3D Virtual Reconstruction and Visualization of Complex Architecture,* The International Archives of Photogrammetry, Remote Sensing and Spatial Information Sciences, XXXVIII-5/W1.

Gabellone, F., and Gianotta, M.T., 2005. Realtime 3D multimedia system for the distance visiting of cultural heritage: a case study on the chamber tombs in Via Crispi, Taranto, In: *International Cooperation to Save the World's Cultural Heritage,* Dequal, S. (Ed.), Proceedings

of the XX International Symposium CIPA 2005, Turin, 26 September–1 October, Vol. 2, The International Archives of Photogrammetry, Remote Sensing and Spatial Information Sciences, XXXVI-5/C34/1, 808–811.

Gannon, M., 2014. Hidden paintings revealed at ancient temple of Angkor Wat. *Livescience*, 27 May.

Genty, A., Callet, P., Lequement, R., de Contencin, F.-X., Zymla, A. and Bonnet, B., 2006. Cultural heritage engineering: measured, calculated and computed color. In: *The e-volution of Information Communication Technology in Cultural Heritage: Where Hi-Tech Touches the Past: Risks and Challenges for the 21st Century*, Ioannides, M., Arnold, D., Niccolucci, F. and Mania, K. (Eds.), Project papers from the joint event CIPA/VAST/EG/EuroMed 2006, 30 October–4 November, Nicosia, Cyprus, Budapest: EPOCH Publication, 132–137.

Giunta, G., Di Paola, E., Mörlin Visconti Castiglione, B. and Menci, L., 2005. Integrated 3D-database for diagnostics and documentation of Milan's Cathedral façade. In: *International Cooperation to Save the World's Cultural Heritage*, Dequal, S. (Ed.), Proceedings of the XX International Symposium CIPA 2005, Turin, 26 September–1 October, Vol. 1., The International Archives of Photogrammetry, Remote Sensing and Spatial Information Sciences, XXXVI-5/C34/1, 322–327.

GLOBUS: Alaskan juppikien aarteita. In *National Geographic*, 2014, No. 10, October, 16. (Finnish edition)

Gostner, P., Pernter, P., Bonatti, G., Graefen, A. and Zink, A.R., 2011. New radiological insights into the life and death of the Tyrolean Iceman. *Journal of Archaeological Science*, 38, 3425–3431.

Gregory, A.P., 2004. Digital exploration: unwrapping the secrets of damaged manuscripts. *Odyssey*, University of Kentucky, Fall, 19–23.

Gregory, D., and Matthiesen, H., 2012. *The 4th International Conference on Preserving Archaeological Remains in situ (PARIS4)*, 23–26 May 2011, FINDES I: Conservation and Management of Archaeological Sites 2012, 14.

Grosman, L., Sharon, G., Goldman-Neuman, T., Smikt, O. and Smilansky, U., 2011. Studying post-depositional damage on Acheulian bifaces using 3D scanning. *Journal of Human Evolution*, 60(4), 398–406.

Grosman, L., Smikt, O. and Smilansky, U., 2008. On the application of 3-D scanning technology for the documentation and typology of lithic artifacts. *Journal of Archaeological Science*, 35, 3101–3110.

Gruen, A., Remondino, F. and Zhang, L., 2003. Computer reconstruction and modeling of the Great Buddha Statue in Bamiyan, Afghanistan. In: *New Perspectives to Save the Cultural Heritage*, Altan, O. (Ed.), CIPA 2003 XIX International Symposium, 30 September–4 October, Antalya, Turkey, The ISPRS International Archives of the Photogrammetry, Remote Sensing and Spatial Information Sciences, XXXIV-5/C15, 440–445.

Gruen, A., Remondino, F. and Zhang, L., 2005. Modeling and visualization of landscape and objects using multi-resolution image data. In: *International Cooperation to Save the World's Cultural Heritage*, Dequal, S. (Ed.), Proceedings of the XX International Symposium CIPA 2005, Turin, 26 September–1 October, Vol. 1, The International Archives of Photogrammetry, Remote Sensing and Spatial Information Sciences, XXXVI-5/C34/1, 338–339.

Grussenmeyer, P. and Yasmin, J., 2003. The restoration of Beaufort Castle (South-Lebanon): 3D restitution according to historical documentation. In: *New Perspectives to Save the Cultural Heritage*, Altan, O. (Ed.), CIPA 2003, XIX International Symposium, 30 September–4 October, Antalya, Turkey, The ISPRS International Archives of the Photogrammetry, Remote Sensing and Spatial Information Sciences, XXXIV-5/C15, 322–327.

Guidi, G., Lazzari, S., Atzeni, C. and Seracini, M., 2004. Painting survey by 3D optical scanning: the case of the *Adoration of the Magi* by Leonardo da Vinci. *Studies in Conservation*, 49, 1–12.

Guidi, G., Remondino, F., Russo, M., Menna, F., Rizzi, A. and Ercoli, S., 2009. A multi-resolution methodology for the 3D modeling of large and complex archaeological areas. *International Journal of Architectural Computing*, 7, 39–54.

Guidi, G., Remondino, F., Russo, M., Rizzi, A., Voltolini, F., Menna, F., Fassi, F., Ercoli, S., Maci, M.E. and Benedetti, B., 2008. A multi-resolution methodology for archaeological survey: the Pompeii Forum. In: *VSSM 2008, Conference on Virtual Systems and Multimedia Dedicated to Digital Heritage* (Limassol), Cyprus, 20–25 October, 51–59.

Guidi, G., Tucci, G., Beraldin, J.-A., Ciofi, S., Damato, V., Ostsuni, D., Costantino, F. and El-Hakim, S.F., 2002. Multiscale archaeological survey based on the integration of 3D scanning and photogrammetry. In *CIPA Work Group 6 International Workshop on Scanning for Cultural Heritage Recording, Korfu, Greece*, 58–64.

Haala, N. and Ashawabkeh, Y., 2006. Combining laser scanning and photogrammetry – a hybrid approach for heritage documentation. In: *VAST 2006, CIPA/VAST/EG/EuroMed 2006*, Ioannides, M., Arnold, D., Niccolucci, F. and Mania, K. (Eds.), The 37th CIPA International Workshop Dedicated on e-Documentation and Standardisation in Cultural Heritage Incorporating: The 7th Symposium on Virtual Reality, Archaeology and Intelligent Cultural Heritage and the 4th Eurographics Workshop on Graphics and Cultural Heritage, 1st Euro-Med Conference on IT in Cultural Heritage, Nicosia, Cyprus, 30 October –4 November, Aire-la-Ville: Eurographics Association,, 163–170.

Haddad, N., 2011. From ground surveying to 3D laser scanner: a review of techniques used for spatial documentation of historic sites. *Journal of King Saud University – Engineering Sciences*, 23, 109–118.

Haddad, N. and Ishakat, F., 2007. Laser scanner and reflectoless total station: a comparative study of the slots of El-Khazaneh at Petra in Jordan. In: *Anticipating the Future of the Cultural Past*, Georgopoulos, A. (Ed.), 21st CIPA Symposium, 01–06 October, Athens, Greece, The ISPRS International Archives of the Photogrammetry, Remote Sensing and Spatial Information Sciences, XXXVI-5/C53, 356–361.

Haggrén, H., Koistinen, K., Junnilainen, H. and Erving, A., 2005. Photogrammetric documentation and modelling of an archaeological site: the Finnish Jabal Haroun Project. In: *3-D ARCH 2005: Virtual Reconstruction and Visualization of Complex Architectures*, El-Hakim, S., Remondino, F. and Gonzo, L. (Eds.), 22–24 August, Mestre-Venice, Italy, ISPRS Archives, Vol. XXXVI, 5-W, I7, 9 pages.

Haggrén, H., Nuikka, M., Junnilainen, H. and Järvinen, J., 2001. Photogrammetric approach for archaeological documentation of an ancient road. In: *Surveying and Documentation of Historic Buildings – Monuments –Sites: Traditional and Mothern Methods*, Albertz, J. (Ed.), XVIIIth International Symposium of CIPA, Potsdam (Germany), 18–21 September, The ISPRS International Archives of Photogrammetry, Remote Sensing and Spatial Information Sciences, XXXIV-5/C7, 108–113.

Harjula, J., 2012. Preliminary thoughts on the Birchbark Letter from the Cathedral Square excavation in Turku. *Suomen Keskiajan Arkeologian Seura* (a Finnish journal in Medieval Archaeology), 1–2, 3–21.

Harris, J., 2007. *Pompeii Awakened: A Story of Rediscovery*. London, New York: I.B. Tauris & Co Ltd.

Heine, K., Brasse, C. and Wulf, U., 2006. WWW-based building information system for 'Domus Severiana' Palace in Rome by open source software. In: *VAST 2006, CIPA/VAST/EG/EuroMed 2006*, Ioannides, M., Arnold, D., Niccolucci, F., and Mania, K. (Eds.), The 37th CIPA International Workshop Dedicated on e-Documentation and Standardisation in Cultural Heritage Incorporating: The 7th Symposium on Virtual Reality, Archaeology and Intelligent Cultural Heritage and the 4th Eurographics Workshop on Graphics and Cultural Heritage, 1st Euro-Med Conference on IT in Cultural Heritage, Nicosia, Cyprus, 30 October–4 November, Aire-la-Ville: Eurographics Association, 75–82.

Helal, H., 2006. Engineering stability and conservation of the Sphinx: diagnosis and treatment. In: *Supplément aux Annales du Service des Antiquités de l'Égypte.* Cairo.

Héno, R. and Egels, Y., 2011. Architectural patrimony management in Yemen. In: *CIPA Heritage Documentation: Best Practices and Applications,* Stylianidis, E., Patias, P. and Santana Quintero, M. (Eds.), Series 1, 2007 & 2009, The ISPRS International Archives of the Photogrammetry, Remote Sensing and Spatial Information Sciences, XXXVIII-5/C19, 35, Greece: CIPA, 29–34.

Heymowski, A., Günther, L., Myrin, M., Andersson, E., Hägnefelt, U., Valanis, A., 2011. Introduction to the architectural conservation project for the facades of the Royal Palace of Stockholm. In: *XXIIIrd CIPA Symposium,* Pavelka, K. (Ed.), Prague (Czech Republic), Sep. 2011, proceedings, http://cipa.icomos.org/fileadmin/template/doc/PRAGUE/073.pdf

Hitchcock, L. and Koudounaris, P., 2002. Virtual discourse: Arthur Evans and the reconstructions of the Minoan Palace at Knossos. In: *Labyrinth Revisited: Rethinking 'Minoan' Archaeology,* Hamilakis, Y. (Ed.), Oxford and Oakville: Oxbow, 40–58.

Hoyle, J., 2009. Lidar survey: applications in the woods, The past in three dimensions. *The Archaeologist,* 71, 28–29.

Hunter, J., Roberts, C., Martin, A., 1997. *Studies in Crime: An Introduction to Forensic Archaeology.* London and New York: Routledge.

Hussein, A.S. and El-Shishiny, H., 2009. Wind flow modelling and simulation over the Giza Plateau cultural heritage site in Egypt. *Journal on Computing and Cultural Heritage,* 2(2), November. DOI: http://dx.doi.org/10.1145/1613672.1613674.

Iakopi, I., 2007. *La casa di Augusto, Le pitture.* Milano: Electa, Ministero per Beni e le Attività Culturali, Soprintendentza Archeologica di Roma.

Iuliano, L. and Minetola, P., 2005. Rapid manufacturing of sculptures replicas, comparison between 3D optical scanners. In: *International Cooperation to Save the World's Cultural Heritage,* Dequal, S. (Ed.), Proceedings of the XX International Symposium CIPA, Turin, 26 September–1 October, Vol. 1, The International Archives of Photogrammetry, Remote Sensing and Spatial Information Sciences, XXXVI-5/C34/1, CIPA, 384–389.

Janaway, R.C, 1997. The decay of buried human remains and their associated materials. In: *Studies in Crime: An Introduction to Forensic Archaeology,* Hunter, J., Roberts, C. and Martin, A. (Eds.), London and New York: Routledge, 58–85.

Jobst, M., 2003. Protecting cultural important writings with new methods in reproduction and electronic publishing. In: *New Perspectives to Save the Cultural Heritage,* Altan, O. (Ed.), CIPA 2003, XIX International Symposium, 30 September–4 October, Antalya, Turkey, The ISPRS International Archives of the Photogrammetry, Remote Sensing and Spatial Information Sciences, XXXIV-5/C15, 302–305.

Jokilehto, J., 2005. Definition of cultural heritage: references to documents in history. In: *ICCROM Working Group 'Heritage and Society.* Originally for ICCROM, 1990, Revised for CIF: 15 January 2005.

Kaneda, A., 2011. Application of a low cost laser scanner for archaeology of Japan. In: *CIPA Heritage Documentation: Best Practices and Applications,* Stylianidis, E., Patias, P. and Santana Quintero, M. (Eds.), Series 1, 2007 & 2009, The ISPRS International Archives of the Photogrammetry, Remote Sensing and Spatial Information Sciences, XXXVIII-5/C19, 35, Greece: CIPA, 55–57.

Kanngiesser, B., Mantovalou, L., Malzer, W., Wolff, T. and Hahn, O., 2008. Non-destructive depth resolved investigation of corrosion layers of historical glass objects by 3D Micro X-ray fluorescence analysis. *Journal of Analytical Atomic Spectrometry,* 23, 814–819.

Karasik, A. and Smilansky, U., 2008. 3D scanning technology as a standard archaeological tool for pottery analyisis: practice and theory. *Journal of Archaeological Science,* 35, 1148–1168.

Kersel, M., 2010. The changing legal landscape for Middle Eastern archaeology in the Colonial Era, 1800–1930. In: *Pioneers to the Past: American Archaeologists in the Middle East, 1919–1920*, Emberling, G. (Ed.), Chicago: Oriental Institute, 85–90.

King Richard III Visitor Centre, Leicester: http:/krii.com and http://kingrichardinleicester.com/ 20.1.2015.

Kite, M., 2006. *Conservation of Leather and Related Materials*. London, New York: Routledge.

Knüsel, C.J., Haddow, S.D., Sadwat, J.W., Dell'Unto, N. and Forte, M., 2013. Bioarchaeology in 3D: three-dimensional modelling of human burials at Neolithic Çatalhöyük. In: *AAPA (American Association of Physical Anthropologists) Symposium* 2013, poster.

Korres, M., 1994a. The History of the Acropolis Monuments. Acropolis Restoration. The CCAM Interventions. London: Academy Editions.

Korres, M., 1994b. The Restoration of the Parthenon. Acropolis Restoration. The CCAM Interventions. London: Academy Editions.

Kotoula, E., 2012. Application of RTI in Museum Conservation, in Computer Applications and Quantitative Methods in Archaeology – *CAA (Computer Applications in Archaeology) E-proceedings*, Southampton.

Kotoula, E., 2013. Microscopic RTI of gilded silver discs from the Derveni tombs, Macedonia, Greece. In: *Multi-light Imaging for Heritage Applications*, Duffy, S. (Ed.), English Heritage, 21–23.

Kovács, K. and Hanke, K., 2013. Automatic tool mark identification and comparison with known Bronze Age hand tool replicas. In: *Proceedings of the XXIV International CIPA Symposium*, Grussenmeyer, P. (Ed.), 2–6 September, Strasbourg, France, ISPRS Annals of the Photogrammetry, Remote Sensing and Spatial Information Sciences, II-5/W1, 181–186.

Kruklidis, P., 2011a. L'epopea omerica. Atene e Menesteo: ricostruzione virtuale di una città e del suo eroe all'interno do un percorso didattico. In: *MUSINT: Le Collezioni archeologische egee e cipriote in Toscana, Ricerche ed esperienza di museologia interrattiva*, Jasink, A.M., Tucci, G. and Bombardieri, L. L. (a cura di), Strumenti per la Didattica e la Ricerca 118, Firenze: Univeristy of Firenze Press, 53–64.

Kruklidis, P., 2011b. L'epopea omerica. Techniche di ricostruzione multimediale. In: *MUSINT: Le Collezioni archeologische egee e cipriote in Toscana, Ricerche ed esperienza di museologia interrattiva*, Jasink, A.M., Tucci, G. and Bombardieri, L. L. (a cura di), Strumenti per la Didattica e la Ricerca 118, Firenze: Univeristy of Firenze Press, 125–135.

Kunicki-Goldfinger, J., Targowski, P., Góra, M., Karaszkiewicz, P. and Dzierżanowski, P., 2009. Characterization of glass surface morphology by optical coherence tomograhy, *Studies in Conservation*, 54, 117–128.

Kuzu, Y. and Sinram, O., 2003. Volumetric reconstruction of cultural heritage artefacts. In: *New Perspectives to Save the Cultural Heritage*, Altan, O. (Ed.), CIPA 2003 XIXth International Symposium, 30 September–4 October, Antalya, Turkey, International Symposium, The ISPRS International Archives of the Photogrammetry, Remote Sensing and Spatial Information Sciences, XXXIV-5/C15, 93–98.

Lambers, K. and Sauerbier, M., 2003. A data model for a GIS-based analysis of the Nasca lines at Palpa (Peru). In: *New Perspectives to Save the Cultural Heritage*, Altan, O. (Ed.), CIPA 2003, XIXth International Symposium, 30 September–4 October, Antalya, Turkey, The ISPRS International Archives of the Photogrammetry, Remote Sensing and Spatial Information Sciences, XXXIV-5/C 15, 713–718.

Larue, F. and Dischler, J.-M., 2006. Automatic registration and calibration for efficient surface light field acquisition. In: *VAST 2006, Joint Event of VAST, CIPA, EG WS G &CH/EuroMed, Eurographical Symposium Proceedings 2006*, Ioannides, N., Arnold, D., Niccolucci, F. and Mania, K. (Ed.), Aire-laVille: Switzerland, 171–178.

Lascaratos, J., Lascaratos, G. and Kalantzis, G., 2004. The ophthalmic wound of Philip II of Macedonia (360–556 BCE). *Survey of Ophthalmology* 49, 256–261.

Lazer, E., 2009. *Resurrecting Pompeii*. London, New York: Routledge.

Lerma, J.L. and Muir, C., 2014. Evaluating the 3D documentation of an early Christian upright stone with carvings from Scotland with multiples images. *Journal of Archaeological Science*, 46, 311–318.

Lerma, J.L., Navarro, S. and Villaverde, V., 2010. Terrestrial laser scanning and close range photogrammetry for 3D archaeological documentation: the Upper Palaeolithic Cave of Parpalló as a case study. *Journal of Archaeological Science*, 36, 499–507.

Lerma, J.S., Akasheh, T., Haddad, N. and Cabrelles, M., 2011. Multispectral sensors in combination with recording tools for cultural heritage documentation. *Change Over Time*, 1(2), 236–250.

Lewis M.J.T., 1980. Industrial Aarchaeology. In: *The Fontana Economic History of Europe: The Industrial Revolution*, Cipolla, C.M. (Ed.), Glasgow: Collins Sons & Co, 574–603.

Lin, Y.-C., Wu, T.-C. and Hsu, M.-F., 2011. The digital reconstruction of a large-scale construction simulated by using 3D laser scanning technology – a brick kiln's chimney in Kaohsiung City of Taiwan as an example. In: *Proceedings of the XXIIIrd CIPA Symposium*, Pavelka, K. (Ed.), Prague, Czech Republic, 12–16 September, http://cipa.icomos.org/fileadmin/template/doc/PRAGUE/164.pdf.

Linder, E. and Raban, A., 1975. *Marine Archaeology*. Cassell's Introducing Archaeology Series. Book 7. London: Cassell.

Lingua, A. and Rinaudo, F., 2003. Comparison of surveys of St. Mark's Square in Venice. In: *New Perspectives to Save the Cultural Heritage*, Altan. O. (Ed.), CIPA 2003 XIXth International Symposium, 30 September–4 October, Antalya, Turkey, The ISPRS International Archives of the Photogrammetry, Remote Sensing and Spatial Information Sciences, XXXIV-5/C15, 252–257.

Livatino, S., Cuciti, D. and Wojciechowski, A., 2006. Virtual reality and stereo visualization in artistic heritage reproduction. In: *The e-volution of Information Communication Technology in Cultural Heritage, Where Hi-Tech Touches the Past: Risks and Challenges for the 21ˢᵗ Century*, Ioannides, M., Arnold, D., Nicolucci, F. and Mania, K. (Eds.), Short papers from CIPA/VAST/EG/EuroMed 2006, 30 October–4 November, Nicosia, Cyprus, 102–107.

Lönnqvist, M., 1998. Anastylosis! Ateenan Akropoliksen pudonneet marmorit nousevat paikoilleen, in *Tekniikan Waiheita*, 3, 14–19. (in Finnish)

Lönnqvist, M., 2013. Saving Pompeii from another death. *CIPA Newsletter*, 1, 3.

Lönnqvist, M.A. and Stefanakis, E., 2009. GIScience in archaeology: ancient human traces in automated space. In: *Manual of Geographic Information Systems*, Madden, M. (Ed.), Bethesda, Maryland: The American Society of Photogrammetry and Remote Sensing, 1221–1259.

Lönnqvist, M. and Törmä, M., 2003. SYGIS – The Finnish Archaeological Project in Syria, In: *New Perspectives to Save the Cultural Heritage*, Altan, O. (Ed.), CIPA 2003 XIX International Symposium, 30 September–4 October, Antalya, Turkey, The ISPRS International Archives of the Photogrammetry, Remote Sensing and Spatial Information Sciences, XXXIV-5/C15, 609–614.

Lönnqvist, M., Lönnqvist, K., Stout Whiting, M., Törmä, M., Nuñez, M. and Okkkonen, J., 2005. Tracing new dimensions in the Roman military organization of the Eastern Limes, In: *Cooperation to Save the World's Cultural Heritage*, Dequal, S. (Ed.), Proceedings of the XX International Symposium CIPA 2005, International Turin, 26 September–1 October, Torino, Vol. 2, The International Archives of Photogrammetry, Remote Sensing and Spatial Information Sciences, XXXVI-5/C34/1, 1074–1079.

Lönnqvist, M., Törmä, M., Lönnqvist, K. and Nuñez, M., 2011. *Jebel Bishri in Focus: Remote Sensing, Archaeological Surveying, Mapping and GIS Studies of Jebel Bishri in Central Syria by the Finnish Project SYGIS*. BAR International Series 2230. Oxford: Archaeopress.

Lopez-Menchero, V.M. and Grande, A., 2011. The Principles of the Seville Charter. In: *Proceedings*, Pavelka, K. (Ed.), XXIIIrd CIPA Symposium, Prague, Czech Republic, 12–16 September, http://cipa.icomos.org/fileadmin/template/doc/PRAGUE/096.pdf

Lucet, G., 2013. 3D survey of Pre-Hispanic wall painting with high resolution photogrammetry. In: *XXIV International CIPA Symposium*, Grussenmeyer, P. (Ed.), 2–6 September, Strasbourg, France, ISPRS Annals of the Photogrammetry, Remote Sensing and Spatial Information Sciences, II-5/W1, 191–196.

Madden, M., 2012. Geovisualizing, reconstructing visions of Wormsloe, State Historic Site, Georgia, paper given in *ISPRS Conference*, Melbourne, September, 1.

Maheu, R., 1967. For Florence and Venice: the appeal Launched on December 2, 1966. *The UNESCO Courier*, January, 4–5.

Maiza, C. and Gaildrat, V., 2006. SemanticArchaeo: a symbolic approach of pottery classification. In: *The e-volution of Information Communication Technology in Cultural Heritage: Where Hi-Tech Touches the Past: Risks and Challenges for the 21st Century*, Ioannides, M., Arnold, D., Niccolucci, F. and Mania, K. (Ed.), Short papers from the joint event CIPA/VAST/EG/EuroMed 2006, 30 October–4 November, Nicosia, Cyprus, Budapest: EPOCH Publication, 227–232.

Mallochou-Tufano, F. and Alexopoulos, Y., 2007. Digital management of the documentation of the Acropolis restoration. In: *Anticipating the Future of the Cultural Past*, Georgopoulos, A. (Ed.), 21st CIPA Symposium, Athens, 1–6 October, The ISPRS International Archives of the Photogrammetry, Remote Sensing and Spatial Information Sciences, XXXVI-5/C53, 475–479.

Manferdini, A.M. and Cipriani, L., 2011. Digital 3D collections of mosaics. In: *Cultura Aumentada 2011*, XV Congreso de la Sociedad Iberoamericana de Grafica Digital, Santa Fe, Argentina.

Manfredi, M., Williamson, G., Kronkright, D., Doehne, E., Jacobs, M., Marengo, E. and Bearman, G., 2013. Measuring changes in cultural heritage objects with reflectance transformation imaging. *Digital Cultural Heritage: International Congress (Digital Heritage)*, Marseilles, 1, 189–192.

Manon, A., 1998. Discovery of inscriptions on the shroud of Turin by digital image processing. *Optical Engineering: The Journal of the Society of Photo-optical Instrumentation Engineers*, 37, 2308–2313.

Mara, H., 2012. *Multi-Scale Integral Invariants for Robust Character Extraction from Irregular Polygon Mesh Data*. PhD thesis, http://archiv.uni-heidelberg.de/volltextserver/13890/.

Mara, H. and Kampel, M., 2003. Automated extraction of profiles from 3D-models of archaeological fragments. In: *New Perspectives to Save the Cultural Heritage*, Altan, O. (Ed.), CIPA 2003 International Symposium, 30 September–4 October, Antalya, Turkey, The ICOMOS & ISPRS Committee for Documentation of Cultural Heritage, CIPA, XIX International Symposium, The ISPRS International Archives of the Photogrammetry, Remote Sensing and Spatial Information Sciences, XXXIV-5/C15, 87–92.

Mara, H. and Portl, J., 2013. *Acquisition and Documentation of Vessels using High-resolution 3D-scanners*. Wien: ÖAW.

Matias, H.C., Montero Santos, F.A., Rodrigues Ferrera, F.E., Machado, C. and Luzio, R., 2006. Detection of graves using micro-resistivity method. *Annals of Geophysics*, 49(6), 1235–1244.

Mayer, I., Scheiblauer, C. and Mayer, A.J., 2011. Virtual texturing in the documentation of cultural heritage – The Domitilla Catacomb in Rome. In: *Proceedings of the XXIIIrd CIPA Symposium*, Pavelka, K. (Ed.), Prague, Czech Republic, 12–16 September, http://cipa.icomos.org/fileadmin/template/doc/PRAGUE.

Mehralizadeh, S., 2013. Documentation project for historical garden complex of Mofakham in Bojnourd – Iran. In: *Proceedings XXIV International CIPA Symposium*, Grussenmeyer, P.

(Ed.), 2–6 September, Strasbourg, France, ISPRS Annals of the Photogrammetry, Remote Sensing and Spatial Information Sciences, II-5/W2, 431–436.

Menci, L., Ceccaroni, F. and Bianchini, D., 2011. Un metodo alternative di digitallizzazione Z-Scan. In: *MUSINT: Le Collezioni archeologische egee e cipriote in Toscana, Ricerche ed esperienza di museologia interrattiva*, Jasink, A.M., Tucci, G. and Bombardieri, L. (a cura di), 101–114.

Menze, B.H., Ur, J.A. and Sherratt, A.G., 2005. Tell spotting – surveying Near Eastern settlement mounds from space. In: *International Cooperation to Save the World's Cultural Heritage*, Dequal, S. (Ed.), Proceedings of the XX International Symposium CIPA 2005, Turin, 26 September–1 October, Torino, Vol. 1, The International Archives of Photogrammetry, Remote Sensing and Spatial Information Sciences, XXXVI-5/C34/1, 458–462.

Merello, P., Garcia-Diego, F.-J. and Zarzo, M., 2012. Microclimate monitoring of Ariadne's house (Pompeii, Italy) for preventive conservation of fresco paintings. *Chemistry Central Journal*, 6(145), 1–16.

Miranda Duarte, A.A. and Von Altrock, P., 2005. The close-range photogrammetry in the documentation of the rocks art: study of case archaeological site Santinho Norte I-SC/Brazil. In: *International Cooperation to Save the World's Cultural Heritage, Proceedings of the XX International Symposium CIPA 2005*, Dequal, S. (Ed.), Turin, 26 September –01 October, Vol. 1, The International Archives of Photogrammetry, Remote Sensing and Spatial Information Sciences, XXXVI-5/C34/1, 463–465.

Mocella, V., Brun, F., Ferrero, C. and Delattre, D., 2015. Revealing letters in rolled Herculaneum papyri by X-ray phase-contrast imaging. *Nature Communications*, 6, 5895.

Monti, C., Brumana, R. and Fregonese, L., 2001. Integrated methodologies of survey digital photogrammetry and 3D model laser scanning, The representation of the Piazza San Marco in Venice. In: *Surveying and Documentation of Historic Buildings – Monuments – Sites: Traditional and Mothern Methods*, Albertz, J. (Ed.), XVIIIth International Symposium of CIPA, Potsdam (Germany), 18–21 September, The ISPRS International Archives of Photogrammetry, Remote Sensing and Spatial Information Sciences, XXXIV-5/C7, 437–444.

Moore, H., 2005. Collaboration between the worlds of science and culture. In: *Flooding and Environmental Challenges for Venice and Its Lagoon: State of Knowledge*, Fletcher, C.A. and Spencer, T. (Eds.), Cambridge: Cambridge University Press, xiii–xiv.

Moretto, G., 1998. *The Shroud: A Guide*. St. Paul's: UK, Eire.

Morimoto, T., Chiba, M., Katayama, Y. and Ikeuchi, K., 2011. Multispectral image analyisis for bas-relief at the inner gallery of Bayon temple. In: *CIPA Heritage Documentation: Best Practices and Applications*, Stylianidis, E. and Patias, P. (Eds.), Series 1, 2007 & 2009 Santana Quintero, M., The ISPRS International Archives of the Photogrammetry, Remote Sensing and Spatial Information Sciences, XXXVIII-5/C19, 35, Greece: CIPA, 65–72.

Moro, A., Vasallo, V. and Vico, L., 2007. From the relief of the 3D reconstruction methodology. In: *Anticipating the Future of the Cultural Past*, Georgopoulos, A. (Ed.), 21ˢᵗ CIPA symposium: Athens, 1–6 October, ISPRS International Archives of the Photogrammetry, Remote Sensing and Spatial Information Sciences, XXXVI-5/C53, 501–504.

Moulden, H., 2009. The past in three dimensions 3D. *The Archaeologist*, 71, 22–23.

Moullou, D. and Mavromati, D., 2007. Topographic and photogrammetric recording of the Acropolis of Athens. In: *Anticipating the Future of the Cultural Past*, Georgopoulos, A. (Ed.), 21ˢᵗ CIPA Symposium: 01–06 October, Athens, Greece, ISPRS International Archives of the Photogrammetry, Remote Sensing and Spatial Information Sciences, XXXVI-5/C53, 515–520.

Mudge, M., Malzbender, T., Schroer, C. and Lum, M., 2006. New reflection transformation imaging methods for rock art and multiple-viewpoint display. In: *VAST 2006, CIPA/VAST/EG/EuroMed 2006*, Ioannides, M., Arnold, D. and Niccolucci, Mania, K. (Eds.), The 37ᵗʰ CIPA International Workshop Dedicated on e-Documentation and Standardisation in

Cultural Heritage Incorporating: The 7th Symposium on Virtual Reality, Archaeology and Intelligent Cultural Heritage and the 4th Eurographics Workshop on Graphics and Cultural Heritage, 1st Euro-Med Conference on IT in Cultural Heritage, Nicosia, Cyprus, 30 October – 4 November, Aire-la-Ville: Eurographics Association, 195–202.

Mudge, M., Voutaz, J.P., Schroer, C. and Lum, M., 2005. Reflection transformation imaging and virtual representations of coins from the Hospice of the Grand St. Bernard. In: *The 6th International Symposium on Virtual Reality, Archaeology and Cultural Heritage-VAST*, 195–202.

Muhammand, S., 2011. Introducing EDM survey for recording vernacular heritage and sites in Pakistan. In: *CIPA Heritage Documentation: Best Practices and Applications*, Stydlianidis, E., Patias, P. and Santana Quintero, M. (Eds.), Series 1, 2007–2009, The ISPRS International Archives of the Photogrammetry, Remote Sensing and Spatial Information Sciences, XXXVIII-5/C19, CIPA: Greece, 73–78.

Müller, P., Verenooghe, T., Wonka, P., Paap, I. and Van Gool, L., 2006. Procedural 3D reconstruction of Puuc Building in Xkipché. In: *VAST 2006, CIPA/VAST/EG/EuroMed 2006*, Ioannides, M., Arnold, D. and Niccolucci, Mania, K. (Ed.), The 37th CIPA International Workshop Dedicated on e-Documentation and Standardisation in Cultural Heritage Incorporating: The 7th Symposium on Virtual Reality, Archaeology and Intelligent Cultural Heritage and the 4th Eurographics Workshop on Graphics and Cultural Heritage, 1st Euro-Med Conference on IT in Cultural Heritage, Nicosia, Cyprus, October 30 – November 4, 2006, Aire-la-Ville: Eurographics Association, 139–146.

Murai, S., Kakiuchi, H. and Hano, K., s.a. Computer-Generated Mosaic of the Underwater Photographs of the Syrian Coastal Excavation Site. In: *Excavation of a Sunken Ship Found off the Syrian Coast – An Interim Report*. Operation Committee for the Syrian Coastal Archeological Excavation.

Mustafa, A.J. and Amhar, F., 2011. 3D model of Gedongsongo temple and topography using terrestrial laser scanner technology. In: *CIPA Heritage Documentation: Best Practices and Applications*, Stydlianidis, E., Patias, P. and Santana Quintero, M. (Eds.), Series 1, 2007–2009, The ISPRS International Archives of the Photogrammetry, Remote Sensing and Spatial Information Sciences, XXXVIII-5/C19, CIPA: Greece, 79–84.

Ndoro, W., 2005. Great Zimbabwe. *Scientific American, Special edition*, 15(1), 74–79.

Neff, D., Reguer, S. and Dillmann, P., 2013. Analytical techniques for the study of corrosion of metallic heritage artefacts: from micrometer to nanometer scales. In: *Corrosion and Conservation of Cultural Heritage Metallic Artefacts*, Dillman, P., Watkinson, D., Agelini, E. and Adriaens, A. (Eds.), European Federation of Corrosion Publications Number 65, Woodhead Publishing in Materials, Cambridge: Woodhead Publishing, 53–81.

Neubauer, W., Doneus, M. Studnicka, N., Riegl, J., 2005. Combined high resolution laser scanning and photogrammetrical documentation of the pyramids at Giza, In: *International Cooperation to Save the World's Cultural Heritage*, Dequal, S. (Ed.), Proceedings of the XX International Symposium CIPA 2005, Turin, 26 September–1 October, Torino, Vol. 1, The International Archives of Photogrammetry, Remote Sensing and Spatial Information Sciences, XXXVI-5/C34/1, 470–475.

Niederoest, J., 2003. A bird's eye view on Switzerland in the 18th century: 3D recording and analysis of a historical relief model. In: *New Perspectives to Save the Cultural Heritage*, Altan, O. (Ed.), CIPA 2003 International Symposium, 30 September–4 October, Atalya, Turkey, The ICOMOS & ISPRS Committee for Documentation of Cultural Heritage, CIPA 2003, XIX International Symposium, The ISPRS International Archives of the Photogrammetry, Remote Sensing and Spatial Information Sciences, XXXIV-5/C15, 589–594.

O'Connor, S.A. and Brooks, M.M., 2007. *X-Radiography of Textiles, Dress and Related Objects*. London, New York: Routledge.

Omari, E., 2011. New applications for mosaics conservation at Butrint UNESCO site: on-line database and photogrammetry. In: *Proceedings of the XXIII CIPA Symposium – Prague*, Pavelka, K. (Ed.), Czech Republic, 12–16 September, http://cipa.icomos.org/fileadmin/template/doc/PRAGUE/107.pdf

Owen, J., 2013. 5 surprising facts about Ötzi the Iceman, *National Geographic*, 16 October.

Ozawa, K., 2006. Computer-assisted estimation of the original shape of a Japanese ancient tomb mound based on its present contour map. In: *The e-volution of Information Communication Technology in Cultural Heritage: Where Hi-Tech Touches the Past: Risks and Challenges for the 21st Century*, Ioannides, M., Arnold, D., Niccolucci, F. and Mania, K. (Eds.), Short papers from the joint event CIPA/VAST/EG/EuroMed 2006, 30 October – 4 November, Nicosia, Cyprus, Budapest: EPOCH Publication, 143–146.

Palma, P., 2009. Shipwrecks and global 'worming', *The Archaeologist* 71, 30–31.

Papakonstantinou, E., Panou, A., Franzikinaki, K., Tsimereki, A. and Frantzi, G., 2007. The surface conservation project of the Acropolis monuments: studies and interventions. In: *Anticipating the Future of the Cultural Past*, 21st CIPA *Symposium*, Georgopoulos, A. (Ed.), Athens, 1–6 October, ISPRS International Archives of the Photogrammetry, Remote Sensing and Spatial Information Sciences, XXXVI-5/C53, 557–561.

Patay-Horváth, A., 2011. The virtual reconstruction of the East Pediment of the Temple of Zeus at Olympia – presentation of an interactive CD-ROM. In: *Proceedings* of *the XXIIIrd CIPA Symposium*, Pavelka, K. (Ed.), Prague, Czech Republic, 12–16 September, http://www.cipa.icomos.org/fileadmin/template/doc/PRAGUE/108.pdf

Patay-Horváth, A., 2012. Reconstructions of the East Pediment of the Temple of Zeus at Olympia – a comparison of drawings, plaster casts and digital models. *International Journal of Heritage in the Digital Era*, 1(3), 331–349.

Paterson, J. and Cain, K., 2006. Efficient field capture of epigraphy via photometric stereo. In: *The e-volution of Information Communication Technology in Cultural Heritage: Where Hi-Tech Touches the Past: Risks and Challenges for the 21st Century*, Ioannides, M., Arnold, D., Niccolucci F. and Mania K. (Eds.), Short papers from the joint event CIPA/VAST/EG/EuroMed 2006, 30 October–4 November, Nicosia, Cyprus, Budapest: EPOCH Publication, 159–162.

Pattyn, C., 1981. Protection et conservation. *Monuments historiques, les grottes ornées*, 118, 2–11.

Pavelka, K., Svatuskova, J. and Kralova, V., 2007. Photogrammetric documentation and visualization of Choli Minaret and Great Citadel in Erbil/Iraq. In: *Anticipating the Future of the Cultural Past*, Georgopoulos, A. (Ed.), 21st CIPA Symposium, 01–06 October, Athens, Greece, ISPRS International Archives of the Photogrammetry, Remote Sensing and Spatial Information Sciences, XXXVI-5/C53, 567–572.

Payne, E., 2013. Imaging techniques in conservation. *Journal of Conservation and Museum Studies*, 10, 17–29.

Payton, R., 1992. *Retrieval of Objects from Archaeological Sites*. London: Archetype Publications.

Pedeli, C. and Pulga, S., 2014. *Conservation Practices on Archaeological Excavations: Principles and Methods*. Los Angeles, California: Getty Conservation Institute.

Peipe, J. and Przybilla, H.-J., 2005. Modeling the Golden Madonna. In: *Anticipating the Future of the Cultural Past*, Georgopoulos, A. (Ed.), 21st CIPA symposium, October 01–06, Athens, Greece, ISPRS International Archives of the Photogrammetry, Remote Sensing and Spatial Information Sciences, Vol. XXXVI–5/C53, 934–936.

Perry, S.G., Reeves, R. and Sim, J., 2008. Landscape Design and the Language of Nature. *Landscape Review*, 12 (2), 3–18.

Petridis, P., White, M., Mourkousis, N., Liarokapis, F., Sifniotis, M., Basu, A. and Gatzidis, C., 2005. Exploring and interacting with virtual museums. In: *Proceedings of the 33rd Conference, CAA (Computer Applications & Quantitave Methods in Archaeology), Portugal*, Tomar, March, 73–82.

Photoarchive3D, see www.Photoarchive3D.org.

Pires, H., Ortiz, Marques, P. and Sanchez, H., 2006. Close-range laser scanning applied to archaeological artifacts documentation: virtual reconstruction of an XVIth century ceramic pot. In: *The e-volution of Information Communication Technology in Cultural Heritage: Where Hi-Tech Touches the Past: Risks and Challenges for the 21ˢᵗ Century*, Ioannides, M., Arnold, D., Niccolucci, F. and Mania, K. (Ed.), Project papers from the joint event CIPA/VAST/EG/EuroMed 2006, 30 October–4 November, Nicosia, Cyprus, Budapest: EPOCH Publication, 284–289.

Plenderleith, H.J., 1967. The Painting Hospital in the Lemon Grow. In: *The UNESCO Courier*, 24–29 January, 34.

Prag, J., 1990. Reconstructing King Philip II: the 'nice' version. *American Journal of Archaeology*, 94, 237–247.

Przybilla, H.-J. and Peipe, J., 2011. 3D modelling of heritage objects by fringe projection and laser scanning systems, In: *CIPA Heritage Documentation: Best Practices and Applications*, Stylianidis, E., Patias, P. and Santana Quintero, M. (Eds.), Series 1, 2007 & 2009, The ISPRS International Archives of the Photogrammetry, Remote Sensing and Spatial Information Sciences, XXXVIII-5/C19, 35, Greece: CIPA, 35–39.

Reilly, P., 1992. Three-dimensional modelling and primary archaeological data. In: *Archaeology and the Information Age: a Global Perspective*, Reilly, P. and Rahtz, S. (Eds.), London: Routledge, 149–173.

Remondino, F. and El-Hakim, S., 2006. Image-based 3D modelling: a review, *Photogrammetria* 21(115), 269–291.

Remondino, F., Rizzi, A., Jimenez, B., Agugiaro, G., Baratti, G. and De Amicis, R., 2011. The Etruscans in 3D: from space to underground. In: *Proceedings of the XXIIIrd CIPA Symposium*, Pavelka, K. (Ed.), Prague, Czech Republic, 12–16 September 2011, http://cipa. icomos.org/fileadmin/template/doc/PRAGUE/117.pdf.

Renfrew, C. and Bahn, P., 2003. *Archaeology: Theory, Methods and Practice*. London: Thames and Hudson.

Riedel, A. and Weferling, U., 2001. From pencil drawing to computer model – a method combining strategy for the documentation of the 'Domus Severiana' at the Palatine in Rome. In: *Surveying and Documentation of Historic Buildings – Monuments – Sites: Traditional and Mothern Methods*, Albertz, J. (Ed.), XVIIIth International Symposium of CIPA, Potsdam (Germany), September 18–21, 2001, The ISPRS International Archives of Photogrammetry, Remote Sensing and Spatial Information Sciences, XXXIV-5/C7, 132–139.

Riederer, J., 1987. *Archäologie und Chemie – Einblicke in die Vergangenheit*: Austellung des Rathgen-Forschungslabors SMPK, September 1987–Januar 1988 Berlin: Rathgen-Forschungslabor.

Riveiro, B., Armesto, J., Carrera, F., Arias, P., Solla, M., Lagüela, S., 2011. New approaches for 3D documentation of petroglyphs in the Northwest of the Iberian Peninsula. In: *Proceedings of the XXIII CIPA Symposium – Prague*, Pavelka, K. (Ed.), Czech Republic, 12–16 September 2011, http://cipa.icomos.org/fileadmin/template/doc/PRAGUE/12.pdf

Rizzi, A., Voltolini, F., Girardi, S., Gonzo, L, and Remondino, F., 2007. Digital documentation and analysis of paintings, monuments and large cultural heritage with infrared technology, digital cameras and range sensors, In: *Anticipating the Future of the Cultural Past*, Georgopoulos, A. (Ed.), 21ˢᵗ CIPA symposium, Athens, 1–6 October, ISPRS International Archives of the Photogrammetry, Remote Sensing and Spatial Information Sciences, XXXVI-5/C53, 631–636.

Robinet, L., 2002. Conservation research group: analysis of a white bloom on Greek and Roman writing tablets. In: *The British Museum CA* 2002/9.

Rostovtzeff, M., 1932. *Caravan Cities*. Oxford: Clarendon Press.

Salemi, G., Cristafulli, C., Asolati, M., Concheri, G., Meneghello, R. and Savio, G., 2011. A unique lead medal of Filarete in the Numismatic Collection of Civico Museo Correr

(Venice, Italy): comparison of multisensor laser scanner systems. In: *Proceedings of the XXIIIrd CIPA Symposium,* Pavelka, K. (Ed.), Prague, Czech Republic, 12–16 September, http://cipa.icomos.org/fileadmin/template/doc/PRAGUE/128.pdf.

Sánchez-Porro, C., Kaur, B., Mann, H. and Ventosa, A., 2010. Halomonas titanicae sp.nov., a halophilic bacterium isolated from the RMS Titanic. *International Journal of Systematic and Evolutionary Microbiology* 60, 2768–2774.

Sasaki, H., Mukoyama, S., Nagata, N. and Namikawa, K., 2008. Digital terrain analysis using airborne laser scanner (LIDAR) data for natural hazard assessment. In: *The ISPRS Proceedings, Beijing 2008,* The ISPRS International Archives of the Photogrammetry, Remote Sensing and Spatial Information Sciences, XXXVII (B8), 1225–1228

Schiffer, M., 1985. Is there a 'Pompeii premise' in Archaeology? *Journal of Anthropological Research,* 41, 18–41.

Schmidt, K., 2012. *A Stone Age Sanctuary in South-eastern Anatolia.* Berlin: Ex Oriente/Dbusiness.

Schur, W. and Kanngieser, E., 2006. The e-volution of stereoview technology in CH data. In: *The e-volution of Information Communication Technology in Cultural Heritage: Where Hi-Tech Touches the Past: Risks and Challenges for the 21ˢᵗ Century,* Ioannides, M., Arnold, D., Niccolucci, F. and Mania, K. (Eds.), Project papers from the joint event CIPA/VAST/EG/EuroMed 2006, 30 October–4 November 2006, Nicosia, Cyprus, Budapest: EPOCH Publication, 187–191.

Scollar, I., 1990. *Archaeological Prospecting and Remote Sensing.* Topics in Remote Sensing 2. Cambridge: Cambridge University Press.

Scott-Ireton, D.A., 2014. When the Land Meets the Sea. Between the Devil and the Deep: Meeting Challenges in the Public Interpretation of Maritime Cultural Heritage. New York: Springer.

Seales, W.B., Griffioen, J., Baumann, R. and Field, M., 2011. Analysis of Herculaneum Papyri with X-ray Computed Tomography. In: *NDTnet* (Nondestructive Testing).

Shelbourn, C., 2008. Prosecuting 'time crime'– some thoughts on law and practice in the United States. *The Archaeologist,* 68, 42–43.

Shi, R., Zhu, G., Zhu, L., Wang, R., Mu, Y., 2011. Digital reconstruction for spatial documentaton of Beijing Old City. In: *CIPA Heritage Documentation: Best Practices and Applications,* Stydlianidis, E., Patias, P. and Santana Quintero, M. (Eds.), Series 1, 2007–2009, The ISPRS International Archives of the Photogrammetry, Remote Sensing and Spatial Information Sciences, XXXVIII-5/C19, CIPA: Greece, 85–92.

Skarlatos, D., Theodorıdou, S., Hennings, D., Ville, S., 2003. Replication of marble exhibits using photogrammetry and laser scanning (or How to forge exhibits). In: *New Perspectives to Save the Cultural Heritage,* Altan, O. (Ed.), CIPA 2003 International Symposium, 30 September –04 October, Antalya, Turkey, XIX International Symposium, The ISPRS International Archives of the Photogrammetry, Remote Sensing and Spatial Information Sciences, XXXIV-5/C15, 457–462.

Sober, B., Faigenbaum, S., Beit-Arieh, I., Finkelstein, I., Moinester, M., Plasetzky, E. and Shaus, A., 2014. Multispectral imaging as a tool for enhancing the reading of Ostraca. *Palestine Exploration Quarterly,* 146, 185–197.

Sobieszek, R.A., 1980. Sculpture as the sum of its profiles: François Willème and photosculpture in France, 1859–1868. *The Art Bulletin,* 62, 617–613.

Soltzberg, L.J., Lor, S., Nnennaya, O.-I. and Newman, R., 2012. 3D Fluorescence characterization of synthetic organic dyes. *American Journal of Analytical Chemistry,* 3, 622–631.

Spagnolo, G.S., Guattari, G., Grinzato, E., Bison, P.G., Paoletti, D. and Ambrosini, D., 2000. Frescoes diagnostics by electro-optic holography and infrared thermography. In: *NDT.net* (Nondestructive Testing), 5.

St. Clair, W., 1972. *Lord Elgin and the Marbles.* Oxford: Oxford University Press.

Steele, C., 2008. Archaeology and the forensic investigation of recent mass graves: ethical issues for a new perspective. *Archaeological Journal of the World Archaeological Congress*, 414–428. DOI: http://dx.doi.org/10.1007/s11750-008-9080-x.

Stoneman, R., 1992. *Palmyra and Its Empire*. Ann Arbor: Univeristy of Michigan Press.

Studnicka, N., Zach, G. and Amon, P., 2011. 'Grand Canal's Palaces' façade maps based on monile scanning data acquired by boat. In: *Proceedings of the XXIIIrd CIPA Symposium*, Pavelka, K. (Ed.), Prague, Czech Republic, 12–16 September 2011, http://cipa.icomos.org/fileadmin/template/doc/PRAGUE/16.pdf.

Sulivan, S. and Mackay, R. (Ed.) Archaeological Sites: Conservation and Management. Series; Readings in Conservation. Los Angeles, California: Getty Conservation Institute.

Sutherland, T., 2005. *Battlefield Archaeology – A Guide to the Archaeology of Conflict*. BAJR, British Archaeological Jobs Resource, http://www.bajr.org/documents/bajrbattleguide.pdf.

Thöner, W., 2002–2003. The Bauhaus life: life and work in the Master's Houses Estate in Dessau. Leipzig: E.A. Seemann Verlag.

Tidblad, J., 2013. Atmospheric corrosion of heritage metallic artefacts: processes and prevention, In: *Corrosion and Conservation of Cultural Heritage Metallic Artefacts*, Dillman, P. Watkisnon, D., Agelini, E. and Adriaens, A. (Eds.), European Federation of Corrosion Publications Number 65, Woodhead Publishing in Materials, Cambridge: Woodhead Publishing Ltd., 37–52.

Timár-Balázsy, Á., 2000. From test-tubes to 3D fluorescence spectra. In: *Textiles Revealed: Object Lessons in Historical Textile and Costume Research*, Brooks, M.M. (Ed.), London: Archetype Publications, 143–148.

Tisato, F., Parraman, C., 2014. An investigation into the micro surface of artworks using alternative lighting techniques. In: *Proc.SPIE9018, Measuring, Modeling and Reproducing Material Appearance*, 901808 (February 24, 2014). DOI: http://dx.doi.org/10.1117/12.2041209.

Torus, B., 2011. Learning from vernacular Turkish house: designing mass-customized houses in Mardin. *Intercultural Understanding*, 1, 105–111.

Toubekis, G., Mayer, I., Döring-Williams, M., Maeda, K., Yamauchi, K., Taniguchi, Morimoto, S., Petzet, M., Jarke, M. and Jansen, M., 2011. Laser scan documentation and virtual reconstruction of the Buddha figures and the archaeological remains (Bamiyan). In: *CIPA Heritage Documentation: Best Practices and Applications*, Stydlianidis, E., Patias, P. and Santana Quintero, M. (Eds.), Series 1, 2007–2009, The ISPRS International Archives of the Photogrammetry, Remote Sensing and Spatial Information Sciences, XXXVIII–5/C19, CIPA: Greece, 93–100.

Tov, E., 2011. The sciences and the reconstruction of the ancient scrolls: possibilities and impossibilities. In: *The Dead Sea Scrolls in Context: Integrating the Dead Sea Scrolls in the Study of Ancient Texts, Languages and Cultures*, Lange, A., Tov, E. and Weigold, M. (Ed.), Vol. 1, Leiden: Brill, 3–25.

Tsoupikova, D., 2007. Passing excellence, the interactive art visualization of the Kizhi Ensemble. In: *Anticipating the Future of the Cultural Past*, Georgopoulos, A. (Ed.), 21st CIPA Symposium, October 01–06, 2007, Athens, Greece, The ISPRS International Archives of the Photogrammetry, Remote Sensing and Spatial Information Sciences, XXXVI-5/C53, 716–720.

Tucci, G. and Bonora, V., 2007. Application of high resolution scanning systems for virtual moulds and replicas of sculptural works. In: *Anticipating the Future of the Cultural Past*, Georgopoulos, A. (Ed.), 21st CIPA Symposium, October 01–06, 2007, Athens, Greece, ISPRS International Archives of the Photogrammetry, Remote Sensing and Spatial Information Sciences, XXXVI-5/C53, 721–726.

Tucci, G. and Bonora, V., 2011. Geomatic techniques and 3D modeling for the survey of the Church of Holy Sepulchre in Jerusalem. In: *Proceedings of the XXIIIrd CIPA Symposium*, Pavelka, K. (Ed.), Prague, Czech Republic, 12–16 September 2011. http://cipa.icomos.org/fileadmin/template/doc/PRAGUE/143.pdf

Tucci, G., Cini, D., Bonora, V. and Nobile, A., 2011. Proposta metoddologica per la digitaz-zlizzazione 3D di riperti archeologici. In: *MUSINT: Le Collezioni archeologische egee e cipriote in Toscana, Ricerche ed esperienza di museologia interrattiva,* Jasink, A.M., Tucci, G. and Bom-bardieri, L. (a cura di), Strumenti per la Didattica e la Ricerca 118, Firenze: Univeristy of Firenze Press, 65–100.

UNESCO, Cairo: http://www.unesco.org/new/en/cairo/tangible-cultural-heritage. 15.01.2015.

Varea, S. and Lemerle, J.-B., 2013. Archaeological rescue excavation and digital cultural herit-age. In: *Proceedings of the XXIV International CIPA Symposium,* Grussenmeyer, P. (Ed.), 2–6 September, Strasbourg, France, ISPRS Annals of the Photogrammetry, Remote Sensing and Spatial Information Sciences, II-5/W1, 669–673.

Vico, L., Moro, A., Galeazzi, F., Di Ioia, M. and Dell'Unto, N., 2006. Integrated methodolo-gies for data elaboration and real time: Villa of Livia (Via Flaminia project). In: *The e-volu-tion of Information Communication Technology in Cultural Heritage: Where Hi-Tech Touches the Past: Risks and Challenges for the 21st Century,* Ioannides, M., Arnold, D., Niccolucci, F. and Mania, K. (Eds.), Short papers from the joint event CIPA/VAST/EG/EuroMed 2006, 30 October–4 November 2006, Nicosia, Cyprus, Budapest: EPOCH Publication, 219–224.

Vidal, L. and Marangoni, A., 2000. *Il Fuoco e la Sindone, The Fire and the Holy Shroud,* L'ultimo incendio – The Last Fire. Bologna: Timeo srl.

Vilbrandt, T., Vilbrandt, C., Pasko, G. and Pasko, A., 2006. Modeling and digital fabrication of traditional Japanese lacquer ware. In: *The e-volution of Information Communication Technology in Cultural Heritage: Where Hi-Tech Touches the Past: Risks and Challenges for the 21st Cen-tury,* Ioannides, M., Arnold, D., Niccolucci, F. and Mania, K. (Eds.), Project papers from the joint event CIPA/VAST/EG/EuroMed 2006, 30 October–4 November 2006, Nicosia, Cyprus, Budapest: EPOCH Publication, 276–279.

Vileilkis, O., Santana Quintero, M., Van Balen, K., Dumont, B. and Tigny, V., 2011. Info-ramtion Management Systems for Cultural Heritage and Conservation of World's Heritage Sites, Silk Roads Case Study. In: *Proceedings of the XXIIIrd CIPA Symposium,* Pavelka, K. (Ed.), Prague, Czech Republic, 12–16 September 2011, http://cipa.icomos.org/fileadmin/template/doc/PRAGUE/150.pdf.

Vita-Finzi, C., 1978. *Archaeological Sites in Their Setting.* Ancient Peoples and Places. London: Thames and Hudson.

Warden, R.B., Burth, R., Briaud, J.-L. and Everett, M., 2007. Laser scanning for historical and geotechnical studies at Pointe du Hoc. In: *Anticipating the Future of the Cultural Past,* Georgopoulos, A. (Ed.), 21st CIPA Symposium, October 01–06, Athens, Greece, ISPRS International Archives of the Photogrammetry, Remote Sensing and Spatial Information Sciences, XXXVI-5/C53, 845–850.

Wong, K., 2014. Oldest footprints outside Africa: English mud captures an ancestral stroll. In: *Scientific American,* May.

Yastıklı, N., Emem, O., Akış, Z., 2003. 3D Model generation and visualization of cultural her-itage. In: *New Perspectives to Save the Cultural Heritage,* Altan, O. (Ed.), CIPA 2003, XIX International Symposium, 30 September–4 October, Antalya, Turkey, The ISPRS Interna-tional Archives of the Photogrammetry, Remote Sensing and Spatial Information Sciences, XXXIV-5/C15 280–282.

Yıldız, F., Karabork, H., Yakar, M., Altunas, C., Karasaka, L. and Goktepe, A., 2007. 3D Modelling by advanced total station. In: *Anticipating the Future of the Cultural Past,* Georgopoulos, A. (Ed.), 21st CIPA Symposium, 01–06 October, Athens, Greece, ISPRS International Archives of the Photogrammetry, Remote Sensing and Spatial Information Sciences, XXXVI-5/C53,

Yılmaz, U., Özün, Ö., Burçak, O., Mulayim, A. and Atalay, V., 2003. Inexpensive and robust 3D model acquisition system for three-dimensional modeling of small artifacts. In: *New Perspect-*

ives to Save the Cultural Heritage, Altan, O. (Ed.), CIPA 2003, XIX International Symposium, 30 September–04 October, Antalya, Turkey, The ISPRS International Archives of the Photogrammetry, Remote Sensing and Spatial Information Sciences, XXXIV-5/C15, 286–291.

Zarmakoupi, M. (Ed.), 2011. The Villa of the Papyri at Herculaneum: Archaeology, Reception, and Digital Reconstruction. Sozomena 1. Berlin: Walter de Gruyter.

Zolfaghari, M. and Malian, A., 2004. Documentation of the King of the Kings. In: *Geo-Imagery Bridging the Continents*, Altan, O. (Ed.), Proceedings of the International Society for Photogrammetry and Remote Sensing XXth Congress, The International Archives of Photogrammetry, Remote Sensing and Spatial Information Sciences, Vol. XXXV, Part B, Turkey: Organising Committee of the XXth International Congress for Photogrammetry and Remote Sensing, 530–535.

Cultural Heritage Management Tools: The Role of GIS and BIM \quad 3

Anna Osello and Fulvio Rinaudo

3.1 Introduction

The use of GIS (Geographic Information Systems) in the framework of cultural heritage management started very soon after the first practical applications of this technology for land planning and environmental monitoring. Up to a few years ago, many examples of GIS projects developed for specific applications were published first for archaeological investigation and some years later for general cultural heritage assets management [Madden, 2009].

At the beginning, GIS was conceived as a repository of structured data coming from excavations and relict analysis, but soon the possibility to locate the different information in a common reference system, opened the door to a deeper use of GIS technology. Many examples showed GIS used for landscapes, naturalistic heritage assets, historical centres or single buildings [Zhou, 2011; Berg, 2012].

In a second step the adoption of GIS as a standard instrument to collect and analyse data offered the possibility to understand the benefit of the GIS technology in data analysis and specific investigation. Standard instruments such as overlay and spatial intersection demonstrated that some basic analysis easily managed by GIS platforms could allow new data interpretation beside the capability to manage large quantities of data [Fabbri, 2012].

Some attempts were made in the past to realise GIS systems able to be used for general items (e.g. archaeological documentation, historical building management, etc.) but all those experiences fell short for various reasons. Cultural heritage assets cannot be grouped in extended families where elements different in age and investigation can be provided by using the same data structure in terms of semantics and ontology (e.g. buildings, landscapes, archaeological excavations) and data collection and interpretation is strictly related to the main aim of the data collection (knowledge, conservation, enhancement, management, etc.) [Myers, 2012].

While GIS application in the framework of cultural heritage can be considered today as a logical and standard tool, the same cannot be applied to BIM (building

information modelling). BIM was defined at the end of the 1970s but it became standard technology when ArchiCAD was launched as the instrument able to build up a virtual building [Osello, 2012].

The first scientific papers on the use of this technology in cultural heritage management started to appear in 2010, but there is no standard approach to this kind of tool even if they are the best tested instruments to solve the management of buildings, technical network and structural analysis. Therefore, in the following section GIS is presented as underlying the achieved standards in cultural heritage applications while BIM is introduced as an 'in progress' technology to be carefully investigated as a possible instrument to integrate and complete the potentiality of GIS.

3.2 GIS

GIS is not simply software able to solve a specific problem (e.g. software able to calibrate a digital camera or rectify a picture) but a real system (e.g. a set of components coordinated and integrated to solve a specific problem) formed by different components:

- hardware
- software
- data
- people

The order of these components does not represent a hierarchy: all of them play a role of some interest in a GIS application.

The term 'system' means that all the components play a specific role and each of them cannot be disregarded or considered with a different weight. In its final realisation, GIS software can be split into spatial data and information data. Spatial data are the geometric and/or raster products useful to locate the information data; information data are all the data correctly located in the used space [Madden, 2009].

Many GIS definitions have been proposed in the last few decades. One of the more coherent with the present development of GIS technology is that proposed by Burrough and Mc Donnell [1998, 2011]:

> GIS is a powerful set of tools for collecting, storing, retrieving at will, transforming and displaying spatial data from the real word for a particular set of purposes. These tools are used to manipulate, and operate on standard geographical primitives, such as points, lines and areas, and/or continuously varying surfaces, known as field.

From this definition, it is clear that a GIS project has to consider the real purposes of the GIS implementation. A correct GIS design allows the reconstruction of the semantic and ontological meanings of the collected data able to give users a correct interpretation by following the ideas of the experts.

The introduction of a GIS approach inside an established research structure usually requires change in the organisation (and in some cases of the mentality of those in the

organisation) due to the new tools that the management of spatial located data can offer for research, management and general investigations [Bastian, 2013].

3.2.1 GIS and Cultural Heritage

Cultural heritage management is not different from other application fields of GIS technology. Many data coming from metric surveys, archive investigations and monitoring can be related to a unique coordinate system allowing further investigation and comprehension of the data to guarantee a good instrument for a correct and exhaustive interpretation and management.

The GIS approach also allows transmission of the data collected to other specialists. Objective data, such as metric information, historical records coming from existing documents, can be recorded in the *shapefile* structure in such a way that other interested people can use them for different purposes also by avoiding the replication of the basic data and the possibilities that different studies on the same object use different data.

As in all the applications of GIS technology, after an initial period where the GIS was mainly conceived as a way to store large amounts of data, specialists started to use the GIS functions to find out spatial relationships between heterogeneous data (e.g. historical, physical, metric) able to drive the manager to find out correct intervention approaches and sustainable maintenance policies [Keinan, 2013].

Up to now, it is not possible to say that GIS technology is considered as a standard approach to cultural heritage management but many experiences demonstrate that the only difficulties in this solution are represented by a common adoption of the GIS technology by the national and international bodies devoted to the safeguarding of cultural heritage.

3.2.2 GIS for Cultural Heritage documentation

By considering that documentation is the common set of information able to understand, modify, maintain and manage a cultural heritage asset, it seems obvious that the GIS potentialities and possibilities have to be used mainly in this important step of the cultural heritage policy.

The use of a unique reference system is a mandatory rule that forces all the data to use the same language in terms of space both if a World reference system or a local reference system is considered. Coherent spatial location represents the best link between all the collected data and a key to reconnect data that seem unrelated. The ability to locate the data developed by the different specialists in recent years is the real 'change' in mentality that the GIS induced in the field of cultural heritage documentation [Rogerio-Candelera, 2014].

The database design is the second important milestone to consider GIS as the optimal solution for cultural heritage documentation. Each specialist involved in data collection for the documentation of a cultural heritage asset has to face the design of the logical links between the data: this means that the 'intelligent data connection' has to be translated in

a form that can be transferred and understood by anyone who wants to access the set of data. This opportunity allows a correct transfer of the 'intelligence' that is always present during data acquisition, thus allowing the correct understanding of the data and, as a consequence, the correct data interpretation and use. [Fernández Freire *et al.*, 2013]

The third important aspect that has to be considered is the possibility of merging in a unique GIS project multiscale approaches where the multiscale concept has to be extended not only to metric information (different accuracies and different level of detail) but also to the database. The necessity imposed by GIS software to link the level of detail of the data strictly related to the scale of the metric support allows the correct reading of the data and forces the data provider to summarise the set of data in more simple information when the scale of the GIS requires this kind of intervention. The generalisations operated by the data providers themselves guarantee the correct approach to complex sets of data without misunderstanding and are another way to ensure the correct and objective interpretation of the data [Madden, 2009].

3.2.3 GIS challenges in Cultural Heritage documentation

Data interoperability

The interoperability of the data inserted in a GIS project refers both to metric and non-metric data.

Metric data (e.g. maps, historical cartography, 3D models) are referred to a unique reference system and today cartographic data sets are transformed into the well-known UTM/WGS84 cartographic system.

Easy accessibility to GNSS devices allows a rapid geo-referencing of cartographic products usually defined in different reference systems. Usually, planar transformations based on a few ground control points are sufficient to ensure acceptable transformation between old cartographic systems and the one commonly adopted inside the GIS project, also if the size of the portion of land of interest is a big city.

Therefore, historical maps can be transmitted to other users with the information needed to locate them in the correct position with respect to the international reference system by avoiding different geo-referencing and, as a consequence, a different metric interpretation of the data connected to the metric supports.

In the same way, the recording of non-metric data inside the tables of a database, correctly described in terms of informatics structure and glossary, allows the correct interpretation and use of the data by avoiding misunderstanding and incorrect interpretation of the different data sets [Rinaudo and Devoti, 2013]

Information recovery

The documentation is a complex and expensive process: it is not simply a collection of data of different origins but more correctly an intelligent merging of data coming from different disciplines linked in order to provide evidence of the interesting relationships between the different data themselves. By linking the data in different ways it is possible to obtain different interpretations of phenomena than the one faced by the GIS project.

Besides the correct transmitting of data sets, the logical links established between them and described by using the standards of communication of databases allow the correct recovery of information by external users who may be interested in the content of a GIS project for different purposes (e.g. conservation, enhancement, and rehabilitation design, valorisation projects, and ordinary management).

In this case, not only the data usually contained inside a simple shapefile (*shp*) structure are required but also a complete description of the logical links between the different data sets which justify the interpretation performed by the specialists. These have to be understood by the different potential users of the GIS project.

Research improvements

The GIS as a basic instrument for the documentation of a cultural heritage asset has to be interpreted in the correct way by all the specialists involved in the documentation process: surveyors, historians, archaeologists, etc. A correct approach is that the documentation GIS has to be created by each of the involved specialists, not just a final step after the conclusion of the different studies performed by using different approaches.

It is necessary for each specialist to define the GIS strategy from the beginning of the data collection and data entry and all the subsequent analyses have to be performed inside a common GIS structure. In this way the relationships between the different data, the possible data integration and the subsequent data interpretation can be decided by the community of specialists by using the same platform. This requirement forces all the specialists to introduce the GIS approach inside each single discipline. In the last few years, many efforts have been realised by the different disciplines in order to drive specialists to expand their skills and in many cases improve the research strategies to be adopted.

3.2.4 GIS planning for Cultural Heritage documentation

Reference systems

The choice of the reference system for a GIS project for cultural heritage documentation has to take many factors into consideration. Generally, it can be assumed that for cultural heritage assets which relate to a specific portion of land the UTM/WGS84 reference system has to be adopted to comply the international agreements and to allow the possibility to link cartographic data coming from different authorities.

If the documentation refers just to a certain historical period where different reference systems were adopted or in case of historical maps without any information about reference systems are used the link to the international standards is not so necessary: the specialists that need this kind of connection can solve it in case of necessity.

In the case of buildings, it is always better to adopt local Cartesian coordinate systems instead of the more complicated cartographic reference systems. In these cases it may be sufficient to give Cartesian coordinates for some points of the buildings as well as the cartographic coordinates in order to allow, in case of necessity, the correct link with the cartographic reference systems. Case by case, decisions have to be discussed

and justified by the specialist team and well documented by means of a technical report of the GIS project. Only correct knowledge of the adopted reference system will allow users of the GIS data in the future to make a correct metric interpretation of the achieved results.

Multiscale approach in metric and alphanumeric data

The multiscale approach is a well-known concept inside the geomatics community but not always well understood by other scientific communities. The correct comprehension of this concept allows a correct use of GIS technology and the adoption of international standards to collect and communicate geo-referred data. The scale (or more precisely the nominal scale) of a geo-referred data set is a ratio which express the metric accuracy of the location data and the level of detail of the data which can be correctly represented.

By considering metric data, those two meanings of the nominal scale are translated into international adopted standards. Given a 1:n scale the accuracy of the metric data is of about 0.2 × n mm (e.g. at 1:1000 scale the metric accuracy is about 0.2 m) and the same values are adopted to limit the sizes of the represented objects (e.g. at 1:1000 scale only the objects which are greater than 0.2 m are represented). For non-metric data, the concept of the accuracy and level of detail is not so strictly defined but must be considered in order to avoid confusion and incorrect data interpretation and comprehension.

Let us consider an urban centre represented inside the GIS project at 1:1000 nominal scale. In this case, each building is well defined in terms of external shape but it is not possible to describe structural details, different flats, etc. Therefore, in this case not all the data concerning the single flat information (e.g. owners, deterioration, stability, use, etc.) can be inserted as information inside the GIS project. To correctly record such information, a larger scale needs to be adopted (e.g. 1:100 scale): this can be done inside the same GIS project but in a different layer that will be described at the correct nominal scale. The data inserted at a certain nominal scale have to be coherent with the data inserted at the different nominal scales of the project. If at 1:100 scale the different flats are characterised with different uses (e.g. residency, commerce); the same building at 1:1000 scale should be defined with a 'mixed use' attribute.

Database implementation

Database implementation is always the hardest topic in a GIS project and usually requires specific information technology (IT) knowledge. The things that IT specialists usually do not know are (i) which are the important data to be inserted and (ii) what are the logical links that have to be established between them? Therefore, in this specific part of the GIS project a strict interdisciplinary strategy has to be adopted. The data providers have to declare the useful data and the relationships that must be established between them and, after the database implementation, they have to test the correct translation of the conceptual model into the database.

IT specialists have to guarantee the easiest database structure to allow the correct translation of the conceptual model and, at the same time, the possibility to interact with the database structure in such a way that all the data providers (surveyors, historians, archaeologists, etc.) could be able to inquire and interact with the database itself. For complex and huge projects also, the metric data are inserted inside the database structures in order to allow a more complete integration between metric and non-metric data.

Data transfer format

The interoperability of the GIS data is still under debate inside the scientific and user communities: many solutions have been proposed during the last few years but no unique answer can be adopted as a rule. For simple GIS projects, shp format can be used to transfer both metric and non-metric data by adding all the information useful to rebuild inside a commercial or open source platform the structure of the complete project (e.g. the order and hierarchy of the layers and sublayers). For more complex project relational database transfer, formats can be adopted to transmit all the data and logical links between them in a unique solution.

By considering the policies about cultural heritage, management open source solutions have to be considered as the preferable solutions in order not to force possible users towards the adoption of expensive hardware and software equipment: open source relational databases such as PostGres/PostGis today give a real and effective solution to the interoperability of GIS projects.

3.3 BIM (Building Information Modelling)

Since the beginning of history, architecture, engineering, construction and operation (AECO) have relied on drawings to represent the data needed for the design, construction and management of each artefact typology. Within a highly fragmented industrial sector such as the building industry, 2D and 3D drawings have evolved over hundreds of years to define the basis of representation as presently codified for every participant in the construction process [Osello, 2012].

To assist the designer during the different design stages, many technological developments have occurred in computer science in the past 50 years, and the current period is characterised by the transition towards the use of highly structured 3D models that are dramatically changing the role of drawing in the construction industry.

BIM under different names such as product model, virtual building and intelligent object model has been in use only for the last twenty years, but it is impossible to understand its history without starting much earlier. To do this it is essential to know the concept of parametric object as the key to realising what a BIM is and how it differs from traditional 2D and 3D drawing. On this point, since the 1980s object-based parametric modelling capabilities were developed for mechanical system design and significant innovations were started in the design workflow: while in traditional 3D CAD users must edit each aspect of an element's geometry manually, shape and geometric

properties in a parametric modeller are automatically adjusted to changes in context. This concept is at the origin of the current generation of BIM [Eastman *et al.*, 2008].

In this connection, in 1986, many years before the acronym BIM – coined in early 2002 to describe the combination of virtual design, construction and facility management (FM) – came into popular usage, Graphisoft introduced the first virtual building solution, known as ArchiCAD.[1] This revolutionary software allowed architects to create a virtual, three-dimensional representation of their design instead of the standard two-dimensional drawing. This was important because architects and engineers were finally able to store large amounts of data within the building model: these data sets included building geometry and spatial data as well as the properties and quantities of the components used in the design or management. Incalculable progress has been made since then.

In parallel with the evolving terminology and the research and development (R&D) results centred in academia, implementation of BIM-related commercial products has a long history, and many BIM functions are nowadays available with software such as AllPlan, ArchiCAD, Autodesk Revit, Bentley Building, Digital Project, Generative Components or Vector Works [Osello, 2012].

With the exception of Fai [2011], very little work has been done to model historic buildings and also generate BIM from laser scan survey data. Existing research [Chevrier *et al*, 2010; De Luca, 2012] in the area of the parametric modelling of architectural heritage has initiated a new direction by examining how historic architectural rules can be exploited to build computer models of structures and their elements. While these works inform the historic building information modelling (HBIM) approach, they differ in their approach to the analysis of historic data and parametric design [Dore and Murphy, 2012]. HBIM has come long way in a few years and further hard work is essential in the field of cultural heritage.

3.3.1 BIM and Cultural Heritage

As stated earlier, despite the widespread adoption of BIM for the design and lifecycle management of new buildings, very little research has been undertaken to explore the value of BIM in the management of cultural heritage. To do this it is essential to investigate the construction of BIMs that incorporate both quantitative assets (e.g. intelligent objects and performance data) and qualitative assets (historic photographs, documents of previous projects, etc.).

In fact, BIM as a methodology/technology able to address the growing demand for a multidisciplinary knowledge base could be essential for the management of life-cycle processes such as the operation, renewal and development of the growing number of cultural heritage sites. This is because the investigation and conservation process in cultural heritage is a system of multidisciplinary activities where each professional is

[1] http://bim-modeling.blogspot.com/2010/12/history-of-bim-and-success-story-till.html

both user and provider of a large amount of information. The accuracy and the completeness of the built heritage knowledge representation deeply affect the activities of the different specialists involved in the investigation, intervention, conservation and maintenance phases. Any decision made by the different participants is based on what is known of the object and any lack of knowledge or inconsistency can lead to errors. In this field, the management of information is crucial to support collaboration and knowledge sharing at all levels of the investigation/conservation.

At present in heritage processes, information is collected, documented and made available virtually by the different professionals involved. Nevertheless, this knowledge is almost inaccessible since it is spread among different professionals with their own sets of tools and standards. The introduction of digital technologies to the built heritage field has left this problem unsolved: while several efforts have been made to develop virtual reality techniques oriented to building original appearance simulation or data acquisition technologies, a more general methodology for knowledge representation and management for cultural heritage is missing. In fact, information management in heritage processes is still mainly document-based and the representation of the artefact is just the sum of the documentation provided by the participants during the heritage process.

The need to create a free access database containing all the information useful to the AECO industry for cultural heritage should be considered as the first step of the renewal of this sector because the current traditional system fails to meet the increasingly demanding needs of performance capabilities in terms of data management.

In this way, BIM and interoperability represent an opportunity for the AECO industry to optimise data exchange among different professionals for both new and existing/historical buildings. Thanks to BIM, an integrated process can be used to explore the physical and functional characteristics of a building digitally. Therefore, a real integrated and interdisciplinary BIM approach allows the understanding, evaluating, simulating and solving of optimally complex problems associated with various types of information using interoperability. The idea, which is the basis of interoperability, consists of the ability to see the 3D model as a database rich in information that can be sorted and queried from time to time according to the specific simulation. For this reason, a BIM model should be planned in order to optimise the data exploitation. Because the BIM approach provides a central model with specific standard and protocols for collaboration and data sharing among different specialist, during the building process data filled in the parametric model can be inserted and removed through import/export processes from different professionals, which are able to improve the information model for different use-cases.

Although the potentials of BIM parametric features are limited by the uniqueness and context-dependence of CH, the representation templates that can be generated for each component are still potentially re-usable in investigation campaigns of similar artefacts. From the point of view of BIM, standardisation has the task of establishing the rules for interoperability with regard to content, methodologies and formats.

The context is so intricate that the successful use of BIM is only possible if all the parties enrich the model using the same language, a shared protocol, and intelligent objects based on well-defined exchange standards. For this reason, there is a significant ongoing international effort to provide usable BIM solutions, which can exchange data internationally and across the full breadth of the construction industry. Fortunately, much of this work has already been planned by the International Alliance for Interoperability (IAI), founded in 2001 and renamed buildingSMART™ in 2007.[2] For example, over the last ten years an industry foundation class (IFC) format has been developed to provide this data exchange standard. The technology for exchanging information using IFC has now been established, but many areas still require additional development before comprehensive interoperability solutions are reached. These areas include: (i) extending the scope to contain a broader range of project information, for more types of projects, and more types of information; (ii) developing the exchange mechanisms; (iii) developing the range of software applications that implement model-based interoperability; and (iv) reorganising project management practices based on new integration technologies.

Now BIM and interoperability are regulated by specific ISO standards[3] such as:

- ISO 12006-2:2001: Building construction – Organisation of information about construction works – Part 2: Framework for classification of information;
- ISO 12006-3:2007: Building construction – Organisation of information about construction works – Part 3: Framework for object-oriented information;
- ISO 22263:2008: Organisation of information about construction works – Framework for management of project information;
- ISO 29481-1:2010: Building information modeling – Information delivery manual – Part 1: Methodology and Format;
- ISO /TC 59/SC 13: Organisation of information about construction works.

Furthermore, a significant role is taken on by the OmniClass Construction Classification System (known as OmniClass™ or OCCS),[4] the scope of which is to encompass building objects at every scale through the entire building environment, from completed structures to vast projects and multi-structure complexes, to individual products and component materials.

OmniClass is designed to address all kinds of buildings (vertical and horizontal, industrial, commercial and residential), but it is not always simple to use for historical artefacts. OmniClass also addresses actions, people, tools, and information that are used or take part in the design, construction, maintenance, and occupancy of the buildings. The OmniClass approach based on the building life cycle is particularly important

[2] http://buildingsmart.com/
[3] http://www.standard.no/sc13
[4] http://www.omniclass.org/

in a field such as construction, traditionally focused on organising segments of information, one portion and one discipline at a time.

Last but not least, the 2008 construction operations building information exchange (COBie) specification denotes how information may be captured during design and construction and provided to facility operators. The COBie approach is to enter the data as it is created during design and construction because gathering this information at the end of the job with today's standard practice is expensive, since most of the information has to be recreated from information created earlier. In this way, designers provide floor space and equipment layouts. Contractors provide make, model and serial numbers of installed equipment, and so on. Since different parties use different kinds of software, COBie information can be displayed in several different formats and all of these formats provide a completely interoperable view of the underlying information specified by COBie. For instance, for designers, COBie can be created using a *SAVE AS* and selecting the IFC file format, while builders may want to use specialised commercial software to update the COBie data with manufacturer's information, or to directly enter information in a spreadsheet display of COBie data. In the end, facility operators can import COBie data, formatted in either IFC or spreadsheet, directly into asset and maintenance data. Thus, COBie simplifies the work required to capture and record project handover data, besides improving the use of international standards over the building life-cycle.

Unlike the AECO industry, where each element is defined and modelled in all its parts and properties, the different components in built heritage are often not clearly identifiable. To overcome this problem, some elements can be used in order to represent these unknown objects in terms of their geometric and material features, waiting for a later interpretation that will associate them.

3.3.2 Challenges of BIM for the 3D recording of Cultural Heritage

A BIM normally originates from the birth of a building or from before it was built, when it was thought of and designed. In contrast, a cultural heritage system starts at an intermediate point in a building's life cycle. In fact, in a cultural heritage BIM, the starting point is the thorough knowledge of an existing artefact, of its geometries and characteristics, its history, and its state of conservation. Then, compared to a new architectural building or industrial structure, cultural heritage is normally somewhat complex. It is rich in decoration, ornamentation, and artistic elements in general, requiring more measurement and modelling than is normally needed in the industrial or building fields. Furthermore, buildings that are typical of archaeological significance are frequently collapsing, deteriorating or abandoned, resulting in remains with undefined shapes that are difficult to represent or simplify. This means an accurate metric survey of the heritage artefact and three-dimensional modelling of the 'real-based' type is required. Moreover, historical buildings undergo significant changes and re-adaptation over the years, in both their architecture and uses. Such 'occurrences' characterise the buildings and must be considered for future intervention.

They need to be identified and understood and normally require both a metric survey by a surveyor and a cognitive and interpretative survey by an expert, followed by graphic, visual and iterative visualising by a BIM system designer. Considering time modifications, modelling in this field must be of the 4D type, in which the fourth dimension is time. The modelling effort often trebles. A representative model of the present state is needed, as are one or more models of what it was like, part of a heritage restoration and reuse perspective and of what it will be like after renovation and maintenance.

Despite everything, world environmental and economic conditions require a change in the development strategies of society, starting with the built environment in which people live. Usually AECO industry focuses on new buildings without paying attention to the cultural building heritage. But, the need to preserve historical buildings or to refurbish existing buildings (for instance, to transform them into 'smart' energy-efficient buildings), has become more important in recent years.

As described above, BIM implies the collaboration of several stakeholders in the different life phases of a facility in relation to inserting, extracting, updating, or modifying information. Therefore, it supports the stakeholders by reflecting their roles. On this point, the United States National BIM Standard (NBIMS) published by the General Services Administration (GSA), through its Public Buildings Service (PBS) Office of Chief Architect (OCA), categorises BIM in three ways:

1. As a product or intelligent digital representation of data about a capital facility. Tools that generate original information and digital representations or intelligent virtual models are used to create and aggregate information, which, before BIM, had been developed as separate tasks with non-machine interpretable information in a paper-centric process.
2. As a collaborative process, which covers business, drivers, automated process capabilities, and open information standards for information sustainability and fidelity.
3. As a facility/lifecycle management which requires well-understood information exchanges, workflows, and procedures,used by the teams as a repeatable, verifiable, transparent and sustainable information-based environment throughout the building lifecycle.

Based on this, it is clear that to use BIM for cultural heritage does not mean to introduce new tools for the data representation, but to change the methodology in order to optimise the process through data management. For this reason, at this point it is essential to introduce the concept of level of detail or level of development (LoD) as described by the American Institute of Architects (AIA):

- Level of detail is essentially how much detail is included in the model element.
- Level of development is the degree to which the element's geometry and attached information have been thought through and the degree to which each stakeholder may rely on the information when using the model.

Summarising, challenges to using BIM require a perfect use of level of detailed thought as input to the element and of level of development as reliable output. Nowadays this is not easy to achieve because of the lack of relevant literature available, particularly for cultural heritage.

To approach correctly this intricate question the starting point must be the fact that while a high LoD provides the most information, it is not necessarily ideal to have a high LoD in all modelled elements. In the case of the cultural heritage, defining LoD is a much more difficult task in comparison to modern buildings. Much of the capacity to model higher LoD in existing buildings relies on how it has been documented rather than the capacity of the modelling programme to create complex geometries.

In the end, a BIM used for cultural heritage must have these characteristics, some of which are common to the classic BIM:

- favour collaboration between sector operators and users;
- offer accurate information to support restoration and maintenance operations;
- supply a standard archive and consultation instrument that lasts over time and can be easily updated and adapted to match technological development;
- build up data collection and maintain information in survey and processing processes typical of the sector;
- be easy to use;
- be low cost or free to facilitate use of these methods in environments that are notoriously not rich.

3.3.3 Examples of using BIM in the management of Cultural Heritage

It is known that the need to maintain or refurbish existing buildings, even historical, converting them into smart buildings exploiting new technologies and methodology is an essential research field because AECO industry requires innovation.

In the SEEMPubS (Smart Energy Efficient Middleware for Public Spaces) and DIMMER (District Information Modelling and Management for Energy Reduction) projects, the Politecnico di Torino campus and its district are under investigation as case study. Their construction period ranges from the 16th century to the 19th century, thus including buildings very different in dimension, envelope construction characteristics and performance. The heterogeneous case study adopts different strategies for modelling.

A detailed survey of architectural features of each case study (geometry, furniture and equipment, surface reflection/transmission properties, lighting / HVAC systems, etc.) was carried out to make accurate 3D models of the selected district / buildings / rooms / elements. The 3D digital construction and documentation of cultural heritage is a complex undertaking that typically involves a hybrid approach to visualisation of heterogeneous data sets such as survey data, CAD drawings, photographs and 3D non-contact imaging data (like laser scanning and photogrammetry).

As there are many advantages of combining BIM products and GIS, as a starting point, the model has been approached using two separate scales as described below.

The building scale using BIMs

BIM software is normally used to model new proposed buildings as opposed to existing buildings, but for the application of cultural heritage, detailed and accurate 3D models are required. In this case, the model must be semantically classified into various objects that can contain all attribute information and references to external data sources. This information can contain historical information about the creation, origin and chronology of the heritage object. Further historical documents can be linked to elements in the model for complete documentation.

In SEEMPubS and DIMMER, the existing drawings have been used as the starting point while relying on site inspection, photographs and thermography to assure accuracy of the model.

The topographic scale using GIS

GIS is used for storing, visualising and analysing geographic data. Spatial features are stored as geometry and referenced with map projections and coordinates. Attributes stored in tables are then associated with spatial features to allow for spatial analysis of data. GIS is traditionally used with 2D mapping to analyse data over large areas. However, because of advances in technology, the principles of 2D GIS can now be applied to 3D spatial data to enable analyses that are more complex, visualisation and documentation. This enables complex analyses to be carried out for many applications such as 3D cadaster, planning, energy management and of course cultural heritage.

In order to guarantee the accuracy of the model, considering the diversity of data sets, in the DIMMER project the building stock is augmented with data related to services (in this case the smart grid of the city of Turin).

Obviously, BIM is mostly used for AECO applications and the products are generally detailed and accurate models of small objects or sites. GIS, on the other hand, is seen as a cartographic tool for mapping and analysing data over larger areas. Spatial data for GIS would not be considered as accurate or detailed as spatial data created in BIM systems. By combining both systems, the capabilities and advantages of both BIM and GIS can be utilised. This results in accurate and detailed BIM products used in a GIS platform that can be linked to additional data to perform complex analysis and spatial queries. Moreover, BIM products, which are based on the international IFC, have great capability for integration into a GIS platform. This is because IFC is an interoperable standard format that is object orientated and semantically classified.

BIM can incorporate semantic data pertaining to structural, material and operational information, in contrast to existing methods that focus primarily on geometrical description of heritage buildings. In these projects, BIM is employed as a platform to incorporate information pertaining to material assembly and construction. As described above, while this LoD (as detail) is common in design documentation of new construction projects, its application in heritage documentation typically involves a reverse engineering and analysis of existing conditions based on disparate heterogeneous data sets, not always simple to achieve.

As just introduced, the SEEMPubS and the DIMMER models are built from a wide range of source data, both analogue and digital as shown below through selected examples.

The first example is related to the refurbishment of the former thermal power plant of Politecnico. Starting from a point cloud, the work has been organised and developed considering three essential elements:

1. the working methodology based on the data exchange following the interoperable way;
2. the data hierarchy during the different phases of the design and the role of professionals in the filling's data steps in the 3D model;
3. the existing rules and the need to update them.

The second example is related to the 3D model of a major door of considerable architectural interest located inside the Valentino Castle, the historical site of Politecnico. Starting from a survey based on the photo-modelling, the work has been carried out without integration with any other kind of survey. 16 photos were included in the programme 123D Catch for an output consisting of 6150 vertices. Then, the photographic model was imported into MeshLab in order to be able to export the mesh to a file *dxf* format that can be opened in the parametric software like Autodesk Revit creating a system family. The main decision was to describe the complexity of the architecture using the photographic model, without spending a long time modelling the detail. This is useful when these data are required for a 3D representation of the building, linking different kinds of documents, without modelling in a parametric way the elements that are not essential.

Figure 3.1 View of the parametric model with the point clouds. [Authors: Matteo Del Giudice and Andrea Lingua.]

Figure 3.2 View of the model of the door with the In Place family of decoration. [Authors: Pablo Ruffino and Matteo Del Giudice.]

The third example is related to the Polito's district, which is composed of both public and private buildings. The main aim of this research is to link BIM and GIS data and visualisation. Starting with district information modelling (DIM), the first step, before the creation of the 3D model, was to research archival documents in order to discover the construction typology of the different buildings. The most important documents were collected and a historical database to link historical data with the 3D parametric models was developed subsequently with Autodesk Revit, and ESRI Arc-GIS 10. The models developed were realised in LoD (as development) 100 for the GIS model and in LOD 100 and LOD 300 for the BIM model. The general model of the target area was developed in Revit using *Masses* as *In place family* able to describe the volume of the district. These items have been enriched by some architectural inform-ation coming from the website of the city of Turin with shared parameters. Then, external and internal walls, floors, roof, windows, rooms, etc. have been modelled and described for LoD 300.

Both 3D models have been oriented and located in the right way. Working on Arc-GIS, first, it was necessary to define the Geographic Coordinate System, then make shapefiles of the buildings and of the addresses. Several different formats of interoper-ability were analysed: IFC,[5] CityGML (geography markup language), ODBC (open

[5] At present, referring to interoperability between software, IFC and CityGML are considered the two principal standard exchange formats in the building industry.

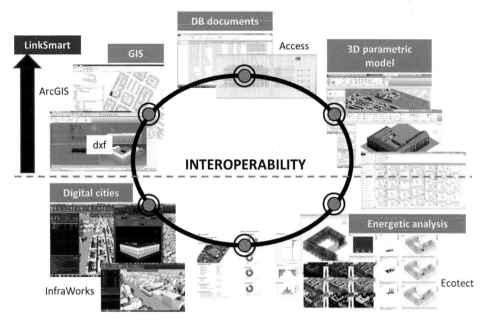

Figure 3.3 Data exchange process based on interoperability used in the DIMMER project.

database connectivity), .rvt, .fbx, .accdb, .mdb, .shp, etc. In this case, the idea of inter-operability can interact with the concept of a common platform where different data-bases can share information. In this way, data can be extracted for a specific calculation in different applications as shown in Figure 3.3. Finally, in order to bring all of the pieces together into a single model, the functions of InfraWorks were adopted as this is a robust visualisation tool able to integrate the diverse elements required for the project.

The results from this work show the capabilities for semantic modelling and analysis from the proposed workflow from survey, HBIM to GIS. The workflow provides new tools and methods for 3D virtual heritage modelling, documentation, management and analysis.

Furthermore, this study indicates that similarly to its impact on the AECO sector, the introduction of BIM in the cultural heritage field can support the management of the information collected, modelled, used and shared by the different actors involved in the investigation/conservation process. It improves availability and accessibility of all the knowledge related to a historical (or archaeological) artefact, making it easier to interpret its nature, monitor its changes and document each investigation and inter-vention activity.

3.4 Conclusions

The use of GIS and BIM technologies in cultural heritage documentation and man-agement developed differently, mainly due to the interest in managing spatial data of different scientific communities (archaeologists, historians, managers, etc.). While

GIS is a well-established technology, BIM seems to be just beginning to interest those working in cultural heritage documentation and management: however, the first results presented in many conferences and specialised reviews about BIM applications allow one to consider the future wholesale adoption of BIM technology.

There have been many experiences in recent years regarding the integration of these two technologies in the civil building industry and some theoretical papers have been written on the possible migration towards a new technology integrating the potentialities of GIS and BIM in a unique platform. This idea starts from the conception that GIS and BIM are simply a non-geometric database connected to a geometric database: therefore there is no reason, from a theoretical point of view, to talk about two different technologies.

In the digital domain, the development of efficient ways to manage large and different sets of data and the realisation of more efficient software solutions may be necessary to allow a real diffusion of those technologies. In fact, it is necessary that all the experts involved in cultural heritage documentation and management (surveyors, historians, conservators, designers, managers, etc.) act directly on the software as protagonists and not as simple data providers.

Acknowledgements

The SEMMPubS and the DIMMER projects have received funding from the European Union's Seventh Framework Programme for research, technological development and demonstration under Grant Agreement n° 260139 and n° 609084.

References and further reading

Auer, M., Agugiarob, G., Billena, N, Loosa, L. and Zipf, A., 2014. Web-based visualization and query of semantically segmented multiresolution 3D Models in the field of cultural heritage. *ISPRS Annals of Photogrammetry, Remote Sensing and Spatial Information Sciences*, 1, 33–39.

Banerjee, R. and Srivastava P.K., 2013. Reconstruction of contested landscape: detecting land cover transformation hosting cultural heritage sites from central India using remote sensing. *Land Use Policy*, 34, 193–203.

Bastian, O., Walz, U. and Decker, A., 2013. Historical landscape elements: part of our cultural heritage—a methodological study from Saxony. *The Carpathians: Integrating Nature and Society Towards Sustainability*. Heidelberg: Springer Berlin, 441–459.

Berg, E., 2012. The use of GIS in the national system for cultural heritage management and dissemination to the general public in Norway: case study: the heritage management database 'Askeladden' and the system for dissemination to the public, 'Kulturminnesøk'. *Progress in Cultural Heritage Preservation*. Heidelberg: Springer Berlin, 578–585.

Burrough, P.A. and McDonnell, R.A., 1998. *Principles of GIS*. London: Oxford University Press.

Burrough, P.A. and McDonnell, R.A., 2011. *Principles of Geographical Information Systems*. Oxford: Oxford University Press.

Chevrier, C., Charbonneau, N., Grussenmeyer, P. and Perrin, J-P., 2010. Parametric documenting of built heritage: 3D virtual reconstruction of architectural details, *International Journal of Architectural Computing*, 8(2), 131–145.

De la Fuente, D., Vega, J.M., Viejo, F., Díaz, I. and Morcillo, M., 2013. Mapping air pollution effects on atmospheric degradation of cultural heritage. *Journal of Cultural Heritage*, 14(2), 138–145.

De Luca, L., 2012. Methods, Formalisms and tools for the semantic based surveying and representation of architectural heritage, *Applied Geomatics*, no. 1866–9298, 1–25.

Dore, C. and Murphy, M., 2012. Integration of historic building information modeling (HBIM) and 3D GIS for recording and managing cultural heritage sites. *18th International Conference on Virtual Systems and Multimedia (VSMM)*, IEEE.

Eastman, C., Teicholz, P., Sacks, R. and Liston, K., 2008. *BIM Handbook: A Guide to Building Information Modelling*. Hobken, NJ: John Wiley & Sons.

El-Hakim, S.F., Beraldin, J.A., Gonzo, L., Whiting, E., Jemtrud, M. and Valzano, V., 2005. *A Hierarchical 3D Reconstruction Approach for Complex Heritage Sites*, CIPA 2005 XX International Symposium, Torino.

Fabbri, K., Zuppiroli, M. and Keoma, A., 2012. Heritage buildings and energy performance: Mapping with GIS tools. *Energy and Buildings*, 48, 137–145.

Fai, S., Graham, K., Duckworth, T., Wood, N. and Attar, R., 2011. *Building Information Modelling and Heritage Documentation*, XXIII CIPA International Symposium, Prague, Czech Republic, 12–16 September.

Fernández Freire, C., *et al.*, 2013. A cultural heritage application schema: achieving interoperability of cultural heritage data, in *INSPIRE*.

Ferretti, V., Bottero, M. and Mondini, G., 2014. Decision making and cultural heritage: an application of the multi-attribute value theory for the reuse of historical buildings. *Journal of Cultural Heritage*, 15(6), 644–655.

Guelke, J. Kay. and Dallen, J. T., (Eds.), 2012. *Geography and Genealogy: Locating Personal Pasts*. Ashgate Publishing, Ltd.

Hadjimitsis, D., *et al.*, 2013. Exploring natural and anthropogenic risk for cultural heritage in Cyprus using remote sensing and GIS. *International Journal of Digital Earth*, 6(2), 115–142.

Ioannides, M., *et al.*, (eds.), 2014. Digital heritage: progress in cultural heritage. *Documentation, preservation, and protection 5th International Conference*, EuroMed 2014, Limassol, Cyprus, November 3–8, 2014, Proceedings. Vol. 8740. Springer.

Jang, M., 2012. Three-dimensional visualization of an emotional map with geographical information systems: a case study of historical and cultural heritage in the Yeongsan River Basin, Korea. *International Journal of Geographical Information Science*, 26(8), 1393–1413.

Keinan, A., 2013. Israeli and Palestinian archaeological inventories, GIS and conflicting cultures in the Occupied West Bank. Diss. UCL (University College London).

Kiviniemi, A., 2011. The effects of iIntegrated BIM in processes and business models. In: *Distributed Intelligence in Design*, Kocaturk, T. and Medjdoub, B., (Eds.), Chichester, West Sussex: Wiley Blackwell.

Lai, J., Jing, L., and Mu, Z., 2012. Design and realization of the intangible cultural heritage information management system based on web map service. *Advances in Information Technology and Industry Applications*. Heidelberg: Springer Berlin, 605–612.

Madden, M., (ed.), 2009. *Manual of Geographic Information Systems*. Bethesda, MD: American Society for Photogrammetry and Remote Sensing.

Merlo, A., Dalcò L. and Fantini, F., 2012. Game engine for cultural heritage: new opportunities in the relation between simplified models and database. *18th International Conference on Virtual Systems and Multimedia (VSMM)*, IEEE.

Mihindu, S. and Arayici, Y., 2008. *Digital Construction through BIM Systems will drive the Re-engineering of Construction Business Practices*, International Conference on Visualization IEEE Computer Society, 29–34.

Myers, D., *et al.*, 2012. Arches: an open source GIS for the inventory and management of immovable cultural heritage. *Progress in Cultural Heritage Preservation*. Heidelberg: Springer Berlin, 817–824.

Oikonomopoulou, E., *et al.*, 2013. An intercultural approach for the protection and promotion of common cultural heritage: the case of Byzantine monuments in Serbia. *International Journal of Heritage in the Digital Era*, 2(4), 547–568.

Orengo, H.A., 2013. Combining terrestrial stereophotogrammetry, DGPS and GIS-based 3D voxel modelling in the volumetric recording of archaeological features. *ISPRS Journal of Photogrammetry and Remote Sensing*, 76, 49–55.

Osello, A., 2012. *The Future of Drawing with BIM for Engineers and Architects*, Dario Flaccovio Editore, Palermo.

Parcero-Oubiña, C., *et al.*, 2013. GIS-based tools for the management and dissemination of heritage information in historical towns. The case of Santiago de Compostela (Spain). *International Journal of Heritage in the Digital Era*, 2(4), 655–676.

Richards-Rissetto, H., *et al.*, 2012. Kinect and 3D GIS in archaeology. *18th International Conference on Virtual Systems and Multimedia (VSMM)*, IEEE.

Rinaudo, F. and Devoti, C., 2013. GIS and land history: the documentation of the ancient Aosta Dukedom. *ISPRS Annals of the Photogrammetry, Remote Sensing and Spatial Information Sciences*, 2, 265–270.

Rogerio-Candelera, M.A., (ed.), 2014. *Science, Technology and Cultural Heritage*. CRC Press.

Ruoss, E., Alfarè, L., *et al.*, 2013. GIS as Tool for cultural heritage Management. *Sustainable Tourism as Driving Force for Cultural Heritage Sites Development: Planning, Managing and Monitoring Cultural Heritage Sites in South East Europe*. www.cherplan.eu. 42–46.

Torres, J.C., *et al.*, 2012. An information system to analyze cultural heritage information. *Progress in Cultural Heritage Preservation*. Heidelberg: Springer Berlin, 809–816.

Vileikis, O., *et al.*, 2012. Information management systems for monitoring and documenting World Heritage – the Silk Roads CHRIS. *International Archives of the Photogrammetry, Remote Sensing and Spatial Information Sciences*, 39, 203–208.

Vileikis, O., *et al.*, 2012. LeGIO Tutorial in cultural heritage of monuments and sites: open GIS e-learning. *GIS-Education: Where are the Boundaries? 8th European GIS Education Seminar 6–9 September.*

Wang, F., Yang, G. and Yang J. Z., 2013. Design and construction of the information system of Hainan's intangible cultural heritage. *Applied Mechanics and Materials*, 373, 1810–1814.

Wang, J., 2014. Flood risk maps to cultural heritage: measures and process. *Journal of Cultural Heritage*, 24, 432–438.

Woodley, C., *et al.*, 2013. Technologies, indigenous cultural heritage and community capacity building. *Global Humanitarian Technology Conference (GHTC)*, IEEE.

Yang, W., Cheng, H. and Yen, Y., 2014. An application of GIS on integrative management for cultural heritage – an example for digital management on Taiwan Kinmen cultural heritage. *Digital Heritage. Progress in Cultural Heritage: Documentation, Preservation, and Protection*. Springer International Publishing, 590–597.

Zhou, M., *et al.*, 2012. The CEDACH DMT: a volunteer-based data management team for the documentation of the earthquake-damaged cultural heritage in Japan.

Zhou, W., Qiang L. and Jian-bo, T., 2011. Reflection on the application of internet of things and GIS in cultural heritage protection. *Sciences of Conservation and Archaeology*, 3.

Basics of Photography for Cultural Heritage Imaging | 4

Geert Verhoeven

4.1 Introduction

In the fields of archaeology, art history and museology, many recording and examination methods are based on imaging techniques. One of the oldest but still heavily used non-destructive imaging approaches is broadband photography. In the field of archaeology, for instance, photography has been incorporated into archaeological practice for at least a century, primarily because it is assumed to provide an 'objective' pictorial record. The related fields of art history and museology (all three from now on denoted as the field of cultural heritage) also use photography for a very wide variety of purposes. Many analyses on frescoes and archaeological artefacts such as vessels and clothing, paintings or ancient manuscripts start with a thorough recording of the artwork with visible or even near-infrared (NIR) photography. Additionally, photographs are often acquired as input for a photogrammetric process that extracts accurate metrical data about the object that was imaged.

Although cultural heritage photography in the film-based era proved to be very successful, the advent of digital photography in the 1990s opened up a completely new world and brought along all the well-known benefits in acquiring, storing, manipulating and retrieving imagery. Combined with the constant technical improvements in camera technology, digital photography really started to replace its analogue counterpart at the beginning of the 21st century. Over the past decade, the number of digital cameras has increased exponentially and even the global economic recession could not prevent new camera designs and lens types appearing constantly. Today, (almost) everyone has a digital camera, whether it is embedded in a tablet, phone, computer, glasses or clothing.

Despite this, many people are still not at all familiar with the basic behaviour of their digital camera. Cameras still mystify to a great extent, which makes maximising their potential difficult. Although this is not a big deal for holiday snapshot photography, it might become an issue when the photographs become the source from which new data (e.g. three-dimensional models, colour-accurate representations) should be extracted.

In this chapter I aim to help the cultural heritage photographer get to grips with digital cameras, their technology, sophisticated features and related imaging concepts. In short, my overall aim is to provide a good, technically sound insight into the basics of photography. I will therefore cover a wide range of topics: from the basic principles of light and colour over the human eye and digital imaging sensors to photographic exposure principles and lens technology. Using this approach, the reader should be able to make a more informed decision about the photographic strategy to be followed as well as the hardware and software solutions that are best suited for their intended purpose. I will not, however, show how to choose the right lens, camera or tripod from the bewildering array of possible choices. To decide on this, it is best to read as many product reviews as possible from a variety of sources. This will help you to appreciate different points of view and get a feel for the prevailing sentiments and thoughts.

This chapter is also not really about creative photography, but rather on documentation-style photography which can deliver images that can be used down the pipeline in photogrammetric and general documentation workflows. To this end, I will take a rather different approach from most books on photography. First, the amount of covered topics is smaller given the fact that it is impossible to cover the field of photography exhaustively in one chapter. Second, I present the material in a slightly more technical, in-depth way than normally found in photography manuals. This is done on purpose, since simplified explanations often make slightly wrong assumptions, which might in the end lead to more confusion. Additionally, this will allow you to more easily explore the photographic topics that could not be tackled here. For those that seek to delve deeper into the field of cultural heritage photography, the excellent compendium of MacDonald [2006] is recommended as well as Deutsches archäologisches Institut [1978], Dorrell [1994], Harp [1975], Howell and Blanc [1995], Matthews [1968] and Warda *et al.* [2011] (note that some of these are purely on film-based photography). For some in-depth, technically sound manuals of photograph in general, consider Adams and Baker [2005a], Arnold *et al.* [1971], Jacobson *et al.* [2000], Morton [1984], Peres [2007], Ray [1999], Salvaggio *et al.* [2013] and Saxby [2011]. Given the fact that Verhoeven [2012] provides an overview of many possible cultural heritage applications that apply normal colour photography, non-visible near-ultraviolet (NUV) and NIR imaging as well as fluorescent photography, an overview of such applications is also omitted here.

Despite being written for those that want to gain a more in-depth knowledge of general photographic principles, this overview assumes no prior knowledge. In section 4.2 I start with a concise exploration of the world of matter, charge and electromagnetic energy. Next, in section 4.3 I tackle the basics of any photographic task: how electromagnetic radiation interacts with an object and how this signal is recorded by the silicon sensor embedded in digital cameras as well as the human eye. Coverage of the latter topic is important as it contains essential information for any discussion on digital colour. In section 4.4, I focus purely on digital images: what is a pixel, how is it created and how does it define spatial resolution? Section 4.5 provides insight into some essential camera and lens characteristics, showing why a lens can blur an image and how to maximise the depth of field. Section 4.6 aims to provide an insight into

photographic exposure and its building blocks shutter speed, aperture and ISO. I also tackle related key photographic concepts such as white balance and colour spaces.

The techniques covered here should allow archaeologists, art conservators and cultural heritage managers alike to get started in scientific photography and enable them to reveal spatial as well as spectral information about the objects under research. I will almost exclusively focus on digital photography since it has virtually completely replaced film-based photography. Unlike video or film-based photographic still cameras, a digital still camera (DSC) is a camera equipped with a digital image sensor for capturing photographs and a storage device for saving the obtained image signals in a digital way [Toyoda, 2006]. Most of the material covered here refers to small format digital single-lens reflex cameras (D-SLRs) as they allow switching lenses and provide a useful (and often necessary) degree of control over the complete photographic process. Notwithstanding this constraint, most principles tackled also hold for other DSC formats and types.

Finally, it needs to be said that photography and imaging are considered synonyms and both terms are used in a very wide sense. Although each of them might have a very specific meaning (e.g. some limit photography only to the recording of visible light), both terms refer to the recording of NUV, visible and NIR radiation with a DSC.

4.2 The nature of electromagnetic radiation

Since photographing cultural heritage artefacts is based upon some essential principles of how these objects interacts with radiant energy, I start with a concise exploration of the world of matter and electromagnetic energy.

4.2.1 Matter, charge and energy

Matter can be described as anything that occupies space and has weight. It is constituted by elements in various combinations. These elements, all described in the periodic table, are made up of atoms. Such atoms can be seen as the smallest matter particle retaining all the physical characteristics of the element. Different atom models have been proposed during the last two centuries. Today, the Bohr model – introduced by Niels Bohr in 1913 – is often used, as it offers an easy and relatively correct way to depict the atom. In this model, the central core or nucleus of each atom is made up of chargeless neutrons and Z positively charged protons, where Z is the atomic number. To compensate for these positive charges, negatively charged particles called electrons orbit this nucleus. Hence, it is correct to say that electric charge is substance-like and all physical objects are composed of electric charge.

Charge differs from energy. Energy should not be considered a substance but rather an attribute of a system that is always conserved. To track energy flows, energy can be conceptualised using the model of fields. In the same way that a massive object can produce a gravity field to which distant objects respond, electrical charges and magnets alter the region of space around them so that they can exert forces on distant objects.

It is exactly this altered space that is called a field (more technically, these fields are just vector quantities). Scientists have known since the early part of the 19th century that electrical fields and magnetic fields are intimately related to each other: moving electric charges (i.e. electric current) create a magnetic field and a changing magnetic field creates an electric current (and thus an electric field). A consequence of this is that changing electric and magnetic fields should trigger each other. The Scottish mathematician and physicist James Clerk Maxwell (1831–1879) put these ideas together and mathematically described the relationship between the magnetic and electric fields, as well as the currents and charges that create them. To conclude this line of reasoning, Maxwell said that visible light is an electromagnetic (EM) wave, consisting of both an electric (E) and magnetic (B) field (Figure 4.1). Both fields are oscillating perpendicular to each other as well as perpendicular to the direction of propagation (which makes them a transverse wave), whilst propagating at 299,792,458 m/s in vacuo [National Institute of Standards and Technology Physical Measurement Laboratory, 2012]. This speed is known as the speed of light, denoted c, and decreases when EM radiation travels in air, glass, water or other transparent substances [Slater and Frank, 1969; Waldman, 2002; Walker, 2004].

The electric and magnetic component vectors vibrate in phase and are sinusoidal in nature: they oscillate in a periodic fashion as they propagate through space and have peaks and troughs (see Figure 4.1). Being a self-propagating and periodic wave-like phenomenon, EM radiation is distinguished by the length of its waves, called the

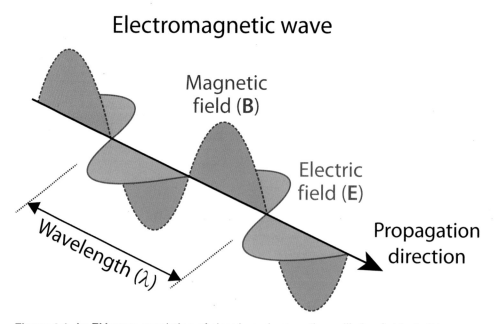

Figure 4.1 An EM wave consisting of electric and magnetic oscillating fields. In this example, the oscillating electric field vectors are indicated in red, while the blue lines represent the magnetic field vectors.

wavelength (λ), its magnitude of change or amplitude as well as its frequency (v): a figure – expressed in hertz (Hz) – that indicates the number of complete waves or sinusoidal cycles passing a certain point in one second and thus inversely proportional to λ. No matter what portion of this broad spectrum is considered, they all obey the same physical laws and the relation $c = \lambda v$ holds for each. Sometimes, the wave number v' is used, expressed in cm^{-1} and denoting the number of waves that fit in a 1 cm length: $v' = v/c$.

4.2.2 Visible or invisible: it is a matter of wavelength

Light and colour

The principle that allows the human visual system (HVS) to observe objects and persons is based on those subjects' reflection of visible light. Dark objects do not reflect much incoming light, whereas a healthy banana principally reflects yellow light. However, this light is only one small portion out of the complete so-called EM spectrum radiated by the sun or other sources (like stars or lamps). The EM spectrum can be considered a continuum of varying EM waves, all consisting of electric and magnetic fields that are described by the Maxwellian theory, but distinguishable by their wavelength.

Visible EM radiation, called visible light or just light, is only a very narrow spectral band with wavelengths ranging from approximately 400 nm (400×10^{-9} m) to 700 nm (700×10^{-9} m), the absolute thresholds varying from person to person and specific viewing conditions. These wavelengths correspond with frequencies comprised between 7.49×10^{14} Hz (749 THz) to 4.28×10^{14} Hz (428 THz). In this range, each wavelength is correlated with a sensory impression of a particular hue, although the change from one hue to another is not a sharp one. Even though the perception of these hues is constructed by neural processes in the human brain rather than being a particular physical property of the EM radiation itself, the light spectrum may be divided roughly as indicated in Figure 4.2. This shows that the light spectrum contains all hues visible in a rainbow: varying from red on the long-wavelength side over orange, yellow, green and blue to violet on the short-wavelength side [Lynch and Livingston, 2001]. For the sake of simplicity, the visible spectrum is usually considered to consist of only three bands: blue (400 nm–500 nm), green (500 nm–600 nm) and red (600 nm–700 nm). Although a coarse approximation, the physical working principles of image-related devices is largely based on this subdivision, not at least the way common DSCs acquire their colour information (see 4.3.3 and 4.3.5).

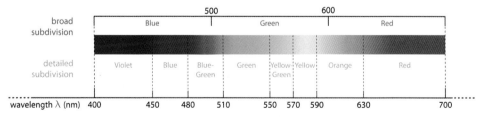

Figure 4.2 Spectral hue names [after Hunt, 2004].

Beyond visible and optical radiation

However, the complete EM spectrum also consists of other wavebands with characteristic frequencies and related wavelengths that are not perceivable by the unaided normal human eye. To both sides of the visible band there is EM radiation which does not produce a visual sensation: gamma rays, X-rays and UV rays with shorter-than-visible wavelengths (and higher frequencies), while IR rays, microwaves and radiowaves can be found in the long-wavelength, low-frequency region (Figure 4.3).

This text will be restricted to imaging in the NUV to NIR portions of the optical radiation spectrum, as this is the spectral range that can be imaged with conventional DSCs. Although the limits and exact subdivisions are to a certain extent dependent on the discipline dealing with EM radiation, it is commonly accepted that the optical spectral band reaches from UV to IR. Since the subdivisions in one spectral band are not unified amongst various sciences, one finds several outer limits for the optical radiation spectrum. I define optical radiation as EM waves with wavelengths between 10 nm (0.1 μm) to 1 mm (1000 μm) [Ohno, 2006; Palmer and Grant, 2010]. This exactly covers a five-decade frequency range from 3×10^{11} Hz to 3×10^{16} Hz and can be logically subdivided into various spectral bands (Figure 4.4). The designation of spectral sub-ranges also varies, with the largest variability in the IR band (even in the same discipline). Often, one finds NIR to end at 1400 nm and SWIR finishing at 2500 nm. Additionally, the visible and NIR range are together often referred to as the VNIR band. In the UV region, there is slightly more agreement, although UV-D is sometimes not considered to be part of the optical radiation spectrum.

Both the UV and IR regions have the advantage that they can convey information about an object that remains unnoticed by the human eye. Reflected (sometimes called direct) NUV–NIR photography monitors the reflected NUV–NIR portion that is produced by the sun or an artificial source. Digital NUV–NIR photography might make certain features of the object under study (more) distinct, because the NUV–NIR reflection will most likely differ from the characteristic visible reflectance properties. Even if

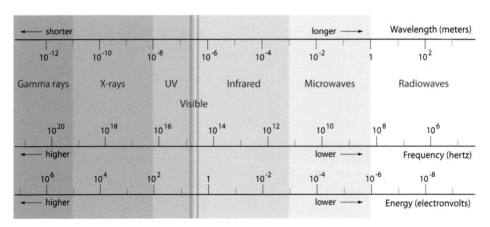

Figure 4.3 The complete EM spectrum.

Division	Subdivision		Abbreviation	Cut-on (nm)	Cut-off (nm)
Optical radiation	UltraViolet (UV)	Vacuum UV	VUV / UV-D*	10	200
		Far UV	FUV / UV-C*	200	280
		Middle-UV	MUV / UV-B	280	315
		Near-UV	NUV / UV-A	315	400
	Visible (Vis)	Blue	B	400	500
		Green	G	500	600
		Red	R	600	700
	InfraRed (IR)	Near-IR	NIR	700	1100
		Short Wavelength IR	SWIR	1100	3000
		Mid Wavelength IR	MWIR	3000	6000
		Long Wavelength IR	LWIR	6000	15000
		Far/Extreme-IR	FIR	15000	1000000

Figure 4.4 The divisions of the optical EM radiation (* VUV does not perfectly correspond to UV-D. While VUV runs from 10 nm to 200 nm and FUV from 200 nm to 280 nm, UV-D encompasses the 10 nm to 100 nm region and UV-C the 100 nm to 280 nm zone).

they exhibit a similar reflectance in the visible spectrum: cultural heritage objects thus often benefit from this uncommon means of imaging [for an overview, see Verhoeven, 2012]. Before delving deeper into the basic principles of imaging optical radiation, it is useful to look more closely at some terminology concerning EM radiation.

4.2.3 Radiometry, photometry, visual psychophysics and their units

In normal communication but also in scientific literature, the terms brightness, lightness, luminance, intensity and radiance are frequently misused and intermingled. However, those terms all have specific scientific meanings and efficient technical communication demands a system of nomenclature, units and symbols that is consistent. Even though a detailed explanation of all these terms is neither possible nor appropriate (for more complete definitions of colorimetry, radiometry and photometry see Lee [2005], Ohno, [2006] and Palmer and Grant [2010]), further discussion requires a careful definition of some basic terms so the correct terminology becomes familiar.

Radiometry

The science of radiometry is used to measure and quantify in an absolute and objective way the phenomena of optical EM radiation [Palmer and Grant, 2010]. Since radiometry evolved in a number of fields including vision, illumination, engineering and physics, not all terms bear the exact same meaning. Here, a common framework is provided, consistent with the concepts and terminology of the Commission Internationale de l'Éclairage (CIE) [CIE, 1987].

In addition to the aforementioned wave properties, EM radiant energy is known to exhibit particle-like behaviour and can be seen as a travelling bundle of indivisible particles or photons (i.e. discrete energy packets, symbolised by γ, the Greek letter gamma) with energy levels that differ according to the wavelength. EM radiation can thus be considered a vehicle for transporting energy from the radiation source to a destination, photons or quanta being the particles of EM energy. To calculate a photon's quantum energy Q_p, Planck's constant h (i.e. 6.626×10^{-34} joule-seconds (J s) or 4.136×10^{-15} eV s) [National Institute of Standards and Technology Physical Measurement Laboratory, 2012] must be multiplied by the frequency v of the radiation:

$$Q_p = hv = \frac{hc}{\lambda}$$

Due to this quantisation, a visible photon with a wavelength of 650 nm will always have 1.9 eV of energy, while a UV 345 nm wavelength is characterised by photons with $Q_p = 3.6$ eV. From these figures, it is obvious that shorter wavelengths have higher radiative energies (see also Figure 4.3). None of the wave-like and particle-like descriptions is complete by itself, but each of them is a valid description of some aspects of EM radiation behaviour. This wave–particle duality is one of the key concepts in quantum mechanics, which states that all things are both waves and particles at the same time and that nothing can be predicted or known with absolute certainty [Slater and Frank, 1969; Waldman, 2002; Walker, 2004].

Because photons are quanta with a single energy level Q_p, optical EM radiation transports a certain amount of energy, called radiant energy Q. This is expressed in joule (J) and the amount of joules depends on both the number and spectral type of the photons. Using the joule as a basic radiometric energy unit, more radiometric units can be established (some of which are used below). Even though the joule is a basic unit in radiometry, it is considered a derived unit in the International System of Units (SI or le Système International d'unités) because joule is equivalent to m^2 kg s^{-2} [Palmer and Grant, 2010].

If a beam of radiant energy is made more intense while keeping the wavelength the same, the photons in the beam are more tightly packed so that the radiant flux or radiant power ϕ increases. This radiant flux expresses the amount of radiant energy per unit time, expressed in joules per second (J/s), or watts (1 W = 1 J/s) [Ohno, 2010].

Photometry and some colorimetry

Another method to measure optical radiant energy is called photometry, developed out of the need for measurement and specification of the visual effectiveness of EM radiation. As explained, EM energy that is capable of producing a visual sensation is called light. Photometry wants to measure this visible optical EM radiation in such a way that the results correspond to the sensation this light would have on an average human observer [Ohno, 2006]. To achieve this, photometry weights the radiant power by the spectral response of the eye, more specifically the photopic/scotopic (i.e. day/night conditions) spectral luminous efficiency function $V_{10}(\lambda)/ V'(\lambda)$ of a standard observer, defined from 360 nm to 830 nm (although 780 nm is often used as a practical upper limit).

To understand this, one needs to go back to the origins of colour science. The first principles of colour science or colorimetry, which is defined as the measurement science that quantifies and physically describes human colour perception, date back to the 19th century during which two prevalent but contradicting colour vision theories were in existence: the Young–Helmholtz trichromatic theory (section 4.3.2) and Edwald Hering's (1834–1918) opponent-colours theory of human colour vision [Hering, 1878, 1920]. Young–Helmholtz theory states that the eye has three different receptor types that are sensitive to red, green and blue wavelengths respectively. Hering, on the other hand, postulated that the human visual system works with three different receptors that were sensitive to couples of opponent colours: red–green, yellow–blue and white–black [Hering, 1878]. To date, it is known that both theories are correct, but they explain colour formation processes at different stages in the HVS. Whereas trichromatic theory is correct for the receptoral part of the visual processing chain, Hering's theory describes the subsequent neural processing of the signals by post-retinal structures in the brain. More specifically, the brain encodes colour in three opponent signals [Valberg, 2005]:

- two chrominance signals: one red–green and one yellow–blue colour difference signal;
- one achromatic channel that represents luminance information and enables the high spatial resolving power of human vision. In dark or scotopic conditions, only luminance information is generated.

However, the spectral contribution to luminance data is strongly wavelength dependent. This becomes obvious when considering the photopic spectral luminous efficiency function or photopic luminosity function $V_{10}^*(\lambda)$ given in Figure 4.5. This function represents the relative sensitivity of a standard human eye (the luminous efficiency value V) to different EM wavelengths (λ) when measured under controlled, photopic viewing conditions [Reinhard *et al.*, 2008; Sharpe and Stockman, 2008]. Hence, it is considered to be the standard for the spectral sensitivity of the achromatic channel [Lennie and D'Zmura, 1988]. $V_{10}^*(\lambda)$, which in Figure 4.5 is displayed together with the scotopic luminous efficiency function $V'(\lambda)$, locates the HVS's main photopic sensitivity in the green–yellow range of the visible spectrum with a peak λ_{max} at 555 nm [Mather, 2006; Reinhard *et al.*, 2008; Sharpe *et al.*, 2005]. Hence, most luminance information is acquired in this specific waveband during daylight conditions.

Using this (photopic or scotopic) spectral luminous efficiency function to weight the radiant energy, photometry takes the average human visual response into account when quantifying EM radiation (although almost all photometric quantities are currently computed for photopic vision) [Ohno, 2006]. Consequently, photometry is just like radiometry in that its quantities are also proportional to EM energy. However, photometry only considers visible optical radiation, while the correspondence between radiometric and photometric units is particular for any given wavelength. Apart from that, photometric quantities and units are basically the same as the radiometric ones, except

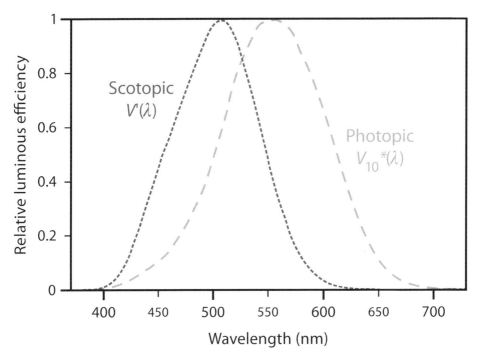

Figure 4.5 The standard CIE 1951 scotopic luminosity curve V'(λ) versus the recently [Sharpe and Stockman, 2008] calculated CIE photopic spectral luminous efficiency function $V_{10}*(λ)$ [data from Colour and Vision Research Laboratory, 2014].

for changed names and symbols which feature a subscript 'v' to denote visual [Lee, 2005]. Some additional units were introduced as well. The photometric equivalent of radiant energy is called luminous energy Q_v, expressed in lumen seconds (lm s) or talbots.

Although the terms light, luminance and illuminance should be used for most photographic applications, imaging with conventional DSCs is also possible – and often very beneficial – in the invisible NUV and NIR domains. As such, I will normally use the radiometric terms EM radiation, radiance and irradiance in this chapter. When specifically visible optical EM radiation is meant or EM radiation as evaluated according to the HVS, the photometric terms will be applied. Figure 4.15 below depicts the overall radiometric chain of imaging a scene and lists some radiometric quantities and units, along with their corresponding photometric quantities and units. Similar to photometry, colorimetry also deals with visible EM radiation as it quantifies and describes the colour sensations evoked by light sources and objects. Together, both photometry and colorimetry are essential for all applications where light is perceived by the HVS. More basic principles of colorimetry are given in section 4.3.2, where the perception of colour is explained.

Visual psychophysics

Besides radiometry, photometry and colorimetry, there is also the field of visual psychophysics: the study of the relationship between physical stimuli and the perception

and sensations they evoke. One of the most fundamental qualities of human visual experience is called brightness [Purves *et al.*, 2004]. Brightness is a perceptual dimension that runs from dim to bright [Gilchrist, 2007; Hunt, 2004]. One can say that luminance is the physical counterpart of brightness, since brightness is the attribute according to which a visual stimulus appears to be more or less intense (i.e. emits more or less light). Therefore, brightness can be considered perceived luminance [Kingdom, 2011]. It is important to understand that any radiometric and photometric quantity is a physical quantity that can be measured by physical devices. Brightness (and other psychophysical dimensions such as lightness) are subjective variables or percepts.

4.3 Imaging visible optical radiation

4.3.1 General principle of imaging

When taking a photograph, the amount and complexity of events that take place under the hood of the camera are enormous. All these events are termed the imaging chain or imaging pipeline. Each part of the chain is studied by experts, all in an attempt to optimise the chain and the final output: the digital image [Fiete, 2010]. The first part of this imaging chain comprises the EM radiation and its interaction with the scene (Figure 4.15) since imaging a medium is always dependent on the influence of matter on incident EM radiation. This interaction involves processes such as refraction, polarisation change, specular reflection, scattering and absorbance [Gauglitz and Dakin, 2006]. In a simplified form: the surface of any natural and synthetic object transmits, reflects and absorbs EM radiation in varying ratios. Besides the specific chemical and physical structure of the object, this interaction and the specific ratio of the three processes is wavelength dependent [Hapke, 2012]. The reflectance R of an object can thus be described as the ratio of all the EM energy reflected by the surface versus the total amount of incident EM energy. When defined per unit wavelength, reflectance is termed spectral reflectance $R(\lambda)$. A medium-specific spectral signature/spectral reflectance curve/spectral reflectance distribution is yielded when the spectral reflectance is plotted over a specific spectral range (Figure 4.6). In the case of visible imaging, the curve is often called the spectrophotometric curve.

Recording this spectral signature not only reveals the object's colour, but can also give insight into its chemical composition since the heterogeneity of diverse elements in an object gives rise to different matter–radiation interactions. However, detecting and imaging such a reflectance spectrum is not that straightforward. When imaging an object with a camera or perceiving it with the HVS, the following steps are involved:

- EM radiation of a source (radiation source) falls onto a scene;
- this radiation is partly absorbed, transmitted and reflected by the object;
- a portion of the reflected radiation is gathered by the lens of the eye of the observer or the camera (sensing device).

This means that imaging reflected optical radiation involves in most cases a multiplicative effect: only the portion of the incoming radiation that is reflected by the object will

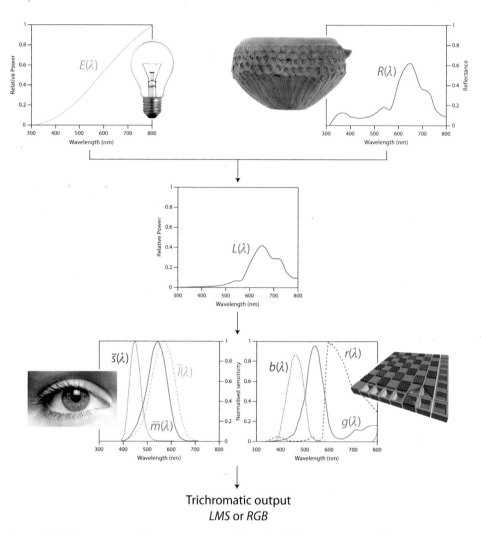

Figure 4.6 The trichromatic output generated by the HVS or any *RGB* DSC results from two multiplications (details to be found in the main text). The linear normalised 10° cone spectral sensitivity curves are based on data from Stockman and Sharpe [2000].

be imaged. As a consequence: a statue of Carystian green marble will never be imaged or perceived as green when the statue is illuminated with a source whose spectral content consists of only blue light. Thus, the radiation source (or for visual perception, the light source) is very important as well.

This principle is summarised in Figure 4.6. The illustration shows why human vision, colour photography or any kind of optical digital imaging (except fluorescence and thermal imaging in which normally only the emitted EM radiation is recorded) generates a signal that is the outcome of at least a three-variable process:

1. first, there is the radiation source which illuminates the scene. This source creates a certain spectral irradiance $E(\lambda)$ (W m^{-2} nm^{-1}) on the object, which expresses

the radiant power per unit area incident from all directions at each wavelength. In photometry, the corresponding quantity of irradiance is called illuminance (E_v; lumen m^{-2} or lux). Most light meters in DSCs measure the total illuminance in lux at all visible wavelengths;

2. second, the object itself has certain reflection properties which will vary with wavelength. This is symbolised by the spectral reflectance $R(\lambda)$. The interaction of both incoming EM energy and reflection ($E(\lambda) \times R(\lambda)$) creates a spectral radiance distribution $L(\lambda)$ (W m^{-2} sr^{-1} nm^{-1}) that is sampled by the human eye or the digital imaging sensor. In photometry, radiance is called luminance (L_v, candela m^{-1}) while the field of psychophysics calls it brightness. Consequently, when an object is said to be bright, its brightness is determined by the combined effects of the surface reflectance and the illumination [Adelson, 2000; Gilchrist, 2007]. In both terrestrial and airborne imaging, radiance (i.e. the total radiance over all wavelengths) or wavelength-specific spectral radiance is always the fundamental optical variable that is measured. Since photography often deals with visible EM radiation only, often the photometric term luminance is used. Spectral irradiance and spectral radiance distributions are examples of spectral power distributions (SPDs);

3. the sensing device (i.e. DSC or human eye) also has its own spectral responses; it will absorb the photons of the incoming radiance in specific spectral regions and interpret them. For both the human eye and a conventional DSC, this means that the incident EM radiation is integrated over only three different spectral bands, hereby significantly reducing the dimension of the incoming spectral signal. Although this dimension reduction might seem convenient, it is often problematic since the underlying spectral reality is disguised, leading to metameric imaging and inaccurate colour perception (both will be explained in section 4.3.4).

To make things even more complicated, the viewing and illumination geometry also matter, although these will be omitted in this chapter. In conclusion: the incoming EM radiation is an inextricable combination of both irradiance source and scene reflectivity. A change in one of those two parameters or the spectral response of the sensing device will lead to different pixel values in the digital image or a dissimilar visual sensation.

When looking at a very hot object, the imaging or perception process is governed by at least two, but most likely four variables. Very hot objects emit their own visible radiation $L_{emit}(\lambda)$, which means that the object itself is the radiation source. In this case, the above process is reduced to two variables. Besides, this hot object might also still reflect energy from an external radiation source. In this case, the signal that is processed by the HVS or the camera is composed of two components: radiation emitted by the object itself due to its temperature [$L_{emit}(\lambda)$] as well as radiance due to reflection of the object [$L(\lambda)$]. Practically, objects need to be heated to about 500 K (i.e. 227 °C) before they start radiating in the NIR range, while a temperature of at least 800 K or 527 °C (e.g. an electric stove burner) must be attained before visible red light is emitted [Barnes,

1963; Ray, 1999]. The principles for fluorescence imaging [see Verhoeven, 2012] are similar to those of thermal imaging. The object might also emit radiation (e.g. fluorescence) in which case the emitted EM radiation $L_{emit}(\lambda)$ is added to $L(\lambda)$. Although the combination of both can be imaged, fluorescence imaging conventionally only images the emitted portion $L_{emit}(\lambda)$.

In the next section, the conceptual differences between the sensors in the human eye and a DSC will be explained in a little more detail.

4.3.2 Human vision and colour perception

Cone fundamentals

A very important and certainly the most familiar detector of optical radiation is the human eye and brain, together forming the HVS. To enable vision under dim lighting conditions (scotopic vision), about 100 million very light-sensitive rods are used. Since rods only generate luminance information, night vision is said to be colour-blind [Livingstone, 2002; Wandell, 1995]. When the light becomes more intense (from bright moonlight up), the rods gradually stop functioning as they get saturated. More importantly, colours will appear as the five to six million cones come into play: i.e. photopic vision [Livingstone, 2002; Wandell, 1995]. As mentioned previously, the cones generate both chrominance and luminance information by combing their responses in a particular way [Buchsbaum and Gottschalk, 1983; Lennie and D'Zmura, 1988; Reinhard *et al.*, 2008].

Most humans have three cone variants with a specific response to visible wavelengths (see Figure 4.6): cones sensitive to short, middle and long (S, M and L) wavelengths, named according to the part of the visible spectrum to which they are most sensitive and characterised by peak sensitivities λ_{max} at about 445 nm, 540 nm and 565 nm respectively [Sharpe and Stockman, 2008; Stockman and Sharpe, 2000]. Due to its working principle based on three different cone types, the human colour vision is said to be trichromatic [Mather, 2006; Wandell, 1995; Wolfe *et al.*, 2006]. Figure 4.6 shows that the three receptors have a quite broad waveband to which they respond and there is significant overlap between the three responses. The cone sensitivity curves are known as the cone fundamentals.

The CIE standard observer

Besides the cone fundamentals, digital imaging and colour science often uses the so-called CIE standard observer [Lee, 2005]. The standard observer is a mathematical representation of the average colour vision of humans in the 360 nm to 780 nm range. To generate the standard observer, seventeen human test persons with healthy, normal colour vision were subjected to colour-matching experiments executed by David Wright and John Guild in the 1920s [Guild, 1931; Wright, 1928–29]. All the volunteers had to look at a white screen through a small aperture. Different test colours from the visible spectrum were projected onto that screen, thereby filling half of the screen. At the same time, the human observers had three different, monochromatic lights of

700.0 nm, 546.1 nm and 435.8 nm at their disposal. The participants were asked to adjust the amounts of each of these red, green and blue lights on the other half of the screen until they matched the colour that was projected.

The number of lights was not arbitrary but in agreement with Young–Helmholtz trichromatic theory, initially established by the English physician Thomas Young (1773–1829) and later further developed by the German physiologist Hermann von Helmholtz (1821–1894) who based his theory on the colour experiments by James Clerk Maxwell (1831–1879). Maxwell had shown that almost every colour could be created by adding three separate light sources. These light sources, which are best monochromatic radiators, are denoted primaries and the process of creating colour with them is known as additive mixing (which is why Maxwell is known as the father of additive colour creation). To be in agreement with Maxwell, Young–Helmholtz theory stated that the eye must have three different receptor types that are sensitive to three different spectra, corresponding to red, green and blue wavelengths. According to trichromatic theory, additively combining the three different receptor responses is able to render all visible colours.

For every projected colour in this colour-matching experiment, the participants thus adjusted the amounts of the three primaries until they obtained an additive combination of primaries that matched the projected colour. This process was repeated until a whole bunch of colours across the visible spectrum was covered (Figure 4.7). For some of those test colours, no match could be obtained by additively mixing the three primaries. The only way to make a match was to take away one of the lights and add it to the test colour. When this happened, the primary was given a negative value.

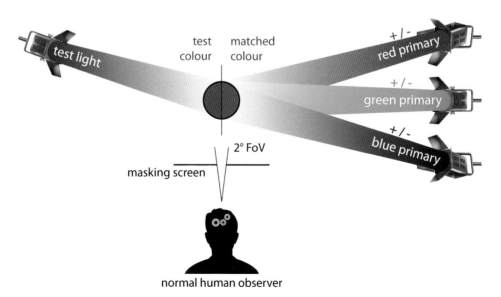

Figure 4.7 The setup of a colour-matching experiment.

In 1931, the Commision Internationale De l'Éclairage (International Commission on Illumination, CIE) collected all aforementioned research results of Wright and Guild and mathematically derived the spectral curves that represented the average human colour perception [Fairman *et al.*, 1997]. This CIE 1931 2° standard observer is thus a statistical fiction and nothing more than a numerical representation of what an 'average person' sees. The '2°' in the name comes from the fact that Wright and Guild had their participants look through a hole that allowed them to have a 2° field of view (FoV) during the colour-matching experiment. The fact that the colour patches subtended a 2° FoV with the eye was chosen because it was believed that all cones were located in such a small area of the eye's fovea. It was only found out later that the cones covered a larger area, spreading beyond the fovea. Therefore, in 1964 the CIE proposed a second standard observer, now applying coloured patches that subtended a 10° FoV with the eye of the test persons. The colour-matching experiments upon which this new CIE 1964 10° standard observer was based, were performed by Stiles, Burch and Speranskaya [Speranskaya, 1959; Stiles and Burch, 1959; Trezona and Parkins, 1998]. This new standard observer was computed from 49 observers and colour-matches were obtained with three new primaries: 645.16 nm, 526.32 nm and 444.44 nm.

Colour-matching functions

The spectral curves that define these CIE standard observers are called colour-matching functions (CMFs). They are denoted the CIE 1931 2° *RGB* CMFs $\bar{r}(\lambda)$, $\bar{g}(\lambda)$, $\bar{b}(\lambda)$ and the CIE 1964 10° *RGB* CMFs $\bar{r}_{10}(\lambda)$, $\bar{g}_{10}(\lambda)$, $\bar{b}_{10}(\lambda)$ [Ohno, 2000; Sharma, 2003a]. Both sets of *RGB* CMFs allow to determine the relative quantity of the corresponding standardised primaries (700.0 nm, 546.1 nm and 435.8 nm or 645.16 nm, 526.32 nm and 444.44 nm) needed to match a monochromatic light at a specific wavelength [Sharma, 2003a; Stone, 2003; Wandell, 1995]. As an example, Figure 4.8a displays the 10° *RGB* CMFs and indicates that a combination of 3.17 parts of the red primary light, 0.26 parts of the green primary and 0 parts of the blue primary light source will produce a perfect match for the colour sensation of a 600 nm monochromatic test light. As such, most perceivable colours can be described by a known set of primaries and three numbers which correspond to the amount of each primary are needed to create that specific colour.[1] These numbers are called the tristimulus values for that colour and today colour televisions, computer monitors, scanners and DSCs exploit this phenomenon of trichromatic additive colour mixing.

However, Figure 4.8a also shows these *RGB* CMFs to have negative lobes. This results from the previously mentioned negative primary: i.e. the observer of the colour-matching experiment had to remove one primary from the mixture and add it to the monochromatic test light to achieve a match with the remaining two primaries [Fairchild, 1998; Hunt, 2004; Stone, 2003; Wandell, 1995]. Even though this

[1] Most colours, as imaginary primaries *XYZ* have to be used to generate all of them.

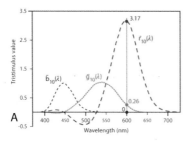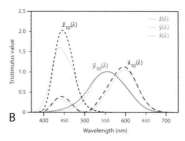

Figure 4.8 (a) 10° *RGB* CMFs of Stiles and Burch [1959] with real primaries of 645.16 nm, 526.32 nm and 444.44 nm. The tristimulus values for an orange hue of 600 nm are indicated; (b) CIE 1931 2° *XYZ* CMFs [modified by Judd, 1951] and CIE 1964 10° *XYZ* CMFs with primaries *X*, *Y* and *Z* [all datasets from Colour and Vision Research Laboratory, 2014].

behaviour is due to the similar spectral responses of the L- and M-cones, these CMFs are inconvenient for colorimetric applications because they create a physically non-achievable solution for *RGB* devices: e.g. a DSC should have to be negatively sensitive to certain wavelengths, which is conceptually equal to saying it should emit these wavelengths.

To avoid negative values at all wavelengths, the CIE performed a mathematical linear transformation of the initially calculated *RGB* CMFs, yielding a new set of imaginary *XYZ* primaries and corresponding *XYZ* CMFs: CIE 1931 2° *XYZ* CMFs $\bar{x}(\lambda)$, $\bar{y}(\lambda)$, $\bar{z}(\lambda)$ and CIE 1964 10° *XYZ* CMFs $\bar{x}_{10}(\lambda)$, $\bar{y}_{10}(\lambda)$, $\bar{z}_{10}(\lambda)$ (Figure 4.8b), respectively for a 2° and a 10° FoV. Both sets of curves were tabulated for every 1 nm and have seven significant figures [Wyszecki and Stiles, 1982]. In Figure 4.8b it can be seen that the CMFs of both observers are slightly different, as the CIE 1964 10° *XYZ* CMFs also involves regions of the retina that are less densely packed with colour sensors [Malacara, 2011]. The 2° standard works well in images were many different colour patches are seen directly next to each other (e.g. books, computer graphics). However, since the 10° standard encompasses more or less all cones, the CIE 1964 10° standard observer is generally advised since it best correlates with any average visual assessment. Note that the *X*, *Y*, *Z* primaries are not physical SPDs like the CIE *R*, *G*, *B primaries*. They are made up from the real CIE *R*, *G*, *B* primaries using a simple matrix transformation. Both *XYZ* CMFs are also normalised such that an equi-energy spectrum (i.e. the spectral distribution of the radiance stimulus which is observed is uniform across the visible spectrum) yields equal tristimulus values. In addition, the $\bar{y}_{10}(\lambda)$ CMF equals the photopic spectral luminous efficiency function $V_{10}^{*}(\lambda)$ [Fairchild, 1998; Ohno, 2000; Sharma, 2003a].

Despite the fact that no single real person is probably exactly like any of the CIE standard observers [Berns, 2000] and notwithstanding the drawback that the CIE *XYZ* CMFs use imaginary primaries because no physical matching lights can be used to

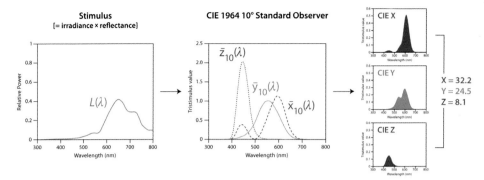

Figure 4.9 Computing the CIE XYZ tristimulus values of a stimulus by integration over the CIE 1964 10° standard observer.

obtain these functions [Fairchild, 1998; Hung, 2006; Sharma, 2003a],[2] these CMFs are still essential in all aspects of colorimetry and one of the base elements in the understanding of colour perception [Giorgianni *et al.*, 2003; Hardeberg, 2001; Stone, 2003; Wandell, 1995]. The CIE *XYZ* CMFs allow to calculate the CIE *XYZ* tristimulus values for any perceivable colour (Figure 4.9). The only thing needed is the spectral radiance distribution $L(\lambda)$, which is generated from the reflectance spectrum of an object and its irradiance. By multiplying this input stimulus $L(\lambda)$ times these *XYZ* CMFs and integrating the result, the value of the *X*, *Y* and *Z* primaries can be calculated [Hunt, 2004; Ohno, 2000]. Just as the cones convert any stimulus into three signals, the CMFs can be used to convert any spectrum into a standard *X*, *Y*, *Z* tristimulus encoding [Wolfe *et al.*, 2006]. From these *X*, *Y*, *Z* tristimulus values (briefly *XYZ* values), all other values such as CIE $L^*a^*b^*$ or sRGB can be computed (see 4.6.3).

It remains, however, essential to say that there is no such thing as one single set of CMFs. If new primaries are used, new CMFs can be calculated by a linear transformation of this set of functions (as in the transformation from the *RGB* CMFs to the *XYZ* CMFs). In this way, a whole family of functions exists and all CMFs are linear transformations of each other. As a result, even the cone fundamentals can be considered a set of CMFs $\bar{l}(\lambda), \bar{m}(\lambda), \bar{s}(\lambda)$ of three non-existing primaries which separately and exclusively stimulate the three cone types [Giorgianni and Madden, 2008; Hardeberg, 2001; Lennie and D'Zmura, 1988; Stockman *et al.*, 1993; Teufel and Wehrhahn, 2002].

[2] Since all possible viewable colours can only be achieved using three imaginary primitives, there is currently no physical way to create three fixed primaries so that humans see all possible colours they are capable of seeing. Until the emitting source is a tuneable laser, specific colours will always be out of reach of any three real primaries.

4.3.3 Digital imaging sensors

Detecting optical radiation in a DSC is accomplished by the conversion of incoming EM radiation into an electrical output signal which is then digitised. All DSCs comprise optical elements such as lenses and filters that gather the EM radiation and focus it onto its imaging sensor. This imaging sensor itself consists of one or more optical detectors (also called photodetectors) that can detect the incoming radiation. Most imaging sensors are focal plane arrays (FPAs), since they consist of an assemblage of individual photodetectors located at the focal plane of the imaging system. Since DSCs use two major FPA technologies, they will be discussed next.

CCD versus CMOS

During the last century, many technologies have been developed to make the detection of optical radiation possible. In the 1920s and 1930, there was the flourishing technology of vacuum tube sensors which culminated in the advent of television [Rogalski and Bielecki, 2006]. A major breakthrough was achieved in 1969, when the charge-coupled device (CCD) was invented at AT&T Bell Labs by Willard Boyle and George E. Smith [1970]. Over forty years later, the CCD is still around and developed into a major digital imaging technology that is nowadays still used in various professional and scientific applications in need for high-quality image data, mainly in the visible and NIR spectrum. One of the most well-known examples of recent history is most likely the CCD-based camera on-board the Hubble space telescope. Although CCDs have always been able to perform very efficiently and uniformly over large areas [Magnan, 2003], the serial access to the image data, the power consumption and the required high charge transfer efficiency were limitations difficult to overcome. In the early 1990s, Eric Fossum led a team at NASA's Jet Propulsion Lab (JPL) that came up in 1993 with CMOS APS (complementary metal oxide semiconductor active pixel sensors) technology as a way to overcome these issues and reduce the size of cameras launched on spacecraft [Fossum, 1997; Mendis *et al.*, 1993]. In the late 1990s and 2000s, further improvements of these CMOS APS imagers were achieved, mostly driven by the mobile phone market that needed cheaper and smaller imagers on top of a lower power consumption and better integration. Anno 2015, both CMOS and CCD imagers have the potential to deliver a very high-quality image output with production costs that are quite similar [Teledyne DALSA, 2011]. However, both have specific advantages and drawbacks that explain why currently CMOS sensors dominate the photographic market (smaller, less power consumption, greater data throughput) and CCDs are king in the very high-quality scientific imaging industries (e.g. astronomy) or for high-resolution digital camera backs (low noise, uniformity, linearity, near-theoretical sensitivity). Both CCDs and CMOS imagers have silicon (Si, $Z = 14$) as their basis and can detect radiation to about 1100 nm (the so-called cut-off wavelength). Longer wavelength radiation has photons whose energy is too small to create a response in the detector [Janesick, 2001]. Although different manufacturing processes can be used, the general useful spectral response of CCDs and CMOS imagers is situated from NUV (around 320–370 nm) to about 1100 nm (the limit of NIR).

The imaging sensor layout

Whatever the type, all DSC image sensors consist of a 2D-photosite array to generate a digital photograph. The radiation-sensitive area of every photosite, in most cases a photodiode or photogate, collects the photons during the exposure time. A digital camera which yields 12.2 million pixels has a sensor built-up by at least 12.2 photosites (e.g. 4288 columns × 2848 rows), as one photosite generally contributes one effective image pixel. The distance from the centre of one photosite to the centre of the neighbouring element is denoted the inter-detector spacing or detector pitch [Fiete, 2010].

On top of the sensor and just below the array of micro-lenses that enable the collimation of the incident radiation to the photodiode [Holst, 1998; Theuwissen, 1995], manufacturers place a colour filter array (CFA): a mosaic pattern of thin optical filters that are coloured red, green or blue [Holst, 1998; Nakamura, 2006]. The use of these three filters is no coincidence. As a result of Young–Helmholtz theory, the *RGB* additive colour model is omnipresent. It represents the trichromatic nature of the HVS and is widely used to produce colour in photographic applications, projectors, monitors and television. In an imaging sensor, every individual photosite of the array is covered by such a coloured filter, allowing only one – but broad – particular range of incident radiant energy to be transmitted and subsequently captured by the photodiode (Figures 4.6 and 4.12). As every pixel will initially have one colour component (R or G or B – Figure 4.10), the other two components get interpolated from neighbouring pixels to create a triplet of integer DNs (Digital Numbers) for every pixel. Generally, DSCs use a red-green-blue (*RGB*) pattern with a repeating group of four photodiodes. This arrangement is called a Bayer pattern. Bayer patterns typically feature two green filters per group of four to mimic the HVS's main photopic sensitivity in the green–yellow range of the visible spectrum (see 4.2.3) and enlarge the perceived sharpness of the digitally recorded scene [Bayer, 1975; Hunt, 1999]. Although the overwhelming majority of DSCs are Bayer CFA-based, a completely different approach was developed by Foveon with their X3® direct image sensor. This privately held corporation patented in 2002 a particular kind of three-layered CMOS image sensor with a stack of three photodiodes at each photosite (Figure 4.10), thereby enabling the capture of all three R, G and B wavebands at the same location [Lyon and Hubel, 2002]. To date, Foveon sensors are mainly limited to Sigma DSCs.

When buying a DSC, the imaging sensor is additionally covered with an NUV–NIR blocking/cut-off filter (also called hot-mirror) that allows only visible light to pass (Figure 4.11). By implementing this filter, the camera manufacturer ensures that the sensor's array of photosensitive detectors will generate a photographic signal by mainly taking the visible EM radiation into account. This approach is of the utmost importance as common silicon sensors are inherently sensitive to NUV and especially NIR, whose imaging contribution would be detrimental for image sharpness (since all wavelengths have a different focus), exposure accuracy (DSC light meters are not calibrated for invisible radiation) and true colour reproduction. Replacing the internal hot-mirror with a visibly opaque filter (Figure 4.11) makes pure NIR imaging easily possible.

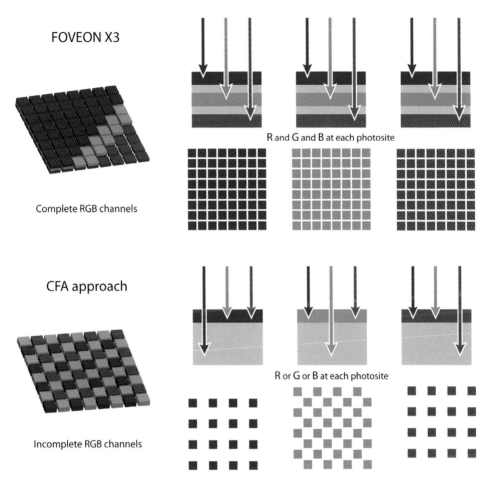

Figure 4.10 Difference in photosite-specific spectral information acquired by the Foveon sensor and the CFA solution.

Upon removing this NUV–NIR blocking filter completely, the DSC becomes sensitive to a range of wavelengths exceeding the initial small visible band (Figure 4.12). Because the spectral response of common silicon detectors found in the current DSCs decreases quite rapidly towards shorter wavelengths, the effect of such a modification is most noticeable when imaging the NIR waveband. Notwithstanding, the DSC's responsivity to NUV radiation increases as well, although its sensitivity is far more modest in absolute terms. As was mentioned previously, the cut-off wavelength for these imagers is at circa 1100 nm, while the cut-on wavelength can be situated in the 320 nm–370 nm range. For an in-depth overview of sensor sensitivity and DSC modification, see Har *et al.* [2004], Verhoeven [2008b] and Verhoeven *et al.* [2009].

Finally, most cameras also feature an extra optical element in the imaging chain (generally just before the sensor-CFA-microlenses array). This element is an optical low-pass filter which slightly blurs the incident image by eliminating spatial frequencies

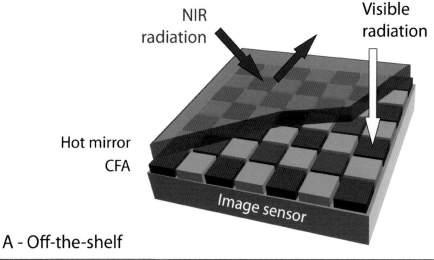

A - Off-the-shelf

B - Modified

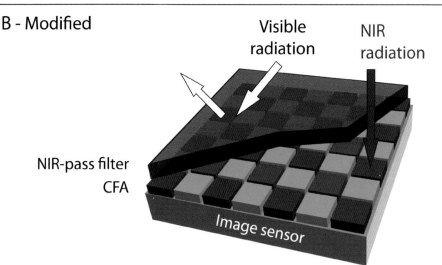

Figure 4.11 Modification of the digital imaging array by replacing the hot mirror.

above the Nyquist frequency to prevent aliasing. This concept and related terminology will, however, be covered in much more detail in section 4.4.3.

The sensor's RGB spectral response

Besides mathematically describing all the colours that can be seen by humans in terms of the three CIE *XYZ* values, the CMFs introduced in 4.3.2 are also important for DSCs because these devices perform image acquisition by filtering the complete scene through the aforementioned set of three coloured filters. In an ideal world, DSCs would be able to capture accurate colours and distinguish exactly the same colours

as the average human eye. To fulfil this aim, DSCs should be colorimetric, which means they have to satisfy the Luther–Ives condition [Berns, 2001; Hardeberg, 2001; Sharma, 2003a; Vrhel, 2000]. This condition, formulated at the beginning of the 20th century, states that any colour-capturing device can reproduce accurate colours that are completely congruent with the colour experience of a human observer if and only if, its spectral responses mimic the cone sensitivity curves or a linear transformation thereof [Hung, 1991; Ives, 1915; Luther, 1927].

For these reasons, it is not surprising that research labs all over the world have shown considerable interest in designing a set of filters which allow to approximate colorimetric characteristics. Some sensor manufacturers even employ CFA alternatives with more than three filters (e.g. Sony introduced an additional Emerald filter) or a complementary mosaic pattern with magenta (M), green (G), yellow (Y) and cyan (C) sensitive photodiodes arranged in M-G and Y-C rows [Parulski and Spaulding, 2003]. Although the sensor technology and the specific characteristics of the CFA are responsible for some variation in the spectral responses of DSCs, it is safe to state that Figure 4.12 illustrates the general response one can expect for most CCD and CMOS-based digital cameras. From this illustration, it can be inferred that current DSCs are far from perfect colour-capturing instruments since the spectral transmission of the CFA filters is not at all related to the human cone responses or another existing set of positive CMFs like the CIE *XYZ* CMFs [Balasubramanian, 2003; Hung, 2006; Parulski and Spaulding, 2003].[3] It is therefore safe to state that there is currently no single DSC which meets the Luther–Ives condition. This is due to the fact that colour accuracy is only one out of several, often mutually exclusive image criteria (such as image noise, low-light sensitivity, resolving power, pleasing colour reproduction and manufacturing costs) taken into account when designing a DSC [Berns, 2001; Imai *et al.*, 2001].

Consequently, the overwhelming majority of DSCs still depend on the Bayer approach to spatially and spectrally sample the scene, capturing more or less the same spectral information in similar, spectrally separated wavebands. To enable acceptable shutter speeds and maximise light gathering efficiency, the Bayer CFA filters are generally designed to be equally spaced in the spectrum, more or less narrowband and spectrally independent [Balasubramanian, 2003]. Compared to the CIE 1694 10° *XYZ* CMFs, this means that in most cases the blue (and sometimes also the red) spectral response curve is shifted a bit to the longer wavelengths, while both the red and green spectral responsivities take considerably less of the longer wavelengths into account than the CIE *XYZ* CMFs. Despite the fact that the green channel can often be considered a decent representation of the photopic spectral luminous efficiency function [Ramanath *et al.*, 2005], the colour space of DSCs is very different from that of the standard human observer and no correct CIE *XYZ* tristimulus values can be obtained

[3] Due to the very high spectral overlap of the M and L cones, the spectral transmission of the CFA filters should rather match the CIE *XYZ* CMFs.

from the data recorded by a digital camera (see 4.3.5). In other words: all digital *RGB* cameras will have difficulty reproducing colour very accurately and metamerism will invariably occur.

4.3.4 Metamerism

It is very important to remember that human vision is trichromatic: the human eye has three independent channels (corresponding to the three different cone types) for conveying colour information. Because there are only three types of cones with rather broad spectral sensitivities, stimuli with different spectral characteristics can produce identical cone responses, hence representing the same colour. Such spectra are called metamers, the perceivable colour match is denoted a metameric match and the effect is known as metamerism [Hung, 2006; König and Herzog, 1999; Sharma, 2003a; Wolfe *et al.*, 2006]. Thus, if two objects match in colour, this only means that the receptor excitations of both stimuli are equal. The aforementioned colour-matching experiments are based on this phenomenon. When two different stimuli, whether they are simply coloured lights or illuminated objects, produce the exact same cone signals, those two stimuli will perfectly match in colour. The additive mixture of appropriate blue and green lights will therefore be indistinguishable from a monochromatic cyan light. Although there is the statistically relevant CIE standard observer, there is some variety in the spectral responses of the eye across the human population. As a result, one picture might look too purple for person A while person B finds it too green. This is called observer metamerism.

Similar to the HVS, DSCs perform dimension reduction by spectrally sampling the incoming signal into three broad bands. As a direct result, the *RGB* values of a pixel (e.g. R: 234, G: 121; B: 67) cannot be associated with a specific wavelength distribution of the incoming signal [Novati *et al.*, 2005]. In practice, this means that a DSC might produce identical spectrally integrated *RGB* responses from two dissimilar SPDs. As such, a three channel DSC (but also any imaging system with only one or two spectral bands) is a metameric imaging system. Given the dissimilar spectral responses of the standard observer and DSCs, the metameric DSC matches will thus differ from those of a human observer [Fairchild *et al.*, 2001; Hung, 2006; König and Herzog, 1999]. A DSC might thus generate identical *RGB* values for two object stimuli which mismatch for the HVS (and vice versa). Metamerism will become worse as a DSC's spectral response curves stray further from a set of CMFs. Although DSCs use composite algorithms to recalculate the initially captured *RGB* triplets as closely as possible to the standardised, device-independent CIE *XYZ* colour space (see 4.3.5), this operation can never distinguish between two perceivably distinct stimuli if they were initially captured by equal *RGB* numbers [Balasubramanian, 2003; Bezryadin, 2007]. As a simple example: a metameric imaging system might not be able to distinguish a blue ball illuminated by white light from a white ball illuminated by blue light.

In conclusion: three-band DSCs are inaccurate colour reproduction instruments and data acquisition using at least four spectral bands is needed to overcome the limits

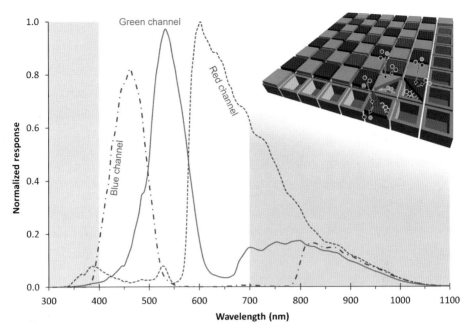

Figure 4.12 The lay-out and working of a typical DSC image sensor with Bayer CFA. The relative spectral response curves obtained from a Nikon D200 without internal hot-mirror reveal that the CFA filters also transmit EM radiation in the invisible NUV and NIR regions (both indicated in grey).

of metameric imaging. For those cultural heritage tasks where colour accuracy is primordial, DSCs are changed in favour of multi- and hyperspectral imaging devices [Berns *et al.*, 2003; Ferreira *et al.*, 2006; Yamaguchi *et al.*, 2008].

4.3.5 Colour in the camera chain

Since a DSC codes the colour information in three wide channels, digital photography is by default metameric. The advantages of this metameric approach are pragmatic: three channels are often considered 'sufficient' for colour production while the approach is inexpensive and minimises both noise and data volume [Fairchild *et al.*, 2001]. The challenge now is to link the *RGB* values produced by the DSC to the colour perceived by the human eye.

When a DSC maps an infinite-dimensional space of SPDs (the radiance signal) to three *RGB* coordinates, these *RGB* values are defined in the camera's specific colour space. This colour space is therefore denoted a so-called device-dependent colour space [Delmas, 2012] (see also section 4.6.3). Just like a camera, printers and monitors have their own, device-dependent colour space. Due to this device-dependent colour reproduction, the same *RGB* triplet will be translated into a different physical colour and cross-media reproductions would become challenging without colorimetric solutions. To make sure that colours captured by a camera are accurately printed or

Figure 4.13 The X-Rite ColorChecker® Digital SG target often used to characterise DSCs.

displayed on any device, all these devices have to do a conversion from the *RGB* values defined in their own, device-dependent colour space into a commonly used, canonical device-independent colour space such as CIE *XYZ* or CIE *L*a*b**. Similar to CIE *XYZ* (see 4.3.2), CIE *L*a*b** (or CIELAB) also mathematically describes how a colour is perceived by a human observer when viewed under standardised conditions. The conversion to CIE *L*a*b** or CIE *XYZ* is performed with a simple 3 × 3 colour correction matrix (CCM) operation and can be considered one of the most crucial conversions in the imaging pipeline [Sharma, 2003b].

A DSC has this CCM stored internally, but one could also make one's own conversion and store it as ICC or DNG camera profile. Both profiles are standardised by different bodies, respectively the International Color Consortium [2010] and Adobe [Adobe Systems Incorporated, 2012]. Creating an own camera profile is, however, not that straightforward and only advised for experienced photographers and the most accurate colour applications (see the discussion in 4.6.3). Despite the effort of several companies to create easy-to-use colour management tools for DSC characterisation/ profiling (such as the ColorChecker® Digital SG target, Figure 4.13), the accuracy of the end-result still largely depends on the illumination conditions [Bianco *et al.*, 2012]. In other words: it does not suffice to take a perfect photograph of such a well-illuminated

target, but the spectral output of the radiation source must be perfectly known as well. Even then, only more or less accurate colour acquisition becomes possible, since a DSC stays a metameric imaging instrument [Berns, 2000; Hunt, 2004].

Whether one uses an ICC/DNG camera profile or the CCM that is already embedded in the DSC/RAW conversion software, the operating system does not expect CIE $L^*a^*b^*$ or XYZ values, but RGB values in a specific device-independent output colour space such as sRGB or Adobe RGB (1998). To convert from CIE XYZ to any output space, a second 3×3 matrix transformation has to be performed. Very often, both operations are executed by one matrix that also takes the WB coefficients into account [Parulski and Spaulding, 2003].

Some of the DNs – which are at this stage still linearly related to the incoming radiance – do not properly fit into the sRGB output colour space since it is generally much smaller than the DSC's colour space. Instead of clipping the colours, the wider gamut is mapped onto a smaller gamut of the sRGB colour space. In the case that the user processes the RAW to a TIFF or JPEG file with the Adobe RGB (1998) colour space, less gamut mapping needs to be executed since the Adobe RGB (1998) space is a much wider colour space (see Figure 4.9 and section 4.6.3 for a description of gamut). As such, the final colour space that is chosen upon the creation of a JPEG or TIFF file will define the variety of colours contained in an image. This gamut mapping takes places in the camera-based processing pipeline (i.e. the temporary RAW is converted into a JPEG file inside the DSC) as well as the computer pipeline (where specific software takes care of the RAW development)., However, the fact that this gamut mapping differs for the various scene shooting modes on a camera (portrait, landscape, sport etc.) is problematic [Kim *et al.*, 2012; Lin *et al.*, 2011, 2012]. Using the same DSC and scene, two in-camera generated JPEGs captured with a changed camera mode will thus be rendered differently. This is less of an issue when developing RAW files on a computer (that is, as long as the same RAW converter is used).

During the final step of the camera processing chain the colour rendering of the image file takes place. This last, non-linear tonal transformation not only applies the colour–space related gamma (fixed for every colour space but often around 1:2.2 – Figure 4.9), but also comprises some additional tonal mapping to produce a contrast-rich image, since most observers prefer imaged objects to be a bit more colourful and contrasted than they were in real life [Parulski and Spaulding, 2003]. This final tonal mapping is also camera dependent [Chakrabarti *et al.*, 2009]. Although developing a RAW file on a computer will also yield a JPEG or TIFF that has this non-linear gamma applied, one has more influence on the tonal curve. In practice, the same tonal curve can be applied to various images from different cameras (that is, again, as long as only one RAW converter is used).

4.4 Digitally recording images

Photography gathers a scene's spatially, temporally, radiometrically and spectrally varying reflected (or sometimes emitted) EM radiation and uses this to generate (digital)

images. In past decades, this detection of radiation was usually accomplished by a photographic emulsion sensitised into one or more spectral regions of the visible and NIR spectrum. To date, most imaging devices provide digital products directly. This section will delve a bit deeper into the world of signals and how digital signals in the form of images come about.

4.4.1 Signals and noise

Signals are everywhere: sound waves, sonar signals of bats, television transmission or signals the brain sends to the body. These signals all have something in common: they convey data. When a sound wave reaches the human ear, a sound is perceived since the alternating low and high pressure areas vibrate the receptors in the ear. Mathematically, a signal is a function that describes how one (or more) dependent parameter is related to another parameter (e.g. how voltage varies with time). However, signals can also be divided into groups where they are characterised by certain properties. One such distinction is the signal's dimension. A second and really important feature of signals is their analogue or digital character. When digitally imaging a portion of the physical world, one tries to capture an analogue, spatio-temporally varying signal of reflected (or emitted) EM radiation and convert it into a discrete signal.

The DNs that make up a digital image are generated by individual photodetectors. However, these DNs are made of several particular contributions. By unravelling all the components that add to the final DN, it will afterwards be possible to untangle the whole process and think about the necessary steps to extract the only component of interest. In scientific digital imaging, only the stream of photons that reaches the sensor (i.e. the photon signal) is of interest. However, the radiance frame/raw image S_{raw} (sometimes called light frame for visible applications) produced by an image sensor is not only produced by the incident photons. Generally, the raw image consists of three particular constituents [Berry and Burnell, 2005; Verhoeven *et al.*, 2009]:

1. the photon signal, which is generated by the accumulated EM radiation during the exposure;
2. the dark current (DC) signal that is produced by thermally induced electrons, even when the sensor is not illuminated. This signal accumulates with exposure time and is temperature dependent. The warmer an image sensor, the more intense the DC that is produced;
3. the bias signal/DC offset, a small and mostly steady zero voltage offset generated due to the effects of electrical charge applied to the detector prior to exposure. Also this signal occurs in the total absence of illumination.

Each of these non-random signals has some corresponding noise embedded, in which noise is defined as the unavoidable random deviations from the nominal signal values. These noise sources, which are always present to a certain extent when detecting optical energy, interfere with the photon signal and can bias or even mask this signal. The topic of noise is very complex since the amount and type of noise varies according to

the imaging technology used [Holst, 1998; Hytti, 2005; Reibel *et al.*, 2003]. However, almost all images incorporate the following noise:

- photon/shot/photon shot noise, caused by the inherently random process of photon arrival; this noise is fundamental, in that it is not correlated with the detector or electronics but results from the detection process itself. This noise obeys the law of Poissonian statistics. With small photosites and in low-radiation conditions, this type of noise is especially prevalent;
- DC/DC shot noise, similarly to photon noise also obeying the law of Poissonian statistics;
- read/readout/bias noise, a signal-independent noise source that is the sum of many components such as reset noise, on- and off-chip amplifier noise and quantisation noise.

So, the raw image constituents are the photon signal (with its corresponding Poisson photon noise), an unwanted DC signal (with Poisson DC noise) and a bias constant (with readout noise). Any type of noise (or a combination of noise powers) sets an upper limit to the detectivity of a photodetector. The ultimate performance limit for a detector is achieved when the photon noise dominates, since this fundamental noise arises from the physical principles of EM radiation detection itself. Many cultural heritage imaging projects implement one or several techniques to reduce the amount of noise in the image and try to extract the photon signal. As soon as a radiance image (stored as a RAW image file) is corrected for the two additive components (DC and bias) and one multiplicative component (the non-uniform response of the individual photodetectors and non-uniform illumination of the object) it is often termed a radio-metrically calibrated image (see Berry and Burnell [2005] for all possible calibration steps). Besides those elementary image correction techniques, there are many other post-processing techniques that can be called upon at a specific stage in a particular imaging workflow: examples are white and black point compensation, contrast adjustments, image alignment and mosaicking, lens distortion correction and image deconvolution. Some of those will be considered later in this chapter.

4.4.2 Pixels: quantised points samples that need reconstruction

Whether they are generated by scanning the analogue film frame or directly produced by the digital image sensor, the fundamental building blocks of any digital image are called pixels or pels, coined terms for picture elements (see Billingsley [1965] and Schreiber ([1967] respectively for the first use of these terms). To date, pixel has become attributed with a variety of conflicting meanings [Lyon, 2006]. In contrast to popular belief, pixels do not occupy any area. They are neither rectangular, square nor round [Smith, 1995]. Pixels are simply dimensionless, quantised point samples that digitally represent an analogous signal. After the acquisition of those pixels, the idea is to view that scene on a monitor. To this end, the original analogous signal is reconstructed from the digitised samples. Therefore, it is convenient to split this whole generic

sampling sequence in three conceptual stages: pre-blur, sampling plus quantisation and reconstruction [Vollmerhausen *et al.*, 2010]. The following subsections cover the latter two stages, since the pre-blur stage is thoroughly covered in section 4.5.6 under lens softness and diffraction.

Sampling and quantisation

While analogue signals are continuous like waves and exist in nature as functions of space or time, digital signals are generally found inside computers and can be considered a collection of discrete states. Once an analogue signal is digitised, digital processing (like copying) is lossless and yields perfect clones. The analogue signal that is digitally captured by photography is the continuously varying reflected or emitted radiance L as a function of space and wavelength range. This translation into a numerical form is accomplished by sampling and quantisation. In imaging, sampling is the process of transforming the spatio-temporally continuous analogue signal into a spatially discrete signal, while quantisation refers to the mapping from the amplitude range of the continuous signal onto a discrete set of values (Figure 4.14).

Sampling is an elementary process that needs to be performed when measuring a property of the physical world since no instrument can measure a physical signal with an infinite resolving power. However, the nature of this sampling should largely be determined by the spatial or spatio-temporal characteristics of the property being sampled [Atkinson, 2009]. To create a digital image, a DSC measures the scene's spatially continuous but varying radiance by integrating its reflected (or sometimes emitted) EM radiation over some pre-defined spectral wavebands in a particular time interval. In other words, photographic pixels are created by sampling the scene in the space, spectral and time dimensions. A digital photograph is thus never a very accurate reproduction

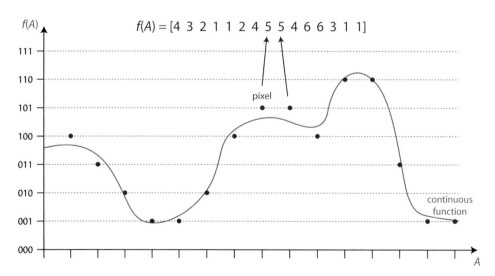

Figure 4.14 Digitising an analogue, spatially varying signal into a collection of 3-bit point samples or pixels.

(in absolute terms), since its pixels represent averages in time, in spectral range and in space. The sampling of the time dimensions is determined by the integration time or shutter speed (see 4.6.1). The two other sampled dimensions define important image characteristics known as spatial resolution and spectral resolution. This sampling is effectively performed by the individual photodiodes of the sensor array. First, the incoming signal is inverted and blurred by the optics due to optical aberrations and diffraction (sections 4.5.5 and 4.5.6 tackle these in more technical detail). The imaging sensor then samples this blurred and inverted scene with its thousands to millions of photosites. Since every photosite integrates the incoming photons – which originate from individual adjacent scene points – over the finite area of the photosite, the sensor further blurs the scene (as does its anti-aliasing filter – see 4.4.3). This integration lasts as long as the exposure lasts. After the exposure, the generated current is read out. This charge is linearly proportional to the amount of incoming radiation. Every charge output of every single detector element represents a sample of the lens- and detector-blurred radiant energy emanating from the imaged scene (see Figure 4.15).

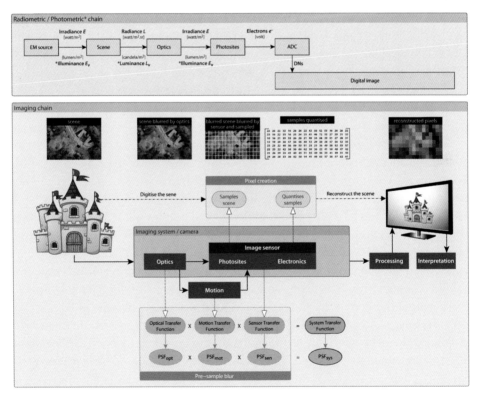

Figure 4.15 The complete imaging chain: a DSC digitally captures a real-world scene, which is afterwards reconstructed on a monitor. The illustration depicts the overall pipeline but also the pixel creation stage (by sampling and quantisation) and the individual blurring stages. On top, the imaging chain is broken down into its radiometric components. For convenience, the corresponding photometric quantities and units are given as well, since these should be used when imaging only visible optical radiation.

A pixel is often thought of as a square for several reasons [Smith, 1995]. One of them is rooted in this sampling process. To obtain sufficient radiation, the samples created by CCD and CMOS sensors are averaged photon counts over the finite area of the photosite. Since the latter is generally square, a pixel is thought of as square, whereas in fact, the more or less square area is the contribution to the pixel's value. A pixel thus remains a point sample, but the contribution to it is the photon arrival integrated over a certain area (which is not even truly square but rather Gaussian in nature) and not one point. Therefore, image sensors are not point sampling devices. The fact that spatial integration is used to create a pixel also functions as a kind of low-pass filter (although its function is far from ideal in removing high frequency components).

Besides sampling, digitising an analogue signal also encompasses quantising the sample values. After sampling the signal in three dimensions, the final pixel is generated by quantising this sample to a discrete digital/data number (DN) by the analogue-to-digital converter (A/D converter or ADC). The total range of different tones or quantisation values an ADC can create is termed the tonal range. An image's tonal range is thus completely determined by the ADC's bit depth: quantisation with N bits rounds all possible voltage levels to these 2^N values. For example: an 8-bit ADC can discriminate 2^8 tones and every pixel will be attributed with one of those 256 possible values. This quantisation also associates photographs with a numerical radiometric resolution which is thus the resolution by which the amplitudes of the continuous analogue radiation signal could be mapped onto a discrete set of digital values.

As such, pixels have to be considered sampled and quantised point samples of a continuous signal. These samples are determined only by a pair of pixel coordinates (r, c indicating row and column) and a certain value or grouping of values that contains information about the measured physical quantity. An array of these pixels is called a digital image, which can be mathematically represented as an $M \times N$ matrix of numbers, M and N indicating the image dimensions in pixels (see Figure 4.14 for a 1×15 matrix of pixels). Just as a pixel of a common digital colour photograph contains three samples or DNs at the same location to represent the amount of radiation captured in three individual spectral bands, a greyscale image consists of one DN per pixel. Digital images can thus be represented by O matrices of $M \times N$ elements, in which O equals the number of spectral bands that are sampled (generally three for a standard DSC – for display purposes, Figure 4.15 shows the matrix with pixels of one band only). Furthermore, the image is characterised by a certain bit depth. Digital images are thus said to be sampled (spatially, spectrally and temporally) and quantised (defined by the number of bits) representations of a scene, defined by a multidimensional matrix of numbers.

Reconstruction

Pixels digitally represent the continuous real-world signal. From these discrete samples, the original scene has to be reconstructed on the display device. It is in this displaying step that roots the basic misconception of rectangular pixels, since magnifying an image on the computer monitor gives birth to the appearance of tiny squares. The more zoom

is applied, the bigger these squares become and the more the pixel is apparently magnified. The appearing squares can, however, be explained by the reconstruction algorithm applied.

Only when every pixel lines up with one triad of the monitor (one triad is needed to display one pixel), all image data are shown. In most cases, the pixel count (i.e. all pixels) of the image is much larger than the monitor's triad count and many pixels are left out when displaying the image. When zooming in, a point is achieved at which there are more triads in the display than there are pixels in the portion of the image that is looked at. To remedy this and still display a continuous representation of the scene, new pixel values are computed to fill in the gaps between the other pixels. This operation is called interpolation and is performed every time the monitor triads do not line up exactly with the image pixels.

The reconstruction (or recovery) of the continuous scene representation by interpolating between the discrete samples is executed by a reconstruction filter [Smith, 1995]. Various reconstruction filters exist, all with their pros and cons. The most common reconstruction filter is the box filter (Figure 4.16) which applies a nearest-neighbour interpolation. This reconstruction filter – whose kernel is displayed in Figure 4.16 – simply duplicates the original pixel value (i.e. at sample number 0) between the location of the original pixel and its nearest neighbouring locations that need a value to be assigned to them (i.e. from –0.5 to 0.5). Since the same procedure happens with all pixels, sample number 1 will replicate its value in the zone [0.5, 1.5]. The area between the original pixels 0 and 1 is therefore nicely divided in two. After applying this operation to the whole image and looking at the filter kernel from above, one would see that the footprint of this box filter is thus square. Since its application simply repeats the pixel value of the nearest pixel, zooming in creates an individual square raster cell around each sample location. As such, it became a well-established misconception that this cell equals the dimension of that pixel (as pixels are dimensionless). In the last few decades, this idea was reinforced by the increasing use of spatial data. In the case of a box reconstruction filter, the reconstruction generates a raster that is typically known from Geographical Information Systems (GIS). Normal GIS raster layers also consist of cells with one specific value per cell. In the case of nearest neighbour interpolation, the reconstructed image also seem to feature those cells which have one value identical to the pixel's DN. However, this cell is just a pixel reconstruction artefact and has nothing to do with the size of the pixel itself. Although box filtering is very fast, it offers the lowest quality reconstruction of the original signal.

Much better are bilinear and bicubic interpolations, executed by the tent-filter and a bicubic spline. Both filters do not have a square footprint and will thus interpolate an average pixel value based on the pixel's neighbours. The result is a less blocky reconstruction with much smoother transitions between the samples. In other words: all little squares are gone and together with it the erroneous concept of pixel size (Figure 4.16). Bicubic interpolation is the more powerful of the two, but also requires the most computations to display an image, thereby leading to slower response times.

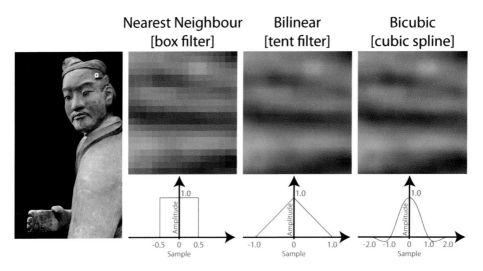

Figure 4.16 Different interpolators used in image reconstruction. The pixels on which these reconstructions are based are indicated in the left image.

4.4.3 The Nyquist criterion

To create an image, the continuous spectral radiance varying with time must be sampled properly, meaning that it must be possible to exactly reconstruct the analogue signal from the samples. This is, however, only possible when the sampling follows the sampling theorem. In the field of information theory and communication, the Nyquist–Shannon sampling theorem is one of the fundamental theorems. Expressed by Harry Nyquist in 1928 and proven by Claude Shannon in 1949, this theorem is also known as the Shannon sampling theorem or simply the sampling theorem. It states that:

> When sampling a signal to convert it from analogue to digital, the equally spaced sampling frequency ξs must be greater than twice the bandwidth Bw of the input signal to be able to reconstruct the original perfectly from the sampled version [Nyquist, 1928; Shannon, 1949].

In this definition, bandwidth can be loosely defined as the highest frequency of the analogous signal. Mathematically, this sampling condition can thus be stated as: $\xi_S > 2Bw$. Although its meaning varies from author to author, the Nyquist rate or frequency ξ_N is the rate that equals one-half of the sampling rate [Smith, 1997].

The Nyquist–Shannon sampling theorem finds a practical application in digital imaging. In this context, the sampling theorem can be stated as follows:

> Assuming a perfect capturing system, a scene can be completely reconstructed if the original continuous spectral radiance signal did not contain frequencies at or above one half of the sampling rate, the latter being determined by the sensor's detector pitch p. In other words: a feature of size d will be imaged unambiguously when the sampling pitch, determined by the inter-detector spacing p, is less than $d/2$.

This means that the incoming spectral radiance cannot contain frequencies above one-half of the sampling rate (i.e. above the Nyquist rate). If it does, aliasing changes these frequencies into something that can be represented in the sampled data with a frequency between 0 and the Nyquist frequency [Smith, 1997]. Since frequencies higher than the Nyquist frequency will not be digitised accurately and manifest themselves as lower frequency signals, the Nyquist frequency is also referred to as the detector cut-off frequency (*cf.* spectral cut-off frequency).

For the field of photography, this of course means that the incoming signal could never be truly converted to a digital image, since the input optical signal is not band-limited: it will always contain extremely high spatial frequency components (i.e. fine details and edges) that surpass the Nyquist frequency. When the digital image is then visualised by a reconstruction filter, the output will contain corrupted components due to aliasing. Since aliasing is a major concern in digital imaging, DSC manufacturers generally counteract it by applying an optical low-pass filter/anti-aliasing filter prior to sampling to suppress this inherent by-product of the sampling process. If, for any reason, the maximum incoming frequency is not properly limited, the digital image might contain moiré patterns (when the original scene contains repetitive fine textures) or jagged outlines (when the original scene has sharp contrasting edges).

For CCD arrays with square photosites, the Nyquist frequency ξ_N in cycles/mm can be expressed as $\xi_N = 1/2p$ where p is the photosite pitch in mm (for a rectangular detector, p can be defined in both directions as p_x or p_y). A 24 megapixel full frame (see 5.7) imaging sensor that features 4000 photosites in width by 6000 in height, effectively packs 166.7 photosites per mm (4000 / 24 mm). One square photosite has thus a side of 6 micrometre and the sensor's inter-detector spacing p is 0.006 mm. The Nyquist frequency f_N then equals $1/(2 \times 0.006) = 83$ cycles per mm. In imaging, a cycle is represented by a black and a white line. As such, a cycle is also called a line pair. However, as already mentioned, a digital image sensor is not a perfect point sampler. One should therefore use the sampling theorem and Nyquist limit with some care in respect to digital photography. Several tests have shown that more than two samples are needed to properly digitise a line pair, because the image detail and the sampling are not necessarily in phase [Clark, 2000]. Although four samples per line pair is ideal, three seems to be a good compromise, which is 1.5 times the Nyquist rate. If this 24 megapixel imaging sensor is to be used to scan a film, this would mean that it could resolve details as small as 0.009 mm (i.e. ξ_N is 55.6 line pairs or 111 lines per mm). Obviously, the real number is highly dependent on several other factors such as the contrast of the objects to be resolved as well as the sensor's noise level.

Since a photographic camera sensor is not used directly on top of the scene to be photographed (such as a scanner), the Nyquist frequency has to be expressed for distant scenes in object space by a scale factor m. It will be shown in section 4.5.2, that scale or magnification m can be expressed as the focal length f divided by object distance s. As such, ξ_N in object space becomes $m(1/2p) = f/2ps$. Thus, an object that is digitised by a DSC which is limited by the sampling of its image sensor, can only capture more

details if the focal length is increased (f), the camera is positioned closer to the object (s) or the sensor's detector pitch is reduced (p). Since the semiconductor industry is constantly finding new ways to etch an increasing number of photosites onto a small piece of silicon, the pixel count of imaging sensors is constantly increasing (and thus the detector pitches are decreasing). Although this is very interesting from a marketing point of view, having more megapixels and decreasing the detector element spacing is not the ultimate solution as image noise will increase.

Although the additional blur by the low-pass filter does not substantially degrade the image, the reduced aliasing still comes at the expense of some spatial resolution. Removing the filter can thus deliver an image with a higher spatial resolution. It should then also not come as a surprise that many new camera models do not have a low-pass filter inside anymore. Although aliasing can then certainly occur, it is currently seen as a nuisance rather than a major problem since these aliasing artefacts can be removed digitally when converting the RAW image file (section 4.6.4).

4.4.4 Spatial resolution and resolving power

Any DSC consists of a multitude of imaging hardware components aside from the necessary signal-processing algorithms and electronics. Together with the wavelength of the EM radiation under study, these components limit the angular size of the smallest object that the whole detection system can resolve. The latter is called spatial resolving power and states nothing but the ability of an instrument to distinguish between neighbouring objects. Although the term is often used interchangeably with spatial resolution, both have a distinct meaning. Generally, the spatial resolution or limit of resolution (also called limiting resolution or simply resolution) is some distance Δx (often called minimum resolvable distance) or angle $\Delta\alpha$, while the (linear) resolving power is its reciprocal ($1/\Delta x$ or $1/\Delta\alpha$) and thus a statement of spatial frequency [Born and Wolf, 1999; Hecht, 2002]. Consequently, resolution or minimum resolvable distance provides a fundamental limit to the information one can extract from an image since it is a measure of the minimum distance between distinguishable objects in an image, while resolving power states the ability of the components of an imaging device to measure the angular separation of the points in a scene (i.e. observe fine detail).

As was the case with pixels, there are many popular but wrong photography statements related to the concept of resolution. Very common, the total number of image pixels (pixel count) is referred to as the image resolution. This is obviously erroneous since the same 24 megapixel sensor can capture the head of a bronze Roman statue as well as a complete submerged Greek temple. The resulting imagery, although both counting 24 megapixels, might feature a spatial resolution of 0.01 cm and 2 cm respectively. Besides, increasing the amount of pixels on an imaging sensor does not mean that the resolving power of the sensor and the image quality of the imagery it produces are increasing at a similar rate. To state that a camera with 24 megapixels is spatially resolving twice as well as a 12 megapixel camera is wrong.

Although the final resolution of an image depends on many factors, one of the key factors is the so-called scene sampling distance or SSD (known as GSD or ground sampling distance in air- and spaceborne imaging). Previously, it was said that the distance from the centre of one photosite to the centre of the neighbouring photosite is denoted the inter-detector spacing or detector pitch. The SSD is the corresponding distance projected in object space, stating the horizontally or vertically measured scene distance between two consecutive sample locations. Although the detector pitch is a fixed property of a sensor, it can generate images with various SSDs. Amongst other factors, the SSD is determined by the scene's local topography, the distance of the camera to the scene (object distance s) and the focal length f of the lens (see 4.5.2). Although it is impossible to predict the information that can be extracted from photographs only on the basis of the SSD, it is already a proper first indication. Bear in mind, however, that the contrast between an object and its surroundings, the shape of the object, the noise level and bit depth of the image as well as the amount and diffuseness of the illumination are equally important. Sometimes the point spread function is used to state the resolving power of an imaging system (see 4.5.6).

A further treatise of these resolution subjects is beyond the scope of this chapter. Just bear in mind that all camera components and more specifically the optics and the image sensor, need to properly work together to deliver an image with the best possible resolution. The only thing that a user can do to further increase the resolution of an image is to image with a shorter wavelength (e.g. NUV), use a larger aperture (see 4.5.6), move the camera closer to the object and use a longer focal length (see 4.5.2). However, even when all these variables have been taken care of, motion blur from camera or object movement still has to be controlled as well.

4.5 Essential lens and sensor characteristics

The basic layout of current DSCs is rather similar to the very first cameras: a box with a lens and a medium sensitive to EM radiation. However, the sophistication of those components has changed to a huge extent, directly impacting the digital image quality and number of creative options that current imaging sensors and photographic lenses are capable of. In such a photographic lens, the different optical lens elements determine its specific characteristics such as focal length. The interplay of focal length and size of the imaging sensor define if a lens belongs to the wide-angle, standard or long focus lens category. All of them have their specific uses and create specific effects (such as depth of field, perspective distortion). Some essential terminology and concepts of photographic optics and DSCs are provided below.

4.5.1 Image formation in a pinhole camera

Humans perceive the world in three geometrical dimensions. Cameras, however, do not and need to apply a dimensional reduction. The lenses they use enable the projection of a certain portion of the three-dimensional (3D) world onto a 2D surface, hereby applying a so-called perspective projection. Photography thus automatically means

geometrical reduction. Before tackling the optical properties of lenses, it is beneficial to consider first lensless imaging with a simple pinhole camera (Figure 4.17). In essence, the camera is nothing more than a simple opaque box (e.g. a shoebox) with a small hole cut in it. The image is formed inverted on the box surface facing the hole, technically denoted the image plane. The first screen holds the pinhole, a punched tiny hole that serves as optical centre O and which passes all optical EM radiation into the camera. The distance from the pinhole to the image plane (i.e. the distance between the two screens) is called the focal length f'. The optical axis of the pinhole camera is the virtual line going through the optical centre and perpendicular to the image plane. Where this optical axis (or better, principal axis, since there is no optic here at all) intersects with the image plane/the negative, the principal point is defined. From now on, the originally formed image will be called the negative, which needs to be converted into a positive image (a photographic print or digital frame). Therefore, the positive image – which is virtual of course – is indicated separately. The same focal length, now denoted f, can also be found in front of the camera between the optical centre and the positive image. Since not a single lens is used to form the image, the pinhole camera can be considered the simplest and most ideal model of camera function. However, the image it generates is very dim because the scene's radiance L is multiplied by the pinhole size. Glass or plastic lenses are thus introduced to generate brighter images, as the larger diameter of a lens allows more EM radiation to pass.

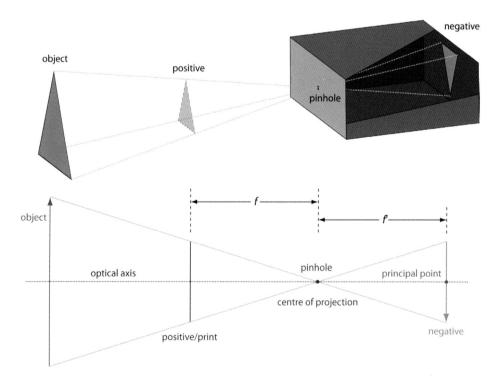

Figure 4.17 A pinhole camera (up) and the geometry of pinhole image formation (down).

4.5.2 Focal length, principal distance and image scale

Before delving deeper into the characteristics of image sensors, it is beneficial to present some basic principles and terminology of optical image formation and lens systems [for more information about this topic, consider Bass *et al.*, 2010; Born and Wolf, 1999; Hecht, 2002; Longhurst, 1967; Mouroulis and Macdonald, 1997; Ray, 2002]. No lens suits every photographic need. However, all lenses, including those that are permanently fixed to the camera body, have certain optical properties.

Refraction

When EM radiation travels in vacuum, it attains it highest speed: 299,792,458 m/s. In any other medium, the EM radiation will travel more slowly. For instance, when radiation enters the lens of a camera, it will slow down because the lens is denser than the surrounding air. The index of refraction or refractive index *n* is a dimensionless numeric value which indicates the amount by which a medium slows EM radiation down compared to its speed in a vacuum [Walker, 2004]. As an example, the index of refraction for vacuum is 1 (i.e. no slowing down), 1.000293 for air (minimal slowing down) and about 1.5 for glass (33% slower radiation propagation). However, with a change in propagation speed also comes a change in direction of propagation. This change of direction, or bending, is called the refraction of EM radiation.

In other words: when optical EM radiation enters a lens, its direction will change as soon as it crosses the boundary between the air and the lens. Because refraction can be explained by the EM radiation moving at different speeds in the two media, the amount of speed reduction induced by these particular media is called the index of refraction. The refractive index for a specific material thus also indicates how much EM radiation will bend upon entering that particular material.

The thin lens

In a photographic lens, image formation is achieved by different optical lens elements which alter optical EM radiation in different ways. It is the combination of all these elements – usually made of glass – that forms the photographic lens, which therefore truly can be seen as a multi-element system. However, to establish an understanding of some theoretical principles and definitions in image formation, a simple lens model will be utilised instead of such a 'real world' compound lens. The simple lens employed here is classified as a thin lens: an imaginary, theoretical lens with zero physical thickness. Consequently, radiation rays refract (i.e. change direction or bend) along a single plane. It must be clear that this thin lens model does not provide the complete picture, as real lens elements do have a finite thickness and two refracting surfaces. This thin lens model is therefore not an exact description of a real photographic lens, but it is sufficient to show the most important lens principles and terminology.

Figure 4.18 depicts a single, thin lens system and is used to sketch the most fundamental lens constants. The centre of such a system is the thin lens (here depicted with a certain width, to improve the visualisation as a lens) in air, so that the amount

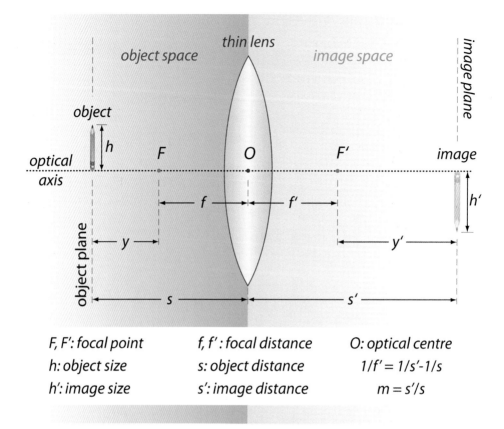

F, F': focal point f, f' : focal distance O: optical centre

h: object size s: object distance 1/f' = 1/s'-1/s

h': image size s': image distance m = s'/s

Figure 4.18 A single thin lens system in air.

of refraction is identical on both sides of the lens. In front of it, the object space can be defined. The lens is located at a certain distance from the object: the object distance *s*. This lens will form an image in the so-called image space, the region behind the lens. Accordingly, the distance between lens and image is referred to as the image distance *s'*.

Through the centre of the lens runs the optical axis on which two focal points can be found: *F* (primary or object-space focal point) and *F'* (secondary or image-space focal point), respectively lying in object and in image space. The distance in mm from these points to the centre of the lens is the so-called focal length of the lens. As every lens has a pair of focal points, two corresponding focal distances *f* and *f'* exist (equal in size and opposite in sign). When one buys a lens, *f* is quoted. Together with the focal length, both the image and object distances (measured parallel to the optical axis) are related by the thin lens equation:

$$\frac{1}{f'} = \frac{1}{s'} - \frac{1}{s}$$

This equation clearly shows that the focal length of a lens equals the distance (expressed in mm) from the lens to the film or sensor plane when focused on an object at infinity [Ray, 2002]. In such a case, s is equal to infinity, yielding $1/s = 0$ and leading to $f' = s'$. Otherwise stated: focal length equals image distance for a far subject. To focus on something closer, the lens is moved further away from the film, producing an image distance s' which surpasses focal length f'. In aerial photography for instance, objects are so far away that the object distance is quasi infinite. Consequently, the image distance may be accepted as equal to f' (i.e. all images are formed in the same plane, one focal length behind the lens). To illustrate this with an example, consider a lens with a focal length of 50 mm and an object distance (earth surface to aerial photographer) of 300 m. The thin lens equation gives: $1/50$ mm $= 1/s' - (-1/300\,000$ mm$) \rightarrow 1/s' = 1/50$ mm $- 1/300\,000$ mm $\rightarrow s' = 50.01$ mm. Notice that the image distance is marginally greater than the focal length. The object distance is negative, because the graphical sign convention for image formation depicted in Figure 4.19 is used.

The linear magnification m of the real-world object is defined by the ratio image to object distance or the proportion of image size to object size: $m = s'/s = h'/h$. As can be seen in the illustration, the image is upside-down here, so the magnification m will be negative (due to the negative object distance). Because s' equals f' in aerial photography, m becomes f'/s. In other words: dividing focal length by flying height delivers the scale of an aerial image. In more general terms, the image scale equals the focal length divided by the object distance.

Figure 4.19 The graphical sign convention for image formation.

The thick lens

A real imaging system such as a photographic lens does, however, not consist of a single thin lens. It can be considered a compound lens: a combination of multiple converging and diverging lens elements having a finite thickness, all mounted concentrically with the optical axis of the device [Ray, 2002]. To characterise the whole lens system, two special refracting planes perpendicular to the optical axis, called principal planes, have to be located (Figure 4.20). The principal planes are conjugates and coincide with so-called nodal planes for a lens system in air. Where the optical axis intersects these planes, the principal points P and P' as well as the nodal points N and N' are found. Although the focal length of such a thick lens is defined as the distance from the rear or secondary nodal point N' to the focal point F', the earlier given definition for focal length will still be used here, both for the sake of simplicity and the fact that the thin lens in air provides a good approximation to the behaviour of real lenses in many cases. Moreover, a thin lens in air can be considered a thick lens where the planes N, N', P and P' are coincident and go through the lens' optical centre [Ditteon, 1998; Ray, 2002].

Ray tracing

Often, certainly in photogrammetry books, focal length is distinguished from principal distance. Although the difference between both can already be inferred from

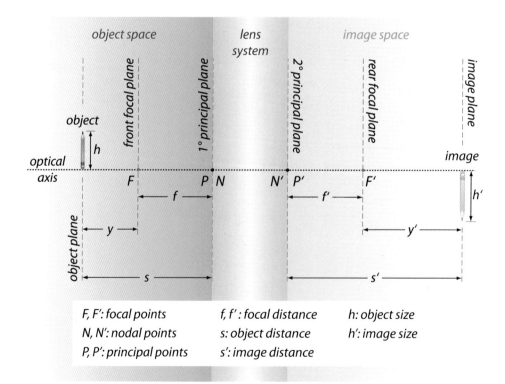

F, F': focal points f, f': focal distance h: object size
N, N': nodal points s: object distance h': image size
P, P': principal points s': image distance

Figure 4.20 A thick lens system in air.

Figures 4.18 and 4.20, ray tracing will be used to explain their difference in a more graphical way while also illustrating some of the implications of specific focal lengths and object distances.

Ray tracing is a process that is used in geometrical optics and which considers the optical EM radiation not to be composed out of EM waves or photons, but simply of rays [Katz, 2002; Mouroulis and Macdonald, 1997]. Ray tracing draws the path of those radiation rays from the object through the lens, hence allowing us to determine where the rays intersect to form the final image. Practically, the location of the generated image in such a thin lens system is defined by three key rays from the object. The first of these rays is the parallel ray (P-ray), a ray from the object, parallel to the optical axis. In the lens, this parallel ray will refract and be redirected on a path which takes it through the image focus (see Figure 4.21). The second key ray is the ray directed to the centre of the thin lens and will therefore not deviate from its path. This ray is called the chief ray. These two rays are sufficient to locate the image, but often a third ray is also included to better identify the image location. This F-ray (focal point ray) is drawn by extending a line from the object, through the primary focal point and to the lens. Since this ray passes through the object focus, it will emerge parallel to the axis after refraction. The two outer rays that pass through the edge of the lens are called marginal rays.

A differentiation can be made between converging and diverging lenses, both having a different effect on optical EM radiation. In particular, the latter will not form an image behind the lens, but yield the projection of a virtual object in front of it. As a converging lens is used in the illustrations, the image is said to be real.

Besides locating the final image, ray tracing also demonstrates that focal length equals image distance for a far subject. The larger the object distance from a lens with a particular focal length, the closer to the focal point F' the image is created (Figure 4.22). In this way, one can imagine that an object at infinity yields an image that is created

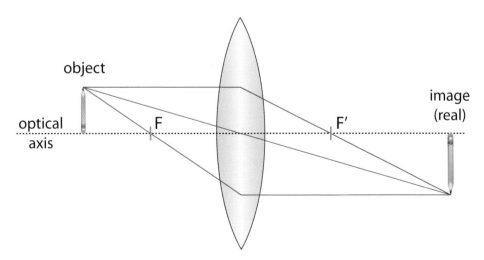

Figure 4.21 Ray tracing for a thin lens in air.

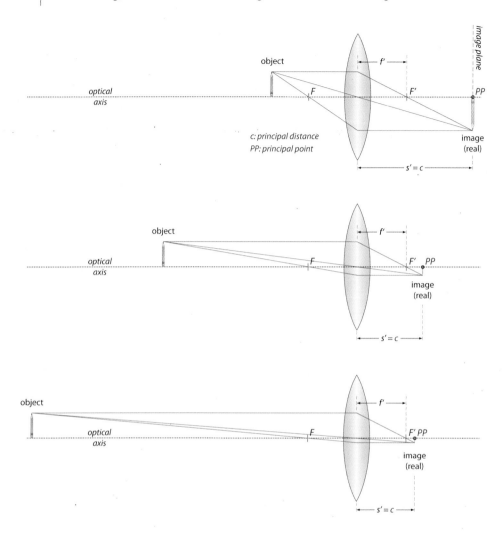

Figure 4.22 Using ray tracing to show the influence of object distance on image distance and linear magnification.

in the plane perpendicular to the optical axis at the location of the focal point, or – as already concluded – that the focal length is the distance from the optical centre of the lens along the optical axis to the principal focal plane (film or digital sensor) when the lens is focused on a subject at infinity. If an object comes closer, the lens must be moved further away from the imaging area to create a sharp image on the latter. Most lenses therefore extend when focusing on objects close at hand.

Although focusing does not change the focal length of the lens (because that is defined at infinity and stays thus invariant), focusing on an object that is not at infinity increases the distance from the perspective centre of the lens (i.e. the rear nodal point

of the optical system) to the image plane (more exactly the principal point *PP* of the image). This distance, which is measured along the optical axis and denoted image distance *s'* in Figure 4.18 and Figure 4.20, is called the principal distance *c* in photogrammetry [Mikhail *et al.*, 2001]. Both photographic symbols *PP* and *c* are indicated in Figure 4.22. Note that the meaning of principal point thus varies between the fields of geometrical optics and photogrammetry. In photogrammetry, the principal point *PP* is the intersection of the optical axis of the lens system with the image plane. To distinguish it from the previously explained principal points *P* and *P'*, the latter two are sometimes denoted optical principal points in the photogrammetric literature [Kraus, 2007]. When the camera is focused at infinity, the principal distance c (or the image distance *s'*) equal the focal length *f* of the lens [Wolf and Dewitt, 2000]. For close range focusing this is no longer the case and the principal distance will thus increase, as shown in Figure 4.22. The same illustration also indicates that great object distances (relative to the focal length *f'*) lead to a very small magnification *m*.

Focal length is one of those primary physical characteristics of a lens that can be measured accurately and remains the same no matter what camera the lens is mounted on. A lens with 50 mm focal length will always be a 50 mm focal length lens, while a 600 mm focal length lens constantly remains a 600 mm focal length lens. The longer the focal length, the more 'tele' effect it has, meaning it has the ability to display distant objects large. This is illustrated in Figure 4.23, where a scene is imaged twice: once by a lens with a particular focal length (say 40 mm) and once by a lens with twice that focal length (80 mm). In the second case, the distant scene appears much larger on the photograph. This explains why long focus lenses magnify distant objects to a great extent, while wide-angle lenses (indicated by a short focal length) do not. As a result, lenses with a shorter focal length enable more of a scene to be captured on the same image area.

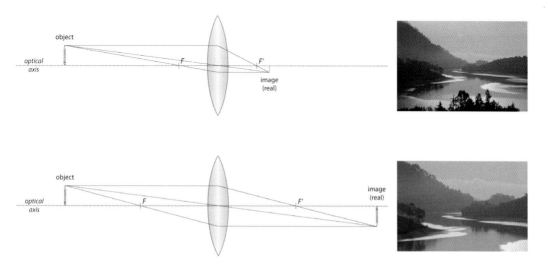

Figure 4.23 The effect of increased focal length on subject magnification.

4.5.3 Prime lens versus zoom lens

Despite the large array of possible lens brands and lens types (Figure 4.24), it is possible to categorise them in two broad groups: zoom lenses and prime lenses.

Zoom lenses have a variable focal length whereas prime lenses have a focal length that is fixed. Although the former have the advantage of versatility (i.e. one or two zoom lenses can cover more or less all focal lengths needed in 95% of the photographic cases), they have several disadvantages over prime lenses: they are heavier, optically often inferior (although some very high-quality zooms can be bought as well) and their largest aperture is smaller and often varies over the zoom range. However, for top notch optical quality and large apertures, one pays the price of carrying many prime lenses to cover the same zoom range. In the end, the total mass of all these prime lenses might become even larger compared to just a few zoom lenses, while the latter also allow for continuous focal length variation. For example, using a 50 mm and an 85 mm prime, there are only two focal lengths at one's disposal. A zoom lens that covers this range will also work at 55 mm, 63 mm etc. The ratio of the maximum over the minimum focal length is known as the magnification or zooming power. A compact camera with a 5.8 mm to 17.4 mm zoom lens is therefore branded as a 3× zoom.

Both prime and zoom lenses are available in all possible prices and size ranges (Figure 4.24). It is, for instance, not uncommon for professional prime lenses to be much more expensive than their consumer zoom counterparts. About the cheapest lens one can buy is the standard 50 mm lens, while very fast (i.e. with a large maximum aperture – see 6.1.2.1) telephoto lenses can cost around €10,000. Although some professional photographers only use prime lenses for their superior performance, establishing a lens collection that is a mixture of zooms and primes can be considered a wise choice, giving many possibilities depending on the shooting circumstances: from small artefacts that necessitate a macro lens to indoor settings for which a wide-angle lens is essential.

Figure 4.24 Overview of a wide variety of Canon lenses [Canon U.S.A., 2015].

4.5.4 Lens mounts

The interface that enables the mechanical (and sometimes also electrical) connection between the camera body and a lens is called the lens mount. Photographic lenses designed for DSCs feature a specific bayonet-type mounting. Long-established camera manufacturers such as Canon, Nikon, Pentax and Sony have a huge legacy of lenses that one can use with the current digital camera line. Certainly Nikon and Pentax excel in this area: Pentax is backwards compatible with all previously sold Pentax K-mount lenses, while also many Nikon F-mount lenses can be used on the digital cameras with the F-mount derived FX and DX mounts (they sometimes require, however, more manual operation such as focusing or setting the aperture). Although Canon twice changed their main lens mount (from the electro-mechanical FD mount to the electric EF mount and later to the EF-S mount), EF lenses can be fit on EF-S cameras with some lost functionality. FD mounted lenses can only be used with special adapters. In 2012, Canon also introduced the EF-M lens mount which enables the use of Canon EF and EF-S lenses when an adapter is used. Sony inherited the A-mount bayonet system from Konica-Minolta and added the E-mount in 2010.

Only a few manufacturers abandoned their initially developed mounting system. Older Olympus lenses are for instance not mountable on newer digital bodies since the old OM-system lens mount was replaced by the four thirds sensor mount standard (and later Micro four thirds standard) that was co-developed with Panasonic. Although the lens mounts of different companies are almost always incompatible, a wide variety of (third-party) adapters is available for most systems to interchange lenses from one mount type to another.

4.5.5 Aberrations

Mono- and polychromatic aberrations

A perfect lens would produce a perfect image. However, from the section above on distortions it is obvious that no lens is perfect. The general name given to lens defects is aberration. All these aberrations or 'lens errors' are the inevitable consequences of the laws of refraction at spherical surfaces. The difficult job of the lens designer is to choose the glass type, curvature and thickness of all lens elements to keep the overall aberrations within acceptable limits. The smaller the range of operating conditions (focal lengths, wavelengths), the simpler the lens design can be. Despite many efforts and exotic glass sorts, it is impossible to design a lens that is well corrected for all wavelengths and focal lengths.

Some aberrations only occur when imaging a spectrum of different wavelengths (the so-called polychromatic aberrations), but there are aberrations even for radiation of only one wavelength (monochromatic aberrations). These are also called Seidel aberrations after the German scientist Philipp Ludwig von Seidel (1821–1896) who explained them mathematically [Smith, 2008]. In total, there are five Seidel aberrations: spherical aberration, coma, astigmatism, field curvature and distortion. In the polychromatic department, one finds the longitudinal/axial and transverse/lateral

chromatic aberrations. Because an in-depth treatise of most aberrations is not impor-tant in this chapter, the reader is asked to consult Longhurst [1967] or Smith [2008]. However, chromatic aberrations and distortion do have a direct, but repairable impact on photographs and will therefore be tackled in the next section.

This paragraph can be finished with some last words on spherical aberration, which is a major image imperfection that occurs when using spherical lens elements. When rays of EM radiation strike a lens near its edge, they will be refracted (bent) more com-pared to rays that strike the spherical lens surface near the centre. In other words: there is a difference in the focal length for paraxial and marginal rays. Since spherical aberra-tion can significantly lower the sharpness of the whole image, lens designers often use aspherical lens elements to remedy this aberration. Although image sharpness is also reduced by astigmatism and coma, the latter two mostly affect the edges and corners of the image [Ray, 2002].

Optical distortion and calibration

In the case of a pinhole or ideal camera, the central projection is perfect and the ima-ging system could be called geometrically distortionless [Billingsley *et al.*, 1983]. The mathematical parameters describing this ideal situation are the principal distance and the principal point (forming the so-called interior/inner orientation). However, since optical distortions are always present in real cameras, the image points are imaged slightly away from the location they should be at according to the central projection. As a result, a rectangle might be reproduced with a pincushion or barrel shape. To metric-ally work with images (e.g. for photogrammetric applications), every image point must be reconstructed to its location according to this ideal projective camera [Gruner *et al.*, 1966]. Therefore, the deviations from the perfect situation are modelled by suitable distortion parameters, which complete the interior orientation. All the parameters of the interior orientation (also called camera intrinsics) are determined by a geometric camera calibration procedure. After this geometric camera calibration, all parameters that allow for the building of a model that can reconstruct all image points on their ideal position are obtained. More specifically, the main elements of interior orientation which camera calibration should determine are the following:

- **Principal distance** (c): the distance measured along the optical axis from the per-spective centre of the lens (more exactly the rear nodal point of the optical system) to the image plane (more exactly the principal point of the image) [Mikhail *et al.*, 2001]. When the camera is focused at infinity, this value equals the focal length f' of the lens [Wolf and Dewitt, 2000]. For close range focusing this is no longer the case and the principal distance will increase. This means that any change in focus or zoom produces a new calibration state. In dedicated mapping cameras, the calibrated focal length f'_c is often given, which equals the principal distance that produces an overall mean distribution of lens distortion [Slater *et al.*, 1983].
- **The location of the principal point** (x_p, y_p): this is the second essential quantity to adequately define the internal camera geometry. It can be defined as the intersec-

tion of the optical axis of the lens system with the focal plane [Mikhail *et al.*, 2001]. This means that the location of the principal point can change with different zoom settings, but it will always be close to the image centre. In an ideal camera the principal point location should coincide with the origin of the image coordinate system.

- **Radial lens distortion parameters** (k_1, k_2, k_3, k_4): it was mentioned above that distortion is one of the five Seidel aberrations. In contrast to many others, this lens aberration does not reduce the resolution of an image [Gruner *et al.*, 1966; Slater *et al.*, 1983]. Radial lens distortion is the central symmetrical component of lens distortion and occurs along radial lines from the principal point. Although the amount may be very small in mapping cameras, this type of distortion is unavoidable [Brown, 1956]. In consumer lenses, radial distortions are usually quite significant. Generally, one to four k parameters are provided to describe this type of distortion. Radial distortion can have both positive (outward, away from the principal point) and negative (inward) values. Negative radial distortion is called pincushion distortion (since an imaged square will appear to have its sides bow inward), while positive distortion is termed barrel distortion (because straight lines bow outward) [Gruner *et al.*, 1966]. Either positive or negative radial distortion may change with image height (Figure 4.25) and its amount is also affected by the magnification at which the lens is used. It can also occur that one lens system suffers from both negative and positive distortion [Kraus, 2007]. Figure 4.25 shows a typical distortion curve. On the left, the distortion scale is indicated in micrometres. In the graph, the distortion is plotted as a function of the radial distance r from the principal point.
- **Decentring lens distortion parameters** (p_1, p_2): this distortion can be broken down into asymmetric radial distortion and tangential lens distortion. Both distortions are caused by imperfections in the manufacture and alignment of individual lens elements during the construction of the lens [Brown, 1966]. Their magnitude is typically much smaller than that of radial lens distortion (Figure 4.25) and conventionally described by two parameters p_1 and p_2 [Burnside, 1985]. Although it is generally not significant in mapping lenses, decentring distortion is common in commercial lenses with variable focus or zoom.

In addition to the abovementioned parameters, several other camera characteristics can be calibrated: affinity in the image plane (consisting of aspect ratio (or squeeze) and skew (or shear)), unflatness of the film plane and the coordinates of the fiducial marks. The latter are used in film-based systems and provide a coordinate reference for the principal point and all image points, while also allowing for the correction of film distortion [Kraus, 2007]. Calibrating a digital frame camera is in many ways more straightforward than calibrating film cameras, since the individual sensor photodetectors are essentially fixed in position, which practically eliminates film distortion considerations [Wolf and Dewitt, 2000]. Fiducials are therefore not needed in DSCs [Graham and Koh, 2002]. Moreover, zero skew (i.e. perpendicular axis) and a unit aspect ratio (i.e. photodetector width to height equals 1) can be assumed for digital frame cameras as well [Remondino and Fraser, 2006; Szeliski, 2011; Xu *et al.*, 2000].

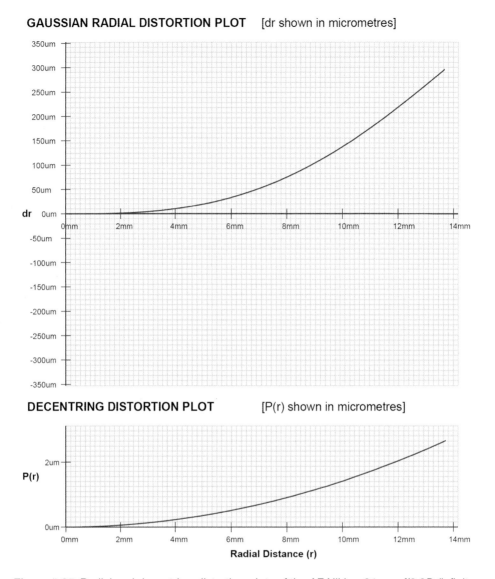

Figure 4.25 Radial and decentring distortion plots of the AF Nikkor 24 mm *f*/2.8*D* (infinity focus). The radial distortion *d*$_r$ (expressed in micrometres) and decentring distortion P(*r*) are given as a function of radial distance *r* (mm).

From the previous paragraphs, it should now be obvious that the non-metric cameras conventionally used in cultural heritage imaging are characterised by an adjustable principal distance, varying principal point and high distortion lenses, while lacking film flattening and fiducial marks (in the case of analogue devices). Finally, it can be mentioned that there is a wide variety of digital camera (auto-) calibration methods [see Remondino and Fraser (2006) for an overview]. Although exceptions exist, the calibration methods applied in photogrammetry are tailored towards high-accuracy and try to recover at

least ten interior orientation parameters. Current computer vision methods generally use camera models described by only four to five interior orientation parameters. When distortion correction is only needed for visual purposes and less for the highest geometrical accuracy, one can also use one of the many RAW converters or standalone software tools that correct lens distortions with embedded profiles for common camera–lens combinations. After identifying the particular camera and lens using the Exif metadata (see 4.6.5), these tools call the correct profile to compensate the image accordingly.

Chromatic aberration

From section 4.5.2, it is known that the index of refraction or refractive index n is a dimensionless numeric value which not only indicates how much EM radiation will slow down in a certain medium relative to its velocity in a vacuum, but also allows us to quantify how much this medium will refract the incident rays that arrived through another medium. However, as with many other optical principles, the refractive index depends on the wavelength of the EM radiation. Consequently, EM radiation with different wavelengths will spread out upon refraction, a phenomenon called dispersion [Ray, 2002]. When a spectrum of radiation is refracted, the longest wavelengths will always refract less than the shorter ones.

Aside from the underlying principle for rainbow occurrence, dispersion also causes a very annoying aberration in lenses. Due to the fact that the individual lens elements in a compound lens have different refractive indices for different wavelengths, not all wavelengths converge to the same point after travelling through the lens. In other words: imaging one object point might result in a coloured, dispersed spot in image space. This optical aberration is known as chromatic aberration (CA) and manifested in an image as horrifically coloured green, red, purple or blue halos which are highly visible around high-contrast edges. Therefore, CA is also denoted colour fringing. A great deal of the complexity of modern lenses is due to efforts on the part of optical designers to reduce CAs. These lenses, which are often denoted apochromatic lenses, use special designs and low-dispersion glass elements to minimise CA. The latter can be subdivided into transverse (or lateral) and longitudinal (or axial) CA [Katz, 2002; Ray, 2002; Smith, 2008].

Longitudinal chromatic aberration

When a lens fails to focus the different wavelengths of incident EM radiation exactly in the same focal plane, the lens is said to exhibit longitudinal chromatic aberration (LCA) (Figure 4.26). Incident EM radiation that is parallel to the optical axis is generally used to explain LCA since it clearly illustrates LCA and the resulting wavelength-dependent focal length of an uncorrected lens: blue light is brought to a focus closer than red light. The distance between the outer focus points along the optical axis is the total amount of LCA. If monochromatic radiation is used with such a lens, re-focusing will solve the problem. When a spectrum of EM radiation is used, the resulting image will always be unsharp due to the different focal points of its component wavelengths. Some wavelengths (e.g. green light) will be in focus (and therefore

sharp), while other portions of the spectrum (e.g. the blue wavelengths) will be out of focus (and therefore unsharp). The net result is a larger and thus less sharp image spot. When, due to LCA, the blue and/or red channel are defocused with respect to the green channel, the so-called 'purple fringing' appears (Figure 4.26a). This purple fringing is especially visible for very high contrast edges such as those of backlit parts. Moreover, LCA occurs throughout the whole image, resulting in an overall and objectionable decreased image sharpness.

Transverse chromatic aberration

Aside from the focal length, also the magnification of an uncorrected lens varies according the incident wavelength. When a lens spreads the image of an off-axis point into a rainbow on the sensor, the total difference between the heights of the imaged wavelengths is called transverse chromatic aberration (TCA), lateral colour error or

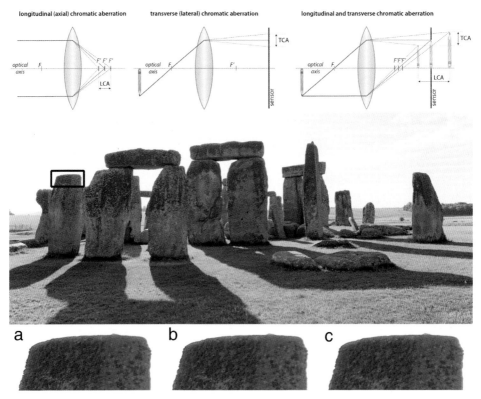

Figure 4.26 The upper part of this image depicts the highly exaggerated occurrence of LCA, TCA and LCA+TCA for a single convex lens element. The middle part of the illustration depicts the Stonehenge monument (United Kingdom) in the early morning, shot with a wide-angle lens (Tokina 11–16 mm f/2.8 AT-X Pro DX) and strong backlight. As a result, both LCA and TCA are present at the edges of the image. (a) shows the uncorrected green and purple fringes around the edges of one of the stones. (b) was extracted from the same image, but with the lateral CA corrected in the camera. (c) had both its lateral and axial CA removed in a dedicated RAW converter.

chromatic difference of magnification [Smith, 2008]. In other words, one object point is imaged at different magnifications that depend on the wavelength of the EM radiation (Figure 4.26). Because object points are only focused at different lateral locations in the image space for obliquely incident radiation, TCA is an off-axis aberration. Since image sensors have still increasing photosite densities, the displaced red, green and blue colour channels of the image spot become increasingly visible as coloured fringes, much like a rainbow. However, TCA only occurs in the peripheries of the frame, especially at corners and edges (e.g. the green colour fringing around the stone in Figure 4.26a).

Both forms of CA are highly lens and focus setting dependent. They are most pronounced with wide angle lenses, zoom lenses and cheaper lens models, although every type of glass – even the most expensive – suffers from this optical aberration to some degree. CA also tends to worsen towards the edges of the image (because then also TCA kicks in) and the extremes of a zoom lens.

Despite the efforts of lens manufacturers, chromatic aberration remains an issue even for prime lenses. Luckily, CA (and certainly longitudinal CA) can be reduced in post-processing. Most RAW converters feature built-in CA removal. Often specifically tuned for certain camera-lens combinations, this tool allows the complete elimination of CA or at least reduces it significantly. Sometimes, DSCs remove CA internally during the production of a JPEG. However, a RAW workflow generally allows a more thorough CA removal (there are typically some small visible fringes left) besides many other benefits (see 4.6.4).

Vignetting

Apart from the five Seidel aberrations and CA, there are also other lens defects such as vignetting and flare. Let us start with lens flare. When the stray radiation from a bright source enters the lens, many internal lens (and even sensor) reflections can occur. When this radiation is finally picked up by the sensor, it causes the image to be 'washed out'. When the bright radiation source (e.g. the unobstructed sun or a studio lamp) itself is in the field of view of the camera, bright spots might appear in the image. Although these spots can be single occurrences, they often appear in a row. The solution to this problem is simple: prevent the radiation source from appearing in the camera's field of view by changing the camera position or focal length, or use an object (e.g. a building) to mask it out. Stopping down the lens (i.e. use of a smaller aperture – see 4.6.1) might significantly reduce internal reflections as well. To prevent any contrast decrease due to peripheral radiation (e.g. the lens is not directly pointed at the radiation source but its stray radiation can still hit the front lens element), use a lens hood [Ray, 2002].

All DSCs yield photographs whose centre is brighter than the periphery of the image due to a non-uniform illumination of the sensor during exposure. This phenomenon is called vignetting and natural as well as optical and mechanical causes may be responsible [more details are provided by Fincham and Freeman, 1980; Ray, 2002]. When the radial decrease of image illumination is purely natural or optical, it is easy to correct since it is inherent to lens design. Natural vignetting is associated with the natural illumination falloff when radiation impinges on the sensor. Since it is angle dependent, it is

most pronounced for wide-angle lenses. Because it is not related to any blocking of the incoming radiation by optical or mechanical elements, it cannot be corrected by stopping down. Closing the aperture to *f*/5.6 or *f*/8 does, however, help when optical vignetting is an issue. This type of vignetting occurs because obliquely incident radiation can be shielded by the lens barrel or other elements in the optical path of the lens. As such, optical vignetting determines the size of the image circle projected by the lens (see 4.5.8). Together with natural vignetting, optical vignetting is an unintentional vignetting that creates a gradually darkened image towards the corners (see Figure 4.27). Luckily, it is easy to correct for in image-processing software. Similar to distortion and CA correction, many software packages feature camera- and lens-specific profiles that can counteract these types of vignetting. Although it might seem strange from a documentation point

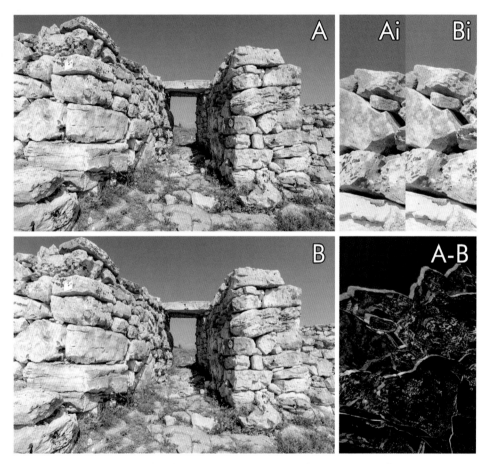

Figure 4.27 Photograph of the Bronze Age stone walls of Monkodonja (Croatia) taken with a wide-angle lens (Tokina 11–16mm f/2.8 AT-X Pro DX). Image B is the distortion- and vignetting-corrected version of image A. Although the differences might be hard to see when considering the image as a whole, they are very apparent when comparing the insets Ai and Bi (notice the change in brightness of the sky and the changed geometry of the stones). The difference image A–B also shows the effect of geometrically correcting the image with a distortion profile in a RAW converter.

of view, many photographers artificially add extra or custom-shaped vignetting during processing to emphasise the subject in the image.

Whereas natural and optical vignetting are inherent to each lens design, mechanical vignetting is created by the photographer, generally due to inattentiveness. This mechanical vignetting pops up when additional mechanical elements such as filters or improper lens hoods are attached to the lens and protrude into its field of view. As a result, the corners of the image will receive less or no EM radiation, which usually causes an abrupt transition with entirely black image corners. Whereas optical and natural vignetting can be cured with image processing software, mechanical vignetting cannot. The only solution for the photographer is to ensure a proper use of appropriate accessories.

4.5.6 The PSF – diffraction and blur

To some extent, blurring is present in all imaging processes, be it vision, medical imaging or photography. To understand the concept of blur, it is essential to understand that an image is a visual representation of a specific physical object and every object point should be represented by a small, well-defined point within the image. In reality, the image of each object point is slightly spread or blurred due to the diffractive nature of EM radiation. In more scientific terms: the image of an object is the convolution of the object's radiance and the point spread function [Jensen, 1968; Lipson *et al.*, 2011]. This section delves deeper into this and explains why a point source will always be a smeared out spot when imaged. Solutions to minimise the problem will be given as well.

Diffraction and the optical PSF

In the previous section, it was mentioned that all imaging systems suffer from certain aberrations. Even if such aberrations would be totally absent, the very nature of EM radiation itself would still put a physical limit on the smallest resolvable object because of diffraction. Diffraction is a phenomenon that comes into play when considering the wave nature of EM radiation: wavefronts of propagating EM waves bend in the neighbourhood of tiny obstacles and spread out when passing apertures. Consider the imaging of a distant star with an optical system. The star can be considered a close approximation of a perfect point source. When the star's EM radiation passes the circular lens aperture and is focused on an image plane, the resulting image is not a perfect point but a diffraction pattern resulting from the wavefronts hitting the edge of the aperture and spreading out.

The spatial energy distribution of this image spot is called the point-spread function (PSF) and describes in three dimensions the smear or spread in the focal plane introduced by the optical chain [Jensen, 1968; Westheimer, 2009]. In the case that the imaging system is aberration-free and completely diffraction limited (i.e. the lens is a flawless optical system without aberrations and its performance is limited only by diffraction), the PSF of a perfectly focused point is a so-called Airy diffraction pattern. This Airy pattern describes the best focused spot of EM radiation that a perfect lens with a circular aperture can generate and looks in the *XY* plane as a bright circular central patch (the Airy disc) and a series of dimmer concentric rings, each ring

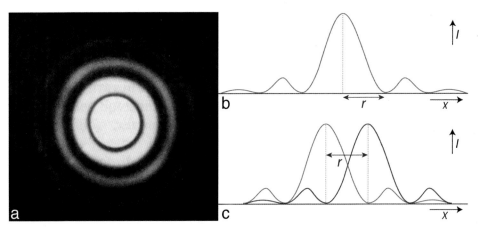

Figure 4.28 (a) is an image of an Airy diffraction pattern (adapted from [Young *et al.*, 2004]: Figure 36.25), while (b) shows the radial profile of the Airy PSF and (c) displays the Rayleigh criterion.

separated by a circle of zero intensity (Figure 4.28a for the *XY* plane and Figure 4.28b for the *Z* plane – or profile – through the middle of the Airy disk).

The radius *r* of this Airy disc is given by:

$$r = \frac{1.22 f \lambda}{D}.$$

The spread thus depends on the wavelength of the EM radiation (λ), the focal length of the lens (f) and the diameter of the lens aperture (D) [Born and Wolf, 1999; Hecht, 2002; Ray, 2002]. Note that smaller wavelengths and large lens apertures (see 4.6.1) yield smaller Airy disks and that both variables can be used to minimise the size of the image spot (theoretically, one would need an infinitely large camera aperture to image a perfect point and not introduce any blur [Fiete, 2012]. Obviously, the size of these central bright areas is crucial for the amount of resolved detail, because the Rayleigh criterion states that two neighbouring small objects can be spatially resolved as long as their Airy discs do not come closer than half their width (see Figure 4.28b). Consequently, the smaller the Airy discs, the higher the theoretical spatial resolving power of an optical imaging system [Longhurst, 1967; Young *et al.*, 2004].

In photography, diffraction has a direct effect on the spatial resolution of the final image. Even when everything is perfectly in focus, too small an aperture gives rise to bigger Airy disks and hence a lower spatial resolution. To increase the spatial resolution in an image, shorter wavelengths such as NUV or a larger aperture can be used. Of course, one can also move the camera closer to the object and use a longer focal length. In this way, the wave nature of EM radiation and the resulting physical principle of diffraction set a fundamental limit by blurring the image, preventing an exact point-for-point copy of the real-world scene.

In most situations, the optical PSF (PSF_{opt}) deviates from this diffraction-limited Airy pattern due to a number of reasons such as the aforementioned lens aberrations or

less-optimal focusing. Both phenomena blur an image spot even more. Finally, there is the anti-aliasing filter which adds a last but major portion of optical blurring. All these various blurring effects integrate into the final PSF_{opt}. Because a scene is considered to be a collection of countless point sources, each of these sources generates its own PSF_{opt} with its amplitude proportional to the source's radiance. Because the irradiance in the focal plane gets spatially sampled by the detector array, every pixel results from the integration of many optical PSFs over the photosite [Cracknell, 1998].

The system PSF

However, Figure 4.15 shows that the PSF of the optics (PSF_{opt}) is not the only contribution to the camera overall/net/system PSF (PSF_{sys}). Two additional blurring components, corresponding to the response of the photosites (PSF_{det}) and sensor electronics (PSF_{el}), also contribute in a specific way to the PSF_{sys} of the imaging system [Breaker, 1990]. Very often, both effects are combined into one sensor parameter PSF_{sen} [Fiete, 2010]. Sometimes, the image motion PSF (PSF_{mot}) is added as a fourth component, resulting from the fact the imager might move during the exposure time. In this way, the system's PSF (also called the system's impulse response or response function – [Markham, 1985; Smith, 1997] can be written as a convolution of the individual components:

$$PSF_{sys}(x, y) = PSF_{opt} \times PSF_{mot} \times PSF_{det} \times PSF_{el} = PSF_{opt} \times PSF_{mot} \times PSF_{sen}$$

in which x and y are the spatial coordinates in image space. Using this equation, it now becomes clear how the sensor spatially blurs the incoming signal (as was also partly explained in a less technical way in section 4.4.2). First, the scene's spectral radiance arrives at the lens which introduces blurring according to the optical PSF. Since the camera (or the object) might move during the exposure, some additional blurring should be taken into account [Smith *et al.*, 1999]. The magnitude of this blurring is obviously related to both the exposure time and the relative velocity of the camera versus the subject. Ideally, this blurring magnitude is much less than the detector pitch p. Afterwards, the image sensor's photosites sample the spectral irradiance and introduce a third step of spatial blurring because they pool together incident photons that might belong to different objects. All three blurring effects are sometimes referred to as the pre-sample blur or simply preblur [Vollmerhausen *et al.*, 2010]. In the final stage, optional denoising of the electronic signal and particular sensor array properties such as charge transfer efficiency and electron diffusion might introduce a fourth blurring step, modelled by the PSF_{el} [Markham, 1985; Park *et al.*, 1984; Schowengerdt, 2007]. Mark that for layout reasons, Figure 4.15 concatenated both the detector PSF_{det} and electronic blur PSF_{el} into one PSF_{sen}. Technically, only the PSF_{det} part of the PSF_{sen} is thus part of the pre-sample blur.

In most real systems, the total PSF_{sys} depends on the position at the imaging plane [Jähne, 2004]. It is typical for PSFs to degrade as the distance from the optical axis is increased (because lens perfections tend to be larger there). As a result, the PSF_{sys} also varies and often becomes quite asymmetrical.

4.5.7 Sensor size

It is often stated that more choice is always better. In terms of lenses and camera bodies, this might be true, but this section on sensor sizes is the perfect example to demonstrate that increased choice might also lead to confusion. The problem is related to the hundreds of different DSCs that are available and the large variety of image sensor sizes that are used to give them photographic capabilities. In this subsection, the different sensors sizes will be introduced. This is necessary to later explain the properties field of view and crop factor.

In the era of analogue photography, a very common photographic emulsion was the 135 general-purpose transparency or negative film (Figure 4.29). Introduced in 1934, the 135 film format has 16 perforations per 72 mm and mostly uses frames which can hold an image of 36 mm by 24 mm, hereby having an aspect ratio of 3:2 (i.e. width/height). Because the film is 35 mm wide, the creation of images by cameras and lenses suited for such 135 format emulsions became commonly known as 35 mm photography. Moreover, its popularity also gave rise to the term standard format photography. Besides 35 mm photography, many other film formats have been commonly used [for an overview see Verhoeven, 2008a].

Instead of film emulsions, digital photography uses a digital image sensor to record the scene. However, the large variety of DSCs means that there is a very large variety of digital sensors sizes as well. Obviously, the larger the camera, the larger the sensor that can be built in. On the other hand, an unobtrusive spy camera can only

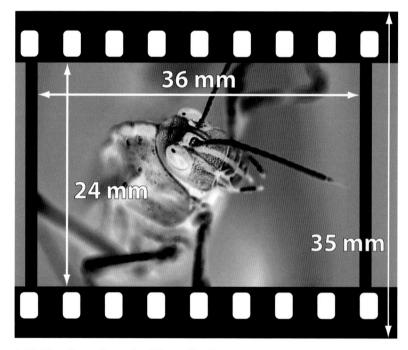

Figure 4.29 The dimensions of a 35 mm film frame.

be small when the sensor (and the other components) allow for it. Although there are no strict guidelines as to which category a specific camera belongs, the distinction is often made between miniature spy cameras, phone and tablet cameras, action cameras, standard compact cameras, zoom compacts (also known as travel cameras and identical to compacts but with more powerful zoom lenses), adventure or weather-proof cameras, advanced compact cameras or large-sensor compacts, bridge or super-zoom cameras, compact system cameras (CSCs) or mirrorless interchangeable-lens cameras and D-SLR cameras. Although also medium and large format cameras can be equipped with digital sensors, 35 mm-like (and smaller) digital cameras are still found in abundance amongst both amateur and professional photographers.

When the size of the digital sensor equals the dimensions of classic 135 format film, the sensor is denoted a full frame sensor. The full frame sensor (indicated by FF) is used as the reference in Figure 4.30. Besides, many other sensor sizes are displayed. The upper row belongs to compact and hybrid cameras (note the 4:3 aspect ratio), but can be found in smartphones and tablets as well. It is obvious that these simple cameras have various sensors at the very low end of the possible sensor dimensions (till the 2/3" format). Their strange kind of designation is rooted in the size of TV camera tubes of the mid-20th century. These glass tubes had typical outer diagonal sizes like 1/1.8" (i.e. 0.56 in or 14.11 mm), 1/2" (0.50 in or 12.70 mm), 2/3" (0.7 in or 16.93 mm) etc. The usable image area of such a tube was less, being more or less two thirds of the tube's diameter. In the case of a 1/1.8" tube, the image area was 7.18 mm × 5.32 mm with a diagonal of 8.93 mm (2/3 of 14.11 mm would yield 9.41 mm). An image sensor which equals these dimensions is nowadays called a 1/1.8" image sensor [Ray, 2002]. It is weird that, even today, sensor manufacturers still insist on using these outdated glass tube diameters to indicate the format of the sensor. The lower part of Figure 4.30 depicts different small format sensors with dimensions starting from 4/3" onwards. Although their sizes vary to a rather large extent, the majority of DSCs uses digital sensors with dimensions that are smaller than the frames of the 135 format. Nevertheless, due to the larger dimensions (compared to the compact cameras), the cost of producing sensors increases significantly, hereby partly explaining the price difference between D-SLRs and other, smaller DSCs. Generally, three main categories of small format sensor sizes can be discriminated:

1. the four thirds (4/3") format: the whole sensor measures 18.0 mm × 13.5 mm, thus covering about 25% of the 135 format. It was introduced by Olympus and Panasonic to cut down the costs of sensor manufacturing. In August 2008, these companies also announced their Micro four thirds system which shares the same sensor size, but allows smaller bodies to be designed;
2. the APS-C format: since an APS 'classic' (C) negative measured 25.1 mm × 16.7 mm, digital sensors approximating this size are called APS-C sized digital sensors. Most D-SLR camera manufacturers stick to this standard. As they all 'approximate' the APS-C dimensions, these sensors are characterised by a lot of size variation;
3. the full frame format.

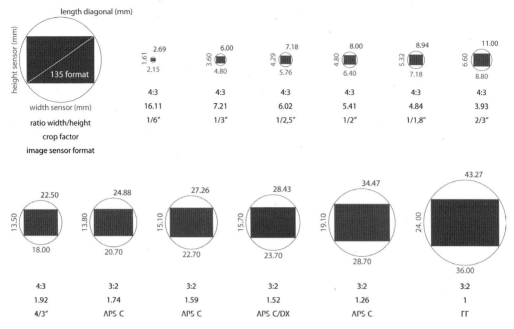

Figure 4.30 Different formats of digital imaging sensors and some of their related properties.

Figure 4.30 also gives the diagonal distance of each of the sensors. In the case of 135 mm film, a frame has a diagonal of 43.27 mm. The value of this diagonal has two meanings. First, a lens with the same focal length as this diagonal is denoted a standard lens for that particular format (see 4.5.10). Second, this numeric value indicates the diameter of the circle which completely circumscribes the rectangular image frame. In this particular example of 135 film, a circle with a minimum diameter of 43.27 mm can completely encompass the whole frame. This circle is also shown for all different sensors in Figure 4.30. The tinier the sensor, the smaller its encompassing circle.

4.5.8 Field of view

Field of view (FoV), field angle of view, angle of view, angular field of view, picture angle or angle of coverage all indicate the same thing: the (solid) angle in object space over which objects are recorded in a camera. Often quoted as a fixed lens characteristic, FoV is a result of the combined play between both the physical size of the camera's sensor and the focal length of the lens attached. Therefore, it must always be quoted in relation to the imaging area. To explain this, imagine the cone of EM radiation rays from a scene reaching the sensor after refraction by a photographic lens (Figure 4.31). As the lens elements are all circular, the picture-forming radiation passes circular openings and delivers a sharp image which is circular itself. This circle cast by the lens is called the image circle, its size not being an inherent property of the focal length of the lens, but completely determined by the optical design [Ray, 1984, 2002].

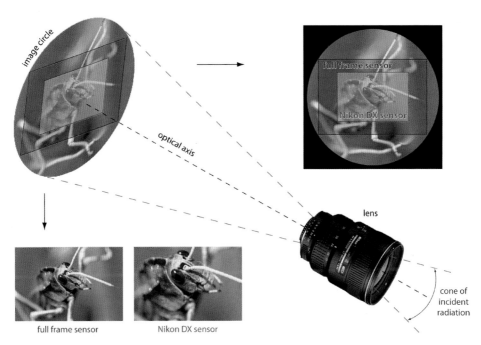

Figure 4.31 Digitally cropping the image circle.

Although a circular image is projected by the lens, different sensors all capture and store a rectangular or square image (Figure 4.31). From an optical point of view, the image sensor is the field stop of the optical system. Stops are devices that prevent rays of EM radiation from reaching the imaging area. They come in two forms: aperture and field stops. An aperture stop simply limits the diameter of the beam of EM radiation that passes through the photographic lens. Such a limit can basically be the size of the first lens element or a hole deliberately incorporated, such as the iris diaphragm. Apart from this, a field stop exists, being the stop that confines which object points are imaged [Fincham and Freeman, 1980; Levi, 1968; Longhurst, 1967]. The edge of the detector limits which part of the image circle is used. Essentially, four curved areas at the edges of the detector are cropped out of the whole projected image.

When it comes to the standard full frame format, only a rectangular zone of 24 mm height and 36 mm width is captured. Using exactly the same lens on a Nikon DX sensor, even a smaller portion of the whole image is stored: only a rectangle of 23.7 mm × 15.7 mm. This indicates a very important photographic issue: lenses are designed to project an image circle, but one must be sure that the corresponding diameter of the image circle equals at least the diameter of the radiation-sensitive area. In other words, the image circle created by the lens must be larger than the circle which just encompasses the sensor. In the case of the full frame sensor, a lens must project an image circle of at least 43.27 mm in diameter. If not, completely black corners will be

the result. In practice, the area that captures optical EM radiation will be somewhat smaller than the image circle to assure reasonable image illumination, as the periphery of the image circle will always suffer from reduced illuminance. This phenomenon – vignetting (section 4.5.5) – results in a radial decrease of image illumination, yielding corners that are less bright than the centre of the image [Fincham and Freeman, 1980; Ray, 2002]. Buying a lens that is designed ('optimised') for the four thirds format and using it on a full frame DSC will not work. Even if the lens could physically be connected by a lens-to-camera adapter, the image circle would not be large enough to adequately cover this larger imaging area due to the fact that the lens manufacturer designed the lens with only an image circle large enough to cover the four thirds format. Without completely tackling the issue whether DSCs should best be fitted with specifically designed 'digital lenses' or not, it is important to note that all 35 mm lenses can be used on today's small format D-SLRs as far as the image circle is concerned.

This explains why FoV is a combination of both focal length and imaging area. Although the lens of Figure 4.31 is in both cases the same, the amount of the scene that is recorded depends on the imaging area. The tinier the sensor is, the smaller the amount of the scene that will be covered. As seen above, changing the focal length will also change the captured portion of the scene. It is common practice with optical instruments to state the complete FoV in terms of the angle α, expressed in degrees (°). This value represents the angle in object space over which the scene is imaged. The semi-field or half-field angle θ is defined as the angle made by the optical axis with the extreme rays of EM radiation falling on the sensor (i.e. $\alpha/2$) [Katz, 2002; Ray, 2002]. The complete FoV can be measured by three parameters: horizontal, vertical and diagonal FoV (Figure 4.32).

As an example, consider a 50 mm lens on a full frame D-SLR:

- horizontal FoV: 39° 35′ 52″;
- vertical FoV: 26° 59′ 29″;
- diagonal FoV: 46° 47′ 33″.

When the same lens is mounted on an APS-C/DX sensor, the values become:

- horizontal FoV: 26° 39′ 58″;
- vertical FoV: 17° 50′ 43″;
- diagonal FoV: 31° 44′ 27″.

How to compute these FoVs is not covered here, but can be found in Verhoeven [2008a]. However, it is important to say that these FoVs will slightly decrease (in the order of a few degrees) when focusing on nearby objects.

In the field of airborne and spaceborne imaging, some additional terms are used in relation to FoV. The angle subtended by an individual photosite on the axis of the complete optical system is called the instantaneous field of view (IFoV) or detector angular subtense (DAS) [Leachtenauer and Driggers, 2001]. The ground-projected instantaneous field of view (GIFoV) is a property that is generated by geometrically projecting the photosite or detector element's width on the ground [Schowengerdt,

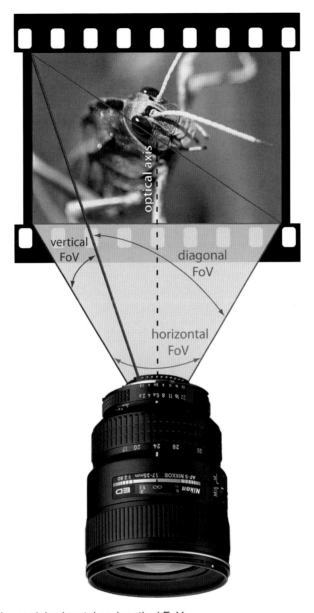

Figure 4.32 Diagonal, horizontal and vertical FoV.

2007]. The smaller the photosite, the smaller the GIFoV. Of course, these terms could also be used for terrestrial applications, although it would be more appropriate to then speak of SIFoV or scene-projected instantaneous field of view.

4.5.9 Digital crop factor

From the last numeric example and Figure 4.31, it is clear that FoV changes with the imaging format. Due to the popularity of the format, most FoVs associated with a

particular focal length are based on 35 mm film photography. If one uses such a lens on a digital small format camera, a so-called focal length factor, focal length multiplier, digital multiplier, digital magnification factor or digital crop factor needs to be applied to calculate the 35 mm equivalent focal length and FoV.

Consider an analogue 135 format lens of 24 mm fitted onto a Nikon specific DX format sensor (23.7 mm × 15.7 mm). The image yielded by the camera will look more 'tele' (i.e. the object is apparently brought closer), because a smaller portion of the image circle is used (see also Figure 4.31). To find the 35 mm equivalent focal length which would produce exactly the same image on a 35 mm film frame, one needs to use a multiplier which can be calculated for the horizontal, vertical or diagonal dimension:

- horizontal: 36.00 mm / 23.7 mm = 1.519;
- vertical: 24.00 mm / 15.7 mm = 1.529;
- diagonal: 43.267 mm / 28.429 mm = 1.522.

Any of these three factors can be used to multiply a given lens' focal length used on the DX sensor to obtain the 35 mm equivalent lens:

- horizontally: 24 mm × 1.519 = 36.46 mm;
- vertically: 24 mm × 1.529 = 36.70 mm;
- diagonally: 24 mm × 1.522 = 36.53 mm.

So, using the mentioned lens with a focal length of 24 mm on a DSC with DX sensor, the same image will be captured as a 35 mm film frame-36.5 mm lens combination would do. Therefore, 36.5 mm is denoted the equivalent focal length for the 135 format. Although there are always three possible outcomes, the camera manufacturers mostly give one value as a conversion factor: the one based on the diagonal of the image plane, to tackle the issue of different aspect ratios. For this camera, Nikon provides 1.5 as a multiplication factor.

Besides focal length, an equivalent FoV also exists. From this particular example, it must be obvious that the FoV set by a focal length of 24 mm and across the diagonal of the DX sensor equals the FoV across the diagonal of the 35 mm film plane with a lens of focal length 36.5 mm. Mathematically this can easily be confirmed [for the exact computations and some related comments consider Verhoeven, 2008a]:

- diagonal FoV of a 36.5 mm lens on the 135 format: 61.27°;
- diagonal FoV of a 24 mm lens on a DX sensor: 61.27°.

Equivalent FoV and focal length can be calculated for every lens–sensor combination whenever the sensor size is smaller (or larger) than the 135 format frame. This gives cameras with a full frame sensor the advantage of not having to take this changed FoV in mind. It is, however, very important to understand that the actual focal length of

the lens remains unaltered, no matter how big or how tiny the sensor's dimensions are. Mounting a 50 mm lens on a digital camera with a four thirds sensor does not deliver a lens with another focal length; neither does the lens behave differently. 50 mm stays 50 mm. In this respect, terms such as 'focal length multiplier', 'focal length factor' and 'digital multiplier' are misnomers. Also, the expression 'digital magnification factor' can be interpreted erroneously. Even though the circular image field can be larger than the field stop, circumscribe it or be wholly within it, reducing or enlarging that field stop just alters the area recorded and does not change the magnification of the object.

Therefore, all lenses of a particular focal length produce the same image magnification at the plane of focus when focused at the same distance. However, cropping the imaging area results in a narrow FoV, making the terms digital crop factor or FoV crop factor the only valid ones. As a rule of thumb: the smaller the imaging area, the shorter the focal length lens is needed to yield the same FoV as a lens with a longer focal length on the 135 format. Figure 4.30 also shows the digital crop factor exercised by various imaging sensor formats. Common crop values range from slightly larger than one to two for D-SLRs, whereas compacts crop the FoV by at least a factor of four.

4.5.10 Lens classification – wide-angle, normal and long focus lenses

Statements such as 'moderate wide-angle lenses are characterised by their short focal length which lies in the 24 mm to 35 mm range' hold true, but only for the 135 format or full frame sensors. Wide-angles for smaller formats will have shorter focal lengths for example. Using FoV on the other hand, is a meaningful and unambiguous method for classifying all lenses into the three main categories of wide-angle, standard and long focus lenses.

Standard lens

A wide-angle lens must provide a wide FoV (e.g. 90°), while long focus lenses have to deliver a narrow FoV (say 7°). A standard, ideal or normal lens on the other hand should give a normal FoV with a correct perspective rendition in the photograph. Therefore, the HVS must be considered. The static human eye has a sharp visual FoV of some 50°. Using a lens with a focal length of 46.40 mm, the same angle is rendered on the 135 format. Because this value of f = 46.40 mm is close enough to the diagonal of the 35 mm frame, Ray [1984] suggested the diagonal of the imaging format is a good way to define a standard focal length.

When applied to the full frame sensor format, the corresponding focal length yields a theoretical diagonal FoV of circa 53°. As FoV changes with imaging area, the standard focal length for smaller or bigger imaging sensors changes correspondingly. However, rather than using one value, lenses are called 'normal' when their focal lengths fall within a certain range. For the full frame format, focal lengths can vary from about 35 to 58 mm (Figure 4.33), with 50 mm the most common value found for a standard lens (a standard which dates back to 1925 when it was introduced on the Leica camera – see Ray [2002]). The idea is that they all come close to the theoretical angle of 53°. Once

the focal length is significantly smaller or larger than the diagonal of the format in use, one deals with wide-angle and long focus lenses respectively.

Wide-angle lens

For wide-angle lenses (i.e. lenses with a diagonal FoV larger than 63°), a division is sometimes made between wide-angle (WA; 63° to 84°), very wide-angle (VWA; 84° to 100°) and extreme wide-angle (EWA; 100° to 120°) (Figure 4.33). 120° to 140° is about the possible limit for rectilinear lenses (due to the diminishing peripheral illumination of the image circle), therefore also called the fisheye limit [Ray, 2002].

In essence, two lens types exist for photographic use: rectilinear and fisheye lenses. So far, all lenses have been considered to be of the more common rectilinear type. These lenses render straight lines in the scene as straight lines in the image (although the images are not perfect rectilinear images due to the distortion phenomena) [Fincham and Freeman, 1980]. Fisheye lenses no longer use this rectilinear central projection, but apply equidistant, orthographic or other projections to record hemispherical (i.e. 180°) or larger (i.e. hyper-hemispherical) subject fields. Although fisheye lenses are less common, they render scenes in a very interesting way because they display straight lines as curves (except for those running through the centre of the frame). Circular fisheye lenses can even project the whole scene as a circle within the imaging area, so that the corners of the image are completely black. In general, fisheye lenses are applied when covering the widest FoV is more important than minimising geometrical distortion [e.g. in canopy photography – Macfarlane *et al.*, 2014]. Fisheye lenses are not further considered in the rest of this chapter

type of lens	appr. field of view (° on diagonal)	appr. *f* (in mm) for the 135 format	appr. *f* (in mm) for the DX sensor	appr. *f* (in mm) for the 4/3" format
extreme wide-angle	120	12	8	6
very wide-angle	100	18	12	9
wide-angle	84	24	16	12
standard	63	35	23	18
medium long focus	41	58	38	30
long focus	18	135	90	70
very long focus	8	300	200	155
extreme long focus	5	500	330	260
	1	2000	1300	1050

Figure 4.33 Classification of lenses which apply a rectilinear projection [data from Ray, 1984, 2002; Weber and Ebeling, 1970].

Long focus lens

Long focus lenses can be found on the other part of the lens spectrum. They are sometimes subdivided in medium long focus lenses (MLF; 18° to 41°), long focus lenses (LF; 8° to 18°) with focal lengths up to six times the format-dependent standard focal length, very long focus (VLF; 5° to 18°) and extreme long focus lenses (ELF; 1° to 5°) (Figure 4.33). Often, LF lenses are erroneously called telephotos. However, telephoto refers to a specific type of lens construction. The telephoto design is indeed used in many LF lenses, but the latter can also be built by other configurations [Ray, 2002]. Figure 4.33 gives a classification of lenses and their matching diagonal FoVs. As the corresponding focal lengths of the 135 format are so well known, their approximate values are given in the third column, followed by the focal lengths that deliver an equivalent FoV on smaller digital imaging sensors. As you can see, a standard lens has a diagonal FoV between 63° and 41°, which results in 35 mm to 58 mm on the 135 format. The same FoV is given by a lens with focal lengths in the 18 mm to 30 mm range on a four thirds sensor. Once again, full frame sensors do not suffer from crop factors, making the calculation of an equivalent FoV unnecessary.

4.6 Key photographic foundations

This section is all about making good photographs. So far, many technical details have been provided on lenses, their aberrations and how a digital image is created. Although many of these concepts are helpful at certain stages in the photographic pipeline (from buying a specific lens to remove vignetting from the acquired digital image), this section concentrates on how to make good photographs with a given camera and lens. Of course, a good photograph is very often all about composition, but in cultural heritage photography this is often considered of second importance. When photography is used to document a building or artefact in two or three geometrical dimensions or capture its spectral properties, it is very important that the image has a proper distribution of tones and sharpness and the colours are properly described and stored in the correct file format. An explanation and illustration of all these essential photographic concepts – which are denoted here key photographic foundations – can be found below.

4.6.1 Photographic exposure: the secret exposed

Writing with light

Photography literally means the art of writing with light, as the term originates from the Greek words *phoos* (genitive *phootos*) and *graphoo*, meaning 'light' and 'to write'. It is the whole process of forming and fixing an image of objects by the chemical and physical actions of visible light (although in this chapter all optical EM radiation between NUV and NIR is considered). As the final image is the resultant of EM radiation interacting with a properly sensitised surface (like film and digital sensors), the amount

of optical radiation falling onto that particular sensitised surface is very important and needs to be calculated carefully. This process of allowing EM radiation to fall on the film emulsion or digital sensor is called exposing. Since accurate exposure is fundamental in creating a high-quality photograph, insight in exposure and knowing how to expose accurately is one of the most critical aspects of the photographic process.

Today, most advanced DSCs calculate the exposure automatically, which leaves many people with the conviction that those calculated camera settings are the only correct ones. In fact, one could use largely different camera settings and still obtain a correct exposure. Even more strikingly, the exposure parameters determined by the DSC could be inappropriate. It is therefore important to understand how a certain exposure will translate the real scene into a photographic image and which specific parameters determine an exposure. To allow the needed quantity of EM radiation to fall on the imaging sensor, the camera and lens work together by varying the aperture of the lens and the shutter speed. Both are totally interdependent and determine together with the sensitivity of the sensor (formerly the film speed), the photographic exposure. In the next section, all three elements will be thoroughly discussed and examples to good use provided. Some real-world examples will be given to indicate the different effects one can obtain by cleverly varying the possible values of all three parameters. Finally, this section will conclude with some possible exposure strategies for less convenient situations.

Exposure components: aperture, shutter speed and sensor sensitivity

Every light meter gives the photographer information about the amount of light available. For example, a particular situation may yield the following values: 1/125 – *f*/8 – 400. The first number equals the shutter speed, the second number indicates the lens aperture and the third indicates the sensitivity of the sensor. The first two, shutter speed and aperture, form a particular combination that enables the transmission of a specific amount of EM radiation to the imaging sensor. On the one hand, the shutter speed regulates how long the film is exposed to EM radiation coming through the lens. On the other hand, the aperture regulates the amount of EM radiation that is allowed through the lens. The interplay between those two ensures that the correct amount of irradiance hits the imaging sensor. Although the sensor has a base sensitivity, one can electronically increase or decrease that sensitivity, so that a third parameter completes the exposure equation. Specific combinations of these three variables can yield particular visual results (such as depth of field, frozen movement etc.) even when the total amount of irradiance reaching the sensor stays identical. In the next section, the meaning and working of the aperture setting, often considered the most difficult of the three to grasp, will be detailed. Since light meters in DSCs only work with visible optical EM radiation, I will now use photometric terminology as well as the word 'light' instead of their radiometric counterparts.

Aperture

Like the pupil in a human eye, the aperture allows light to pass through the lens. The aperture thus determines the lens' light gathering power. As such, the maximum

aperture of a specific lens is often said to determine 'the speed of a lens'. Although the aperture can have a fixed size, it is most commonly formed by an iris diaphragm: an adjustable device that is fitted into the barrel of the lens and consists of a series of thin, curved, metal blades that overlap each other. In imaging systems, the device that physically limits the angle of rays passing through the whole system is often called the aperture stop. In photographic lenses, the iris diaphragm is designed to act as a variable aperture stop. It can form a smaller or larger (diaphragm) aperture (see Figure 4.34), just like the iris in the human eye adjusts the size of the pupil.

To achieve a circular aperture, there should be an odd number of straight or curved blades. Nevertheless, the exact number of blades and the shape of the aperture they create may differ, including diamond shapes, hexagons, heptagons etc. When changing the size of the aperture (manually by turning the aperture control ring on the lens or electronically with a dial on the camera), the blades move in unison, changing the size of the aperture's circumference.

Working with the physical size of the aperture would be rather difficult. An aperture of 48.3 mm allows more light to pass in that lens than if it had its aperture set to 21.7 mm, but how much more? Moreover, an aperture diameter of 25 mm on a 50 mm lens is not able to transmit the same amount of light as the same physical aperture on a 200 mm lens. To enable easy calculation with and comparisons of apertures, *f*-stops or relative apertures were introduced. These *f*-stops are ratios, more precisely the ratio of the focal length of the lens to the diameter of the aperture. In the example above, the 50 mm lens with a 25 mm aperture diameter would yield a relative aperture of 50 mm / 25 mm or 2. On the 200 mm lens, the same aperture would yield a relative aperture of 200 mm / 25 mm = 8.

Knowing that the relative aperture $RA = f/D$, the aperture diameter D can be written as $D = f/RA$ which equals in the latter case 200 mm/8, or more briefly *f*/8. This and similar values are used to indicate the specific lens aperture. Lens aperture values thus always consists of a lowercase *f* with a slant (/) between the *f* and the specific value. The great benefit of these notations is that there is no need to bother about the real physical, absolute aperture that the diaphragm encloses. For example, *f*/8 means that the diameter of the diaphragm opening is one eight of the lens focal length.

For a 100 mm lens, *f*/8 thus corresponds to a physical aperture diameter D of 12.5 mm, whereas for a 320 mm lens, *f*/8 indicates a physical aperture diameter of 40 mm.[4] Since the area A of a circle equals $\pi \times (D/2)^2$, a 12.5 mm circle diameter corresponds to a circular area of 122.7 mm². So, although one could impart correct information by saying that 'this image was shot with a 100 mm lens at an effective

[4] When taking a lens apart, it will be apparent that the real physical aperture is nowhere near as big as these calculations show. The latter would only be accurate if the diaphragm blades were mounted directly in front of the front lens element. Since the iris diaphragm is generally buried in the lens, the physical aperture can be made much smaller than these calculations indicate while still retaining the same relationship between each of the adjacent stops.

aperture area of 123 square millimetres', nobody will understand this statement and no photographer could even remember this absolute physical aperture. It is much more convenient to say 'I took this image with a relative aperture setting of *f*/8.'

Using this form of expression, even the exact focal length of the lens is not of relevance anymore. Of course, it would be relevant if one wants to convey information about the possible perspective and framing that was used. To communicate exposure settings, however, the relative aperture takes the focal length out of the equation. Consider again the example of the 123 mm² aperture (i.e. a diameter of 12.5 mm). This aperture area is only equal to *f*/8 with a 100 mm lens. In the case that a 35 mm a 280 mm lens are considered, this ratio is changed around. In fact, 12.5 mm diameter is about *f*/2.8 on the 35 mm lens (35 mm/12.5 mm) and about *f*/22 on the 280 mm lens (280 mm/12.5 mm). Knowing only the *f*/stop thus eliminates the need to know the exact aperture and the focal length used. Additionally, *f*-stops make it easy to compare the speed of different lenses or even switch a lens without the need for different exposure settings, since an aperture of *f*/5.6 will transmit the same amount of light in a 50 mm lens as an aperture of *f*/5.6 will pass light in a 500 mm lens. [As a side note, the latter statement is not 100% correct. A lens consists of different lens elements, each of them blocking very small portions of light by reflecting or absorbing it. Although this effect is normally marginal and therefore neglected in the communication of exposure settings, the *T*-stop (transmission stop) was invented exactly to remedy this. Although *T*-stops can vary from the *f*-stops, certainly when dealing with many (coated) lens elements, only professional cinematographers use the *T*-stop to set the exposure. Moreover, *f*-stops remain important because they control the depth of field (see below).]

A series of relative aperture values are often engraved on the lens barrel (see the lens in Figure 4.34), forming a series like:

<div align="center">1 1.4 2.8 4 5.6 8 11 16 22 32.</div>

Each of these numbers indicates a possible *f*-stop of that lens. What is more, every *f*-stop exactly halves or doubles the amount of light compared to its neighbouring *f*-stops. Thus, an *f*/11 setting allows double the amount of light to pass compared to an *f*/16 aperture, while *f*/5.6 only passes only 25% or ¼ of the light transmitted by the *f*/2.8 aperture (for an explanation, consider Figure 4.34). Every doubling or halving of the amount of light is called a photographic stop or exposure value (EV). As such, *f*/2.8 is said to be one photographic stop faster than *f*/4 and two stops faster than *f*/5.6. Although it may seem counterintuitive, a smaller *f*-stop number indicates a larger aperture and leaves more visible radiation to pass. The reason for this behaviour is that the *f*-stop is a ratio, so small denominators yield big results (one can compare it with a cake which is divided into three or six pieces, the latter cake pieces being smaller – see also Figure 4.34). Closing down the aperture is often denoted 'stopping down a lens'.

So high *f*-numbers = small apertures = small amount of light passed. However, turning the aperture ring from *f*/8 to *f*/11 does not really sound like halving the amount of light. Consider the following example and illustration (Figure 4.34) to clarify this:

The aperture is usually a set of five to fifteen blades which create an approximate circular hole. Using the formula for the area of a circle ($\pi \times (D/2)^2$ or $\pi \times$ radius2), the image shows that with every aperture stop, the surface of the aperture doubles or halves: *f*/8 on an 80 mm lens yields an area of 79 mm^2, whereas *f*/5.6 equals 158 mm^2. The diameter, however, increases/decreases in steps of 1.4 and not 2. For the 80 m lens, *f*/8 yields a diameter of 10 mm and 14.29 mm for *f*/5.6. More exactly, this factor is the square root of two or 1.414. The explanation for this is provided on the right-hand side of Figure 4.34.

The *f*/stop sequence listed above and in Figure 4.34 is the list of full photographic stops (i.e. exactly doubling or halving the amount of light). Lenses will often have a maximum aperture at other-than-full *f*/stops (e.g. *f*/3.5 or *f*/6.3) and photographic exposure settings might be given in 1/2 and 1/3 stop increments. In this chapter we are not concerned with the exact calculation of them as this complicates matters too much. The aperture range of most lenses is about seven to eight stops [Ray, 1999]. This is also the case with the *f*/1.4 50 mm lens depicted in Figure 4.34, which stops down to *f*/16. Since every stop halves the amount of transmitted light, seven stops is said to correspond with a light range of 128:1 (the lower portion of Figure 4.34, which indicates only the first six stops, clearly shows that *f*/11 corresponds to a 64:1 range).

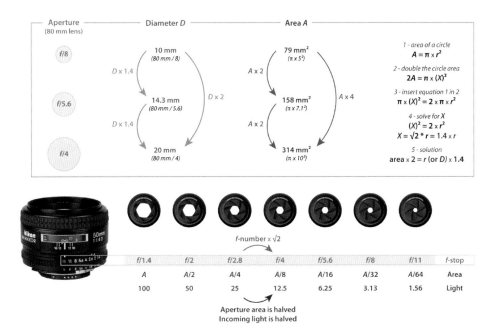

Figure 4.34 Explanation of relative aperture and *f*-stop series.

Thus, the take home lesson here is that the aperture number is inversely related to light collected:

- larger *f*-numbers pass less light;
- full *f*-stops increase/reduce the illumination by a factor of 2;
- each step is called a stop or exposure value (EV).

Since the shutter speed is used to counteract this effect, this will be considered next.

Shutter speed

When a DSC exposes a frame, it allows a specific amount of EM radiation to fall on the imaging sensor. Besides the aperture, this amount is regulated by the shutter speed. As such, the shutter speed is the second main component to determine the final exposure. In a camera, the shutter blocks all incoming light from exposing the sensor until the shutter button is pressed. Then, it opens and closes again, allowing light to reach the imaging sensor for a specific period of time. This duration is called shutter speed. Shutter speeds are measured in seconds and fractions of a second. A typical sequence is:

<div align="center">

2 seconds 1 second 1/2 second 1/4 1/8 1/15 1/30
1/60 1/125 1/250 1/500 1/1000

</div>

Each of these settings is (almost) exactly double/half the length of time of its direct neighbours. Whereas a shutter speed of 1/30 s will allow double the amount of light to reach the film compared to 1/60 s, it is half 1/15 s. From the section on aperture, it is known that such a doubling or halving of light is called a photographic stop or one EV. A half second exposure is thus two stops darker than an exposure of two seconds (keeping all other parameters identical of course), while an exposure of 1/125 s passes three stops of light more than a 1/1000 s exposure (Figure 4.35). Most cameras offer a shutter speed range that is larger than the aperture range [Ray, 1999]. Currently, shutter speeds of 30 s to 1/2000 s are generally available in most consumer digital cameras, hereby effectively creating a sixteen-stop range. Sometimes, a bulb mode (denoted by 'B' on the dial of Figure 4.35) can be chosen as well. This mode allows for exposure times to be determined by the photographer. It is mainly used when much longer shutter speeds are needed to allow enough light to fall on the imaging sensor (e.g. photographing stars) or to increase the chance of capturing a specific event (flashes of fireworks or lightning).

It is crucial to understand that shutter speed and aperture work together in a camera. Changing one generally means that the other has to change in the opposite direction (that is, when leaving the ISO value – see below – out of the equation). Imagine that a camera indicates an exposure of *f*/8 and 1/125 s. When one wants to change the aperture to *f*/11, the amount of light is reduced by one stop. This has to be made up by opening the shutter speed one stop, effectively setting it at 1/60 s. Therefore, the following combinations all transmit an equal amount of light:

<div align="center">

f/2.8 @ 1/500 s = *f*/4 @ 1/250 s = *f*/16 @ 1/15 s.

</div>

This principle is called the law of reciprocity in photography. As explained above, it simply states that there is an inverse relationship between the amount of transmitted light (controlled by the aperture) and the duration that this light exposes the camera sensor (controlled by the shutter speed) to obtain a correct exposure. This law of interchange is graphically explained in Figure 4.35: if the aperture is opened up (i.e. smaller *f*-number) the shutter has to close faster (i.e. a shorter shutter speed). In film-based photography, there were some situations whereby the law of reciprocity broke apart. Those cases of reciprocity failure occurred when the photographer had to expose the film for more than a few seconds, since film emulsions were disproportionately sensitive to various light levels. Luckily, the linear behaviour of digital imaging sensors has put reciprocity failure to the dust bin (although long exposures are very noise-prone in the digital age). Below, it will be shown how the interplay between shutter speed and aperture can create specific effects and how a thorough understanding of their reciprocal relationship is essential to successfully increase the depth of field or maximise the quality of an image.

Generally, shutter speeds are achieved by incorporating an on-chip electronic shutter or installing a mechanical shutter, all with their own cons and pros. Although some digital cameras might even use a combination of a mechanical and electronic shuttering mechanism [Eastman Kodak Company, 2011], most photo cameras use the mechanical shutter types, located either within the lens (a leaf shutter) or just in front of the

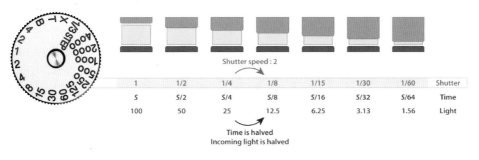

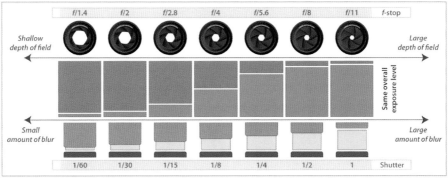

Figure 4.35 Explanation of shutter speed (up) and its reciprocal relationship with aperture (down).

sensor, the so-called focal plane shutters [see Ray (1999) for an overview of shutter technology]. Conventionally, medium- and large-format cameras feature lenses with built-in leaf shutters or a shutter that is positioned just behind the lens (some might even work as the aperture mechanism). On the other hand, 35-mm-type cameras that use interchangeable lenses are equipped with focal plane shutters, consisting of blinds that run either horizontally or vertically just in front of the sensor. Figure 4.36 depicts the operation of such a two-curtain focal-plane shutter which travels vertically. Before the exposure (1), the first blind or curtain covers the whole imaging sensor. As soon as the exposure is initiated (2), this curtain runs downwards, hereby uncovering the sensor and allow light to fall on it. When this first curtain has completed its travel, the entire frame is fully exposed to light (3). When exposure time ends (e.g. after 1/30 s), the second curtain is released (4) and moves vertically across to entirely cover the sensor again (5). At this moment, the exposure is completed.

Figure 4.36 (1–5) illustrate a slow shutter speed: the first blind has finished moving before the second starts. As a result, the sensor is completely uncovered for a short time. When photographing with a fast shutter speed such as 1/2000 s, the first curtain will not even be at the other side of the imaging sensor before the second curtain starts chasing it (Figure 4.36 (6)). The whole imaging sensor will thus only be uncovered by the gap between the two curtains and as such exposed by a narrow moving slit of light.

The fact that focal plane shutters do not allow the sensor for a single moment to be completely exposed to the incident light is often an issue in flash photography. To shoot with a flash, a shutter speed must be selected so that the first curtain reaches the end of the frame before the second curtain runs across, leaving just a brief instant of total frame exposure during which the flash can be fired. Consequently, flash synchronisation (flash sync) is limited to a relatively slow speed: 1/90 s to 1/250 s. The fastest shutter speed that will synchronise the electronic flash with a fully uncovered sensor

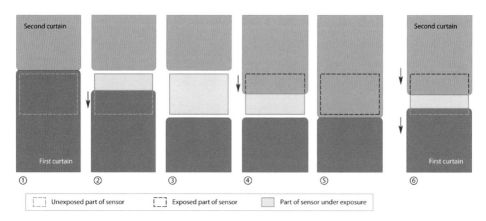

Figure 4.36 The principle of first and second curtain of a focal plane shutter. (1–5) depict the individual steps of a slow shutter speed, while (6) represents a fast shutter speed.

is also called X-sync. Some of the more modern cameras feature sometimes X-sync speeds of 1/500 s. This can, however, only be effectively put to use when the electronic flash fires several times during the slit movement across the sensor.

In this situation, vertical moving shutters have the edge over the horizontal moving blinds. Although the horizontal travelling shutter mechanisms were once believed to be more durable and reliable, they need to travel across the long dimension of the imaging sensor. Compared to the vertical travelling shutter, the shutter curtain travelling time is longer, making the maximum sync slower. This whole issue is off course of no importance when dealing with electronic shutters. Cameras without physical shutters can thus allow for very high X-sync speeds.

Although it is a much less-known characteristic of focal-plane shutters, they might induce shape deformations for very fast moving subjects. Since certain shutter speeds sequentially uncover the sensor by the travelling slit, one edge of the film is exposed slightly before the other end and moving objects might thus be slanted. The end-result can be a shortened or elongated object, but the exact geometrical distortion depends on the relationship between the curtain's travel direction, the subject's movement and the camera orientation (see the nice drawing from 1949 in Figure 4.37 to illustrate this effect). Although this kind of deformation is generally very difficult to notice and therefore often neglected in practice, it might be of importance for specific photogrammetric applications such as airborne mapping [Ferrano *et al.*, 2010]. Similar but much larger geometric deformations might, however, really become an issue when imaging with a specific type of electronic shutters.

Electronic shutters are often used instead of a physical shutter for simpler and smaller DSC such as pocket or action cameras, because an all-electronic design keeps the camera compact. When lacking a mechanical shutter, the sensor itself has to start and stop the exposure. Ideally, all photosites of the imaging array start and stop the accumulation of photons simultaneously. In that case, the sensor is said to have a uniform/global/non-rolling shutter. Although this property characterises almost all consumer and industrial CCD-based imagers, simultaneous charge collection with a global shutter is only found in the most expensive CMOS-based devices.

When manufacturers decide to implement such a global shutter in a CMOS imager, it requires more opaque transistors per photosite to temporarily hold the charge, hereby reducing the photosensitive area and increasing the cost [Dalsa Corporation, 2005; Litwiller, 2005]. So, to cut costs and design complexity, the CMOS sensors embedded in the consumer reflex cameras and action cameras have simpler photosite designs and only read out one row (or a group of rows) of their array at a time. As a result, these imaging sensors are said to have an electronic rolling shutter. In contrast to global electronic shutter CMOS imagers, these rolling shutter sensors cannot properly freeze any fast object. Because the sensor processes the image row by row, a specific row of photosites is read out while other lines of photosites are still exposed. Due to its analogue with a focal plane shutter, rolling shutters are sometimes denoted as electronic focal plane shutters [Eastman Kodak Company, 2011].

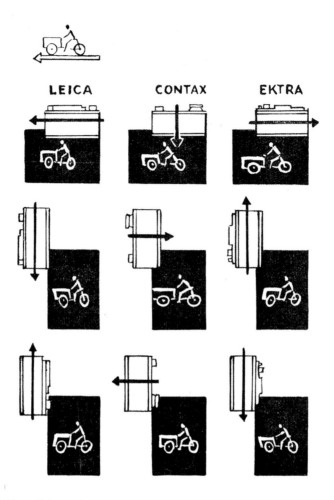

Figure 4.37 Object deformations caused by the shutter. Deformations clearly depend on the relation between the subject's direction of movement, the camera's orientation and the curtain's travel direction [Tadeusz, 1949], p. 54.

Analogous with focal plane shutters, rolling shutters might also produce images with geometric distortions (although the artefacts produced by mechanical focal plane shutters are more rare and generally smaller). Since a rolling shutter builds up the image over the whole frame in a sequential way from top to bottom, each row will represent the object at a different point in time. This 'moving' exposure process induces geometric distortions in the collected footage when the object (or the camera) is moving during the exposure, since the DSC will then image the object at different points in space. As an example: if a school bus is moving through the image frame during the image capture, light emanating from the top of vehicle will be integrated earlier than light from the bottom of the bus. As a result, the bus appears skewed. Additionally, fast changing light conditions might not be imaged accurately, since the entire frame is not exposed for the same time window, leading to partially captured phenomena or

abrupt exposure differences. Depending on the subject imaged, its speed and direction of movement as well as the position and movement of the camera, distortions such as partial exposure, jello, skew and smear may occur due to the rolling shutter technology [Eastman Kodak Company, 2011; Liang *et al.*, 2008].

Luckily, most scenes that are imaged for cultural heritage purposes are static scenes for which the relationship between scene and camera stays unchanged and rolling shutter sensors work problem-free. The issues only become apparent when dealing with dynamic scenes: i.e. if the object or camera is moving fast and the readout speed of the imaging sensor is too slow. In these circumstances, the artefacts caused by a rolling shutter device not only decrease the visual quality of the footage, but they can make 3D reconstruction from video or stills impossible, as one image provides multiple points in time within the same frame and each row of the image has its own projection parameters [Forssén and Ringaby, 2010; Jia and Evans, 2012].

ISO

The film speed or sensitivity of the sensor is the third factor of importance in a photographic exposure. The ISO value is a figure which expresses the sensitivity of the film or the sensor to incoming light. The basic value, which was standardised by the International Organisation for Standardisation (hence ISO), is ISO 100. When the photosensitive device is said to have an ISO value of 200, it is twice as sensitive as the basic sensitivity of 100. As such, a film or sensor characterised by ISO 200 needs only half the amount of light to yield the exact same exposure of an ISO 100 device. Every time the ISO value is doubled, the film/sensor's sensitivity is doubled and the amount of light needed for proper exposure is halved (Figure 4.38). Every doubling or halving is again called a (photographic) stop. It is thus said that ISO 400 is a stop slower than ISO 800, but three stops faster than ISO 50. As with aperture and shutter speeds, there are half- and third-stops intervals in the ISO series as well.

In the film era, two other values were used to denote the sensitivity of the sensing device. One was ASA, short for American Standards Association which followed the exact same numeric values as the current ISO notation. The other one was DIN, a standard established by the Deutsches Institut für Normung, which expressed sensitivity logarithmically in degrees. Each additional stop was indicated by adding 3°. The relation between all three is illustrated in Figure 4.38.

ISO x 2

25	50	100	200	400	800	1600	ISO
15°	18°	21°	24°	27°	30°	33°	DIN
25	50	100	200	400	800	1600	ASA

Sensitivity is doubled
Necessary light is halved

Figure 4.38 Explanation of the ISO value and its relation with other sensitivity standards.

Although it might be tempting to use very high ISO values, there is a significant drawback to this practice: less resolved details and more image noise. For photographic film, which is simply a light-sensitive emulsion on a plastic base, the sensitivity is determined by the size of its millions of light-sensitive crystals. Less sensitive (i.e. slower) films have finer and more closely packed crystals, while faster, more sensitive films have coarser crystals [Jacobson *et al.*, 2000]. High ISO films therefore look 'grainy'. Whereas one has to physically switch the film to work with another ISO setting, digital photography makes it possible to switch the DSC's ISO sensitivity between individual exposures. This ease of change means that in digital imaging, the ISO value really became an integral part of the whole exposure chain. Despite the possibility to change ISO on-the-fly, imaging sensors have a fixed response to incoming radiation. This means that, irrespective of the ISO setting dialled in, the response of the sensor to a fixed amount of incoming light results in an identical charge. A DSC is therefore said to have just one base ISO. However, DSCs can vary their ISO setting digitally. When the sensor generates the small analogue voltages from the incident photons, these voltages can be amplified with a certain gain by the read-out amplifier to correspond to the DSC's specific ISO value set [White, 2006]. These voltages are then quantised. ISO is thus determined by the DSCs gain, which is said to represent the conversion factor from electrons into DNs [Nelson, 2013].

Due to this digital amplification, the following rule is valid:

the lower the ISO setting, the less noise will be found in the image
and the higher the image quality.

However, the penalty is that one has to deal with a less light-sensitive device and that tripods might be essential to obtain a pin-sharp image. High ISO settings on the other hand provide a very light-sensitive device, but they come at the penalty of grainy or noisy images. This results from the high gains that need to be applied to artificially increase the base ISO to the ISO value set by the photographer. Small amounts of noise that would go unnoticed at low ISO setting are now significantly amplified and become very easy to spot as a kind of random speckling. The higher the ISO, the worse this noise becomes. Due to their smaller photosites, images of compact cameras are often already very noisy at ISO 640 to ISO 800. The latest full frame D-SLRs on the other hand can easily be used up to ISO 3200 before noise really becomes an issue.

The effects of shutter speed and aperture

Apart from their function in controlling the exposure, aperture and shutter speed can be used creatively to obtain specific photographic effects.

Depth of field

When photographing a subject, it is not only very important to know on which point the lens was focused, but also how far this zone of 'sharpness' reaches, since an unsatisfying sharpness might be easy to resolve by increasing the depth of field. This depth of field (DoF) can be defined as the range of object distances over which objects appear

acceptably sharp in the photograph. Although Dof can be easily influenced by changing the sensor size, the lens aperture, the focal length and the object distance, the exact DoF that one needs depends on the definition of sharpness. What exactly is sharp? Not only is the perception of sharp versus blurry dependent on the individual that needs to asses it, it also depends on the metric that is used to quantify it.

In Figure 4.39 there are seven different photographs of the same scene. The only difference between these images is the aperture that was used (of course, the shutter speed was changed correspondingly to yield six identical exposures). Upon observing this illustration, it is easy to notice that photographic sharpness is not clearly divided into a perfect sharp and a completely unsharp zone with an abrupt border between them. No, there is a gradual decrease in sharpness. The part of the scene on which the lens was focused is perfectly sharp, but in front and behind this focusing point, blur gradually increases. To clearly define what is considered sharp and unsharp in an image, a well-defined metric – based on human vision – is needed. Despite being a wonderful sense that works in an amazingly complex way, human vision is not perfect. A point does not need to be infinitesimally small to appear sharp, but it can have some finite dimensions before it is perceived as blurry. This is very beneficial, since a photographic lens is also unable to render an object point as a perfect point in image space due to several lens aberrations and the effect of diffraction (tackled in 4.5.5 and 4.5.6 respectively). The dimension of the spot or circle that results from imaging a point by a lens is denoted blur circle or circle of confusion (CoC). As long as this CoC is smaller than the minimum circle which is no longer perceived as a point but as a circle (denoted the CoC threshold or maximum permissible CoC), the point is said to be sharp.

To understand this principle and the influence of the CoC on the perception of digital image sharpness, consider Figure 4.40. Using again some simple principles of geometrical optics, it is easy to visualise that radiation from a point in object space will be focused by the lens into a spot in image space. When the lens is perfectly focused on that object point, the image point will be located exactly on the imaging sensor. Although lens aberrations and diffraction still limit the smallest size of this image spot, it is denoted the circle of least confusion since it is the smallest spot reproducible by that lens [Katz, 2002]. The circle of least confusion equals thus the spot where the image is blurred the least. From section 4.5.6, it can be deduced that the circle of least confusion is determined by the PSF of the complete imaging system (PSF_{sys}).

Object points that are further away from the focus point do not come to a perfect focus on the imaging sensor, but before or after it. In both cases, the object spots are rendered as much larger circles than the circle of least confusion. The upper part of Figure 4.40 shows that these objects spots will still be perceived as sharp as long as their CoCs remain smaller than an established CoC threshold. The lower part of Figure 4.40 illustrates how the same object points are imaged as much smaller spots when photographed with a smaller aperture. By limiting the angle of incident EM radiation, all the CoCs decrease. Moreover, objects points that lie much further from the initial focus point can now still be imaged before their CoC surpasses the CoC threshold. As a result, there is a major increase in the distances in objects space (the DoF) over which objects

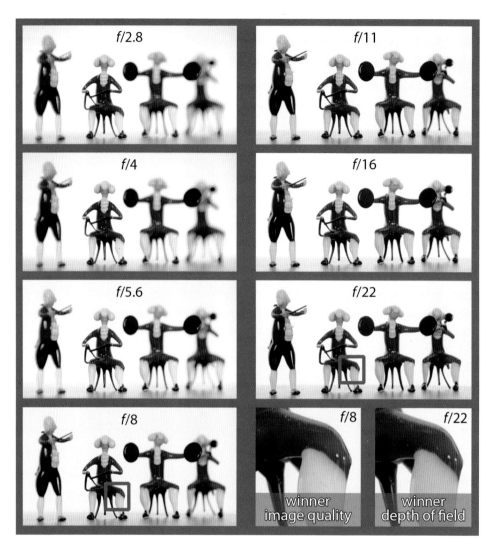

Figure 4.39 The visual effect of aperture on the amount of image sharpness. Although the f/22 frame has by far the largest DoF, the f/8 frame features the highest image quality since the aberrations of this lens (Nikon AF-S VR Zoom-Nikkor 70–200mm f/2.8G IF-ED @ 200 mm) are minimised at this aperture and diffraction is much less compared to the smaller apertures.

still remain acceptably sharp in the photograph. Stopping down the lens will thus always maximise the DoF. The image–space conjugate of DoF is often termed depth of focus [Ray, 2002]. The object distances that correspond to the object points whose CoCs are identical to the CoC threshold are called the far and near focus limits. Any object point that lies before the near focus limit or behind the far focus limit will be perceived as an unsharp spot. How aesthetically those unsharp spots are rendered is often denoted with the Japanese word for 'fuzzy': bokeh. Although bokeh is a very subjective appreciation of big CoCs, most photographers agree that specific lenses yield more pleasing bokeh than others (usually those lenses which have more blades in the diaphragm).

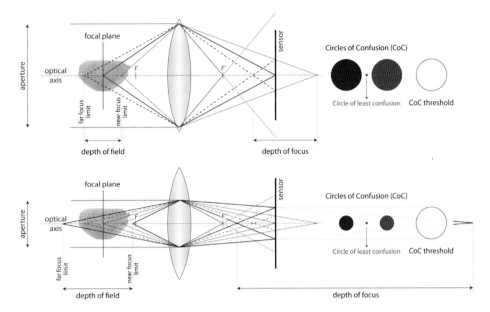

Figure 4.40 The influence of aperture size on the DoF, the depth of focus and the far and near focus limits.

However, as mentioned before, these far and near focus limits should not be considered abrupt transition zones. Moreover, their exact values depend on various parameters, not least the particular value of the CoC threshold. So far, the CoC threshold has not been given a specific value. This is deliberate, since its value is dependent on the vision properties of the observer, the viewing distance to the image and the enlargement of the image (e.g. its printing size). As such, the CoC is subjective and variable.

Often, one will find that the standard CoC threshold equals 0.03 mm [Jacobson *et al.*, 2000]. This dimension is, however, specified for very specific conditions. First, it assumes that a human observer with normal vision (i.e. 6/6 or 20/20 vision) looks from 30 cm at a 20 cm by 30 cm print from a photograph that was acquired with a full frame sensor [Ray, 2002]. If all these conditions are satisfied, the observer will perceive any spot with a size smaller than 0.03 mm as a sharp point. If the observer has a worse than average vision, the CoC can be larger of course. When dealing with smaller viewing distances, 0.03 mm will be perceived as fuzzy so the CoC threshold has to decrease. It might sound strange, but photographs that are acquired with smaller sensors also demand smaller CoC thresholds. The explanation is, however, straightforward since smaller sensors must be magnified more to equal a print of a given size. An easy way to compute the sensor-dependent CoC threshold is to divide the sensor diagonal (mentioned in Figure 4.30) by 1500.

- full frame / 35 mm → 43.27 mm / 1500 = 0.03 mm;
- APS-C sensor → 28.21 mm / 1500 = 0.02 mm;
- iPhone 5 sensor → 5.68 mm / 1500 = 0.004 mm.

Because the physical dimensions of an APS-C sensor are 1.5 times smaller than the full frame sensor, all the image data captured by the APS-C sensor have to be magnified 1.5 times more than the full frame data to yield a print of 30 cm by 20 cm. Therefore, the CoC threshold of the APS-C sensor is 1.5 times smaller than the full frame CoC threshold. Because the CoC threshold of these smaller-than-full-frame image sensors is also smaller than the full frame CoC threshold, the DoF of small sensor photographs will be more limited. That is, when using the same object distance and focal length! Consider the flowing example: a Sony SLT-A77 II (23.5 mm × 15.6 mm; 1.5 crop factor) versus a Canon EOS 5D Mark III (full format) camera. Both DSCs feature a 50 mm lens, which is set at *f*/8 and focused at a subject on 3 m distance. Using a small piece of software to compute the DoF for the Sony yields 1.2 m, while the full frame Canon delivers 1.8 m (or 1.5 times the Sony DoF). However, because the sensor sizes are different, both DSCs would render a completely different scene due to their dissimilar FoVs. As such, one should always compare DoF for the same FoV.

Section 4.5.8 made it clear that the focal length should be changed on one of the cameras and/or the object distance should be altered. Since a smaller sensor yields a much smaller FoV than a larger sensor when fitted with the same focal length lens (see Figure 4.33), obtaining the same FoV as the larger sensor can be achieved by applying a shorter focal length or stepping away from the scene to increase the object distance. However, both operations would largely increase the DoF because they shrink the scene on the image sensor so that more of the scene fits in the image (i.e. a wider scene). When a print of this shrunk but wider scene is viewed next to a print of the limited but less shrunk scene (recorded with the smaller FoV but with the same image sensor), objects in the wider scene will be printed smaller than the same objects in the confined scene. As such, more object spots will appear sharp in the wider scene because their absolute magnification is less than the same object's prints of the limited scene. Moreover, this DoF increase largely surpasses the DoF decrease because of the smaller CoC threshold. The same happens when the FoV of the larger sensor is equalised to the scene viewed by the smaller sensor: the focal length is increased and/or the object distances decreased, both yielding a much smaller DoF because smaller FoVs further enlarge the scene on the image sensor.

As such, it can be safely stated that the DoF is inversely proportional to format size for the same FoV and aperture. This can be verified with the same DSCs from the example before. Now, the Sony SLT-A77 II (23.5 mm × 15.6 mm; 1.5 crop factor) is still fitted with the 50 mm lens, while the full format Canon EOS 5D Mark III features a 75 mm lens. The aperture and subject distance remain identical: *f*/8 and 3 m respectively. These parameters yield a DoF for the smaller sensor of 1.1 m, whereas the full frame body generates a DoF of 0.7 m. Since everything in photography has pros and cons, so do smaller image sensors. Although their larger DoF might be very beneficial for certain situations, they will also make it more difficult to isolate a subject from its background by throwing the latter completely out-of-focus. Additionally, smaller sensors are more prone to image noise.

To summarise, DoF is influenced by:

1. sensor size;
2. FoV (determined by object distance and focal length);
3. aperture.

Since it is not that straightforward to keep all these parameters in mind and compute the exact DoF for a given setup, it is advised to use one of the many DoF calculators (even as a smart phone application) that can be found freely on the Web. Besides all the parameters described here, such applications also compute the DoF fraction which is in front of and behind the focus point. This is a useful feature because this ratio changes with focal length. Many older lenses also feature colour-coded DoF indicators engraved on the lens barrel. Finally, most D-SLRs have a DoF preview button. When looking through the viewfinder of a D-SLR, the scene is shown at the largest lens aperture for ease of focusing. Since this is not really helpful to properly assess DoF, a dedicated DoF preview button that allows to check the exact zone of sharpness can come in handy. Of course, one can always review the image using the LCD (liquid crystal display) at the back of the camera to check the DoF and focus.

Hyperfocal distance

DoF is of the utmost importance in most aspects of photography. Not only are the manipulation of its extent and exact position a great creative way of photographic expression, rendering objects reasonably sharp is also of great importance in technical photography (e.g. if 3D data needs to be extracted from the image). Equally import-ant is the maximum DoF that can be obtained in a specific situation. To accomplish this, the hyperfocal distance needs to be used. To determine the hyperfocal distance, a camera lens should be focused on infinity. The distance to the nearest object that is rendered acceptably sharp equals then the hyperfocal distance [Saxby, 2011]. As said before, the use of this hyperfocal distance can be of great value. Given a certain aperture and focal length, when a lens is focused at the hyperfocal distance, it means that the DoF of that camera-lens-aperture combination is maximised and everything from half the hyperfocal distance to infinity is reasonably sharp [Ray, 2002].

As an example: the hyperfocal distance of a Pentax K-5 II (23.7 mm × 15.7 mm; 1.5 crop factor) that is fitted with a 20 mm lens set at *f*/8 is 2.52 m. When focusing this lens on a subject 2.52 m away from the camera, everything from 1.26 m (i.e. the near focus limit) to infinity (i.e. far focus limit) will be sharp. As with DoF, formulas exist to compute this hyperfocal distance, but it is again easier to use a simple computer programme to do so.

Image quality

By now, it should be known that smaller apertures increase the DoF in an image. Besides, stopping down a lens also reduces the effects of vignetting, spherical lens aber-ration and coma while also positively influencing the effects of astigmatism and field

curvature, albeit to a smaller extent. However, small apertures lead to larger image spots because of diffraction. Since a specific aperture can thus both positively and negatively influence the scene rendering, every lens has one *f*-stop or a small range of apertures at which the ideal balance between lens aberrations and diffraction is reached. Although the optimum aperture varies from lens to lens, it is a reasonable assumption to state that the maximum image quality can be found by stopping down the lens about two to three stops from wide open. For most modern lenses, this means that the ideal aperture range is normally between *f*/5.6 and *f*/8. This could be verified for the Nikon AF-S VR Zoom-Nikkor 70–200mm f/2.8G IF-ED that was used at 200 mm for the photographs in Figure 4.39. Close examination of all frames proved the *f*/8 setting to yield the best image quality when used at 200 mm (which is three stops from the maximum lens aperture *f*/2.8). The sharpness at higher *f* numbers is generally too much constrained by diffraction. On full frame cameras, *f*/11 can sometimes be used before diffraction softening starts to appear.

Of course, if a faster shutter speed is needed or a larger DoF, one still has to choose the corresponding aperture. Although these very large or tiny apertures will reduce the maximum attainable image sharpness to a certain extent, they are the only options to get the overall result one is looking for.

Motion blur and its prevention

Besides aperture, shutter speed can also greatly influence the look of an image. Shutter speed is for instance of primordial importance to omit motion blur, resulting from both subject movement as well as camera shake. Short shutter speeds are said to 'freeze' object motion. A fast-moving subject such as a car will not be depicted sharp if the shutter speed is too slow (e.g. 1/15 s). In those situations, image motion blur will occur. To overcome this, a much faster shutter speed such as 1/2000 s or even 1/4000 s should be used. In essence, it means that the image distance over which an object point is imaged (i.e. the blur) must be less than the threshold CoC (see earlier).

The appearance of motion blur is, however, not only dependent on the object, but also on the movement of the camera itself. If the camera itself moves during the exposure even a static object will be blurred when the shutter speed is too slow to freeze the camera shake. This camera motion is not only present when shooting from fast moving subjects such as a car, an airplane or a bike, but even user tremor can result in vibrations whose magnitude is too big to counteract by the shutter speed. This kind of hand-shake induced blur worsens with longer lenses. To still obtain a sharp image from a hand-held camera and lens combination, the general rule-of-thumb is that the shutter speed should be equal or faster than the reciprocal of the focal length in use. As an example: a 300 mm lens necessitates a shutter speed of at least 1/320 s. If this is not possible, three other options remain.

Shooting images in rapid succession significantly increases the chance of getting at least one sharp image while hand-holding the camera. This technique could also be combined with some form of vibration reduction/image stabilisation to further reduce camera shake. Generally, good stabilisation (which can be implemented in the lens as

well as in the camera body) allows for shutter speeds that are two to three stops slower than the reciprocal of the focal length. The 300 mm lens could thus be used hand-held at shutter speeds of 1/80 s. Although very effective, such optical stabilisation mechanisms do not offer any added benefit when shooting fast moving subjects!

Finally, if none of these techniques work, extra support is essential. Although a very sturdy tripod comes directly to mind, other means of support such as a bag of sand or a wall can also suffice to avoid results that are ruined by hand-held camera shake. Since not all tripods are created equal, one should opt for the most sturdy (which often means heavy and expensive) possible. Very light and flimsy tripods can be a nightmare to position correctly with a decent camera and lens attached; a gust of wind might easily knock them over as well. Moreover, sturdy tripods mean less overall camera movement. A good general tip to make a tripod even sturdier is to attach something heavy (such as the camera bag) at its base.

For true pin-sharp imaging, putting the camera on a solid tripod is often not sufficient. Although the tripod will drastically reduce any camera shake, pressing the camera shutter button might result in vibrations that limit the sharpness of the final image, certainly when dealing with shutters speeds of 1/10 s or longer. Using the built-in self-timer or a separate remote shutter release (preferably a wireless release) will ensure vibration-free shutter operation. Additionally, it might be essential to use the mirror-lockup function of a D-SLR. Since these DSCs feature a mirror which flips up just before the exposure starts, the vibrations that originate from this mirror slap are still present in the camera body at the beginning of the exposure. Although they will be tackled by very fast shutter speeds or extremely long exposures (all the vibrations will die out in the very beginning of the exposure), they influence shutter speeds in the 1/125 s to about 1 s range. For the best possible result, mirror-lockup should always be combined with a remote shutter release. Unless the lens has a mechanism to detect if it is positioned on a tripod (yes, some modern lenses really do have this feature), lens image stabilisation should always be turned off when using a tripod. Since these mechanisms try to reduce vibrations, they might actually cause them when they don't find any to cancel. For photogrammetric image acquisitions, any vibration reduction mechanism should always be turned off since they constantly change the internal camera geometry.

Correct exposure

A DSC is a rather well-programmed piece of equipment that can make many photographic decisions. However, to do so, the DSC has to assume certain facts. Since these assumptions might be wrong or the photographer wants to create another visual effect than the one envisioned by the DSC's internal computer, it is good to use the basic knowledge of exposure components and the effects of shutter speed and aperture to delve a bit deeper into the mysteries of photographic exposure.

The ISO-A-S interplay

By now, it should be clear that shutter speed S, aperture A and ISO all determine a specific exposure. Books often mention the exposure triangle to illustrate that these three

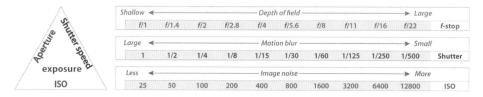

Figure 4.41 The interplay between aperture, shutter speed and ISO value.

factors balance the light equation of every photo (Figure 4.41). Since they act together, there is a strong interdependency between them. More specifically, when one of those three parameters changes its value, one or both remaining parameters have to be altered as well to compensate for this effect. Very often, one of the three parameters is set to a specific value to obtain a particular effect.

For example: short shutter speeds can freeze the action, but their use necessitates a higher ISO value and/or a larger aperture. Very small apertures maximise the DoF in an image, but using high *f*-numbers demands longer shutter speeds or higher ISOs to compensate for the reduced amount of radiation that travels through the optics (Figure 4.41). With the effects of shutter speed and aperture in mind, consider the following real-world situation: a landscape scene in the late afternoon for which the DSC computed the following exposure settings: *f*/8 and 1/125 s at ISO 200. In the following example, these exposure settings will be altered to create two completely different images of this landscape scene. To better understand the reasoning behind the possible photographic solutions and ease the general understanding of adding/removing stops of light, it is advisable to use Figure 4.42.

Solution 1 – Although one could agree with the DSC settings and simply acquire the image, the landscape might feature a waterfall. Very often, landscape photographers love longer shutter speeds when photographing water as it renders the water more creamy (short shutter speeds freeze all water drops). In this case, the photographer opts for 1/30 s. Compared to the initial shutter speed of 1/125 s, this is an increase of two stops (one from 1/125 s to 1/60 s and one more from 1/60 s to 1/30 s). To use this changed shutter speed and still render the scene properly exposed, the aperture and/or ISO value have to be altered in such a way that they counteract these

Auto exposure settings	f/1	f/1.4	f/2	f/2.8	f/4	f/5.6	f/8	f/11	f/16	f/22	f-stop
	1	1/2	1/4	1/8	1/15	1/30	1/60	1/125	1/250	1/500	Shutter
	25	50	100	200	400	800	1600	3200	6400	12800	ISO

1st creative exposure solution	f/1	f/1.4	f/2	f/2.8	f/4	f/5.6	f/8	f/11	f/16	f/22	f-stop
	1	1/2	1/4	1/8	1/15	1/30	1/60	1/125	1/250	1/500	Shutter
	25	50	100	200	400	800	1600	3200	6400	12800	ISO

2nd creative exposure solution	f/1	f/1.4	f/2	f/2.8	f/4	f/5.6	f/8	f/11	f/16	f/22	f-stop
	1	1/2	1/4	1/8	1/15	1/30	1/60	1/125	1/250	1/500	Shutter
	25	50	100	200	400	800	1600	3200	6400	12800	ISO

Figure 4.42 Three visually different exposures of a normal landscape scene.

two extra stops of light. Keeping the ISO value identical, one can dial the aperture to *f*/16. However, since most lenses already suffer from significant diffraction at this *f*-stop (see 5.6), it is better to remove just one photographic stop by reducing the aperture from *f*/8 to *f*/11. Decreasing the ISO from 200 to 100 takes care of the last stop. The new exposure setting (*f*/11 and 1/30 s at ISO 100) is thus equivalent to the initial one concerning the amount of captured light, but it will render the water in the landscape more creamy while slightly increasing the image's DoF. Depending on the lens that is used, a tripod might be needed to acquire a hand-shake-free image with this shutter speed.

Solution 2 – If the photographer wants to have a Roman milestone in the foreground of the image and a large DoF extending from this milestone to the horizon, a very small aperture and hyperfocal distance focusing become essential. In this case, the smallest aperture possible on the lens is *f*/22, which effectively transmits three stops less light than *f*/8. Using this aperture together with the sensor size and focal length, the hyperfocal distance can be computed. The photographer then positions the DSC so that the milestone still falls in the camera's DoF when focused on a point that is one hyperfocal distance away from the camera. Of course, that point of focus could also be the milestone itself, so that the DoF extents in front of it. Now, the remaining exposure parameters should be set. If the aperture change is counteracted with an identical three-stop change in shutter speed (i.e. 1/15 s), there is a serious danger of inducing image blur when no tripod is available (even with very short focal lengths, 1/15 s is generally too long an integration time to keep a camera and lens perfectly steady). Leaving the shutter speed at its initial value and increasing the ISO value with three stops to ISO 1600 might result in a noisy image. Although ISO 1600 is not a big hurdle for most recent cameras that have APS-C or larger image sensors, it will always lead to (very) noisy photographs when acquired with a smaller image sensor. Therefore, choosing 1/60 s (i.e. one stop slower than 1/125 s) and ISO 800 (i.e. two stops faster than ISO 200) might be the best compromise for most camera systems: the image can be taken without a tripod (if the focal length is shorter than 60 mm), while the DoF is maximised and the amount of noise kept under control.

Shooting modes

In the example above, the basic reasoning behind two different photographic exposures was explained. To help the photographer in his creative process and omit the calculations that were executed above, almost all cameras have different shooting modes which one can choose from. These shooting modes can be subdivided in three broad categories, being the auto, scene and exposure modes. The auto and scene modes take all possible control over shutter speed and aperture away from the photographer. The P, S, A and M exposure modes allow one or more elements of the exposure to be manually controlled by the photographer.

Auto – Although all but the very basic DSCs come with different shooting modes, many people do not dare to venture away from the settings the camera had when they took it

out of the box. In that case, the camera is still in the so-called auto(matic) mode. This mode leaves all thinking and decision making to the camera. The camera will set all exposure settings to obtain an assumed optimal exposure, even if this means that the flash has to pop up. Since the resulting images will always look 'good enough', this mode is ideal for beginners. However, the auto mode should be quickly moved away from as it does not exploit the full potential of the camera, nor does it allow the expression of a photographer's ideas.

Scene modes – Many DSCs in the consumer and prosumer segment feature a number of modes that are optimised for specific scenes like sports, macro, landscapes, fireworks or sunsets. These scene modes, whose number and naming differs from camera to camera, are nothing more than some pre-programmed parameter behaviour. The sport mode, for instance, will try to use the shortest shutter speed possible, whereas a macro and landscape mode will stop down the lens to maximise the DoF in the image. Similar to the auto mode, scene modes are intended for the absolute beginner who wants quick and decent-looking results and does not feel the need for a slightly deeper understanding of the photographic basics.

Exposure modes
- P (Programme)

Although the programme mode might differ from camera to camera, it is usually an auto-mode with added flexibility that allows the user to choose different combinations of aperture and shutter speed. This means that the DSC will still compute all three elements of the exposure triangle to yield an optimal exposure, but the photographer can easily shift the aperture or shutter speed settings in one or another direction.

- A (Aperture priority)

Aperture priority mode was invented so that the photographer could have precise control over the aperture setting, while the camera determines the correct amount of light that falls onto the sensor by regulating the shutter speed (and sometimes also the ISO setting). In the landscape example, a small aperture was used to increase the DoF. To isolate an artefact from its distracting background, one could use mode A and set a very small *f*-number (e.g. *f*/2.8) to obtain a shallow DoF. Of all possible modes, mode A is most often used by professional photographers since the DoF is one of the key elements in a striking image.

- S (Shutter speed priority)

In the shutter speed priority mode, the photographer is only tasked by determining the shutter speed. Using mode S frees the photographer from thinking about correct aperture (and sometimes also the ISO value) since the DSC bothers with them. This setting is very handy when the photographer wants to take control over the motion or blur in the photograph.

- M (Manual)

Although professional photographers might use mode M, setting all three elements of exposure manually is not for the ill-prepared. This manual mode puts all exposure settings in the photographer's hands, so that she or he must rely on the camera's light meter and personal experience to set the correct parameters in a reasonable amount of time. Since every parameter influences the other parameters of the exposure triangle, it is very easy to become overzealous with different settings and even blow a nice photographic opportunity because one parameter was not set properly.

Getting correct exposures

Standard scene – As already explained in Figure 4.6, the spectral radiance signal $L(\lambda)$ that reaches the camera is always the result of both the spectral irradiance $E(\lambda)$ and the scene's spectral reflectivity $R(\lambda)$. When the camera computes an exposure, it does not know what type of scene it is recording: a highly reflective white marble statue or a piece of charred wood that barely reflects any visible light. Moreover, the lighting of both objects can be totally different: the marble can be photographed in the shadow (i.e. very low irradiance), whereas the charred wood might be fully sunlit (i.e. high irradiance). From the overall radiance signal L, it is thus impossible to say anything about the reflectivity or illumination of the scene. Since a camera's built-in meter is a light meter, it will not take just any EM radiation into account but only the visible one. It is therefore better to use the photometric terms and say that the luminance signal L_v will be used by the DSC to set the exposure values.

To deal with this situation, the light meter inside a DSC is programmed in such a way that the overall reflectivity R of the scene is assumed to be a fixed value. Although there is no well-defined standard, the average scene reflectance R is often said to be 11.5%, 12.5%, 13% or 18%. Although they differ by some percentage, these numbers represent most scenes very well. When the reflectivity of all elements that normally make up a scene is averaged (i.e. from very high over medium to low reflective objects), the result is very often in this 11.5% to 18% range. As a result, different manufacturers have their light meters calibrated to dissimilar values, but all are in this narrow range. High illumination conditions (e.g. a sunny day) will create a large luminance signal L_v, forcing the camera to use a shorter exposure time, larger *f*-number or lower ISO. The reverse will happen when imaging a weakly illuminated standard scene.

When expressing 18% reflectivity as a grey tone between absolute white (100% reflectance) and black (0% reflectance), middle grey is obtained. Although this might sound strange, it originates from the fact that the HVS functions in a non-linear way [Stevens, 1961a, 1961b]. For example: two light bulbs do not make the room seem twice as bright compared to one light bulb. More specifically, humans perceive luminance logarithmically and an object with 18% reflectance is perceptually half way between black and white. The net result is that the incident light meters of DSCs are calibrated to reproduce subjects as middle grey. Although this works very well for the

majority of scenes, the exposure computed by the DSC can be completely off when dealing with subjects that are much lighter or much darker than 18% reflectance. To illustrate this, consider Figure 4.43. In the left column, the correct rendering of three different targets is given: a Kodak exposure card which represents a middle grey tone of 18% reflection, the back of this Kodak exposure card which reflects 90% of the incoming light and a black surface whose reflectance is just a few percentages. Upon photographing those three targets, the amount of luminance reaching the camera will be highly different. However, since the DSC cannot determine whether this difference originates from a changed reflectance or a changed illumination, it assumes the latter and changes the shutter speed so that all three targets are rendered as a middle grey value. This is shown in the second column. Note that all ISO and aperture values were kept identical and only the shutter speed was allowed to vary. As a result, the white target is chronically underexposed and the opposite happened with the black subject.

For the photographs in the third column, the shutter speed was determined manually. Now, all three targets are rendered accurately. Note that all photographs in the third column feature identical ISO, aperture and shutter speed values. This should not come as a surprise: the illumination was kept constant and only the subject's reflectance changed. This means that all three frames should feature the same exposure value if one wants to render their tonal differences accurately so that white looks white and not as

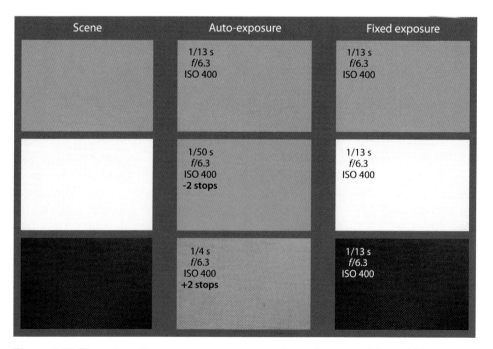

Figure 4.43 The automatic and manual exposure values of a grey, white and black target.

a washed-out grey. From this test, two very important and seemingly counterintuitive facts can be deduced:

- very light subjects are often underexposed by one to two stops. As a result, one needs to deliberately allow more light to reach the sensor compared to what the camera determined to accurately render the scene;
- very dark subjects are often overexposed by one to two stops, so in this case the amount of light reaching the sensor needs to be decreased.

Some solutions are given below to accurately determine the exposure for such scenes.

Grey cards – Basically all DSC luminance meters are set to assume everything they will ever record is average grey, not 4% reflectance like charcoal or 90% like snow. When the scene's reflectance does not average out to about 12–18%, grey cards come in very handy. These cards, such as the one used in the upper row of Figure 4.43, are simple pieces of cardboard that are carefully produced to reflect about 18% of the incident light. Since they are always exposed correctly, it suffices to place them in the same illumination conditions as the main subject and fill the camera's FoV with them. After the DSC takes an exposure reading from this card, those values can be used to photograph the scene (do not forget to remove the card). In that way, the tonal values of the photograph will be rendered accurately since the grey card worked as an 18% reflectance benchmark and took the reflectance guessing away from the equation.

Although they are often intermingled with white balance cards (see 4.6.2), grey and white balance cards are not the same. Grey cards are really made to reflect circa 18% (or a similar value such as 12.5%) of the incident light. However, they often do not reflect all wavelengths in exactly the same way such as a spectrally neutral target would. White balance cards have to be spectrally neutral, but their amount of overall reflectance is less important. Although they might be grey, Figure 4.44 shows that most white balance cards do not even come close to 18% reflectance. Although the Kodak grey card does also not perfectly reflect the claimed 18%, its reflectance varies mainly between 15% and 17.3% in the visible range. Although its reflectance curve is rather flat, the grey card is spectrally slightly less neutral than the dedicated white balance card. As such, white balance cards should not be used to nail down the exposure and neither should exposure grey cards be used for the most accurate white balancing (although the Kodak Grey card could be quite successfully used for both).

Without a grey card, another average tone could be used to measure off. For the outdoor photographer, many subjects with average tones abound: most rocks, tree trunks and green foliage. Even skin tones might qualify. Very often, the back of the hand is used as a back-up neutral tone. In practice, you should first measure the back of your hand and determine how many stops it is above or below average grey. Very often, the back of a Caucasian hand is about one stop lighter than 18% grey. When photographing a very dark- or light-toned subject, it suffices to make an exposure reading off the back

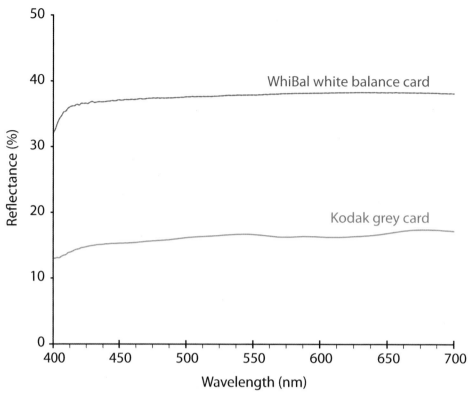

Figure 4.44 The spectral reflectance curves of a white balance card and a grey card.

of the hand (taking care that it receives the same illumination as the scene) and then overexpose the DSC's reading by one stop to get a perfect exposure.

Incident light meters – A DSC's light meter calculates a combination of *f*-stop and shutter speed for a given ISO value to photograph the area as was it a middle grey tone. Since it uses the luminance signal L_v that was created by the interplay of illumination and scene reflectivity, such meters are called reflective light meters. Many professionals – certainly those working in photographic studios – do not use the camera's internal metering capabilities, but rely on a hand-held incident light meter. These devices allow us to measure the amount of incident light (illuminance E_v) that hits an object before it gets reflected towards the camera. Since only the amount of total illuminance is measured (in lux), the exact reflectance of the object is taken out of the equation. As can be inferred from Figure 4.43, this is an ideal solution because only the amount of illuminance determines the correct exposure value and not the object's reflectivity. To use an incident light meter correctly, it should be held very close to the subject so that it receives the same illumination as the scene. For aerial imaging or backlighted subjects, incident light meters cannot be used.

Exposure compensation and bracketing – If it is not an option to use a grey card or a hand-held incident light meter, one can estimate the amount of over- or underexposure and verify the tonal values using the preview image and its corresponding histogram on the LCD screen of the camera (although both the preview and its histogram are known to be slightly inaccurate representations of the real data). The general rule for compensation is simple: photographing a light subject means that one has to allow more light to reach the imaging sensor: i.e. set the camera to +1 or +2 stops, check the result on the back of the camera and adjust further if needed. A dark subject means that one should let less light impinge on the sensor compared to what the DSC's meter recommends: i.e. dial in a –1 or –2 stop compensation and adjust further if needed. Normally –2 to –3 stops each way is the furthest one should go, depending on the subject of course. Beside full stops, most cameras allow us to compensate the exposure even with intervals of a 1/2 or 1/3 stop.

Very often, one does not have time to bother with over- and underexposure corrections. Some photographers also like to assess the final exposure on the computer screen rather than the back LCD of the camera. For those situations, exposure bracketing comes in handy. Bracketing means that the same scene is captured with two or more different exposures. Most cameras provide an auto-bracketing function that allows the photographer to automatically shoot a predefined amount of over- and underexposed frames in addition to the 'correct' exposure (at least as assumed by the camera). Acquiring a bracketed series of photographs normally boils down to a two-step process: first, the number of photos in the sequence is set; second, the EV spacing is set. The 0 EV photograph is usually taken first and equals the 'correct' exposure as measured by the DSC's light meter. All the other photographs are deliberately overexposed (positive EV) and underexposed (negative EV) by varying the shutter speed, ISO or the *f*-number. For a five-image series, two photographs will be underexposed (e.g. with –1 and –2 stops) and two will be overexposed so that one ends up with the following photo sequence:

$$-2 \text{ EV}, -1 \text{ EV}, 0 \text{ EV}, +1 \text{ EV and } +2 \text{ EV}.$$

Dealing with different illumination conditions

Using a grey card or incident light meter to measure the correct exposure is easy if all objects in a scene receive the same illumination. However, many scenes feature very dark as well as bright regions due to object geometry, the creation of shadows and multiple light sources. Since a properly exposed photograph is almost always a mix of overexposed, ideally exposed and underexposed regions, these scenes with heterogeneous illumination should also not pose any problem for the DSC. Rendering issues do arise, however, when some bright or dark portions are proportionally overrepresented in the frame or when the difference between the darkest and brightest image portions is so large that it surpasses the sensor's dynamic range. In such situations, some specific techniques could be used to acquire a satisfying image. Before outlining those, a proper definition of dynamic range is provided.

Dynamic range and tonal range – Dynamic range (DR) and tonal range are dissimilar, but often intermingled concepts. If a DSC is capable of capturing a DR of eleven photographic stops, it means that the sensor can simultaneously discern intensities that are 2^{11} or 2048 times higher than the smallest amounts of light detectable by that sensor during a normal exposure [Rudolf, 2006]. Besides expressing DR on a logarithmic scale in *f*-stops, it is also possible to express DR linearly: if the amplitude of the smallest detectable signal is said to be 1, the sensor's DR can be expressed as the contrast ratio 2048:1. The bigger the difference between the faintest and the brightest object a sensor is able to capture in one exposure, the larger its DR [Janesick and Blouke, 1987; Yoshida, 2006]. A DSC with a high DR is preferable to capture weak light signals without washing out the highlights. Outside this DR, everything becomes absolutely white (in which case the sensor is said to be saturated) or hidden in noise. The tonal range on the other hand refers to the number of tones that a digital image has at its disposal to describe the whole DR. A useful analogy may be a staircase: while the height of the staircase is its DR, bit depth equals the number of staircase steps [Fraser, 2005].

Consider again the example of the image sensor with approximately eleven stops of DR, in which case the brightest region of a digital image can be 2^{11} times more luminous than the darkest region. To fully render these approximately 2000 different intensities, the ADC needs to have at least a bit depth of 11, enabling the discrimination of 2048 (= 2^{11}) tones. However, if this 11-bit image would be remapped to an 8-bit output, only 256 tonal levels would be possible in the final image. Although the DR could be almost unaltered, the image would suffer from major posterisation or banding, a phenomenon where abrupt changes between tones become apparent [Clark, 2004]. In this example, all eight units of linear intensity (2000/256) will be grouped into one of these 256 categories, disregarding 87.5% (7/8) of all tonal values. Very often, scenes surpass the DR that can be captured with a DSC. For such high DR situations, any of the following techniques can prove helpful.

Reduce contrast – The easiest way to handle scenes with a large DR is to reduce the contrast between the highly illuminated portions and the shadow areas. This can be done in a variety of ways. Photographic flash lights or (studio) lamps could be used to illuminate the shadowed portions and bring their illumination level closer to the other portions of the scene. Highly illuminated zones can be shielded from the incoming light to throw them in the shadow (Figure 4.45a). This is regularly done on archaeological excavations, where the structures to be photographed are often partly in the sunlight and partly in the shadow. A last useful tool to reduce the contrast is a graduated neutral density (ND) filter. Such an optical filter is perfectly transparent on the bottom and slightly opaque on the top. The shift between both zones of transmission happens in the middle of the filter and is either very abrupt (hard-edge) or gradual (soft-edge). Graduated ND filters are extremely handy to darken the brighter part of the scene so that the overall scene can be captured by the camera's DR. The density of the opaque zone is available in various strengths, usually given in stops (e.g. a two-stop ND filter will darken the bright area by a factor of 4). Figure 4.45d2 shows

Figure 4.45 (A) Creating shade on an excavation when photographing features;
(B) Example of a scene (city centre of Sienna, Italy) where one can use spot metering;
(C) Stone ornament of the Stephansdom in Vienna, photographed with matrix metering
(C1) and spot metering on the ornament (C2) and its background (C3) respectively;
(D) Medieval building on the Croatian island of Palacol. (D1) shows the scene as acquired
with matrix metering; (D2) shows the same scene acquired with a gradual ND filter; (D3)
is a tone-mapped result of an HDR image series (five exposures), while (D4) depicts the
exposure fusion result of the same image series.

the use of a soft-edge gradual ND filter. Notice that these filters work best when the scene features well-defined areas with a clear edge between them. This example shows that the ND filter could clearly darken the sky and bring back details in the clouds (compared to Figure 4.45d1), but the whole building (and certainly the tower) was darkened as well.

Averaging versus one-zone metering – Most DSCs have a rather complex matrix metering system. After metering several parts of the scene, they evaluate those results and provide a best-guess exposure, either based on highly sophisticated logic or after comparing all those frame portions with an internally stored database of properly exposed photographs. This matrix or evaluative metering is currently built into most DSCs. Despite its power, matrix metering will still result in an average exposure when dealing with high DR scenes (e.g. Figure 4.45c1). The DSC might also under- or overexpose the main subject when the subject's illumination is very different from the surrounding elements and proportionally underrepresented as well. In both situations, matrix metering will very often sub-optimally render the main subject.

If there is clearly one object of interest in the photograph, you could follow two strategies. On the one hand, a correct exposure for that specific zone can be established with an incident light meter. On the other hand, the DSC's spot meter can be used. Such spot meters (or partial spot meters) are built into every D-SLR and allow you to read the luminance of a very small area. This technique was used for Figure 4.45b. Since the column is very differently illuminated compared to its background and also comprises a much smaller part of the frame, spot metering on a neutral tone of the column's capital (indicated by the yellow circle) makes sure that a correct exposure was obtained for this feature of interest. Figure 4.45c1 represents another scene for which matrix metering yields unsatisfying results: the large DR does not allow the capture of details in both highlights (the city in the background) and shadow portions of the scene (a stone ornament on the roof of Vienna's Stephansdom). The matrix metering opted for an average exposure between fore- and background, yielding a shutter speed that was too short to render the ornament properly but far too long to properly expose the background buildings. Spot metering on the stone ornament (Figure 4.45c2, measurement area indicated by the yellow circle) did indeed depict the feature of interest properly, but washed out the city background completely. When exposing for the city background (Figure 4.45c3), the stones facing the camera turned into a silhouette as an unavoidable side-effect. This lack of ideal exposure or 'middle-point' characterises all high DR scenes. If reducing contrast with any of the aforementioned techniques is no option, one always has to sacrifice some shadow and/or highlight details to get at least one part of the image properly exposed. Or … use exposure fusion.

Exposure fusion and HDR – For the scene in Figure 4.45c, it seemed like the only solution would be to capture two completely different exposures, each of them optimised for one part of the scene. Merging the best exposed parts with image processing

software would create an image that has foreground and background both rendered perfectly. Although this technique is certainly applicable, it would demand quite some time as well as decent image processing skills from the photographer. Therefore, two other techniques are often used, both trying to obtain more or less the same result as the manual process explained above, but in a much faster way.

These techniques, high-dynamic range (HDR) imaging and exposure fusion, originate in the film-based era. To deal with such HDR scenes, professional photographers would often follow Ansel Adams' zone system, in that they would expose the emulsion for the shadows and develop it for the highlights [Adams and Baker, 2005b, 2006]. Digital HDR and exposure fusion are like Ansel Adams's zone system on steroids. Both techniques start from the same principle: they need multiple source images with different exposures as input. Although it is highly advisable to fix the aperture, the differently exposed images can theoretically be achieved by altering any of the three exposure parameters. The easiest way to accomplish this is through the use of the DSCs auto-bracketing function. The main idea is that each photograph of the series covers a part of the DR of the scene, while all images together should encompass the scene's complete DR. Often, three exposures (−2 EV, 0 EV and +2 EV) or five (adding +1 EV and −1 EV) are sufficient. For rare situations, seven or nine images might be necessary.

Afterwards, HDR imaging and exposure fusion try to compute a single low-dynamic range (LDR) image out of all source images by keeping only the properly exposed elements. How they accomplish this differs. The HDR workflow first merges all these images into a 32-bit HDR image which holds the complete DR. The problem is that a conventional monitor cannot display such an HDR image. At this stage, tone-mapping kicks in. In essence, the tone-mapping algorithm takes all the radiance data that are held by the HDR image and uses one of the many available methods to compress all the data into one single LDR image that can be rendered by the monitor. Although these tone-mapping algorithms vary from extremely dramatic to realistic, they mostly generate rather unrealistic scene renderings. Despite the effort of software companies to create more naturally looking tone-mappers, creating a very realistic LDR image from the intermediate HDR image is still very challenging (see Figure 4.45d3). Although it is very easy to create really bad LDR images with unrealistically oversaturated colours, large halos at high-contrast edges and enhanced noise, many people still like them.

In contrast to HDR imaging, the exposure fusion pipeline is much more basic and requires fewer steps. In essence, exposure fusion software tries to find a balance between the differently exposed pixels by assigning a weight to them, all without any intermediate step of tone-mapping. The end result is thus more or less an average of the whole exposure stack. Because the tone-mapping algorithm of the HDR workflow tries to squeeze the DR of the intermediate 32-bit HDR file into a displayable LDR image, the original relationships between tones can be changed. A very bright sky and dark foreground can sometimes be rendered as a dark sky with a bright foreground. This will never happen with exposure fusion, for which the relationships between the

original tones is always retained. As a result, exposure fusion results look most of the time far more realistic. This can also be observed when comparing the tiles d3 and d4 of Figure 4.45. First, a five-stop exposure series was acquired with auto-bracketing. Figure 4.45d1 represents the 0 EV frame of the whole scene. This base exposure was used by the DSC to acquire two underexposed frames (–1 and –2 stops) in which all the details of the highlights (i.e. the sky) were rendered properly. The two overexposed frames (+1 and +2 stops) provided properly exposed details of the building. This image series was then converted into a tone-mapped LDR image (tile D3) and an exposure fusion variant. Although the results are subtle because everything was done to create a very realistic LDR image from the HDR workflow, the exposure fusion variant is the more realistic of the two.

Since HDR imaging and exposure fusion merge all source images, the photographed scene and the camera should be static. Many software packages feature de-ghosting approaches to deal with moving scene elements and automatic alignment procedures for co-registering hand-held image series. However, for the very best results, it is mandatory to shoot the image series from a tripod so that no or minimal use of these tools is needed. When shooting multiple exposure series for photogrammetric applications, perfect sub-pixel registration between the bracketed shots is of the utmost importance. As such, a sturdy tripod is primordial as are a wireless remote shutter release and – if possible on the D-SLR – the mirror lock-up mode to make sure that the vibrations of the mirror-slap do not influence the exposure.

For more tips and tricks on photographic exposure and how to deal with complicated situations, the following books are recommended: Meehan [2001]; Peterson [2010] and Weston [2004]. The final piece of advice that can be given regarding exposure is:

> it is generally safer to slightly underexpose the photograph than to overexpose it. There is a lot of shadow detail that can be recovered by a decent RAW converter, whereas even the most fancy algorithms cannot rescue details from blown-out highlights.

4.6.2 White balance

Because the channel specific DNs are generally unequal when photographing a spectrally flat object (white, black or grey), the values in each channel must be multiplied by a certain scaling factor to yield the expected identical channel numbers and tackle the unequal spectral camera responses [Giorgianni and Madden, 2008; Lam and Fung, 2009]. This is shown in Figure 4.46. The RAW 12-bit values are yielded by photographing a spectrally neutral WhiBal™ White Balance Reference Card, displayed on the left-hand side (consider its spectral reflectance curve in Figure 4.44). To generate a perfectly neutral grey card on screen, the red and blue channels are normalised here to the green channel.

However, it is also clear from the illustration that these multipliers change according to the source used to illuminate the object. A perfect white wall might reflect more blue wavelengths than red light when photographing on a cloudy, overcast day. On

	RAW 12-bit Digital Number			Normalised multiplier			
	R	G	B	R	G	B	
Sunny	1136	1933	1215	1.7	1	1.59	
Cloudy	831	1656	1283	1.99	1	1.29	
Incandescent	738	704	224	0.95	1	3.14	
Flash	702	1345	1037	1.92	1	1.3	

Figure 4.46 Channel specific DNs and calculated normalised multipliers retrieved from a WhiBal™ white balance reference card photographed under different illumination conditions.

the other hand, several artificial light sources abundantly generate red wavelengths [Parulski and Spaulding, 2003]. This large variety of generated EM radiation attributes to each light source a certain so-called correlated colour temperature (CCT) T_{cp}: a number expressed on the Kelvin temperature scale, relating the specific spectral output of that EM source to the same colour perceived by heating a blackbody.

A blackbody is a hypothetical idealised dense object which absorbs all incident energy regardless of wavelength and direction and emits the maximum amount of EM radiation possible at a given temperature for any given wavelength. Hence, it is a perfect direction-independent absorber and emitter. The higher the temperature at which a blackbody is heated, the more its colour shifts to shorter wavelengths (from red to orange to bluish white) and the more intense the emitted EM radiation is [Walker, 2004]. As mentioned in section 4.3.1, objects need to be heated to at least 800 K before visible red light is emitted [Barnes, 1963; Ray, 1999]. However, at this temperature, the light is still very faint. Only when an object reaches a temperature of 2000 K, it will glow red-hot. An object that is heated to 3200 K (e.g. the tungsten filament of a bulb) has an increased emission in the visible range with wavelengths extending to orange (Figure 4.47).

A good example to illustrate this is heated iron. In a first stage, there will be a deep red glow. By raising the temperature, the iron shall radiate brighter, reddish-orange light. Increasing the temperature even more yields a brilliant blue-white light. Otherwise said: the emitted spectral radiance $L(\lambda)$ of a blackbody is only a function of its absolute surface temperature T [Walker, 2004], hence the term colour temperature (CT), T_c. Since a blackbody is an idealised object and most EM sources are far from ideal blackbody radiators – apart from the sun (ca. 5800 K), halogen tungsten lamps (ca. 3200 K) and tungsten filament lamps (ca. 2850 K) – these sources cannot be described solely as a function of their temperature. This led to the concept of CCT: the blackbody temperature that yields the same chromaticity experience as the EM source under consideration [Borbély *et al.*, 2001; Fraser *et al.*, 2005] (Figure 4.47). It

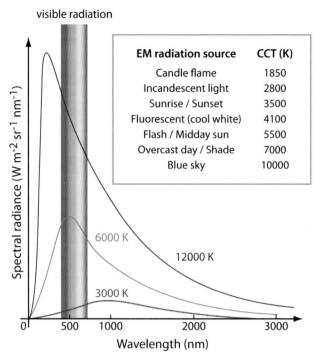

Figure 4.47 Blackbody radiation and common sources with their CCT values.

is important to notice that CT or CCT only work for glowing hot objects. There is nothing that glows green or magenta!

Human eyes constantly adjust to such CCT changes and will therefore be able to tell a wall is white, irrespective of the illumination conditions [Hung, 2006; Livingstone, 2002]. Digital sensors and film are unable to do so. In the analogue era, one had to change the type of film and/or use appropriate filters to avoid colour casts. In digital photography, the DSC only needs to know that the wall is supposed to be white so it can accordingly calculate the correct multipliers [Lam and Fung, 2009]. This is also explained in Figure 4.46. Within the WhiBal, four differently coloured patches are displayed, showing the WhiBal's spectrally flat grey surface photographed under different illumination conditions (flash light, incandescent bulb, cloudy and open sky) and without any WB applied. By reading out the particular *RGB* values of these reference pictures, the different channel multipliers were calculated by normalising everything to the green channel. Both these patches and multipliers (which are also graphically displayed on the right) obviously demonstrate incandescent light to emit much more red wavelengths than the other sources, indicated by the much lower *R* multiplier and the orange-yellowish colour cast of the patch. A cloudy sky on the other hand creates a bluish cast, indicated by the high DN in the blue channel (relative to the *R* channel) and the low *B* multiplier.

At the time of capture, the WB setting is determined automatically or manually and stored in a dedicated Exif metadata tag (see Figure 4.50). It has no effect on the

generated DNs until the specific normalisation values are effectively applied in the final calculation of the pixel values. When processing the RAW file inside the camera into a JPEG or TIFF, these multipliers are used to recalculate the initially generated DNs of all channels to make sure that the spectrally neutral zones – and by extension also all the other colours in the digital image – appear without major colour casts, irrespective of illumination condition. When storing RAW files, the RAW conversion software reads the values of the WB metadata tag and applies it to the image upon opening it. The user can always override this setting by applying other channel multipliers which are determined using dedicated WB hard- and software tools.

Because even the automatic WB determination of professional DSCs can be fooled to a certain extent, a workflow with spectrally neutral WB cards – or similar WB utilities – can be of great benefit. Their application in a RAW-based pipeline is very straightforward. The first image of a photographic shoot should always be of a WB card that is placed in the same illumination as the main subject. Afterwards, the WB card is removed and all necessary photographs are acquired (without the WB card in the frame of course). Upon processing the images in the RAW converter, one needs to find the first photograph that has the WB card included and use the specific WB tools of the RAW converter to accurately determine the CCT for that frame. These settings can then be applied to all other images that were shot under the same illumination.

When computing an in-camera processed JPEG or TIFF, an incorrect WB will lead to a colour cast in the image. Although this can also be partly dealt with in post-processing, the quality of the picture will degrade to a certain extent and the cast is often difficult to remove completely. RAW is therefore an ideal solution when the photographer is not completely sure about the CCT of the EM radiation and/or maximum possibilities in post-processing have to be maintained [Verhoeven, 2010].

For Figure 4.48, the same scene was photographed under two different illumination sources: an on-camera flash and an incandescent bulb. While keeping the exposure constant, all ten photographs were acquired using a different WB setting (indicated by the CCT). It is obvious that an incandescent light bulb has a very low CCT (around 2500 K) whereas the CCT of a flash light is very similar to that of the sunlight at noon.

4.6.3 Colour description

Colour models

> Color is the general name for all sensations arising from the activity of the retina of the eye and its attached nervous mechanisms, this activity being, in nearly every case in the normal individual, a specific response to radiant energy of certain wave-lengths and intensities [Troland, 1922].

Colour is thus not a property of an object: a Roman red gloss terra sigillata bowl illuminated by blue light will never be perceived as a red recipient but as a black one. Colour is thus not a primary physical property but a perceptual result that is said to have three perceptual dimensions: hue, chroma and lightness [Fairchild, 1998; Hunt,

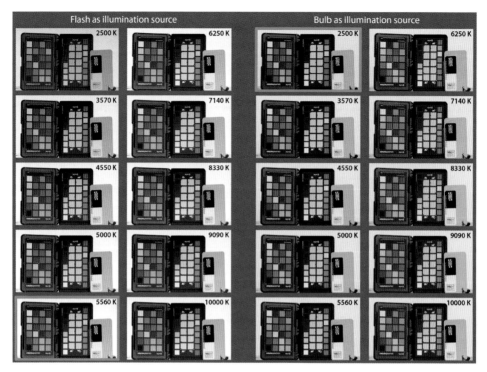

Figure 4.48 Varying the WB for two different illumination sources. The frame with the best WB setting is indicated.

2004]. In the digital world, however, colour is represented using global colour models and more specific colour spaces. From the sections above, it should be obvious that colour is often mathematically defined as a three-dimensional (3D) property. However, a point in a 3D space can be defined using many different coordinate systems (CSs). In cartography, a CS defines a set of axes used (i.e. the dimensionality of the system) and the attributes of these axes (direction, name, abbreviation, units, order). As an example: a three-dimensional Cartesian XYZ system using meter. If any of these attributes changes, the coordinate system changes [Iliffe and Lott, 2008].

The same goes more or less for colour. As such, many CSs for colour exist, built upon three or four coordinate axes. A specific set of coordinate axes used to describe colour is called a colour model. Although a colour model is thus a particular CS to describe colour (e.g. *RGB*, *CMYK*), it only describes its dimensionality (three or four variables/axes) and the specific name, direction and order of its axes. Colour models can thus be thought of as systems that describe how colours can be mathematically represented. Most models use three different axes to represent one colour (like the *RGB* colour model which uses red, green and blue axes), while others such as *CMYK* use four components/axes. Although their aim is to minimise formulation complexity and maximise 'completeness' for the specific applications they are needed for, all colour models have their drawbacks and advantages [Giorgianni *et al.*, 2003; Pascale, 2003].

However, a specific *RGB* triplet such as R:50 – G:25 – B:255 does not define a particular colour, but only indicates the ratio of the three components used. Although 255 is the maximum value for each *R*, *G* and *B* channel in an 8-bit image, a colour model does not specify how 'vibrantly blue' this maximum should be? In other words: a colour model is a mathematical system with no connection to any reference system of colour so that there is no description at all on how these values should be interpreted. Therefore, colour models such as *RGB*, *CMYK* (using the primaries cyan, magenta, yellow and blacK/Key), *HSV* (hue – saturation – value) and *HSL* (hue – saturation – lightness) are said to be relative. To accomplish an unambiguous description of colours, the *RGB* values need to be defined with respect to a particular scale of reference, more specifically a well-defined colour standard. Generally, the CIE *XYZ* or CIE *L*a*b** colour spaces are used as reference standard since they define all the colours an average human perceives. Thus, as soon as the colour model has an associated mapping function that maps the arbitrary *RGB* values to absolute CIE *XYZ* values, a colour space is born. In practice, this means that the units of the axes are explicitly described. Since the exact description of a particular colour is accomplished by numbers that are given in relation to a specific colour space, colour spaces are absolute descriptions [Siniscalco and Rossi, 2014].

Colour spaces

A colour space is thus much more specific than a colour model, as it is just one possible instance of the more general colour model. Using different mapping functions, various absolute colour spaces can be created. Without going into further detail, the following elements are essential for describing a colour space (see also Figure 4.49).

- well-defined primaries (e.g. specific *RGB* or *CMYK* primaries);
- a specific CIE illuminant (which represents the assumed illumination: CIE illuminants can be considered quantified and standardised illumination sources);
- a specific gamma-value.

The best-known colour spaces that use the *RGB* colour model are sRGB, Adobe RGB (1998) and ProPhoto RGB (also known as ROMM RGB). Figure 4.49 compares all three in the CIE (*x,y)* chromaticity diagram. The chromaticity coordinates (*x,y*) are defined by

$$x = \frac{X}{X+Y+Z}, y = \frac{Y}{X+Y+Z}$$

so that the chromaticity of a colour can be described irrespective from its luminance [Hunt, 2004]. The three points that form one triangle correspond to the chromaticity coordinates of the three primaries of that particular colour space (these values can also be found in Figure 4.49). The area in the triangle is known as the colour gamut and encompasses all the colour values that can be created by mixing those three primaries.

Values outside the triangle are said to be out-of-gamut for these primaries. Despite the criticism on such diagrams [see Fairchild, 1998], they are still one of the most straightforward – although not very accurate – means to compare different gamuts on a sheet of paper.

From Figure 4.49 it can be inferred that a colour space such as sRGB has a rather limited gamut, while Adobe RGB (1998) and ProPhoto RGB have much wider gamuts. In other words: the ProPhoto RGB colour space can represent more colours than the Adobe RGB (1998) space which can in turn store a wider range of colours than the sRGB colour space. Despite these differences, all three are based on the RGB colour model to mathematically represent colours. Given the fact that colour management with different colour spaces is rather technical and characterised by many pro and contra opinions, it is beyond the scope of this chapter to give in-depth guidelines on the use of these colour spaces.

However, the following general advice concerning colours spaces can be given: Adobe RGB (1998) or even ProPhoto RGB is best suited for the 16-bit master TIFF image files. This also means that when shooting in-camera JPEGs, the DSC should be set to Adobe RGB (1998) if this is possible. Otherwise, information will be thrown away since the DSC's colour space is much larger than sRGB. Those Adobe RGB (1998) files are also perfect to send to professional printing services. As soon as imagery needs to be put on the Web or the whole image workflow should be as simple as possible, it is advisable to use a decent image processing software and convert the file to an 8-bit JPEG with an embedded sRGB profile.

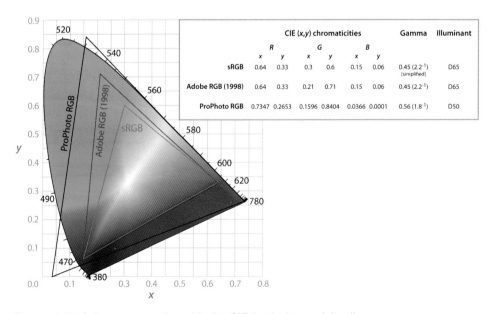

	CIE (x,y) chromaticities						Gamma	Illuminant
	R		**G**		**B**			
	x	y	x	y	x	y		
sRGB	0.64	0.33	0.3	0.6	0.15	0.06	0.45 (2.2⁻¹) [simplified]	D65
Adobe RGB (1998)	0.64	0.33	0.21	0.71	0.15	0.06	0.45 (2.2⁻¹)	D65
ProPhoto RGB	0.7347	0.2653	0.1596	0.8404	0.0366	0.0001	0.56 (1.8⁻¹)	D50

Figure 4.49 Colour spaces plotted in the CIE (x, y) chromaticity diagram.

To profile or not to profile?

Colour is often used in art and photography to be pleasing, but sometimes its description also needs to be accurate. Accurate colour means that if the reproduction is placed under the exact same illumination as the original, the objects look indistinguishable for most observers [MacDonald, 2014]. In a pleasing representation, colour is changed with respect to the original since most observers prefer a greater contrast and higher colour saturation than the real values [Yendrikhovskij *et al.*, 1999]. Even if high colour accuracy would be possible with the metameric three-channels DSCs, it is not an easy task to compute better camera profiles than the ones embedded in most RAW converters.

If photographs would only be taken under one standard Illuminant (e.g. D50 or D65), it could still pay off to create a high-end mono-illuminant profile and always work with that. However, for most photographers, the illumination constantly varies (morning sunlight, cloudy sky, indoor with artificial illumination etc.). Although a DSC profile could theoretically be created for every situation, the biggest problem would still be the non-standardised illuminants. The published CIE *XYZ* values of all colour charts such as the one in Figure 4.13 are computed for specific illuminants. When using a non-standardised illuminant, the correct *XYZ* values of these colour patches are not known (unless both the spectral illuminance from the light source and the reflectivity of each and every colour patch is measured with a spectrophotometer and used to compute the *XYZ* patch values for that specific illuminant).

To tackle this rather impossible situation, Adobe developed DNG profiles which can be based on two different illuminants (so the RAW converter can interpolate between them). However, this feature does not remove the issue of non-standardised illuminants, nor does it solve the problem that DSCs do not adhere to the Luther–Ives condition. As such, it is advised – for everyone but the seasoned professional – to stay away from dedicated camera profiling. The most important recommendation is to shoot RAW files and make sure that the exposure and WB of the photographs is accurately determined. During the development of the RAW file into a JPEG or TIFF, the camera profiles/CCM embedded in the RAW converter can be put to good use. Since developing a RAW file in dedicated computer software also allows for the assignment of a specific colour space to the image – irrespective of the space set during image acquisition – a RAW workflow also has an edge here over in-camera JPEG or TIFF processing. Using this simple workflow, very decent colour reproduction should be feasible without too much hassle.

However, having decent colours in a digital image does not pay off when the monitor (and ideally also the printer) are not properly characterised and profiled. When an image with an embedded ICC profile is displayed, its profile will be used to translate the pixel values back into CIE *XYZ* or CIE *L*a*b** triplets, which in turn are looked up in the monitor profile and converted to *RGB* values that can steer the monitor [Balasubramanian, 2003; Parulski and Spaulding, 2003]. As long as this profile information is embedded in the original photograph, one can rest assured that the image will appear correctly in any ICC-compliant application and on ICC-profiled devices. The

latter thus means that it does not make sense to look at images on monitors that are not properly calibrated and profiled. The calibration process first sets the monitor to a set of standard settings: a specific luminance level (e.g. 100 cd/m²), white point (e.g. 5500 K) and gamma (e.g. 2.2). Afterwards, the monitor is characterised or profiled to link its own colour representation (device-dependent) to the CIE *L*a*b** or CIE *XYZ* colour space.

The worst that can happen is that an image does not have any ICC profile embedded or even the wrong one assigned. In these cases, image colours might vary from almost normal to very weird, even if the monitor is calibrated and profiled.

4.6.4 File formats: RAW – JPEG – TIFF

File formats are containers, created to hold digital data permanently and securely in files by offering a particular way of encoding these data. To define the format used for a specific file, a filename extension is often utilised, being a text string of usually three or four letters that comes in the file name after the final period. As there are many different data types into circulation, various file formats exist. In essence, three fundamentally different graphical data types occur: raster data (such as photographs), vector or geometry data (e.g. CAD-drawings) and latent image data (like the sensor's RAW image). The latter stores both incomplete radiance information and metadata that need to be processed into a raster image file format, holding complete colour or greyscale data. Both TIFF and JPEG are raster file formats specifically designed to store still (or static) images like photographs.

RAW

In accordance with common terminology from the digital world, one would think RAW is an acronym. However, the word is an exception and signifies just what it sounds like: raw data. Although most texts describe RAW as the unprocessed data from the sensor of the DSC [e.g. Andrews *et al.*, 2006], it is more accurate to consider a RAW file as the analogue sensor information which has been amplified and converted to digital data, without being subjected to any major processing by the camera's embedded software (called firmware). This means that a RAW file might have undergone minimal processing such as DC subtraction and linearisation.

Once it is created, such a RAW file holds two separate parts: the metadata stored in a separate header (see 4.6.5) and a bunch of quantised samples in *X* and *Y* direction, with every sample characterised by one DN (except in DSCs using a Foveon sensor as those sensors capture *RGB* data at every photosite). In this collection of DNs, each individual number represents one spectral value, generated by one photodiode and linearly related to the incoming EM radiation. Consequently, this RAW image still has a greyscale character with embedded CFA pattern [Andrews *et al.*, 2006; Fraser, 2005]. Aside from the aforementioned amplification, A/D conversion and optional small processing steps, no further adjustments are performed. Given the very small amount of data processing, a RAW file equals the most pure form of generated digital

photographic data. As such, RAW can be seen as the digital negative: it will never degrade, allowing an infinite number of digital prints (such as JPEG or TIFF) to be made in the future. It might even be better to consider it the equivalent of the latent image, as a RAW file holds all captured information without any digital development done afterwards. When RAW files of different manufacturers are compared, it becomes obvious that this file type lacks a general standard. As such, RAW is not a specific file format but a class of file formats which encompasses many proprietary file formats and one open format, being Adobe's digital negative (DNG) format (which was introduced by Adobe in 2004 in an attempt to standardise a file format for RAW files). Although this absence of a common structure is often considered to be a major drawback, all RAW files store the original DNs and the metadata, as was outlined above.

As soon as a DSC generates a RAW file, two paths can be followed for the generation of a JPEG of TIFF file: an in-camera chain and a computer-based chain. Both pipelines perform more or less the same steps, but the device that executes them differs. Characteristic of the in-camera approach is that the DSC's image processing engine decides how the final photograph will look. Most notably, the WB used during acquisition and the tonal rendering defined via the camera's menu (saturation, contrast etc.) define the final result. The computer-based workflow leaves all RAW development decisions to the photographer. To enable this development, dedicated and ever-improving RAW development software is available. This computer-based pipeline provides control over the colour correction, tonal adjustments, noise suppression, chromatic aberration and vignetting removal, sharpening and much more. Although the image processing engines of DSCs are very specialised and even feature fancy names (Expeed for Nikon, DIGIC for Canon, BIONZ for Sony, PRIME for Pentax etc.) the quality of conversion they can achieve and the choice in conversion parameters they provide is always inferior to the dedicated computer RAW conversion engines.

Given this and the fact that a RAW file contains the absolute maximum amount of original data generated by the sensor, it is the choice of preference for professional photography and the only scientifically justifiable file format. Its tremendous flexibility in both processing and post-processing thus makes RAW beneficial from a workflow as well as an image quality point of view. In several of the sections above, the specific advantages and possibilities offered by computer-based RAW workflows have already been mentioned (e.g. removing chromatic aberration, WB determination, assigning a specific colour profile). For a more dedicated overview of the benefits and particularities of RAW (scientific) photography, please consult Verhoeven [2010].

JPEG

Rather than being a specific file format, JPEG is a large and complex compression standard created in 1986 and defined in 1992 by the Joint Photographic Experts Group [Pennebaker and Mitchell, 1993]. Instead of encompassing one algorithm, JPEG can be seen as a toolbox. In this toolbox, several algorithms reside together with optional capabilities [Wallace, 1991, 1992]. When an application wants some of this standard

to be implemented, a particular subset of the JPEG standard is selected to meet the requirements best.

As a matter of fact, the JPEG standard allows for two compression methods: lossy and lossless, meaning respectively 'throwing away information' and 'storing all inform-ation' [Gonzalez and Woods, 2002]. Lossless compression always yields smaller files than the original ones, but the compression gained by a lossy technique can be much higher. Because it typically can only compress full colour data by a factor 2:1 (i.e. the resulting file is two times smaller), lossless JPEG was never that popular. Lossy JPEG, on the other hand, is another story. With a typical compression of 10:1, files can become really small when compressed with the baseline lossy JPEG algorithm, hereby almost visually indistinguishable from the input file. More compression can be achieved, but as more data need to be thrown away, the quality of the file will gradu-ally deteriorate. Due to its possibility to trade off quality against file size, this baseline JPEG subset (which also features a few optional extensions) became implemented worldwide in most applications dealing with photographs [Pennebaker and Mitchell, 1993; Wallace, 1991, 1992].

To store this JPEG encoded stream of pixel data together with the header contain-ing all compression parameters (i.e. quantisation tables and Huffman coding tables), a file format is needed. The JFIF standard (JPEG file interchange format) was therefore created by Eric Hamilton [Pennebaker and Mitchell, 1993]. When one talks about a JPEG file – recognisable by one of the possible extensions jpe, jpg, jpeg, jif, jfif and spf – in reality a JFIF or SPIFF (still picture interchange file format) file is meant (the latter being a more advanced substitute for JFIF, but without ever achieving significant adop-tion – [Murray, 1996; Parulski and Reisch, 2009]). However, this situation changed in 1996 when JEIDA (Japan Electronic Industry Development Association) approved version 1 of the Exif (exchangeable image file format) standard, a file format that was specifically designed for storing image data originating from DSCs. In essence, this format stores fully processed images using the baseline subset of the JPEG compres-sion standard, a small thumbnail image and additional metadata. The latter comprises information about image acquisition parameters in one or more specific segments near the beginning of the image file (see section 4.6.5). The thumbnail image of 160 pixels by 120 pixels is also stored in this first file segment [Parulski and Reisch, 2009]. The structure of the file was cleverly designed, so existing JPEG/JFIF readers can process these new files without a problem. Consequently, virtually all consumer DSCs cur-rently (i.e. anno 2015) store JPEG compressed images in this Exif-JPEG file format with the JPG extension.

Aside from the fact that the lossy compression throws original data away, Exif-JPEG can be considered a scientifically unjustifiable file format because its limited tonal range often has implications on the displayed DR. Using a modern DSC to cap-ture an scene with an eleven-stop DR by saving a JPEG will cause many tonal values to be lost, because a JPEG file can maximally store eight bits/colour channel/pixel. The final DR will, however, depend on the workflow followed. Dealing with an in-camera

generated JPEG, firmware generally sacrifices a portion of the DR originally present in the RAW data by using a highlight-clipping tonal curve, consequently attributing enough tones to the shadow areas where the HVS can discern most gradations. What remains is a smaller but better rendered DR (normally around seven to eight stops), yielding a smoother image with good detail in the darker areas using the available tonal range. The largest DR most in-camera produced JPEGs can attain is about nine stops for ISO 100 (even when applying user defined curves), a value that will decrease with higher ISO settings [Clark, 2014].

When shooting in RAW mode, no tonal curve is applied to the data, thus storing the sensor's full DR. Note that due to the linear input–output relationship of a sensor, the ADC's bit depth puts a theoretical upper limit to a RAW's maximum achievable DR. As an example, 12-bit encoding allows at the most 4096 tonal levels or 12 f-stops: 2048 values in the first stop, 1024 levels in the second stop and only one tonal value to represent the twelfth stop. Because almost all current prosumer and professional DSCs utilise a 12-bit or 14-bit ADC, the shortage of possible tonal values as well as the omni-present noise limits their DR to a maximum of about eleven to thirteen stops [Clark, 2014]. As a result, a RAW workflow can extend the DR by at least one to two stops. In this respect, capturing RAW enables some exposure flexibility as shooting JPEG would ask for two different exposures of the same scene (i.e. bracketing) to capture the RAW's file DR.

Besides the possibility to recover highlight detail that would be lost forever if the camera was set to JPEG mode, the wider tonal range of RAW files offers more freedom to play around with tones and lowers the posterisation risk in case of image manipulation [Fraser, 2005; Sheppard, 2005; Steinmüller and Steinmüller, 2004]. In both respects, JPEGs (certainly in-camera generated ones) reduce the creative and scientific options. Besides disregarding most of the acquired tonal values – which is scientifically indefensible – the saved image will always be worse than the original data (perceivable or not), making JPEG totally unsuited as the master file for cultural heritage documentation. Moreover, resaving a JPEG file (e.g. after post-processing) generally introduces compression errors, which means that the file's quality is diminished every time it is opened and saved again. Therefore, Exif-JPEGs should only be used at the end of the complete imaging workflow, serving purposes like small preview files and e-mail attachments, imagery to be embedded in databases, websites and presentations. When the DSC only offers the in-camera JPEG pipeline, one must make sure to use the largest file size and least compression possible. When image processing of the JPEG image is needed, it should ideally first be converted into a 16-bit TIFF file.

TIFF

First published by Aldus Corporation in 1986 but currently maintained by Adobe Systems Incorporated, this image file format describes and stores raster images using tags [Adobe Systems Incorporated 1992]. All the pixels which make up an image

are stored in the body section of the TIFF file, while these so-called tags (which would later also be used in the Exif standard) hold information about width and depth of the image, acquisition date and time, copyright data, colour profiles, etc. TIFF was designed with the flexibility to define new tags in the future [Parulski and Reisch, 2009], which has for instance led to the development of a tag-set for carrying georeferencing information. This new standard was called GeoTIFF [Ritter and Ruth, 2000].

In contrast to JPEG, TIFF can handle 16-bit/colour channel data and serves as a container for both uncompressed and compressed images. In the latter category, often the lossless LZW (Lempel-Ziv-Welch, named after Abraham Lempel, Jacob Ziv and Terry Welch) is offered [Adobe Systems Incorporated, 1992] aside from the lossy JPEG compression algorithm. The virtue of a TIFF file (recognisable by the extension TIFF or TIF) is its ability to store all data in the original order, hereby containing all captured colours and other pixel related information (if no lossy JPEG compression is applied). Uncompressed or lossless compressed TIFFs are insensitive for the aforementioned accumulative data loss. Additionally, its support for 48-bit imagery and the fact that it is portable (i.e. supported across different platforms as Windows, Macintosh, UNIX and no favour for particular file systems) make it the world's number one preservation format for master copies – and hence the standard to save developed RAW frames (although the latter should never be thrown away). These characteristics have, of course, their drawbacks. Due to the fact that all possible data are stored, large file sizes occur. Although the maximum size is limited to four Gigabytes, many applications only support file sizes of up to two Gigabytes. What is more, the flexible set of information fields or tags sometimes leads to problems concerning the correct opening or interpretation of the image file, because TIFF-enabled software packages do not always support the new tags added by the wide variety of (scientific) users. Although this issue created a new interpretation of the acronym – Thousands of Incompatible File Formats – it is a problem that is rarely encountered.

Finally, shooting in-camera generated TIFFs is far from ideal. Even though most of the sensor's DR could be captured in the case that a 16-bit/colour channel TIFF can be saved, this file format presents at the capturing stage no advantages over RAW, as its file size will be much larger and the interpretation of the scene is already performed (just as in the case of JPEG), with no chance of addressing the originally captured DNs. Consequently, few DSCs provide TIFF as an option.

4.6.5 Image metadata

Exif

In addition to the DNs that encode the real-world scene, metadata are generated as well. These metadata describe the content, quality, condition, owner rights and other characteristics of the photographic data. In the world of digital photography, different metadata schemas are used to store information about digital frames. The

Exif (exchangeable image file format) metadata standard is probably the best known one. Created by JEIDA (Japan Electronic Industry Development Association), the Exif specification provides a rigid format to record shooting data (e.g. the serial number and model of the DSC, the aperture, focal length, shutter speed, possible flash compensation, the colour space, the date and time of shooting) in mandatory, recommended and optional tags stored in a separate segment of the file (Figure 4.50). If the camera is GNSS (Global Navigation Satellite System)-enabled, tags can also hold the latitude, longitude and altitude of the geographical location the particular photo was taken in. Moreover, new vendor-defined metadata can also be added [Camera & Imaging Products Association, 2010–2012]. These Exif defined tags, for which the structure was borrowed from TIFF image files, are created and stored simultaneously with the DNs, making it possible to analyse them afterwards. In addition, RAW files also hold some tags to define the CFA pattern and additional image reconstruction parameters like WB (see Figure 4.50), sharpening and noise settings [Parulski and Reisch, 2009].

IPTC

Besides Exif tags, digital photographs might also include metadata formatted to the IPTC or IPTC–NAA schema (International Press Telecommunications Council – Newspaper Association of America). As indicated by its name, this standard was originally designed with press photographers in mind. The possibility of adding a caption and keywords to the file, the photographer's name, the location of the image and particular copyright info allowed them to accompany their pictures with information the newspaper editor could need (Figure 4.50). IPTC metadata are not made upon creation of the file (such as Exif metadata), but afterwards added by the photographer.

XMP

XMP (extensible metadata platform) is often considered a third metadata standard. However, XMP is a data model developed by Adobe to write metadata rather than an actual metadata scheme [Adobe Systems Incorporated, 2013]. XMP metadata are normally used to store image adjustment instructions (such as RAW conversion parameters) or IPTC metadata using the IPTC4XMP specification (see the XMP section in Figure 4.50). Although the XMP data can be embedded in file formats such as TIFF, JPEG and the DNG format, these data are often stored in a separate *.xmp sidecar file. These separate files feature the same name and reside in the same folder as the original image file. Where exactly the XMP data are stored depends both on the programme that is used to write the metadata as well as the other programmes in the whole photographic workflow. Since many newer applications will only look for specific metadata in sidecar files, it is advised to always create these separate *.xmp files (if possible, even in addition to the embedded XMP data).

Figure 4.50 Exif and IPTC image metadata extracted from a RAW file.

4.7 Conclusion

Since its invention, photography has enabled the non-invasive examination and documentation of cultural heritage for a variety of reasons and applications. This chapter did not enumerate all those applications, but considered photography from a more technical point of view. I aimed to give an overview of general imaging concepts, specific lens and camera properties as well as the most important key photographic principles. I have been more technical than a conventional magazine or book on photography to allow you to get a more in-depth view on several issues and possibilities related to cultural heritage photography, while additionally enabling the transition to more exhaustive publications on scientific imaging. As stated in the introduction, I did not aim to provide specific hardware and software advice, so kept the text as brand-free as

possible (except for some necessary illustrations and examples). No specific software packages have been mentioned since opting for one of them is as much related to their features as to their user-friendliness. Both are, however, very subjective criteria that depend on the photographer's experience and existing (or non-existent) photographic workflow. Reading product reviews from a variety of sources will help to get a feel for the prevailing sentiments and thoughts on these matters.

Despite the technical detail of some sections, many relevant photography topics such as composition and image editing have not been covered. Apart from the space constraint a book chapter brings along, those topics were deliberately left out since there is a big difference between a photograph that is a work of art and a technically excellent image. Works of art, although often photographed with a proper technique, might also deliberately ignore all possible technical rules. However, image composition and unique post-processing are regularly an essential part of 'arty' photographs. Although imaging cultural heritage has often an art aspect related to it, most photographs are considered illustration rather than art given their intended uses: the documentation of object geometry, material structure or scene spectral properties. Composition and image editing have therefore been left out in favour of topics that might help to realise technically better photographs.

In summary, photographing cultural heritage should always invoke at least the following questions:

- Are the camera and the lens(es) suitable for the intended purpose? Should the sensor be larger or smaller? Does the sensor have a rolling shutter? Should the focal length be shorter or longer?
- Have the camera batteries been charged and are spare ones available?
- Is the memory card formatted in the camera?
- Are the lens(es) and sensor dirt free?
- Are any of the illumination sources in the camera's field of view? Is flare minimised by a lens hood?
- Can any of the attached filters or lens hoods create mechanical vignetting?
- What exposure technique is preferable for the situation at hand? Matrix metering or spot metering? Reflected or incident light metering? Is a grey card needed or should bracketing deliver the correct exposure?
- Is there any need to reduce the contrast of the scene? Is exposure fusion essential?
- Which exposure mode should be used? P, A, S or M?
- Is the depth of field sufficient? Does the aperture not create too much diffraction?
- Is the focus set correctly? Should the hyperfocal focus distance be used?
- Is the shutter speed fast enough to freeze the object and hold the camera vibration free?
- Is a tripod essential and if so, are a remote shutter release and mirror-lockup mode needed and available? Is vibration reduction turned off when shooting on a tripod?
- Is this a photogrammetric data acquisition task? If so, are vibration reduction and camera auto-rotation deactivated? Is a geometric camera calibration necessary?

- Is the white balance set correctly? Is a spectrally neutral target included in at least one frame to set the white balance afterwards?
- Can the camera record RAW? Is the camera set to record RAW in the highest bit depth? If not, is the image size maximised and JPEG compression minimised?
- Is, in the case of JPEG or TIFF recording, the colour space set to Adobe RGB (1998)?

And there it is: a photographic checklist as a chapter summary. However, mind that this checklist is not a comprehensive how-to guide, but a simple tool that should allow the photographer to consider some important factors before photographing cultural heritage. Since one can only learn by doing (and doing it a lot), I can only hope that this chapter stimulates you to take more photographs in an attempt to steadily improve upon the image quality (in whatever meaning possible) of those digital, light-written cultural heritage records.

References

Adams, A. and Baker, R., 2005a. *The Camera.* The Ansel Adams Photography Series Book 1. Little, New York and Boston: Brown and Company.

Adams, A. and Baker, R., 2005b. *The Negative.* The Ansel Adams Photography Series Book 2. Little, New York and Boston: Brown and Company.

Adams, A. and Baker, R., 2006. *The Print.* The Ansel Adams Photography Series Book 3. Little, New York and Boston: Brown and Company.

Adelson, E.H., 2000. Lightness perception and lightness illusions. In: *The Cognitive Neurosciences*, Gazzaniga, M.S., (Ed.), 2nd edn. Cambridge. MA: MIT Press, 339–351. Available at: http://persci.mit.edu/pub_pdfs/gazzan.pdf.

Adobe Systems Incorporated, 1992. TIFF. Revision 6.0. Adobe Systems Incorporated, Mountain View, 121. Available at: http://partners.adobe.com/public/developer/en/tiff/TIFF6.pdf (Date of access: 17 January 2015).

Adobe Systems Incorporated, 2012. Digital Negative (DNG) Specification: Version 1.4.0.0. Adobe Systems Incorporated. Available at: http://www.adobe.com/content/dam/Adobe/en/products/photoshop/pdfs/dng_spec_1.4.0.0.pdf (Date of access: 6 April 2014).

Adobe Systems Incorporated, 2013. Extensible Metadata Platform (XMP). Adobe Systems Incorporated. Available at: http://www.adobe.com/products/xmp/ (Date of access: 14 April 2013).

Andrews, P., Butler, Y.J. and Farace, J., 2006. *Raw Workflow from Capture to Archives: A Complete Digital Photographer's Guide to Raw Imaging.* Oxford: Focal Press.

Arnold, C.R., Rolls, P.J. and Stewart, J.C.J., 1971. *Applied Photography.* London, New York: Focal Press.

Atkinson, P.M., 2009. Geoinformatics. In: *Geoinformatics Volume I. Encyclopedia of Life Support Systems – Earth and Atmospheric Sciences*, Atkinson, P.M. (Ed.), Oxford: Eolss Publishers–UNESCO, 1–35.

Balasubramanian, R., 2003. Device characterization In: *Digital Color Imaging Handbook. Electrical Engineering and Applied Signal Processing Series*, Sharma, G. (Ed.), CRC Press, Boca Raton, 269–383. DOI: http://dx.doi.org/10.1201/9781420041484.ch5.

Barnes, R., 1963. Thermography of the human body. *Science and Technology for Cultural Heritage*, 140(3569), 870–877.

Bass, M., DeCusatis, C.M., Enoch, J.M., Lakshminarayanan, V., Li, G., MacDonald, C.A., Mahajan, V.N. and van Stryland, E.W. (eds.), 2010. *Handbook of Optics: Volume I. Geometrical and Physical Optics, Polarized Light, Components and Instruments*, 3rd edn. New York: McGraw-Hill.

Bayer, B.E., 1975. Color imaging array. United States Patent 3 971 065. Available at: www.freepatentsonline.com/3971065.pdf (Date of access: 12 January 2015).

Berns, R.S., 2000. *Billmeyer and Saltzman's Principles of Color Technology*, 3rd edn. New York: Wiley.

Berns, R.S., 2001. The science of digitizing paintings for color-accurate image archives: a review. *The Journal of Imaging Science and Technology*, 45(4), 305–325. Available at: http://ritdml.rit.edu/dspace/bitstream/1850/4293/6/RBernsArticle07-2001.pdf.

Berns, R.S., Taplin, L.A., Imai, F.H., Day, E.A. and Day, D.C., 2003. Spectral imaging of Matisse's Pot of Geraniums: a case study. In: *Eleventh Color Imaging Conference: Color Science and Engineering Systems, Technologies, and Applications*, Scottsdale, AZ. 3–7 November, 149–153. Available at: http://art-si.org/PDFs/Acquisition/CIC03_Berns.pdf.

Berry, R. and Burnell, J., 2005. *The Handbook of Astronomical Image Processing*, 2nd edn. Richmond, VA: Willmann-Bell.

Bezryadin, S., 2007. Quality criterion for digital still camera. In: *Digital Photography III*, San Jose, California, USA. 29–30 January. SPIE, Bellingham, WA, 65020M–65020M-9. DOI: http://dx.doi.org/10.1117/12.704524.

Bianco, S., Colombo, A., Gasparini, F. and Schettini, R., 2012. Applications of spectral imaging and reproduction to cultural heritage. In: *Digital Imaging for Cultural Heritage Preservation. Analysis, Restoration, and Reconstruction of Ancient Artworks*, Stanco, F., Battiato, S., Gallo, G. (Eds.), Digital Imaging and Computer Vision Series. Boca Raton, CA: CRC Press, 183–213.

Billingsley, F.C., 1965. Digital video processing at JPL. In: *Electronic Imaging Techniques I*. SPIE, Bellingham, 15.

Billingsley, F.C., Anuta, P.E., Carr, J.L., McGillem, C.D., Smith, D.M. and Strand, T.C., 1983. Data processing and reprocessing. In: *Manual of Remote Sensing. Volume 1: Theory, Instruments and Techniques*, Colwell, R.N., Simonett, D.S. and Ulaby, F.T. (Eds.), 2nd edn. American Society of Photogrammetry, Falls Church, 719–792.

Borbély, Á., Sámson, Á. and Schanda, J., 2001. The concept of correlated colour temperature revisited. *Color Research & Application*, 26(6), 450–457. DOI: http://dx.doi.org/10.1002/col.1065.

Born, M. and Wolf, E., 1999. *Principles of Optics: Electromagnetic Theory of Propagation, Interference and Diffraction of Light*, 7th edn. Cambridge: Cambridge University Press.

Boyle, W.S., Smith, G.E., 1970. Charge coupled semiconductor devices. *Bell System Technical Journal*, 49, 587–593. Available at: http://www.alcatel-lucent.com/bstj/vol49-1970/articles/bstj49-4-587.pdf.

Breaker, L.C., 1990. Estimating and removing sensor-induced correlation from advanced very high resolution radiometer satellite data. *Journal of Geophysical Research*, 95(C6), 9701. DOI: http://dx.doi.org/10.1029/JC095iC06p09701.

Brown, D.C., 1956. The simultaneous determination of the orientation and lens distortion of a photogrammetric camera. *Air Force Missile Test Center Technical Report* 56–20. Patrick AFB, FL.

Brown, D.C., 1966. Decentering distortion of lenses: The prism effect encountered in metric cameras can be overcome through analytic calibration. *Photogrammetric Engineering and Remote Sensing*, 32(3), 444–462.

Buchsbaum, G. and Gottschalk, A., 1983. Trichromacy, opponent colours coding and optimum colour information transmission in the retina. *Proceedings of the Royal Society B: Biological Sciences*, 220(1218), 89–113. DOI: http://dx.doi.org/10.1098/rspb.1983.0090.

Burnside, C.D., 1985. *Mapping from Aerial Photographs*, 2nd edn. London: Collins.

Camera & Imaging Products Association, 2010–2012. Exchangeable image file format for digital still cameras: Exif Version 2.3. CIPA-JEITA, Tokyo. Available at: http://www.cipa.jp/english/hyoujunka/kikaku/pdf/DC-008-2012_E.pdf. (Date of access: 6 April 2013).

Canon U.S.A., 2015. EOS 5D Mark II. EOS (SLR) Camera System. Available at: http://www.usa.canon.com/cusa/windows_vista/cameras/eos_slr_camera_systems/eos_5d_mark_ii?selectedName=Features&fileName=0901e0248004269a_feature8.html (Date of access: 9 Jan 2015).

Chakrabarti, A., Scharstein, D. and Zickler, T., 2009. An empirical camera model for internet color vision. In: *Proceedings of BMVC 2009*, London. 7–10 September. BMVA Press, 51.1–51.11. DOI: http://dx.doi.org/10.5244/C.23.51.

CIE, 1987. *International Lighting Vocabulary*. CIE Publication 17.4 / IEC Publication 50 (845). CIE–IEC.

Clark, R.N., 2000. Image detail. (How much detail can you capture and scan?) (And other information on digital camera detail and print resolution.). Available at: http://www.clarkvision.com/articles/scandetail/index.html (Date of access: 9 January 2015).

Clark, R.N., 2004. Dynamic range and transfer functions of digital images and comparison to film (Intensity Detail of Images). Available at: http://www.clarkvision.com/articles/dynamicrange2/ (Date of access: 9 January 2015).

Clark, R.N., 2014. Digital camera review and sensor performance summary. Available at: http://www.clarkvision.com/articles/digital.sensor.performance.summary/ (Date of access: 17 January 2015).

Colour and Vision Research Laboratory, 2014. Colour and vision research database. http://www.cvrl.org/ (Date of access: 20 July 2014).

Cracknell, A.P., 1998. Synergy in remote sensing – what's in a pixel? *International Journal of Remote Sensing*, 19(11), 2025–2047. DOI: http://dx.doi.org/10.1080/014311698214488.

Dalsa Corporation, 2005. Electronic shuttering for high speed CMOS Machine Vision Applications. Photonik 5. Available at: http://www.google.com/url?sa=t&rct=j&q=&esrc=s&source=web&cd=2&cad=rja&ved=0CEoQFjAB&url=http%3A%2F%2Fwww.teledynedalsa.com%2Fshared%2Fcontent%2Fpdfs%2Fphotonik_cmos_shuttering_english.pdf&ei=dIT1UMiqEsHJtAax4YDIDg&usg=AFQjCNH6YFkNr3WhAr2gcHFcFmr_wwmmSg&sig2=xkM_QQQjP46qLPehLguAqA&bvm=bv.41018144,d.Yms.

Delmas, J., 2012. *La gestion des couleurs pour les photographes, les graphistes et le prépresse*. Paris: Eyrolles.

Deutsches archäologisches Institut, 1978. *Archäologie und Photographie: Fünfzig Beispiele zur Geschichte und Methode*. Mainz am Rhein: Verlag Philipp van Zabern.

Ditteon, R., 1998. *Modern Geometrical Optics*. New York: Wiley.

Dorrell, P.G., 1994. *Photography in Archaeology and Conservation*, 2nd edn. Cambridge manuals in archaeology. Cambridge: Cambridge University Press.

Eastman Kodak Company, 2011. KODAK image sensors: Shutter operations for CCD and CMOS image sensors. Kodak Application Note Revision 3.0 MTD/PS-0259. Eastman Kodak Company, 8. Available at: http://www.kodak.com/ek/US/en/ShutterOperations.htm. (Date of access: 17 January 2013).

Fairchild, M.D., 1998. *Color Appearance Models*. Reading. MA: Addison-Wesley.

Fairchild, M.D., Rosen, M.R. and Johnson, G.M., 2001. Spectral and metameric color imaging. RIT-MCSL Technical report. Munsell Color Science Laboratory, 8. Available at: http://www.cis.rit.edu/research/mcsl2/research/PDFs/Spec_Met.pdf. (Date of access: 11 September 2011).

Fairman, H.S., Brill, M.H. and Hemmendinger, H., 1997. How the CIE 1931 color-matching functions were derived from Wright–Guild data. *Color Research & Application*, 22(1), 11–23. DOI: http://dx.doi.org/10.1002/(SICI)1520-6378(199702)22:1<11:AID-COL4>3.0.CO;2–7.

Ferrano, G., Walser, B. and Morin, K., 2010. Metric camera with focal plane shutter. In: *Proceedings of the International Calibration and Orientation Workshop EuroCOW 2010*, Castelldefels, Spain. 10–12 February 2010. EuroSDR – ISPRS. Available at: http://www.isprs.org/proceedings/XXXVIII/Eurocow2010/euroCOW2010_files/papers/09.pdf.

Ferreira, F.M.P.B., Fiadeiro, P.T., Almeida, V.M.N., de Pereira, M.J.T., Bernardo, J. and Nascimento, S.M.C., 2006. Spectral characterization of a hyperspectral system for imaging of large art paintings. In: *Proceedings of CGIV 2006*. The Third European Conference on Color in Graphics, Imaging and Vision, Leeds, UK. The Society for Imaging Science and Technology, 350–354.

Fiete, R.D., 2010. *Modeling the Imaging Chain of Digital Cameras*. Tutorial Texts in Optical Engineering TT92. SPIE, Bellingham.

Fiete, R.D., 2012. *Formation of a Digital Image: The Imaging Chain Simplified*. SPIE Press Monograph PM218. SPIE Press, Bellingham.

Fincham, W. and Freeman, M., 1980. *Optics*, 9th edn. London: Butterworths.

Forssén, P.-E. and Ringaby, E., 2010. Rectifying rolling shutter video from hand-held devices. In: *Proceedings of IEEE Conference on Computer Vision and Pattern Recognition (CVPR)*, San Fransisco, CA, USA. 13–18 June. IEEE. Available at: http://www.cvl.isy.liu.se/research/rs-dataset/0382.pdf.

Fossum, E.R., 1997. CMOS active pixel sensor (APS) technology for multimedia image capture. In: *Proceedings of the 1997 Multimedia Technology & Applications Conference (MTAC97)*, University of California, Irvine, USA. March 23–25, 199, 1–5. Available at: http://ericfossum.com/Publications/Papers/CMOS%20active%20pixel%20sensor%20(APS)%20technologyt%20fo%20rmultimedia%20image%20capture.pdf.

Fraser, B., 2005. Real world camera raw with Adobe Photoshop CS2: industrial-strength production techniques. Real World. Berkeley, CA: Peachpit Press.

Fraser, B., Murphy, C. and Bunting, F., 2005. *Real World Color Management: Industrial-Strength Production Techniques,* 2nd edn. Berkeley, CA: Peachpit Press.

Gauglitz, G. and Dakin, J.P., 2006. Spectroscopic analysis. In: *Handbook of Optoelectronics*, Dakin, J.P. and Brown, R.G. (Eds.), Boca Raton: Taylor & Francis, 1399–1441.

Gilchrist, A.L., 2007. Lightness and brightness. *Current Biology*, 17(8), R267. DOI: http://dx.doi.org/10.1016/j.cub.2007.01.040.

Giorgianni, E.J. and Madden, T.E., 2008. *Digital Color Management: Encoding Solutions*, 2nd edn. Wiley-IS&T series in imaging science and technology. Chichester: Wiley.

Giorgianni, E.J., Madden, T.E. and Spaulding, K.E., 2003. Color management for digital imaging systems. In: Sharma, G. (Ed.), *Digital Color Imaging Handbook*. Electrical Engineering and Applied Signal Processing Series. Boca Raton: CRC Press, 239–268.

Gonzalez, R.C. and Woods, R.E., 2002. *Digital Image Processing, 2,* International edn. Upper Saddle River, NJ: Prentice-Hall.

Graham, R. and Koh, A., 2002. *Digital Aerial Survey: Theory and Practice*. Boca Raton: CRC Press/Whittles Publishing.

Gruner, H., Pestrecov, K., Norton, C.L., Tayman, W.P. and Washer, F.E., 1966. Elements of photogrammetric optics. In: Thompson, M.M., Eller, R.C., Radlinski, W.A. and Speert, J.L. (Eds.), *Manual of Photogrammetry. Volume I,* 3rd edn. American Society of Photogrammetry, Falls Church, 67–132.

Guild, J., 1931. The colorimetric properties of the spectrum. *Philosophical Transactions of the Royal Society A: Mathematical, Physical and Engineering Science*s, 230(681–693), 149–187. DOI: http://dx.doi.org/10.1098/rsta.1932.0005.

Hapke, B., 2012. *Theory of Reflectance and Emittance Spectroscopy,* 2nd edn. Cambridge: Cambridge University Press.

Har, D., Son, Y. and Lee, S., 2004. SLR digital camera for forensic photography. In: *Sensors and Camera Systems for Scientific, Industrial, and Digital Photography Applications V*, San Jose, CA. 19–21 January. IS&T – SPIE, Bellingham, 276–284.

Hardeberg, J.Y., 2001. Acquisition and reproduction of color images: colorimetric and multispectral approaches. Dissertation.com, Parkland.

Harp, E., Jr. (ed.), 1975. *Photography in Archeological Research*. University of New Mexico Press, Albuquerque.

Hecht, E., 2002. *Optics*, 4th edn. San Francisco, CA: Addison Wesley.

Hering, E., 1878. Zur Lehre vom Lichtsinne: Sechs Mittheilungen an die Kaiserl. Akademie der Wissenschaften in Wien, zweiter unveränderte Abdruck edn. Wien: Gerold.

Hering, E., 1920. Grundzüge der Lehre vom Lichtsinn. Berlin: Julius Springer.

Holst, G.C., 1998. *CCD Arrays, Cameras, and Displays*, 2nd edn. Winter Park, FL and Bellingham, WA: JCD Pub., Spie Optical Engineering Press,.

Howell, C.L. and Blanc, W., 1995. *A Practical Guide to Archaeological Photography*, 2nd edn. Institute of Archaeology, University of California, Los Angeles, CA.

Hung, P.-C., 1991. Colorimetric calibration for scanners and media. In: *Camera and Input Scanner Systems*. 27 February, San Jose, CA. SPIE, 164–174. DOI: http://dx.doi.org/10.1117/12.45355.

Hung, P.-C., 2006. Color theory and its applications to digital still cameras. In: *Image Sensors and Signal Processing for Digital Still Cameras*. Nakamura, J. (Ed.), Boca Raton: Taylor & Francis, 205–221.

Hunt, R.W.G., 1999. Why is black and white so important in colour?. In: *Colour Imaging. Vision and Technology*, MacDonald, L.W. and Luo, M.R. (Eds.), Chichester: Wiley, 3–15.

Hunt, R.W.G., 2004. *The Reproduction of Colour*, 6th edn. The Wiley-IS&T Series in Imaging Science and Technology. Chichester: John Wiley & Sons.

Hytti, H.T., 2005. Characterization of digital image noise properties based on RAW data. In: *Image Quality and System Performance III*. 15-01-2006. SPIE. Available at: http://www.mit.tut.fi/staff/hytti/noise_characterization.pdf.

Iliffe, J. and Lott, R., 2008. *Datums and Map Projections for Remote Sensing, GIS, and Surveying*, 2nd edn. Caithness: Whittles Pub; CRC Press.

Imai, F.H., Quan, S., Rosen, M.R. and Berns, R.S., 2001. Digital camera filter design for colorimetric and spectral accuracy. In: *Proceedings of the Third International Conference on Multispectral Color Science*, University of Joensuu, Finland. Available at: http://www.art-si.org/PDFs/Acquisition/MCS01_Imai.pdf.

International Color Consortium, 2010. Specification ICC.1:2010 (Profile version 4.3.0.0). Image technology colour management – Architecture, profile format, and data structure, 1st ed. International Color Consortium ICS 37.100.99. Available at: http://www.color.org/specification/ICC1v43_2010–12.pdf. (Date of access: 17 January 2015).

Ives, H.E., 1915. The transformation of color-mixture equations from one system to another. *Journal of the Franklin Institute*, 180(6), 673–701. DOI: http://dx.doi.org/10.1016/S0016-0032(15)90396-4.

Jacobson, R.E., Ray, S.F., Attridge, G.G. and Axford, N.R., 2000. *The Manual of Photography: Photographic and Digital Imaging*, 9th edn. Oxford: Focal Press.

Jähne, B., 2004. *Practical Handbook on Image Processing for Scientific and Technical Applications*, 2nd edn. Boca Raton: CRC Press.

Janesick, J.R., 2001. *Fundamentals of Scientific Charge-Coupled Devices*. SPIE Press Monograph 83. Bellingham, WA: SPIE.

Janesick, J.R. and Blouke, M.M., 1987. Sky on a chip: the fabulous CCD. *Sky and Telescope Magazine*, 74(3), 238–242. Available at: http://www.phy.duke.edu/~kolena/sky_on_a_chip.pdf.

Jensen, N., 1968. *Optical and Photoghraphic Reconnaissance Systems.* Wiley Series on Photographic Science and Technology and the Graphic Arts. New York – London – Sydney: John Wiley & Sons.

Jia, C. and Evans, B.L., 2012. Probabilistic 3-D motion estimation for rolling shutter video rectification from visual and inertial measurements. In: *Proceedings of the IEEE International Workshop on Multimedia Signal Processing*, Banff, Canada. 17–20 September. IEEE. Available at: http://users.ece.utexas.edu/~bevans/papers/2012/rolling/rollingShutterRectification MMSP2012Paper.pdf.

Judd, D.B., 1951. Report of U.S. secretariat committee on colorimetry and artificial daylight. In: *Proceedings of the Twelfth Session of the CIE*. Volume 1, Stockholm, Sweden. Bureau Central de la CIE, Paris, 11.

Katz, M., 2002. *Introduction to Geometrical Optics.* World Scientific, River Edge.

Kim, S.J., Lin, H.T., Lu, Z., Süsstrunk, S., Lin, S. and Brown, M.S., 2012. A new in-camera imaging model for color computer vision and its application. *IEEE Transactions on Pattern Analysis and Machine Intelligence*, 34(12), 2289–2302. DOI: http://dx.doi.org/10.1109/TPAMI.2012.58.

Kingdom, F.A.A., 2011. Lightness, brightness and transparency: a quarter century of new ideas, captivating demonstrations and unrelenting controversy. *Vision Research*, 51(7), 652–673. DOI: http://dx.doi.org/10.1016/j.visres.2010.09.012.

König, F. and Herzog, P.G., 1999. On the limitations of metameric imaging. In: *PICS 1999: Proceedings of the Conference on Image Processing, Image Quality and Image Capture Systems (PICS-99)*, Savannah, Georgia, USA. April 25–28. Society for Imaging Science and Technology, 163–168.

Kraus, K., 2007. *Photogrammetry: Geometry from Images and Laser Scans,* 2nd [English] edn. Berlin – New York: Walter de Gruyter.

Lam, E.Y. and Fung, G.S., 2009. Automatic white balancing in digital photography. In: *Single-0cessing Series 9.* Boca Raton: CRC Press, 267–294.

Leachtenauer, J.C. and Driggers, R.G., 2001. *Surveillance and Reconnaissance Imaging Systems: Modeling and Performance Prediction.* Artech House Optoelectronics Library. Boston, MA: Artech House.

Lee, H.-C., 2005. *Introduction to Color Imaging Science.* Cambridge: Cambridge University Press.

Lennie, P. and D'Zmura, M., 1988. Mechanisms of color vision. *CRC Critical Review Neurobiology*, 3(4), 333–400. Available at: www.cns.nyu.edu/~pl/pubs/Lennie%26DZMura88.pdf.

Levi, L., 1968. *Applied Optics. A Guide to Optical System Design: Volume 1.* Wiley Series in Pure and Applied Optics. New York – London – Sydney:John Wiley & Sons.

Liang, C.-K., Chang, L.-W. and Chen, H.H., 2008. Analysis and compensation of rolling shutter effect. *IEEE Transactions on Image Processing*, 17(8), 1323–1330. DOI: http://dx.doi.org/10.1109/TIP.2008.925384.

Lin, H., Kim, S.J., Süsstrunk, S.E. and Brown, M.S., 2011. Revisiting radiometric calibration for color computer vision. In: *Proceedings of the 2011 IEEE International Conference on Computer Vision (ICCV)*, Barcelona, Spain. 6–13 November. IEEE, Piscataway, 129–136. DOI: http://dx.doi.org/10.1109/ICCV.2011.6126234.

Lin, H.T., Lu, Z., Kim, S.J. and Brown, M.S., 2012. Nonuniform lattice regression for modeling the camera imaging pipeline. In: *Computer Vision – ECCV 2012. Proceedings of the 12th European Conference on Computer Vision*, Fitzgibbon, A., Lazebnik, S., Perona, P., Sato, Y. and Schmid, C. (Eds.), Florence, Italy, October 7–13. Part I, vol. 7572. Lecture notes in computer science 7572. Springer, Berlin, 556–568. DOI: http://dx.doi.org/10.1007/978-3-642-33718-5_40.

Lipson, A., Lipson, S.G. and Lipson, H., 2011. *Optical Physics,* 4th edn. Cambridge: Cambridge University Press.

Litwiller, D., 2005. CMOS vs. CCD: maturing technologies, maturing markets. *Photonics Spectra*, 39(8), 54–59. Available at: http://www.dalsa.com/public/corp/CCD_vs_CMOS_Litwiller_2005.pdf.

Livingstone, M., 2002. *Vision and Art: The Biology of Seeing*. New York: Abrams.

Longhurst, R.S., 1967. *Geometrical and Physical Optics*, 2nd edn. London: Longmans.

Luther, R., 1927. Aus dem Gebiet der Farbreizmetrik. *Zeitschrift für technische Physik*, 8, 540–558.

Lynch, D.K. and Livingston, W.C., 2001. *Color and Light in Nature*, 2nd edn. Cambridge: Cambridge University Press.

Lyon, R.F., 2006. A brief history of 'pixel'. In: *Digital Photography II: IS&T/SPIE Symposium on Electronic Imaging*, San Jose, California, USA. 15–19 January. SPIE, 606901–606901–15. DOI: http://dx.doi.org/10.1117/12.644941.

Lyon, R.F. and Hubel, P.M., 2002. Eyeing the camera: into the next century. In: *Final Program and Proceedings of the 10th Color Imaging Conference: Color Science and Engineering Systems, Technologies, Applications*, Scottsdale, Arizona, USA. November 12–15. IS & T, Springfield, 349–355.

MacDonald, L.W. (ed.), 2006. *Digital Heritage: Applying Digital Imaging to Cultural Heritage*, 1st edn. Amsterdam: Elsevier.

MacDonald, L.W., 2014. Colour and visual realism in cultural heritage. In: *Colour and Colorimetry. Multidisciplinary Contributions Vol. X B. Proceedings of the 10th Conferenza del Colore*, Genova, Italy. 11–12 September. Milano: Gruppo del Colore, 494–497.

Macfarlane, C., Ryu, Y., Ogden, G.N. and Sonnentag, O., 2014. Digital canopy photography: exposed and in the raw. *Agricultural and Forest Meteorology*, 197, 244–253. DOI: http://dx.doi.org/10.1016/j.agrformet.2014.05.014.

Magnan, P., 2003. Detection of visible photons in CCD and CMOS: a comparative view. *Nuclear Instruments and Methods in Physics Research Section A: Accelerators, Spectrometers, Detectors and Associated Equipment*, 504(1–3), 199–212. DOI: http://dx.doi.org/10.1016/S0168-9002(03)00792-7.

Malacara, D., 2011. *Color Vision and Colorimetry: Theory and Applications*, 2nd edn. Press Monograph 204. Bellingham: SPIE.

Markham, B.L., 1985. The Landsat sensors' spatial responses. *IEEE Transactions on Geoscience and Remote Sensing*, 23(6), 864–875. DOI: http://dx.doi.org/10.1109/TGRS.1985.289472.

Mather, G., 2006. *Foundations of Perception*. Hove, New York: Psychology Press.

Matthews, S.K., 1968. *Photography in Archaeology and Art*. London: John Baker.

Meehan, L., 2001. *Creative Exposure Control: How to get the Exposure you want Every Time*. London: Collins & Brown.

Mendis, S.K., Kemeny, S.E. and Fossum, E.R., 1993. A 128 × 128 CMOS active pixel image sensor for highly integrated imaging systems. *IEEE International Electron Devices Meeting (IEDM)*, 583–586. Available at: http://trs-new.jpl.nasa.gov/dspace/bitstream/2014/36040/1/93-1773.pdf.

Mikhail, E.M., Bethel, J.S. and McGlone, J.C., 2001. *Introduction to Modern Photogrammetry*. New York: Wiley.

Morton, R.A. (ed.), 1984. *Photography for the Scientist*, 2nd edn. London: Academic Press.

Mouroulis, P. and Macdonald, J., 1997. *Geometrical Optics and Optical Design*. Oxford Series in Optical and Imaging Sciences 7. Oxford: Oxford University Press.

Murray, J.D., 1996. SPIFF: still picture interchange file format. *Dr. Dobb's Journal of Software Tools*, 21(7), 34–41.

Nakamura, J. (ed.), 2006. *Image Sensors and Signal Processing for Digital Still Cameras*. Boca Raton: Taylor & Francis.

National Institute of Standards and Technology Physical Measurement Laboratory, 2012. *The NIST Reference on Constant, Units and Uncertainty*. NIST Physical Measurement Laboratory. Available at: http://physics.nist.gov/cuu/index.html .

Nelson, K., 2013. *Understanding Gain on a CCD Camera. Quantum Scientific Imaging.* Available at: http://www.qsimaging.com/blog/?p=81 (Date of access: 27 March 2013).

Novati, G., Pellegri, P. and Schettini, R., 2005. An affordable multispectral imaging system for the digital museum. *International Journal on Digital Libraries*, 5(3), 167–178. DOI: http://dx.doi.org/10.1007/s00799-004-0103-y.

Nyquist, H., 1928. Certain topics in telegraph transmission theory. *Transactions of the American Institute of Electrical Engineers*, 47(2), 617–644. DOI: http://dx.doi.org/10.1109/T-AIEE.1928.5055024.

Ohno, Y., 2000. CIE fundamentals for color measurements. In: *Proceedings of IS&T's NIP16 International Conference on Digital Printing Technologies*, Vancouver, B.C., Canada. October 15–20. Springfield: The Society for Imaging Science and Technology, 540–545.

Ohno, Y., 2006. Basic concepts in photometry, radiometry and colorimetry. In: *Handbook of Optoelectronics*, Dakin, J.P. and Brown, R.G. (Eds.), Boca Raton: Taylor & Francis, 287–305.

Ohno, Y., 2010. Radiometry and photometry for vision optics. In: *Handbook of Optics. Volume II. Design, Fabrication, and Testing; Sources and Detectors; Radiometry and Photometry*, Bass, M., DeCusatis, C.M., Enoch, J.M., Lakshminarayanan, V., Li, G., MacDonald, C.A., Mahajan, V.N. and van Stryland, E.W. (Eds.), 3rd edn. New York: McGraw-Hill, 1–37.

Palmer, J.M. and Grant, B.G., 2010. *The Art of Radiometry.* SPIE, Bellingham, WA.

Park, S.K., Schowengerdt, R. and Kaczynski, M.-A., 1984. Modulation-transfer-function analysis for sampled image systems. *Applied Optics*, 23(15), 2572. DOI: http://dx.doi.org/10.1364/AO.23.002572.

Parulski, K.A. and Reisch, R., 2009. Digital camera image storage formats. In: *Single-Sensor Imaging. Methods and Applications for Digital Cameras*. Lukac, R. (Ed.), Image Processing Series 9. Boca Raton: CRC Press, 351–379.

Parulski, K.A. and Spaulding, K., 2003. Color image processing for digital cameras. In: *Digital Color Imaging Handbook*, Sharma, G. (Ed.), Electrical Engineering and Applied Signal Processing Series. Boca Raton: CRC Press, 727–757.

Pascale, D., 2003. *A Review of RGB Color Spaces: … from xyY to R'G'B'.* The BabelColor Company, Montreal. Available at: http://www.babelcolor.com/download/A%20review%20of%20RGB%20color%20spaces.pdf. (Date of access: 21 November 2011).

Pennebaker, W.B. and Mitchell, J.L., 1993. *JPEG Still Image Data Compression Standard.* New York: Van Nostrand Reinhold.

Peres, M.R. (ed.), 2007. *Focal Encyclopedia of Photography: Digital Imaging, Theory and Applications, History, and Science*, 4th edn. Amsterdam, London: Focal Press.

Peterson, B., 2010. *Understanding Exposure: How to shoot Great Photographs with any Camera*, 3rd edn. New York: Amphoto Books.

Purves, D., Williams, S.M., Nundy, S. and Lotto, R.B., 2004. Perceiving the intensity of light. *Psychological Review*, 111(1), 142–158. DOI: http://dx.doi.org/10.1037/0033-295X.111.1.142.

Ramanath, R., Snyder, W.E., Yoo, Y. and Drew, M.S., 2005. Color image processing pipeline: A general survey of digital still camera processing. *IEEE Signal Processing Magazine*, 22(1), 34–43. DOI: http://dx.doi.org/10.1109/MSP.2005.1407713. Available at: http://mysite.verizon.net/rajeevramanath/Research/pipeline-SPM-05.pdf.

Ray, S.F., 1984. Photographic optics. In: *Photography for the Scientist*, Morton, R.A. (Ed.), 2nd edn. London: Academic Press, 87–167.

Ray, S.F., 1999. *Scientific Photography and Applied Imaging.* Oxford: Focal Press.

Ray, S.F., 2002. *Applied Photographic Optics: Lenses and Optical Systems for Photography, Film, Video, Electronic and Digital Imaging*, 3rd edn. Oxford: Focal Press.

Reibel, Y., Jung, M., Bouhifd, M., Cunin, B. and Draman, C., 2003. CCD or CMOS camera noise characterisation. *The European Physical Journal Applied Physics*, 21(1), 75–80. DOI: http://dx.doi.org/10.1051/epjap:2002103.

Reinhard, E., Khan, E.A., Akyüz, A.O. and Johnson, G.M., 2008. *Color Imaging: Fundamentals and Applications.* Wellesley: A.K. Peters.

Remondino, F. and Fraser, C., 2006. Digital camera calibration methods: considerations and comparisons. In: *ISPRS Commission V Symposium 'Image Engineering and Vision Metrology'*, Dresden, Germany. 25–27 September. Dresden: ISPRS, 266–272. Available at: http://www.photogrammetry.ethz.ch/general/persons/fabio/Remondino_Fraser_ISPRSV_2006.pdf.

Ritter, N.and Ruth, M., 2000. GeoTIFF format specification. GeoTIFF revision 1.0. Available at: http://www.remotesensing.org/geotiff/spec/geotiffhome.html (Date of access: 17 Jan 2015).

Rogalski, A. and Bielecki, Z., 2006. Detection of optical radiation. In: *Handbook of Optoelectronics.* Dakin, J.P. and Brown, R.G. (Eds.), Boca Raton: Taylor & Francis, 73–117.

Rudolf, P., 2006. Principles and evolution of digital cameras. In: *Digital Heritage. Applying Digital Imaging to Cultural Heritage,* MacDonald, L.W. (Ed.), 1st edn. Amsterdam: Elsevier, 177–209.

Salvaggio, N., Stroebel, L.D. and Zakia, R.D., 2013. *Basic Photographic Materials and Processes,* 3rd edn. Burlington: Focal Press.

Saxby, G., 2011. *The Science of Imaging: An Introduction,* 2nd edn. Boca Raton: CRC Press.

Schowengerdt, R.A., 2007. *Remote Sensing: Models and Methods for Image Processing,* 3rd edn. Burlington, MA: Academic Press.

Schreiber, W., 1967. Picture coding. *Proceedings of the IEEE,* 55(3), 320–330. DOI: http://dx.doi.org/10.1109/PROC.1967.5488.

Shannon, C.E., 1949. Communication in the presence of noise. *Proceedings of the IRE,* 37(1), 10–21. DOI: http://dx.doi.org/10.1109/JRPROC.1949.232969.

Sharma, G., 2003a. Color fundamentals for digital imaging. In: *Digital Color Imaging Handbook,* Sharma, G. (Ed.), Electrical Engineering and Applied Signal Processing Series. Boca Raton: CRC Press, 1–114.

Sharma, G. (ed.), 2003b. *Digital Color Imaging Handbook.* Electrical Engineering and Applied Signal Processing Series. Boca Raton: CRC Press.

Sharpe, L.T. and Stockman, A., 2008. Luminous efficiency functions. In: *Visual Transduction and Non-Visual Light Perception. Ophthalmology Research.* Tombran-Tink, J. and Barnstable, C.J. (Eds.), Humana Press, Totowa, 329–351. DOI: http://dx.doi.org/10.1007/978-1-59745-374-5_15.

Sharpe, L.T., Stockman, A., Jagla, W. and Jägle, H., 2005. A luminous efficiency function, V*((λ), for daylight adaptation. *Journal of Vision,* 5(11), 948–968. DOI: http://dx.doi.org/10.1167/5.11.3.

Sheppard, R., 2005. *Adobe Camera Raw for Digital Photographers Only.* Hoboken: Wiley.

Siniscalco, A. and Rossi, M., 2014. A review on digital colour for teaching in the courses of representation techniques. In: *Colour and Colorimetry. Multidisciplinary Contributions Vol. X B.* Proceedings of the 10th Conferenza del Colore, Genova, Italy. 11–12 September. Milano: Gruppo del Colore, 55–66.

Slater, J.C. and Frank, N.H., 1969. *Electromagnetism.* New York: Dover Publications.

Slater, P.N., Doyle, F.J., Fritz, N.L. and Welch, R., 1983. Photographic systems for remote sensing. In: *Manual of Remote Sensing. Volume 1: Theory, Instruments and Techniques,* Colwell, R.N., Simonett, D.S. and Ulaby, F.T. (Eds.), 2nd edn. Falls Church:American Society of Photogrammetry, 231–291.

Smith, A.R., 1995. *A Pixel Is Not A Little Square, A Pixel Is Not A Little Square, A Pixel Is Not A Little Square! (And a Voxel is Not a Little Cube).* Microsoft Technical Memo 6. Microsoft. Date of access: 2 July 2006.

Smith, S.L., Mooney, J., Tantalo, T.A. and Fiete, R.D., 1999. Understanding image quality losses due to smear in high-resolution remote sensing imaging systems. *Optical Engineering,* 38(5), 821–826. DOI: http://dx.doi.org/10.1117/1.602054.

Smith, S.W., 1997. *The Scientist and Engineer's Guide to Digital Signal Processing*, 1st edn. San Diego, CA: California Technical Publishing.

Smith, W.J., 2008. *Modern Optical Engineering: The Design of Optical Systems*, 4th edn. New York: McGraw-Hill – SPIE Press,.

Speranskaya, 1959. Determination of spectrum color co-ordinates for twenty seven normal observers. *Optics and Spectroscopy*, 7, 424–428.

Steinmüller, B. and Steinmüller, U., 2004. *Die digitale Dunkelkammer: Vom Kamera-File zum perfekten Print: Arbeitsschritte, Techniken, Werkzeuge*. Heidelberg: Dpunkt-Verlag.

Stevens, S.S., 1961a. The psychophysics of sensory function. In: *Sensory Communication. Contributions to the Symposium on Principles of Sensory Communication*, Rosenblith, W.A. (Ed.), July 19–August 1, 1959, Endicott House, MIT. Cambridge, MA: MIT Press, 1–33. Available at: http://www.cs.ubc.ca/~tmm/courses/cs533c-02/readings/ss.pdf.

Stevens, S.S., 1961b. To honor Fechner and repeal his law: a power function, not a log function, describes the operating characteristic of a sensory system. *Science*, 133(3446), 80–86. DOI: http://dx.doi.org/10.1126/science.133.3446.80.

Stiles, W.S. and Burch, J.M., 1959. N.P.L. Colour-matching Investigation: Final Report (1958). *Optica Acta: International Journal of Optics*, 6(1), 1–26. DOI: http://dx.doi.org/10.1080/713826267.

Stockman, A., MacLeod, D.I.A. and Johnson, N.E., 1993. Spectral sensitivities of the human cones. *Journal of the Optical Society of America A*, 10(12), 2491–2521. DOI: http://dx.doi.org/10.1364/JOSAA.10.002491.

Stockman, A. and Sharpe, L.T., 2000. The spectral sensitivities of the middle- and long-wavelength-sensitive cones derived from measurements in observers of known genotype. *Vision Research*, 40, 1711–1737.

Stone, M.C., 2003. *A Field Guide to Digital Color*. Natick: AK Peters.

Szeliski, R., 2011. *Computer Vision: Algorithms and Applications*. Texts in Computer Science. New York: Springer.

Tadeusz, C., 1949. *Technika nowoczesnej fotografii. Fotografia praktyczna*. Cz. 1–2. Wilak, Poznan.

Teledyne DALSA, 2011. *The Evolution of CMOS Imaging Technology*. Teledyne DALSA. Available at: http://www.teledynedalsa.com/public/mv/appnotes/EvolutionofCMOS_Technology_wp.pdf (Date of access: 15 January 2013).

Teufel, H.J. and Wehrhahn, C., 2002. From tristimulus color space to cone space. In: *Proceedings of the Eighteenth Annual Meeting of the International Society for Psychophysics*, Rio de Janeiro, Brazil. 22–26 October. Rio de Janeiro: The International Society for Psychophysics, 539–545.

Theuwissen, A.J.P., 1995. *Solid-State Imaging with Charge-Coupled Devices*. Dordrecht: Kluwer Academic Publishers.

Toyoda, K., 2006. Digital still cameras at a glance. In: *Image Sensors and Signal Processing for Digital Still Cameras*, Nakamura, J. (Ed.), Boca Raton: Taylor & Francis, 1–19.

Trezona, P.W. and Parkins, R.P., 1998. Derivation of the 1964 colorimetric standards. *Color Research & Application*, 23(4), 221–225. DOI: http://dx.doi.org/10.1002/(SICI)1520-6378(199808)23:4<221:AID-COL6>3.0.CO;2-Q.

Troland, L.T., 1922. Report of Committee on Colorimetry for 1920–21. *Journal of the Optical Society of America*, 6(6), 527. DOI: http://dx.doi.org/10.1364/JOSA.6.000527.

Valberg, A., 2005. *Light Vision Color*. Hoboken: John Wiley & Sons.

Verhoeven, G.J.J., 2008a. Digitally cropping the aerial view. On the Interplay between focal length and sensor size. *Archeologia Aerea. Studi di Aerotopografia Archeologica*, 3, 195–210.

Verhoeven, G.J.J., 2008b. Imaging the invisible using modified digital still cameras for straightforward and low-cost archaeological near-infrared photography. *Journal of Archaeological Science*, 35(12), 3087–3100. DOI: http://dx.doi.org/10.1016/j.jas.2008.06.012.

Verhoeven, G.J.J., 2010. It's all about the format – unleashing the power of RAW aerial photography. *International Journal of Remote Sensing*, 31(8), 2009–2042. DOI: http://dx.doi.org/10.1080/01431160902929271.

Verhoeven, G.J.J., 2012. Methods of visualisation. In: *Analytical Archaeometry*. Edwards, H.G.M. and Vandenabeele, P. (Eds.), Selected Topics. Cambridge: Royal Society of Chemistry, 3–48. DOI: http://dx.doi.org/10.1039/9781849732741-00001.

Verhoeven, G.J.J., Smet, P.F., Poelman, D. and Vermeulen, F., 2009. Spectral characterization of a digital still camera's NIR modification to enhance archaeological observation. *IEEE Transactions on Geoscience and Remote Sensing*, 47(10), 3456–3468. DOI: http://dx.doi.org/10.1109/TGRS.2009.2021431.

Vollmerhausen, R.H., Reago, D.A., Jr. and Driggers, R.G., 2010. *Analysis and Evaluation of Sampled Imaging Systems*. Tutorial Texts in Optical Engineering TT87. SPIE, Bellingham.

Vrhel, M.J., 2000. Color imaging: current trends and beyond. In: *Proceedings of the 2000 International Conference on Image Processing*, Vancouver, BC, Canada. 9–13 September. IEEE, 513–516. DOI: http://dx.doi.org/10.1109/ICIP.2000.901008.

Waldman, G., 2002. *Introduction to Light: The Physics of Light, Vision, and Color*, Expanded and Rev. edn. Mineola, NY: Dover Publications.

Walker, J.S., 2004. *Physics*, 2nd International edn. Upper Saddle River, NJ: Pearson Education.

Wallace, G.K., 1991. The JPEG still picture compression standard. *Communications of the ACM*, 34(4), 30–44. DOI: http://dx.doi.org/10.1145/103085.103089.

Wallace, G.K., 1992. The JPEG still picture compression standard. *IEEE Transactions on Consumer Electronics*, 38(1), xviii. DOI: http://dx.doi.org/10.1109/30.125072.

Wandell, B.A., 1995. *Foundations of Vision*. Massachusetts: Sinauer Associates.

Warda, J., Frey, F.S., Heller, D., Kushel, D., Vitale, T. and Weaver, G., 2011. *The AIC Guide to Digital Photography and Conservation Documentation*, 2nd edn. American Institute for Conservation of Historic and Artistic Works, Washington.

Weber, E.A. and Ebeling, G., 1970. *Fotoprakticum*. Amsterdam: Foton.

Westheimer, G., 2009. Visual acuity: information theory, retinal image structure and resolution thresholds. *Progress in Retinal and Eye Research*, 28(3), 178–186. DOI: http://dx.doi.org/10.1016/j.preteyeres.2009.04.001.

Weston, C., 2004. *The Photographic Guide to Exposure*. Lewes: Photographers' Institute Press.

White, R., 2006. *How Digital Photography Works*. Indianapolis: Que.

Wolf, P.R. and Dewitt, B.A., 2000. *Elements of Photogrammetry with Applications in GIS*, 3rd edn. Boston, MA: McGraw-Hill.

Wolfe, J.M., Kluender, K.R., Levi, D.M., Bartoshuk, L.M., Herz, R.S., Klatzky, R.L. and Lederman, S.J., 2006. *Sensation & Perception*. Sunderland: Sinauer Associates.

Wright, W.D., 1928–29. A re-determination of the trichromatic coefficients of the spectral colours. *Transactions of the Optical Society*, 30(4), 141–164. DOI: http://dx.doi.org/10.1088/1475-4878/30/4/301.

Wyszecki, G. and Stiles, W.S., 1982. *Color Science: Concepts and Methods, Quantitative Data, and Formulae*, Wiley classics library edition edn. Wiley Series in Pure and Applied Optics. New York: John Wiley & Sons.

Xu, G., Terai, J.-i. and Shum, H.-Y., 2000. A linear algorithm for camera self-calibration, motion and structure recovery for multi-planar scenes from two perspective images. In: *Proceedings of the IEEE Conference on Computer Vision and Pattern Recognition 2000*, Hilton Head Island, SC, USA. 13–15 June. Los Alamitos: IEEE Computer Society Press, 474–479. DOI: http://dx.doi.org/10.1109/CVPR.2000.854886.

Yamaguchi, M., Haneishi, H. and Ohyama, N., 2008. Beyond red–green–blue (*RGB*): spectrum-based color imaging technology. *Journal of Imaging Science and Technology*, 52(1), 010201-010201-15. DOI: http://dx.doi.org/10.2352/J.ImagingSci.Technol.(2008)52:1(010201).

Available at: http://scitation.aip.org/getpdf/servlet/GetPDFServlet?filetype=pdf&id=
JIMTE6000052000001010201000001&idtype=cvips&doi=10.2352/J.ImagingSci.Technol.
(2008)52:1(010201)&prog=normal.

Yendrikhovskij, S.N., MacDonald, L.W., Bech, S. and Jensen, K., 1999. Enhancing colour
image quality in television displays. *Imaging Science Journal*, 47(4), 197–211.

Yoshida, H., 2006. Evaluation of image quality. In: *Image Sensors and Signal Processing for Digital
Still Cameras*, Nakamura, J. (Ed.), Boca Raton: Taylor & Francis, 277–303.

Young, H.D., Freedman, R.A. and Sears, F.W., 2004. *Sears and Zemansky's University Physics:
with Modern Physics*, 11th edn. San Francisco, CA: Pearson/Addison Wesley,.

Basics of Image-Based Modelling Techniques in Cultural Heritage 3D Recording | 5

Efstratios Stylianidis, Andreas Georgopoulos
and Fabio Remondino

5.1 Cultural heritage 3D documentation

5.1.1 The documentation of cultural heritage

Monuments, including immovable structures of any kind and movable artefacts, are undeniable documents of world history. Their thorough study is an obligation of our era to mankind's past and future. Respect towards cultural heritage has its roots in the era of the Renaissance. Archaeological excavations became common practice during the 19th century and matured in the 20th century. International bodies and agencies have passed resolutions concerning the obligation for protection, conservation and restoration of monuments. The Athens Convention [1931], the Hague Agreement [1954], the Chart of Venice [1964] and the Granada Agreement [1985] are some of the resolutions in which the need for the full documentation of the monuments is stressed, as part of their protection, study and conservation. Nowadays, all countries of the civilised world use science and technology to protect and conserve the monuments within their borders, and even outside, when assisting other countries. These general tasks include geometric recording, risk assessment, monitoring, restoration, reconstruction and the management of cultural heritage.

The integrated documentation of monuments includes the acquisition of all possible data concerning a monument which may contribute to its safeguarding in the future. Such data may include historic, archaeological and architectural information, but also administrative data and past drawings, sketches, photos etc. Moreover, these data also include metric information which defines the size, the form and the location of the monument in 3D space, to document the monument geometrically.

5.1.2 The geometric documentation of cultural heritage

The geometric documentation of a monument, which should be considered as an integral part of the greater action, the integrated documentation of cultural heritage may be defined [UNESCO, 1972] as:

- the action of acquiring, processing, presenting and recording the necessary data for the determination of the position and the actual existing form, shape and size of a monument in the three-dimensional space at a particular given moment in time;
- the geometric documentation records the present of the monuments, as this has been shaped in the course of time and is the necessary background for the studies of their past, as well as the care of their future.

The geometric documentation of a monument consists of a series of necessary measurements, from which visual products such as vector drawings, raster images, 3D visualisations etc. may be produced at small or large scales. These products have usually metric properties, especially those in orthographic projections. Hence one could expect from the geometric documentation a series of drawings, which actually present the orthoprojections of the monument on suitably selected horizontal or vertical planes (Figure 5.1). Very important properties of these products are their scale and accuracy. These should be carefully defined at the outset, before any action on the monument.

In this context, 'large scale' implies scales larger than 1:250. The various alternative scales may be grouped in three main categories:

1. scales between 1:250 and 1:100, which serve purposes of general surveys, in order to relate the monument to its immediate surroundings.
2. the group of scales between 1:50 and 1:20 covers most of the geometric recording cases providing a highly detailed product for practically any sort of serious study.
3. scales larger than 1:20, even enlargements (i.e. 2:1, 5:1 etc.), are used for drawings of special details of interest.

Figure 5.1 The complete geometric documentation of a monument.

The accuracy required in each case varies with the scale coefficient. Considering that users are able to distinguish and measure up to 0.25 mm on any drawing, the accuracy requirements for these scales range from 7 cm to a few millimetres.

Another important issue is the level of detail which should be present in the final product. For a justified decision on this, the contribution of the expert who is going to be the user is indispensable. A survey product, a line drawing or an image, implies generalisation to a certain degree, depending on the scale. Hence, the requirements or the limits of this generalisation should be set very carefully and always in co-operation with the architect or the relevant conservationist, who already has deep knowledge of the monument [Georgopoulos and Ioannidis 2007].

5.1.3 Tools for the geometric documentation of cultural heritage

Several surveying methods may be applied for geometric recording, ranging from the conventional simple topometric methods for partially or totally uncontrolled surveys, to the elaborate contemporary surveying and photogrammetric ones for completely controlled surveys. The simple topometric methods are applied only when the small dimensions and simplicity of the monument allow it, when an uncontrolled survey is adequate, or in cases when a small completion of the fully controlled methods is required.

Surveying and photogrammetric methods are based on direct measurements of lengths and angles, either on the monument or on images thereof. They determine three-dimensional point coordinates in a common reference system and ensure uniform and specified accuracy. Moreover, they provide adaptability, flexibility, speed, security and efficiency. All in all they present undisputed financial merits, in the sense that they are the only methods which may surely meet any requirements with the least possible total cost and the biggest total profit. To this measurement group belong the terrestrial laser scanners (TLS). They are able to collect a huge number of points in 3D space, usually called point clouds, in a very limited time frame.

It should, however, be stressed that, since to date there is no generally acceptable framework for specifying the level of detail and the accuracy requirements for the various kinds of geometric recording of monuments, every single monument is geometrically documented on the basis of its own accuracy and cost specifications. Therefore it is imperative that all disciplines involved should cooperate closely, exchange ideas and formulate the geometric documentation requirements in common, while they understand the monument itself and each other's needs in detail.

5.1.4 ICT at the service of cultural heritage

Impact of ICT advances on cultural heritage documentation

Nowadays, the rapid advances of digital technology (DT) also referred to as information communication technologies (ICT), have provided scientists with powerful new

tools. We are now able to acquire, store, process, manage and present any kind of information in digital form. This may be done faster, more completely and it can ensure that this information is easily available for a larger base of interested individuals. Those digital tools include instrumentation for data acquisition, such as scanners, digital cameras, digital total stations etc., software for processing and managing the collected data and – of course – computer hardware, for running the software, storing the data and presenting them in various forms.

The introduction of DTs has already altered the way we perceive fundamental notions like indigenous, artefact, heritage, 3D space, ecology etc. At the same time they tend to transform the traditional work of archaeologists and museums as they are so far known. In other words DT redefines the relationship to cultural heritage, as they enable universal access to it and they also connect cultural institutions to new 'audiences'. Finally, they appeal to new generations, as the latter are, by default, computer literate. In this way we experience a 'democratisation' of cultural information across geographic, religious, cultural and scientific borders. Cultural heritage is nowadays an international, interdisciplinary and intercultural responsibility.

Common practice in taking care of the world's cultural heritage starts with initial historical studies and the thorough consultation of literature and written or other sources. Next comes an extensive bibliographic documentation from previous excavations and published studies in a particular area. Theoretical studies are then followed by the main archaeological research, which includes exploratory field research, excavation research, structural archaeological research and landscape archaeological activities. These in situ activities initiate the thorough study and processing of the archaeological material discovered, in conjunction with related publications. This leads then to protection and management actions, either for extended archaeological sites or for archaeological finds. The culmination of archaeological practice is the conservation of material and of course the publication of results. The introduction of DT may contribute to all of the above traditional steps. 'Contribution' here means 'enhancement' and 'support' rather than 'replacement'. It goes without saying that the degree of contribution of ICT differs at various stages and in different cases.

Initial historical studies benefit from the expansion and operation of digital libraries. Practically all related bibliography is readily available via a simple search engine and a standard computer. Modern technologies of remote sensing and archaeological prospection assist the touchless and rapid detection of objects of interest. Spectroradiometers or ground penetrating radars, or even the simple processing of multispectral satellite images, may easily lead to the rapid location of underground or submerged objects of interest. Contemporary survey technologies, such as photogrammetry, terrestrial laser scanning and digital imaging, may be used to produce accurate base maps for further study, or 3D virtual renderings and visualisations. The collected data may be stored in interactive databases, georeferenced or not, and managed according to the needs of the experts. Finally, ICT may assist in the presentation stage, by producing virtual models, which may be displayed in museums or included in an educational

DVD, or serve purposes of enabling handicapped persons to admire the treasures of the world's cultural heritage.

The use of DT in preservation and curation in general of cultural heritage is also mandated by UNESCO. With the Charter on the Preservation of the Digital Cultural Heritage [UNESCO 2003] this global organisation proclaims the basic principles of digital cultural heritage for all civilised countries of the world. At the same time, numerous international efforts are underway with the scope to digitise all aspects of cultural heritage, be they large monuments, tangible artefacts or even intangible articles of the world's legacy.

The impact of DT on the domain of cultural heritage has been to increase speed and automation of the procedures which involve processing of the digital data and presentation of the results. At the same time accuracy and reliability have been substantially enhanced. However, most important is the ability to provide users with new and alternative products, which include 2D and 3D products, such as orthoimages and 3D models. All in all, the digitisation of the world's cultural heritage, both tangible and intangible, is now possible.

3D modelling is the process of virtually constructing the three-dimensional representation of an object. The use of 3D models is highly increased nowadays in many aspects of everyday life (cinema, advertisements, games, museums, medicine etc.).

Contemporary tools for cultural heritage documentation

ICT tools may be of different kinds: contemporary digital instrumentation for data acquisition, powerful computers with high resolution monitors capable of 3D presentations and specially developed software to process the acquired data in the most suitable and effective way. The instrumentation necessary to support heritage conservation activities should always be at the technological edge nowadays. Modern instrumentation includes data acquisition instruments, processing software and powerful computers. Data acquisition instruments should include devices which are capable of digitally collecting:

- images or image sequences;
- points in 3D space;
- other pieces of information related to cultural heritage objects.

Rapid technological progress has provided scientists with sophisticated instrumentation, which includes calibrated high resolution digital cameras, digital high resolution video recorders, accurate angle and distance measuring devices, GPS receivers, TLS, 3D non-laser scanners for small artefacts, film scanners and printed document scanners. Moreover, instruments such as thermal and range cameras, material sampling devices and ultrasonic non-destructive inspecting instruments also contribute to data acquisition.

Processing of all acquired multisource data includes position calculations, processing of the digital images or image sequences and working with point clouds. For these actions, related software has been developed to cover all possible needs. The processing

stage is supported by the powerful computing units which are available today. Processing usually aims to store, archive, manage, visualise, present and publish the collected data and the information derived. In recent years much research effort is directed to multi-image matching techniques, thus complementing TLS technology.

This interaction of heritage objects with their geographic location is a well-known fact nowadays. It has bridged geoinformatics and monument preservation. Geographic Information Systems (GIS) is the scientific tool with which monuments and related information are connected to place. In this way the monument information systems (MIS) have evolved. In addition, the relation of intangible information with tangible cultural heritage is highly important and definitely required. Hence, intangible cultural heritage may be linked to location, while at the same time important attributes of both forms of cultural heritage are preserved and interrelated.

Digital data acquisition is nowadays performed with (a) geodetic digital total stations, which produce 3D coordinates of single points in space, (b) digital image processing, which produces 2D or 3D products and (c) with digital scanning devices, which produce 3D point clouds of the objects. The common attribute of the above is 3D data acquisition, which enables the development of 3D virtual models. It is these 3D models that have made 3D virtual reconstructions possible.

3D models can be simple linear vector models or they can consist of complex textured surfaces depending on the object and their final use. As the specific technology advances, 3D models are used for multiple purposes. Initially they simply served as means for visualisation. Gradually, however, they have contributed to other uses, such as study, description purposes and restoration interventions and recently for virtual reconstruction and engineering applications [Valanis *et al.*, 2009].

Technological advances have provided 3D modelling software with numerous capabilities, which enable them to go beyond the simple representation of an architectural structure. They can provide information regarding the materials used and the realistic texture of the surfaces and also be interconnected with a database for storing, managing and exploiting diverse information. The organisation of all these pieces of information, quantitative and qualitative, into one information system is very much enabled by building information modelling (BIM) technology [Logothetis *et al.*, 2015]. Implemented to cultural heritage, this technology is referred to as HBIM [Agapiou *et al.*, 2010, Brumana *et al.*, 2013, Bregianni *et al.*, 2013].

Typical implementations of 3D modelling can be found in modern museums and educational foundations helping their visitors and students to communicate in a special way with the monument or site of interest as they can 'walk' through it or fly over it and thus examine it better, having always in mind its level of accuracy and likelihood.

5.2 Image properties

The image is one of the basic and most important elements used in photogrammetry. Without images, photogrammetry from the image-based perspective does not exist. The need to understand image and its characteristics is also essential since:

- mcasurements are made on an image;
- image processing is usually necessary for improving the visual appearance of the image to viewers;
- image is the source for creating outcomes (e.g. orthoimage).

5.2.1 Classification of images

For many years, photography was a chemical process and the images were captured on a photographic film made up of layers of light-sensitive silver halide emulsion coated on a flexible base. The film is exposed to light in a camera and this process creates a latent image. In order to make this image visible, a solution of chemicals called a 'developer' are applied. The printed image is created by projecting the filmed-image on a sensitised paper and processing it in a series of chemical baths. Many of these processing steps are required to take place in a darkened room so as to avoid light reaching the sensitised blends.

The evolution of sensor technology led to the development of digital cameras. Digital photography has changed this entire concept. There is no need for film, chemicals or darkrooms. In the digital model, the images are captured directly with photo sensors arrays and are processed by software on a personal computer. The printed digital images are made by a typical printing process on laser or inkjet printer, coloured or greyscale.

Thus, there are two main types of images – analogue and digital – used in cultural heritage recording and documentation. Analogue images are the type of images that we find easiest to understand. In practice, what we see in an analogue image is the various levels of brightness and colours. In principle, this is a continuous representation. On the other hand, a digital image is recorded as many numbers. In this case, the image is divided into a matrix of picture elements; well-known as pixels where each pixel is represented by a numerical value (Figure 5.2).

Figure 5.2 The digital image.

5.2.2 Image characteristics

Real images display four essential characteristics:

1. noise;
2. contrast;
3. sharpness;
4. resolution.

Noise

With respect to noise, real images consist of two components: a meaningful pattern which carries information about the object (signal) and a false pattern which carries no information about the object (noise).

Noise limits the amount of information which can be extracted from the image. Particularly, the better details of the objects illustrated may be lost by being swamped by the noise effect. A typical example is the fogging on an image (Figure 5.3).

Under optimum conditions, the magnitude of the signal is much greater than the magnitude of the noise, so the signal-to-noise ratio is considered to be high and much information is gained for the image. However, under adverse conditions the signal-to-noise ratio is low and much information from the image is lost.

Contrast

Contrast is the difference of presence of a feature in an image from its surroundings. Contrast can be described as the difference between the shades of grey or degree of luminance on an image. Figure 5.4 shows a typical example from an image representing a part from an ancient wall, illustrated in three different conditions: with high contrast, with low contrast and with the optimum contrast.

Figure 5.3 Good image with high signal-to-noise ratio (left) and bad (fogged) image with low signal-to-noise ratio (right).

Figure 5.4 An image with high contrast (left), low contrast (centre) and optimum contrast (right).

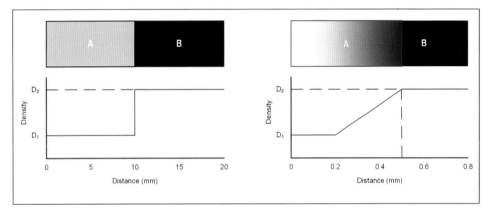

Figure 5.5 Sharpness (left) and fuzziness (right).

Sharpness

Sharpness is concerned with how rapidly darkening changes at the boundary between neighbouring parts. In Figure 5.5, on the left the boundary between the two areas A and B appears very sharp and distinct, while on the right the boundary between the two areas A and B appears fuzzy and invisible. The steeper the slope, the sharper the image appears while the shallower the slope the more blurred the image.

In practice, no image is perfectly sharp; every image has a certain absence of sharpness. Sharpness is the observer's subjective perception of fuzziness and typically depends on contrast and unsharpness. The observer can consider one image boundary to be sharper than another one, despite the fact they are both similarly fuzzy, if the contrast of the first image is greater.

Resolution

Resolution of an image refers to its ability to show small structures separately: resolution means the detail an image holds, and higher resolution means more image details. The resolution term is applicable in digital and analogue images. In the case of digital images where the interest is comparatively higher than any other category, the resolution of digital cameras can be described in many different ways.

Pixel resolution

A pixel is a unit of the digital image and thus pixel resolution depends upon the size of the pixel. The smaller the pixel size, the higher the resolution is and the clearer the object in the image. An image of 4096 pixels in width and 3072 pixels in height has a total of $4096 \times 3072 = 12{,}582{,}912$ pixels or 12.6 megapixels. One could refer to this as a 4096 by 3072 pixel or a 12.6 megapixel image.

Radiometric resolution

Radiometric resolution defines how a system can represent or distinguish differences of intensity. The finer the radiometric resolution of a sensor the more sensitive it is to detecting small differences in reflected or emitted energy. Typically, radiometric resolution is expressed as a number of levels or a number of bits: for example, 8 bits or 256 levels. If a sensor uses 8 bits for data recording, there would be $2^8 = 256$ digital values available, ranging from 0 to 255. However, if the sensor uses only 4 bits then only $2^4 = 16$ values ranging from 0 to 15 would be available.

5.2.3 Geometric properties of images

The geometric properties of the images used in cultural heritage applications can be assumed as those having the main required properties and following the central projection model considered for these cases. The most important properties are presented below and are the image scale, the focal length, the principal point and the camera axis.

The image scale

The image scale can be approximated by the formula:

$$s = \frac{c}{H}$$

This is the case where the photographed object is plane. The term c refers to the (calibrated) focal length, while the term H refers to the distance of the image from the object or the flight height above mean ground elevation in the case of aerial images (Figure 5.6).

The scale for point A can be determined as the ratio of the image distance $(O\text{-}a)$ to object distance $(a\text{-}A)$.

The image scale varies from point to point in the case an anaglyph exists on the object. In this case, the average scale introduced and now H refers to the average distance or ground elevation. If it is with respect to the datum, it is called flight altitude and can be calculated by the formula:

$$H_A = H + h$$

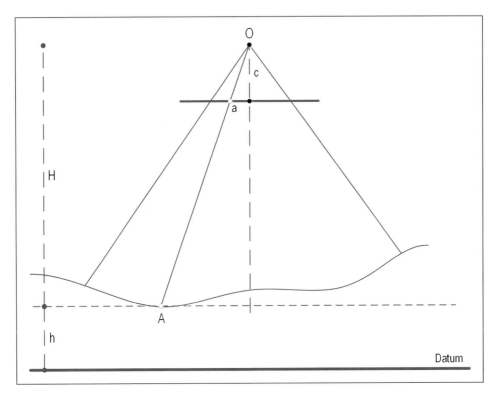

Figure 5.6 Definition of image scale.

Ground sampling distance

In a digital image, ground sampling distance (GSD) is the distance between pixel centres measured on the ground. For example, in an image with a 0.1 m GSD, adjacent pixels image locations are at a distance of 0.1 m on the ground. As the GSD decreases, the sampling rate increases in order to cover the same area on the ground, so the image resolution increases as well.

In digital imaging, the sensor's natural pixel size (*ps*) is fixed. A specific GSD value can be achieved only by changing the image altitude or the shooting distance from the object, in the case of close range mode.

Image scale is given by the formula:

$$s = \frac{ps}{GSD}$$

As explained above, image scale is given by the formula:

$$s = \frac{c}{H}$$

Therefore,

$$\frac{c}{H} = \frac{ps}{GSD}$$

Thus imaging altitude H can be derived from the formula:

$$H = \frac{GSD \times c}{ps}$$

For example, having a digital camera with the following characteristics:

$$c = 50 \text{ mm}$$

$$ps = 5.0 \text{ μm}$$

In order to achieve a GSD of 0.01m, the shooting distance from the object is:

$$H = \frac{0.01 \text{ m} \times 0.05 \text{ m}}{0.000005 \text{ m}} = 1 \text{ m}$$

This means that in order to achieve a GSD of 0.01 m with the specific camera, the images should be captured from the distance of 1 m from the object.

The photogrammetric model and the coordinate systems

The image is a perspective projection, what is known as the central projection. Figure 5.7 shows the central perspective projection setup on which the photogrammetric model for a camera is based.

An object point A is projected onto the project plan, namely the camera sensor used and thus an image point a. The line $(A\text{-}a)$ that connects the two points is passing through the perspective centre o. The line orthogonal to the projection plane that passes through the perspective centre o is called the principal axis or camera axis while the point which intercepts the projection plane is called the principal point. The distance between this point, i.e. the principal point, and the perspective centre o is called the principal distance or focal length and usually is indicated by c.

In addition, Figure 5.7 illustrates the two coordinate systems that are used to describe the specific model:

1. the object coordinate system (X, Y, Z), i.e. the reference system which is located in the 3D space (real world). In the object coordinate system, the coordinates of the perspective centre are indicated by (X_o, Y_o, Z_o)while the coordinates of the object point A by (X_A, Y_A, Z_A).
2. the image coordinate system (x, y, z) has its origin at o and the z-axis concurs with the principal axis. The x-axis and the y-axis of the image coordinate system are parallel to the projection plane while their direction is along the horizontal

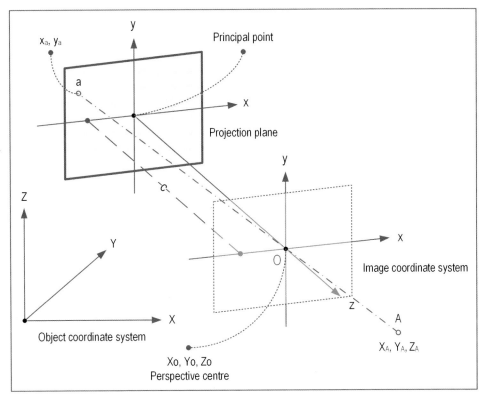

Figure 5.7 Central perspective projection – the photogrammetric model.

and vertical axes of the camera's sensor respectively. The coordinates of point A on the image coordinate system are (x_a, y_a) or $(x_a, y_a, -c)$ considering the principal distance.

5.3 Sensors and cameras

In this section, a general overview of the main sensors and cameras is presented in terms of their use in image-based modelling techniques. In fact, the two main types used in cultural heritage recording are digital cameras and the range-imaging cameras.

5.3.1 Digital cameras

The imaging sensor is normally a device that converts an optical image into an electronic signal. This technology is used regularly in digital cameras. The previous technology, i.e. the analogue one, refers to the analogue sensors where video camera tubes were used. It was a technology used until the 1980s and was a type of cathode ray tube in order to capture the television image.

In the late 1980s and 1990s, the introduction of charge-coupled devices (CCDs) and complementary metal oxide semiconductor (CMOS) sensor technology started the era of digital photography allowing the acquisition of digital images. A CCD/CMOS

sensor has photosites, arranged in an X-Y matrix or linear array, comprising photodiode elements able to convert light (i.e. photons) into charge (i.e. electrons). In CCD sensors every photodiode's charge is transferred to an output node to be converted to voltage, buffered and sent as an analogue signal. In CMOS sensors each photodiode has its own charge-to-voltage conversion and the chip outputs already digital bits. CCD and CMOS sensors have advantages and disadvantages which are summarised in Figures 5.8 and 5.9.

Digital cameras nowadays mainly come in three types (Figure 5.10): single-lens reflex (SLR) cameras, mirrorless interchangeable-lens cameras (MILCs) and amateur / consumer / compact / mirrorless cameras. SLR cameras are the most professional ones, with high quality and clear pictures, large sensor size (equivalent to the old photography films of 35 mm, Figure 5.11) and the possibility to change the lens. MILCs integrate the characteristics of SLR cameras with the dimensions of compact cameras. Compact cameras are small in size, light and they have very small sensors (up to 10 times smaller) and no mirror inside.

Regarding the specifications of a digital camera, the important aspects are the sensor's (CCD/CMOS) size, its resolution, image quality and availability of RAW format, lens quality and focal length, metering and focusing accuracy, performance or speed, low light or high ISO performance, its actual weight and interfacing (in particular when used on UAVs).

Figure 5.8 Schematic differences between CCD and CMOS sensors.

	CCD	**CMOS**
Windowing	no	yes
Sensitivity	high	high
Power need	high	low
Integration	low	high
Speed	middle	high
Blooming	yes	no
Costs	high	low
Noise	low	middle
Image quality	high	middle
Pixel random access	no	yes

Figure 5.9 Strengths and weakness in CCD and CMOS sensors.

Figure 5.10 Examples of consumer, MILC and SLR digital cameras.

Figure 5.11 Typical sensor size of a compact camera (left) and SLR camera (right) compared to 35 mm photographing films; typical pixel size of a compact camera compared to the dimensions in a SLR camera (centre).

5.4 Data collection

5.4.1 Planning and image acquisition

The planning of the image acquisitions is a crucial part of the entire image-based pipeline. Indeed, with the recent advent of automated processing techniques, the image quality (in terms of network geometry and radiometry) is fundamental to achieve successful results. Waldhäusl and Ogleby [1994] presented a 3 × 3 rule for photogrammetric documentation purposes. A modified version, which takes into consideration the digital era and the new software developments, can read as shown in Figure 5.12.

Geometric	Photographic	Organisational
Acquire control/ground information	Keep constant interior geometry of the camera	Make proper sketches
Multiple convergent image coverage with adequate B/D[1] ration	Keep homogeneous illumination	Write proper protocols and keep metadata
Separate calibration and orientation	Select a stable combination of large format camera and lenses	Perform a final check

Figure 5.12 A modified version of the 3 × 3 rule.

[1] Base to distance.

The planning and image and data acquisition should be done carefully, taking into consideration the following issues:

- The GSD should be at least 2–3 times smaller than the smallest geometric detail to be captured and digitised as the smallest image element (pixel) is normally not sufficient to reconstruct entirely and correctly an object's detail.
- The images should be captured to cover the entire object and in a way so that every detail is visible in at least 2–3 images.
- If no ground control points (GCPs) (5.4.2) are available, a scale bar of precisely known length should be placed in some images to establish the scale.
- If there are no restrictions on where to place the camera in relation to the object, a medium focal length (equivalent to 50 mm on a full frame camera) is the most favourable one, to avoid distortion effects or small field of view.
- Pre-calibrate the camera and keep the calibration valid throughout the acquisition phase by not adjusting optics parameters (e.g. zooming) as they change the camera's internal geometry.
- For large-scale reconstructions, use large depth of field settings (i.e. high f-values like f/11–f/14 – thus small aperture) on views with significant depth variation.
- Make sure colour settings are the same between successive imaging sessions.
- For indoor acquisition and in case of slow shutter speed, use a tripod to ensure a smooth image acquisition.
- Store, label and associate a possibly known position to all the collected data.

5.4.2 Control points

In order to proceed with the absolute orientation process (often called 'geo-referencing'), it is necessary to establish the relation between the image and the object coordinates. For this reason, control points (CPs) or GCPs are essential to be measured.

A GCP is a point of the object which is illustrated in the image while at the same time its 3D coordinates (X, Y, Z) are known, either in a local reference system or in a global reference system.

In practice, for each image we need at least 3 well-distributed GCPs. If more GCPs are available the rule of 'the more the better' can be used for a robust determination. The distribution of the points is important and, in particular in the case of only 3 points, they should be neither coplanar nor collinear.

Two types of GCPs can be identified (Figure 5.13);

- signalised; i.e. target points;
- non-signalised; i.e. natural points.

Before image acquisition, and when it is feasible to do so, topographic points are signalised and measured on the ground or on the object. Usually, these points are signalised by targets of different kinds. In addition to these points, real (natural) object points or terrain points which can be clearly identified in the images are measured. Very often and due to the restricted conditions in cultural heritage (e.g. impossibility to touch an object), non-signalised points are required. As far as possible, corners and

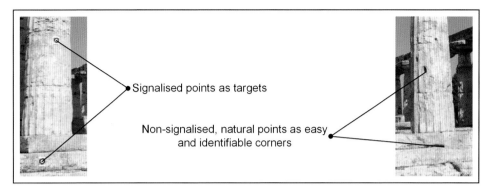

Figure 5.13 Signalised and non-signalised points, acting as GCPs in a building façade.

well-defined structural points are chosen in this case. For instance, a corner natural point has the advantage of being scale-invariant.

5.5 Photogrammetric procedures

5.5.1 Image pre-processing general guidelines

Image pre-processing is an essential procedure before starting the photogrammetric pipeline and then the production of the outcomes. The quality of the acquired and used images is becoming fundamental to allow the success of automated processing methods. Motion blur, sensor noise, jpeg artefacts, wrong depth of field are just some of the possible problems negatively affecting automated 3D reconstruction methods. Typical pre-processing methods consist of:

- Colour balance: it ensures colour consistency and resolution in the acquisition and visualisation procedures.
- Image de-noising: it is useful to remove (a) fixed pattern noise, (b) random noise due to intensity and colour fluctuations above and below the actual image intensity and (c) banding noise characterised by the straight band in frequency on the image which is highly camera-dependent.
- *RGB*-to-grey conversion: this is mandatory as traditional feature matching and multi-view dense matching algorithms are conceptually designed to work on greyscale images.
- Image enhancement: this is not necessary but sometimes very useful, in particular in the case of textureless surfaces (e.g. Wallis filtering).

Some of these procedures are hidden within commercial tools or can be performed by users in order to have better control of the final image quality.

5.5.2 Interior orientation

Affine transformation

As already explained, the desired outcome of the photogrammetric procedure is to reconstruct as well as possible the bundle of rays for each image and consequently

obtain a reliable geometric locus of all points imaged in the picture. The only available data is of course the image and all measurements on it, i.e. the image coordinates. In addition, the geometry of the camera should also be known to a satisfactory extent. Based on these two pieces of information it is possible to transform the measured image coordinates to those compatible with the central projection model.

This model assumes that 3D space is imaged on a plane via a projection centre and best – but not fully – describes the photographic procedure. The central projection is defined by (i) the position of the projection centre in relation to the projection plane, (ii) the distance of the projection centre from that plane and (iii) that the 3D space is imaged with straight lines. It is necessary to determine these three parameters in order to reconstruct the bundle of rays.

The first two parameters are given by the position of the projection of the projection centre on the image plane (xo, yo) and the principal distance c which is not exactly equal to the lens' focal length. In addition, the projection lines are not straight because of the radial distortion and hence a transformation is needed to 'move' the measured points to the positions expected by the central projection model. The best mathematical equation describing this transformation is the so-called affine transformation:

$$x = a_1 \cdot x' + a_2 \cdot y' + a_3$$

$$y = a_4 \cdot x' + a_5 \cdot x' + a_6$$

which comprises two translations, two rotations and two scale factors. The effects of the affine transformations are illustrated in Figure 5.14.

Camera calibration

The term 'camera calibration' comprises all measuring and processing procedures which lead to the determination of the internal camera geometry. This is also known as interior orientation, although it has nothing at all to do with orientation. Camera calibration actually compares the geometric behaviour of the system camera–lens–light-sensitive material with the ideal model of central projection. Obviously, it does not matter how these two deviate and the image is deformed, as long as this deviation and, consequently, image deformation are accurately known. In this way all image measurements may be rectified according to the central projection model, which best describes the specific camera system.

The central projection is the mathematical and geometrical model chosen to describe the ideal photographic procedure, i.e. a physical phenomenon. Photographic imaging is closer to the perspective projection, which is a subset of the central projection, as it

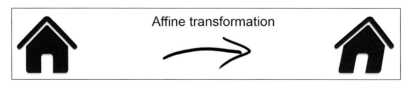

Figure 5.14 Effects of the affine transformation.

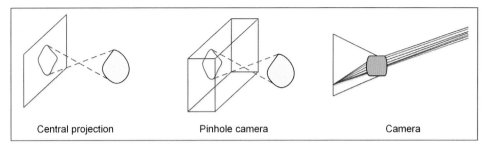

| Central projection | Pinhole camera | Camera |

Figure 5.15 The central projection model and the photographic camera.

projects the 3D world on a 2D plane, the image. In the case of the perspective projection, the geometric model is defined by the following:

1. the relative position of the projection plane and the perspective centre;
2. the distance of the perspective centre from the projection plane;
3. the straight lines that project the 3D world through the perspective centre onto the projection plane.

Consequently, it suffices to determine the above parameters in order to describe the photographic imaging by the theoretical model or, in other words, to mathematically express the geometry of the camera. However, the physical process of photography presents some deviations from the ideal geometrical model, which is only fulfilled by the pinhole camera (Figure 5.15).

For the implementation of this model to the physical camera several considerations should be taken into account in order to overcome the main deviations which are the following:

1. The lens, or better the lens system of the modern cameras, used for focusing the image on the light-sensitive material, has some physical dimensions, which may not be neglected and hence cannot be replaced by one single point to undertake the role of the projection centre. Consequently, it is impossible to determine its exact distance from the projection plane and its exact position in relation to that plane. Hence, a point is sought in the lens system which should be considered as the projection centre.
2. Due to the unavoidable eccentricity of the lens elements, deformations occur, but also it is not clear where exactly is the projection onto the image plane of the projection centre, which would serve as the origin for the image coordinate measurements. In the case of analogue metric cameras, this problem was solved by the introduction of fiducial marks.
3. Finally, construction defects of the lens elements cause several errors to the final image, of which the only one affecting geometry is radial distortion. This in essence is the deviation of the projection rays from straight lines, which is assumed by the theoretical model of the central projection.

For images to be used as metric documents, the central projection model should be enforced. This may only be achieved by reinstating the interior orientation, by

implementing the camera constant c, the position of the principal point (projection of the perspective centre on the image, $[x_o, y_o]$) and the corrections on the position of the imaged points caused by the radial distortion Δr. This process will ensure that all image coordinates abide to the theoretical model of the central projection, i.e. that they are free from any geometric deformations caused by the deviations of the imaging system from that model.

Usually these parameters, i.e. the camera constant, c, the coordinates of the principal point (x_o, y_o) and the values of the radial distortion, Δr, are called the parameters of the interior orientation of the camera. Camera calibration determines these parameters exactly and the user should always take them into account for increasing the final accuracy of the photogrammetric procedure.

There are a lot of different methodologies and procedures for determining the parameters of the interior orientation. All of them compare how accurately a set of known bearings is imaged by the camera–lens–light-sensitive plane system. Camera calibration may be performed in the laboratory by employing purely optical measurements, or by involving the imaging procedure. Alternatively, camera calibration may be performed simultaneously with the rest of the photogrammetric adjustments. This method, which nowadays is more usual, is called self-calibration. It is offered by almost all photogrammetric software. Camera calibration should be determined for taking various distances, as focusing affects the geometric properties of the lens system. This is especially important for terrestrial applications, such as monument recording.

As to which method is suitable each time, it is a question of experience and available means. One should always pay attention to the repeatability of the camera geometry, a fact which nowadays with the multitude of cameras in the trade this plays an important role.

The calibration of digital cameras does not differ significantly from that of conventional analogue cameras, as their behaviour is quite similar. The main difference is the absence of film, which is replaced by the CCD or CMOS chip (see section 5.3.1). Hence, by default, the images are not affected by the non-planarity of the light-sensitive material.

Digital cameras should also be calibrated for the size and shape of their pixels, and also for eventual geometric influences caused by the electronic procedure for transferring the image from the chip to the computer. All these deformations are added to the mathematical model as two extra coefficients in the transformation. Hence, one of the most commonly used mathematical models for digital camera calibration is the following:

$$\Delta x = x_0 + \overline{x} \cdot (r^2 - 1) \cdot a_1 + \overline{x} \cdot (r^4 - 1) \cdot a_2 + (r^2 - 2 \cdot \overline{x}^2) \cdot a_3 + 2 \cdot \overline{x \cdot y} \cdot a_4 + \overline{x} \cdot a_5 + \overline{y} \cdot a_6$$

$$\Delta y = x_0 + \overline{y \cdot x} \cdot (r^2 - 1) \cdot a_1 + \overline{x} \cdot (r^4 - 1) \cdot a_2 + 2 \cdot \overline{x \cdot y} \cdot a_3 + (r^2 - 2 \cdot \overline{y}^2) \cdot a_4 + \overline{y} \cdot a_5$$

where:

x_o, y_o = the image coordinates of the principal point;
$\overline{x}, \overline{y}$ = the image coordinates of the points referring to the principal point;
r = the radial distance of the measured point from the principal point;

a_1, a_2 = parameters for the radial distortion;
a_3, a_4 = parameters for the tangential distortion;
a_5, a_6 = parameters of the affine transformation.

Several geometric models have been proposed and implemented over the years to take into account the problem of determining the interior geometry of the camera, in order to assist the photogrammetric applications, especially for those of close range photogrammetry. All these are based on the model of the central projection, i.e. perspective imaging, usually through adjustment algorithms [Brown 1971]. The basic mathematical model is provided by the non-linear equations of the collinearity condition, usually augmented with additional parameters for the interior orientation and the radial and tangential distortion of the lenses [Fraser, 1997; Gruen and Beyer, 2001]. The bundle adjustment procedure provides the possibility of simultaneously determining all the system parameters by estimating the accuracy and reliability of the calibration parameters that are computed. In addition, eventual correlations among the parameters of the interior and exterior orientations as well as the determined geodetic coordinates can be quantified.

Favourable network geometry is a prerequisite for the correct determination of the calibration parameters, i.e. the images acquired should be convergent with well distributed known points on the image surface. If the network is geometrically weak, these correlations may lead to unstable least squares adjustment. The use of unsuitable additional parameters may further weaken the bundle adjustment solution, thus leading to over-parametrisation, especially in cases of adjustment with minimum constraints [Fraser, 1982]. Bundle adjustment with auto calibration (as it is usually called) may be implemented with or without constraints in object space imposed with the use of known CPs.

The most common set of additional parameters used for the compensation of the systematic errors in digital cameras is the 8-term model, first proposed by Brown [1971]. This comprises the position of the principal point (x_o, y_o), the principal distance and also the parameters of the radial distortion and the tangential one. The three additional parameters used to model the radial distortion Δr are in general expressed by the coefficients of the odd order polynomial $\Delta r = K_1 \cdot R^3 + K_2 \cdot R^5 + K_3 \cdot R^7$, where r is the radial distance. The coefficients Ki usually are highly correlated and the larger part of the distortion is described by the term $K_1 \cdot R^3$. The other two are used mainly for the photogrammetric and wide angle lenses and also for higher accuracy requirements.

The tangential distortion is caused by the incomplete alignment of the lens elements of the photographic lens. The parameters p_1 and p_2 describing it are from the equations [Brown, 1966]:

$$dx_D = p_1 \cdot (r^2 + 2 \cdot x^2) + 2 \cdot p_2 \cdot x \cdot y$$
$$dy_D = p_2 \cdot (r^2 + 2 \cdot y^2) + 2 \cdot p_1 \cdot x \cdot y$$

and are always correlated with x_o and y_o. This relationship between tangential distortion and principal point position increases with increasing focal length and may cause problems for telephoto lenses. This should be taken into account when calibrating such lenses.

Calibration methods

Both the deviations from the collinearity, i.e. the central projection model, as well as the equations of the perspective geometry, may be modelled and implemented for the calibration of cameras. The nature of the application and the required accuracy are the main factors which affect which of the two should be used each time. Remondino and Fraser's [2006] rough categorisation of calibration methods for digital cameras is given below.

Model based on the collinearity condition

This model is based on the perspective projection, where the interior orientation is constant and all deviations from collinearity, linear and non-linear, may be incorporated. In this model, at least 5 point correspondences are required in a network of many images and, because of its non-linear nature, provisional values for the unknowns are also needed, for the least squares bundle adjustment from which the calibration parameters are determined.

Model based on the perspective geometry equations

This is a projective model which supports the projective resampling of the image. In this model, which is described by the epipolar matrix, many parameters may be included provided that there are at least 6–8 point correspondences in order to get a solution. Non-linear deformations in the image, like radial distortion, cannot be easily compensated with such models.

Other criteria for the categorisation of calibration methods

Indirect and direct models

The photogrammetric approach directly modelling the physical procedure is comparable to the indirect models which are used in scene reconstruction from motion and which compensate the point positions on the image according to the requirements of real projection alignment [Hall *et al.*, 1982; Wei and De Ma, 1994].

Figure 5.16 Example of photogrammetric test fields for a correct camera calibration procedure (left and centre); a 2D (flat) test field (right) could be also employed, although much attention should be paid to the data acquisition in order to have a reliable image network.

Methods using 3D instead of flat (2D) test fields [Triggs, 1998; Zhang, 2000]

While some computer vision and self-calibration methods may handle both cases, provided the network has a favourable geometry, models like that of the epipolar matrix are unable to compensate for points on planar surfaces.

Methods based on points rather than on linear features [Caprile and Torre, 1990; Fryer and Brown, 1986]

Calibration methods based on points are widely accepted in photogrammetry, while the only notable methods based on linear features are those using vertical lines (plumb line method) and the one developed by Habib and Morgan [2004].

A more detailed categorisation of calibration methods

A more detailed categorisation may be done based on the way the parameters are estimated and determined and also on the optimisation method used.

Linear versus non-linear methods

Linear methods are fairly simple and easy to implement, but in general they are not capable of handling lens deformations and require a lot of control points with known coordinates. They usually simplify the camera model and lead to low accuracy results. A characteristic example of such a method is the application of the direct linear transformation DLT [Abdel-Aziz and Karara, 1971]. The non-linear methods are more common within the photogrammetric community as they provide rigorous and accurate modelling of the interior orientation of the camera and the distortion parameters [Brown, 1971] through an iterative least squares estimation procedure. A characteristic example is the model of the augmented collinearity condition which is the base of the self-calibration bundle adjustment.

Combination of linear and non-linear techniques

For estimating the initial values of the parameters a linear method is firstly implemented and later the orientation and the calibration are iteratively optimised [Faugeras and Toscani, 1986; Heikkilä and Silven, 1997; Tsai, 1987; Weng *et al.*, 1992]. This two-step method has today, in most cases, been replaced by the bundle adjustment.

Classic calibration methods

Three-dimensional test fields

Camera calibration demands metric information, which often is realised as a test field. Test fields comprise a set of discrete points, usually marked with suitable targets established and measured with highly accurate surveying methods. It should be noted that these points are distributed in 3D space, a vital characteristic of the test fields for the determination of the interior orientation parameters.

For the calibration of a camera with this method, a number of images of the test field are taken. Then a large number of the targeted points are measured on the images and the equations of the collinearity condition are used for the determination of the relationship between the image coordinates and the geodetic coordinates of the targets imaged. A noteworthy disadvantage is that space is required for the deployment of the test field, which should be very accurately measured.

Calibration with planar targets

An alternative camera calibration method is the one using two sets of parallel lines perpendicular to each other. The use of linear features offers some advantages over the use of targets, as they may easily be determined automatically in the test field. The lines may be accurately extracted from the image employing image processing techniques. Additionally, the linear features, which are actually sequences of points, increase the degree of freedom of the system and consequently enhance the error detection possibilities. The straight lines in the object space should ideally be imaged as straight lines in the image, i.e. without any deformation. Hence any deviations from the linearity in the image could easily be modelled and attributed to the deformation parameters like the radial or tangential distortions.

Calibration with special test fields

Zhang's [2000] calibration method

This calibration method is realised with the use of a planar checkerboard, which is placed in front of the camera and photographed from more than 2 different taking angles. The algorithm developed uses the extracted points from the square corners of the checkerboard and calculates a projective transformation between the point sets. Then the intrinsic and extrinsic parameters of the camera are determined using a closed form solution, while the 3rd and 5th order radial and tangential distortion coefficients are calculated using a least squares adjustment. Finally, a non-linear minimisation of the errors is performed using the Levenberg–Marquardt method, thus optimising all the calculated parameters. The above method by Zhang is similar to the one proposed by Triggs [1998], in which at least 5 images of a planar target surface, e.g. a checkerboard, are required.

Heikkila and Siliven's [1997] method

Initially the provisional values of the calibration parameters are determined using a closed form solution (e.g. DLT) and subsequently a non-linear least squares estimation follows using the Levenberg–Marquardt algorithm in order to optimise the interior orientation and to calculate the coefficients of the radial and tangential distortion.

5.5.3 Exterior orientation

The collinearity equation

In a previous section the relationships were developed which correlate the image coordinates to the world coordinates for vertical images. In that case those relation-

ships were merely a scale transformation ($s = c/H$) and a parallel displacement (ΔX, ΔY) from one system to the other. In the general case of a near vertical image, the rotation angles (ω, φ, κ) should be taken into account in addition to the perspective centre coordinates (X_0, Y_0, Z_0). These six parameters define fully the position of the camera (or the bundle of rays) and its orientation in 3D space. Hence they are called the exterior orientation parameters.

For the ground coordinates to be determined from the measured image coordinates a relationship is sought which will correlate both sets of coordinates while using the exterior orientation parameters and the scale factor. This relationship is the necessary and sufficient condition for the two vectors $O\alpha$ and OA (Figure 5.17) to lie on the same line (i.e. to be collinear), as is required by the ideal central projection model (i.e. perspective projection).

The name collinearity equation (or condition) is obvious, as it forces the two vectors to be collinear. In general this relationship is formulated as follows:

$$
\begin{bmatrix} X_A \\ Y_A \\ Z_A \end{bmatrix} = k \cdot R \cdot \begin{bmatrix} x_a \\ y_a \\ -c \end{bmatrix} + \begin{bmatrix} X_o \\ Y_o \\ Z_o \end{bmatrix}
$$

where:

X_A, Y_A, Z_A = the geodetic coordinates of point A in the object space;
k = the scale factor of the image at point A;
R = rotation matrix, composed of the elementary rotations ω, φ, κ;
x_a, y_a = the image coordinates of an image of A on the image;
c = the focal length of the camera lens, also referred to as the camera constant;
X_o, Y_o, Z_o = the coordinates of the perspective centre o (world coordinate system).

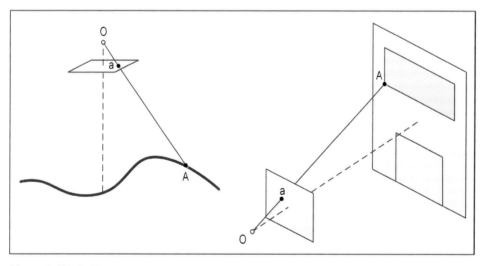

Figure 5.17 Collinearity condition.

Note that the scale factor k refers to the specific point A on the image, i.e. it is the point scale factor and not that of the image. This fact significantly limits the usefulness of the collinearity equation, as it is very difficult to determine the scale factors for all points on the image, or include them as unknowns in an adjustment. For that purpose the two first equations of relationship are divided by the third one, thus relieving them from the presence of the point scale factor k. This results in:

$$\frac{x_a}{-c} = \frac{R_{11}(X_A - X_o) + R_{12}(Y_A - Y_o) + R_{13}(Z_A - Z_o)}{R_{31}(X_A - X_o) + R_{32}(Y_A - Y_o) + R_{33}(Z_A - Z_o)}$$

$$\frac{y_a}{-c} = \frac{R_{21}(X_A - X_o) + R_{22}(Y_A - Y_o) + R_{23}(Z_A - Z_o)}{R_{31}(X_A - X_o) + R_{32}(Y_A - Y_o) + R_{33}(Z_A - Z_o)}$$

where Rij are the elements of the 3 × 3 rotation matrix R mapping the orientation of the object coordinate system (X, Y, Z) on that of the image coordinate system (x, y, z); ω for X, φ for Y and k for the Z-axis.

$$R = \begin{bmatrix} R_{11} & R_{12} & R_{13} \\ R_{21} & R_{22} & R_{23} \\ R_{31} & R_{32} & R_{33} \end{bmatrix}$$

$$R = \begin{bmatrix} \cos\varphi \cdot \cos\kappa & \cos\omega \cdot \sin\kappa + \sin\omega \cdot \sin\varphi \cdot \cos\kappa & \sin\omega \cdot \sin\kappa - \cos\omega \cdot \sin\varphi \cdot \cos\kappa \\ -\cos\varphi \cdot \cos\kappa & \cos\omega \cdot \cos\kappa - \sin\omega \cdot \sin\varphi \cdot \sin\kappa & \sin\omega \cdot \cos\kappa + \cos\omega \cdot \sin\varphi \cdot \sin\kappa \\ \sin\varphi & -\sin\omega \cdot \cos\varphi & \cos\omega \cdot \cos\varphi \end{bmatrix}$$

In this form, the collinearity equation describes a special projective relationship of the two reference systems involved. It expresses the transformation of the coordinates from the planar image system (x, y, c) to the 3D coordinate system of the object (X, Y, Z) and vice versa. This means that the collinearity equation may also function in the reverse sense, i.e.

$$\begin{bmatrix} x_a \\ y_a \\ -c \end{bmatrix} = \frac{1}{k} \cdot R^{-1} \cdot \begin{bmatrix} X_A - X_o \\ Y_A - Y_o \\ Z_A - Z_o \end{bmatrix}$$

And hence it may be considered as the equation of a line, the ray $AO\alpha$ in 3D space.

Generalising, these two equations may be considered as the transformation functions of the observations (i.e. the raw image coordinates). In a more general way, these equations may be written as follows:

$$x = f_1(c, x_o, y_o, \Delta r) + g_1(X_0, Y_0, Z_0, \omega, \varphi, \kappa) + h_1(X, Y, Z)$$

$$y = f_2(c, x_o, y_o, \Delta r) + g_2(X_0, Y_0, Z_0, \omega, \varphi, \kappa) + h_2(X, Y, Z)$$

The first function includes the coefficients for the interior geometry of the camera, the second one the exterior orientation parameters of the camera and the third one the world coordinates of the imaged points. From these equations it becomes apparent that the collinearity equation may find a multitude of uses. It is possible (a) to determine the parameters for the interior orientation (f_1, f_2) (i.e. to perform camera calibration), (b) to determine the exterior orientation parameters (g_1, g_2) (i.e. to perform photogrammetric resection) and (c) to determine world coordinates of the points imaged (h_1, h_2) (i.e. to perform photogrammetric intersection, provided a second image of the same object is available). Nowadays, with the rapid advancement of ICT technologies, these functions may be executed simultaneously through an integrated adjustment procedure. These possibilities of the collinearity equation are summarised in Figure 5.18.

Theoretically, every problem where the collinearity equation is valid can be solved if the known parameters are replaced in the equations and if a sufficient number of points' image coordinates are measured (observed) on the image in order to solve the system for the rest of the unknown parameters. In this procedure, however, there are two drawbacks. Firstly, the equations are not linear and, secondly, usually more than the exactly necessary points are observed. In order to get a viable and statistically acceptable solution, the linearised form of the equations should be used and an adjustment with the least squares method should be performed. This way, all acquired and observed data will be taken into account and will contribute to the solution.

The linearised equations of the collinearity equations undertake the role of the observation equations in the solution. For this purpose, they are expanded according to Taylor around some initial values for the unknowns. In this expansion, differentials of higher than second order are ignored, which leads to a successive iterations solution. Hence the equations become:

$$F_x = (x_a - x_o) + \frac{c \cdot N_1}{DN}, F_y = (y_a - y_o) + \frac{c \cdot N_2}{DN}$$

Collinearity equation			
Applications	Observations	Parameters	
		Known	Unknown
Calibration	$x'\ y'$	$X_o, Y_o, Z_o, \omega, \varphi, \kappa$	$c, x_o, y_o, \Delta r$
Resection	$x'\ y'$	$c, x_o, y_o, \Delta r$ X, Y, Z	$(X_o, Y_o, Z_o, \omega, \varphi, \kappa)$
Intersection	$x'\ y'$ $x''\ y''$	$c, x_o, y_o, \Delta r$ $(X_o, Y_o, Z_o, \omega, \varphi, \kappa)'$ $(X_o, Y_o, Z_o, \omega, \varphi, \kappa)''$	X, Y, Z

Figure 5.18 The uses of the collinearity equation.

N_1 and N_2 are the two nominators and DN the – common from the third equation – denominator. The Taylor expansion gives:

$$x = F_x = F_x^{(0)} + \frac{\partial F_x}{\partial x_o}dx_o + \frac{\partial F_x}{\partial y_o}dy_o + \frac{\partial F_x}{\partial c}dc + \frac{\partial F_x}{\partial k_1}dk_1 + \frac{\partial F_x}{\partial k_2}dk_2 + \frac{\partial F_x}{\partial X_o}dX_o + \frac{\partial F_x}{\partial Y_o}dY_o$$

$$+ \frac{\partial F_x}{\partial Z_o}dZ_o + \frac{\partial F_x}{\partial \omega}d\omega + \frac{\partial F_x}{\partial \varphi}d\varphi + \frac{\partial F_x}{\partial \kappa}d\kappa + \frac{\partial F_x}{\partial X}dX + \frac{\partial F_x}{\partial Y}dY + \frac{\partial F_x}{\partial Z}dZ$$

$$y = F_y = F_y^{(0)} + \frac{\partial F_y}{\partial x_o}dx_o + \frac{\partial F_y}{\partial y_o}dy_o + \frac{\partial F_y}{\partial c}dc + \frac{\partial F_y}{\partial k_1}dk_1 + \frac{\partial F_y}{\partial k_2}dk_2 + \frac{\partial F_y}{\partial X_o}dX_o + \frac{\partial F_y}{\partial Y_o}dY_o$$

$$+ \frac{\partial F_y}{\partial Z_o}dZ_o + \frac{\partial F_y}{\partial \omega}d\omega + \frac{\partial F_y}{\partial \varphi}d\varphi + \frac{\partial F_y}{\partial \kappa}d\kappa + \frac{\partial F_y}{\partial X}dX + \frac{\partial F_y}{\partial Y}dY + \frac{\partial F_y}{\partial Z}dZ$$

The coefficients are the first partial derivatives of the functions F_x and F_y respectively for all parameters. It is obvious that according to the desired use of these equations some of the terms are omitted. These equations are the basis for the photogrammetric adjustment, which will be briefly dealt with later.

Single image resection

One of the basic functions of the collinearity condition is to determine the position and orientation of the reconstructed bundle of rays in space. The bundle of rays in space boils down to a tranformation of a rigid body. For that reason the six parameters of the exterior orientation should be determined. These are:

- The three coordinates of the perspective centre X_o, Y_o, Z_o and
- The three rotations around the main axes ω, φ, κ.

As these parameters are present in the equations of the collinearity condition, it seems ideal to use this as observation equation in order to determine them. This procedure is called photogrammetric resection, as it is 100% analogue to the standard geodetic resection where, by standing on an unknown point and measuring, with a total station, directions to known trig points an algorithm is applied and the unknown position is calculated.

In the case of the photogrammetric resection, the unknown point is the perspective centre, i.e. the camera position the total station is the camera itself and the image and all one needs are some points with known coordinates in the desired coordinate system. These are usually called GCPs (see 5.4.2). Additionally, in the case of photogrammetric resection, the orientation of the camera axis is also unknown; hence, the total number of unknowns is 6. Considering that each point measured on an image provides two equations (from the collinearity condition) at least 3 points with known coordinates are required. Usually there are more available and in this case a least squares adjustment is necessary.

Provided that N GCPs are available, the number of observation equations are then $2N$ and the unknowns are 6. The observation equations are:

$$x = F_x = F_x^{(0)} + \frac{\partial F_x}{\partial X_o} dX_o + \frac{\partial F_x}{\partial Y_o} dY_o + \frac{\partial F_x}{\partial Z_o} dZ_o + \frac{\partial F_x}{\partial \omega} d\omega + \frac{\partial F_x}{\partial \varphi} d\varphi + \frac{\partial F_x}{\partial \kappa} d\kappa$$

which, for the adjustment are transformed as following:

$$y = F_y = F_y^{(0)} + \frac{\partial F_y}{\partial X_o} dX_o + \frac{\partial F_y}{\partial Y_o} dY_o + \frac{\partial F_y}{\partial Z_o} dZ_o + \frac{\partial F_y}{\partial \omega} d\omega + \frac{\partial F_y}{\partial \varphi} d\varphi + \frac{\partial F_y}{\partial \kappa} d\kappa$$

This is a system of $2N$ equations with six (6) unknowns:

$$\begin{pmatrix} \frac{\partial F_x}{\partial X_o} & \frac{\partial F_x}{\partial Y_o} & \frac{\partial F_x}{\partial Z_o} & \frac{\partial F_x}{\partial \omega} & \frac{\partial F_x}{\partial \varphi} & \frac{\partial F_x}{\partial \kappa} \\ \frac{\partial F_y}{\partial X_o} & \frac{\partial F_y}{\partial Y_o} & \frac{\partial F_y}{\partial Z_o} & \frac{\partial F_y}{\partial \omega} & \frac{\partial F_y}{\partial \varphi} & \frac{\partial F_y}{\partial \kappa} \\ \cdot & \cdot & \cdot & \cdot & \cdot & \cdot \\ \cdot & \cdot & \cdot & \cdot & \cdot & \cdot \\ \frac{\partial F_y}{\partial X_o} & \frac{\partial F_y}{\partial Y_o} & \frac{\partial F_y}{\partial Z_o} & \frac{\partial F_y}{\partial \omega} & \frac{\partial F_y}{\partial \varphi} & \frac{\partial F_y}{\partial \kappa} \end{pmatrix} \begin{pmatrix} \Delta X_o \\ \Delta Y_o \\ \Delta Z_o \\ \Delta\omega \\ \Delta\varphi \\ \Delta\kappa \end{pmatrix} = \begin{pmatrix} x_1 - F_x^{(o)} \\ y_1 - F_y^{(o)} \\ \cdot \\ \cdot \\ y_n - F_y^{(o)} \end{pmatrix}$$

For its solution the standard procedure of indirect observations adjustment is followed, i.e.

$$A \cdot x = L$$
$$A' \cdot A \cdot x = A' \cdot L$$

formation of the normal equations, which may be solved in many ways in order to determine the unknowns. The most straightforward solution would be to inverse the matrix of the normal equations:

$$A' \cdot A \cdot x = A' \cdot L$$
$$N \cdot x = A' \cdot L$$
$$x = N^{-1} \cdot A' \cdot L$$

It should be stressed here that the solution is iterative, as the observation equations have been linearised and hence approximated. Provisional values for the unknowns are also necessary and the unknowns are the corrections which should be applied to the initial values in order to approach the desired solution. The iterations stop when the corrections become less than the required accuracy. This procedure is essential as it forms the basis for the bundle adjustment (see 5.5.4).

The coplanarity condition

The coplanarity condition is the analytical expression of relative orientation (see below). As illustrated in Figure 5.19, the rays from the projections centres O' and O'' in an image pair (a left and right image), the positions of the points P' and P'' of the homologous points on the images and the point P on the ground belong to the same plane; the epipolar plane.

Orientation of a stereo pair

As already mentioned, photogrammetry determines the 3D position of points in space by actually performing intersections between pairs of homologue rays coming from adjacent and overlapping images. For this to be achieved, the relative position of the two images should be known. This is commonly referred to as relative orientation. If it is required that the determination of the point's position occurs in a specific coordinate system, then an additional procedure should be performed, namely the similarity transformation of the oriented pair to the specific position, orientation and scale in space. This is usually referred to as absolute orientation. Relative and absolute orientations together form the orientation of a stereo pair, which is a prerequisite for stereoscopic restitution of the object imaged in the two images.

Relative orientation

Relative orientation is the establishment of the relative position of two images as they were at the time of the photography. This is also referred to as pose estimation, an expression originating from the computer vision community. Nowadays this is preformed analytically.

Relative orientation is a prerequisite for any point determination, and consequently, for any object reconstruction. It ensures that the corresponding (homologue) rays from the two (or more) images intersect at the object point (Figure 5.20). To achieve this intersection of all pairs of homologue pairs of rays, it is necessary to ensure that at

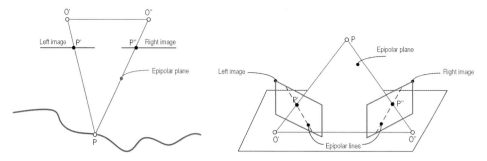

Figure 5.19 Sketches for the coplanarity condition, epipolar plane and epipolar line concepts.

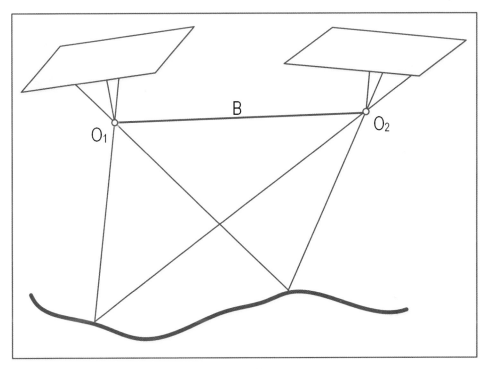

Figure 5.20 A pair of images in relative orientation.

least five such pairs intersect. This can be explained in two ways, mathematically and geometrically.

It is obvious that the two bundles of rays are connected with a projective relation. This is mathematically expressed by the projective transformation in 3D space:

$$X = \frac{\alpha_1 x + \alpha_2 y + \alpha_3 z + \alpha_4}{\alpha_{13} x + \alpha_{14} y + \alpha_{15} z + 1}$$

$$Y = \frac{\alpha_5 x + \alpha_6 y + \alpha_7 z + \alpha_8}{\alpha_{13} x + \alpha_{14} y + \alpha_{15} z + 1}$$

$$Z = \frac{\alpha_9 x + \alpha_{10} y + \alpha_{11} z + \alpha_{12}}{\alpha_{13} x + \alpha_{14} y + \alpha_{15} z + 1}$$

The 15 coefficients should be calculated in order to determine this transformation. Hence, at least 5 known points (i.e. intersecting ray pairs) must be known in both spaces (bundles).

The two bundles have 2 × 6 = 12 unknowns for their exact position in space, which includes their relative position (Figure 5.21). The parameters of the second bundle may be expressed as the differences from those of the first one (Figure 5.21). However, for the relative orientation their position in 3D space is not of interest. Hence, the

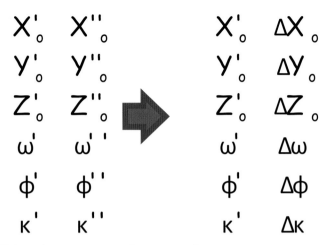

Figure 5.21 Orientation parameters of a stereo pair.

6 parameters of the exterior orientation of the first bundle do not contribute to the relative orientation. From the remaining 6 parameters, ΔX does not affect the intersection of the corresponding ray pairs, but only the size of the reconstructed object. Hence, the parameters necessary to achieve the relative orientation are the remaining 5, i.e. ΔY, ΔZ, $\Delta \omega$, $\Delta \varphi$ and $\Delta \kappa$. To determine them using an adjustment procedure you need to measure the position of 5 point pairs.

This adjustment may be performed using two different equations as observation equations. Either the parallax equation or the equations of the coplanarity condition (see above) are used. The first is based on the fact that the rays initially do not intersect. Their distance has two components, one in x and one in y. The y component is usually called y-parallax and its elimination leads to the two rays intersecting. Consequently, the elimination of the y-parallax is equivalent to the intersection of the ray pairs, i.e. to relative orientation.

$$P_y = (db y_1 - db y_2) - \frac{Y_M}{Z_M}(db z_1 - db z_2) + X_M dk_1 + (X_M - b)dk_2 + \frac{X_M Y_M}{Z_M}d\varphi_1$$

$$- \frac{(X_M - b)Y_M}{Z_M}d\varphi_2 - Z_M(1 + \frac{Y_M^2}{X_M^2})(d\omega_1 - d\omega_2)$$

Nowadays, the equations of the coplanarity condition are used, as they are more favourable for programming. As already mentioned, the coplanarity condition forces the three vectors (i.e. the two rays $a_1 = O_1 m_1$ and $a_2 = O_2 m_2$) and the distance between the two projection centres, usually referred to as base B to be coplanar (Figure 5.22).

Mathematically this may be expressed as:

$(\vec{a_1} \times \vec{B}) \cdot \vec{a_2} = 0$ which actually means that the volume (i.e. the mixed product) of the three vectors is zero.

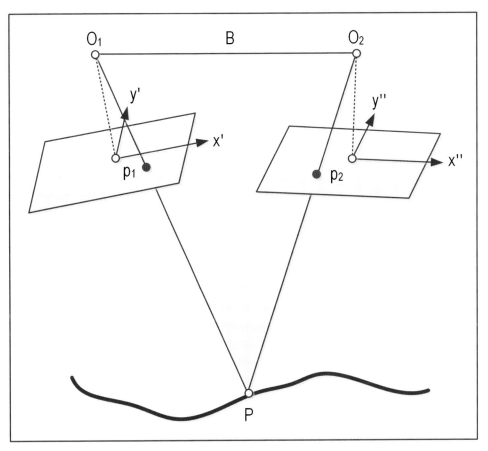

Figure 5.22 The coplanarity condition.

5.5.4 Image triangulation

Definition

For the orientation of each photogrammetric stereo pair at least three control points are necessary, i.e. two *XYZ* and one with known *Z*. Usually more than 4 are employed. If the project calls for the orientation of a few pairs, determining and measuring control points is just a small percentage of the total time needed. In cases, however, where more stereo pairs are needed, the cost and labour needed to determine the control points may become an obstacle.

Determining control points using classic geodetic and surveying techniques (triangulation, resection, intersection and GNSS) requires time and is costly. In order to overcome this problem, a methodology was developed which facilitates the determination of the orientation of the images and the calculation of control points. This methodology is called photogrammetric triangulation or aerial triangulation or photo-triangulation to cover terrestrial applications.

McGlone [2004] defines aerial triangulation as the procedure used:

- to recover the complete orientation parameters of each image in the project, namely the coordinates of the projection centre (X_o, Y_o, Z_o) and the ω, φ and κ rotations, and
- to determine the ground coordinates (X, Y, Z) of points observed in them.

The main product of photogrammetric triangulation nowadays is the exterior orientation parameters of the images involved. Ground coordinates of points measured on the images is considered a by-product. Aerial triangulation drastically diminishes the time needed to prepare images for photogrammetric restitution. However, for some ground measurements, such as the coordinates of ground, a few control points or selected distances, are still necessary. All modern digital photogrammetric workstations offer the possibility of performing triangulation of the images involved in a strip or a block in a project.

Photogrammetric triangulation is a necessary step towards the production of the various photogrammetric products, such as line drawings, orthoimages, 3D textured models etc. The quality of these products depends largely on the results of the triangulation. Hence, the parameters set for its execution are determined according to the specifications of the project.

Performing the adjustment of the photogrammetric triangulation

The procedure for solving the photogrammetric triangulation consists of the following steps:

1. Performing suitable measurements on images, or image pairs, which should be controlled for their gross and systematic errors.
2. Performing suitable calculations to relate these measurements to each other and to the coordinate reference system.
3. Applying suitable procedures to eliminate errors which originate from the above actions or other sources.

Before any action a careful preparation of the images and the points to be measured should be done. Measurements in photogrammetric triangulation involve three kinds of points:

1. Geodetically determined points, usually referred to as GCPs (see 5.4.2). These are pre-marked or natural detail points in suitably selected positions in space, which are necessary for the connection of the images to the coordinate reference system.
2. Points common in adjacent images, usually referred to as tie points. These are natural points on the object and serve to connect the images to each other, i.e. perform their relative orientation. Their ground coordinates are determined from the adjustment of the photogrammetric triangulation.
3. Geodetically determined points, usually referred to as check points. These are pre-marked or natural detail points with known ground coordinates, which are not used as GCPs in the solution but as tie points. They serve to objectively control the solution by comparing their calculated ground coordinates with the measured ones.

Tie points (or correspondences, or homologue points) were normally extracted manually by an expert operator or automatically using markers or coded (signalised) targets. Now, markerless solutions are available, pushed by the great developments in the computer vision community. These solutions employ feature-based methods [Apollonio *et al.*, 2014] to automatically detect interest points in the images, describe them with a vector of invariant information and link the correspondences through the image data set [Agarwal *et al.*, 2009; Barazzetti *et al.*, 2010; Snavely *et al.*, 2008]. This has led to the so-called structure from motion (SfM) approach, i.e. the automatic identification of image correspondences, camera poses and sparse 3D reconstruction of the surveyed scene.

Bundle adjustment

The main block adjustment methods used today for solving the large systems of image observations are (a) independent models and (b) bundle adjustment. They differ in that in the first one the elementary unit in the adjustment procedure is the stereo pair, while in the latter it is the bundle. Nowadays, the latter method is mostly used as it allows for any image block geometry and for including the interior orientation parameters as unknowns in the solution.

The observation equations are based on the collinearity condition (see 5.5.3) and the unknowns are the coordinates of the tie points, the exterior orientation parameters and those of the interior orientation in the case of a self-calibration adjustment.

For the bundle adjustment the direct relationships of image coordinates to ground coordinates of the measured points are used. The initial observations are the image

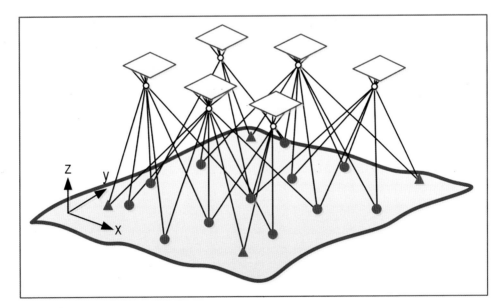

Figure 5.23 Bundle adjustment.

coordinates of the tie points and the GCPs and as known data the ground coordinates of the GCPs are used.

The bundles are translated (3 translations) and rotated (3 rotations) in order for the corresponding rays (a) to intersect as best as possible at the tie points and (b) to go through the GCPs (Figure 5.23).

As already mentioned, the observation equations are the collinearity equations. Every measured point on an image provides two such equations for the 6 unknowns of the exterior orientation. If it is a tie point, it adds 3 unknowns (X, Y, Z) to the system. The equations are not linear; hence they are linearised through a Taylor expansion. Consequently, the adjustment follows an iterative process, in which the unknowns are actually the corrections for the initial values of the unknowns. It is possible to use images from any kind of camera and involve in the same adjustment images from different cameras. In addition, it is possible to include the interior orientation parameters as unknowns (self-calibration) and also additional parameters, such as GNSS measurements.

$$
\begin{pmatrix}
\dfrac{\partial F_x}{\partial x_0} & \dfrac{\partial F_x}{\partial y_0} & \dfrac{\partial F_x}{\partial c} & \dfrac{\partial F_x}{\partial k_1} & \dfrac{\partial F_x}{\partial k_2} \\
\dfrac{\partial F_y}{\partial x_0} & \dfrac{\partial F_y}{\partial y_0} & \dfrac{\partial F_y}{\partial c} & \dfrac{\partial F_y}{\partial k_1} & \dfrac{\partial F_y}{\partial k_2} \\
\cdot & \cdot & \cdot & \cdot & \cdot \\
\cdot & \cdot & \cdot & \cdot & \cdot \\
\dfrac{\partial F_y}{\partial x_0} & \dfrac{\partial F_y}{\partial y_0} & \dfrac{\partial F_y}{\partial c} & \dfrac{\partial F_y}{\partial k_1} & \dfrac{\partial F_y}{\partial k_2}
\end{pmatrix}
\begin{pmatrix}
\Delta x_0 \\ \Delta y_0 \\ \Delta c \\ \Delta k_1 \\ \Delta k_2
\end{pmatrix}
+
\begin{pmatrix}
\dfrac{\partial F_x}{\partial X_0} & \dfrac{\partial F_x}{\partial Y_0} & \dfrac{\partial F_x}{\partial Z_0} & \dfrac{\partial F_x}{\partial \omega} & \dfrac{\partial F_x}{\partial \varphi} & \dfrac{\partial F_x}{\partial \kappa} \\
\dfrac{\partial F_y}{\partial X_0} & \dfrac{\partial F_y}{\partial Y_0} & \dfrac{\partial F_y}{\partial Z_0} & \dfrac{\partial F_y}{\partial \omega} & \dfrac{\partial F_y}{\partial \varphi} & \dfrac{\partial F_y}{\partial \kappa} \\
\cdot & \cdot & \cdot & \cdot & \cdot & \cdot \\
\cdot & \cdot & \cdot & \cdot & \cdot & \cdot \\
\dfrac{\partial F_y}{\partial X_0} & \dfrac{\partial F_y}{\partial Y_0} & \dfrac{\partial F_y}{\partial Z_0} & \dfrac{\partial F_y}{\partial \omega} & \dfrac{\partial F_y}{\partial \varphi} & \dfrac{\partial F_y}{\partial \kappa}
\end{pmatrix}
$$

$$
\begin{pmatrix}
\Delta X_0 \\ \Delta Y_0 \\ \Delta Z_0 \\ \Delta \omega \\ \Delta \varphi \\ \Delta \kappa
\end{pmatrix}
+
\begin{pmatrix}
\dfrac{\partial F_x}{\partial X} & \dfrac{\partial F_x}{\partial Y} & \dfrac{\partial F_x}{\partial Z} \\
\dfrac{\partial F_y}{\partial X} & \dfrac{\partial F_y}{\partial Y} & \dfrac{\partial F_y}{\partial Z} \\
\cdot & \cdot & \cdot \\
\cdot & \cdot & \cdot \\
\dfrac{\partial F_y}{\partial X} & \dfrac{\partial F_y}{\partial Y} & \dfrac{\partial F_y}{\partial Z}
\end{pmatrix}
\begin{pmatrix}
\Delta X \\ \Delta Y \\ \Delta Z
\end{pmatrix}
=
\begin{pmatrix}
x_1 - F_x^{(0)} \\ y_1 - F_y^{(0)} \\ \cdot \\ \cdot \\ y_n - F_y^{(0)}
\end{pmatrix}
$$

The bundle adjustment observation equations for self-calibration
For the bundle adjustment the unknowns are:

- the parameters of the exterior orientation of the images;
- the geodetic coordinates of the tie points;
- the parameters of the interior orientation of the camera(s) in the case of a self-calibration.

The observations are:

- the image coordinates of the points (tie points and GCPs).

The known parameters used are:

- the geodetic coordinates of the GCPs;
- the parameters of the interior orientation (if they are known);
- the position of the perspective centres (in case GPS/INS measurements are available).

In the following table, part of the design matrix of a bundle adjustment is shown. It assumes two images taken with the same camera and three points measured on each image, two tie points and one GCP.

$$A = \begin{bmatrix}
\frac{\partial x_{11}}{\partial X_{01}} & \frac{\partial x_{11}}{\partial Y_{01}} & \frac{\partial x_{11}}{\partial Z_{01}} & \frac{\partial x_{11}}{\partial \omega_1} & \frac{\partial x_{11}}{\partial \phi_1} & \frac{\partial x_{11}}{\partial \kappa_1} & 0 & 0 & 0 & 0 & 0 & 0 & \frac{\partial x_{11}}{\partial X_1} & \frac{\partial x_{11}}{\partial Y_1} & \frac{\partial x_{11}}{\partial Z_1} & 0 & 0 & 0 & \frac{\partial x_{11}}{\partial x_0} & \frac{\partial x_{11}}{\partial y_0} & \frac{\partial x_{11}}{\partial c} & \frac{\partial x_{11}}{\partial k_1} & \frac{\partial x_{11}}{\partial k_2} \\
\frac{\partial y_{11}}{\partial X_{01}} & \frac{\partial y_{11}}{\partial Y_{01}} & \frac{\partial y_{11}}{\partial Z_{01}} & \frac{\partial y_{11}}{\partial \omega_1} & \frac{\partial y_{11}}{\partial \phi_1} & \frac{\partial y_{11}}{\partial \kappa_1} & 0 & 0 & 0 & 0 & 0 & 0 & \frac{\partial y_{11}}{\partial X_1} & \frac{\partial y_{11}}{\partial Y_1} & \frac{\partial y_{11}}{\partial Z_1} & 0 & 0 & 0 & \frac{\partial y_{11}}{\partial x_0} & \frac{\partial y_{11}}{\partial y_0} & \frac{\partial y_{11}}{\partial c} & \frac{\partial y_{11}}{\partial k_1} & \frac{\partial y_{11}}{\partial k_2} \\
& & & & & & & & & \vdots & & & & & & & & & & & & &
\end{bmatrix}$$

The accuracy of the bundle adjustment is given as follows for pre-marked points:

- horizontal accuracy $\sigma_{xy} = \pm 3$ μm on the image (x scale factor);
- vertical accuracy $\sigma_z = 0.03$ ‰ of the flying height (for normal and wide-angle lenses);
- $\sigma_z = 0.04$ ‰ of the flying height (for super wide-angle lenses).

The accuracy of the adjusted parameters from a triangulation procedure is a function of:

- the block geometry;
- the base-to-distance ratio;
- the image scale;
- the measuring accuracy of the image coordinates;
- the pixel size of the digital image;
- the accuracy of the ground coordinates of the GCPs.

Automatic photogrammetric triangulation

The rapid development of photogrammetry has radically changed the way its procedures are performed as well as the way the various photogrammetric results are produced. Automated methods are now state-of-the-art. However, the basic algorithms, such as the bundle adjustment procedure described above, have not changed. What has

changed is the computing power and, hence the ability to solve more complex problems in shorter time and in an automated mode.

As far as photogrammetric triangulation is concerned, all new photogrammetric systems/software offer the possibility of combined adjustments using additional parameters of any kind (e.g. surveying measurements, GPS observations). In addition, digital photogrammetry in combination with computer vision has led to the automation of almost all photogrammetric procedures, including photogrammetric triangulation: so called structure from motion (SfM). SfM refers to the simultaneous determination of camera (interior and exterior) parameters and scene's 3D structure. Nowadays, it is part of all photogrammetric software, although the degree of automation and reliability differs from solution to solution [Remondino *et al.*, 2012].

The tendency today is to solve the photogrammetric triangulation problem as one batch process, with minimal or no intervention by the user [Schenk, 1999]. The automation of the image coordinate measurements has been made possible through the advancement of the digital photogrammetric procedures and feature-based methods (e.g. SIFT, SURF) [Apollonio *et al.*, 2014].

5.6 Photogrammetric production

5.6.1 Dense image matching

Matching can be defined as the establishment of a correspondence between various data sets (e.g. images, maps, 3D shapes). In particular, image matching is referred to as the establishment of correspondences between two or more images and estimating the corresponding 3D coordinates via collinearity or a projective camera model. Dense image matching is therefore the creation of a dense set of image correspondences (up to every pixel) and 3D points. In image space this process produces a depth map (that assigns relative depths to each pixel of an image) while in object space we normally call it point cloud. The earliest image matching algorithms were developed in the photogrammetry community in the 1950s and the topic is still an open and hot research issue [Remondino *et al.*, 2014]. The most intuitive classification of image-matching algorithms is based on the utilised primitives: (i) image intensity patterns (windows composed of grey values around a point of interest) or (ii) features (for example, edges and regions), leading to area-based matching (ABM) or feature-based matching (FBM) algorithms, respectively. The image-matching problem is nowadays solved using stereo-pairs (stereo-matching) or via identification of correspondences in multiple images (multiview stereo – MVS). Most of the proposed matching methods are based on similarity or photo-consistency measures; in other words, they compare pixel values between the images. These measures can be defined in either image or object space, according to the algorithms. The most common measures (or matching costs) include squared and absolute intensity differences, normalised cross-correlation (NCC), dense feature descriptors, census transform, mutual information, gradient-based algorithms and bidirectional reflectance distribution functions (BRDFs).

In case of aerial or satellite images, a dense matching algorithm delivers a 2.5D point cloud, normally called DEM or DSM (5.6.2). However, in the case of terrestrial convergent images, a 3D point cloud is delivered.

As mentioned, most of the image matching approaches are based on stereo pairs. The principle of stereo imagery and thus of 3D stereo vision is based on using the parallax theory of a stereo pair as shown in Figure 5.24. Stereo parallax is a physical condition that refers to the apparent displacement of a (height) point in an image caused by a shift in the position of observation. This occurs in aerial or close-range images that have been acquired from two different points of view but with some overlap. Parallax is defined as the difference between left and right images and specifically the difference between the image coordinates, thus having two components: P_x and P_y.

- P_x is directly connected with the elevation. The higher the elevation is, the greater the parallax. If the parallax is constant, equal elevation or contour lines will be produced.
- P_y is directly connected with stereoscopic vision and should be removed, otherwise is not possible to establish stereoscopic vision in an image pair.

The determination of 3D point coordinates is achieved by searching corresponding points along the respective epipolar lines (see also Figure 5.19). The intersection of the two corresponding 3D rays will give the 3D coordinates of the points. 3D rays are generated by photogrammetric geometry which reflects to the collinearity equation as explained in 5.5.3

Automated generation of DSM/DTM is achieved by automatic searching of corresponding points on a stereo pair or multiple images.

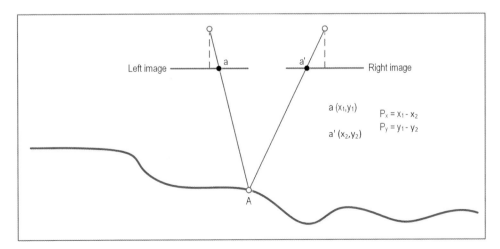

Figure 5.24 Stereo parallax in an image pair.

5.6.2 DSM / DTM modelling

Overview of DSM / DTM

Nowadays, many techniques and technologies are used for DSM/DTM generation, such as ground surveys, digitisation of existing data sources (e.g. cartographic), radar, satellite imagery, etc. In the following we only consider the image-based approach, i.e. the derivation of DSM/DTM from image data sets and 3D points. A set of points with known planimetric position (X, Y) and elevation (Z), and the use of a mathematical function, i.e. model, compose a consistent surface.

A digital and mathematical representation of existing or computer-generated objects (including their environment) constitutes the digital elevation model (DEM). The most characteristic example is terrain undulations. In practice, it refers to the elevation of the ground and at the same time to any layer above, such as trees, bushes or buildings. In the case the elevation information is reduced to the ground the model is called digital terrestrial model (DTM). Lastly, when coming from the ground to the highest elevation of each point, then the model is called the digital surface model (DSM), as illustrated in Figure 5.25.

Representation of surface models

Usually the surface models, of any type, are represented by two main ways:

- triangular irregular networks (TIN)
- regular grid (GRID)

A TIN covers the surface based on triangle shaped elements as a result of three neighbouring irregular distributed elevation points which are selected based on explicit criteria, as explained next. GRID uses elevation points located at the nodes of a grid.

In the TIN case, accurate surface models are composed by joining points as sets of three points in order to form non-overlapping triangles. In this case, there are many configurations of the same points to form different triangles. To overcome this, additional criteria are set for the optimum points selection.

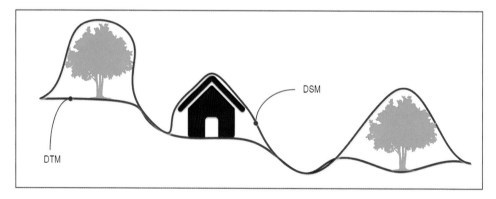

Figure 5.25 DSM/DTM representation.

The Delaunay triangulation is one of the most common conditions used in practice. This ensures:

- there is no overlapping between the triangles;
- the sum of the triangle sides are minimum;
- the triangle shape tends to be an equilateral triangle.

As illustrated in Figure 5.26, the circumscribed circle in the selected triangle should not contain any other neighbouring point. In the case of the correct triangle, i.e. *ABC*, no other point is within the circumscribed circle. On the contrary, in the case of the wrong configuration where the triangle *CDE* is chosen, two points, *A* and *B*, are within the circumscribed circle.

Normally, the 3D points are calculated in irregular locations. The representation of the surface through a GRID is feasible by using interpolation methods where the points now are calculated in the nodes of a regular grid.

As illustrated in Figure 5.27, irregular points (dots) shown on the left are measured directly or indirectly, considering the method used. The grid nodes, on the right, are the points where the new values are calculated by interpolation using the initial points. In order to do so, a mathematical model to represent the surface is chosen in a way to best fit over the initial points. Indicative mathematical models are:

$z = a \cdot x + b \cdot y + c$ [plane]
$z = a \cdot x + b \cdot y + c \cdot x \cdot y + d$ [bilinear]
$z = a \cdot x^2 + b \cdot y^2 + c \cdot x \cdot y + d \cdot x + e \cdot y + h$ [second degree polynomial]

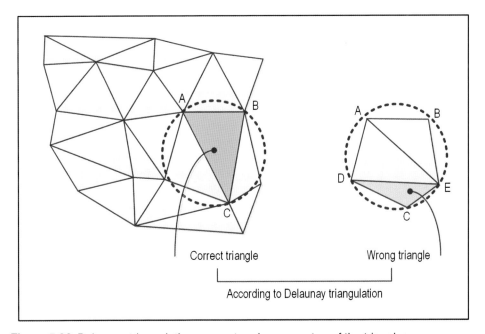

Figure 5.26 Delaunay triangulation; correct and wrong setup of the triangles.

Figure 5.27 Irregular points are transformed to regular grid by interpolation.

where: z is the elevation, x, y the planimetric coordinates and a, b, c, ... the coefficients defined by the mathematical model used in each case.

The mathematical model is chosen considering the surface characteristics, the precision specifications set each time and the surface use. The interpolation methods used on sampling the elevation points vary while the most commonly used are the GRID from weighted mean of the neighbouring points and the GRID using finite elements.

5.6.3 Quality issues for DSM / DTM

The quality of a DSM/DTM is affected by both point position accuracy and resampling efficiency. The point position technique used for DSM/DTM has specific sources of error. The main errors are originated from system used (e.g. the sensor), and the acquisition and processing parameters.

With respect to resampling, it is known that its influence on the quality of the DSM depends on: (a) the grid geometry; both in the structure and the density and (b) the data format. Grid structures have been reviewed and discussed by several authors [Carter 1988]. The DSM's density reflects a balance between economic constraints and accuracy requirements. The digital format of the data is one more factor contributing to the DSM quality; particularly the number of bytes used per sample.

5.6.4 Production of a digital orthoimage

Why orthoimage?

A differentially rectified image, better known as an orthoimage, is geometrically identical to a map. In fact, an orthoimage is an image of the object surface in orthogonal parallel projection. The orthogonal projection reflects a uniform scale since no relief

displacements appears on the product. This is in contrast to the perspective projection where non-uniform scale exists and there is displacement due to relief.

Because of the orthographic property, an orthoimage can be used like a map for measurement of distances, angles, areas etc. The scale appears constant in every product point. In addition, such products can be used as map layers in GIS or other computer-based manipulation, overlaying, analysis etc.

Orthoimage differs from a map in a way of detail representation. On the map, selected details are shown by typical symbols; however, on an orthoimage all details appear just as in the original imagery. On the other hand, digital images without terrain correction differ from the orthoimage in scale variation with respect to the height and the tilt distortions as well.

The orthoimage production pipeline

The orthoimage production pipeline is an automatic process and considers the following elements as input and known:

- an image of the surface/object of interest;
- the interior and exterior orientation of the image;
- a DSM of the surface/object.

As illustrated in Figure 5.28, the orthoimage is divided into pixels by considering a specific pixel size based on the ground coordinate system. For each one of these pixels on the orthoimage, a specific greyscale or *RGB* value corresponds. This value is obtained from the original image concerning the appropriate pixel, by using one of the resampling methods. In order to find the appropriate pixel refer to the original image, the collinearity equations are used.

Resampling methods

Nearest neighbour

Each pixel value in the resampled image is determined by copying the value from the closest input pixel.

Bilinear

In the bilinear method the output pixel value is the linear distance-weighted average of the four closest input pixel values. The bilinear method minimises aliasing but introduces significant blurring.

Bicubic

In the bicubic method the closest 4 × 4 block of the input pixels is used to calculate the output pixel value. Bicubic resampling reduces both aliasing and blurring compared to the nearest neighbour and bilinear methods.

Figure 5.29 illustrates the different resampling methods used during orthoimage production; namely nearest neighbour, bilinear and bicubic.

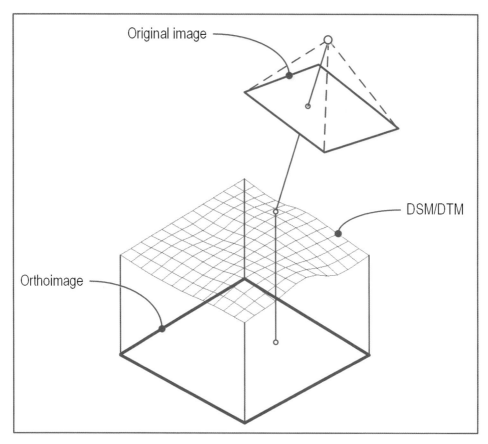

Figure 5.28 The typical photogrammetric pipeline for orthoimage production.

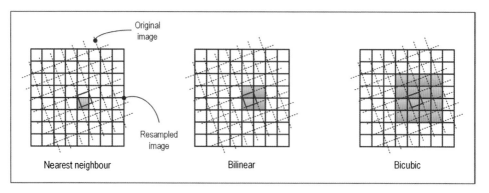

Figure 5.29 Resampling methods.

Orthoimage – accuracy

The accuracy of an orthoimage is affected by two main sources of error, namely:

- non-accurate DSM/DTM;
- occlusions.

In the case of inaccurate DSM/DTM, the height errors of the surface model are mapped to planimetric errors in the orthoimage. In addition, the points are displaced in radial direction with respect to the nadir point.

In the case of occlusions, the required intensities for orthoimage production cannot be found on the original image. The strong relief of the surface leads to occlusions.

5.7 Case studies of image-based modelling techniques in cultural heritage 3D recording

5.7.1 Example 1: Monitoring the deformations of a Byzantine church

Description of the monument and its problems

Samarina, the highest village in Greece, at an elevation of 1450 m, is situated approximately 70 km west of Grevena in northwestern Greece. Samarina's post-Byzantine church of Megali Panayia (Great St. Mary's church) was built in 1816 and is the area's main religious landmark, as well as a wonder of nature. The church is famous for its painted ceilings, frescoes, and a finely carved iconostasis, but also because the roof of the altar, covering the apse, in the east side of the 40 m long building, 'accommodates' a big pine tree with no sight of the tree's roots to be found within the church or outside the wall (Figure 5.30). The church is constructed of local stone and has very shallow foundations sitting on unfavourable ground, composed mainly of clay, silt and peat, with the solid rock found in depths of more than 15 m from the surface [Georgopoulos *et al.*, 2010].

Figure 5.30 The church of Megali Panayia in Samarina, Greece.

Methodology and presentation of results

However, before any maintenance intervention, a quantitative analysis of the evident and likely critical deformations of the church building was deemed to be of utmost importance. Therefore, before deciding upon the best possible solution for the support of the damaged monument and the engineering measures to be taken for preventing the risk of possible sliding of the building due to the soil erosion, a highly accurate geodetic network for monitoring over a period of time the deformations of the church building and the surrounding ground was considered necessary. The main objective was, through the synthesis of various types of repeated measurements and the variations of the coordinates of observed points, to detect and monitor the building's deformations through time and relate any changes in its geometry to likely terrain displacements and the rebounding of the terrain caused by the winter induced variations of the underground water levels in the surrounding area of the monument.

For the integrated detection of the deformations and the micro-movements of the church, it was decided that periodical measurements were necessary for a total period of one year, so that the impact of the various seasons of the year on the movement of the ground would be investigated. So far, four measurement epochs have been completed, in intervals of about 45 days, from June to October 2009. The measurements to be carried out were to answer two vital concerns: (a) whether the building is tilting or moving on a suspected slide-prone slope, in what direction, the magnitude of that movement, and the time evolution of such movements, and (b) whether any deformations of risk to the building do occur and how big they are.

A local deformation geodetic network and a greater GPS network involving international stations were established for the repeated measurements. The results were presented in 2D drawings, but for better understanding and for the support of engineering decisions they were also presented in 3D using a 3D textured model (Figure 5.31) which was produced using TLS and a high resolution DSLR. It was established that the monument is moving, but with no apparent deformations and follows the cycle of rainfalls.

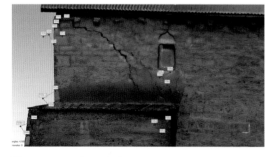

Figure 5.31 Detail of the deformations of the northern façade on the 3D textured model.

5.7.2 Example 2: Virtual restoration

Description of the monument and its problems

The monument of Zalongon is a huge complex of sculptures, situated on top of an 80 m high and steep cliff about 30 km north of Preveza in northwestern Greece. The sculpture is about 18 m long and 15 m high and is a composition of several female figures and commemorates the sacrifice of the Souli village women, who in 1803 preferred death to humiliation by their Ottoman conquerors. Although fairly recently constructed (1957–1961), the sculpture has suffered severely from frost, strong winds and tourists inscribing their names on the monument's surface. The restoration work that was carried out involved cleaning the sculpture's surface, the extraction and replacement of large pieces that had suffered damage from harsh weather and were deteriorating rather quickly, and the restoration of parts that had been destroyed by frost. A detailed and accurate geometric documentation and a 3D model of the construction were required. Given the size and complexity of the monument, contemporary digital techniques were employed for this purpose.

Methodology and presentation of results

The digital data required to build high resolution 3D textured models were 3D scans, geodetic measurements and a significant number of images. The detailed geometric documentation of the current situation of the monument included the production of 2D drawings, orthoimages and an accurate 3D model [Valanis *et al.*, 2009]. The most interesting product, possible only with the use of contemporary digital methods, was the 3D model. For the creation of the surface of the 3D model all of the original scans were registered into a common reference system by applying a method that was specially developed. The creation of high resolution textured 3D models is undoubtedly a non-trivial task as it requires the application of advanced data acquisition and processing techniques, such as geodetic, photogrammetric, scanning, programming, surfacing, modelling, texturing and mosaicking [Valanis *et al.*, 2009].

To achieve restoration, the basic steps are (i) identify the destroyed parts, (ii) interact with the 3D model and extract the geometry of the parts to be restored, (iii) insert these virtually into the 3D model and (iv) assess the result, before the final decision. In the present case the main points of interest were of course the destroyed figure heads, but there was also other damage to be repaired (Figure 5.32). Engineers who are involved in restoration are greatly facilitated if they can interact with a 3D model and immediately obtain various kinds of information by measuring various distances, areas, volumes, by creating cross-sections, outlines or even by formulating and adding missing parts. However, in cases where the formulation and addition of 3D data is desired different methods and algorithms are required. This was also the case for the monument of Zalongon, where the upper parts of the two tallest figures were almost destroyed. Two main categories of data were extracted, namely the part of the surface that was healthy and would be retained and the broken part that was recorded only in order to help reconstruct what was missing. Efforts were also made to completely restore the original surface virtually. However, in order to obtain a better result, another approach

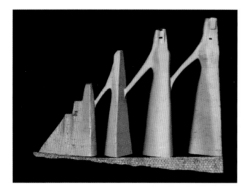 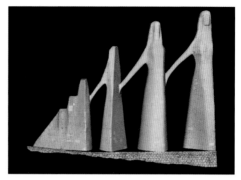

Figure 5.32 Virtual restoration: before (left) and after (right).

was preferred. The partially complete surfaces were used for the creation of analogue models on a 1:5 scale and a sculptor was assigned the task of completing the forms based on the existing model and old photographs and sketches made by the original sculptor. The new plaster models were scanned with an *XYZRGB* SL2™ structured light scanner and the data acquired were registered with the 3D model. The final mesh was exported, appropriately scaled and in such a form to enable masonry experts to reproduce exactly the missing parts and to restore the monument (Figure 5.32).

5.7.3 Example 3: Virtual reconstruction

Description of the problem

The Ancient Athenian Agora is today one of the most important archaeological sites in Athens and is situated at the northern foot of the Acropolis hill. It was a large open space to the south of Eridanos River and served as the administrative, philosophical, educational, social and economic centre of the town of Athens for many centuries. The Middle Stoa was an elongated building 147 m by 17.5 m, which ran east–west across the old square, dividing it into two unequal halves. This large building was constructed with Doric colonnades at both the north and south sides as well as an Ionic colonnade along the middle. The original steps and three columns remain in situ at its eastern end; to the west, only the heavy foundations of reddish conglomerate survive. The Middle Stoa was built between ca. 180 and 140 BC and it was continuously used even during of the Roman era [www.agathe.gr]. Foreign architects were responsible for its construction; hence it presents particular design and construction elements not usual for that time in the area. Today, only the foundations of this majestic building and some individual parts of it are visible on the site (Figure 5.33).

Methodology and presentation of results

For the virtual reconstruction several different data were available. Artefacts from the initial construction in the museum, drawings by scholars who had studied the monument thoroughly [Travlos 1971, Muller-Wiener, 1995], survey measurements of the

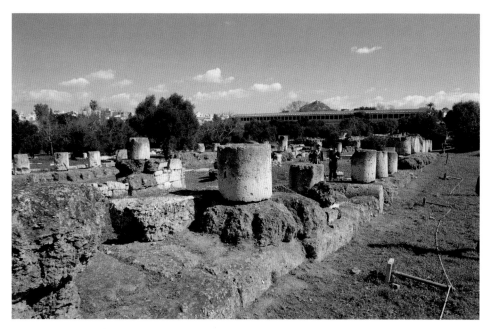

Figure 5.33 The foundations of the Middle Stoa.

foundations which are visible today and artists' reproductions of pertinent descriptions from travellers of the past. All data were evaluated (Figure 5.34) for their reliability and accuracy before usage for the final virtual reconstruction (Figure 5.35).

This final product reconstructs a building that does not exist today. The visitor may only see the foundations of the building, which at the time of its peak (2nd c. BC) were buried under the ground. Consequently, the virtual reconstruction is a combination of existing detailed architectural drawings, sketches, descriptions, digitisation of real artefacts and other minor sources of information. Of utmost importance were the discussions and suggestions of scientists who have studied the monument from an historical and archaeological point of view, proving once again that a reconstruction is a multidisciplinary process.

Data sources	Characteristics		
	Year	Accuracy	Likelihood
3D model	2010, 2012	1	1
Architectural plans	1963, 1966	2	2
Other plans	Varies	3	3
Images	Varies	5	5
Literature	Varies	4	4
Assumptions	–	6	6

Figure 5.34 Data evaluation.

Figure 5.35 The reconstructed Middle Stoa.

References

Abdel-Aziz, Y.I. and Karara, H.M., 1971. Direct linear transformation into object space coordinates in close-range photogrammetry, *Proc. Symposium on Close-Range Photogrammetry*, 1–18.

Agapiou, A., Georgopoulos, A., Ioannidis, Ch. and Ioannides, M., 2010. A digital atlas for the Byzantine and post Byzantine Churches of Troodos region (central Cyprus). *Proceedings of the 38th Conference on Computer Applications and Quantitative Methods in Archaeology* Granada, Spain, April.

Agarwal, S., Snavely, N., Simon, I., Seitz, S.M. and Szeliski, R., 2009. Building Rome in a day. *Proceedings of International Conference on Computer Vision*, Kyoto, Japan.

Apollonio, F., Ballabeni, A., Gaiani, M. and Remondino, F., 2014. Evaluation of feature-based methods for automated network orientation. *ISPRS Archives of the Photogrammetry, Remote Sensing and Spatial Information Sciences*, XL-5, 47–54.

Barazzetti, L., Scaioni, M. and Remondino, F., 2010. Orientation and 3D modeling from markerless terrestrial images: combining accuracy with automation. *The Photogrammetric Record*, 25(132), 356–381.

Boehler, W. and Heinz, G., 1999. *Documentation Surveying Photogrammetry*. CIPA International Symposium, Recife, Brazil.

Bregianni, A., Raimondi, A., Georgopoulos, A., Brumana, R. and Oreni, D., 2013. HBIM for documentation, dissemination and management of built heritage. The case study of St. Maria in Scaria D'Intelvi. *International Journal of Heritage in the Digital Era*, 2(3), 433–451, ISSN 2047–4970.

Brown, D.C., 1966. Decentering distortion of lenses, *Photogrammetric Engineering*, 32(3), 444–462.

Brown, D.C., 1971. Close-range camera calibration, *PE&RS*, 37(8), 855–866.

Brumana, R., Oreni, D., Cuca, B. and Georgopoulos, A., 2013. HBIM for conservation and management of built heritage: towards a library of vaults and wooden beam floors. *ISPRS Annals* II-5/W1, 2013 TC V XXIV International CIPA Symposium 2–6 September, Strasbourg, France, 215–221.

Caprile, B. and Torre, V., 1990. Using vanishing points for camera calibration. *International Journal of Computer Vision* 4(2), 127–139.

Carter J., 1988. Digital representations of topographic surfaces. *Photogrammetric Engineering and Remote Sensing*, 54(11), 1577–1580.

Faugeras, O. and Toscani, G., 1986. The calibration problem for stereo. *IEEE CVPR*, 15–20.

Fraser, C.S., 1982. On the use of non-metric cameras in analytical non-metric photogrammetry', *International Archives of Photogrammetry and Remote Sensing*, 24(5), 156–166.

Fraser, C.S., 1997. Digital camera self-calibration. *ISPRS Journal of Photogrammetry and Remote Sensing*, 52, 149–159.

Fryer, J. and Brown, D., 1986. Lens distortion for close-range photogrammetry, *PE&RS*, 52(1), 51–58.

Georgopoulos, A. and Ioannidis, Ch., 2004. *Photogrammetric and Surveying Methods for the Geometric Recording of Archaeological Monuments*. FIG International Week, Athens, http://www.fig.net/pub/athens/papers/wsa1/WSA1_1_Georgopoulos_Ioannidis.pdf.

Georgopoulos, A., Delikaraoglou, D., Ioannidis, Ch., Lambrou E. and Pantazis G., 2010. *Using Geodetic and Laser Scanner Measurements for Measuring and Monitoring the Structural Damage of a Post Byzantine Church*. 8th International Symposium on Conservation of Monuments in the Mediterranean Basin – Monument Damage Hazards and Rehabilitation Technologies, 31 May–2 June, Patras, Greece.

Gruen A. and Beyer, H.A., 2001. System calibration through self-calibration. In: *Calibration and Orientation of Cameras in Computer Vision*, Gruen and Huang (Eds.), Springer Series in Information Sciences 34, 163–194,

Habib, A. and Morgan, M. 2005. Stability analysis and geometric calibration of off-the-shelf digital cameras, *Journal of Photogrammetric Engineering and Remote Sensing*, 71(6), 733–741.

Hall, E.L., Tio, J.B.K., McPherson, C.A. and Sadjadi, F.A., 1982. Measuring curved surfaces for robot vision, *Computing Journal*, 15, 42–54.

Heikkilä, J. and Silven, O., 1997. *A Four-Step Camera Calibration Procedure with Implicit Image Correction*, CVPR97.

Ioannidis, Ch., Valanis, A., Tapinaki, S. and Georgopoulos A. 2010. Archaeological documentation and restoration using contemporary methods. *Proceedings of the 38th Conference on Computer Applications and Quantitative Methods in Archaeology*. Granada, Spain, April

Kontogianni, G., Georgopoulos, A., Saraga, N., Alexandraki, E. and Tsogka, K., 2013. 3D Virtual reconstruction of the Middle Stoa in the Athens Ancient Agora, *International Archives of Photogrammetry, Remote Sensing and Spatial Information Science*, XL-5/W1, 125–131, DOI: http://dx.doi.org/10.5194/isprsarchives-XL-5-W1-125-2013.

Logothetis, S., Delinasiou, A., and Stylianidis, E., 2015. Building Information Modelling for Cultural Heritage: A review, ISPRS Ann. Photogramm. Remote Sens. Spatial Inf. Sci., II-5/W3, 177-183, DOI: http://dx.doi.org/10.5194/isprsannals-II-5-W3-177-2015.

McGlone C., (Editor), 2004. *Manual of Photogrammetry*. 5th edn. *ASPRS, Washington DC*

Meyer, E., Grussenmeyer, P., Perrin, J.P., Durand, A. and Drap, P., 2007. A web information system for the management and the dissemination of cultural heritage data, *Journal of Cultural Heritage*, 8, 396–411.

Muller-Wiener, E., 1995. *The Architecture in Ancient Greece*. University Studio Press, Thessaloniki (in Greek).

Remondino, F. and Fraser, C.S. 2006. Digital camera calibration methods: considerations and comparisons, *ISPRS Commission V Symposium Image Engineering and Vision Metrology*, Part 5, Dresden.

Remondino, F., Del Pizzo, S., Kersten, T. and Troisi, S., 2012. Low-cost and open-source solutions for automated image orientation – A critical overview. *Proc. EuroMed 2012*, LNCS 7616, 40–54.

Remondino, F., Spera, M.G., Nocerino, E., Menna, F. and Nex, F., 2014. State of the art in high density image matching. *The Photogrammetric Record*, 29(146), 144–166.

Schenk, T., 1999. *Digital Photogrammetry, Volume I: Background, Fundamentals, Automatic Orientation Procedures*.

Snavely, N., Seitz, S.M. and Szeliski, R., 2008. Modeling the world from internet photo collections. *International Journal of Computer Vision*, 80(2): 189–210.

Travlos J., 1971. *Pictorial Dictionary of Ancient Athens*, London: Thames and Hudson.

Triggs, B., 1998. Autocalibration from planar scenes, *ECCV 98*, 89–105.

Tsai, R.Y., 1987. A versatile camera calibration technique for high-accuracy 3D machine vision metrology using off-the-shelf TV cameras and lenses, *IEEE International Journal Robotics and Automation*, 3(4), 323–344,

UNESCO, 2003). *Guidelines for the Preservation of Digital Heritage*, CI-2003/WS/3

Valanis, A., Georgopoulos, A., Tapinaki, S. and Ioannidis, C.H., 2009. High resolution textured models for engineering applications. *Proceedings XXII CIPA Symposium*, October 11–15, Kyoto, Japan, http://cipa.icomos.org/text%20files/KYOTO/164.pdf.

Waldhäusl, P. and Ogleby, C., 1994. 3-by-3-rules for simple photogrammetric documentation of architecture. *International Archives of Photogrammetry and Remote Sensing*, 30(5), 426–429.

Wei, G. and De Ma, S., 1994. Implicit and explicit camera calibration: theory and experiments, IEEE Trans. on PAMI, 16(5), 469–479.

Weng, J., Cohen, P. and Herniou, M., 1992. Camera calibration with distortion models and accuracy evaluation, *IEEE Trans. on PAMI*, 14(10), 965–980.

Zhang, Z., 2000. A flexible new technique for camera calibration. *IEEE Trans, on PAMI*, 22(11), 1330–1334.

Basics of Range-Based Modelling Techniques in Cultural Heritage 3D Recording | 6

Pierre Grussenmeyer, Tania Landes,
Michael Doneus and José Luis Lerma

6.1 Introduction

Chapter 5 showed that the processing of point clouds from sets of images is an affordable solution for 3D documentation. Nevertheless, the management of a photogrammetric project and the processing of the images are sometimes time consuming and require some experience from the user's point of view. Laser scanning is often presented as an alternative and simpler solution to get point clouds directly without any processing, although a laser scanner is not a low-cost system. There is a large variety of range-based systems available on the market for the recording of various sizes of objects in terrestrial and aerial configurations. But the choice of the right system is not an easy task. To help the reader better understand the range-based techniques, this chapter presents some theoretical aspects of laser scanning as well as related applications in the field of cultural heritage documentation. Section 6.2 is dedicated to definitions, 6.3 to classification of laser scanning systems and 6.4 aims to make the user aware of possible errors while using range-based systems. Section 6.5 describes the processing of terrestrial scanning data and 6.6 presents airborne laser scanning data. Finally, in section 6.7 a selection of applications in cultural heritage is presented.

6.2 A few definitions

Laser scanning is a technique using laser light for measuring in a regular pattern directly 3D coordinates of points on surfaces from any position [Pfeifer, 2007]. This technique allows a fast and automatic acquisition of points in 3D with high density, and does not require direct contact with the object. It is an active remote sensing system, because it produces its own electromagnetic radiation. Therefore, we can complete the definition as follows:

> Laser scanning is an active, fast and automatic acquisition technique using laser light for measuring, without any contact and in a dense regular pattern, 3D coordinates of points on surfaces.

Two main fields of application are terrestrial laser scanning (TLS) and airborne laser scanning (ALS) [Vosselman and Maas, 2010]. While a TLS system can be stationary (mounted on a tripod) or dynamic (mobile laser scanning), an ALS sensor is usually mounted below an aeroplane, helicopter or drone.

The orientation of the laser beam as well as the travelling time is accurately measured, so that the position of the impacted point on the object surface can be also accurately calculated. Since the laser beam emission is performed at very high frequency, this allows the acquisition of several thousands of points in a very short time. The laser emitted radiation is a beam of small diameter at the aperture (from 1 mm to 1 cm) and of reduced beam divergence angle (about 1 mrad). The beam divergence angle affects the size of the laser beam diameter (footprint), which grows with the range.

Compared to conventional total station measurements, TLS measurements seem to be very easy to perform. The role of the surveyor is not to guide the measurements in order to have to choose characteristic points or lines describing the object's surface. With a TLS system, only the acquisition frame and the point density must be defined. The scanning is performed automatically. However, it is crucial to make carefull decisions about the scan stations, target positions, as well as the registration method in order to ensure an efficient post-processing phase.

6.2.1 Point cloud and coordinates

A point cloud is a set of 3D points representing the surface measured by any instrument used such as a laser scanner, cameras or total stations. A terrestrial laser scanner measures the range, i.e. the distance between the scanner (transmission system) and the object, as well as both horizontal and vertical angles just as does a total station. The spherical coordinates (d, φ, θ) of each point are defined in a coordinate system whose origin is located at the scanner centre (Figure 6.1). The set of measured points is called 'point cloud'.

Figure 6.1 Measurement of spherical coordinates (d, φ, θ) of points, in a frame (X, Y, Z) located at the centre of the scanner; ρ denotes the horizontal distance.

Three-dimensional Cartesian coordinates X, Y, Z of points are provided by the following equations

$$\begin{cases} X = d \cos \theta. \cos \varphi \\ Y = d \cos \theta. \sin \varphi \\ Z = d \sin \theta \end{cases} \quad (1)$$

with d = distance between scanner and object;
φ, θ = orientation angles of the laser beam.

The intervals $[\varphi_{min}, \varphi_{max}]$ and $[\theta_{min}, \theta_{max}]$ represent the available field of view of the scanner. Nowadays, it is quite common for a laser scanner to cover the maximal field of view around it, i.e. 360° in the horizontal plane and 270° vertically. Only the area around the tripod remains unscanned. Scanners that are restricted to a specific vertical or horizontal field of view are also produced. Staiger [2003] suggests the following terminology (Figure 6.2):

(a) a 'panoramic' scanner is able to scan the entire environment around the setup, i.e. a hemispherical coverage;
(b) a 'camera' scanner is limited in the vertical and horizontal plane, as is the case for a camera (e.g. 40° × 40°);
(c) a 'hybrid' scanner covers an intermediate field of view, i.e. with a limited vertical field of view of about 60°, but scanning at 360° in the horizontal plane (Figure 6.2). Panoramic scanners are very useful in the context of urban mapping, topographic surveying, and are almost essential in the 3D acquisition of industrial facilities.

In ALS (Figure 6.3) the aircraft will cover a predefined area in parallel and overlapping strips (plus some perpendicular strips). The laser scanner emits short infrared pulses (typically between 30,000 and 200,000 per second) towards the Earth's surface, fan-shaped across the flight path. The position and orientation of the system is post-processed accurately based on synchronised Global Positioning Systems (GPS) and inertial measurement unit (IMU) measurements.

(a) (b) (c)

Figure 6.2 Classification of laser scanners regarding their field of view: (a) panoramic; (b) hybrid; (c) camera [Staiger, 2003].

Figure 6.3 Flight path and footprint in ALS (Figure: Martin Fera).

6.2.2 Angular and spatial resolution

The smallest available angle that a laser scanner can distinguish corresponds to the angular resolution. Therefore, the angular resolution characterises the device's ability to measure two objects located on adjacent laser beams.

For example, if a scanner is provided with an angular resolution of 0.01 degrees, i.e. $\varphi_{i+1} - \varphi_i = 0.01$ degrees with $\varphi \in [\varphi_{min}, \varphi_{max}]$ and $\theta_{i+1} - \theta_i = 0.01$ degree with $\theta \in [\theta_{min}, \theta_{max}]$, this will result in 100 points per degree on the surface of the object. In practice, it is easier to appreciate a step in terms of distance than in terms of angle. The above example thus results in a spacing between laser beams of 2 cm at the 100 m range. This leads to the definition of spatial resolution:

> The spatial resolution of a terrestrial laser scanner is the smallest distance between two successive points that can be measured at a specific distance from the object.

Before performing the scanning, the user defines the area to scan as well as the scanning spatial sampling, in terms of vertical and horizontal (angular or spatial) steps (generally identical in both directions). It is important to notice that a spatial step must be related to a specific range. For instance, if the user chooses 1 point every 10 mm at 100 metres, the spatial sampling becomes equivalent to 5 mm at 50 m, 20 mm at 200 m, etc. Therefore, the point density reduces when the distance scanner-to-object grows.

The reader should distinguish between 'resolution' and 'sampling'. The resolution is a limit below which the scanner cannot distinguish two neighbouring objects. The '(spatial) sampling' is the distance between successive points selected by the user before starting the laser scanning. In fact, the sampling is a multiple of the resolution.

Nevertheless, several manufacturers provide with their scanners 'high resolution scanning' or 'low resolution scanning' terms although they refer to 'high density' (short spatial sampling) and 'low density' (large spatial sampling), respectively.

As already mentioned, every point is calculated through its spherical coordinates. The distance d between the laser scanner and every impact point is related to the horizontal and vertical angles measured for that point i, as $d_i = f(\varphi_i, \theta_i)$. This value is then stored in a regular 2D grid (matrix) whose rows and columns represent the chosen angular steps, denoted as θ and φ. The resulting matrix is called the 'depth map' or 'range image' in which the pixel value provides the distance observed between scanner and object directly (Figure 6.4).

6.2.3 Point density

The point density refers to the number of points acquired by unit area. It depends on the spatial sampling chosen for the scanning (spacing between points) and on the object–scanner distance. Figure 6.5 shows the result of scanning performed on a building façade in Strasbourg.

As shown in Figure 6.5, the level of detail visible in the point cloud is directly correlated to the selected spatial sampling and therefore to the point density. The higher the density, the larger the point cloud files will be. However, it must be noticed that edges of objects cannot be measured directly, because of mixed pixels artefacts. Edges may be derived by calculating the intersection of geometric primitives composing the object. However, a high density point cloud will a priori get closer to the edge than a low density point cloud.

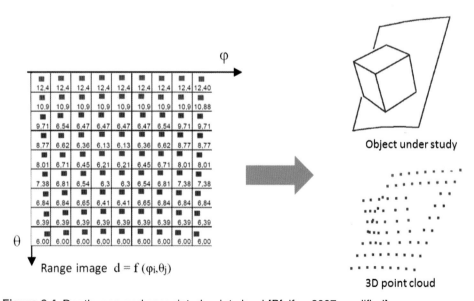

Figure 6.4 Depth map and associated point cloud [Pfeifer, 2007 modified]

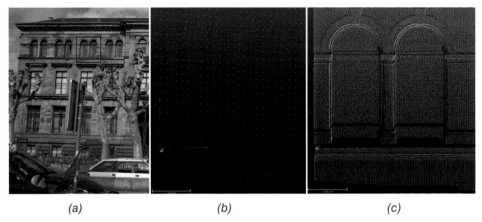

(a) *(b)* *(c)*

Figure 6.5 Effect of the selected spatial sampling on the level of details: a) picture of the scanned façade; b) point cloud obtained with one point every 150 mm at 30 m from the façade; c) with one point every 10 mm at 30 m

As shown in Figure 6.4, the beam cannot reach all parts of the object of study, which generates areas without points, also called laser shadows. To complete the cloud, additional scan stations should be considered.

6.2.4 Intensity and RGB point clouds

Simultaneously to recording point coordinates, laser scanners also capture the intensity of the backscattered laser wave. If the scanner integrates a digital camera, colour information *RGB* (red, green, blue) can directly be associated to each laser pulse. The intensity and *RGB* information are very useful for visualisation (distinction of objects), and as a support for object extraction from point cloud.

The laser intensity returned by the object represents the amount of light reflected by the scanned surface (ranged from 0 to 255 for an 8-bit coded system). This intensity is a function of the beam incidence angle, the squared object–scanner distance (range), the surface reflectance (albedo) and the emitted power [Soudarissanane *et al.*, 2007]. The reflected intensity provides information about the nature of the scanned objects. In general, the intensity increases when the range decreases. It can be stated that the intensity values obtained for the same object with several laser scanners are not comparable. It seems that the intensity is not absolutely calibrated by the manufacturers. Generally, they calibrate the intensity as a function of distance and albedo.

Figure 6.6 displays the point cloud shown in Figure 6.5, (a) with colour-coded intensity information, (b) with intensity in grey levels and (c) with *RGB* information. The intensity colour-coded point cloud clearly shows out joints that were not visible in the cloud alone.

RGB values are taken by a digital camera, often integrated to the scanner system. The colour point cloud then reflects more realistically the scanned object (Figure 6.6c).

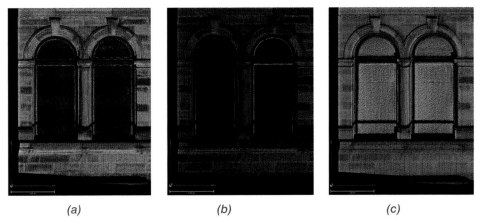

(a) (b) (c)

Figure 6.6 Point cloud (Figure 6.5): (a) with pseudocolour intensity values; (b) with grey level intensity values; (c) with *RGB* information.

The *RGB* values of the corresponding point in the cloud are retrieved by calculating the image coordinates of the corresponding pixel in the digital image. If the digital camera is not integrated in the scanner system, the process of matching the image to the point cloud can be performed in the same way.

6.3 Classification of terrestrial laser scanner systems

Depending on the technology the scanners are based on for measuring the distance scanner–object, three major categories can be distinguished: pulse-based scanners, phase-based and triangulation-based scanners.

The pulse-based and phase-based laser scanners are also commonly called 'time of flight' laser scanners, since they both determine the range based on time measurements, i.e. the delay between transmitted and returned laser signal. Since the pulse-based laser scanners measure directly the delay, they are called 'direct TOF' scanners, whereas phase-based laser scanners are 'indirect TOF' measurement systems. Similar range measurement systems are provided by total stations with reflectorless electronic distance measurement (EDM) devices.

6.3.1 Pulse-based scanners

The pulse-based laser scanners are composed of rangefinders, a laser transmitter, a laser receiver, a clocking mechanism, as simplified in Figure 6.7. Measuring devices are linked to a mechanical system (mirror actuated by a motor) for scanning the object under study.

This technology measures the time taken by a short laser pulse to make the round trip scanner–object–scanner. The delay between the transmitted and the backscattered signal is denoted by t in Figure 6.8. The shape of the returned pulse is simplified in Figure 6.7. Obviously, the returned amplitude is lower than the transmitted one.

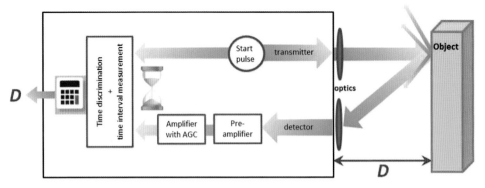

Figure 6.7 Components of a pulse-based scanner [Reshetyuk, 2009, modified].

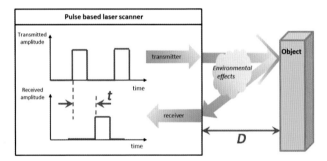

Figure 6.8 Distance measurement principle for a pulse-based scanner [Wehr and Lohr, 1999 modified].

The distance D between the scanner and the object can be computed using equation (2):

$$D = c \cdot \frac{t}{2} \tag{2}$$

with: D = distance between scanner and object (in m);
c = speed of light in the medium (in m/s);
t = travelling time between transmission and reception (in s).

Due to the fact that energy is concentrated in very short pulse widths, pulse-based laser scanners are adapted for long-range measurements. The laser scanner transmitter will not transmit another pulse until the echo of the previous one has been

returned. This characteristic impacts the acquisition speed (pulse repetition frequency) of such scanners. Increasing the maximum range means reducing the pulse repetition frequency, and therefore the acquisition speed.

Considering the speed of light as a constant, equation (2) means that an error in time measurement directly impacts the distance measurement. Consequently, also it means that the ability to measure (accurately) a short interval of distances, called 'distance resolution', is directly dependent on the ability to measure (accurately) a short time interval, called 'time resolution'. This dependency is a drawback for pulse-based laser scanners. Regardless of the refractive index of the medium, if we want the system to be able to measure distance intervals of 1 mm, the system should be able to measure time intervals of less than 10 ps ($t = 2 \cdot \dfrac{D}{c} = 2 \cdot \dfrac{10^{-3}}{3.10^3} = 6.7 \cdot 10^{-12}\,\mathrm{s}$). This involves the use of a high-precision clock (atomic clock), which implies a significant investment in terms of cost.

As specified in Wehr and Lohr [1999], the distance measurement accuracy of pulse-based laser scanners can be estimated as denoted in equation (3).

$$\sigma_D \cong \frac{c.t}{2.\sqrt{S/N}} \qquad (3)$$

with: c = speed of light in the medium (in m/s);
t = travelling time between transmission and reception (in s).

S/N: signal-to-noise ratio

Equation (3) suggests that the uncertainty in distance measurement is dependent on the travelling time and consequently on the range. However, when the range increases, the laser footprint increases, as well as the power loss of the backscattered signal, which in turn depends on the reflectivity of the object, on the distance to the scanner, and other environmental effects. All these factors contribute to the noise component (N) of the signal-to-noise ratio (denoted S/N). When the noise increases, the signal-to-noise ratio decreases, therefore the range accuracy decreases (and the standard deviation increases). This technology is particularly adapted for long-range measurements.

Figure 6.9 presents a few present pulse-based laser scanners with some technical specifications, as given by the manufacturer.

To get round the problem of integrating high precision clocks, other scanning systems have been developed which are based on phase-shift measurements.

6.3.2 Phase-based laser scanners

Phase-based laser scanners send a sinusoidal amplitude-modulated continuous wave, with high intensity, in the direction of the object and compare the phase difference (shift) between the transmitted and the received signal. They belong also to the family

Company / Manufacturer	LEICA P40	RIEGL VZ 2000	OPTECH ILRIS-LR	TOPCON GLS2000	Trimble TX8
Range (min. – max.)	0.40 – 270 m	2.5 m–2000 m	3 m–3000 m	Up to 350 m	0.6 m–340 m
Accuracy (of point position)	3 mm at 50 m	8 mm at 150 m	7 mm at 100 m (4 mm when 4 shots averaged)	3.5 mm (up to 150 m)	2 mm at 100 m
Measurement rate	Up to 1000000 pts/s	21,000 to 396,000 pts/s (50 kHz– 1 MHz)	10,000 Hz	n/a	1 MHz

Figure 6.9 Examples of pulse-based terrestrial laser scanners.

of time of flight systems, since the phase difference is proportional to the signal travelling time. The ranging can be performed with an amplitude modulated continuous wave (AMCW) or a frequency modulated continuous wave (FMCW). In the latter case, the signal travelling time is determined by measuring the beat frequency of an FMCW-modulated signal and its reflection [Reshetyuk, 2009].

This technique is suitable for the measurement of short scanner–object ranges because it requires a high intensity continuous wave, whose energy is many times less powerful than the energy that can be produced by a pulse-based laser scanner. This is also a reason why phase-based laser scanners are not suitable on board airborne platforms.

Figure 6.10 illustrates the principle of distance measurement by phase comparison. The emitted signal, continuously amplitude modulated with a constant frequency f_{mod}, is received with a time delay, t, corresponding to the wave travelling time [Wehr and Lohr, 1999]. Since the period T of the signal is known, t is directly proportional to the phase difference $\Delta\phi$ between the received and transmitted signal as expressed in equation (4).

$$t = \frac{\Delta\varphi}{2\pi} \cdot T + N.T \qquad (4)$$

with: $\Delta\varphi$ = phase difference between received and transmitted signals;
T = period of the signal;
t = travelling time between transmission and reception (in s);
N = number of full wavelengths included in the distance from laser transmitter to receiver.

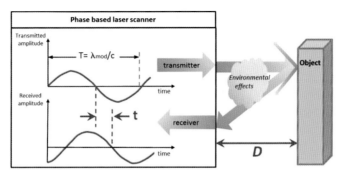

Figure 6.10 Distance measurement principle for a phase-based laser scanner [Wehr and Lohr, 1999 modified).

When the total distance travelled by the wave is equal to an exact number of wavelengths λ_{mod}, the received and transmitted signals have the same phase. Otherwise, there is a phase difference $\Delta\varphi$. We can therefore express the scanner–object distance (D) as equation (5).

$$D = c \cdot \frac{t}{2} = \frac{\Delta\varphi \cdot c}{4\pi} T + N \cdot \frac{cT}{2} = \frac{\Delta\varphi}{4\pi}\lambda_{mod} + N \cdot \frac{1}{2}\lambda_{mod} \qquad (5)$$

Whereas distance resolution for pulse-based scanners is directly dependent on time resolution, the ability of phase-based systems to measure short intervals of distances is directly dependent on the ability to measure short phase differences and to decrease the period (or increase the frequency), for a given phase resolution. For instance, if $N = 0$, with a frequency of 10 MHz and 0.01° phase resolution, the shortest measurable distance interval is about 0.5 mm.

Regardless of the contribution of N wavelengths, if we want the system to be able to measure distance intervals of 1 mm, given 0.01° phase resolution, the system should be able to use frequencies of 5 MHz, which is quite realistic.

The maximum measurable phase difference is 360° or 2π radians. Consequently, considering the case where $\Delta\varphi_{max} = 2\pi$ in equation (5) and ignoring N, the maximum unambiguous range for a phase-based scanner is given by equation (6).

$$D_{max} = \frac{\lambda_{mod}}{2} \qquad (6)$$

For a system using two frequencies, the frequency with the longest wavelength determines D_{max}. For instance, for a system using one of 1 MHz (wavelength of 300 m)

and one of 10 MHz, the maximum unambiguous range will be 150 m [Baltsavias, 1999]. This result means that if we observe objects beyond this range, the system may provide errors in distance of about one module 2π. It will not be possible to determine if these objects are at a distance $\frac{\lambda_{\text{mod}}}{2}$ or at $150 \text{ m} + \frac{\lambda_{\text{mod}}}{2}$.

The distance measurement accuracy of phase-based laser scanners can be estimated as denoted in equation (7), according to Wehr and Lohr [1999]. It depends mainly on the modulation wavelength (shortest wavelength of the frequency used in a multifrequency system) and on the square root of the *S/N* ratio which depends on many factors, such as the received signal power, input bandwidth (measurement rate), background radiation and environmental factors.

$$\sigma_D \cong \frac{\lambda_{\text{mod}}}{4\pi\sqrt{S/N}}$$

(7)

where:

λ_{mod} = modulation wavelength (the shortest one in the case of multifrequency systems).

Restricted by the maximum unambiguous range, the use of this type of laser scanner is appropriate for medium-distance measurements (ranges below 300 m generally), but it is much faster than the pulse-based laser scanners. Figure 6.11 presents a few examples of phase-based laser scanners, with a few technical specifications.

Laser scanners combining both pulse-based and phase-based technologies such as Trimble CX and Callidus Precision Systems CPW 8000 are available on the market.

Distance measurement can also be performed by triangulation (section 6.3.3), but the maximal operating range is limited to a few metres.

	FARO Focus3D X330	Z+F IMAGER 5010	Trimble FX	Surphaser 25HSX (ER_XQ configuration)
Company / Manufacturer	FARO Focus3D X330	Z+F IMAGER 5010	Trimble FX	Surphaser 25HSX (ER_XQ configuration)
Range (min. – max.)	0.60–330 m	Up to 187.3 m	Up to 70 m	0.4 m–70 m
Accuracy (of point position)	2 mm at 25 m	2 mm to 10 mm at 100 m	2 mm at 50 m	0.2 mm at 8 m (range noise)
Measurement rate	Up to 976,000 pts/s	1,016,000 pts/s	216,000 pts/s	216,000– 1,200,000 pts/s

Figure 6.11 Examples of phase-based laser scanners.

6.3.3 Triangulation-based scanners

Triangulation-based scanners achieve distance measurement based on solving plane triangles. The technique relies on the observation of a spot emitted by a laser diode with an optical receiver system. The optical receiver is located at a distance *dAB* from the transmitter (Figure 6.12). A CCD-camera takes a picture of the spot on the object. The three components called P for impact point, A for transmitter and B for the camera comprise the vertices of a triangle. In fact, the geometrical characteristics of the emitted laser beam and the respective positions of transmitter A and receiver B are known, i.e. also distance *dAB*.

Whereas the angle α is constant, the value of β varies, because it depends on the position of P at the object surface. Knowing these angles, the triangle (APB) can be solved easily using fundamental trigonometric laws and the distance *D* can be computed (equation 8).

$$D = d_{AB} * \frac{1}{\cot an(\alpha) + \cot an(\beta)} \tag{8}$$

With: *D* = distance between scanner and object;
 d_{AB} = base length between receiver and transmitter;
 α = angle between the emitted beam direction and the AB axis;
 β = angle between the received beam direction and the AB axis.

The laser source might produce a single spot on the surface when a single beam is generated, as illustrated in Figure 6.11. Single or multiple light sheet sources can

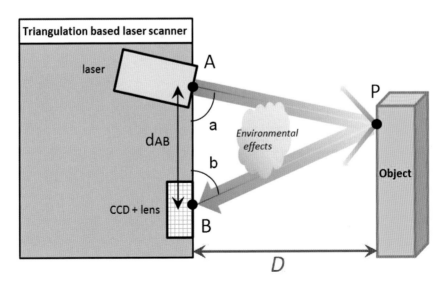

Figure 6.12 Distance measurement principle for triangulation-based scanners.

replace the single beam source. In this case, the source illuminates the surface with one or several light planes. Therefore, the object is scanned through the projection of lines and the camera captures profiles of the object.

The main drawback of this measurement principle is that the range accuracy decreases with the square of the object–scanner distance [Lerma Garcia *et al.*, 2008], as expressed in equation (9).

$$\sigma_D \cong \frac{D^2}{focd_{AB}}\sigma_p \qquad (9)$$

with: D = distance between scanner and object;

d_{AB} = base length between receiver and transmitter;

σp = uncertainty on laser position (depending on the laser, the peak detection algorithm, the S/R ratio and the shape of the laser spot);

f_{oc} = focal length.

Equation (9) includes the photogrammetric well-known base–height ratio, i.e. D/d_{AB}. To reduce uncertainty on D, the scanner–object distance should decrease or d_{AB} should increase. Unfortunately, these solutions increase the effect of laser shadows. Another solution is to increase the focal length, but this would reduce the camera's field of view [Lerma Garcia *et al.*, 2008].

These laser scanners are designed for scanning objects at close range (15 cm to 30 cm range) and consequently relatively small objects (1 m × 1 m × 1 m), as we will see with handheld scanners.

However, specific systems, such as the Soisic scanner produced initially by Mensi (France), can operate at two different ranges. In the SD (short distance version), the

Figure 6.13 Soisic triangulation scanner.

distance from laser mirror to camera lens (base *dAB*) is 0.5 m and allows distance measurements between 0.8 and 10 m; the LD (long distance) version has a base of 0.8 m and can measure up to 25 m range [Boehler *et al.*, 2005].

6.3.4 Handheld scanners

Handheld scanners operate on a principle which relies on the triangulation-based principle, but allow more flexible movements around the object. With these kinds of systems, the user turns around the object via either a handheld articulated mechanical arm or arm-free. Generally, the transmitter projects laser lines (or crosses) onto the object while the camera records cross-sectional depth profiles.

Handheld scanners coupled with a mechanical arm allow the acquisition of georeferenced point clouds all around the object, which must keep static during the scan. The measurement device is connected with a mechanical arm, from which the 6 degrees of freedom (DoF), i.e. 3 rotation angles and 3 translations, can be deduced. Therefore, the registered point clouds are referenced in real-time in the coordinate system (Figure 6.14).

Arm-free handheld scanners are stand-alone units that allow total freedom of movement. Their position in the space can be determined provided there are elements on the object which make possible the calculation of the 3D transformation between two successive scan positions. In order to ensure this alignment calculation, a specific acquisition protocol must be followed. For instance, if the geometry of the object is not specific enough to enable easy alignment of the point clouds acquired from successive scan positions, the relative orientations of the scanner can be calculated based on targets regularly distributed on the surface of the object.

Figure 6.15 presents a few examples of hand scanners. These systems are particularly appreciated in the field of rapid prototyping, 3D measurement, archiving, archaeology, animation and more.

	FARO Edge ScanArm with its 3D laser head	ROMER Absolute Arm with integrated scanner (Hexagon)
Company / Manufacturer	FARO Edge ScanArm with its 3D laser head	ROMER Absolute Arm with integrated scanner (Hexagon)
Range (min. –max.)	Up to 3.70 m (depending on the model)	Up to 4.50 m (depending on the model)
Accuracy (of point position)	0.025 mm	0.058–0.214 mm depending on the model
Measurement rate	560,000 pts/s (2000 pts/line)	50,000 pts/s (1000 points/line)

Figure 6.14 Handheld scanners with mechanical arm.

Company / Man-ufacturer	CREAFORM Handy-SCAN 700	ARTEC 3D Spider	POLHEMUS FastScan Cobra C1
Range	0.30 m	0.30 m	0.20 m
Accuracy (of point position)	Up to 0.030 mm	0.05 mm	0.75 mm
Measurement rate	480,000 meas-ures/s (7 laser crosses)	Up to 1,000,000 pts/s	n/a

Figure 6.15 Examples of hand scanners.

6.3.5 Miscellaneous aspects related to laser scanners

Other characteristics of laser scanners might be taken into consideration given the project requirements (its autonomy, its weight, wireless communication solutions, ease of use, etc.). Technical datasheets should be studied in detail before making a choice. However, the laser scanner is not sufficient to ensure the success of a project. Indeed, the importance of the acquisition and post-processing software supplied with the scanner should not be overlooked. If the acquisition of a point cloud by laser scanner is carried out with a very high degree of automation, it is not (yet) the case for the post-processing steps (see section 6.5). Effective and efficient processing software may be considered as an additional asset to the laser scanner.

Phase-based laser scanners operate at a very high rate and with a high degree of accuracy, but only over middle distances. They are particularly appropriate for indoor acquisitions. Pulse-based scanners, with an almost comparable accuracy, work at much longer distances but generally at a reduced measurement rate. Therefore, they are very useful for outdoor acquisitions, for covering areas of a few hundred metres (mines, quarries, buildings, etc.). Triangulation-based scanners are suitable for scanning man-sized objects. Regarding the accuracy, maximal scanning range and measurement rate characteristics mentioned above, it becomes clear that all three measurement principles are complementary.

To conclude this section, it is worthwhile to refer to other techniques used to generate point clouds, such as the interferometric laser scanner, structured light scanners [Guhring, 2001], photogrammetric multiview stereo methods, or systems without a laser transmitter, like 3D cameras [Remondino and Stoppa, 2013]. Structured light scanners use the triangulation method (see section 6.3.3) but without the use of a laser system. It is based on an active light source, which projects a pattern on the object. The distortions of the pattern give indications of the object geometry.

Time-of-flight (ToF) cameras are range-imaging camera systems that resolve distance based on the known speed of light, measuring the ToF of a light signal between the

camera and the subject for each point of the image. ToF cameras (e.g. Mesa or PMD) as well as Kinect-like sensors (Kinect, Asus, Linx Lab, etc.) are nowadays a very active common source of 3D data but their use in cultural heritage documentation is still rare.

6.4 Errors in TLS measurements

A good knowledge of sources of errors affecting the measurements of terrestrial laser scanners is needed to quantify the accuracy of the data provided by TLS. A large number of these sources are interdependent. We can, however, try to classify them into four groups [Staiger, 2005; Reshetyuk, 2009]: instrumental errors, errors related to the scanned object, environmental errors and methodological errors.

6.4.1 Instrumental errors

Instrumental errors encountered with terrestrial laser scanners are similar to those that we know from total stations, when working in reflectorless modus. These errors are generally systematic errors attributable to the design of the scanner and might affect angular and range measurements (elevation angle errors, horizontal axis errors, collimation errors, range errors, circle index errors). Hebert and Krotkov [1992] suggest distinguishing errors inherent in the physics of laser rangefinder (e.g. the laser type), which cannot be removed and those caused by the mechanical state of the scanner hardware, which can potentially be removed by calibration (e.g. axis errors, assembly errors). Whenever possible, the scanner should be calibrated regularly by the manufacturer (preferably every 1 or 2 years). Laser scanner self-calibration approaches require a specific network design. Several targets must be disposed in an appropriate geometric configuration and observed from several scanning positions [see also Reshetyuk, 2009]. Nevertheless, substantial improvements can be achieved either in the range or in the horizontal/vertical angle [García-San-Miguel and Lerma, 2013; Lerma and García-San-Miguel, 2014].

6.4.2 Errors related to the scanned object

Regarding characteristics of objects, the primary factor affecting TLS measurements is its reflectance, as the scanners perform reflectorless measurements. According to [Lichti and Harvey, 2002, Soudarissanane *et al.*, 2011; Thiel and Wehr, 2004, Boehler *et al.*, 2003], the way an object reflects the laser beam depends on following factors:

- **the colour of the surface** (relative to the surface reflectance): the ideal object is an illuminated surface (ultra bright yields ranging errors); a dark surface absorbs a large part of the transmitted signal, returning a weak intensity and producing large noise.
- **its orientation to the laser beam direction** (incidence angle): grazing angles (<60°) should be avoided.
- **the surface roughness**: its effect depends on the wavelength and the local incidence angle of the beam; a smooth and polished surface may cause specular reflectance, whereas a rough surface tends to Lambertian surface reflections. Also, retro-reflective targets like mirrors may produce artefacts.
- **the temperature of the surface**: particularly problematic in industrial environments; the radiation emitted by hot surfaces reduces the quality of the S/N ratio and therefore the accuracy of the distance measurement; the surface moisture, etc.

- **the edge effects**: the presence of edges on the object might produce artefacts. When the beam hits a corner, a part of it is reflected while the rest continues its path until it meets another obstacle. In this case, wrong points (sometimes called 'ghost' points) appear near the edges of the scanned objects.
- **the material properties of the object**: such as permittivity, permeability and surface conductivity.

6.4.3 Environmental errors

Environmental factors might affect the propagation of the signal in the atmosphere by changing the refraction index. Factors such as room temperature, pressure, relative humidity should be taken into account. The effect of these factors is not always negligible. Environmental factors also include the lighting conditions or its stability (ground vibrations). In TLS the dual-axis compensator provided by most of the scanners corrects small instabilities; however, the scanner should be installed on stable ground. When scanning a very bright lighting source (for instance, when the scanner scans in the direction of the sun), the precision of the range measurement is strongly affected and wrong points might occur in the scanner–object direction.

6.4.4 Methodological errors

Terrestrial laser scanning (TLS) measurements offer a relatively high level of automation compared to a survey performed with a total station. Once the scanner is in position and levelled, the user intervention is limited to choosing scanning settings (scanning frame, spatial sampling, according to the project specifications). Apart from the risk of over-sampling or under-sampling the point cloud, errors coming from the operator's manipulation are limited. More critical is the survey planning. Before starting the scanning, the operator should decide how to register the different point clouds (either with direct or indirect georeferencing). Specific errors must be considered depending on this choice. In the case of direct georeferencing, errors may occur in the instrument height measurement, in the coordinates determination of its centre, in the levelling of the scanner, etc. In the case of indirect georeferencing, errors occur in the target centre determination, in the control points quality, in the precision of the 3D transformations parameters between the scans, etc. [Reshetyuk, 2006]. An adequate target distribution must be achieved and every upcoming stand-point of the scanner must be anticipated, in order to optimise scanning locations.

After terrain operations, errors can arise during the georeferencing step and of course during the post-processing steps.

6.5 Processing of TLS data

Processing of point clouds means applying series of algorithms for achieving the required deliverables (aligned point clouds, cross-sections, drawings, visualisations, 3D models, etc.). First of all, the useful parts of the scanned site must be isolated or cleaned through pre-processing. Afterwards, registration and/or georeferencing follow to unify

the coordinates in a local/global cartographic framework. Next, additional processing steps such as segmentation, modelling and eventually texturing can be encountered on the way to creating 3D models.

6.5.1 Pre-processing of point clouds

The purpose of pre-processing steps is to correct and/or remove noise or unwanted points. Point cloud noise is detectable by analysing the dispersion of points around a planar and relatively bright (but not very reflective) surface. Given the 'thickness' of this layer of points, the user can decide whether it is acceptable or if a filtering process for noise reduction is required. Also, the false points produced by the scanning of edges must be excluded.

In addition to noise, the point cloud might contain unwanted points coming, for example, from obstacles located between the station and the scanned object (vehicles, trees, pedestrians). Furthermore, by scanning transparent openings such as glass doors and windows, the laser beam enters the room and generates points located indoors, i.e. beyond the surface under study (see Figure 6.16). The effect of obstacles is the most troublesome, because it causes laser shadows (holes) on the scanned object and consequently discontinuities appear. This problem can partially be circumvented by the multiplication of scan stations provided the obstacle is not leaned against the object. However, every additional scanning station leads to an increase in data.

6.5.2 Point cloud registration and/or georeferencing

It mostly happens that an object cannot be scanned from a single station, either because the scanner field of view vision is limited, or because the object is large or complex, or because obstacles prevent direct scanning. In these cases, several stations are required. As mentioned in section 6.2, every point cloud is defined in a local coordinate system. In order to produce one unified point cloud for the whole object, the point clouds acquired from several stations must be merged into a single coordinate system. This process is referred to as 'registration' (Figure 6.17).

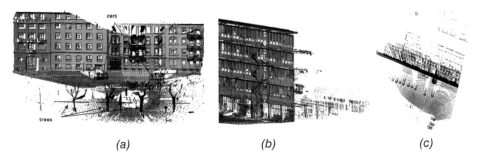

(a) (b) (c)

Figure 6.16 Examples of unwanted points: (a) trees and cars are obstacles in front of the facade ; (b) the laser beam passes through glass doors and windows and produces unwanted points inside the building; (c) top view of (b).

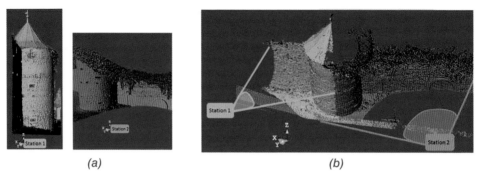

(a) (b)

Figure 6.17 Registration principle: (a) two point clouds acquired in different local coordinate systems; (b) merging of both point clouds into one coordinate system.

Georeferencing is a process aiming to transform local coordinates (scanned points from one or several stations) to a general pre-existing coordinate system (global or national coordinate system or site-specific). As soon as the scanned data must be tied to other survey data or supplement other data, georeferencing is necessary.

There are two main approaches for georeferencing a point cloud or a set of point clouds: direct georeferencing or indirect georeferencing (Figure 6.18). Registration

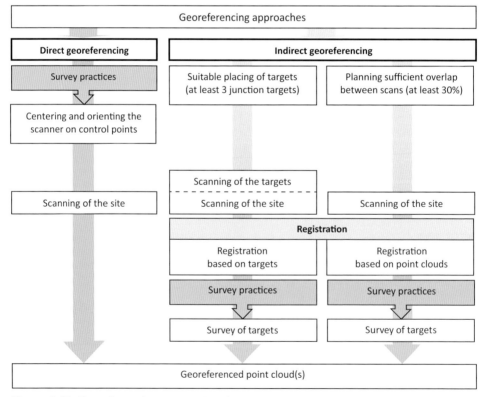

Figure 6.18 Georeferencing approaches for projects using scanning [inspired by Lerma Garcia *et al.*, 2008].

and/or georeferencing steps are the processing steps for which expertise in survey practices and technology is the most important [Jacobs, 2005]. They are crucial to ensure the success and the adequate accuracy of further steps.

Direct georeferencing

Direct georeferencing is possible when the scanner can be centred on a control point and oriented on references. In that case, the scanner is used like a total station and measures the points directly in the general coordinate system. It allows performing traverse and closure as well as free stationing, except that prism reflectors are replaced by specific targets (Figure 6.21).

As soon as the object is scanned, the corresponding point cloud is located accurately in the general coordinate system (the same as that of the control points). It is easy to check if the scanning is complete or not before leaving the site. Additional total station measurements are not required. With this approach, registration and georeferencing are achieved on-site and in real-time, with controls and reduced surveying errors.

Figure 6.19a presents an example of traverse network set up around the building to allow its scanning. Figure 6.19b shows the resulting georeferenced clouds, i.e. one colour per station of scanning.

In industrial complex facilities, it is usual to perform registration of scans first and to georeference the set of scans subsequently. This approach is called indirect georeferencing.

Indirect georeferencing

As shown in Figure 6.18, indirect georeferencing means that registration is achieved prior to georeferencing. The registration is carried out at the office, as a post-processing

(a) (b)

Figure 6.19 Direct georeferencing: (a) Traverse set up around the building; (b) Resulting georeferenced point cloud of a historical building in Strasbourg (Lycée des Pontonniers).

step. Registration can be performed based on targets or on clouds and requires the identification of at least three (more is better) 'corresponding points' between pairs of clouds. Corresponding points are in the best case targets or in the worst case characteristic points which are well defined in the point cloud. Obviously, post-processing might show that some scanned targets are not reliable. In this case, the solution of a cloud-to-cloud based registration remains, provided the overlap between the clouds is sufficient.

Registration based on targets

Registration based on targets requires that a sufficient number of targets have been distributed in the scene in order to lie in the field of view of the scan stations. The process is similar to photogrammetric acquisition protocols, since enough targets must be seen from several stations in order to be able to calculate the relative orientation of the clouds. If the positions of the targets have been determined by conventional surveying techniques, the point cloud can be georeferenced. The choice of the target positions as well as the targets distribution all around the object determines the reliability of the registration as well as its quality.

Purpose-built planar and spherical targets can be used, depending on the manufacturer (Figure 6.20). Targets are conceived with very reflective material and are generally automatically identified by the software belonging to the scanner. Figure 6.20b shows the point cloud acquired on a spherical target as well as the adjusted sphere whose centre can be estimated.

Once the centres of the targets have been identified, the 6 adjusted parameters of the 3D transformations tying the point clouds (i.e. 3 rotations and 3 translation parameters) can be calculated with respect to the least squares theory. Therefore, if in Figure 6.21 the point cloud acquired from scan station 2 (magenta) is defined as the reference, the point cloud from scan station 1 (yellow) can be aligned on station 2.

The accuracy of target centre estimation also affects the registration quality. That is why it is recommended to scan the targets with high density. After visual check and before further processing, registration errors should be studied carefully with respect to the required accuracy.

(a) (b)

Figure 6.20 Examples of target types: (a) planar targets; (b) spherical target (left) and corresponding adjusted sphere (right).

<div align="center">(a) (b) (c)</div>

Figure 6.21 Registration based on targets: (a) targets and object defined in frame (0, X_1, Y_1, Z_1); (b) targets and object defined in frame (0, X_2, Y_2, Z_2); (c) rotation and translation of (0, X_1, Y_1, Z_1) to (0, X_2, Y_2, Z_2).

Registration based on point clouds

This registration method uses only 'corresponding' points for merging point clouds in the same coordinate system; that is why it requires high overlap between the clouds. Based on these points, the adjusted parameters of the 3D transformations tying the point clouds can be calculated with respect to the least squares theory. It must be noticed that two point clouds, even with very high density, will never contain exactly the same scanned points. In this context, the terminology 'corresponding' points is preferred to 'homologous' points. Obviously, this registration solution is less accurate than the previous one.

In order to automate the process of registration based on point clouds, an ICP process (iterative closest point) is most frequently used and largely developed in the software. This method was proposed by Besl and McKay [1992]. It is an iterative method aiming to minimise the distance between a 'reference cloud', staying fixed, and an 'observed' cloud, based on 'closest points'. Figure 6.22 illustrates the ICP based on two point clouds to be merged.

Figure 6.22 Iterative alignment of an 'observed' cloud (green) with a 'reference' cloud (red), based on an ICP.

Besl and McKay [1992] proposed a minimal distance calculation to define the closest point in space (belonging to a geometrical set) from another point considered as reference. Equation (10) presents the function f to minimise.

$$f(R,T) = \frac{1}{N_p} \sum_{i=1}^{N_p} \| x_i - R \cdot p_i - T \|^2$$

(10)

With: R = rotation matrix;

T = translation vector;

N_p = number of points of the less dense cloud located in the overlap area;

x_i = a point of the 'reference' cloud;

p_i = 'corresponding' point in the cloud to align with the reference.

To solve this overdetermined system using the least squares, a linearisation of the equation is necessary. Once the transformation parameters are calculated, the cloud to align will be transformed, and moved after successive iterations as close as possible to the reference cloud, until the distances between points do not exceed a certain threshold. The main drawbacks of the method of ICP in its original form are firstly that it converges to a minimum which may be false (local minimum), especially when the data contains noise or outliers. On the other hand, a large number of iterations may be required until the minimisation function reaches a minimum. Several ICP variants have been implemented to overcome these drawbacks. But in spite of all the studies that try to automatically find the initial values of the ICP algorithm and accelerate the process, it remains a semi-automatic method. Therefore, the user has to select three corresponding points in the two clouds to be merged. With these starting points, it is possible to calculate an initial rigid transformation and then start the iterations.

Another well-known method is called DARCES (data-aligned rigidity-constrained exhaustive search) which was proposed by Chen *et al.* [1999]. This method takes advantage of the RANSAC algorithm to search the corresponding points in the two clouds. The method is based on the assumption that there are always triplets of 'corresponding' points in the two clouds. But this is not always the case, especially for clouds with different densities. This is why it is often necessary to set a large membership tolerance, which can lead to inaccurate results.

Registration can also be performed based on previously detected geometric entities like spheres, cylinders and planes. Instead of looking for the minimum distance between sets of points, this method tries to minimise the distance between geometric entities in an iterative way, as achieved by the ICP algorithm. This method is interesting when geometric entities composing the cloud can be detected automatically before alignment. However, visual check remains essential.

When pairwise registration is achieved sequentially with the objective to align multiple views, errors accumulate through error propagation and the global registration might be far from optimal. It is recommended to register simultaneously all the clouds or to proceed to direct georeferencing, which compensates for the errors.

6.5.3 Segmentation

Segmentation of point clouds consists of subdividing all 3D points into subsets, also called 'segments', according to predefined criteria. In general, the points are assigned to segments if they satisfy the same mathematical conditions.

Many techniques have been developed for segmenting point clouds derived from ALS or TLS data. Some of them are based on the principle of region growing and clustering, others on the automatic detection of geometric entities. For example, the points that describe a planar cluster satisfy the mathematical condition to respect the same plane equation, given a predefined tolerance. Figure 6.23 presents the segmentation of a point cloud acquired on several facades into planar segments using the RANSAC (random sample consensus) algorithm [Fischler and Bolles, 1981].

The RANSAC paradigm [Fischler and Bolles, 1981] and the Hough transform [Hough, 1962] deserve mention. Both techniques have proven their robustness for automatic detection of geometric primitives, even in the presence of outliers. [Tarsha-Kurdi *et al.*, 2007] conducted a comparative study of both algorithms for automatic roof planes extraction from ALS data. Results showed that RANSAC is more suitable in terms of processing time and insensitivity to noise.

6.5.4 Modelling

Sometimes the point cloud itself is sufficiently deliverable, since measurements or 2D drawings can be deduced from it. Point cloud viewers or measurement interfaces are

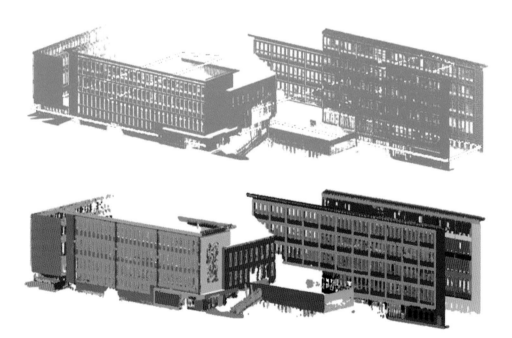

Figure 6.23 Automatic segmentation of a point cloud (above) into planar segments (below) [Boulaassal *et al.*, 2011].

developed in this direction. If a 3D model is required over a site or objects, an appropriate 3D modelling pipeline must be considered. Through 3D modelling, the point cloud is transformed into a surface by connecting the points together. Depending on the destination of the final product, the model must feature some characteristics of the real object. A distinction between 'as-reconstructed', 'as-built' and 'as-conceived' models follows.

- Often used in the archeological domain, 'as-reconstructed' models are produced for the representation of archaeological remains (fragmentary statements). A model produced from surveys alone may not be enough, so the measures are supplemented by the expertise of specialists such as archaeologists and architects. Familiarity with these models is essential to achieve a fully reconstructed object, as it was supposed at the beginning.
- 'As-built' models represent the object as it looks like at the time of acquisition. Only the acquired data are used for its generation. As-built models are replicas of the reality and are faithful to the observed object.
- 'As-conceived' models are CAD-models produced based on conception plans in addition to a few measurements made on it, but without integrating the defects or degradation of the object, like the erosion on stones or minor alterations. The aim of these models is to represent the object in its ideal state, as it was just after its construction.

Modelling methods commonly used and widely integrated in point cloud processing software are meshing methods, geometric primitives modelling methods and a mix of both.

Modelling based on mesh creation

A mesh model makes sense whether the captured objects are complex or cannot be easily adjusted by geometrical primitives. Algorithms developed for mesh creation are based generally on either triangulation algorithms or on the finite element method [George and Borouchaki, 1997]. Facets are constructed between the points of the cloud by Delaunay triangulation (Figure 6.24a). Then, a texture, like a photograph or simply a colour can be rendered to every facet (Figure 6.24b), providing in this way a surface model.

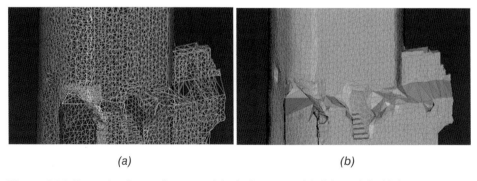

(a) (b)

Figure 6.24 Example of a castle tower: (a) wireframe model; (b) model with homogeneous colour.

The main asset of mesh methods is that they lead to models whose geometry is very faithful to reality, outlining the object with its actual shape. The resulting mesh model belongs to the 'as-built' category (Figure 6.25).

The disadvantage of this method is the big size of the produced files. Indeed, generally the mesh is not optimised, i.e. even on surfaces with simple geometry (such as planes), the facet's density might be similar to the facet's density covering complex surfaces. It is possible to optimise the cloud or the mesh, but this implies subsequent pre- or post-processing steps. For these reasons, when the object and the project specifications allow it, it is wise to achieve modelling based on geometric primitives.

Modelling based on geometric primitives

Modelling based on geometric primitives makes sense when working on objects whose geometry can easily be described from a mathematical point of view. It consists in adjusting the point cloud covering the object with multiple geometric primitives such as planes, cylinders, spheres and torus, or by extrusion of 2D polylines along a path. The models resulting from this method are 'as-conceived' because they represent the state of the object as it was originally, without any deformation or damage related to time.

Figure 6.25 illustrates the result of a modelling based on geometric primitives, applied on the window of a cathedral.

This method allows users to replace the point clouds or parts of them by simple geometric primitives described by a few parameters. Therefore, it generates much smaller files than the previous method. The models are appropriate for viewing and navigation.

In contrast to the mesh model, a model based on geometric primitives is more sober aesthetically. It represents the object in a perfect geometric form, but it requires a certain level of simplification and abstraction (Figure 6.25).

According to the project specifications and the suitable level of detail, it is interesting to combine both modelling principles. The resulting model (also called the 'hybrid model') is therefore composed of a set of geometric primitives (on parts of simple or well-preserved geometry) and on meshes (Figure 6.26). An appropriate balance between the level of detail and a manageable data set must be found [see Landes *et al.*, 2015].

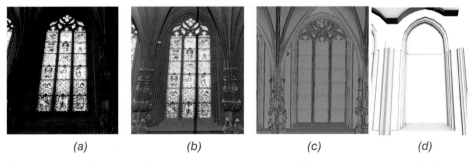

| (a) | (b) | (c) | (d) |

Figure 6.25 (a) Photograph; (b) colourised point cloud; (c) surface mesh model; (d) geometric primitives model of a cathedral window. [Courtesy INSA Strasbourg.]

Figure 6.26 Hybrid model obtained by combination of geometric primitives and meshes for a part of the Strasbourg's Cathedral [from Landes *et al.*, 2015].

6.5.5 Model texturing

Once the 3D model is achieved, different textures can be projected on the facets or geometric entities composing it. The rendering can be carried out based on artificial colours, image textures selected from a library or real textures. Real textures can be obtained from images acquired in parallel to the point clouds (with the built-in camera) or better with independent photographic campaigns. This kind of texturing is generally preferred to any other textures because it allows the production of realistic models, also called 'photo-realistic' models (Figure 6.27). However, pre-processing of the images is necessary before projecting them onto the model facets.

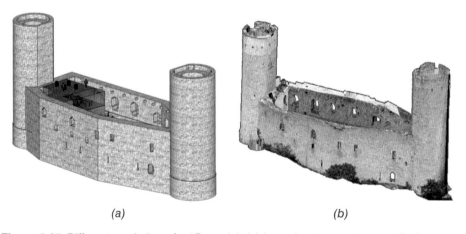

(a) *(b)*

Figure 6.27 Different rendering of a 3D model: (a) 'stone' pattern texture applied on geometric primitives; (b) real texture applied on a mesh to deliver a photo-realistic 3D model [Landes *et al.*, 2007].

6.6 ALS data processing

The production of a DTM using the technology of ALS is a complex process, which involves several assumptions and decisions throughout the workflow of project preparation, data acquisition, georeferencing, echo detection, classification, DTM modelling and subsequent visualisation. Therefore, the resulting DTM and its applicability for a certain archaeological purpose will depend largely on the original intention of the ALS data acquisition campaign. This is reflected in the meta-information, which becomes an important aid to understanding the archaeological potential and limitation of the DTM.

There are a number of well-written texts detailing the principles of ALS and its use in archaeology [Crutchley, 2010; Fernandez-Diaz *et al.*, 2014; Opitz, 2013]. The purpose of this part of the chapter[1] is to help the reader understand the most important metadata and to assess their implication for archaeology and cultural heritage management.

6.6.1 Data acquisition

The process of data acquisition has the most crucial effect on any resulting data set. At least some key parameters of the metadata will help to evaluate whether a general purpose data set may be suitable for archaeological purposes. Type of scanner, date (i.e. season) of data acquisition, and point density are among the most important factors.

6.6.2 Type of scanning system, footprint size and echo detection

There are several different types of scanning systems [Crutchley, 2010; Fernandez-Diaz *et al.*, 2014; Opitz, 2013], which differ in terms of optical scanners (e.g. oscillating mirror, rotating polygon, fiber optic or Palmer scanner), laser beam divergence (which has an effect on the size of the footprint), pulse repetition frequency, wavelength (typically at 532, 1064 and 1550 nm), and method of echo detection.

The effects of the optical scanner type seem to be – archaeologically speaking – of minor importance. In terms of echo detection, at the time of writing [2014], there are two different types of sensor systems available: (1) discrete echo scanners using analogue detectors to record multiple echoes in real time and (2) full-waveform (FWF) recording systems digitising the entire analogue echo waveform for each emitted laser beam (typically with an interval of 1 ns). While discrete echo scanners have been successfully used in most of the current archaeological applications [see e.g. papers in Opitz and Cowley, 2013], we are convinced that FWF–ALS systems will show considerable advantages for the generation of DTMs in vegetated areas for the following reasons.

The digital data stream of a FWF system has to be post-processed [Wagner *et al.*, 2004, 105], but this can be seen as an advantage as you are not restricted to a group of discrete echoes controlled by an analogue detector but can choose your own algorithms that are best suited for the individual application. When, for example, the full waveform is modelled as a series of Gaussian distribution functions [Hug *et al.*, 2004;

[1] This part of the chapter is based on Doneus and Briese, 2011.

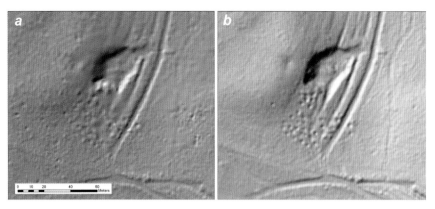

Figure 6.28 (a) Shading of a DTM derived from a discrete echo ALS (b) The same area scanned using a FWF-ALS with similar point density: the low and dense vegetation could be removed; the small pits are now clearly visible. They have been verified on the ground. Both data sets were captured with similar point density at the same season (however, in different years).

Wagner *et al.*, 2006], it allows further physical observations (intensity and echo-width) of the reflecting surface elements to be gained. As those observations can be used for subsequent object classification, it was, for example, possible to distinguish piles of brushwood and branches from solid ground [Doneus and Briese, 2006a]. As a result, in comparison with the discrete echo ALS data, a more reliable classification of the laser points and a higher accuracy of the terrain points can be expected (Figure 6.28).

Also, the repetition rate, i.e. the interval between two consecutive echoes, which the analogue detectors of discrete echo systems can discern, typically equals a height difference of a few decimetres [Kraus, 2004]. This is good enough to clearly distinguish trees from the terrain surface, but will not allow discrimination of low-level vegetation from the ground.

Archaeologically speaking, the DTM derived from a discrete echo scan may show considerable problems in areas with low and dense vegetation, as can be seen in Figure 6.28. While Figure 6.28a shows a scene scanned using a discrete echo system, Figure 6.28b depicts the same area as scanned using FWF-ALS. Both scans have a comparable original point density (4 points per m^2). As can be demonstrated, the quality of the discrete echo derived DTM is highly reduced in the area of low and dense vegetation – only a few of the pits can be discerned and the remaining terrain point density is quite low. A recent investigation in a Mesoamerican jungle environment revealed that the above-mentioned limitations of discrete echo systems can also produce data artefacts that resemble archaeological features [Fernandez-Diaz *et al.*, 2014].

6.6.3 Date of data acquisition

There is still a lack of research on limitations due to the type of tree cover and the seemingly short time-frame available for scanning wooded areas. The best time for data collection is the dormant period, when deciduous trees and most of the understory have

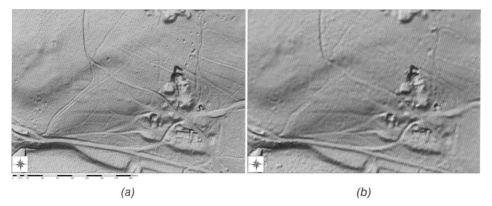

<div style="text-align:center">(a)</div>
<div style="text-align:center">(b)</div>

Figure 6.29 (a) Shading of a DTM derived from a laser scan beginning of April; (b) the same scene as scanned end of May.

lost their leaves. Freshly fallen leaves at the beginning of the period (which in Central Europe can be between October and November) might fill up the shallow depressions archaeologists are interested in. Only when the leaves have subsided after some rainfall or snow will micro-topographic features become visible again. There should be no 'wet' surfaces, because they will reflect the laser pulses poorly toward the sensor.

As soon as deciduous trees become foliated again, the number of laser pulses hitting the ground will be reduced. Figure 6.29 displays the resulting DTMs from two data acquisition campaigns: beginning of April and end of May. The reduced ground point density due to the increased foliage means that almost all smaller features have become invisible (especially the round sunken features, which are interpreted as the remains of former lime kilns). Most of the linear features are still visible but have become blurred due to the reduced resolution of the derived DTM.

6.6.4 Point density

The point density is a function that mainly relies on the pulse repetition frequency (typically between 30,000 and 200,000 per second), field of view, flying height above the terrain, overlap between two neighbouring scan stripes and speed of the aircraft. In a forest, only part of the laser pulses will pass through to the ground surface. To get a high density of ground points, a slow moving platform with a high pulse rate has to be used. Using a wide scan angle and a large overlap (e.g. more than 50%) can increase the number of points per square metre.

Although it is often argued that scanning a forest demands a narrow opening angle of the scanner to receive only nadir or near-nadir returns, using the maximum scan angle (up to 45–60 degrees) with a large overlap (e.g. 50%) seems to be advantageous. Furthermore, the large overlapping area of two neighbouring strips will be an advantage during the process of strip-adjustment for advanced geo-referencing. With a large overlap it will also be certain that every object on the ground would be hit at least twice from two view points, and that there is a good chance that some of the oblique laser

pulses will hit the ground below conifers where the almost vertical laser pulses of a system operating with a narrow scan angle might not get through. Also in steep terrain, a wide scan angle will result in a higher number of points hitting the slopes almost perpendicularly. A possible drawback of a wide opening angle with a large overlapping area is an increasing number of echoes which are not returning from the terrain surface. Especially near the borders of the scanning strip, a high number of last echoes will be returned from tree trunks and consequently have to be filtered out later on.

Other effects and dependencies between these parameters have been investigated recently in more detail by Fernandez-Diaz *et al.* [2014].

6.6.5 Georeferencing

Georeferencing of the airborne lidar data is usually done by the data providers, where a calibration over asphalt or flat horizontal areas with sparse, very low vegetation is usually performed [Pfeifer *et al.*, 2004]. The georeferencing process still leaves inaccuracies in the resulting point cloud [Kager, 2004]. These inaccuracies lead to problems within the overlapping area of strips, where the coordinates of a single object point, which was scanned at least twice, will deviate from each other horizontally and vertically. This results in multiple objects, noisy data and formation of non-existing structures (sinusoidal curves, but also edges). During the process of archaeological interpretation these can be considerably irritating. This is demonstrated by an example from the Iron age hillfort in Schwarzenbach (Figure 6.30). In the displayed area a large number of roundish depressions can be observed which resemble archaeological features such as lime kilns. These features are, however, non-existent. They are errors resulting from inadequate georeferencing.

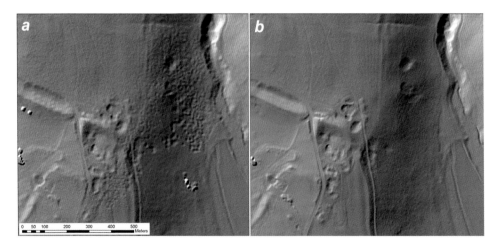

Figure 6.30 Schwarzenbach, Iron age hillfort: (a) Roundish depressions are introduced to the DTM shading due to a missing strip-adjustment (errors in the georeferencing); (b) the same area after a simultaneous 3D strip adjustment.

These inaccuracies can be improved by doing a simultaneous 3D strip adjustment [Kager, 2004]. For this, tying features between the overlapping stripes are used analogously to tie points in aerotriangulation. As tying features, homologous planes and straight lines with low noise from covering vegetation are used (e.g. roofs, meadows, roads). In the example from Figure 6.30a, the errors visible in the area with strip overlap could be reduced by strip adjustment, resulting in a significantly improved DTM (Figure 6.30b).

6.6.6 Choice of filtering software and parameters

Since the archaeological interpretation of an ALS campaign is typically based on the derived DTM, it is critical that all off-terrain points are removed from the dataset used for DTM generation. Therefore, the last echo data has to be classified (typically the term filtering is used) into terrain and off-terrain points (as often the laser pulse will not be able to reach the ground surface and the last echo will therefore be returning from cars, tree-trunks, dense vegetation and the like). At this point it has to be mentioned that archaeologists usually are not interested in a 'pure' DTM as they need to interpret all cultural remains. This also involves remains of buildings, like ruined castles or individual walls, which typically are not part of a DTM. Therefore, instead of DTM, one should maybe define the desired result as an archaeological digital terrain model (aDTM).

There are a large number of filtering techniques available. Each of them was produced for a special purpose and each works best in specific environments. Depending on the methods and settings used, whole buildings can be deleted from the data, or small-scaled features, like round barrows and lime-kilns, flattened and removed. This is demonstrated in Figure 6.31, where a general purpose DTM is compared with an aDTM derived from ALS data scanned and filtered for archaeological purposes. Both were filtered using the same software [SCOP++, see Kraus and Pfeifer, 1998; Kraus and Otepka, 2005] with different settings. The result clearly demonstrates that the process of filtering is of crucial importance for the archaeological interpretability of a DTM.

6.6.7 Visualisation

When working with general purpose data archaeologists often are not provided with the resulting DTM but with a standard hillshade (i.e. light source is in the northwest) of the desired area. The advantage of a hillshade visualisation is that it is easy to comprehend and understand. However, if one tries to interpret a single shaded image, one will certainly miss linear features which run parallel to the rays of the light source.

So, while it is easily perceived and 'read', its major drawback lies in the fact that it has reduced information content [Doneus and Briese, 2006b; Devereux *et al.*, 2008]. As a consequence, the number of publications dealing with the problem of displaying and interpreting archaeological ALS data is constantly growing. Published techniques include dense contour mapping [Bewley *et al.*, 2005], a simple combination of slope and hillshade [Doneus and Briese, 2011, 66–67], geostatistical filtering [Humme *et al.*, 2006], local relief model [LRM, Hesse, 2010], principal component analysis (PCA)

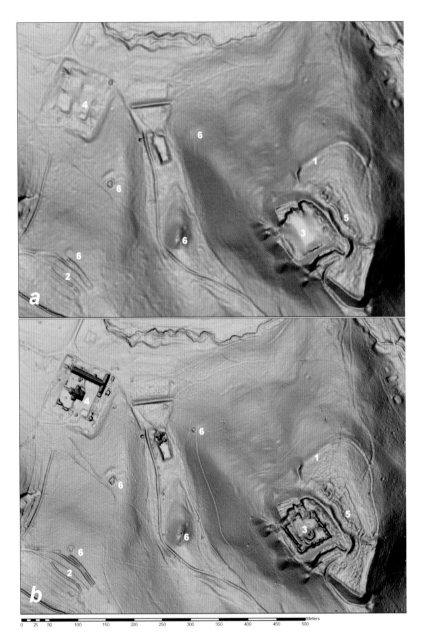

Figure 6.31 St. Anna in der Wüste: (a) General purpose data filtered for the purpose of topography using a parameter setting which removes building structures and to a certain degree flattens micro-topographic structures. While the result does show important archaeological information, such as the rampart of a prehistoric hillfort (1) or hollow ways (2), the building structures of the ruined castle of Scharfeneck (3) and a monastery (4) have been completely removed due to the filtering parameters. Finer archaeological detail, such as pit-structures surrounding the castle (5) and three out of four hermit's cells (6) can hardly be recognised; (b) the same area can, however, reveal more information when the original ALS point cloud is filtered in an archaeologically adapted way or special purpose ALS data is used.

based on several shaded reliefs with varying illumination angles [Devereux *et al.*, 2008], and sky-view factor [SVF, Zakšek *et al.*, 2011]. A recent article has examined the use of positive and negative openness to visualise digital terrain models for interpretative mapping of topographic archaeological features. The technique helps to distinguish the highest as well as the lowest areas of features such as banks, ditches and barrows and therefore helps with accurate interpretative mapping [Doneus, 2013]. A combination of these techniques is the only way to obtain a maximum amount of information on potential archaeological sites in relief [Bennett *et al.*, 2012].

6.7 TLS and ALS cultural heritage applications

For a long time, laser scanning was the main solution to produce dense 3D point-cloud data allowing high-resolution geometric models, while photogrammetry was more suited to produce high resolution 3D textured models representing just the main structure. Today, both photogrammetry and laser scanning can produce dense and accurate point clouds. Methodologies based on multi-image matching techniques are reported in Chapter 5. The laser scanning process follows a pipeline where all the steps are by no means automated (only the scanner can be considered as robotic application controlled by the scanner software):

- survey planning;
- field operation;
- data preparation;
- data registration;
- data processing;
- quality control and delivery.

The main data processing steps from TLS and ALS point clouds were discussed in the two previous sections. More examples from the authors' projects are below. The reader is also invited to downloaded project-papers from CIPA Symposia [http://cipa. icomos.org] and from the ISPRS Commission V/II workshops which aims to promote the integration of measurement techniques supporting metric and remote sensing survey, monitoring and the presentational requirements of archaeological, architectural, conservation, restoration and archiving communities [http://www2.isprs.org/commissions/comm5.html]. Other guidelines for the practice of terrestrial laser scanning are given in Lerma *et al.* [2008] and English Heritage [2011].

6.7.1 Applications of TLS in architecture

3D documentation of the Palace of Justice in Valencia, Spain

TLS is one of the most suitable techniques to record in 3D complex and large architectural objects such as castles, churches, palaces and streetscapes. The deliverables from the survey are not only 3D point clouds and 3D models but also traditional line drawings, cross-sections, orthoplans (draping textures onto orthogonal views) and more complex outputs such as lack of planarity plans.

(a) *(b)*

Figure 6.32 Palacio de Justicia: (a) northwest view; (b) north view of the central part [Courtesy of José Luis Lerma].

The monument selected for this project was the Palace of Justice (courthouse) in Valencia (Figure 6.32a). It follows a Classic Valencian Baroque style from the late 18th century. The rectangular building presents four brickwork stories, Doric dressed stone pilasters and balconies with rectilinear and curved pediments. On the upper side of the central stone gateway (Figure 6.32b) there is a slightly convex frontal with a coat of arms, and on top a statue of Charles III accompanied by two matron statues representing justice and prudence.

The aim of the TLS of the Palace of Justice in 2013 was to determine and test the performance of a state-of-the-art scanner for architectural surveying of a whole palace in an urban environment at high accuracy, medium-high resolution and medium distance. The main façade of the building will be considered herein.

The 3D laser scanning system Leica ScanStation C10 was used for this survey. The topographic system features a panoramic field of view of 360° (horizontal) × 270° (vertical). The distance measurement is based on the ToF principle measuring up to 50,000 points per second. A positional accuracy of 6 mm is declared for single measurements up to 50 m range. The reported precision for paddle planar targets can be improved up to 2 mm (standard deviation) based on mathematical fitting. Similarly, a modelled surface precision of 2 mm can be achieved subject to appropriate modelling methodology. Duca *et al.* [2011] report different issues while modelling sculptures photo-realistically due to the specified settings for the output mesh considering identical input laser scanner data sets.

Although the selected laser scanner integrates a 4 megapixel digital camera for colour mapping of point clouds, external high resolution digital images were acquired with a wide-angle (24 mm) calibrated Canon 1Ds Mark III (5616 × 3744 pixels). Images were used for both the final ortho-image mosaic and the photo-realistic 3D modelling.

Four point clouds were acquired at two resolutions in order to minimise occlusions: high resolution (2 mm at 10 m) for the two central scans; and medium resolution (5 mm at 10 m) for the lateral sides. A total number of 20.2 million points were acquired from the four scans. Three non-aligned paddle targets were also measured to perform the indirect target-to-target registration with 3DVEM – Register software, achieving positional estimates of 2 mm for the three axes. A visualisation of the registered point clouds is presented in Figure 6.33.

After registration, extensive point cloud cleaning followed to remove non-building features such as lamp posts, pedestrians, cars, trees and flags [Asensio Ors, 2013]. 3DReshaper software was selected for processing. Furthermore, additional filtering followed to remove instrumental gross errors and, last but not least, mixed edge effects [Lerma *et al.*, 2008], namely on the salient features of the façade.

Modelling requires additional processing, not only handling with appropriate mesh settings but creation of auxiliary meshes for different surfaces (namely flat, non-flat and 3D), filtering of additional points, smoothing, hole filling, extrusion and fusion of the variety of meshes that conform the final model. A detail of the fused model is presented in Figure 6.34a. The final model had an average point spacing of 1 cm with more than 15 million triangles for the whole façade, excluding openings such as windows and doors.

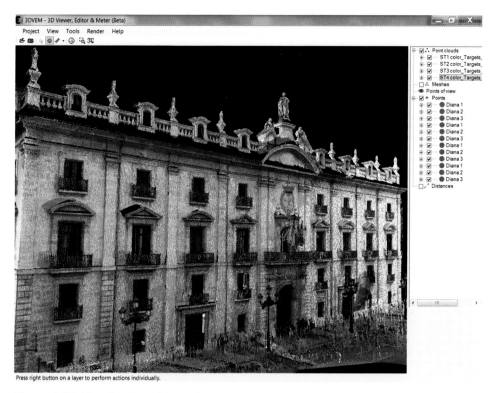

Figure 6.33 Visualisation of the unfiltered 3D point clouds after registration.

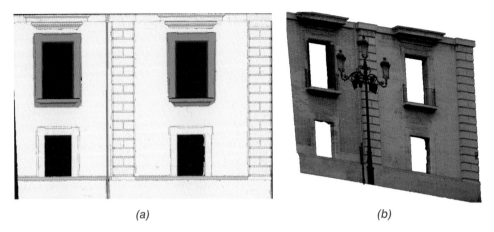

(a) *(b)*

Figure 6.34 (a) Detail of a fused 3D model of the façade. (b) Partial view of the textured 3D model [From Asensio Orts, 2013].

 Accurate texture draping follows after the final model is fulfilled to enrich the model appearance. For this purpose, it is necessary to know accurately both the interior and the exterior orientation parameters of the digital camera. Figure 6.34b displays a detail of the façade after texturing one image onto the 3D model. As many images are required to cover the final model, additional image balance is required to create a continuous (seamless) mosaic, mainly in orthogonal projection. Figure 6.35 presents the final metric ortho-rectified image mosaic of the main façade with overlaid line drawings of the architectural features. Additionally, the main linear notes added to the final survey. Worth noticing is the partial inclusion of colourful point clouds to avoid missing information beyond the 3D models, for instance, adornments above the cornice, and doors and windows of the balconies.

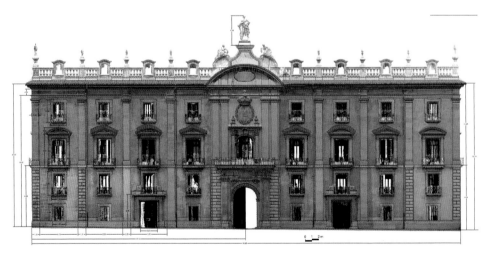

Figure 6.35 Ortho-rectified image mosaic with line drawings and metric notes [From Asensio Orts, 2013].

The work was carried out by Carlos Asensio Orts under the Final Project supervision of José Luis Lerma at the Higher Technical School of Geodesy, Cartography and Surveying, Universitat Politècnica de València. The authors acknowledge the final notes provided by Prof. Juan B. Aznar, and the support form Leica Geosystems (Valencia).

From TLS data to automated building modelling

Today, elevations or sectional views of buildings are often produced from TLS. However, due to the amount of data to process and because 2D maps are usually required by customers, the 3D point cloud is often degraded into 2D slices. In a sectional view, not only the portions of the object which are intersected by the cutting plane but also edges and contours of other parts of the object which are visible behind the cutting plane are represented. To avoid the tedious manual drawing, a semi-automatic approach for creating sectional views by point cloud processing has been proposed in Landes *et al.* [2014], applied to the Abbey-church of Ottmarsheim, France (Figure 6.36). The extraction of sectional views requires as a first step the segmentation of the point cloud into planar and non-planar entities (Figure 6.36d). Since arches, vaults and columns can be found in cultural heritage buildings, the position and direction of the sectional view must be taken into account before contour extraction. Indeed, the edges of surfaces of revolution depend on the chosen view. The developed extraction approach is based on point clouds acquired inside and outside buildings. The resulting sectional view (Figure 6.36f) has been evaluated in a qualitative and quantitative way by comparing it with a reference sectional view made by hand. A mean deviation of 3 cm between both sections proves that the proposed approach is promising. Regarding the processing time, despite a few manual corrections, it has saved 40% of the time required for manual drawing.

The following step is to develop algorithms to automate the segmentation in geometric primitives and the boundaries extraction of point clouds in order to create 3D models, as proposed in Macher *et al.* [2014]. The proposed approach consists of the development of two successive algorithms. First, the segmentation of the point cloud in geometric primitives is made based on the RANSAC paradigm. Then, in a modelling step, the geometric primitives are used for either surface modelling or boundaries extraction and more particularly sectional view extraction.

6.7.2 Applications of TLS in archaeology

Recording heritage sites using TLS

As stated above, both photogrammetry and laser scanning can produce dense and accurate point clouds. As an example of merging TLS and image-based point clouds, we consider the site of Mandeure (France) [Grussenmeyer *et al.*, 2011]. The theatre in this city from the Roman era (Epomanduodurum) was built after the 1st century AD with a diameter of 142 m and a seat capacity estimated between 15,000 and 18,000. These characteristics make this theatre the second largest in Gaule. Excavations have been carried out for about ten years. Figure 6.37a shows an aerial image of the site.

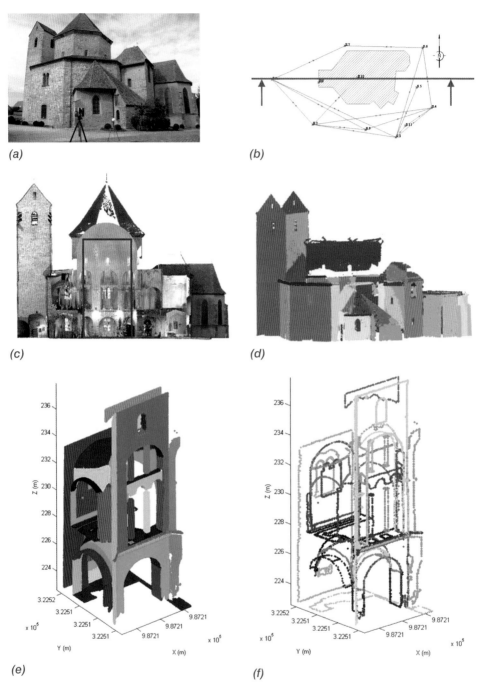

Figure 6.36 (a) Abbey-church of Ottmarsheim (France). (b) Topographical network (in green) and axis of the sectional view to create. (c) Point cloud of the expected sectional view (along west/east axis, seen from the south). (d) Segmentation results obtained for the point cloud of the exterior of the church (one colour per entity). (e) Segmentation results obtained for the interior of the church; (i) automatically; (ii) manually. (f) Contour points extraction based on the segments of (e) [Landes *et al.*, 2014] [Courtesy INSA Strasbourg].

The main objective of the recording project consists of the realisation of a digital terrain model and built elements of the theatre in its current state. Because of the size of the site and the resources available we opted for a combination of photogrammetric methods and TLS. The hybrid model (Figure 6.37b) is thus obtained from the fusion of different georeferenced data based on TLS and photogrammetry dense matching. The final point cloud obtained by merging several georeferenced point clouds was used as a reference frame by the architect to simulate the reconstruction of the Antique theatre (Figure 6.37c).

Point clouds are used more and more as input data for simulations. Figure 6.38 show the results of the 3D model of the Abbey-church of Ottmarsheim [Landes *et al.*, 2014] and a simplified CAD model processed from the meshed data. The point cloud combined with historical data was also used by the architect to simulate different reconstructions (Figure 6.39).

Recording caves by TLS

TLS of caves: Remigia Cave, Spain

The aim of the Remigia Cave (Cova Remígia, Ares del Maestre, Castellón) project was to deliver both high resolution and high accuracy photorealistic 3D models of

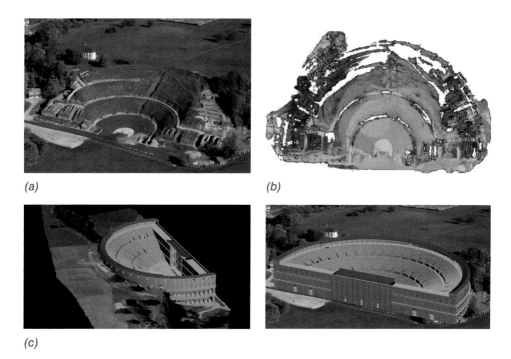

(a)

(b)

(c)

Figure 6.37 (a) Oblique photo from the Gallo-Roman Theatre of Mandeure (France). (b) Point clouds (in red) based on image-based techniques are merged with TLS data (green-blue). (c) Gallo-roman Theatre of Mandeure (France): simulation of the reconstructed Antique 3D model merged with the digital terrain model processed from the point clouds [Courtesy INSA Strasbourg].

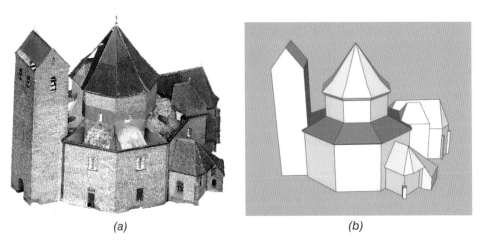

(a) *(b)*

Figure 6.38 (a) Colourised point cloud of Ottmarsheim's abbey-church (France). (b) Current simplified 3D model of the monument [Courtesy INSA Strasbourg].

the six cavities with outstanding paintings. The Remigia Cave at the Cingle de la Mola Remígia, La Gasulla ravine (Castellón) is part of the late prehistoric Rock Art of the Mediterranean Basin on the Iberian Peninsula [UNESCO, 1998]. TLS and close-range photogrammetry were successfully integrated to deliver the final 3D model overlying the rock art paintings. The collected data provide a solid database for any further recording, analysis, monitoring and research related to archaeological conservation and dissemination of this World Heritage Site.

A medium-range laser scanner Leica ScanStation 2 and a calibrated Canon EOS 1Ds Mark III digital camera were selected for this project. The former was used to acquire dense point clouds of the whole cave while the latter delivered colour images from which high resolution and high accuracy point clouds were achieved on relevant areas (patches) with paintings. Additionally, the colour images were used for texturing the final 3D models. Lerma *et al.* [2010] detail the process to integrate external imagery onto laser scanning 3D models.

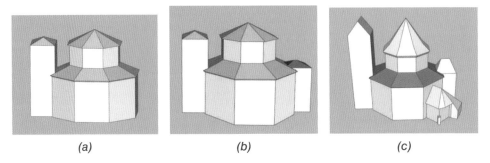

(a) *(b)* *(c)*

Figure 6.39 CAD models processed from TLS data: (a) the state of the abbey-church in 1050; (b) addition of a chapel around 1055; (c) abbey in the middle of the 15th century [Courtesy INSA Strasbourg].

The four acquired point clouds (summing up to 4.6 million points) were processed with 3DReshaper software, except for indirect registration and texturing. For the registration, four high definition surveying (HDS) targets well-distributed across the archaeological sites were measured from the four scans. Figure 6.40 displays the registered point clouds with the distribution of scan positions. The model produced had an average point spacing of 5 mm with more than 3,800,000 triangles (Figure 6.41).

FOTOGiFLE software (developed by the Photogrammetry and Laser Scanning Research Group GIFLE, at the Universitat Politècnica de València) was used to determine the camera spatial positions and orientations in the coordinate system of the geometric model. Texture draping followed in order to generate photo-realistic models of the complex scene. Figure 6.42 shows the photorealistic 3D model of Cave Shelter IV (Remigia). It is worth noticing the need to undertake extensive visibility analysis in order to drape the best patch from the set of oriented imagery.

The photo-realistic 3D models of the cave (Figure 6.42) demonstrate the effective integration of laser scanning and close-range photogrammetry to deliver high-accuracy and high-resolution replicas of any complex scene. Furthermore, this 3D information can be enhanced with 2D tracings or drawings provided by rock art professionals and archaeologists in order to create a unique 3D record of the site that integrates all sources of graphical data. Particularly interesting is the presentation of single motifs onto the 3D model with and without non-relevant image content (Figure 6.43) to enhance both reading and understanding of prehistoric rock art [Domingo *et al.*, 2013].

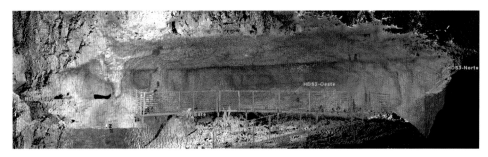

Figure 6.40 Registered point clouds displaying the 4 HDS targets used at Remigia Cave [Courtesy of GIFLE].

Figure 6.41 Remigia Cave: perspective view of the final 3D model [Courtesy of GIFLE].

Figure 6.42 Remigia Cave: Shelter IV photorealistic 3D model achieved with FOTOGiFLE [Courtesy of GIFLE].

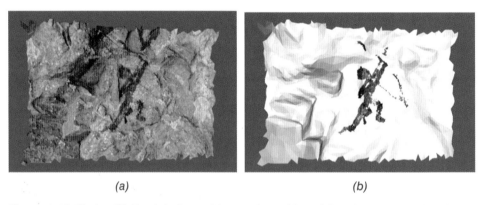

(a) (b)

Figure 6.43 Shelter IV, Remigia Cave: (a) superimposition of the pigment onto the photo-realistic 3D model; (b) pigment provided by Esther López-Montalvo and the 3D model [Courtesy of GIFLE].

This work was carried out by José Luis Lerma and Miriam Cabrelles [Lerma García and Cabrelles López, 2011] from GIFLE at the Universitat Politècnica de València, as part of the research project PROMETEOII/2013/016 (Generalitat Valenciana).

Multi-scale scanning of the archaeological cave 'Les Fraux' in Dordogne (France)

In this second example dedicated to cave documentation, we present the Bronze Age cave 'Les Fraux', discovered in 1989, made of a complex underground network of narrow horizontal galleries of more than 1 km long. Humans occupied this underground

paleo-ecosystem during the Bronze Age (end of Middle Bronze Age to Late Bronze Age: 1450–1150 BC).

An interdisciplinary team of archaeologists, surveyors, environmentalists and archaeometrists have jointly carried out the study of the Bronze Age 'Les Fraux' (Saint-Martin-de-Fressengeas, Dordogne, France) since 2007. This archaeological decorated cave, registered as a French Historical Monument, forms a wide network of galleries, characterised by the exceptional richness of its archaeological remains such as ceramic and metal deposits, parietal representation and domestic fireplaces. Accurate 3D models of the cave constitute the common framework for the different partners. An overview of methods of data recording are based on contact-free measurement techniques in order to acquire a full 3D-documentation of the site [Grussenmeyer *et al.*, 2012]. Different techniques based on TLS, digital photogrammetry and spatial imaging total stations were used in order to generate geometric and photorealistic 3D models from the combination of point clouds and photogrammetric images. Various scales were considered for right acquisition and diverse resolutions were applied according to the subject (e.g. global volume of the cave, parietal representations and deposits). Measurements from an original method of 3D indoor magnetic field recording were combined with the 3D models in order to locate magnetic anomalies in the cave [Burens *et al.*, 2014]. All the surveys were conducted in compliance with the integrity of the site.

Various documentation techniques have been used since 2008 (Figure 6.44):

- A network of accurate geodetic reference points, defined by Global Navigation Satellite System (Figure 6.44a), was first of all set up on the terrain above the cave and linked to the entrance of the cave by traverse measured by total station (Figures 6.45c, 6.45d). The documentation of the cave and its surroundings was therefore linked to the National Reference Coordinate System;
- The terrain surface was recorded by TLS (Figure 6.44b) and a DTM processed to visualise the cave and the ground surface (Figure 6.44b);
- 600 m of the underground network were recorded by TLS between 2008 and 2014 (Figure 6.44c);
- Dense point clouds based on image-based techniques were processed to document several clay-wall panels;
- In some sectors of the cave, SLR cameras mounted on panoramic photography heads were use to to display parietal art features in high-resolution panoramas;
- A few deposits (Figure 6.44g) were recorded in situ by TLS;
- Clay walls with fingetings were recorded with a Faro ScanArm (section 3.4) to reach sub-millimetre accurate point clouds (Figure 6.45).

As the huge amount of data is not directly usable by the archaeologists, the final models were resampled at a spatial resolution of 1 pt/cm, and finally exported in the PDF-3D format. Thus, the user is able to handle the 3D model in the Acrobat Reader

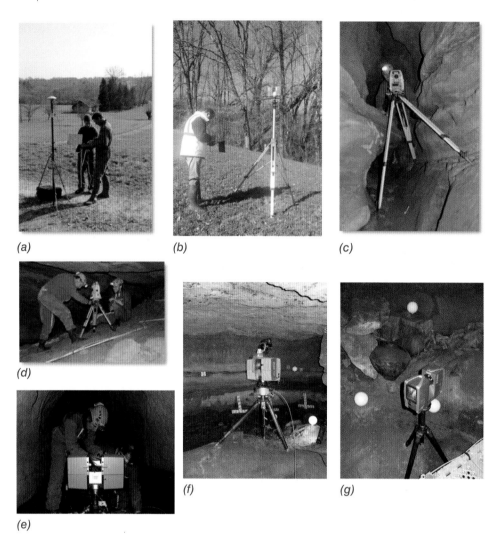

(a) (b) (c)

(d)

(f) (g)

(e)

Figure 6.44 Geodetic, tacheometric and TLS recording on the site of the cave 'Les Fraux' (France): (a) GNSS positioning; (b) TLS with the Faro X330 scanner; (c, d) Traverse measurement in the cave; (e) Faro Photon laser scanner; (f) Faro Photon laser scanner equiped with a SLR camera; (g) Faro Focus 3D laser scanner [Grussenmeyer *et al.*, 2014].

application. This format also allows some measuring functions and toolkits (distances, sections, etc.) and visualisation options such as wireframe, shaded, solid and vertices (meshed and rendered views are shown in Figure 6.46).

This work was carried out by the Photogrammetry and Geomatrics Group from INSA Strasbourg and the GEODE Laboratory from Toulouse University (France) between 2008 and 2014, as part of a research project dedicated to the study of global ecology founded by the Institute of Ecology and Environment (INEE) from the French Research Science Council (CNRS).

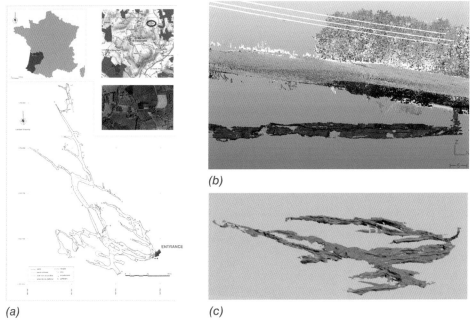

(b)

(a)

(c)

Figure 6.45 (a) Location of the Bronze Age cave of Les Fraux (Saint-Martin-de Fressen-geas, Dordogne, France) and map of the underground network [survey: Y. Billaud, 2013]; (b) Section West–East showing the meshed underground network and the digital terrain point cloud; (c) Global 3D model of the underground network of the cave [2013].

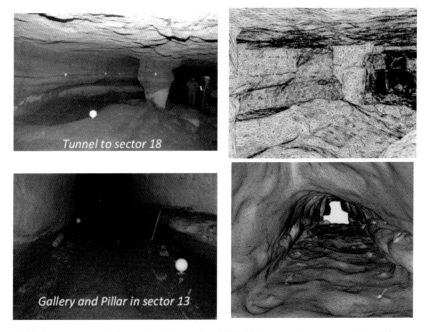

Figure 6.46 Examples of 3D models from the PDF-3D viewer (images on the left, corresponding models on the right).

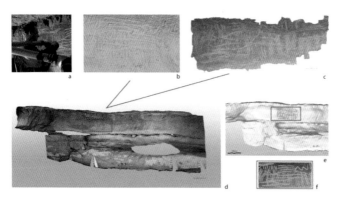

Figure 6.47 3D-recording of Bronze Age fingerings in the clay-wall of the main panel from the sector 13 of the cave: (a) recording test with the Faro ScanArm; (b) view of the high density point cloud recording using ScanArm; (c) digital surface of a selected piece of the panel, (d) textured 3D model; (e) projection of drawn fingerings on to the 3D model; (f) detail of the digital drawing from the orthophoto extracted from the 3D model [Burens *et al.*, 2013].

Recording excavations and headstones

Surveying archaeological excavations by TLS

An archaeological excavation has to produce a complete description of the stratification within any excavated area. This is done during the excavation process by removing single deposits in the reverse order to which they were formed. This results in the complete destruction of the investigated area of a site. Therefore, full 3D documentation of each deposit ('single surface planning') is of key importance. This can be done by describing its top and bottom surfaces [Doneus and Neubauer, 2006].

Due to the destructive nature of the excavation process, the documentation of each deposit's surfaces has to be detailed, accurate and reliable, while time constraints demand highly efficient systems. Documenting the topography of all excavated surfaces using a total station is very time consuming, especially when the topography is rough. The quality largely depends on the skills and capability of the person handling the reflector. Additionally, quite often the archaeologist is confronted with situations where the excavated surface is too vulnerable to be walked on (e.g. waterlogged environment, mosaics, organic material). Recently, techniques from photogrammetry and computer vision have been employed on archaeological excavations: using structure from motion and multiview stereo approaches, a multitude of photographs covering an excavated surface can be used to automatically generate 3D models of its topography [Doneus *et al.*, 2013; Reu *et al.*, 2013]. However, demands on computing resources are

high: ground control points have to be measured manually for each surface, and so the final result is not immediately at hand.

Therefore, the University of Vienna's Department of Prehistoric and Historical Archaeology together with the Vienna Institute of Archaeological Science (VIAS) started in 2002 to test the usability of laser scanners throughout archaeological excavations. Since then, TLS has become a standard method for the systematic documentation of these archaeological excavations [Doneus and Neubauer, 2005, 2006].

During the last 12 years, TLS has turned out to be highly accurate, efficient, reliable and fast, while the applied scanners (RIEGL's LMS-Z210i, LMS-Z420, and VZ400) have proven to be sufficiently robust for excavation conditions (dust, wind, both hot and low temperatures, moisture). The detailed 3D surface models are further used to rectify the photographic excavation record. Orthophotographs and surface models are combined in a GIS environment and consequently used for interpretative mapping. Finally, arbitrary sections (Figure 6.48) out of the three dimensional spatial record can be calculated within GIS and help to understand the excavated features.

The following example presents examples of recent archaeological excavations around and under the cathedral of Strasbourg (France).

The presence of a Roman legionary camp in the heart of the city of Strasbourg, built at the end of the Ist century AD by the Legio VIII Augusta who occupied it until

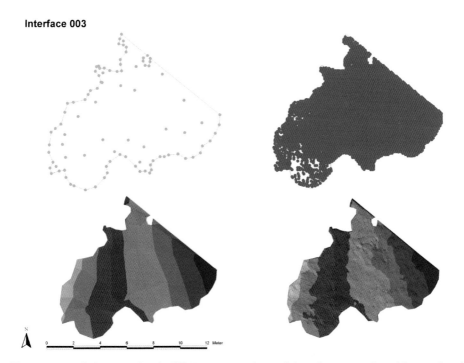

Figure 6.48 Schwarzenbach, SE005: comparison of data (upper row) and interpolated surfaces (lower row) of the top surface using a total station (left) and a laser scanner (right). Note that the roughness of the surface can be clearly seen in the visualisation of the scanner data.

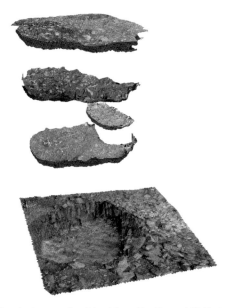

Figure 6.49 Schwarzenbach, Lower Austria. Visualisation of TLS-documented top and bottom surfaces of all stratigraphic units from an Iron Age pit.

Grube 1

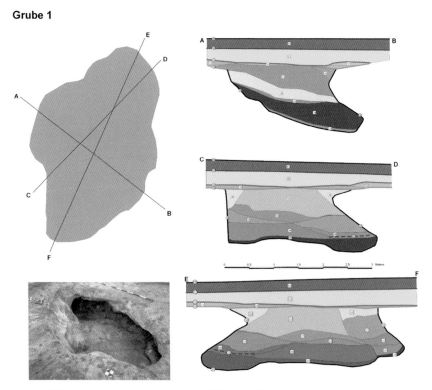

Figure 6.50 Platt, Lower Austria – Late Neolithic pit. Multiple arbitrary cross-sections calculated from a systematic TLS-based 3D record of excavated surfaces.

(a) *(b)* *(c)*

Figure 6.51 3D model of an excavation; (a) point cloud; (b) mesh model; (c) textured mesh model. (INRAP/INSA Strasbourg project – H. Cicutta/T.Landes)

the 4th century AD, led INRAP (the National Institute for Preventive Archaeological Research) to carry out many excavations in the surroundings of Notre Dame Cathedral, under the supervision of Gertrud Kuhnle and Heidi Cicutta. From 2012, excavations under the Castle Square next to the cathedral revealed the presence of Roman remains. 3D modelling of the excavation area using TLS techniques was performed with the purpose of documentation, because a few days later, the whole area was recovered for re-landscaping of the square (Figure 6.51).

A specific excavation area in the basement of the St. Lawrence Chapel in the Cathedral revealed, in 1968–1972, masonry from Roman times and from the Middle Ages, including the foundations of the first known Cathedral dating back to 1015 which serve today for the current Gothic Cathedral. Figure 6.52 presents the model produced on

(a) *(b)*

Figure 6.52 3D mesh and textured model of St. Lawrence Chapel's basement: (a) texturing process on the 1015 wall; (b) final model, used for communication [INRAP/INSA/Inventive studio project – G. Kuhnle/T.Landes/S. Potier].

that wall and on the whole basement. It is used for further archaeological analysis, for documentation, but also for communication, because access to this area is forbidden to tourists [see Landes *et al.*, 2015].

3D modelling of archaeological headstones

Several headstones from the 2nd and 3rd centuries were discovered during excavations in the South of Alsace (France) in 2011 and stored at the Regional Directorate of Cultural Affairs Office in Strasbourg. In this section we present the results of the 3D documentation of a figured sandstone. Both image-based and scan-arm technology were used and compared in order to check if the accuracy (1 mm) required by the archaeologists could be reached. For the image-based point cloud generation, Photo-Modeler and PhotoSynth followed by PhotoSynth Toolkit for densification were used. For assessing the point clouds quality, both results have been compared to a reference point cloud, previously generated by the scanning of a headstone with the FARO ScanArm instrument (Figure 6.53a). The specifications of this system estimate the accuracy at 0.04 mm. The point cloud produced in this way contains 47 million points (Figure 6.53b), but covers only the upper part of a stele. To lighten it and to reach a

(a)

(b)

(c)

(d)

Figure 6.53 (a) Faro ScanArm used to record a headstone. (b) 3D mesh from the Faro ScanArm point cloud. (c) Textured 3D model of a headstone (PDF3D format in Adobe Acrobat environment), Landes *et al.*, 2013. (d) Replica obtained with a 3D printer. [Courtesy INSA Strasbourg.]

spatial resolution equivalent to that produced with images, the point cloud is resampled to 0.5 mm spacing. For both software used for generating the point cloud, an accuracy of about 0.7 mm is reached. These results are satisfactory, because they prove that the millimetre accuracy required by the archeologists is respected [Landes *et al.*, 2013].

For meshing and texturing the models (Figure 6.53c), other software were used and evaluated (Cloud Compare, 3DReshaper, Meshlab, Geomagic, Adobe Acrobat). The final products were photo-realistic 3D models of 13 headstones, and a 3D replica was printed in the INSA Strasbourg Fab Lab (Figure 6.53d).

6.7.3 Applications of ALS

Since its archaeological use was first demonstrated in the year 2000, ALS has been finding wide application in cultural heritage [Opitz and Cowley, 2013]. The reason seems to be obvious: ALS has helped to visualise even faint topographic variations in agriculturally used areas and – more importantly – under forest canopies. In this way, it provides access to hitherto hidden archaeological landscapes. Today we can state that regardless of whether ALS is used in open fields, meadows or forested and otherwise densely vegetated areas it has the potential to serve three main aspects of cultural heritage protection: detection, documentation, and monitoring of sites, monuments and landscapes.

Detection of archaeological structures

Vegetation protects archaeological remains to a certain degree from erosion. Therefore, in forested areas, archaeological sites often survive in relief and can be detected and mapped on the ground. If the relief is distinct, sites are detected easily in situ, but their layout can only be understood after a considerable amount of time spent walking across the features and mapping them. However, there are many instances where relic features had been subject to erosion during periods when the forest had been cleared. Here, sites are hard to find from the ground and even more difficult to map. While country-wide LiDAR-derived DTMs become available, systematic archaeological interpretation of large data sets has started in various institutions [e.g. Crutchley, 2013; Hesse, 2013].

In the so-called 'Leithagebirge' (south of Vienna, Austria), which is amongst the previously quoted examples, a forested area of approximately 190 km² was scanned with a high point density (a minimum of 3–4 terrain points per square metre after filtering) and archaeologically analysed [see Doneus and Briese, 2011]. The area to be examined rises some 200 m to 300 m above the valley of the river Leitha. It is covered by a forest of mixed deciduous trees, mainly oak and beech with varying degrees of understory. The resulting DTM was then systematically analysed in a GIS environment. At the end of the project, the mapped structures could be ascribed to roughly 400 sites (Figure 6.54). This clearly demonstrates the suitability of ALS to detect archaeological information under vegetation.

However, at this point it has to be mentioned that ALS can only document sites and features which are still surviving in (micro-)relief. The survival of features in relief depends on a broad range of factors such as type and dimension of the original structure,

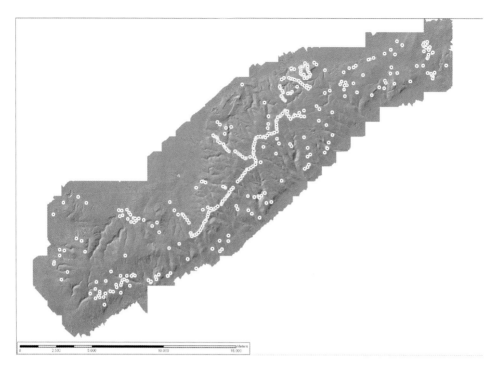

Figure 6.54 Shading of a DTM of the total project area with the resulting sites. Note that the linear arrangements of sites in the centre of the Leithagebirge are rows of Medieval border-markers.

attitude of later generations towards abandoned monuments and sites, environmental conditions (geology, vegetation, climate, etc.) and time. Many factors will have erosive effects on various scales which add up through time. Therefore, the range of archaeology to be found in an ALS-based project is usually biased in terms of chronology and site-type. For example, in this case study most of the mapped structures were Medieval and post-Medieval in date.

Nevertheless, in the case study, the registered sites range from late-Neolithic and Iron Age hillforts, round barrows, building structures, stone quarries, fields of hollow-ways, Medieval field systems, medieval border-markers (so called 'Hotter'), hundreds of lime-kilns, military trenches from the post-Medieval period to World War II and a large number of bomb craters from World War II. Altogether, these prove the value of ALS for systematic, large-scaled archaeological prospection.

The high detail, ALS-derived DTMs can provide for archaeology is demonstrated by remains of a monastery and its surroundings (St. Anna in der Wüste), which are located in the project area. During interpretative mapping, more than 1.600 features were drawn including ramparts of a hillfort, building structures, barrows, field boundaries, hollow-ways, quarries, kilns and bomb craters (Figure 6.55).

Using laser scanners @ 532 nm wavelength (i.e. in the green region of the electromagnetic spectrum), for high resolution hydrographical surveying in very clean shallow

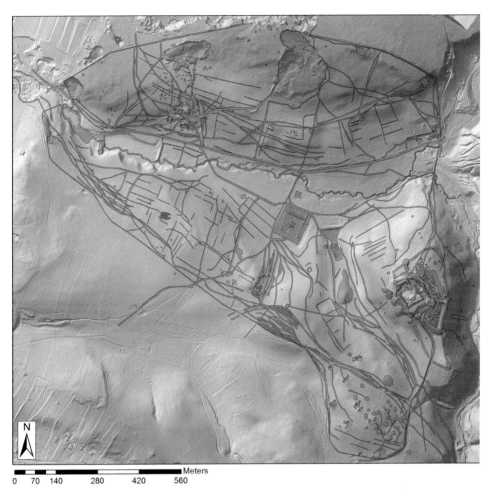

Figure 6.55 St. Anna in der Wüste – interpretative mapping of archaeological structures from an ALS-derived DTM.

water (depth <10 m) becomes possible. Detailed knowledge of underwater topography is essential for many research fields. In archaeology, this is a premise to the understanding of the organisation and distribution of archaeological sites along and within water bodies. Here, special attention has to be paid to intertidal and inshore zones where, due to sea-level rise [Lambeck *et al.*, 2004], coastlines have changed and many former coastal sites are now submerged in shallow water. Mapping the relief within these areas is therefore important to be able to reconstruct former coastlines, identify sunken archaeological structures and recognise navigable areas which can help to locate potential former harbour sites.

Airborne bathymetric laser scanner systems (that deliver two frequencies of light: one reflects from the water surface and one passes through the water column and reflects from the sea bed) are able to measure these underwater surfaces over large areas in high detail, even revealing sunken archaeological structures in shallow water.

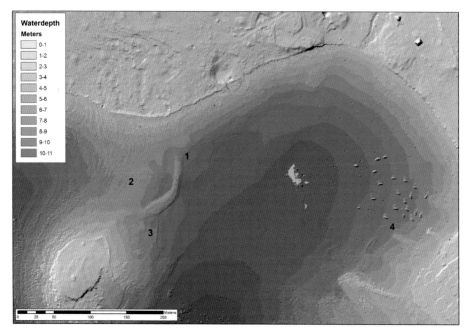

Figure 6.56 Shaded filtered DTM generated from an ALB data acquisition campaign over the Roman harbour site of Kolone, Croatia. The shaded DTM combines land surface and underwater topography. Furthermore, a colour-coded map of the water depth is superimposed. The following archaeological features can be recognised: (1) Presumably Roman embankment connecting the small island with the main land (2) previously unknown, undated square structure, 15 m by 15 m with 0.5 m high walls, (3) wall with unknown function, and (4) Roman mole.

Using an airborne RIEGL VQ-820-G laser scanner over the coastal area in Kolone, a Roman harbour site in the southwest of Croatian Istria, a digital model of the underwater topography with a planimetric resolution of 50 centimetres was measured in water at depths of up to 10 m [see also Doneus *et al.*, 2013]. The GIS-based analysis of the data reveals a Roman embankment and breakwater walls in their topographical context (Figure 6.56).

Documentation

The detection of a site is certainly the most important step in the archaeological process. To be able to take adequate measures for protection and to plan further archaeological investigations, detailed three-dimensional site and elevation plans must be produced. ALS does provide archaeologists with a detailed and accurate documentation of its features and its topography.

A direct comparison of ALS and terrestrial surveying at the Iron Age hillfort in Purbach [see also Doneus *et al.*, 2008] clearly demonstrates the potential of ALS (Figure 6.57a). Both ALS-derived DTM and topographical maps corresponded well in

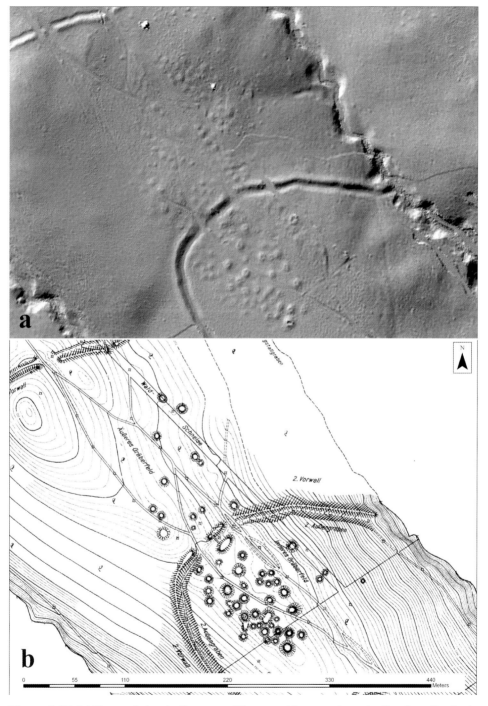

Figure 6.57 (a) Zoomed view to the area of the round barrows in a shading from the final DTM. The individual round barrows of the graveyard can now be seen in detail. Most of them show traces of looting in the form of shallow depressions. (b) The same area as mapped in the 1960s. © BEV, 2007.

geometrical terms. The most marked differences occurred with the micro-topographical features as many of the very low earthworks were not identified by the trained surveyors and archaeologists in the field, but are clearly visible in the final DTM generated from the ALS-data. Therefore, the number of round barrows could almost be doubled and a field visit verified most of the newly identified barrows. In addition, it was seemingly not possible to identify the terminals of the two outer ramparts during the terrestrial survey. Even during a recent field visit it was impossible to see these areas because of the steep terrain and the dense vegetation cover. Nevertheless, they are quite evident in the shaded DTM (compare the end of the ditch in Figures 6.57a and 6.57b).

ALS-based documentation of well-known sites is also worthwhile as it often gives new information. This could be demonstrated at a case study site of the LBI ArchPro, namely the Viking Age royal burial site of Borre at the western coast of the Oslofjord in Norway. Next to all of the known barrows, a close investigation of an ALS-derived DTM revealed the potential harbour site, whose location had been a matter of debate for a long time (Figure 6.58). Due to the fact that the area is subject to a still ongoing crustal uplift related to post-glacial rebound, the Viking Age harbour area today is

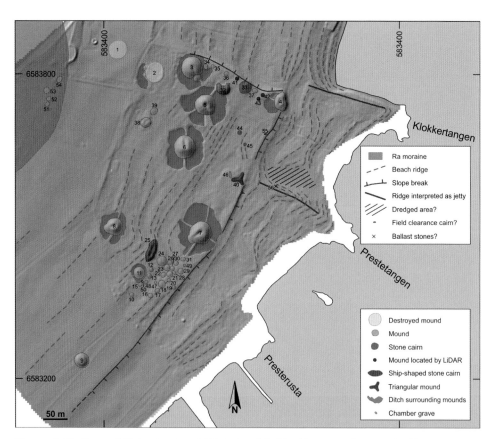

Figure 6.58 Borre: Hillshade of an ALS-derived DTM with geoarchaeological interpretation [from Draganits *et al.*, 2014, Fig.10].

located above the current sea level. The harbour was constructed by at least two jetties. Their chronological dating could be argued by the fact that a sequence of elevated beach ridges displaying a stratigraphic younger age [see Draganits *et al.*, 2014].

Monitoring

Heritage sites have to be monitored time and again to document their current condition and compare it with previous records. In that way, structural changes can be detected and potential threats identified. The process of monitoring sites in forested areas can be very time consuming and costly. Therefore, quick, cheap, precise and accurate methods have to be developed that give the means to repeatedly compare the current state of a monument with previous documentations. Repeated terrestrial surveying is in most situations no option – especially with extensive and complex sites. When it comes to monuments in forested areas and to questions of erosion, ALS, especially in combination with aerial photography, seems to be a particularly promising approach [see also Barnes, 2003].

Recently, monitoring using ALS data was applied in Mølen (Vestfold County, Norway – within a case study area of the LBI ArchPro), a pebble stone beach holding a large number of cairns, which date from the Roman Iron Age period to the late Iron Age (AD 1–1000). Comparing two ALS data sets with digital elevation models derived from historical air photographs (years 1968, 1979 and 1999) changes on individual monuments (removal of stones, archaeological reconstructions – Figure 6.59) could be monitored [Risbøl *et al.*, 2014].

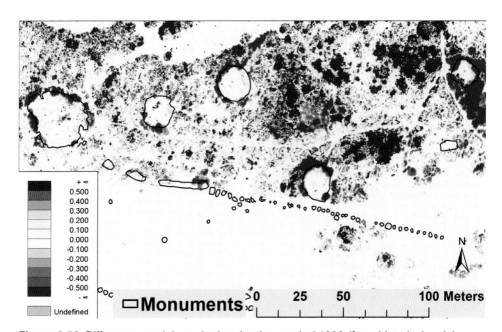

Figure 6.59 Difference model monitoring the time period 1999 (from historical aerial photographs) and 2010 [from ALS data – from Risbøl *et al.*, 2014, Figure 9].

References

Asensio Ors, C., 2013. Análisis métrico y patológico de la fachada principal del Tribunal Superior de Justicia de Valencia. Diploma Thesis. Universitat Politècnica de València.

Baltsavias, E.P., 1999. Airborne laser scanning: basic relations and formulas. *ISPRS Journal of Photogrammetry and Remote Sensing*, 54, 199–214.

Barnes, I., 2003. Aerial remote-sensing techniques used in the management of archaeological monuments on the British Army's Salisbury Plain training area, Wiltshire, UK. *Archaeological Prospection*, 10, 83–91.

Bennett, R., Welham, K., Hill, Ross, A. and Ford, A., 2012. A Comparison of visualization techniques for models created from airborne laser scanned data. *Archaeological Prospection*, 19, 41–48.

Bewley, R.H., Crutchley, S. and Shell, C., 2005. New light on an ancient landscape: LiDAR survey in the Stonehenge World Heritage Site. *Antiquity*, 79, 636–647.

Boehler, W., Bordas, V.M. and Marbs, A., 2003. Investigating laser scanner accuracy. *CIPA International archives for Documentation of Cultural Heritage*, Antalya, Turkey, XIX, 696–701.

Boehler, W., Heinz, G. and Marbs, A. 2005. The potential of non-contact close range laser scanners for cultural heritage recording. In: *Proceedings of CIPA XXth International Symposium*, 26 September –1 October, Torino, Italy, 430–435.

Boulaassal, H., Landes, T. and Grussenmeyer, P., 2011. Reconstruction of 3D vector models of buildings by combination of ALS, TLS and VLS Data. *Proceedings of the 4th 3D-ARCH Int. Conference on '3D Virtual Reconstruction and Visualization of Complex Architectures'*, Trento (Italy), 2–5 March 2011, Int. Arch. of Photogrammetry, Remote Sensing and Spatial Information Sciences, XXXVIII, Part 5/W16, ISSN 1682–1777.

Burens, A., Grussenmeyer, P., Carozza, L., Leveque, F., Guillemin, S. and Mathe, V., 2014. Benefits of an accurate 3D documentation in understanding the status of the Bronze Age heritage cave 'Les Fraux' (France). *International Journal of Heritage in the Digital Era*, ISSN 2047–4970, 3(1): 179–196. DOI: http://dx.doi.org/10.1260/2047-4970.3.1.179.

Chen, C., Hung, Y. and Cheng, J., 1999. RANSAC-based DARCES: a new approach to fast automatic registration of partially overlapping range images, *IEEE Transactions on Pattern Analysis and Machine Intelligence*, 21(11), 1229–1234.

Crutchley, S., 2010. *The Light Fantastic. Using Airborne Lidar in Archaeological Survey*. Swindon: English Heritage Publishing.

Crutchley, S., 2013. Using lidar data – drawing on 10 years experience at English Heritage. In: *Interpreting Archaeological Topography. Airborne Laser Scanning, 3D Data and Ground Observation*, Opitz, R.S. and Cowley, D. (Eds.), Occasional Publication of the Aerial Archaeology Research Group 5. Oxford: Oxbow Books, 136–145.

Devereux, B.J., Amable, G.S. and Crow, P., 2008. Visualisation of LiDAR terrain models for archaeological feature detection. *Antiquity*, 82, 470–479.

Devereux, B.J., Amable, G.S., Crow, P. and Cliff, A.D., 2005. The potential of airborne lidar for detection of archaeological features under woodland canopies. *Antiquity*, 79, 648–660.

Doneus, M. and Neubauer, W., 2005. 3D laser scanners on archaeological excavations. In: *Proceedings of the XXth International Symposium CIPA*, Dequal, S. (Ed.), Torino 2005. The International Archives of Photogrammetry, Remote Sensing and Spatial Information Sciences, XXXVI-5/C34/1, 226–231.

Doneus, M. and Neubauer, W., 2006. Laser scanners for 3D documentation of stratigraphic excavations. In: *Recording, Modeling and Visualization of Cultural Heritage*. Baltsavias, E., Gruen, A., van Gool, L. and Pateraki, M. (Eds.), London: Taylor and Francis, 193–203.

Doneus, M. and Briese, C., 2006a. Digital terrain modelling for archaeological interpretation within forested areas using full-waveform laserscanning. In: *The 7th International Symposium*

on Virtual Reality, Archaeology and Cultural Heritage VAST, Ioannides, M., Arnold, D., Nic-colucci, F. and Mania, K. (Eds.), 155–162.

Doneus, M. and Briese, C., 2006b. Full-waveform airborne laser scanning as a tool for archae-ological reconnaissance. In: *From Space to Place. International Conference on Remote Sensing in Archaeology*; Campana, S. and Forte, M. (Eds.), Proceedings of the International Workshop, CNR, Rome, Italy, 2–4 December. Oxford: Archaeopress (BAR International Series, 1568), 99–106.

Doneus, M., Briese, C., Fera, M. and Janner, M., 2008. Archaeological prospection of fores-ted areas using full-waveform airborne laser scanning. *Journal of Archaeological Science,* 35, 882–893.

Doneus, M., Verhoeven, G., Fera, M., Briese, C., Kucera, M. and Neubauer, W., 2011. From deposit to pointcloud. A study of low-cost computer vision approaches for the straightfor-ward documentation of archaeological excavations. *Geoinformatics,* 6, 81–88.

Doneus, M. and Briese, C., 2011. Airborne laser scanning in forested areas – potential and lim-itations of an archaeological prospection technique. In: *Remote Sensing for Archaeological Her-itage Management,* Cowley, D. (Ed.), Proceedings of the 11th EAC Heritage Management Symposium, Reykjavik, Iceland, 25–27 March 2010. Occasional Publication of the Aerial Archaeology Research Group 3. Archaeolingua; EAC, Budapest, 53–76.

Doneus, M., 2013. Openness as visualization technique for interpretative mapping of airborne lidar derived digital terrain models. *Remote Sensing of Environment,* 5, 6427–6442.

Doneus, M., Doneus, N., Briese, C., Pregesbauer, M., Mandlburger, G. and Verhoeven, G., 2013. Airborne laser bathymetry – detecting and recording submerged archaeological sites from the air. *Journal of Archaeological Science,* 40, 2136–2151.

Domingo, I., Villaverde, V., López-Montalvo, E., Lerma, J.L. and Cabrelles, M., 2013a. Latest developments in rock art recording: towards an integral documentation of Levantine rock art sites combining 2D and 3D recording techniques. *Journal of Archaeological Science,* 40(4), 1879–1889.

Draganits, E., Doneus, M., Gansum, T., Gustavsen, L., Nau, E., Tonning, C., Trinks, I., Neubauer, W., Draganits, E., Doneus, M., Gansum, T., Gustavsen, L., Nau, E., Tonning, C., Trinks, I. and Neubauer, W., 2014. The late Nordic Iron Age and Viking Age royal burial site of Borre in Norway: ALS- and GPR-based landscape reconstruction and harbour loca-tion at an uplifting coastal area. *Quarternary International.*

Duca, F., Cabrelles, M., Navarro, S., Seguí, A.E. and Lerma, J.L., 2011. Photo-realistic 3D modelling of sculptures on open-air museums. *Geoinformatics* FCE CTU, 6, 89–96.

English Heritage, 2011. *3D Laser Scanning for Heritage (2nd edin.). Advice and Guidance to Users on Laser Scanning in Archaeology and Architecture.* Available at: www.english-heritage.org.uk (accessed 23 January 2015).

Fernandez-Diaz, J., Carter, W., Shrestha, R. and Glennie, C., 2014. Now you see it … now you don't: understanding airborne mapping LiDAR collection and data product generation for archaeological research in Mesoamerica. *Remote Sensing,* 6(10), 9951–10001.

Fischler, M.A. and Bolles, R.C., 1981. Random sample consensus: a paradigm for model fitting with application to image analysis and automated cartography. *Communications of the ACM,* 24(6), 381–395.

García-San-Miguel, D. and Lerma, J.L., 2013. Geometric calibration of a terrestrial laser scan-ner with local additional parameters: an automatic strategy. *ISPRS Journal of Photogrammetry and Remote Sensing*, 79, 122–136.

George, P-L. and Borouchaki, H., 1997. *Triangulation de Delaunay et maillage, application aux éléments finis.* Paris: Edition Hermes.

Grussenmeyer, P., Alby, E., Assali, P., Poitevin, V., Hullo, J.-F. and Smigiel, E., 2011. Accurate documentation in cultural heritage by merging TLS and high-resolution photogrammetric

data. *SPIE Optical Metrology 2011*, Munich, 23–26 May, Videometrics, Range Imaging, and Applications XI, Proc. of SPIE 8085, 808508.

Grussenmeyer, P., Burens, A., Moisan, E., Guillemin, S., Carozza, L., Bourrillon, R. and Petrognani, S. 2012. 3D multi-scale scanning of the archaeological cave 'Les Fraux' in Dordogne (France). In: *EuroMed 2012: Lecture Notes in Computer Science (including subseries Lecture Notes in Artificial Intelligence and Lecture Notes in Bioinformatics)*, Ionnadis, M., et al. (Eds.), 7616, 388–395.

Grussenmeyer, P., Burens, A., Carozza, L., Leveque, F., Guillemin, S. and Mathe, V., 2014. Numérisation 3D de la grotte ornée des Fraux (Dordogne): apport à l'archéologie et à la cartographie du champ magnétique. *Revue de l'Association Française de Topographie*, 138, 33–41.

Guhring, J., 2001. Dense 3-D surface acquisition by structured light using off-the-shelf components, *Photonics West, Videometrics VII*, 4309, San Jose: SPIE .

Hebert, M. and Krotkov, E., 1992. 3D measurements from imaging laser radars: how good are they? *Image and Vision Computing*, 10(3), 170–178.

Hesse, R., 2010. LiDAR-derived local relief models – a new tool for archaeological prospection. *Archaeological Prospection*, 17(2), 67–72. DOI: http://dx.doi.org/10.1002/arp.374

Hesse, R., 2013. The changing picture of archaeological landscapes: lidar prospection over very large areas as part of a cultural heritage survey. In: *Interpreting Archaeological Topography. Airborne Laser Scanning, 3D Data and Ground Observation*, Opitz, R.S. and Cowley, D. (Eds.), Occasional Publication of the Aerial Archaeology Research Group 5. Oxford: Oxbow Books, 171–183.

Hough, P.V.C., 1962. *Method and Means for Recognizing Complex Patterns*. U.S. Patent 3.069.654.

Hug, C., Ullrich, A. and Grimm, A., 2004. Litemapper-5600 – a waveform-digitizing LIDAR terrain and vegetation mapping system. In: *Laser-Scanners for Forest and Landscape Assessment*, Thies, M., Koch, B., Spiecker, H. and Weinacker, H. (Eds.), *Proceedings of Natscan, Laser-Scanners for Forest and Landscape Assessment – Instruments, Processing Methods and Applications*, International Archives of Photogrammetry and Remote Sensing, XXXVI, Part 8/W2, 24–29.

Humme, A., Lindenbergh, R. and Sueur, C., 2006. Revealing Celtic fields from lidar data using Kriging based filtering. In: *Proceedings of the ISPRS Commission V Symposium 'Image Engineering and Vision Metrology'*, Maas, H.G. and Schneider, D. (Eds.), Dresden (International Archives of Photogrammetry, Remote Sensing and Spatial Information Sciences, XXXVI, Part 5).

Jacobs, G. 2005. Registration and geo-referencing. *Professional Surveyor Magazine*, July, 30–37.

Kager, H., 2004. Discrepancies between overlapping laser scanning strips – simultaneous fitting of aerial laser scanner strips. In: *Geo-Imagery Bridging Continents*, Altan, O. (Ed.), XXth ISPRS Congress, 12–23 July, Istanbul, Turkey. Istanbul (International Archives of Photogrammetry and Remote Sensing, XXXV, Part B/3), 555–560.

Kraus, K. and 2004. *Photogrammetrie*. Band 1. Geometrische Informationen aus Photographien und Laserscanneraufnahmen. 7., vollständig bearbeitete und erweiterte Auflage. Berlin, New York: Walter de Gruyter.

Kraus, K., Otepka, J., 2005. DTM modelling and visualization – the SCOP approach. In: *Photogrammetric Week*, Fritsch, D. (Ed.), Heidelberg, 241–252.

Kraus, K. and Pfeifer, N., 1998. Determination of terrain models in wooded areas with airborne laser scanner data. *ISPRS Journal of Photogrammetry and Remote Sensing*, 53(4), 193–203.

Lambeck, K., Anzidei, M., Antonioli, F., Benini, A. and Esposito, A., 2004. Sea level in Roman time in the Central Mediterranean and implications for recent change. *Earth and Planetary Science Letters*, 224, 563–575.

Landes, T., Grussenmeyer, P., Voegtle, T. and Ringle, K., 2007. *Combination of Terrestrial Recording Techniques for 3D Object Modelling regarding topographic constraints. Example of the Castle of Haut-Andlau, Alsace, France.* XXIth CIPA International Symposium, Athens, Greece, 2007. International Archives of Photogrammetry, Remote Sensing and Spatial Information Systems XXXVI-5/C53, 435–440.

Landes T., Waton M.D., Alby, E., Gourvez, S. and Lopes, B., 2013. 3D modeling of headstones of the 2nd and 3rd century by low cost photogrammetric techniques. *Proceedings of the XXIVth CIPA Symposium*, Strasbourg, France, 2–6 September.

Landes, T., Bidino, S. and Guild, R., 2014. Semi-automatic extraction of sectional view from point clouds. The case of Ottmarsheim's abbey church. *Technical Commission V Symposium*, 23–25 June, Riva del Garda, Italy, The International Archives of the Photogrammetry, Remote Sensing and Spatial Information Sciences, XL-5, ISPRS, 343–348.

Landes, T., Kuhnle, G. and R. Bruna, R., 2015. 3D modeling of the Strasbourg's Cathedral basements for interdisciplinary research and virtual visits. In: *Proceedings of CIPA XXVth International Symposium*, 31 August - 4 September, Taipei, Taiwan, 263–270.

Lerma Garcia, J.L., Van Genechten, B., Heine, E. and Quintero, M.S., 2008. *3D RiskMapping – Theory and Practice on Terrestrial Laser Scanning.* Universidad Politecnica De Valencia.

Lerma, J.L., Navarro, S., Cabrelles, M. and Villaverde, V., 2010. Terrestrial laser scanning and close range photogrammetry for 3D archeological documentation: the Upper Palaeolithic Cave of Parpalló as a case study. *Journal of Archaeological Science*, 37(3), 499–507.

Lerma García, J.L. and Cabrelles López, M., 2011. Levantamiento 3D de la Cova Remígia, Ares del Maestre (Castellón) – Memoria provisional. Unpublished report (in Spanish). Universitat Politècnica de València.

Lerma, J.L. and García-San-Miguel, D., 2014. Self-calibration of terrestrial laser scanners: selection of the best geometric additional parameters. *ISPRS Annals of the Photogrammetry, Remote Sensing and Spatial Information Sciences*, II–5, 219–226.

Lichti, D. and Harvey, B., 2002. The effects of reflecting surface material properties on time-of-flight laser scanner measurements. *International Archives of Photogrammetry, Remote Sensing and Spatial Information Sciences*, XXXIV, Tome 4, 9–12 July, Ottawa.

Macher, H., Landes, T., Grussenmeyer, P. and Alby, E., 2014. Semi-automatic segmentation and modelling from point clouds towards historical building information modelling. In *EuroMed 2014, Digital Heritage: Progress in Cultural Heritage: Documentation, Preservation, and Protection; Lecture Notes in Computer Science*, Ionnades, M., et al. (Eds.), 8740, 111–120. DOI: http://dx.doi.org/10.1007/978-3-319-13695-0_11

Opitz, R.S., 2013. An overview of airborne and terrestrial laser scanning in archaeology. In: *Interpreting Archaeological Topography. Airborne Laser Scanning, 3D Data and Ground Observation (Occasional Publication of the Aerial Archaeology Research Group, 5)*, Opitz, R.S. and Cowley, D. (Eds.), Oxford: Oxbow Books, 13–31.

Opitz, R. and Cowley, D., 2013. *Interpreting Archaeological Topography. Airborne Laser Scanning, 3D Data and Ground Observation (Occasional Publication of the Aerial Archaeology Research Group, 5)*. Oxford: Oxbow Books, 13–31.

Pfeifer, N., Gorte, B. and Elberink, S.O., 2004. Influences of vegetation on laser altimetry – analysis and correction approaches. In: *Laser-Scanners for Forest and Landscape Assessment – Instruments, Processing Methods and Applications* (International Archives of Photogrammetry and Remote Sensing, XXXVI, Part 8/W2), Thies, M., Koch, B., Spiecker, H. and Weinacker, H. (Eds.), 283–287.

Pfeifer, N., 2007. *Overview of TLS Systems, Overall Processing and Applications, Theory and Application of Laser Scanning.* ISPRS summer school. Ljubljana, Solvenia.

Remondino, F. and Stoppa, D. (Eds.), 2013. *TOF Range-Imaging Cameras*, Springer-Verlag Berlin Heidelberg. DOI: http://dx.doi.org/10.1007/978-3-642-27523-4_2

Reshetyuk, Y., 2006. Investigation and calibration of pulsed time-of-flight terrestrial laser scanners. Licentiate thesis in Geodesy Royal Institute of Technology (KTH), Department of Transport and Economics, Division of Geodesy.

Reshetyuk, Y., 2009. *Terrestrial Laser Scanning: Error Sources, Self-Calibration and Direct Georeferencing*. VDM Publishing House Ltd.

Reu, J., de Plets, G., Verhoeven, G., Smedt, P., de Bats, M., Cherretté, B., et al., 2013. Towards a three-dimensional cost-effective registration of the archaeological heritage. *Journal of Archaeological Science*, 40(2), 1108–1121.

Risbøl, O., Briese, C., Doneus, M. and Nesbakken, A., 2014. Monitoring cultural heritage by comparing DEMs derived from historical aerial photographs and airborne laser scanning. *Journal of Cultural Heritage*.

Soudarissanane, S., van Ree, J., Bucksch, A. and Lindenbergh, R., 2007. Error budget of terrestrial laser scanning: influence of the incidence angle on the scan quality. Proceedings 3D-NordOst, 10. Anwendungsbezogener Workshop zur Erfassung, Modellierung, Verarbeitung, and Auswertung von 3D-Daten, 6–7 December, Berlin.

Soudarissanane, S., Lindenbergh, R., Menenti, M. and Teunissen, P., 2011. Scanning geometry: Influencing factor on the quality of terrestrial laser scanning points. *ISPRS Journal of Photogrammetry and Remote Sensing*.

Staiger, R., 2003. Terrestrial laser scanning: technology, systems and applications. *Second FIG Regional Conference*, Marrakech, Morocco, 2–5 December.

Staiger, R., 2005. The geometrical quality of terrestrial laser scanner. *FIG Working Week*, Cairo, Egypt, 16–21 April.

Tarsha-Kurdi, F., Landes, T. and Grussenmeyer, P., 2007. Hough-transform and extended RANSAC algorithms for automatic detection of 3d building roof planes from Lidar data. *International Archives of Photogrammetry, Remote Sensing and Spatial Information Sciences*. Workshop Laser scanning. Espoo, Finland, 12–14 September.

Thiel, K.-H. and Wehr, A., 2004. Performance capabilities of laser scanners: an overview and measurement principle analysis. *International Archives of Photogrammetry, Remote Sensing and Spatial Information Sciences*, 36(8), 14–18.

UNESCO, 1998. Rock art of the Mediterranean Basin on the Iberian Peninsula. http://whc.unesco.org/en/list/874/ (Accessed on 2 Jan 2015)

Vosselman, G. and Maas, H.G. (eds.), 2010 *Airborne and Terrestrial Laser Scanning*. Whittles Publishing, 271–290.

Wagner, W., Ullrich, A., Ducic, V., Melzer, T. and Studnicka, N., 2006. Gaussian decomposition and calibration of a novel small-footprint full-waveform digitising airborne laser scanner. *ISPRS Journal of Photogrammetry and Remote Sensing*, 60(2), 100–112.

Wagner, W., Ullrich, A., Melzer, T., Briese, C. and Kraus, K., 2004. From single-pulse to full-waveform airborne laser scanners: potential and practical challenges. In: *Geo-Imagery Bridging Continents*, Altan, O. (Ed.), XXth ISPRS Congress, 12–23 July, Istanbul, Turkey, Istanbul (International Archives of Photogrammetry and Remote Sensing, XXXV, Part B/3), 201–206.

Wehr, A. and Lohr, U., 1999. Airborne laser scanning—an introduction and overview, *ISPRS Journal of Photogrammetry and Remote Sensing*, 54, 68–82

Zakšek, K., Oštir, K. and Kokalj, Ž., 2011. Sky-view factor as a relief visualization technique. *Remote Sensing of Environment*, 3(2), 398–415.

Cultural Heritage Documentation with RPAS/UAV | 7

Fabio Remondino and Efstratios Stylianidis

7.1 Introduction

In the past, the development of remotely piloted aircraft systems / unmanned aerial vehicles (RPAS/UAV) was primarily motivated by military goals and applications. Unmanned inspection, surveillance, reconnaissance and mapping of inimical areas were the primary military aims. In the last decade RPAS/UAV has also become a common platform for data acquisition in the heritage and geomatics fields. UAV photogrammetry [Colomina *et al.*, 2008; Heisenbeiss, 2009] indeed opens various new applications in the close-range aerial domain, introducing a valid alternative to the classical manned aerial photogrammetry for large-scale topographic mapping or detailed 3D recording of ground information and being also a valid complementary solution to terrestrial acquisitions. The latest UAV success and developments can be explained by the spreading of low-cost platforms combined with amateur or SRL digital cameras and miniaturized GNSS/INS navigation devices, necessary to navigate the platforms, predict the acquisition points and possibly perform direct geo-referencing. Although conventional airborne remote sensing has still some advantages and the tremendous improvements of very high-resolution satellite imagery are closing the gap between airborne and satellite mapping applications, UAV platforms are a very important alternative and solution for studying and exploring our environment, in particular for heritage locations or rapid response applications. Private companies are now investing and offering photogrammetric products (mainly digital surface models – DSM – and orthoimages) from UAV-based aerial images as the possibility of using flying unmanned platforms with variable dimensions, small weight and high ground resolution allow them to carry out flight operations at lower costs compared to conventional aircraft. Problems and limitations still exist, but UAVs are a really capable source of imaging data for a large variety of applications.

This chapter will review the most common RPAS/UAV platforms and applications in the heritage field, highlighting open problems and research issues related to regulations and data processing.

7.1.1 Terminology

Terminology is quite inhomogeneous and differs according to the research community. According to the *UVS* (unmanned vehicle system) *International* definition, an unmanned aerial vehicle (UAV) is a generic aircraft designed to operate with no human pilot on-board (http://www.uvs-international.org/). The term UAV is the most used in the geomatics and heritage communities, but other terms abound: drone, uninhabited air vehicle, remotely piloted aircraft system (RPAS), unmanned aerial system (UAS), remotely piloted vehicle (RPV), remotely operated aircraft (ROA), micro aerial vehicle (MAV), unmanned combat air vehicle (UCAV), small UAV (SUAV), low altitude deep penetration (LADP) UAV, low altitude long endurance (LALE) UAV, medium altitude long endurance (MALE) UAV, remote controlled (RC) helicopter and model helicopter are often used, according to their propulsion system, flying altitude, endurance and the level of automation in the flight execution. Some terms include the word 'system' to stress the fact that there is a bunch of components including a platform, some sensors, possibly an operator and a ground control station (GCS).

7.1.2 Platforms

It is quite complicated to classify RPAS/UAV platforms (Figure 7.1). Based on size, weight, endurance, range and flying altitude, *UVS International* defines three main categories of UAVs (Figure 7.2a):

1. Tactical UAVs which include micro, mini, close-, short-, medium-range, medium-range endurance, low altitude deep penetration, low altitude long endurance, medium altitude long endurance systems. The mass varies from a few kg up to 1,000 kg, the range from few km up to 500 km, the flight altitude from a few hundred metres to 5 km and the endurance from some minutes to 2–3 days.

Figure 7.1 Some commercial RPAS/UAV platforms for geomatics applications.

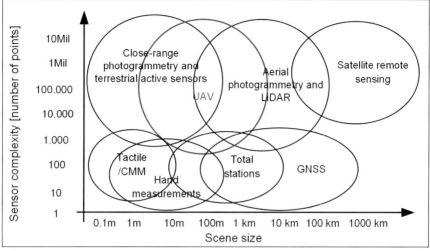

(a)

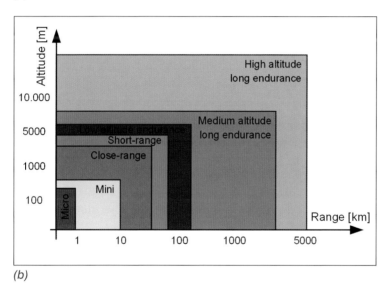

(b)

Figure 7.2 (a) Surveying techniques and platforms for geomatics applications. (b) A possible classification of RPAS/UAV platforms according to their range and flying altitude.

2. Strategical UAVs, including high altitude long endurance, stratospheric and exo-stratospheric systems which fly higher than 20,000 m altitude and have an endurance of 2–4 days.
3. Special tasks UAVs like unmanned combat autonomous vehicles, lethal and decoys systems.

UAVs for heritage and geomatics applications can also be briefly classified according their engine/propulsion system, i.e. (i) unpowered platforms (e.g. balloon, kite, glider, paraglider) and (ii) powered platforms (e.g. airship, glider, propeller, electric, internal

combustion engine – ICE). Alternatively, they could be classified according to their aerodynamic and 'physical' features as (i) lighter-than-air (e.g. balloon, airship), (ii) rotary wing, either electric or with combustion engine (e.g. single-rotor, coaxial, quadrocopter, multirotor) and (iii) fixed wing, either unpowered, electric or with combustion engine (e.g. glider or high wing).

Big and stable systems, generally based on an ICE, have longer endurance with respect to UAVs with electric engine and, thanks to the higher payload, they can carry medium format (SLR) cameras or LiDAR or SAR instruments on-board. Among the available platforms (Figure 7.1), the primary airframe types are fixed and rotary wings while the most common launch/take-off methods are, beside the autonomous mode, air-, hand-, car/track-, canister- or bungee cord launched.

A typical UAV platform for Geomatics purposes can cost from €1,000 up to €50,000 or more, depending on the on-board instrumentation, payload, flight autonomy, type of platform and degree of automation needed for its specific applications. Low-cost solutions are not usually able to perform autonomous flights, but require human assistance in the take-off and landing phases. Low-cost and open-source platforms and toolkits are presented in Bendea *et al.* [2008], Grenzdörffer *et al.* [2008], Meier *et al* [2011], Neitzel and Klonowski [2011] and Stempfhuber *et al.* [2011]. Simple and hand-launched UAVs which perform flights autonomously using MEMS-based (micro electro-mechanical systems) or C/A code GPS for the auto-pilot are the most inexpensive systems [Vallet *et al.*, 2011], although stability in windy areas might be a problem.

The developments and improvements at hardware and platform levels are done in the robotics, aeronautical and optical communities where breakthrough solutions are sought in order to miniaturise the optical systems, enhance the payload, achieve complete autonomous navigation and improve flying performance [Huckridge and Ebert, 2008; Schafroth *et al.*, 2009]. Researchers have also performed studies on flying invertebrates to understand their movement capabilities, obstacle avoidance or autonomous landing/take-off capabilities [Franceschini *et al.*, 2007; Moore *et al.*, 2007].

Among the various surveying techniques (Figure 7.2a), RPAS/UAV close the gap between aerial and close-range application and allow the derivation of very high-resolution 3D products.

7.1.3 History

UAVs were originally developed for military applications (using the term 'drone'), with flight recognition in enemy areas – without any risk for human pilots. In 1883, the first aerial photograph was acquired using a kite and a very long cable attached to the camera shutter. In 1898, during the Spanish–American War, the first military aerial reconnaissance photos were acquired. During World Wars I and II various radio-controlled unmanned aircraft were developed and tested to bombard the enemies. In the post-war years many military national organisations and forces started programmes to convert surplus aircraft into target drones. Thus the platforms improved in terms of performance,

propulsion and guidance systems. The first experiences for civil and geomatics applications were carried out at the end of the 1970s [Przybilla *et al.*, 1979]. Their use has greatly increased in the last decades thanks to the fast improvements of platforms, communication technologies and software as well as the growing number of possible applications.

7.1.4 Regulations

The use of such flying platforms in civil application has been restricted to increase the security of RPAS/UAV flights and avoid dangers for human beings. Thus, some years ago the international community started to define some security criteria for UAV. In particular, NATO and EuroControl started their cooperation in 1999 in order to prepare regulations for UAV platforms and flights. This work has not yet led to a common and international standard, especially for civil applications. But the great diffusion and commercialisation of new UAV systems has pushed several national and international associations to analyse the operational safety of UAVs. Each country has one or more authorities involved in the UAV regulations that operates independently. Due to the absence of cooperation between all these authorities, it is difficult to describe the specific aims of each of them without loss of generality. The elements of UAV regulations are mainly to increase the reliability of the platforms, underlining the need for safety certifications for each platform and ensuring the public safety. UAVs currently have different safety levels according to their dimensions, weight and on-board technology. For this reason, the rules applicable to each UAV could not be the same for all the platforms and categories. For example, in the US safety is defined according to their use (public or civic), in Europe according to the weight, as this parameter is directly connected to the damage they can produce when a crash occurs. Other restrictions are defined in terms of minimum and maximum altitude, maximum payload, area to be surveyed, etc. These rules are in continuous progress in most of the countries (http://www2.isprs.org/commissions/comm1/icwg15b/resources.html). As they are conditioned by technical developments and safety standards, rules and certifications should be set equal to those currently applied to comparable manned aircraft, although the most important issue, because UAVs areunmanned, is the safety of citizens in case of an impact. For these reasons, in 2013 the European Commission launched a roadmap for the integration of civil RPAS into the European aviation system. This roadmap should facilitate the decisions to be taken by the different organisations and stakeholders involved in the RPAS field, provide transparency and efficiency in the planning of different initiatives and support the coordination of the related activities in Europe.

7.2 Data acquisition and processing

7.2.1 On-board instruments and sensors

UAV platforms can be equipped with different type of sensors:

- **positioning sensors:** used to geo-locate the platform, autonomous navigation and navigation control. Such sensors consist of low-cost and light GNSS or IMU/INS devices.

- **imaging sensors:** used to acquire (vertical or oblique) images for inspection, documentation or mapping purposes. Such sensors can be compact or SLR digital cameras (according to the platform payload), working in the visible, thermal or multispectral domain.
- **ranging sensors:** used to survey a scene of interest and acquire directly 3D information. Such sensors can be light and cheap Kinect-like devices or more heavy LiDAR instruments.
- other devices like **gas or radiation sensors** to measure pollution and monitor environmental conditions.

These sensors collect different types of data which have various resolutions, formats, and dimensions. Data synchronisation and fusion is thus mandatory to fully exploit all the intrinsic characteristics and advantages of RPAS/UAV platforms.

7.2.2 Flight planning

The mission (flight and data acquisition) is normally planned in the lab with dedicated software, starting with the knowledge of the area of interest (AOI), the required ground sampling distance (GSD) or footprint and the intrinsic parameters of the on-board digital camera or LiDAR. In case of an imaging sensor, the camera perspective centres ('waypoints') are computed fixing the longitudinal and transversal overlap of the strips (e.g. 80%–60%). All these parameters vary according to the goal of the flight: missions for detailed 3D model generation usually request high overlaps and low altitude flights to achieve small GSDs, while quick flights for emergency surveying and management need wider areas to be recorded in few minutes, at a lower resolution. In case of LiDAR sensors, the flying height and paths are fixed based on the required ground sampling step (see also section 5.2.3).

There are also flights with no planning: the platform flies and the operator remotely controls the movements while the camera shoots images at a regular interval (e.g. 2 seconds).

7.2.3 Image acquisition

The flight is normally done in manual / assisted or autonomous mode (if planned), according to the mission specifications, platform type and environmental conditions. The presence on-board of GNSS/INS navigation devices is usually exploited for the autonomous flight (take-off, navigation and landing) and to guide image acquisition. The image network quality is strongly influenced by the typology of the performed flight (Figure 7.3): in the manual mode, the image overlap and the geometry of acquisition is usually very irregular, while the presence of GNSS/INS devices, together with a navigation system, can guide and improve the acquisition. The navigation system, generally called auto-pilot, is composed of both hardware (often in a miniaturised form) and software devices. An auto-pilot allows the UAV to perform a flight according the planning and communicate with the platform during the mission. The small size and the reduced payload of some UAV platforms limits the transportation of high-quality navigation devices like those coupled to airborne cameras or LiDAR sensors. The cheapest

(a) (b)

Figure 7.3 Typical image network configurations derived from (a) manual and (b) automated flying acquisitions.

solution relies on MEMS-based inertial sensors which feature a much reduced weight but accuracy not sufficient, up to now, for direct geo-referencing. More advanced and expensive sensors, perhaps based on a single/double frequency positioning mode or approaches based on the use of RTK, improve the quality of positioning to a decimetre/centimetre level, but they are still too expensive to be commonly used for low-cost solutions. During the flight, the autonomous platform is normally observed with a GCS which shows real-time flight data such as position, speed, attitude and height, GNSS observations, battery or fuel status, rotor speed, etc. Remotely controlled systems are piloted by an operator from the ground station. Most of these systems allow image data acquisition following the computed waypoints while low-cost systems, generally, acquire images with a scheduled interval. The devices used (platform, auto-pilot and GCS) are fundamental for the quality and reliability of the final result: low-cost instruments can be sufficient for small extensions and low altitude flights, while more expensive devices must be used for long endurance flights over wide areas. Generally, in the case of lightweight and low-cost platforms, a regular overlap in the image block cannot be assured as the platforms are strongly influenced by the presence of wind, piloting capabilities and GNSS/INS quality, which all randomly affect the attitude and location of the platforms during the flight. Thus, higher overlaps, with respect to flights performed with manned vehicles or very expensive UAVs, are usually recommended to keep these problems in check.

7.2.4 Photogrammetric image processing

Camera calibration and image orientation are two fundamental prerequisites for any metric reconstruction from images. In metrological applications, it is better to separate the two tasks into two different steps [Remondino and Fraser, 2006]. Indeed, calibration and orientation procedures require different block geometries, which can be better

optimised if they are treated in separate stages. On the other hand, in many applications where lower accuracy is required, calibration and orientation can be computed at the same time by solving a self-calibrating bundle adjustment. In the case of aerial cameras, the camera calibration is generally performed in the lab although in-flight calibration can also be performed [Colomina *et al.*, 2007], possibly adding at least one strip at different flying height. Camera calibration and image orientation tasks require the extraction of common features visible in as many images as possible ('tie points') followed by a bundle adjustment, i.e. a non-linear optimisation procedure in order to minimise an appropriate cost function [Brown, 1976; Gruen and Beyer, 2001; Triggs *et al.*, 2000].

Procedures based on the manual identification of tie points by an expert operator or based on signalised coded markers are well assessed and used today. Recently, fully automated procedures for the extraction of consistent and redundant sets of tie points from markerless close-range images have been developed for photogrammetric applications [Barazzetti *et al.*, 2011; Pierrot-Deseilligny and Clery, 2011]. Some efficient commercial solutions have also appeared on the market (e.g. PhotoModeler Scanner, Eos Inc; PhotoScan, Agisoft; Pix4DMapper, Pix4D) while commercial software for aerial applications still needs some user interaction or the availability of GNSS/INS data for automated tie point extraction. In *Computer Vision*, the simultaneous determination of camera (interior and exterior) parameters and 3D structure is normally called 'structure from motion' [Robertson and Cipolla, 2009; Snavely *et al.*, 2008]. Some free web-based approaches (e.g. Microsoft Photosynth, Autodesk ReCap, etc.) and open source solutions (VisualSfM, Bundler, Apero, etc.) are also available although generally not reliable and accurate enough in the case of large and complex image blocks with variable baselines and image scales. The employed bundle adjustment algorithm must be reliable, able to handle possible outliers and provide statistical outputs to validate the results. The collected GNSS/INS data, if available, can help for the automated tie point extraction and can allow the direct geo-referencing of the captured images. In applications with low metric quality requirements, e.g. for fast data acquisition and mapping during emergency response, the accuracy of direct GNSS/INS observation can be enough for direct geo-referencing purposes [Pfeifer *et al.*, 2009; Zhou, 2009; Turner *et al.*, 2013].

If the positioning system cannot be directly used (even for autonomous flight) as the signal is strongly degraded or not available (downtowns, rainforest areas, etc.), the orientation phase must rely solely on a pure image-based approach, thus requiring GCPs for scaling and geo-referencing. These two latter steps are very important in order to get metric results. To perform indirect geo-referencing, there are basically two ways to proceed:

1. Import at least three GCPs in the bundle adjustment solution, treating them as weighted observations inside the least squares minimisation. This approach is the most rigorous as (i) it minimises the possible image block deformations and possible systematic errors, (ii) it avoids instability of the bundle solution (conver-

gence to a wrong solution) and (iii) it helps in the determination of the correct 3D shape of the surveyed scene.

2. Use a free-network approach in the bundle adjustment [Dermanis, 1994; Granshaw, 1980] and apply only at the end of the bundle a similarity (or Helmert) transformation in order to bring the image network results into a desired reference coordinate system. This approach is not rigorous: the solution is sought minimising the trace of the covariance matrix, introducing the necessary datum with some initial approximations. As no external constraint is introduced, if the bundle solution cannot determine the right 3D shape of the surveyed scene, the successive similarity transformation (from the initial relative orientation to the external one) would not improve the result.

In theory, the two approaches are thus not equivalent and they can lead to totally different results, in particular for long image block with small strip overlap. In the first approach, the quality of the bundle is only influenced by the redundant control information and, moreover, additional check points can be used to derive some statistics of the adjustment. On the other hand, the second approach has no external shape constraints in the bundle adjustment so the solution is only based on the integrity and quality of the multi-ray relative orientation. The fundamental requirement is thus to have a good image network in order to achieve correct results in terms of computed object coordinates and scene's 3D shape.

Once a set of images has been oriented, the next steps follow the workflow described in Chapter 4. Starting with the known camera orientation parameters, a scene can be digitally reconstructed by means of interactive procedures or automated dense image matching techniques [Remondino *et al.*, 2014]. The output is normally a sparse or dense point cloud, describing the salient corners and features in the former case or the entire surface's shape of the surveyed scene in the latter case. For mapping purposes, an orthoimage is the final product which can reach some mm resolution. In case of low-accuracy applications (e.g. rapid response or disaster assessment) a simple image rectification method (without the need of dense image matching) can be applied followed by a stitching operation [Neitzel and Klonowski, 2011].

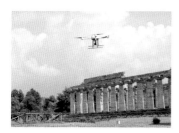

Figure 7.4 Example of RPAS campaign over the Roman-Greek temple in Paestum, with the recovered camera positions (centre) and final textured polygonal model (right).

7.3 Final remarks

The chapter has provided an overview of RPAS/UAV platforms, problems and acquisitions. RPAS can be used nowadays in different application domains, respecting the guidelines and security issues dictated by law. RPAS/UAV have recently received a lot of attention, since they are fairly inexpensive platforms, with navigation/control devices and recording sensors for quick digital data production. The great advantage of actual RPAS/UAV systems is the ability to quickly deliver high temporal and spatial resolution information and to allow a rapid response in a number of critical situations where immediate access to 3D geo-information is crucial. Indeed, they feature real-time capability for fast data acquisition, transmission and, possibly, processing. UAVs can be used in high-risk situations and inaccessible areas although they still have some limitations: for payload, insurance and stability in particular. Rotary wing UAV platforms can even take-off and land vertically, thus no runway area is required, while fixed wing UAVs can cover wider areas in a few minutes. For some applications not demanding very accurate 3D results, complete remote sensing solutions based on open hardware and software are also available. And in the case of small-scale applications, UAVs can complement or replace terrestrial acquisition (images or range data). The derived high-resolution images (GSD generally in the mm/cm level) can be used, alongside generating very dense point clouds, for texture mapping purposes on existing 3D data or for orthoimage production, mosaic, map and drawing generation. If compared to traditional airborne platforms, RPAS/UAV decrease the operational costs and reduce the risk of access in harsh environments, still keeping high accuracy potential. But the small or medium format cameras which are generally employed, in particular on low-cost and small payload systems, enforce the acquisition of a higher number of images in order to achieve the same image coverage at a comparable resolution. In these conditions, automated and reliable orientation software are strictly recommended to reduce the processing time. Some reliable solutions are nowadays available, even in the low-cost open-source sector.

The stability of low-cost and light platforms is generally an important issue, in particular in windy areas, although camera and platform stabilisers can reduce weather dependency. Generally, the stability issue is solved shooting many images (continuous acquisition or multiple shots from the predefined waypoints) and using, during the processing phase, only the best image. High altitude surveying can affect gasoline and turbine engines while the payload limitation enforces the use of low weight GNSS/IMU, thus denying direct geo-referencing solutions. New reliable navigation systems are nowadays available, but the cost has limited their use until now to very few examples. A drawback is thus the system manoeuvre and transportation that generally requires at least two persons.

UAV regulations are under development in several countries all around the world, in order to propose some technical specifications and areas where these devices can be used (e.g. over urban settlements), increasing the range of their applications. At the moment, the lack of precise rule frameworks and the tedious requests for flight per-

missions represent the biggest limitation for UAV applications and market take-off. Hopefully, the incoming EU regulations and framework will regulate UAV applications for surveying issues with a simple letter of intent.

In the near future, the most feasible improvement should be related to payload, autonomy and stability issues as well as faster (or even real-time) data processing thanks to GPU programming [Wendel *et al.*, 2012]. High-end navigation sensors, like DGPS and inexpensive INS, would allow direct geo-referencing with accurate results. In the case of low-end navigation systems, real-time image orientation could be achieved with on-board advanced SLAM (simultaneous localisation and mapping) methods [Strasdat *et al.*, 2010]. Lab post-processing will most probably always be mandatory for applications requiring high accuracy results. On the other hand, the acquisition of image blocks with a suitable geometry for photogrammetric process is still a critical task, especially in the case of large-scale projects and non-flat objects (e.g. buildings, towers, rock faces). While the planning of image acquisition is quite simple when using nadir images, the same task becomes much more complex in the case of 3D objects requiring convergent images. Two or more flights can be necessary over large areas, when UAV with reduced endurance limits are used, leading to images with illumination changes due to the different acquisition time that may affect the DSM generation and orthoimage quality. Future research is needed to develop tools for simplifying this task.

References

Barazzetti, L., Scaioni, M. and Remondino, F., 2011. Orientation and 3D modeling from markerless terrestrial images: combining accuracy with automation. *The Photogrammetric Record*, 25(132), 356–381.

Bendea, H., Boccardo, P., Dequal, S., Giulio Tonolo, F., Marenchino, D. and Piras, M., 2008. Low cost UAV for post-disaster assessment. *International Archives of Photogrammetry, Remote Sensing and Spatial Information Sciences*, Beijing, China, 37(B1), 1373–1379.

Brown, D.C., 1976. The bundle adjustment – progress and prospects. *International Archives of Photogrammetry*, 21(3).

Colomina, I., Aigner, E., Agea, A., Pereira, M., Vitoria, T., Jarauta, R., Pascual, J., Ventura, J., Sastre, J., Brechbühler de Pinho, G., Derani, A. and Hasegawa, J., 2007. The uVISION project for helicopter-UAV photogrammetry and remote-sensing. *Proc. of the 7th International Geomatic Week*, Barcelona, Spain.

Colomina, I., Blázquez, M., Molina, P., Parés, M.E. and Wis, M., 2008. Towards a new paradigm for high-resolution low-cost photogrammetry and remote sensing. *International Archives of Photogrammetry, Remote Sensing and Spatial Information Sciences*, Beijing, China, 37(B1), 1201–1206.

Dermanis, A., 1994. The photogrammetric inner constraints. *ISPRS Journal of Photogrammetry and Remote Sensing*, 49(1), 25–39.

Eisenbeiss, H., 2009. UAV photogrammetry. Dissertation ETH No. 18515, Institute of Geodesy and Photogrammetry, ETH Zurich, Switzerland, Mitteilungen 105.

Franceschini, N., Ruffier, F. and Serres, J., 2007. A bio-inspired flying robot sheds light on insect piloting abilities. *Current Biology*, 17(4), 329–335.

Granshaw, S.I., 1980. Bundle adjustment method in engineering photogrammetry. *Photogrammetric Record*, 10(56), 111–126.

Grenzdörffer, G.J., Engel, A. and Teichert, B., 2008. The photogrammetric potential of low-cost UAVs in forestry and agriculture. *International Archives of Photogrammetry, Remote Sensing and Spatial Information Sciences*, Beijing, China, 2008, 37(B1), 1207–1213.

Gruen, A. and Beyer, H.A., 2001. System calibration through self-calibration. In: *Calibration and Orientation of Cameras in Computer Vision, Springer Series in Information Sciences*, Gruen and Huang (Eds.), 34, 163–194.

Huckridge, D.A. and Ebert, R.R., 2008. Miniature imaging devices for airborne platforms. *Proc. SPIE*, Vol. 7113, 71130M. DOI: http://dx.doi.org/10.1117/12.799635.

Meier, L., Tanskanen, P., Fraundorfer, F. and Pollefeys, M., 2011. The PIXHAWK open-source computer vision framework for MAVS. *International Archives of Photogrammetry, Remote Sensing and Spatial Information Sciences*, Zurich, Switzerland, 38(1/C22).

Moore, R.J.D., Thurrowgood, S., Soccol, D., Bland, D. and Srinivasan, M.V., 2007. A bio-inspired stereo vision system for guidance of autonomous aircraft. *Proc. International Symposium on Flying Insects and Robots*, Ascona, Switzerland.

Neitzel, F. and Klonowski, J., 2011. Mobile 3D mapping with low-cost UAV system. *International Archives of Photogrammetry, Remote Sensing and Spatial Information Sciences*, Zurich, Switzerland, 38(1/C22).

Neitzel, F. and Klonowski, J., 2011. Mobile 3D mapping with low-cost UAV system. *International Archives of Photogrammetry, Remote Sensing and Spatial Information Sciences*, 38(1/C22), Zurich, Switzerland.

Pfeifer, N., Glira, P. and Briese, C., 2012. Direct georeferencing with on board navigation components of light weight UAV platforms. *International Archives of Photogrammetry, Remote Sensing and Spatial Information Sciences*, Melbourne, Australia, 39(7).

Pierrot-Deseilligny, M. and Clery, I., 2011. APERO, An Open Source Bundle Adjustment Software for Automatic Calibration and Orientation of Set of Images. *International Archives of Photogrammetry, Remote Sensing and Spatial Information Sciences*, 38 (5/W16).

Przybilla, H.-J. and Wester-Ebbinghaus, W., 1979. *Bildflug mit ferngelenktem Kleinflugzeug. Bildmessung und Luftbildwesen. Zeitschrift fuer Photogrammetrie und Fernerkundung*. Herbert Wichman Verlag, Karlsruhe, Germany.

Rehak, M., Mabillard, R. and Skaloud, J., 2013. A micro-UAV with the capability of direct georeferencing. *International Archives of Photogrammetry, Remote Sensing and Spatial Information Sciences*, 40 (1/W2), 317–323.

Remondino, F. and Fraser, C., 2006. Digital cameras calibration methods: considerations and comparisons. *International Archives of Photogrammetry, Remote Sensing and Spatial Information Sciences*, 36(5), 266–272.

Remondino, F., Spera, M.G., Nocerino, E., Menna, F. and Nex, F., 2014: State of the art in high density image matching. *The Photogrammetric Record*, 29(146), 144–166.

Robertson, D.P. and Cipolla, R., 2009. Structure from motion. In: *Practical image processing and computer vision*, Varga, M., (Ed.), John Wiley, Chapter 13.

Schafroth, D., Bouabdallah, S., Bermes, C. and Siegwart, R., 2009. From the test benches to the first prototype of the muFly micro helicopter. *Journal of Intelligent and Robotic Systems*, 54(1–3), 245–260.

Snavely, N., Seitz, S.M. and Szeliski, R., 2008. Modeling the world from Internet photo collections. *International Journal of Computer Vision*, 80(2), 189–210.

Stempfhuber, W. and Buchholz, M., 2011. A precise, low-cost RTK GNSS system for UAV applications. *International Archives of Photogrammetry, Remote Sensing and Spatial Information Sciences*, Zurich, Switzerland, 38(1/C22).

Strasdat, H., Montiel, J.M.M. and Davison, A.J., 2010. Scale drift-aware large scale monocular SLAM. *Robotics: Science and Systems*.

Triggs, W., McLauchlan, P., Hartley, R. and Fitzgibbon, A., 2000. Bundle adjustment – a modern synthesis. In: *Vision Algorithms: Theory and Practice*, Triggs, W., Zisserman, A. and Szeliski, R., (Eds.), LNCS, Springer Verlag, 298–375.

Turner, D., Lucieer, A. and Wallace, L., 2013. Direct georeferencing of ultrahigh-resolution UAV imagery. *IEEE Trans. Geoscience and Remote Sensing*, 52(5), 2738–2745

Vallet, J., Panissod, F., Strecha, C. and Tracol, M., 2011. Photogrammetric performance of an ultra-light weight Swinglet UAV. *International Archives of Photogrammetry, Remote Sensing and Spatial Information Sciences*, Zurich, Switzerland, 38(1/C22).

Wendel, A., Maurer, M., Graber, G., Pock, T. and Bischof, H., 2012. Dense reconstruction on-the-fly. *Proc. IEEE International CVPR Conference*, Providence, USA.

Zhou, G., 2009. Near real-time orthorectification and mosaic of small UAV video flow for time-critical event response. *IEEE Trans. Geoscience and Remote Sensing*, 47(3), 739–747.

Index